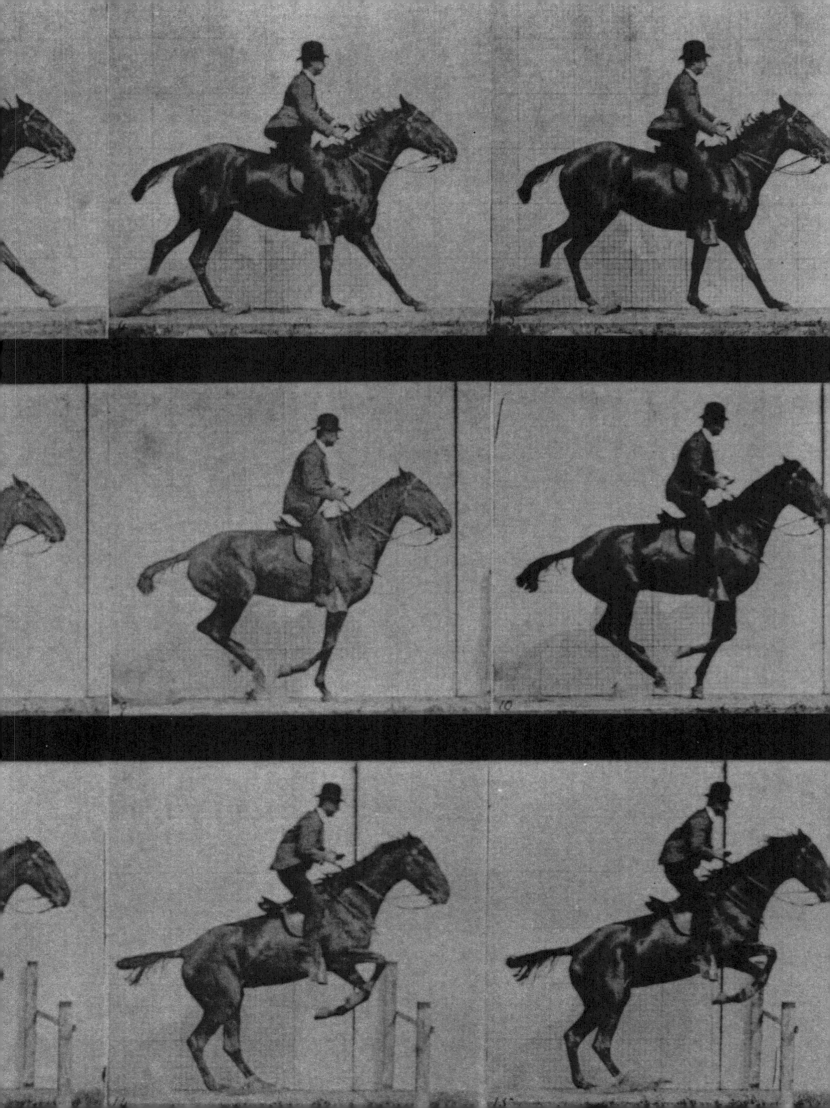

# The Artist
## and the Camera

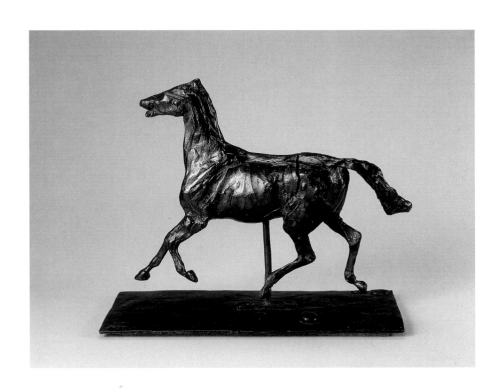

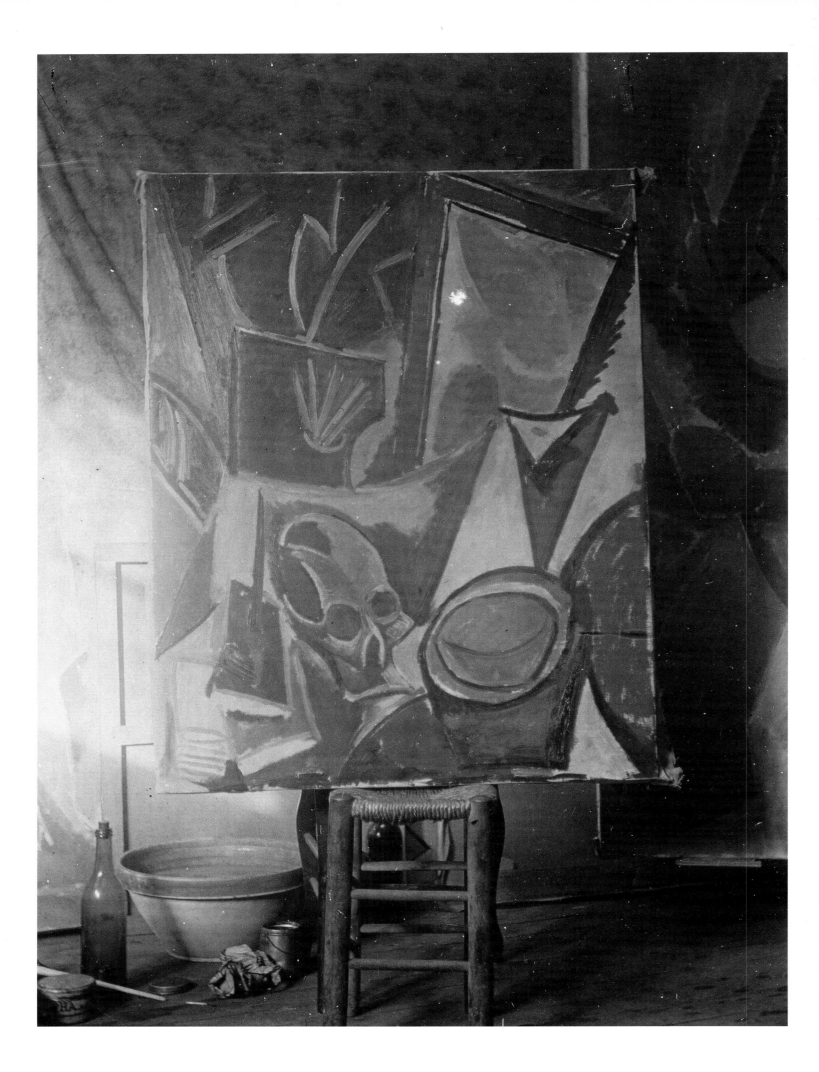

BONNARD

BRANCUSI

DEGAS

GAUGUIN

KHNOPFF

MOREAU

MUCHA

MUNCH

PICASSO

RODIN

ROSSO

VON STUCK

VALLOTTON

VUILLARD

# The Artist and the Camera

## *Degas to Picasso*

DOROTHY KOSINSKI

DALLAS MUSEUM OF ART

distributed by
YALE UNIVERSITY PRESS
New Haven and London

*The Artist and the Camera: Degas to Picasso* was organized by the Dallas Museum of Art. Bank of America is the National Sponsor. American Airlines is the official carrier of the exhibition. Additional funding for the exhibition, publication, and related programs was provided by The Eugene McDermott Foundation, Mr. and Mrs. John Tolleson, Michael L. Rosenberg, The Irvin L. Levy Family Fund of Communities Foundation of Texas, Inc., and the Chairman's Circle of the DMA.

EXHIBITION ITINERARY

San Francisco Museum of Modern Art
October 2, 1999–January 4, 2000

Dallas Museum of Art
February 1–May 7, 2000

Fundación del Museo Guggenheim, Bilbao
June 12–September 10, 2000

DMA Managing Editor: Debra Wittrup
Assistant Curator: Eik Kahng
Curatorial Assistant: Jed Morse
Publications Assistant: Suzy Sloan Jones
Visual Resources Manager: Rita Lasater

Front endsheet: Eadweard Muybridge, *Animal Locomotion, Horse and Rider with Derby Jump,* Plate 636, 1887, Gernsheim Collection, Harry Ransom Humanities Research Center, The University of Texas at Austin (cat. 30)

Page 1: Edgar Degas, *Trotting Horse, the Feet Not Touching the Ground,* c. 1881, Fine Arts Museums of San Francisco (cat. 18)

Page 2: Pablo Picasso, *"Composition with Skull" in the Bateau-Lavoir Studio,* Paris, summer 1908, Private Collection

Page 8: (top) Mary or Franz von Stuck, *Study for "Sisyphus,"* c. 1897–99, Nachlaß Franz von Stuck Privatbesitz; (bottom) Franz von Stuck, *Sisyphus,* 1920, Katharina Büttiker Collection, Galerie Wühre 9—Art Deco–Zürich (cat. 350)

Page 10: Pablo Picasso, *Young Man with a Fan,* c. 1899–1900, Musée Picasso, Paris (cat. 474)

Distributed by Yale University Press.

**Library of Congress Cataloging-in-Publication Data**
Kosinski, Dorothy M.
    The artist and the camera : Degas to Picasso / Dorothy Kosinski.
        p.   cm.
    Catalog of an exhibition held at the San Francisco Museum of Modern Art, Oct. 2, 1999–Jan. 4, 2000, the Dallas Museum of Art, Feb. 1–May 7, 2000, and the Fundación del Museo Guggenheim, Bilbao, June 12–Sept. 10, 2000.
    Includes bibliographical references and index.
    ISBN: 0-300-08168-5
    1. Art and photography—Europe—History—19th century Exhibitions. 2. Art and photography—Europe—History—20th century Exhibitions.   I. San Francisco Museum of Modern Art. II. Dallas Museum of Art. III. Fundación del Museo Guggenheim, Bilbao. IV. Title.
N72.P5K67   1999
701'.05—dc21                                                    99-38276

Edited by Fronia W. Simpson

Proofread by Amy Smith Bell with assistance by Elizabeth White

Designed by John Hubbard with assistance by Patrick David Barber

Index by Frances Bowles

Typeset by Marie Weiler in Le Monde Sans with heads and selected type in Mrs. Eaves

Produced by Marquand Books, Inc., Seattle

PRINTED AND BOUND BY CS GRAPHICS PTE., LTD., SINGAPORE

# Contents

# Lenders to the Exhibition

Allen Memorial Art Museum, Oberlin, Ohio

Archives Picasso, Musée Picasso, Paris

Archives Jacques Rodrigues-Henriques, Paris

The Art Institute of Chicago

John Berggruen Gallery, San Francisco

Mr. Christian Beslu, Tahiti

Bibliothèque nationale de France, Paris

Sarah Campbell Blaffer Foundation, Houston

Mr. Miles Booth

Bridgestone Museum of Art, Ishibashi Foundation, Tokyo

The Brooklyn Museum of Art

Katharina Büttiker Collection, Galerie Wühre 9—Art Deco–Zürich, Switzerland

Camera Works, Inc.

The Iris & B. Gerald Cantor Foundation, Los Angeles

Carnegie Museum of Art, Pittsburgh

Centre des Archives d'Outre-Mer, Aix-en-Provence

The Cleveland Museum of Art

Dallas Museum of Art

Dallas Public Library

the deLIGHTed eye, London–New York

Patrick Derom Gallery, Brussels

Des Moines Art Center

Fine Arts Museums of San Francisco, M. H. de Young Memorial Museum

Fogg Art Museum, Harvard University, Cambridge, Massachusetts

Collection Fondation Pierre Gianadda, Martigny, Switzerland

Mr. Fabrice Fourmanoir, Tahiti

Fridart Foundation

Gernsheim Collection, Harry Ransom Humanities Research Center, The University of Texas at Austin

Glasgow Museums: Art Gallery & Museum, Kelvingrove

Greentree Foundation, New York

Mr. David Grob

Solomon R. Guggenheim Museum, New York

Hamilton Library, University of Hawaii at Manoa

The Alex Hillman Family Foundation, New York

Hirshhorn Museum and Sculpture Garden, Smithsonian Institution, Washington, D.C.

Didier Imbert Fine Art, Paris

Indiana University Art Museum, Bloomington

The Israel Museum, Jerusalem

Collection Josefowitz

Kern Institute, Leyden, The Netherlands

Kunsthaus Zurich

Galerie Claude van Loock, Brussels

Los Angeles County Museum of Art

Galerie Daniel Malingue, Paris

Collection of Peter Marino, New York

The Mayor Gallery, London

The Metropolitan Museum of Art, New York

Minneapolis Public Library

The Mucha Trust, London

Munch-museet, Oslo

Münchner Stadtmuseum

Musée d'Art Moderne de la Ville de Paris

Musée Cantonal des Beaux-Arts de Lausanne, Switzerland

Musée de Grenoble

Musée Gustave Moreau, Paris

Musée Picasso, Paris

Musée national de l'Orangerie, Paris

Musée d'Orsay, Paris

Musée départemental Stéphane Mallarmé, Vulaines-sur-Seine

Musée Rodin, Paris

Musées Royaux des Beaux-Arts de Belgique, Brussels

Museo Rosso, Barzio

Museu Picasso, Barcelona

Museum der bildenden Künste, Leipzig, Germany

Museum of Fine Arts, Boston

Museum of Fine Arts, Springfield, Massachusetts

Museum moderner Kunst, Stiftung Ludwig, Vienna

Museum Villa Stuck, Munich

Edward Tyler Nahem Fine Art, New York

The Patsy R. and Raymond D. Nasher Collection, Dallas

National Gallery of Art, Washington, D.C.

The Nelson-Atkins Museum of Art, Kansas City

Openluchtmuseum voor Beeldhouwkunst Middelheim, Antwerp

The Phillips Collection, Washington, D.C.

Posters Please, Inc., New York

Rijksmuseum, Amsterdam

The Saint Louis Art Museum

Mr. Antoine and Mrs. Colette Salomon, Paris

San Francisco Museum of Modern Art

Smith College Museum of Art, Northampton, Massachusetts

Staatsgalerie Stuttgart

Estate Franz von Stuck, Munich

The Tate Gallery, London

Mr. Antoine Terrasse, Paris

Mr. Ronny van de Velde, Antwerp, Belgium

Westfälisches Landesmuseum für Kunst und Kulturgeschichte, Münster

Collection Wildenstein, New York

Yale University Art Gallery, New Haven, Connecticut

Zabriskie Gallery, New York

And the generous lenders who wished to remain anonymous.

# Sponsor's Preface

BANK OF AMERICA is a company rich in history and possibilities. We are proud and honored to be working in partnership with the Dallas Museum of Art and the San Francisco Museum of Modern Art as principal sponsors of *Degas to Picasso: Painters, Sculptors, and the Camera.* This major exhibition explores the role of the photograph in the work of fourteen turn-of-the-century artists, including such well-known favorites as Edgar Degas, Auguste Rodin, and Pablo Picasso, as well as several lesser known artists, such as Fernand Khnopff and Félix Vallotton. The complex interplay between photographs, paintings, drawings, and sculpture reveals the surprising prevalence of the camera in the symbolist aesthetic.

BANK OF AMERICA has long supported the arts. We believe that our involvement provides opportunities for cultural enrichment for the communities we serve and for our stakeholders and customers. The exhibition also provides a pathway for cultural and artistic enjoyment and learning for our BANK OF AMERICA associates and their families and friends. We believe that our commitment to the arts translates into an enduring investment in the quality of life in our communities.

We hope you enjoy *Degas to Picasso* as an example of the timeless vitality of the arts in enriching our lives.

Rowland K. Robinson
*President*
*Bank of America, Dallas*

Barbara J. Desoer
*President*
*Bank of America, Northern California*

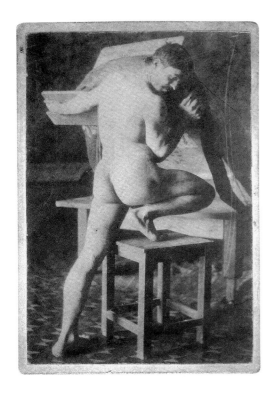

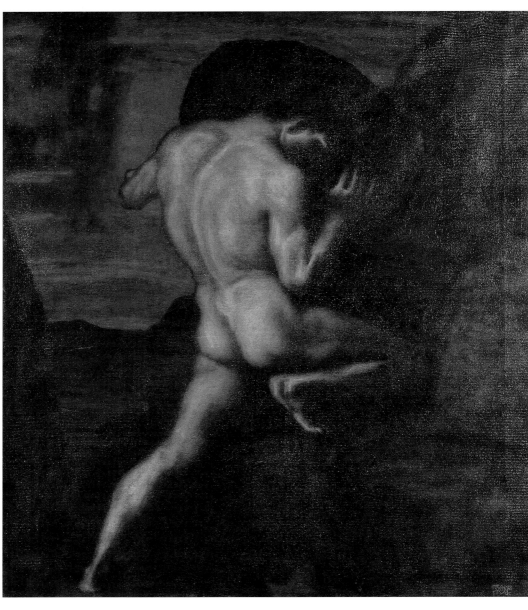

# Director's Foreword

This publication and the exhibition it accompanies, *Degas to Picasso: Painters, Sculptors, and the Camera,* offer an alternative vision of the place of photography in late-nineteenth- and early-twentieth-century art history as, together, they explore the role of the photograph in the working and conceptual processes and the artistic production of fourteen turn-of-the-century artists. While previous investigations have tended to align photography and Realism, this project intrepidly situates the photograph at the heart of the symbolist aesthetic.

Modernist studies have lately been broadened in their scope of examination, and *Degas to Picasso: Painters, Sculptors, and the Camera*—by presenting not only the well-known avant-garde leaders Edgar Degas, Auguste Rodin, Paul Gauguin, Edvard Munch, Pierre Bonnard, Edouard Vuillard, Constantin Brancusi, and Pablo Picasso but also a number of other important artists who have traditionally been located somewhat on the periphery, Fernand Khnopff, Gustave Moreau, Alphonse Mucha, Medardo Rosso, Franz von Stuck, and Félix Vallotton—aspires to contribute to this endeavor. Some of these artists were photographers themselves; some used others' photographs; some made photographs as independent artworks; some took pictures or borrowed others' photographic images to use as source materials for their work in different media; and yet others made photographic afterimages of their own sculpture and paintings, some for documentation, others with the purpose of artistic expression. The diverse stories of these artists' engagement with the photograph are, individually, deeply revealing; the overall phenomenon of photography as a central factor in the developing modernist enterprise is doubly and crucially fascinating.

This project was the concept of Dorothy Kosinski, the Barbara Thomas Lemmon Curator of European Art at the Dallas Museum of Art, and its realization—among the most ambitious undertakings the museum has mounted—is testament to her curiosity, scholarly insight, and dedication to the art and culture of early modernism. We offer great thanks to her for her accomplishment. At the venture's inception in the early 1990s, Dr. Kosinski benefited enormously from a series of conversations with Elizabeth C. Childs, professor of art history at Washington University in St. Louis. Not only has Dr. Childs contributed major essays to this book, she has also continued to enrich the project as a whole in her role as curatorial consultant. In her endeavors Dr. Kosinski was supported by Jay Gates, my predecessor as director of the museum, and by Charles L. Venable, its interim director and chief curator. Dr. Kosinski also enjoyed the particular collaboration of Eik Kahng, assistant curator of European art, as well as the invaluable assistance of Jed Morse, the Edward and Betty Marcus Curatorial Intern. The project was brought to fruition through the efforts of key members of the Museum's staff: Giselle Castro-Brightenburg, Alex Contreras, Patti Broyles, Kim Bush, Randy Daugherty, Nancy Davis, Rick Floyd, Shelley Foster, Tom Jenkins, Suzy Sloan Jones, Ellen Key, Mary Leonard, Rita Lasater, Gabriela Truly, Debra Wittrup, and Cathy Zisk.

Several years ago, when I was serving as director of the San Francisco Museum of Modern Art, through the good offices of David Resnicow, Dorothy Kosinski visited and told us the story of the exhibition she was organizing at the Dallas Museum of Art. We were instantly engaged, sensing that SFMOMA shared in its rich and lively photography program a kindred interest in just the issues she was exploring. We are very pleased that the exhibition will have its premier at SFMOMA and, in this happy coincidence of my present and past circumstances, I warmly thank my successor, David A. Ross, and my former colleagues Lori Fogarty, Sandra Phillips, Douglas Nickel, and Janet Bishop for their continuing commitment to this project. We further thank our European partner in the presentation of the exhibition, the Guggenheim Museum Bilbao.

This publication's executive editor is Dorothy Kosinski, who is also author of substantial portions of its content, joined by Elizabeth C. Childs, Ulrich Pohlmann, director of the Fotomuseum in Munich, and Douglas R. Nickel, associate curator of photography at the San Francisco Museum of Modern Art. Additional essays were prepared by Jane R. Becker, Eik Kahng, and Jack Rennert. Anne Baldassari, curator at the Musée Picasso, and Elizabeth Brown, chief curator, University Art Museum, University of California at Santa Barbara, not only supplied monographic essays to the catalogue but also added their curatorial expertise to the shaping of the Picasso and Brancusi chapters, respectively. To each of these scholarly collaborators we offer special thanks for their contributions. The publication was copyedited by Fronia W. Simpson, designed and produced by Marquand Books, and copublished with Yale University Press, all of whom deserve our rich appreciation.

A project of this scope, drawing on collections from around the world and demanding original scholarship, could not have been undertaken without generous sponsorship. Bank of America, with highly important banking centers in both Dallas and San Francisco, is the major contributor and national sponsor. We are especially appreciative of the guidance from and encouragement of DMA trustee J. Tim Arnoult as well as Rowland K. Robinson and Cynthia Fisher in Dallas and Caroline Boitano, Barbara Desoer, and Christine and Michael Murray in San Francisco. American Airlines is the exhibition's official carrier, and we particularly thank DMA trustee Gerard J. Arpey and his company for their long-standing support of the Museum. The project additionally enjoyed substantial gifts from The Eugene McDermott Foundation, Mr. and Mrs. John C. Tolleson, Michael L. Rosenberg, and The Irvin L. Levy Family Fund of Communities Foundation of Texas, Inc. It is further significantly supported by the DMA Chairman's Circle: Linda and Bob Chilton, Dallas Museum of Art League, Adelyn and Edmund Hoffman, Barbara Thomas Lemmon, Joan and Irvin Levy, The Edward and Betty Marcus Foundation, Howard E. Rachofsky, Deedie and Rusty Rose, and Mr. and Mrs. Charles E. Seay. I extend my deepest gratitude to each of these benefactors for making possible the exhibition, its publication, and its interpretive programming.

On behalf of Dr. Kosinski, we also wish to thank the many individuals who have assisted with invaluable scholarly advice, practical guidance, and indispensable resources: Anne Baldassari, Félix Baumann, Janet Bishop, Rachael Blackburn, Emily Braun, Linda Briscoe, Elizabeth Brown, Isabelle de la Brunière, Elizabeth C. Childs, James Clifton, Pieter Coray, Carlos Alberto Cruz, Joanne Birnie Danzker, Lisa Dennison, Patrick Derom, Matthew Drutt, Elizabeth Easton, Arne Eggum, Sylvester Engbrox, Dominique de Font-Réaulx, Bonny J. Forrest, Gary Garrels, Jay Gates, Pierre Georgel, Léonard Gianadda, Ellen Gordesky, Gloria Groom, Françoise Heilbrun, Phyllis Horan, Roger Horchow, Anne Horton, Ellen Josefowitz, Paul Josefowitz, Stephen Kadwalader, Thomas Krähenbühl, Geneviève Lacambre, Mary Levkoff, Irvin Levy, Henri Loyrette, Jason McCoy, Daniel Malingue, Edouard Malingue, Patrice Marandel, James Mayor, Margaret McDermott, Sarah Mucha, Stephen Nash, Raymond D. Nasher, Douglas Nickel, Ronald Pickvance, Hélène Pinet, Joachim Pissarro, Lionel Pissarro, Sandrine Pissarro, Ulrich Pohlmann, Gérard Régnier, Jack Rennert, Danila Marsure Rosso, Antoine and Colette Salomon, Katharina Sayn-Wittgenstein, Laura Schwartz, Hélène Seckel, Carrie Shargel, Howard Stein, Jean-Louis Tréhin, Douglas Walla, Barbara Wiedenmann, Virginia Zabriskie, and Jörg Zutter.

Finally, and of paramount importance, I would like to extend very special thanks to the many lenders to *Degas to Picasso: Painters, Sculptors, and the Camera,* who have been so kindly liberal in making their works available to this exhibition.

John R. Lane
*The Eugene McDermott Director*
*Dallas Museum of Art*

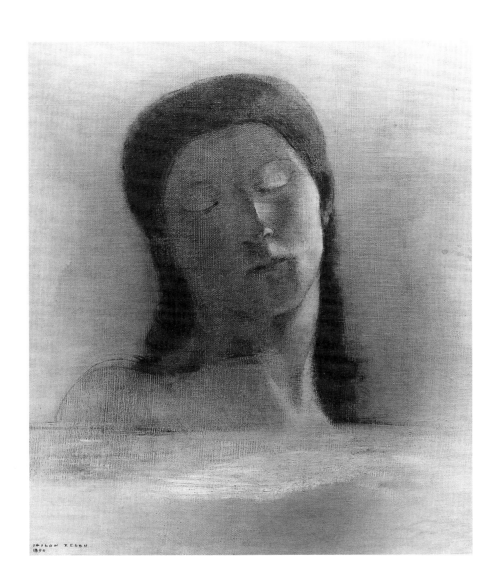

*Dorothy Kosinski*

# Vision and Visionaries: The Camera in the Context of Symbolist Aesthetics

*Here, near my hut, in total silence, I dream of violent harmonies amid the natural perfumes that intoxicate me. . . . Eyes that dream have the quivering surface of an unfathomable enigma. And now comes night—everything rests. My eyes are closed so that they might see without understanding the dream that flees before me into infinite space; and I feel the sweet, sad progress of my hopes.*

—Paul Gauguin,
letter to André Fontainas,
Tahiti, March 1899

*Alas! My eyes no longer lead
My soul to my eyelids' shore,
It has flowed back into the ebbing tide
Of its prayers
It is deep within my closed eyes,
And only its weary breath
Still raises just above the water
Its frosty lilies.*

—Maurice Maeterlinck,
*Serres chaudes,* 1955

*We go simply, like a woman carrying the severed head of Orpheus, before the* Femme portant la tête d'Orphée, *and we see something in this head of Orpheus that looks at us, the thought of Gustave Moreau painted on this canvas, which looks at us with these beautiful blind eyes which are thought colors.*

—Marcel Proust,
"Notes sur le monde mystérieux de
Gustave Moreau," c. 1898–1900

Paul Gauguin's letter, dedicated to Stéphane Mallarmé ("[In] vague memory of a beautiful, beloved face, with a limpid glance in the darkness"), Maurice Maeterlinck's poem, "Aquarium," and Marcel Proust's description of his solemn pilgrimage to the Musée de Luxembourg to view Gustave Moreau's famous painting of Orpheus, all emphasize the negation of sight or vision. Eyes are closed; eyes look within; eyes dream; eyes are blind.

Odilon Redon's evocative, indeterminate painting *Closed Eyes* (fig. 1) is another paradigmatic expression of the symbolists' favored theme of the interior landscape. Redon's means are subtle and few: the delicately featured, even androgynous figure, bathed in a gentle golden illumination and immersed in an unmoving pool of water up to the shoulders, is effectively decorporealized. The aqueous, thinly brushed blue-gold environment is a synaesthetic or metonymic equivalent for the contemplative state of mind of the meditative figure, an oceanic oneness with nature.

These texts and image capture the symbolists' preoccupation with vision turned inward toward a psychological landscape. The eye is redirected from the visible to the visionary. This theme is consonant with their aesthetic goals generally: the symbolists rejected "objective" naturalism in favor of creative individuality. The artist aspired to an exalted, almost sacerdotal function, withdrawing from the everyday world. The symbolists do not name or depict things, but rather evoke the idea of things. They aspire to an art free from the mediation of traditional metaphor and allegory, eloquent in its essential formal elements. Small wonder that painter and critic and poet alike embraced music —an art that imitates nothing—as the paradigm for their aesthetic ideal: the synthesis of all the arts,

Fig. 1 Odilon Redon, *Closed Eyes,* c. 1890, oil on canvas, Musée d'Orsay, Paris

13

the correspondences between the senses, the revelation of unseen truths.

What possible function could the photograph have in this context, so adamantly removed from the everyday world? What meaning could it carry in the suffocatingly charged environment of Joris-Karl Huysmans's decadent hero Des Esseintes, or in Mallarmé's refined sphere of "poetic perfection" and "sacred language"? The common assumption (and that which has informed the literature on Symbolism) is that the photograph and photographic equipment would have been an unthinkable intrusion of technology in the rarefied symbolist environment, a visual artifact too factual, too closely tied to its referent to hold meaning and resonance in the symbolists' works. What is revelatory about our project is a demonstration of the pervasive role of the photograph in the work and working methods of an international panoply of the most noted artists of the symbolist era. We also reveal how photography is intrinsically related to the symbolists' redefinition of vision and the role of the artist.

One might be tempted to dismiss the pervasiveness of this medium as the reflection of superficial factors, for instance, an inexpensive substitute for elaborate studio sessions with live models; or as souvenirs from the World Expositions that became so popular in the nineteenth century; or as the result of a banal middle-class play with quick and easy cameras; or as collectibles forming an "imaginary museum"; or as convenient records of works in progress. Indeed, at the end of the nineteenth century the ready availability of photographs and the accessibility of easy photographic techniques rendered the medium a ubiquitous visual phenomenon. Photographs existed across a vast range of quality, style, subject, and purpose: from the painters' or sculptors' own photographs of their ambience or of their own works, to cartes de visite, to commercially produced tourist photographs, to professional-quality art photographs of monuments or works of art; to double-exposed photographs passed off as "spirit photographs," to chronophotographic experiments, and so forth.

What is more instructive, however (and about both sides of the equation of Symbolism and photography), is to explore how pervasiveness of the photographic medium is complicit in the changing notions of the visible, the visual, and the visionary. In other words, at the turn of the century photography had evolved to be much more than an efficient technical tool, more than a precedent for or paradigm of a way of seeing. Rather, photography emerged as another expression of a new way of thinking about the phenomena of perception, time, and space—in short, of rationalizing ideas about psychological or emotional realities. Aesthetic-philosophic questions about transience,

fragmentation of time and space, and duration of memory were tied to a loss of confidence in traditional concepts of perception and codes of representation, issues that permeated all the artistic media at the turn of the century and the dawn of modernism.

Antiocularcentric critics have of late emphasized photography's part in a general "frenzy of the visible" that held the nineteenth century in sway but contributed ironically to a crisis in confidence in human sight and in the tradition of Cartesian perspectivalism.[1] Essentially, far beyond superficial aspects of convenience or curiosity, our artists were fascinated with unseeable things that photography could reveal in X-ray photographs, in microscopic photographs, in double exposures, in chronophotographic experiments. If the symbolist artist turned away from objects in the visible world, the photograph suggested a new scopic realm often inflected with issues of time, memory, nostalgia, motion, and space. These aesthetic ideas are contemporaneous with the concepts of Henri Bergson, for example, whose philosophy entails an explicit devaluation of vision, vesting perceptual power instead in the body, in all of its senses. Reality is something internal, private, *la durée,* which embraces self and space, in time—rather than as an external construct.[2]

The Artist, the Photograph, the Camera

Let us consider the variety of the artists' uses of photographs, and also their differing abilities with the camera and varying familiarity with technical aspects of the medium. At first glance, it seems that many of the artists (Fernand Khnopff, Gustave Moreau, Alphonse Mucha, Edvard Munch, and Franz von Stuck) simply used the photograph as a quick sketch, an expedient aid toward the completion of the final work of art. In these cases, however, this simple explanation proves deceptive, with each artist embracing the photograph in his work in unique and surprising ways.[3]

With Edgar Degas the photograph is a deliberately elaborate confirmation of the suspicion of other visual realities. Alternatively, it can provide an intense picturing of the inner psychic terrain (Munch); a means of seeing and preserving or controlling the essential qualities of the work of art (Constantin Brancusi, Auguste Rodin, Medardo Rosso); a collection or encyclopedia of images from remote places, from the past, or from memory (Gauguin, Khnopff, Moreau, Pablo Picasso); or a reification of the texture of one's daily surroundings (Pierre Bonnard, Félix Vallotton, Edouard Vuillard).

There is a wide range of meaning in the artists' uses of photographs. Degas's photographs are independent explorations of motifs and compositions that the artist explores in other media as well. Several magnificent and unsettling negatives

of ballet dancers in casual or relaxed poses clearly form the basis for the intimate studies of dancers in pastel, oil, and bronze. Gauguin kept a picture-postcard image of Borobudur in his vest pocket like a treasured if tattered talisman, a tonic, as it were, to his personal disappointment with his own experiences in the French colonies, a simulacrum for an unattainable ideal. Moreau made meticulous tracings of lacelike details of photographs he had studied in public exhibitions. He also made detailed drawings based on photographs of models taken in his studio, part of an elaborate multi-phased process that resulted in the completion of his large-scale and complicated finished compositions. Rosso obsessively cropped and annotated his photographs to articulate and frame the essential aspects of his sculptures. Khnopff reappropriated photographs of his painted works, delicately and meticulously reworking the surfaces of the prints, creating thereby another finished and independent work of art, a "remembrance" of the earlier work two times removed, part of an interrelated series that recapitulates the ideas of nostalgia and memory, which are the dominant themes of his aesthetic world. In Mucha's case the photographic print occasionally bears the crisscrossed lines of the grid that allowed easy transfer of the motif to a large-scale canvas. Rodin and Stuck sometimes explored compositional alterations on the surfaces of the photographic prints, considering changes in the size of objects or disposition of figures. Stuck (or perhaps his wife) made enlargements of his photographs, which he subsequently transferred to canvas by means of a tracing technique. In contrast, the palm-sized format of the prints produced by the Nabis' hand-held Kodaks would seem to prescribe the intimate size and visual density of many of their canvases.

Making photographs was for several of the artists apparently unimportant. Rodin seems never to have made photographs himself but rather worked intimately with a number of different photographers, from Eugène Druet to Jacques-Ernest Bulloz to Edward Steichen, orchestrating through their work a vast interpretive record of his sculpture and working methods. Gauguin, though he was surely familiar with photographic techniques, more importantly surrounded himself with photographic images that nurtured his compositions in specific ways. Moreau clearly staged photographic sessions in his studio, but it appears likely that it was his assistant-secretary, Henri Rupp, who was the actual photographer of the carefully posed models.

For others, taking photographs was of paramount importance. The anecdote of Rosso's demise, succumbing to a gangrenous injury from the fall of a stack of heavy glass photographic plates, is a poignant closure to the story of his intensely creative role as photographer. Brancusi was the butt of comments from a number of professional photographers (such as Man Ray) who criticized the lack of technical finish of his photographs. Brancusi, like Rosso, remained totally indifferent to that issue and was resolutely adamant that he alone could know, and with the camera interpret, the essence of the sculptural object.

Some of Degas's other photographs, also dating from 1895–96, are laboriously posed portraits of friends and family, usually in a dimly lamplit twilight, revealing the artist's commitment to cumbersome photographic techniques. Despite the arduous poses that Degas apparently "inflicted" on his sitters, these photographs represent an intimate view of his inner circle of friends quite in contrast to the elaborately staged mise-en-tableaux of Khnopff, Mucha, or Stuck. In addition, Mucha is the photographer of an evocative series taken during a trip to Russia, used, of course, as the inspiration for specific motifs in his *Slav Epic,* but which constitutes a remarkably evocative study of the Russian people. Stuck frequently relinquished his camera to his wife when he wished to play the role of model (or more precisely in his case, dramatic actor), providing the perfect expressive direction for the completion of the canvas in progress. In addition to the high-quality photographs of his works commissioned from the professional photographer Arsène Alexandre, Khnopff's house-studio also encompassed a sophisticated photographic studio, which he and others used to produce the carefully staged shots most frequently of his sister in the guise of symbolist priestess of his interiorized world.

Bonnard, Vallotton, and Vuillard surely did not require their many Kodak snapshots as aides-mémoires, as quicker-than-the-hand sketches of their intimate environment directly at hand. On the contrary, their scenes of family and friends were readily accessible, unfolding continually before their eyes. Rather, it seems that with photography, these artists re-created their environment at an aesthetic remove. They could eradicate sound and any other ephemeral sensory distractions. Their tiny Kodak prints are like small clips of memory, intimate moments, images in which the breath is held, protected from the sequential flow of time. Fragments of reality, these images are dense and saturated with intimacy and closeness.

"Is the Camera the Friend or Foe of Art?" Nonetheless, a significant discrepancy exists between this apparent enthusiastic engagement with the medium and many of the artists' public statements about photography. Gauguin, for instance, relegated photography to a nonemotive technical device employed by the academics. As Elizabeth C. Childs points out in her essay in this catalogue on the artist, photography was dismissed by Gauguin as a technological gizmo: "Machines have come,

art has fled, and I am far from thinking photography can help us."[4] Munch dissimulated, too, with this ambiguous statement: "The camera cannot compete with painting so long as it cannot be used in heaven and hell."[5] Surveys in a variety of art journals and photography magazines indicate the currency of the artists' ambiguous stance toward the (by then not so very) new medium. The *Magazine of Art* in 1899 posed the question directly: "Is Photography among the Fine Arts?"[6] In another survey the English artist Walter Sickert seems loath to pollute the realm of painting with photography: "It would be well if the fact that a painting was done from or on a photograph were always stated in the catalogue."[7] His is a very traditional standpoint, echoing the ambivalence that characterized the debates earlier in the century. Jean-Dominique Ingres's comment, for example, was, "Which of us could achieve this exactitude . . . this delicate modeling . . . indeed, what a wonderful thing photography is—but one dare not say that aloud."[8] Small wonder that those responsible for Moreau's estate sought to protect his reputation by hiding his cache of photographs. Degas's photographic experiments remained until recently unknown and unstudied. They seem to have been private documents, products of Degas's persistently inventive exploration of the potential of different media; but at the same time an expression of a dark, melancholic moment in his life and an intimate reflection, too, of his circle of close friends and family. Was it only Rodin who professed an admiration for photography, championing Steichen with the following words: "I believe that photography can create great works of art, but hitherto it has been extraordinarily bourgeois and babbling. No one ever suspected what could be got out of it; one doesn't even know today what to expect from a process which permits of such profound sentiment and such thorough interpretation of the model, as has been realized in the hands of Steichen."[9]

This anguished ambivalence about the aesthetic value of photography is evidently linked to its perception as a pure, mechanical record of reality, to, as John Szarkowski has described it, its inherent "factuality."[10] The photograph was perceived as an automatic medium, which could not help but record outside reality, without subjectivity, sentiment, or interpretation. As Szarkowski points out, this attitude only hardened, even reached a point of crisis, as the technical aspects of photography evolved and improved and thereby stripped away any mollifying aura of mystery and difficulty.[11] The international pictorialist movement at the turn of the century was clearly a response to this situation and an effort to shore up the dignity of art photography. Charles H. Caffin tackles this dilemma in his 1901 book, *Photography as a Fine Art*,[12] differentiating between utilitarian

and aesthetic photographs. His analysis seems to hinge at least partially on issues of pure subject matter, the utilitarian photographs adopting machines, war scenes, and daily life as their subjects. More generally, he explains that one exists to "record facts" and the other as "an expression of beauty." What is remarkably perplexing and especially relevant to our examination of the symbolists' attitudes toward the medium is Caffin's statement: aesthetic photography "is the photograph whose motive is purely aesthetic: to be beautiful. It will record facts, but not as facts."[13]

## Photography and Symbolism's "Special Language"

How can a fact not be a fact? Caffin's apologia for aesthetic photography indulges an apparent oxymoron that sounds very close to the pains that the symbolist theorist, G. Albert Aurier, took to differentiate *idéaliste* from *idéiste* in his exegesis of the synthetic, subjective, and decorative essence of Symbolism. Not unlike Caffin, Aurier struggles to distance symbolist painting from figurative, anecdotal, and narrative qualities of realist painting; to strip Symbolism, as it were, from subject as fact.

> Many individuals even admit that they cannot understand how painting, a representational art above all else, able to imitate to the point of illusionism all the visible attributes of matter, might be anything other than a faithful and exact reproduction of objective reality, an ingenious facsimile of the so-called real world. The idealists themselves (again I stress that one must not confuse them with the artists I call ideists) were most often, whatever they may say, nothing but realists. The goal of their art was the direct representation of material forms; they were satisfied to arrange objective reality according to conventional notions of quality. They prided themselves on representing beautiful objects, but those objects are beautiful only inasmuch as they are objects, the interest of their work residing always in the form—that is, in reality. Indeed, what they call ideal was only crafty makeup applied over ugly tangible things. In a word, they have painted a conventional objective reality, but objective reality nonetheless.[14]

Is Aurier claiming that the true symbolist painter, his ideist, paints fact but not as fact? In the same essay Aurier pointedly adopts photography as a paradigm of hackneyed realism: "as impersonal and banal as photographs."[15] Clearly there is a concurrence between the controversy about art photography and the aesthetic debates concerning Symbolism, and each case, it would seem, focused on the rub between the metaphysical reality of the medium and its purported aspirations. Aurier rejects illusionism, but just as surely traditional

allegory or metaphor and any ordinary subject matter. "The goal of painting, as of all the arts . . . cannot be the direct representation of objects. Its end purpose is to express ideas as it translates them into a special language."[16]

Ironically, the concept of Symbolism's "special language"—freed from representation, liberated from the banality of realistic form and subject, aspiring to the nondescriptive power of music, and anticipating the nonobjective basis of abstract art—was decidedly influenced in its formulation by technological developments, and notably by the field of photography, and their resultant resonance with philosophical ideas that called into question the reliability of our commonly held notions of reality and fact. The marvel of the chronophotographic experiments of Etienne-Jules Marey and Eadweard Muybridge was their revelation of an aspect of reality normally not perceived, an incontrovertible confirmation that there was more to reality than met the eye.[17] In this sense, for instance, X-ray technology made manifest another dimension normally undetectable with the naked eye. Linda D. Henderson has thoroughly explored the relevance of X rays to contemporaneous spiritist notions of the fourth dimension and its impact, in turn, on symbolist theories and evolving abstraction.[18] Jonathan Crary has explored the dramatic revolution (or crisis) in optics in *Techniques of the Observer: On Vision and Modernity in the Nineteenth Century.*[19] Martin Jay, exploring a different and later context, has referred to this dramatic revolution as the "denigration of vision."[20] Technological innovations offered compelling confirmation of the suspicion that our eyes were blinded—due to conventions of perception, observation, and representation—to other or parallel or higher realities.[21]

Let us return to Symbolism's special language, the aspiration to depict a fact but not as a fact. The Belgian poet Emile Verhaeren invoked this concept in his discussion of the works of Khnopff,[22] with the idea of a secret language, "an algebra the key to which is lost."[23] The aesthetic means are "evocation . . . apart from any description or enumeration of facts."[24] Mallarmé's "intentional obfuscation," his notion of artist as priest to decipher the *grimoire* (secret tome), Charles Baudelaire's *forêt de symboles* are all expressions of this central idea of the symbolist aesthetic. Is not Khnopff himself close to the idea of depicting a fact, but not as a fact, with his comment to Jules Du Jardin: "one must take the tangible object as something intellectual"?[25] Though Khnopff hides behind a veil of dissimulation—"We have no opinion for or against photography. The photograph can facilitate the artist's documentation, the artist can refine the taste of the photograph. As far as the technical side of photography, our ignorance is still bigger than that of M. de la Sizeranne"[26]—

we submit that it is precisely the photograph that facilitates Khnopff's depiction of fact but not as a fact. It is the means by which the artist purifies the object and transforms it into symbol. Khnopff's extensive use of photography is the key to his eschewal of description and allegory; to paraphrase Emile Verhaeren, it is a means of purification: "The symbol, therefore, purifies itself through the process of evocation as it becomes idea; it is a sublimation of perceptions and sensations; it is not demonstrative but suggestive; it destroys any contingency, any fact, any detail; it is the highest and most spiritual artistic expression possible."[27]

Khnopff's photographs of his sister can hardly be adequately understood as something like quick sketches. He posed her in elaborate costumes, mysteriously gesturing, to apparently precious if unidentifiable accoutrements. He thereby distances her from reality. These photographs have nothing to do with her portrait but are documents of a fiction, simulacra of a deity of a world of Khnopff's imagination. In like fashion, Khnopff's velvety evocations of his birthplace, Bruges, are not based on his direct recent experience in that mysterious town, and perhaps only remotely on his childhood memories, but most specifically on the heliogravures by E. Neurdein that illustrated the 1882 Flammarion edition of Georges Rodenbach's book *Bruges-la-Morte.* And this does not even touch on the poet's text as the intermediate "reality" on which Khnopff based his symbolist images.[28] By means of a reappropriation of his own imagery via photographs of his works of art, Khnopff suspends yet another scrim in the complex and expanding space between the work of art and fact or reality. His pastel strokes blend almost imperceptibly with the subtle tonalities of the photographic print, obfuscating the ontological distance between the "model" (that is, the original work of art) via its simulacrum (the photograph) and the new composition.

PHOTOGRAPHY AND "NEW PSYCHOLOGY"

The visual arts of the turn of the century reveal an obsession with psychological reality appropriate to the age of Freud. The inner landscape supplants objective reality but without giving way to self-confessional anecdote. Here one thinks of Gustave Kahn's axiom: "The essential goal of our art is to objectify the subjective (the exteriorization of the Idea) rather than to subjectify the objective (nature viewed through a temperament)."[29] Munch characterized his artistic mission as the "dissection of psychic phenomena."[30] The Polish writer Stanislaw Przybyszewski characterized Munch's paintings as *Seelenlandschaften* (soulscapes), as "absolute correlatives of bare feelings." "He paints, as only a naked individuality can see, whose eyes are turned away from the world of events toward his inner world."[31] The psychic

complexity of self and the subjectivity of optical reality are joined in his body of work from 1927 to 1932, which includes photographs, drawings, and paintings of May 1930, recording the visual distortions resulting from the ruptured blood vessel (cats. 328a, 328b). His self-portraits focus quite literally on his eye; the camera, sometimes hand-held at arm's length, defines the artist's visual field and its impaired quality.[32] Munch's photographic self-portraits confirm this reading of his work in their probing intensity. They are, however, not narrative or descriptive but direct and seemingly free of careful orchestration. Munch's art, including his photographic experiments, are unfiltered expressions of raw feelings, embodiments of what the Viennese critic Hermann Bahr termed "in the nerves" *(auf den Nerven)* in his "romanticism of the nerves," coupling "new psychology" and "new painting."[33]

There is incidentally an almost photographic element in Bahr's description of the ability of the new psychology to probe the darkness of the unconscious, to bring the truths of the soul to light:

> *The old psychology still only finds the end effects of feelings, expression formed at the end of consciousness and retained in memory. The new psychology would look for the initial elements of feeling, the beginnings in the dark regions of the soul before they emerge into the clarity of day. . . . Psychology is transferred from the intellect to the nerves. The new psychology, therefore, which seeks the truth about feelings, looks for feelings in the nerves, just as the new painting, which insists on true colors, looks therefore for colors in the eyes, while all older art barricaded itself into consciousness which carries lies into everything.[34]*

So one must consider Degas's laborious, penetrating photographic examinations of his sitters in a condition of almost total darkness, as though searching with his lens for something hidden within those faces that could not readily be perceived by the human eye in the light of day. The catalogue accompanying the recent exhibition of Degas's photographs probes the symbolist elements of his experimentation in this medium. Eugenia Parry wrote: "Degas exploited the formal language of Symbolism by eradicating clues of tactile experience and navigable space for unknowable darkness. Figures arise like lost souls from deep shadow, having relinquished their worldly identity. These Symbolist qualities are perhaps more apparent in Degas's photography than anywhere else in his work."[35] Does the mysterious, crepuscular quality of so many of the Nabis's lamplit interiors infuse a psychological tension into these works that are usually seen as casual scenes of everyday life?[36]

## THE PAINTER–PHOTOGRAPHER

A major issue, as we have already mentioned in the context of Khnopff, is the artists' photographing their own preexisting works of art. This, too, is a crucial aspect of the work and working methods of Brancusi, Picasso, Rodin, Rosso, and Stuck. Khnopff used photographs of his work literally as the basis for new works of art. Stuck appears to have integrated photography completely into the process of finishing his major oil paintings. He would, as I discuss in the monographic essay on him, literally bring his painting to a halt to change his own position, thrusting himself in front of the camera lens, refining a motif, even with the as yet incomplete work of art photographed in the background. In December 1912 Picasso interrupted his work in his boulevard Raspail studio to photograph a wall-mounted assemblage of his *papiers collés* and related drawings and cardboard constructions, so he could visualize and thereby more fully understand the complex interplay he had established between media (cat. 504; fig. 2). To describe this photography as simply technical assistance would seem to skirt its crucial conceptual significance within Picasso's radical experimentation with media. At the moment of the birth of Synthetic Cubism, Picasso was battling with the visual conundra of void representing volume, of printed paper's being manipulated to function as a visual transparent veil and yet signify the density of objects. In one instance the individual *papiers collés* compositions visible in the photograph are numbered, so as to establish a sequence. Near the cardboard construction of a guitar, which is given pride of place at upper center, Picasso inserted the cover of a journal—*Illustration.* Clearly visible, it serves as the "title" of this new assemblage and photographic work of art. By 1913 Picasso was indulging in an even more daring interchangeability of media. For instance, he put sand into his painted compositions, real upholstery fringe into a wood construction, and an actual absinthe spoon into a painted bronze sculpture.[37]

Picasso's photograph from early 1913 records an elaborate assemblage that combined real studio objects, such as a bottle, table, chair, canvases, frames, and posters, with a large-scale, unfinished figure composed of a drawing, *papiers collés,* collaged string, and newspaper "arms" that "hold" an actual guitar. This wonderfully humorous tableau vivant is a complicated and intellectually deft manipulation of signs within the multilayered realities of the visual realm. The figure is the central subject of the composition; certainly the canvas support dominates the studio. Yet the figure—logically the artist himself or his sitter—is absent, in that the drawing remains as yet still clearly unfinished. We can take the drawing to be a surrogate for Picasso himself who has changed

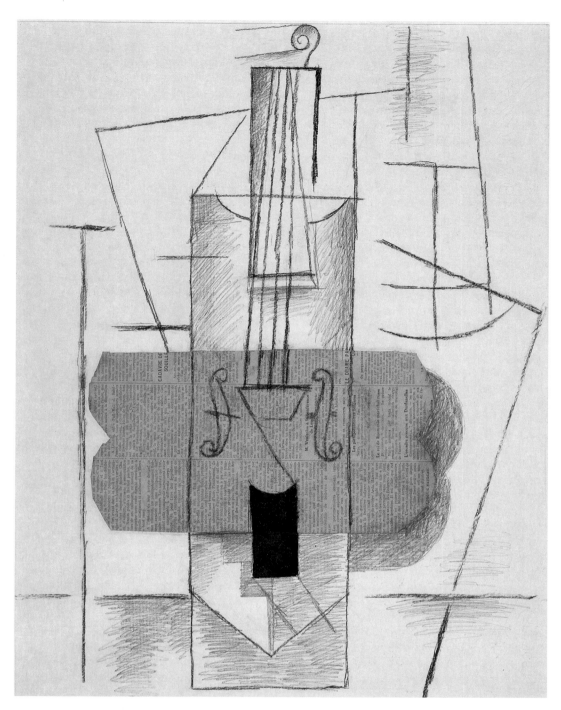

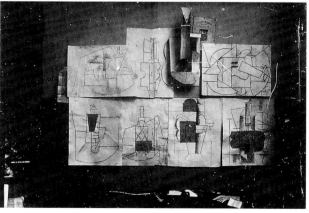

Cat. 504 Pablo Picasso,
*Composition with Violin,* 1912,
pencil, charcoal, gouache, and
newspaper on paper, 24 ×
18¼ in., Private Collection

Fig. 2 Pablo Picasso, *Wall
Arrangement of Papiers Collés
in the boulevard Raspail Studio*
*(No. 2),* Paris, winter 1912,
gelatin silver print, Private
Collection

positions, abandoning his guitar and the role of self-portrait subject (leaving behind too his papers and scissors to function as *coupeur/colleur/assembleur*) to take up a position behind the camera to create this new composition that embraces all these media and roles. In her rich study *Picasso's Variations on the Masters,*[38] Susan Grace Galassi barely mentions photography except in terms of Picasso's collection of postcard reproductions, part of his "imaginary museum," an idea that Anne Baldassari discusses at some length, too, in her essay in the present volume. Galassi links Picasso's "confrontations with the past" to his active dialogue with his own seminal works from earlier periods in his long and fruitful career, a dialogue that would seem to function already in the 1912–13 *papiers collés* and the related photographs under discussion here. They reflect a basic and underlying aesthetic attitude that informs all of Picasso's work, which Galassi sums up in her final pages: "Picasso's dialogue with Manet reveals a similar ambition to encompass within a continually transforming suite of works all of the possibilities of pictorial representation, while reaching beyond painting to drawing, graphic work, and sculpture to a synthesis of all the arts."[39]

## SCULPTOR AS PHOTOGRAPHER

A concept of the synthesis of all the arts, and especially an obsessive consciousness of the sculptural object within its environmental envelope of light and atmosphere, would seem to be the reason for Rosso's passionate involvement with photography. Some scholars have even privileged photography as Rosso's primary aesthetic medium. It seems evident, however, that photography became integral to his work because it was consonant with or appropriate to his artistic goals. Rosso understood his sculptures as part of a phenomenological whole that embraced the dimensions of time and space, memory and movement. Photographs of his sculptures allowed him to push experiments that he could not accomplish in the sculptures themselves, even with his startling innovations with wax, unusual patinas, or the bronzing of plasters. In photography Rosso could explore the dimensions of time, space, and movement by introducing effects of blurring through veils of emulsion, with vibration during exposure, or with abrasion of the print surface. Rosso was apparently possessed with a desire to control how his sculptures were perceived—in effect, to control the observer. Most of all, Rosso adamantly insisted that the sculpture is not an object to be explored through touch. Rather, its life, its interior significance, is tied to its visual qualities—values, tones, colors. With the techniques mentioned already, but also with radical croppings and mounting of the prints, Rosso attempted to ensure the object's perceptual environment/reception, not relinquishing it to the happenstance of an insensitive eye. For Rosso the photograph was never as insubstantial as a document and is surely more than a surrogate for a sculpture. Indeed, Rosso's evocative photographs, which he scratched and painted, are innovative multimedia works of art of mysterious power.

## OPERATOR/SPECTATOR/SPECTRUM— PHOTOGRAPH AS SELF-PORTRAIT

If one recalls in this context Roland Barthes's ontological reflections on photography in *Camera Lucida,*[40] it would seem that Rosso takes on all three of the "practices" that Barthes discovers in photography: that of the Operator/Photographer, the Spectator/Viewer, and the Spectrum/Object. Rosso's obsession can be understood in the following way: having assumed the roles of both photographer and viewer, he refuses to relinquish control of the object that is his own creation. He hence creates anew in the manipulation of the print and refocuses the entire process on his own vision, making his oeuvre entirely self-referential, a self-portrait.

Powerful evidence of the impact of the artist's orchestration of the photography of his works is surely found in Rodin's dialogue with Edward Steichen, resulting for instance in photographic images that would seem almost to supersede the actual sculpture in the viewer's imagination. In the case of the *Monument to Balzac,* one can say that here the sculptor does indeed relinquish his work, allowing Steichen to re-create it as a colossal dark silhouette in moonlight, a sculptural menhir beyond human time, and thereby to determine (beyond Rodin's or Steichen's own time) how we understand and view it.

Let us return, this time with the example of Brancusi's work, to the notion of the artist's own photographs of his own sculptures as a kind of self-portrait. Is this act always and inherently a self-portrait but ironically embodying at the same time Mallarmé's insistence on the "elocutionary disappearance of the poet"?[41] Elizabeth A. Brown has described Brancusi's photographs of his sculptures: "like a striking portrait of a person, they reveal multifaceted personalities and suggest something of the individual's unique sensibility."[42] They are indeed highly inflected with Brancusi's own vision, his thoughts and innermost intentions with his art. "The photographs are intimate, having recorded an emotional interaction between the artist and his creation. . . . To see a Brancusi sculpture reproduced in the artist's own photograph can infuse the viewing of the actual object with some of the artist's own desire, his own thoughts on the work."[43] One can argue that, in their insight into his creative personality, these photographs of the sculptural oeuvres surpass

the actual self-portraits that Brancusi also shot. In symbolist terms one might describe the photographic images of the sculptor's studio as a *Seelenlandschaft.*

## CONCLUDING COMMENTS

Our project probes the role, function, and meaning of the photograph in the world of an international selection of turn-of-the-century artists from roughly 1885 to 1915. We examine especially the relevance of the photograph to the nineteenth century in general, specifically the symbolist redefinition of the scopic.

We do not aim to replicate the all-embracing aspirations of recent symbolist exhibitions.[44] Our project follows on previous exhibitions that have probed the relationship of the painter and the photograph. A 1977 presentation at the Kunsthaus Zürich was, however, framed in the broadest possible terms, exploring a 150-year period, embracing all types of cross-fertilization between photography and other visual arts and embracing such diverse artists as Louis-Jacques Daguerre and William Wegman.[45] Twenty years later, Erika Billeter, who had spearheaded the 1977 project, launched another major exhibition, this time devoted to the dialogue between sculpture and photography.[46] Moreover, recent years have witnessed monographic exhibitions and book-length publications and articles dealing with individual artists and photography.[47] Our project represents the first attempt at a synthetic examination, not only of what the artists of the turn of the century did with photographs, but what the photograph signified in an era gripped by a growing lack of confidence in the factual and the visible and yet inspired by a search to give aesthetic form to metaphysical truths.

We have examined the artists' expressions of distrust vis-à-vis photography. It is nonetheless important not to exaggerate this ambivalence toward the new medium. It has recently been demonstrated—for instance, in the recent František Kupka exhibition[48]—that science was integral to important aspects of the symbolist aesthetic and to nascent abstraction. Kupka embraced photographic images—microscopic, telescopic, chronophotographic, X-ray—into his quest for a holistic vision of nature and his art as the revelation of those truths. Kupka's aesthetic and philosophical reflections (first written in the years 1907–13 and published in Czech in 1923), titled *Creation in the Plastic Arts,* focuses on his desire to accommodate two cognitive impulses: the rational and the irrational, the objective and the subjective. Hardly opposed to natural science, Kupka contended

Fig. 3 František Kupka, Illustration for *Creation in the Plastic Arts,* Prague, S.V.U. Manes, 1923

that science would have a positive influence on art: "Physiology and biology could well become a compulsory grammar for every artist."[49] His attitude is reflected in the illustrations to his treatise, including drawings after microphotographs and astronomical photographs (fig. 3). The human eye is juxtaposed to a planetary body; the cortex of the brain with the craters on the lunar surface. The antagonism between art and technology may in fact be exaggerated as a result of the modernist criticism, which stresses polarization and teleological linearity.

On the other hand, late-nineteenth-century artists surely felt the impact of that period's tidal wave of visual information. They inevitably reacted to the quality of those images; the reductive aspect of the reproduction with its inherent disregard for size, medium, and the physicality of the original object. They were also confronted with the phenomenon of homogenization and decontextualization of images through their ready display in expositions, sale in photo shops and archives, and distribution in a variety of publications. From easy access emerged the question of reproducibility versus authenticity. One cannot help but be struck by the parallel between the last fin de siècle and our own turn of the century, one hundred years later, similarly fraught with ambivalence about an avalanche of visual information, this time via electronic media. We should perhaps be heartened by the symbolist generation's ability to derive poetry and inspiration from photography. Despite Walter Benjamin's dire reading of the impact of technology and mass culture,[50] our project makes clear that the artists of the turn of the century succeeded in assimilating the photograph into their work and discovering in masses of eclectic visual material a rich and sustaining treasure trove.

NOTES

Epigraphs:

Quoted in Henri Dorra, ed., *Symbolist Art Theories: A Critical Anthology* (Berkeley, Los Angeles, and London: University of California Press, 1994), p. 209.

"Hélas! Mes yeux n'amènent plus/Mon âme aux rives des paupières,/Elle est descendue au reflux/De ses prières/Elle est au fond des mes yeux clos,/Et seule son haleine lasse/Elève encor à fleur des eaux/Ses lys de glace." Maurice Maeterlinck, *Serres chaudes* (Paris: Librairie des Lettres, 1955), p. 63. As translated by Elaine L. Corts in Patrick Laude, "'Souls under Glass': Poetry and Interiority in the Works of Rodenbach and Maeterlinck," in *Georges Rodenbach: Critical Essays,* ed. Philip Mosley (Cranbury, N.J., London, and Mississauga, Ontario: Associated University Presses, 1996), p. 117.

In Marcel Proust, *Contre Sainte-Beuve* (Paris: Pléiade, 1971), p. 671.

1. Jean-Louis Comolli, "Machines of the Visible," in *Cinematic Apparatus,* ed. Teresa de Lauretis and Stephen Heath (New York: St. Martin's Press, 1985), p. 122, as quoted in Martin Jay, *Downcast Eyes: The Denigration of Vision in Twentieth-Century French Thought* (Berkeley, Los Angeles, and London: University of California Press, 1993), p. 149. Comolli's attitude is extreme: "At the very same time that it is thus fascinated and gratified by the multiplicity of scopic instruments which lay a thousand views beneath its gaze, the human eye loses its immemorial privilege; the mechanical eye of the photographic machine now sees *in its place,* and in certain aspects with more sureness. The photograph stands as at once the triumph and the grave of the eye. There is a violent decentering of the place of mastery in which since the Renaissance the look had come to reign. . . . Decentered, in panic, thrown into confusion by all the new magic of the visible, the human-eye finds itself affected with a series of limits and doubts." Comolli, p. 123, as quoted in Jay, pp. 149–50.

2. Ibid., p. 151.

3. Indeed, the least interesting issue of our project is the idea of influence—that of the artists' own photographic "sketches" on later "finished" compositions, or that of other photographers' work on the formal innovations or iconography of these artists' oeuvres. Indeed, the simplistic idea of ascribing historical precedence to photography as the source for our notion of avant-garde compositional formulas has already been effectively debunked by Peter Galassi and Kirk Varnedoe. See Galassi, *Before Photography: Painting and the Invention of Photography* (New York: The Museum of Modern Art, 1981); Varnedoe, "The Artifice of Candor: Impressionism and Photography Reconsidered," *Art in America* 68, no. 1 (January 1980): 66–78; and Varnedoe, "The Ideology of Time: Degas and Photography," *Art in America* 68, no. 6 (summer 1980): 96–110. Instead, what is remarkable are the multiple significances and uses of the photograph, and, most important, the fluidity that exists between photography, painting, and sculpture.

4. Paul Gauguin, *Oviri, écrits d'un sauvage,* ed. Daniel Guérin (Paris: Gallimard, 1974), p. 158.

5. Arne Eggum, *Munch and Photography* (Newcastle upon Tyne: The Polytechnic Gallery, 1989), p. 59.

6. *Magazine of Art* 23 (1899): 157 ff. And "A Propos de la photographie dite d'art," *Annexe aux Bulletins de la Classe des Beaux Arts* (1916): 224–26. See also Fritz Mathies-Masuren and Fernand Khnopff, "Zählt die Photographie zu den schönsten Künsten," *Photographisches Centralblatt* 5 (1899): 203–8.

7. Gleeson White, "Is the Camera the Friend or Foe of Art," *Studio* 1, no. 3 (June 1893): 96–102.

8. In O. Stelzer, *Kunst und Photographie* (Munich: Piper, 1966), p. 37, quoted by J. A. Schmoll gen. Eisenwerth, "Franz von Stuck, Der Deutschrömer, Der Jugendstilära," in *Villa Franz von Stuck* (Munich: Villa Franz von Stuck, 1977).

9. Rodin in *Camera Work* (October 1908), as quoted in Albert Elsen, *In Rodin's Studio: A Photographic Record of Sculpture in the Making* (Oxford: Phaidon, 1980), p. 11. See also Kirk Varnedoe, "Rodin and Photography," in *Rodin Rediscovered,* ed. Albert E. Elsen (Washington, D.C.: National Gallery of Art, 1981).

10. John Szarkowski, *Photography until Now* (New York: The Museum of Modern Art, 1989), p. 160.

11. Ibid., p. 159.

12. Charles H. Caffin, *Photography as a Fine Art: The Achievement and Possibilities of Photographic Art in America* (New York: Doubleday, Page & Co., 1901), p. 9, as quoted in Szarkowski, *Photography until Now,* p. 159.

13. Ibid.

14. G. Albert Aurier, "Symbolism in Painting: Paul Gauguin" (1891), as quoted in Dorra, ed., *Symbolist Art Theories,* p. 198.

15. Ibid.

16. Ibid., p. 199.

17. For more on Eadweard Muybridge and Etienne-Jules Marey, see James L. Sheldon and Jock Reynolds, *Motion and Document— Sequence and Time: Edweard Muybridge and Contemporary American Photography* (Andover, Mass.: Addison Gallery of American Art, 1991); Anita Ventura Mozely, introduction to *Muybridge's Complete Human and Animal Locomotion* (New York: Dover Publications, 1979); *Seeing the Unseen* (Rochester, N.Y.: International Museum of Photography at George Eastman House, 1994); *Le Mouvement,* with preface by André Miquel and forewords by Alain Berthoz and Marion Leuba (Nîmes: Jacqueline Chambon, 1994); Marta Braun, *Picturing Time: The Work of Etienne-Jules Marey (1830–1904)* (Chicago and London: University of Chicago Press, 1992); idem, "Muybridge's Scientific Fictions," *Studies of Visual Communication* 10 (winter 1984): 2–21; Michel Frizot, *Histoire de voir: Les Medium de temps modernes* (Paris: Centre National de la Photographie, 1989).

18. See Linda D. Henderson, *The Fourth Dimension and Non-Euclidean Geometry in Modern Art* (Princeton, N.J.: Princeton University Press, 1983); and idem, *Duchamp in Context: Science and Technology in the Large Glass and Related Works* (Princeton, N.J.: Princeton University Press, 1998).

19. (Cambridge, Mass., and London: MIT Press, 1990).

20. Jay, *Downcast Eyes.*

21. Robert de Sizeranne, however, offered a negative answer to the question "La photographie est-elle un art?" He granted, for instance, to chronophotographic experiments credit as revelations of truth, but a truth that falls short from that required by high art. De Sizeranne, "La Photographie est elle un art?" *Revue des deux mondes,* pp. 564–95, and also in *Les Questions esthétiques contemporaines* (Paris, 1904).

22. Emile Verhaeren, "Un Peintre symboliste, "*L'Art moderne* (Brussels), April 24, 1887, pp. 129–31.

23. As cited in Dorra, *Symbolist Art Theories,* p. 61.

24. Ibid.

25. As quoted in J. Du Jardin, *L'Art flamand, les artistes contemporains* (Brussels: A. Boitte, 1900), 2:70, here as quoted in Charles de Maeyer, "Fernand Khnopff et ses modèles," *Bulletin des Musées royaux des Beaux-Arts de Belgique* 1–2 (1964): 43–56.

26. Fernand Khnopff, "A propos de la photographie dite d'art," conférence June 8, 1916, published in *Annexe aux Bulletins de la Classe des Beaux-Arts de l'Académie royale de Belgique* (1915–18): 93–99. See also Gisèle Ollinger-Zinque, "Fernand Khnopff et la Photographie," *Kunst & Camera* (1980): 19–25. Khnopff was undoubtedly familiar with technical aspects of photography: he took his own shots. Fairly sophisticated photographic equipment was found in Khnopff's studio-house, including a camera by Steinheil of Munich, a tripod, and plates.

27. Dorra, *Symbolist Art Theories,* pp. 61–62.

28. See *Georges Rodenbach: Critical Essays,* ed. Philip Mosley (Cranbury, N.J., London, and Mississiqua, Ontario: Associated University Presses, 1996), esp. Dorothy Kosinski, "With Georges Rodenbach—Bruges as State of Mind—The Symbolist Psychological Landscape," pp. 129–60.

29. Gustave Kahn, "Réponse des symbolistes," *L'Evénement,* September 28, 1886.

30. From a manuscript letter in the archives of the Munchmuseet, Oslo, T2734, as quoted in Pierre-Louis Mathieu, *La Génération symboliste, 1870–1910* (Geneva: Skira, 1990), p. 23.

31. Stanislaw Przybyszewski, *Das Werk des Edvard Munchs* (Berlin: S. Fischer Verlag, 1894), pp. 24 ff.

32. Please see Walter Benjamin, "A Short History of Photography," as noted by Jay, *Downcast Eyes,* p. 133, and *Witkacy, Metaphysische Portraits. Photographien, 1910–1939, von Stanislaw Witkiewicz* (Leipzig: Connewitzer Verlag, 1997), pp. 8 and 22.

33. See Hermann Bahr, *Zur Ueberwindung des Naturalismus, Theoretische Schriften, 1887–1904,* ed. Gotthart Wunberg (Stuttgart: W. Kohlhammer Verlag, 1968), pp. 57–58.

34. Ibid.

35. Eugenia Parry, "Edgar Degas's Photographic Theater," pp. 52–73; and Malcolm Daniel, "The Atmosphere of Lamps or Moonlight," pp. 17–51; both in *Edgar Degas, Photographer* (New York: The Metropolitan Museum of Art, 1998).

36. See Erika Billeter, "Intérieur—Effet de lampe," in *Die Nacht* (Vienna: Haus der Kunst, 1998).

37. See William Rubin, *Picasso and Braque: Pioneering Cubism* (New York: The Museum of Modern Art, 1989), pp. 30–41; note esp. Rubin's note 71 discussing Yve Alain Blois's and Edward Fry's discussions of Synthetic Cubism and the discovery of a language of signs.

38. Susan Grace Galassi, *Picasso's Variations on the Masters: Confrontations with the Past* (New York: Abrams, 1996).

39. Ibid., p. 202.

40. Roland Barthes, *Camera Lucida: Reflections on Photography,* trans. Richard Howard (New York: Hill and Wang, 1981), p. 9.

41. Stéphane Mallarmé, *Variations sur un sujet* (Paris: Pléiade, Gallimard, 1945), p. 366.

42. Elizabeth A. Brown, *Constantin Brancusi Photographer* (Paris: Editions Assouline, 1995), pp. 12–13.

43. Ibid., pp. 4–5.

44. Take, for instance, the 1995 project *Lost Paradise: Symbolist Europe,* at the Montreal Museum of Fine Arts. This project was decidedly contextual, interdisciplinary, and international, presenting Symbolism as a pan-European cross-cultural phenomenon with richly complex aesthetic-intellectual substance defying traditional thematic or iconographic categories and traditional artistic hierarchies. Photography played a significant role in the exhibition, with the pictorialists especially privileged but also including works by an international array of photographers in the orbit of Symbolism. Note especially the essay by Ulrich Pohlmann, which examined the heated debate about the artistic versus utilitarian functions of photography, the impact of symbolism on contemporary photography, and especially the role and impact of technical developments in this process. Pohlmann usefully outlined some of the basic tenets of the symbolist aesthetic, exploring how aesthetic ideals of subjectivity, inner psychological reality, timeless beauty, and utopianism inspired new experiments in photography. Though Pohlmann's essay touched on the issue of painters' photographs, this subject did not figure in the exhibition itself.

45. The catalogue, an invaluable compendium of 917 images and including a useful bibliography on the subject, fails, however, to offer an embracing and probing analysis of the implication and meaning of the many tantalizing juxtapositions offered in its pages. *Malerei und Photographie im Dialog* (Zurich: Kunsthaus Zürich, 1977). One notes in particular the extensive contribution by Professor J. A. Schmoll genannt Eisenwerth. (Schmoll gen. Eisenwerth had earlier organized the 1970 Munich exhibition *Malerei nach Fotographie* at the Münchener Stadtmuseum.) In her foreword, Erika Billeter outlines the most noteworthy earlier examinations of the interactions of painting and photography: a 1952 exhibition in Lucerne organized by Robert Lohse; a 1955 exhibition, *Une Vision nouvelle,* at the Bibliothèque Nationale in Paris organized by Jean Adhémar; *Mit Kamera, Pinsel, und Spritzpistole: Realistische Kunst in unserer Zeit,* in Recklinghausen, 1973; *Medium Fotografie—Fotoarbeiten bildender Kunstler, 1910–1973,* Städtisches Museum Leverkusen, 1973; *Kunst aus Fotografie,* Kunstverein Hannover, 1973; *Beyond Painting and Sculpture,* British Arts Council, London, also 1973. Billeter acknowledges, moreover, the pioneering work of Van Deren Coke in *The Painter and the Photograph* (Albuquerque: University of New Mexico Press, 1964), and Aaron Scharf in *Art and Photography* (London: Allen Lane, 1968; reprint, London: Penguin, 1974).

46. The exhibition *Skulptur im Licht der Fotografie: Von Bayard bis Mapplethorpe* traveled from the Wilhelm Lehmbruck Museum Duisberg, Europäisches Zentrum moderner Skulptur, to the Musée d'Art et d'Histoire in Fribourg, to the Museum Moderner Kunst Stiftung Ludwig in Vienna's Palais Liechtenstein. Note especially the essays that deal with Brancusi, Rodin, and Rosso; see the essays by Hélène Pinet, "'Das Wichtigste ist zu zeigen.' Rodin und die Fotografie," pp. 71–80, and Christoph Brockhaus, "Vision statt Reproduktion," pp. 81–86.

47. This information can be found in our bibliography, pp. 323–26.

48. *Painting the Universe: František Kupka, Pioneer of Abstraction* (Stuttgart: Verlag Gerd Hatje, 1997). The exhibition was organized by the Dallas Museum of Art and traveled to the Kunstmuseum Wolfsburg and the National Gallery in Prague.

49. Ibid., p. 88.

50. Walter Benjamin, *Illuminations, Essays, and Reflections,* ed. Hannah Arendt, trans. Harry Zohn (New York: Schocken, 1968).

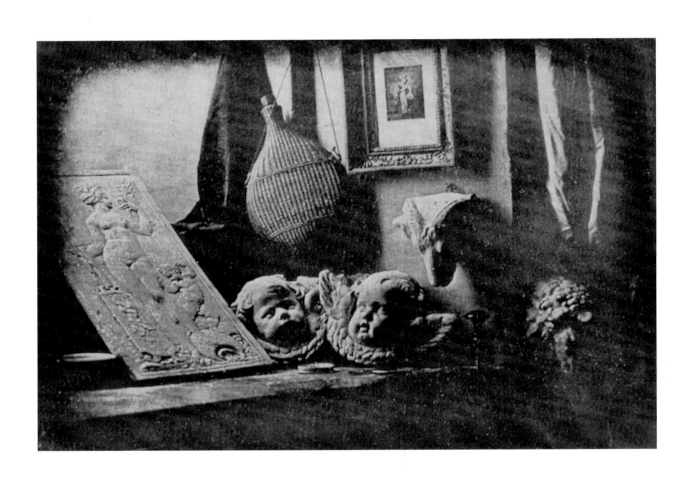

*Elizabeth C. Childs*

# The Photographic Muse

The year 1839 appears as both a birth date and a death date in histories of modern art. It was the year in which the public learned of the experiments in photography by Louis-Jacques-Mandé Daguerre in France and William Henry Fox Talbot in England, and the news exploded across a curious world. The crowd that packed the Institut de France in August 1839, eager for details of the process, resembled a hushed court awaiting news of the birth of a new monarch who would reign over twin realms of art and science. The nearly simultaneous publication of Daguerre's instruction manual in more than twenty countries gave birth to another creature as well: the amateur photographer. The new medium was novel, affordable, and available; any person of intelligence and patience could learn to use it and could establish a hobby or even a business. Such a new world of opportunities also constituted an attack on long-established boundaries of the practice of fine art. For some artists the announcement of photography's birth was tantamount to the death of painting. J. M. W. Turner, whose canvases resonate with sensitive attention to the power of light, supposedly lamented at his first encounter with a daguerreotype, "This is the end of Art. I am glad I have had my day."[1] Of course, there was never a simple passing of any baton of visuality from the palette to the lens. Rather, photography's arrival introduced new terms into long-standing aesthetic debates and forcibly opened the practice of painting to new considerations. Along with these developments of 1839, a dialogue began that engaged artistic minds for the rest of the century.

From the start the two worlds of photography and painting mixed, and early photographers claimed some of the prerogatives of traditional painters. Daguerre, whose career began in the worlds of the public spectacle—with stage design and panoramas—had considerable success as a painter before he turned to the photographic experiments that would revolutionize how the middle class consumed its own image. His earliest surviving daguerreotype, a still life taken in his studio (fig. 4), announced the traditional concerns of a painter—a shallow relief of a classical female nude depicted as a life-giving "source"; a pair of plaster casts of winged putti heads; a hanging wicker-covered wine bottle; a curtain draped dramatically over the window sill to emphasize stark contrasts of light and dark. Crowning this scattered pile of artistic bibelots is an elaborately framed image, probably a small oil sketch—a reminder of the products of studio labors. Photography here captures the cloistered life of the atelier. Soon the camera would move onto the street, the battlefield, and into the laboratories of science and the field kits of exploration. But in Daguerre's studio in Paris, it was first an extension of the painter's eye. That he signed and dated the image suggests that he immediately and emphatically claimed authorship not only of his technique but also of the compositions he could record with it.

Photography was so unlike any previously known form of representation that it did not fit easily into existing discourses on art. Initially, photographs were received, paradoxically, both as extensions of drawing and as products of nature. Photography required a human hand to set up the camera and to actually take the picture. Early reports of Daguerre's methods described his results as "the most perfect of drawings."[2] But since the action of the sun generated the image on the sensitized copperplate of the daguerreotype, or on the light-sensitive paper of Talbot's photogenic drawings, the role of the human hand might be

Fig. 4 Louis-Jacques-Mandé Daguerre, *Still Life,* 1837, daguerreotype, Sociéte Française de Photographie, Paris

25

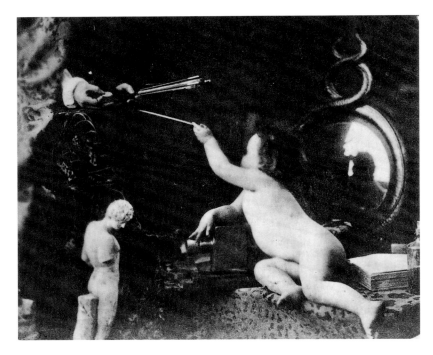

Fig. 5 Oscar Rejlander, *Infant Photography Giving the Painter an Additional Brush,* 1856, albumen print, Collection of the J. Paul Getty Museum, Malibu, California

regarded as a mere servant to a grander process of nature. Daguerre had found a way to "fix images which paint themselves."[3] Joseph Nicéphore Niépce described his work as fixing "the images which nature offers, without the assistance of a draughtsman."[4] The pioneer photographers may have argued passionately over the originality of their work, but none strove to claim it in terms of purely human invention; they all proclaimed that photography, a process of nature, had been disclosed to them.[5] By effacing their own agency, even these makers facilitated the position of those critics who would soon dismiss photographic practice as a matter of pure skill and instruction, located at opposite ends of the creative scale from the genius needed to make "real" art.

For advocates of photography the medium added a younger partner to the artistic enterprise of the painter, as suggested in the sentimentalized allegory by the photographer Oscar Rejlander (fig. 5). But for others the new medium was no colleague; rather, it threw the modern artist into an identity crisis. The verisimilitude of the photograph inevitably weakened the traditional mimetic domain of illusionistic art, the precious legacy of the Renaissance. Suddenly, painting and drawing seemed inadequate, impoverished, ineffectual. A language of competition entered the discourse. For Samuel F. B. Morse, who visited Daguerre's studio, the earliest photograph resembled an engraving but with an "exquisite minuteness of delineation [that] cannot be conceived. No painting or engraving ever approached it."[6] The old academic debate between the relative merits of painting and drawing, between line and color, suddenly was complicated by this new third term. From the start, photography could be figured as

the dangerous Other that would permanently disrupt the practice of art. The French Academy in 1839 strove to reassure artists: "Let not the painter or draftsman despair. M. Daguerre's results are something else from their work and *in many cases* cannot replace it."[7] At the medium's debut, before the practitioners and audience of photography had time to develop a critical language of their own, ideas of defensiveness, competition, and the potential "replacement" of art emerged in the discourse surrounding photography's relationship to painting.

One of the most eloquent and yet begrudging members of photography's new audience was that avatar of the imagination, the poet and critic Charles Baudelaire. In an essay of 1859, Baudelaire summarized what he saw as the slim potential and the considerable limitations of the medium.[8] The occasion was the debut of photography at the annual Salon exhibitions held in Paris at the Palais de l'Industrie. After years of knocking on the door, the Société Française de Photographie finally had its way, and in a distinctly separate gallery, the Salon presented some 1,300 photographs. In the wake of recent banal peregrinations of Realism in French painting (exemplified by the anecdotal and sentimental genre scenes of the day), the poet recoiled from the popular conclusion that art's greatest goal had become the reproduction of nature. Baudelaire the aesthete decried the modern masses, who judge the world sequentially and analytically, as opposed to his ideal of the artist, who responds with feeling and with wonder. He disdained those who would so value exactitude that they could ever confuse "Photography" with "Art." At the door of photography he lay the blame for the narcissistic fanaticism of the modern French, who rush "to gaze at [their] trivial image on a scrap of metal," and for the modern passion for vulgar photographic pornography.

In his disdain, Baudelaire concluded that photography offers art little more than a refuge for untalented or lazy painters, and that it is but one more purely material development of a progress that has "contributed much to the impoverishment of the French artistic genius." His oppositions are harsh: "poetry and progress are like two ambitious men who hate one another with an instinctive hatred, and when they meet upon the same road, one of them has to give place." Poor photography is not allowed a place on Baudelaire's stage of art, lest it supplant or corrupt what little is left of true art. For Baudelaire, photography has an ample but undistinguished mission—to enrich the tourist albums of the bourgeoisie, to save crumbling books and archives (did he here foresee the microfilm?), to serve scientists, astronomers, and archaeologists, and to be the "secretary and clerk" of whoever needs factual exactitude. He poises himself above the entropic maelstrom of poor taste and

Fig. 6 Nadar [Gaspard Félix Tournachon], *Portrait de Baudelaire*, 1862, salt print, Bibliothèque nationale de France, Paris

Fig. 7 Edouard Manet, *Portrait of Baudelaire*, 1868, etching, third state, Bibliothèque nationale de France, Paris

bemoans that each day "art further diminishes its self-respect by bowing down before external reality; each day the painter becomes more and more given to painting not what he dreams but what he sees. . . . It used to be a glory to express what one dreamt." In retrospect, we might well fault Baudelaire for his lack of imagination in considering the creative potential of the camera. But in 1859, with the realistic paintings of Jean-Léon Gérôme hanging in the Salon near a huge gallery of photographs, Baudelaire the art critic assumed the posture of a host of good taste, whose lavish dinner party has been crashed by camera-toting boors. His position was reiterated by such key figures of French academic thought as Charles Blanc, who dismissed photography as an art of imitation that shows all and expresses nothing.[9]

But in spite of such invective, many progressive painters nonetheless appreciated photography for its suggestive qualities, and even for its technical imperfections. In 1859, the same year that Baudelaire decried the artistic limitations of the medium, Eugène Delacroix speculated on its power to help one see the world afresh: "The most striking photographs are those in which certain gaps are left—owing to the failure of the process itself to give a complete rendering. Such gaps bring relief to the eyes, which are thereby concentrated on only a limited number of objects."[10] Delacroix's own highly expressive art of the Second Empire was certainly counted among what the discerning Baudelaire would regard as "the most ethereal and immaterial aspects of creation."[11] Yet it might well have surprised Baudelaire to learn that the poetic Delacroix kept an album of photographic studies, took lessons in daguerreotyping, made *cliché-verre* prints, and often included motifs and poses in his art developed from studio photographs he had made in concert with the photographer Eugène Durieu.[12]

As painters and critics debated the artistic merits of the medium, serious photographers such as Nadar made their own passionate case for the expressive qualities of the medium. In portrait photography, for example, he argued that one needed to study light, which could be employed as an agent of the photographer's own temperament, to grasp the subject. For Nadar, photography was never just a matter of skill. According to him, "photographic theory can be taught in an hour, the technique in a day. But what can't be taught is the feeling for light: it's how the light lies on the face that you as artist must capture."[13] The selection and manipulation of light, pose, and expression would result, not in a banal reproduction of a body, but in an "intimate likeness" of a particular individual. Nadar's defense of his medium represents a studied appreciation of photography's own capacities and a crucial effort to differentiate the practice of the photographic artist from the mere practitioner. His photographic oeuvre stands fully on its own, separate from the realm of the painter (if it calls on any other genre, it is his earlier avocation, caricature, a visual language that reduces physiognomic traits to coded essences).

But Nadar's photographic project engaged a broad audience, including the most unconventional of contemporary painters. In 1868 Edouard Manet based his own posthumous portrait etching of Baudelaire, made in 1868 (the year after the poet's death), on a photographic portrait of Baudelaire made by Nadar in 1862 (figs. 6, 7). For Manet the Nadar photograph powerfully reasserted the existence of a dead friend: the photograph bears the physical trace of a vanished body and spirit. Manet's print does not copy Nadar, but reinvents Baudelaire. Manet keeps Nadar's distinctive language of shadow that sculpts Baudelaire's face, but the printmaker reduces the scale of Baudelaire's head and plunges the poet into a

shadow that echoes more the aesthetic of Rembrandt than the light of the photographer's studio. Nadar's Baudelaire possesses a disconcerting and intense stare and a tentative curl of the lips, crucial details that are muted in Manet's more generalized rendering. The artist's transformation of the photograph into his own graphic rendering fails to sustain the power or idiosyncratic character of the original photograph. But the example is indicative of the increasingly common use of the photograph by painters and printmakers as both model and muse.

By the turn of the century, photography was commonplace in the visual culture of the life of the artist. But if familiarity did not necessarily breed contempt, it did at least generate a deep-seated ambivalence toward photography. Fifty years of experience with the camera and its products had not reduced the range of critical response to the medium among painters and art critics. Indeed, in 1893 the English art review the *Studio* conducted a survey of leading English artists to determine whether or not "the camera has, on the whole, been beneficial or detrimental to art?"[14] By this time it was a given fact of modern life that the camera had permanently disrupted the traditional mimetic business of art in mass culture. The "mechanical artist" of the camera had "killed the miniaturist, banished the lesser portrait-painters, rendered the wood-engraver obsolete, . . . much as the steam-engine upset the systems of ships and coaches."[15] The *Studio*'s inquiry concerned the exchange of photography with contemporary fine art. Responses came from eighteen artists, ranging from the academic Sir Frederic Leighton to the progressive modernist Walter Sickert. Three artists simply declined to answer this "large question," as it evidently required too much thought. One artist excused himself as too feeble to think about such an important matter; one G. Du Maurier declined any opinion but promised to send one in should one ever occur to him.

Among the remaining artists, the results were split: seven concluded in general favor of photography's positive influence over painting, and eight against it. Claims among the defenders of photography were that its value depended on the artist's disciplined selection of useful form and detail, and that it was a good reference tool, offering useful empirical knowledge of how the world looked and how motion occurred. Some applauded the convenience of a photograph as an aide-mémoire of detail; Joseph Pennell claimed that photography was a good "trick of the trade" for "duffers" too lazy to make their own sketches. On this latter point, Sickert articulated a widespread concern over the ethics of "using" photographs, suggesting that an artist was morally obliged to reveal any debt he or she owed to photographic truth. His piety on this point (inspired no doubt by candid statements he

made elsewhere on his own occasional dependence on photography[16]) led to a suggestion that exhibition catalogues publish any relationship between a particular painting and a photograph. Such a position underscores this generation of painters' continuing concerns over issues of workmanship, authorship, originality, and authenticity in their art, which they oppose to the allegedly mechanical, easy, and automatic eye of the camera. Among the artists who openly denigrated the camera as a useful tool for painting, most recycled variations of the complaints formulated by the indignant Baudelaire thirty years previously. The responses combine nostalgia for old Fine Art with disdain for the mechanical and the modern. Photography should be an aid, not a substitute for the sketchbook, cautioned one. Another lamented that the camera and the telescope have led us to a world where the artist knows too much and have lured us from the realm of the imagination. Another reiterated Baudelaire's standard dichotomy between document and art. Because photography belongs to the realm of scientific aids, it cannot be related to art, "which is essentially human and emotional." This cross section of English painters was largely content to keep modern photography at bay and to reinscribe the hierarchical boundaries that divided the practices of nineteenth-century painting and photography.

Yet by the 1890s a self-consciously aesthetic style of photography had emerged on the international art scene. In Paris the international Photo-Club began in 1894 to mount its annual international exhibitions that explored the expressive potential of the camera. Key pictorialist artists exhibited here, including Robert Demachy, Réné Le Bègue, Constant Puyo, and the young Alfred Steiglitz. A broad range of photographers from Austria, Belgium, England, France, Holland, Portugal, Switzerland, and the United States submitted work that addressed themes similar to those of the symbolist painters. These photographs embraced the fin-de-siècle retreat to the contemplative, the natural, and the essential: contemplative women pose by a reflecting pond or float in wispy drapery by the shore of a calm lake; young girls regard themselves dreamily in mirrors; women in Greek dress play lyres in a field (fig. 8); shafts of radiant sunlight penetrate and illuminate dense forests; billowing fog envelops the Thames river; sunset falls over the cliffs of Monet's Etretat. The introductions to these exhibitions emphatically proclaim the Photo-Club's goal of promoting an "essentially artistic" photography, characterized by an artistic choice of subjects, lighting, and compositions.[17] Each work was exhibited separately, framed and under glass, with information regarding the precise technique employed; juries often included notable academic painters. Pictorialist photography had a growing presence,

whether or not it was observed by the painters of the days. Auguste Rodin, who first eschewed photography as an art form and who generally exerted extraordinary control over photographs made of his sculpture, grew to appreciate the artistic vision of such pictorialists as Edward Steichen, who devised subtle photographic means of diffused light and silhouette to reinforce the poetry of Rodin's monumental *Balzac* (cat. 102, on p. 106).

Yet, while such photographic artists worked to cultivate their art form and to establish a sophisticated audience, the cult of the middle-class photographic amateur also flourished. Kodak introduced its hand-held box camera, the Kodak No. 1, in 1889 and found ready markets for the one-hundred-shot, fixed-focus single-lens camera at home and abroad; other companies developed other lightweight models suitable for outings, travel, and adventure (fig. 9).[18] Inexpensive, portable, and easy to use, the newer cameras made it possible to become a photographer overnight. Required skills were minimal. One did not even have to know how to load film or to develop negatives: the owner returned the camera to Kodak or its agents, which carried out the lab work. For many painters the amateur camera was an "invitation au voyage" to take up photography. Pierre Bonnard reveled in the ease of such a camera; Edouard Vuillard owned a Kodak and had a nearby store reload it and his mother develop the pictures at home; Edvard Munch started photography only in 1902 when he bought his first small hand-held Kodak; John La Farge, traveling in the Pacific in 1893 with the American historian Henry Adams, caught his friend's shutterbug pas-

sion. The age of the self-taught middle-class amateur had arrived. Some artists stubbornly resisted such easy technical solutions. The intractable and somewhat technophobic Edgar Degas preferred to work indoors with a large, old-fashioned box camera that required a formidable tripod and cumbersome gas-lamp lighting. An obsessive inventor of form, he enjoyed the sheer labor of photography and submitted himself and friends to long, grueling sittings that constituted both a form of parlor entertainment and a ritual of bonding with members of his intimate circle. But for those who were attracted by the relative spontaneity of the new hand-held camera for recording their experiences and perceptions of the larger world, an option of convenience had emerged.

The avant-garde of the fin de siècle generally positioned itself in opposition to middle-class mass culture, with its values of convenience, speed, and technological progress. Yet of course these artists participated in modernity even as they spun a discourse of antimodernism and retreat from mundane urban life. Pragmatism played a far greater role in the management of careers than the mythology of the avant-garde usually allows: in an era when progressive artists had abandoned church and state as patrons, artists produced not only products for private delectation but commodities for independent exchange on an open market.[19] Artists might retreat to garrets, but most of them were extremely savvy in promoting their work in the galleries and among critics and collectors; many carefully groomed their own reputation in both text and images. Even artists (like Paul Gauguin) who claimed vociferously that they had little use for photography as an art form found it an enormously useful tool in the studio and in the management of their careers.

First, artists commonly used photographs as documentation and for personal archives, a practice that Baudelaire, in his limited vision of the matter, would have approved. Rodin was, as Jane Becker observes in her essay on the artist in this catalogue, the first sculptor to use photography to

Fig. 8 Emma-Justine Tarnsworth, *A Muse*, 1894, platinum print, current location unknown, from *Première Exposition d'Art Photographique* (Paris: Photo-Club de Paris, 1894)

Fig. 9 Anonymous, *Illustration of the Amateur Photographer's Equipment*, 1892, from F. Panajou, *Manuel du photographe amateur*, 3d ed. (Paris: Gauthier-Villars, 1892)

record the stages of his progress in the creation of his sculpture *St. John the Baptist.* Such documents allowed for reflection and a useful distancing of creator from creation. The photograph enabled evaluation in medias res, or even a perpetual fresh start. Consider the obsessiveness of this practice in the twentieth century with Picasso's recording of *Guernica* (Reina Sofia, Madrid) or Matisse's compulsive preservation of the progress of *The Pink Nude* (Baltimore Museum of Art). Matisse photographed it at twenty-one stages of development. After each, he directed his model to selectively wipe out the freshly painted surface each day so he could return to a tabula rasa. The photograph, while registering the past, could also free the artist from it, for as the day's work entered the archive, an artist achieved a balance between past and present, stasis and change, creation and alteration.

The photograph allowed the artist to exert control not only over time but also over space. When working in Tahiti in self-imposed exile from Paris, Gauguin commissioned a local colonial photographer, his friend Henri Lemasson, to record his painting *Where Do We Come From? What Are We?*

*Where Are We Going?* (Museum of Fine Arts, Boston).[20] The photograph, taken outside Gauguin's hut, registers for the benefit of his friend Daniel de Monfreid and a distant art community in Paris not only the canvas but a few suggestive details of the tropical studio: a rough blanket, grasses strewn on the floor. Gauguin retouched the photograph with pastel to give it an effect of color—combining the documentary effect of the photograph with the touch of the artist. Such photographs are more than reproductions, they are assertions of a presence, a position, an active studio life. For Rodin a passionate will to control the image of his sculpture led him to dictate the angle, the lighting, and the background of each reproduction of his work. Imposing his signature on these photographs asserted his artistic claim not only over the work but over our controlled perception of it. At several exhibitions, photographs of Rodin sculpture were sold as souvenirs of the viewing experience (fig. 10), assuming the role played in the early nineteenth century by the reproductive print sold, in entrepreneurial fashion, at special exhibitions marketed as public spectacles.[21]

Fig. 10 Eugène Druet, *Balzac in the Salon of 1898,* 1898, gelatin silver print, Musée Rodin, Paris

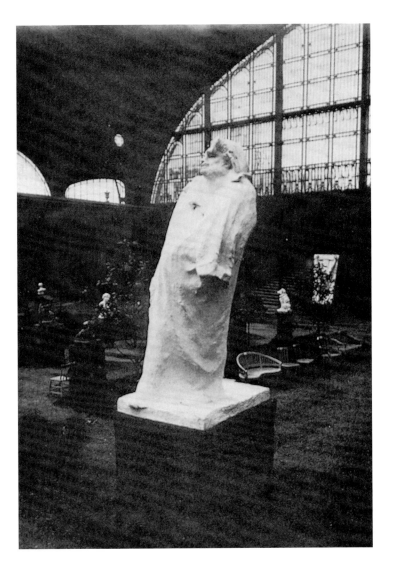

Artists commonly extended such photographic attentions to themselves. The photograph was a perennial public relations tool from the time of Gustave Courbet, who posed for photographs with the wooden *sabots* and peasant vest that reinforced his chosen image as a man of the soil. When Gauguin left Paris for Tahiti in 1893, he showered his friends with photographic souvenirs of himself as parting mementos (fig. 11). After his return to Paris two years later, he posed for a publicity photograph of himself next to one of his Tahitian paintings in the Galerie Durand-Ruel exhibition that he hoped would remake his Parisian reputation. Such exercises are the forerunners of the press kits and publicity agents artists commonly employ today. This role-playing for the camera allowed the artist both to establish and to play with her or his professional identity. This consciousness of the power of the photographic public image followed an era when artists had increasingly collaborated with galleries and critics in the production of texts to represent themselves.[22] The publication of Delacroix's journals stimulated modern artists, notably Vincent van Gogh, to track their lives and thoughts with an eye to publication. Aware of the need to establish his reputation, Gauguin produced four manuscripts intended for publication.[23] The photograph could serve as a visual extension of these public acts of self-presentation and are quite separate from the artistic efforts at photographic self-

portraiture engaged in by such artists as Degas, who generally kept his image of himself to himself.

At the end of the century, the photograph plays a crucial role of bringing the world of visual experience under the artist's control. As Ulrich Pohlmann explores in his essay in this catalogue, artists had increasing access to photographic services and archives where they could acquire vast repertoires of images. A growing market developed for the photographic simulacrum of the original work of art.[24] The photographic art reproduction, a late-nineteenth-century phenomenon, has also flourished in our own age, resulting in the mail-order companies that specialize in framed, textured color reproductions of famous oil paintings. A desire for the perfect copy has besieged the mass culture of our times, and ideas of cybermuseums, digitized masterpieces, holographic galleries, and the mass-marketed simulacra of masterpieces (printed on umbrella or coffee mug) have long complicated our age's sensual and optical experience of unique works of art. This world of the facsimile, traceable to the nineteenth century's rage for reproductive prints and lithographs, has significant origins in the wake of the nineteenth century's commercialization of photography. Late in that century the photographic reproduction of paintings still labored under so many technical limitations that the unavoidable distance between copy and original opened up a creative space for artistic play, and even appropriation. Black-and-white photographs could never be "confused" with an original painting or sculpture; rather, they emphatically stated their Otherness in their small scale, glossy format, and lack of hue. Among the avant-garde, artists from Manet to Degas to Gauguin and Van Gogh, many hung reproductions of works of art in their studios; these did not generally lead to precise transcription or slavish copying but inspired personalized acts of reinvention. These artists foreshadowed André Malraux's idea of a "museum without walls," in which the beholder of art reproductions is encouraged to deny the specific orientation of time and place, or the cultural aura, that would accompany original works of art viewed in the context of their own culture.[25] As with Gauguin's numerous appropriations from the photographs of reliefs from Borobudur (see cats. 117, 118, on p. 125), the photographic art reproduction enters the internal life of an artist's studio as muse, as visual idea, as suggestion of form and theme distanced (perhaps even severed) from the authority and presence that the original work of art holds in some external history or community of images.

These are some of the liberating effects of the photograph for the painter at the end of the century. But for all the creative freedoms they engendered, photographs also constructed certain

Fig. 11 Anonymous, *Paul Gauguin,* 1893, photograph, inscribed *à l'artiste ami P. Go,* René Huyghe Archives, National Gallery Photograph Archives, Washington, D.C.

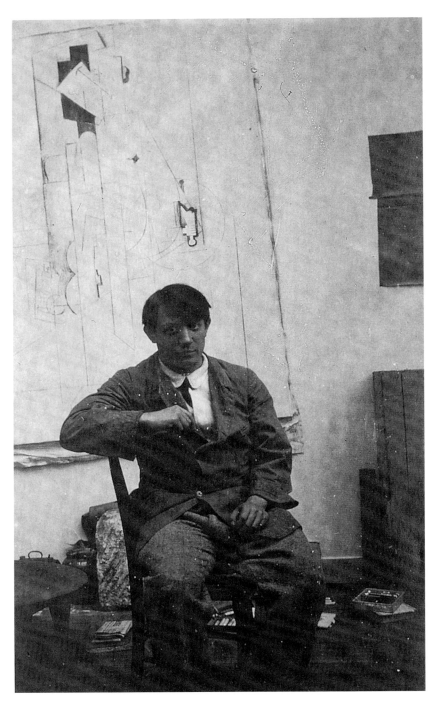

inexorable ties, most notably in the realm of memory and experience. When the photograph is one commissioned or taken by the artist, it bears the subjective traces of the artist's own *sensation* (which in French implies not only an experience but the feelings associated with it, and the memories through which one regards it). An artist may use the photograph to register a moment (as in the snapshots of Bonnard), a group of figures gathered in a compelling manner on the street (as in the late photographs of Degas), a tableau vivant of costumed models in the studio (as in the case of Franz von Stuck or Gustave Moreau). But as these photographs enter the studio, they stand as both objective documents of a world out there and autobiographical traces of the artist's eye, the material residue of perception.

In this way the question of the painter and the photograph in the fin de siècle leads us full circle back to a dialogue central to artistic practice in the modern age. With the advent of plein-air painting, with the development of Realism and Impressionism, painters had increasingly abandoned the studio to gather initial impressions of their motifs. Pencil sketches, oil sketches, and eventually entire canvases were composed out-of-doors. The sacred practices of the atelier were abandoned or modified: only the academically inclined pressed through the years of training, the careful study of plaster casts, the apprenticeship to a master artist in a huge atelier. For the avant-garde the studio remained a more private place of contemplation and artistic invention, and perhaps of modest exhibition, but it also became a repository of the souvenirs of excursion. For the entire century the studio was a location of personal display and of the exertion of one's control over one's world (consider Courbet's famous exhortations in his description of his own *Studio* (Musée d'Orsay) as a record of all the world coming *to him* to be painted). Moreover, the late-nineteenth-century studio was itself more and more portable—in pursuit of authentic sensations of his motifs, Claude Monet, for example, set up his easel on a boat only after Charles-François Daubigny had done so, on a hillside, in front of the trains at the Gare Saint-Lazare in Paris, and in the room he rented opposite the west facade of the cathedral of Rouen. But in this last instance he also retreated back to the studio at Giverny, carrying not only his canvases from Rouen but, as George Heard Hamilton demonstrated long ago, the modern commercial photographs and wood engravings that reinforced the design of his compositions of the cathedral.[26] Monet's final elaboration of these canvases, crafted to represent the sensations of fleeting retinal impressions, occurred in dialogue, back in the studio, with a modest commercial photograph in which the artist could confirm details of architectural contour and his angle of vision. Photography offered

Monet a stabilizing vision, reinforcing his mature goals of replacing fleeting impression with sustained vision and of reducing the distraction of arbitrary detail with the understanding of essential form.

By the 1890s most avant-garde artists, including the symbolists, had rejected the impressionist landscapes of leisure and the urban bustle of the city and had retreated to subjects constructed through imagination in the studio and in the familiar milieu of the domestic world. The photographs of Bonnard and Vuillard refocused their attention on the subjects they knew best—the familiar faces, the beloved figures, the wallpaper patterns that formed the background of their daily lives. Degas converted his apartment, and those of his friends, into a living studio, where he could examine the faces of his most intimate acquaintances. As he deconstructed the principles of spatial illusion in his painting, Picasso used the camera to record the process of studio life, contrasting a stable world of three dimensions—his studio props, his colleagues, his own body—with the flat walls filled with his fast-changing art (fig. 12). At the very moment his art moved into a dissolving world of destabilized and fluctuating form, he reverted to the camera, a modern agent of registering a fixed time and place. Perhaps the camera appealed to him as a vehicle through which he could inhabit and control two spatial domains at once. At the turn of the century and beyond, many artists publicly eschewed the mimetic powers of the camera: artists such as Moreau strove to hide their dependence on photographic tools; Sickert worried over the ethics of borrowing motifs without disclosing photographic sources. Yet photography was a force, a way of seeing, experiencing, and remembering the world that intrigued many artists, in spite of their hesitations or ignorance. Some, like Degas, probed the medium itself for new expressive potential; others, like Rodin and Constantin Brancusi, grew to appreciate its rich artistic potential through the dialogue this two-dimensional art form could pose with their sculpture. For this generation the photograph served not just as document, tool, or aid but as an essential intermediary—between the experience of memory and the knowledge of the eye, between the external world of nature and the private world of the studio, and between the phenomenological world of action and objects and the private exercise of creativity.

NOTES

I am grateful for the opportunity to discuss some of the preliminary ideas for this essay with members of my seminar in photographic history at Washington University in the spring of 1997.

1. Quoted in A. M. W. Stirling, *The Richmond Papers* (London: William Heinemann, 1926), p. 163.

2. *Journal des artistes,* September 27, 1835, pp. 203–5.

3. "The Fine Arts: A New Discovery," *La Gazette de France* (Paris), January 6, 1839, trans. Beaumont Newhall in Newhall, ed., *Photography: Essays and Images. Illustrated Readings in the History of Photography* (New York: The Museum of Modern Art, 1980), p. 17.

4. Joseph Nicéphore Niépce, quoted in Mary Warner Marien, *Photography and Its Critics: A Cultural History, 1839–1900* (New York: Cambridge University Press, 1997), p. 3.

5. Marien, *Photography and Its Critics,* p. 3.

6. *New York Observer,* April 19, 1839, as quoted in Beaumont Newhall, *The History of Photography* (New York: The Museum of Modern Art, 1982), p. 16.

7. "The Fine Arts: A New Discovery," in ibid., p. 18.

8. Charles Baudelaire, "The Salon of 1859," in Baudelaire, *Art in Paris,* trans. Jonathan Mayne (London: Phaidon, 1965), pp. 149–55.

9. Charles Blanc, *Grammaire des arts du dessin* (Paris, 1867).

10. Eugène Delacroix, 1859, quoted in Eugenia Parry Janis, "Photography," in *The Second Empire: Art in France under Napoléon III* (Philadelphia: Philadelphia Museum of Art, 1978), p. 401.

11. This is the criterion Baudelaire forwarded in "The Salon of 1859" to distinguish between the best of fine art and the vulgar modern art contaminated by photography.

12. See Henri Zerner, "Delacroix, la photographie, le dessin" in *Quarante-huit quatorze* 48–14, No. 4, Conférences du Musée d'Orsay (Paris: Réunion des musées nationaux, 1991), pp. 7–14. See also Beaumont Newhall, "Delacroix and Photography," *Magazine of Art* 45 (November 1952): 300–302.

13. Newhall on Nadar's testimony in a lawsuit of 1856, as quoted in Newhall, *The History of Photography,* p. 66.

14. Gleeson White, "Is the Camera the Friend or Foe of Art?" *Studio* 1, no. 3 (June 1893): 96–102.

15. Ibid., p. 96.

16. For accounts of Sickert's use of photography, see Aaron Scharf, *Art and Photography* (London: Allen Lane, 1968; reprint, London: Penguin Press, 1974), p. 365. See also *Sickert* (London: Arts Council of Great Britain, 1977), pp. 32–34.

17. For example, see the "Règlement de l'Exposition," in *Troisième Exposition d'Art Photographique* (Paris: Photo-Club de Paris, 1896).

18. See J. P. Francesch, M. Bovis, and J. Boucher, *Guide des appareils photographiques français* (Paris: Maeght Editeur, 1993), pp. 228 and ff.

19. See the discussion of avant-garde market strategies in Griselda Pollock, *Avant-Garde Gambits, 1888–1893: Gender and the Color of Art History* (London: Thames and Hudson, 1993), p. 15 ff.

20. The photograph made in Punaauia, Tahiti, by Henri Lemasson in 1898 is in the Archives de la France d'Outre Mer in Aix-en-Provence. On Gauguin's retouching of the photograph with pastel, see *Lettres de Gauguin à Daniel de Monfreid* (Paris: G. Falaize, 1950), p. 126.

21. One thinks here of the reproductive prints sold in connection with exhibitions of major paintings by artists ranging from Benjamin West to Théodore Gericault to Frederic Church and Albert Bierstadt.

22. See Nicholas Green, "Dealing in Temperaments: Economic Transformation of the Artistic Field in France during the Second Half of the Nineteenth Century," *Art History* 10, no. 1 (March 1987): 59–75.

23. Only *Noa Noa* appeared in print during his lifetime.

24. For a comprehensive discussion of the various theories of the simulacrum, see Michael Camille, "Simulacrum," in Richard Shiff and Robert Nelson, *Critical Terms for Art History* (Chicago and London: University of Chicago Press, 1996), pp. 31–44.

25. A useful discussion of Malraux, and more generally of the relativity of photography's verity in the case of "documentary" photographs, is Mary Bergstein, "'Lonely Aphrodites': On the Documentary Photography of Sculpture," *Art Bulletin* 74, no. 3 (September 1992): 475–98.

26. The classic essay by George Heard Hamilton, "Claude Monet's Paintings of Rouen Cathedral" (1959), is reprinted in H. W. Janson, ed., *Painting from 1850 to the Present* (New York: Garland Publishing, 1976), pp. 43–72.

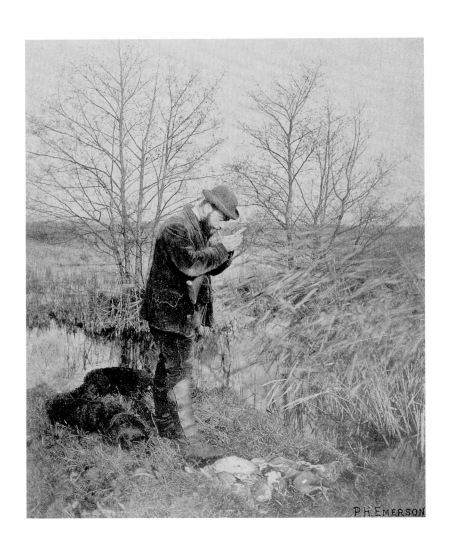

Douglas R. Nickel

# Photography and Invisibility

Writing in 1844, the Englishman William Henry Fox Talbot introduced his recent invention of photography to the world by comparing the operation of the camera to the physical activity of seeing: "It may be said to make a picture of whatever *it sees*. The object glass is the *eye* of the instrument—the sensitive paper may be compared to the *retina*. And, the eye should not have too large a *pupil*.... When the eye of the instrument is made to look at objects through [a] contracted aperture, the resulting image is much more sharp and correct."[1] Talbot's was just an early example of an idea that became prevalent in the nineteenth century—the notion that photography was by its very nature allied with vision, that indeed it was vision made perfect, through the agency of optics and modern chemistry. A critic for the *Quarterly Review* restated the concept in 1864: "Of all the marvellous discoveries which have marked the last hundred years, Photography is entitled in many respects to take its rank among the most remarkable.... It has furnished to mankind a new kind of vision that can penetrate into the distant or the past—a retina, as faithful as that of the natural eye, but whose impressions do not perish with the wave of light that gave them birth."[2] The imagery in such descriptions underscores the fact that the nineteenth century actually witnessed two inventions of "photography"—the first a functional means for recording lens-derived images on light-sensitive materials, and the second a constellation of metaphors and linguistic figures pertaining to the new technology that served to condition its reception into Western culture and naturalize its operations. Clearly the two were interrelated: metaphors framing the photographic had to derive from identifiable, salient aspects of the apparatus and process. Likewise, though perhaps less obviously, the popu-

lar understanding of photography-as-idea influenced how it was then used and what its results should look like. The camera-eye analogy, for example, with its implication of vision instrumentalized, aligned the invention with a widespread faith in *seeing* as a way of *knowing* the world; Talbot and his contemporaries believed that the more distinctly the world was viewed, appraised, and catalogued, the more deeply its wonderous complexity might be understood.[3] By the 1850s photographic practice followed principle: local debates among amateurs the previous decade about focus, artistic *effet,* and so on notwithstanding, photography after 1851 coalesced into something overwhelmingly sharp, detailed, factual, and implicitly objective. An epistemological logic that instinctively related knowledge to sight had little difficulty assimilating the ocular medium of photography into its culture as a new, mechanically improved version of human perception, one readily put to work gathering and archiving visual information about an exterior world that was a priori rational, knowable, and reflective of an overarching, predetermined order.

Lodged within Victorian photography's empiricist foundations lay seeds of doubt, however. Even at the moment of its invention, photography had some difficulty fully sustaining the concept of the photographic: the technique itself in many instances failed to deliver on its promise of transparent and automatic visibility—in its inability to stop moving subjects, for instance, or its deficiency in recording a panchromatic tonal scale, let alone color. More important, the period's tacit equation of visibility with truthfulness was not without its detractors, and as the century progressed, what were at first philosophical qualms about the manifest location of truth erupted into a full-fledged

Fig. 13 Peter Henry Emerson, *At the Covert Corner,* photogravure, Plate XI, from *Pictures of East Anglian Life* (London: Sampson Low, Marston, Searle and Rivington, 1888)

35

crisis, revolving around the prestige of the visual. After 1880 and well into the twentieth century, European artists—academic and avant-garde alike—invariably became entangled in this crisis, as new epistemological paradigms conflicted more and more with older models of visual truth. Simultaneously, photographic technology was improving, to the extent that the medium became increasingly capable of registering phenomena beyond the limits of normal human perception. In other words, photographic practice after 1880 began to outstrip the very concepts that had made it seem rational, legible, and empirically verifiable even the decade before, as it pushed past the horizons of visibility that previously defined it. Thus, if we are to approach any understanding of the complex relationship between photography and the handmade arts at the end of the century, it is necessary to recognize that the painters and sculptors under consideration were responding to the photograph not only as a kind of source material but also as the manifestation of an ambient (if progressively contingent) cultural metaphor about mimetic representation and direct, unmediated seeing that authorized their embrace—or their repudiation—of its evidence.

The crisis in visuality and the photographic can be effectively illustrated by considering three brief episodes in its evolution. The first involves the figure Peter Henry Emerson, regarded in most standard histories of the medium as the "father of art photography." Emerson, born in Cuba to an American father and an English mother, was raised in the United States but schooled at Cranleigh and King's College, London, where he studied medicine. After a decade of medical activity and research, Emerson took up photography in 1882, specializing in landscapes and genre scenes of the rural marshlands of East Anglia, north of Cambridge. His atmospheric, Whistleresque studies appeared as platinum prints and photogravures in a series of beautifully illustrated albums throughout the 1880s and 1890s, while Emerson himself rose to political prominence within the established circles of the Royal Photographic Society and other camera clubs in England. His zealous denunciation of studio props, retouching, combination printing, and other mediating techniques popular in these circles garnered many enemies but served to situate him as leader of the new faction of "naturalistic" practitioners.[4]

Emerson's fame in photographic history rests largely upon his authorship of a treatise titled *Naturalistic Photography for Students of the Art,* which appeared in 1889.[5] The book is seen as the first cogent apology for photography as a medium of creative expression, predicated on its relationship to a preexisting art-historical tradition. That tradition, for Emerson, is Naturalism, a term to him equivalent to Impressionism but radically distinct from Realism, in that the latter subscribes to a style of overall, undifferentiated detail, whereas the former registers the artist's selective impression of some unidealized subject found in nature. *Naturalistic Photography* traces naturalism in art from the ancient Egyptians down to Emerson's day, and with characteristic vitriol, its writer asserts that truth-to-nature is the only valid basis on which good art can lie. Jean-Baptiste-Camille Corot, Jean-François Millet, and James McNeill Whistler are the *terminus ad quem* of this highly selective trajectory; Emerson encourages students of photography to study these modern naturalists, to avoid the inanities and transgressions of "imaginative" artists who paint from their heads and not from nature.

Emerson's text would remain an unremarkable piece of period criticism were it not for the strictly physiological foundation upon which he wished to build his aesthetic edifice. Shifting from the humanistic tradition of painting, the author introduces his argument thus:

> Having demonstrated that the best artists have always tried to interpret nature, and express by their art an impression of nature as nearly as possible similar to that made on the retina of the human eye, it will be well to inquire on scientific grounds what the normal human eye really does see. Our contention is that a picture should be a translation of a scene as seen by the normal human eye. . . . We will, then, proceed to consider how well we see external nature, that is, within what limits, for we never see her exactly as she is.[6]

Accordingly, Emerson reverts to his background in anatomy and commences to catalogue imperfections of the eye—optical dispersion, astigmatism, turbidity of the vitreous humor, the scoma or "blind spot" of the retina, and so forth—citing such authorities as Michael Foster, Joseph Le Conte, and especially Hermann von Helmholtz, whose 1867 manual *Handbook of Physiological Optics* grounded many of his ideas about perception. The overall implication of these physical defects, Emerson writes, is that vision is not naturally sharp: a theoretically perfect lens would resolve details acutely and brightly across its entire field, but a normal human eye is not perfect and only renders one small area of its field of vision—the center of attention—distinct at any given moment, with outer areas of the field falling off into increasing blurriness. Since no hard outlines exist in nature or ordinary eyesight, he contends, they should not exist in art. Moreover, humans perceive a much greater range of light intensities than can be registered in a picture and understand

depth through the binocular synthesis of images from two eyes. Therefore what is shown in a picture is never and can never be what one would perceive before the subject itself; the job of the artist is to approximate an *impression* of nature, as he or she perceives it.

Here Emerson was compelled to argue that, if they wanted their images to be true to vision, photographers should soften the focus of their lenses, setting them on the most important subject in the composition and letting the periphery and background fall naturally obscure around it.[7] Since the eyes adjust to compensate for bright lights and dark shadows in a scene, photographers should avoid an exaggerated tonal range in their prints; they should seek a flatter scale, with details in the shadows and highlights, but a preponderance of information in the middle regions, which subject the eye (in both pictures and the environment) to the least fatigue. Emerson adhered to these precepts in this own work (fig. 13); extremist followers of the school, such as George Davidson, went a step further and advocated comprehensive fuzziness in their prints, an application Emerson criticized for its "destruction of structure."[8] The ensuing debates are complicated, but out of this theoretical context arose Pictorialism, the movement that was to define self-conscious art photography for the next thirty years.

What is extraordinary about Emerson's position on photography is how it marks a shift from the prevailing Victorian norms that preceded it. Not only does he excoriate the all-encompassing detail and deep focus that had heretofore characterized photography as an ocular medium, but he also topples the camera-eye analogy, effectively undermining the photograph's transparency and mimetic force and, with it, its privileged epistemological relation to exterior reality. Perception is no longer a function of the eye in this scheme: it is a psycho-physiological complex of paired eyes, transmitting nerves, and a cognitive apparatus trained to make sense of the raw, unprocessed data they deliver. Visual truth is thus relocated in the subjectivity of the observer. The undifferentiating camera eye of realist photography is reduced to an inert, insensible mechanism; seeing and, by extension, art are interiorized, to be matched for their truth-value against a mental image and not against objective nature or established convention. Emerson appropriates photography from the mechanical realm of classical optics to the corporeal realm of perceptual psychology; the redefinition of visual truth presupposed in his model anticipates not only the pictorialist practice that was to follow but the entire symbolist project in the visual arts.

A second episode enacted at this historical juncture involves the scientific motion studies of Eadweard Muybridge and Etienne-Jules Marey.

The English-born Muybridge was working as a commercial landscape photographer in 1870s San Francisco when he was contracted by the former California governor and racehorse enthusiast Leland Stanford to confirm, with the camera, the theory of "unsupported transit": the supposition that at some point in its stride a galloping horse has all four hooves off the ground. In the spring of 1872, using Stanford's Sacramento stables, Muybridge began conducting experiments to capture this instant photographically; after a hiatus of five years, Muybridge returned to his task in 1877 at Stanford's Palo Alto farm, now determined to register successive phases of the gait by means of a battery of twelve cameras in a row, activated with trip wires the subject would break as it sped by. Tangible realizations of this method were published in 1878 to popular acclaim, in newspapers, the journal *Scientific American,* and the French journal *La Nature.*[9]

It was there that Marey, the most distinguished experimental physiologist working in France, came on Muybridge's work. Unlike Muybridge, Marey was fully trained in physics and medicine, and his professional interest in the mechanics of animal movement had led him to devise various instruments to record graphically the rhythms of biomechanical motion—he invented the first electrocardiograph, for example. Marey's 1874 publication of *Animal Mechanism*, in fact, helped inspire the Muybridge-Stanford serial experiments, so he greeted the 1878 appearance of Muybridge's work—and his 1881 lecture appearance in Paris—with excitement and a spirit of confraternity. Soon after Marey set about devising his own, more precise system of chronophotography, using a camera-gun to record the consecutive phases of a subject's motion on a single plate.[10]

The history of motion photography that follows—often narrated as the preamble to accepted histories of the cinema—need not be rehearsed here. Muybridge's break with Stanford over authorship of the experiments; his 1884 move to the University of Pennsylvania, which sponsored the work that resulted in the issue, three years later, of 781 plates as *Animal Locomotion*; Marey's influence on Frederick Winslow Taylor and the industrialization of worker efficiency through scientific management—these make for engaging reading, but central to photography's implication in modern art after 1880 is the new way chronophotography reconfigured optical data as meaning, and the equivocal ramifications this had for working artists. At a basic level, it is clear that artists as diverse as Edgar Degas, Thomas Eakins, Jean-Louis Meissonier, and Frederic Remington encountered Muybridge's motion studies and transcribed their documentation into paintings and sculpture.[11]

Fig. 14 Edgar Degas, *Draft Horse,* late 1880s/early 1890s, wax, Virginia Museum of Fine Arts, Collection of Mr. and Mrs. Paul Mellon

Fig. 15 Eadweard Muybridge, *"Hornet" Rocking,* Plate 649 from *Animal Locomotion* (Philadelphia, 1887)

Degas in particular used Muybridge's *Animal Locomotion* photographs as the starting point for a series of equine studies in pastel and sculpted wax (figs. 14, 15), and one might initially be inclined to explain this borrowing as simply symptomatic of Degas's progressive quest for representational realism. Paul Valéry noted in 1938 that Degas "was one of the first to study the true appearance of the noble animal by means of Major Muybridge's instantaneous photographs,"[12] but their association with relatively private works in his oeuvre, made in a brief span between 1889 and 1890 (just after their publication), suggests Degas was at the outset more struck by the images as a problem than as a tool. The widespread dissemination of Muybridge's imagery had, by this point, provoked just the kind of perceptual upheaval envisioned by Marey on first seeing it: "As for artists, it is a revolution, since they will be provided with the true attitudes of movement, those positions of the body in unstable balance for which no model can *pose.*"[13]

This was the crux of the problem, for the Muybridge photographs did not merely fly in the face of artistic convention (the traditional hobby-horse stance for a gallop, for example) but contradicted visual experience, showing the animal in states of "unstable balance" never before seen by unaided eyes. What struck contemporaries as the absurd postures of Muybridge's horses were invisible to human observers and therefore incapable of empirical verification: they existed phenomenologically only as images, a kind of phantasmagoria. Yet the camera guaranteed their authenticity, their factuality, and their method of creation and pre-

sentation (identical, precisely equidistant instruments shooting against a gridded backdrop) articulated the results in the idiom of the physical sciences. In his brief flirtations with photographic source material, Degas might be seen as trying on the hyperempiricism of Georges Seurat and Paul Signac, artists who, like Muybridge, were also given over to frozen, repetitive, system-driven performances of optical theory. Chronophotography's status as a subject of popular discourse—it was debated in the Académie des Beaux-Arts and in daily newspapers alike—point to the psychic disturbance the new imagery engendered in modern culture, suggesting, as it did, that there existed more than one order of "truth" that the camera might verify. Defending Emerson's approach contemporaneously in 1890, the editor of the *Photographic News* says as much:

> Truth in photography has two very distinct meanings, each being after a fashion reasonable and correct; but the confusion rises when both meanings are used indiscriminately. The man who, like Mr. Muybridge, brings to light, by photography, things hidden from the unaided senses, is an exponent of one phase of truth; while he who represents a scene as the eye perceives it, with atmosphere, light, and shadow, expounds the other phase of truth; and the latter phase is the sort of truth the artist seeks to realize.[14]

That modernist artists increasingly rejected perceptual truths for existential truths as the twentieth century commenced is amply demonstrated in

the continuing influence of chronophotography on Marcel Duchamp, Pablo Picasso, the futurists, and any number of their followers.

A third episode typifying this moment of disorientation attends Wilhelm Conrad Röntgen's 1895 discovery of X-ray photography. Röntgen had been conducting research on cathode rays in his Würzburg laboratory, using a type of vacuum tube developed by the English chemist William Crookes, when he noticed that a barium light screen lying on his worktable had begun to fluoresce. Suspecting he had stumbled upon a new form of radiation, he placed an object on a photographic plate and exposed it to the shielded tube, generating to his amazement a shadow record of the rays' penetration through the material.[15] In his first paper on the subject, published in December 1895, Röntgen reported that this previously undetected "x-ray" did not behave like visible light: it did not appear capable of being reflected, refracted, or polarized, and was probably a new form of ultraviolet emission.[16] Experiments using human hands quickly revealed the property that was to capture the imagination of so many—the revelation of bones and solid objects under the skin, the ability to see through surfaces to the hidden structures within (fig. 16).

More than the medical and scientific applications to which it would be put, it was the X ray's explosion into popular consciousness in the following decades that marks its import to artistic culture. Newspapers around the world picked up reports of Röntgen's paper; by March 1896 twenty lectures had been delivered on the subject at the Academy of Sciences in Paris.[17] Cartoonists seized upon the risqué possibilities, and journals such as *La Photographie Française* described for amateurs the relationship between X-ray pictures and traditional photographic methods, as manufacturers

quickly marketed equipment for the home hobbyist.[18] A witty 1897 advertisement for an English tire company (fig. 17) testifies to the speed with which X-ray imagery had become part of the average citizen's cultural equipment, as a curious public flocked to Parisian movie houses and Bloomingdale's department store in New York to see live demonstrations of the fluoroscope in action.[19]

Even more than motion photography, X-ray photography (and radioactivity in general) was understood to disclose a new reality outside the realm of the visible. Articles in mass circulation periodicals carried titles like "Photographing the Unseen," "The Invisible World around Us," and "The World beyond Our Senses," intimating an association with spiritualism.[20] The visual correspondence between radiographs and descriptions of psychic "auras" inclined some to see Röntgen's X rays as forecasting the scientific confirmation of clairvoyance, spirits, and other extrasensory phenomena.[21] The blurred line between empirical science and mysticism in discussions of the X-ray image suggests, if nothing else, its rapid ascension to the condition of cultural metaphor, a conception articulating the shift away from Victorian positivism to the antimaterialism and antiocularcentrism of Henri Bergson and Sigmund Freud.[22] For these thinkers reality lay, not on the surface of things—the domain of the photographic—but in the structures of time, experience, and memory buried beneath, accessible only through penetration.

Duchamp, the cubists, and especially the futurists seized on this metaphorical figure as a way of characterizing the underlying ambitions of their art. "Who," the *Futurist Manifesto* asks, "can still believe in the opacity of bodies, since our sharpened and multiplied sensitiveness has already penetrated the obscure manifestations of the medium? Why should we forget in our creations the

Fig. 16  P. Mitchell, *Exposed to X-Rays One Minute, May 3, 1897,* albumen print, Courtesy Lincoln Turner

Fig. 17  Advertisement for Midland Tyre Company, Birmingham, England, 1897, silver print, Courtesy Swann Galleries, Inc.

doubled power of our sight, capable of giving re- sults analogous to those of the x-rays?"[23] Duchamp gravitated to the idea of auras and X rays about 1910—his brother Raymond had studied medicine with the celebrated pioneer of X-ray photography in France, Albert Londe—incorporating allusion to "la photosphère humaine" into his *Portrait du Docteur Dumouchel* of that year.[24] Duchamp's professed desire to overcome "the retinal aspect in painting" paralleled Analytic Cubism's turning away from the three-dimensional world in search of essential, internal form, the elemental geometry of nature Picasso believed it was Paul Cézanne's goal to represent. The fractured, radiating objects of early Cubism consequently deny surface and volumetric solidity; like the X ray, they refer to an invisible reality scaffolding the physical world. "The Cubists taught a new way of imagining light," write Albert Gleizes and Jean Metzinger in *Du cubisme* (1912), using an occult version of the language of radiography and spectrometry:

> *According to them, to illuminate is to reveal; to color is to specify the mode of revelation. They call luminous that which strikes the mind, and dark that which the mind has to penetrate. . . . Here are a thousand tints which escape from the prism, and hasten to range themselves in the lucid region for- bidden to those who are blinded by the immediate.*[25]

The distance traveled, from Emerson's Natu- ralism to Cubism's suprasensible fabric of reality, is great, though less than a quarter century had transpired between their initial codifications. As modernist art rushed headlong from the percep- tual mode of Impressionism to the conceptual modes of Symbolism and Cubism, photography could only seem an equally fleet moving target, by turns materialist and divinatory, optical and eso- teric. Not surprisingly, photographic discourse became a sanctioned cultural arena in which ques- tions about the visual played themselves out, an index of the anxieties and optimism ushered in with new technologies and attendant new ways of thinking about the world. Insofar as the period from Degas to Picasso gave us the airplane, tele- communications, relativity, and film, we might well see ourselves as still caught in the aftermath of its metaphors, and heirs to its intellectual constructions.

NOTES

1. William Henry Fox Talbot, "Plate III: Articles of China," in *The Pencil of Nature* (London: Longman, Brown, Green and Longmans, 1844), unpaginated.

2. "Photography," *Quarterly Review* 116, no. 232 (July–October 1864): 482–83.

3. Jonathan Crary refers to this epistemological order as the classical or "Cartesian" model: in the seventeenth century, Descartes drew an analogy between the human eye and the camera obscura, which served to figure the acquisition of human knowledge upon a direct causal relationship between reality and the perceiving mind. Crary argues that this model had approached exhaustion by the beginning of the nineteenth century; art and culture over the next hundred years in this account register nothing so much as an ever-increasing destabilization and subjectivization of vision, as it manifested itself in a new strain of "observer." See Crary, *Techniques of the Observer: On Vision and Modernity in the Nineteenth Century* (Cambridge, Mass., and London: MIT Press, 1990). The relationship between seeing and knowing from ancient times to Kant is delineated by Krzysztof Pomian in his essay "Vision and Cognition," in *Picturing Science, Producing Art,* ed. Caroline A. Jones and Peter Galison (New York and London: Routledge, 1998), pp. 211–31.

4. Nancy Newhall, *P. H. Emerson: The Fight for Photography as a Fine Art* (New York: Aperture, 1975); Neil McWilliam and Veronica Sekules, eds., *Life and Landscape: P. H. Emerson, Art, and Photography in East Anglia, 1885–1900* (Norwich: Sainsbury Centre for Visual Arts, 1986).

5. P. H. Emerson, *Naturalistic Photography for Students of the Art* (London: Sampson Low, Marston, Searle and Rivington, 1889).

6. Ibid., p. 97.

7. He writes: "It will be understood that a picture should not be quite sharply focussed in any part, for then it becomes false; it should be made just as sharp as the eye sees it and no sharper, for it must be remembered the eye does not see things as sharply as the photographic lens, for the eye has the faults due to dispersion, spherical aberration, astigmatism, aerial turbidity, blind spot, and beyond twenty feet it does not adjust perfectly for the different planes"; ibid., p. 119.

8. Ibid., p. 121.

9. Anita Ventura Mozley, ed., *Eadweard Muybridge: The Stanford Years, 1872–1882* (Palo Alto, Calif.: Stanford University Museum of Art, 1972), p. 69.

10. See Marta Braun, *Picturing Time: The Work of Etienne-Jules Marey (1830–1904)* (Chicago and London: University of Chicago Press, 1992), esp. pp. 42–149.

11. James L. Sheldon and Jock Reynolds, *Motion and Document—Sequence and Time: Eadweard Muybridge and Contemporary American Photography* (Andover, Mass.: Addison Gallery of American Art, 1991), p. 14.

12. Paul Valéry, *Degas danse dessin* (Paris, 1938), quoted in Jean Sutherland Boggs, ed., *Degas at the Races* (Washington, D.C.: National Gallery of Art, 1998), p. 196.

13. Quoted in Braun, *Picturing Time,* p. 47.

14. Thomas Bolas, *Photographic News,* May 3, 1890, quoted in Newhall, *P. H. Emerson* (as in n. 4), p. 67.

15. On the discovery and early history of X rays, see W. Robert Nitske, *The Life of Wilhelm Conrad Röntgen, Discoverer of the X Ray* (Tucson, 1971), cited in Linda Dalrymple Henderson, "X Rays and the Quest for Invisible Reality in the Art of Kupka, Duchamp, and the Cubists," *Art Journal* 47, no. 4 (winter 1988): 337 n. 13.

16. W. C. Röntgen, "Upon a New Kind of Rays" (1895), reprinted in *Annual Report of the Smithsonian Institution, 1897* (Washington, D.C.: Smithsonian Institution, 1898).

17. Nitske, *The Life of William Conrad Röntgen,* p. 117.

18. Henderson, "X Rays," p. 337 n. 17.

19. Ibid., p. 325.

20. A. A. C. Swinton, "Photographing the Unseen," *Cornhill Magazine* 26 (January 1896): 290–96; James T. Bixby, "Professor Roentgen's Discovery and the Invisible World around Us," *Arena,* no. 78 (May 1896): 872; Carl Snyder, "The World beyond Our Senses," *Harper's Monthly Magazine* 107 (June 1903): 872; cited in Henderson, "X Rays," p. 337 nn. 21, 27, and 28. Henderson discusses the spiritual association of X rays, pp. 325–28.

21. See Georges Didi-Huberman, "Photography—Scientific and Pseudo-Scientific," in *A History of Photography: Social and Cultural Perspectives,* ed. Jean-Claude Lemagny and André Rouillé (Cambridge and New York: Cambridge University Press, 1987), pp. 71–75.

22. On the antiocularcentrism of Bergson and Freud, see Martin Jay, *Downcast Eyes: The Denigration of Vision in Twentieth-Century French Thought* (Berkeley, Los Angeles, and London: University of California Press, 1993).

23. Umberto Boccioni, Carlo Carrà, Luigi Russolo, Giacomo Balla, Gino Severini, "Manifeste des peintres futuristes" (February 1910) in *Les Peintres futuristes italiens* (Paris: Galerie Bernheim-Jeune & Cie, 5–24, 1912), p. 17, as cited in Henderson, "X Rays," p. 337 n. 10.

24. Jean Clair, *Duchamp et la photographie: Essai d'analyse d'un primat technique sur le développement d'une oeuvre* (Paris: Chêne, 1977).

25. Quoted in Henderson, "X Rays," p. 335.

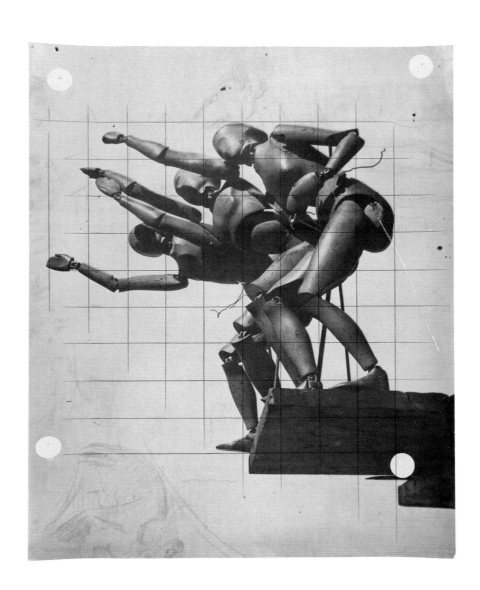

*Ulrich Pohlmann*

# Another Nature; or, Arsenals of Memory: Photography as Study Aid, 1850–1900

In 1893 the English journal the *Studio* sent a questionnaire to leading British artists about the influence of photography on the representation of nature and artistic production. Later, the journal's editor, Gleeson White, noted that it was just about as difficult to find an answer to his questions as it was to the question of whether the invention of gunpowder had exerted a bad or a good influence on human progress.[1] This comparison highlights the insolubility of the question, referring as it does to a state of affairs that already seemed common in the world of artistic practice, for at that time photography had long since become an indispensable working tool for painters and sculptors. The influence of photography on English art could already be ascertained both in its monochrome paintings, its accuracy and its attention to detail, and in its preference for snapshotlike compositions. It was this particular photographic aesthetic in English art of the 1890s that the painter Walter Sickert had in mind when he demanded a special designation in exhibitions and catalogues for paintings that had been inspired by a photographic model.[2]

This controversial debate on the pedagogic and artistic use of the medium of photography carried on in the *Studio*—kindled in Germany in 1896 in the journal *Gut Licht!*[3] and in America in 1901 in *Camera Notes*[4]—illustrates the profound change that photography had brought about in artistic production. By the late nineteenth century, many artists had photographic archives at their disposal. The contents and structure of these archives will be studied later in this essay. Then, however, we will be confronted with the paradox that, although in practice, artists obviously resorted to photographic models for their work—as is borne out in numerous accounts by contemporaries—

only in rare cases have corresponding photographic collections survived.

Although we certainly know of the existence of extensive photographic stockpiles, such as in the estates of Camille Corot or Hans Thoma, unfortunately these must now be considered lost to posterity. Despite a few exceptions, such as Franz Lenbach or the neoclassicist Sir Lawrence Alma-Tadema,[5] it is the lesser-known representatives of the applied arts, decorative painting, and sculpture whose photographic estates have been preserved. Among these are the French artists Amable Dauphin Petit, Théophile-Narcisse Chauvel,[6] and José Maria Sert (fig. 18),[7] the German painters Hermann Frobenius and Otto Gebler, and the North American Charles Henry Miller.[8] In England the *Punch* illustrator Edward Linley Sambourne built up a huge archive of photographs for his work.

Yet a distinction must be made between the artists' own photographic activities, which had become increasingly widespread since the 1880s, and the use of photographs taken especially for artists to use as models by commercial photographers and available generally for sale. Despite all the writings on the relationship between photography and art, the use by artists of photographs in the nineteenth century is a phenomenon that has been little studied.[9] One of the reasons for this may lie in the attitude of the artists themselves, who did not draw attention to their use of photographs, looking on them primarily as visual aids. In some cases the use of photographs may even have been concealed, as this studio "secret" did not quite square with the idealized notion of the artist-as-genius, drawing solely on his imagination and not requiring any mechanical aids.

So let us now take a closer look into the artist's

Fig. 18 José Maria Sert, *Study for the Great Hall, Rockefeller Center, New York*, c. 1931, Georg Kolbe Museum, Berlin

Pierre Caloine highly praised this supporting function of photography.[11] He described photographic reproductions of masterpieces from the realms of painting, drawing, architecture and sculpture, ethnological portraits, depictions of matter (material studies), and natural phenomena as useful components of a pictorial archive for artists. In photographic studies of natural meteorological phenomena such as waves, rain, clouds, or storms, which could only be studied from nature to a limited degree because of their fleeting character, Caloine recognized photography's significant potential for exerting a fruitful influence on painting. The directness and mathematical precision of the photographic gaze were regarded as fascinating features of a medium that could capture any motif with factual veracity.

Theoretically, at that time it was already possible for artists themselves to practice photography. A wealth of treatises, brochures, and handbooks had been published in the 1850s, all containing detailed instructions on the various photographic techniques: daguerreotypes, talbotypes, and the wet collodion process.[12] Yet artists only rarely availed themselves of these possibilities, preferring instead to rely on the artists' studies readily available on the market.

## Model Studies: The Emergence of an Industry

Any presentation of the genesis of the photographic archive and its significance in artistic production in the nineteenth century naturally has to include a description of the distribution channels and the international trade in such pictures. Of decisive importance for the production and distribution of artists' studies was the Imprimerie photographique, which, between 1851 and 1855 under the direction of Louis-Désiré Blanquart-Evrard produced an estimated one hundred thousand prints, which in turn were sold internationally by book and print traders.[13] Thanks to the shorter exposure times of chemical positive development, Blanquart-Evrard had created the basis for the industrial mass production of prints, even though he never actually realized his original objective of producing four to five thousand prints a day at the reasonable prices of between 5 and 15 centimes per print. Instead, individual prints were sold at between 2.50 and 10 francs each, depending on their format and presentation. Compared to the cheaper lithograph (about 1 franc per sheet), the purchase of a photograph from the Imprimerie photographique represented a certain luxury, with the result that the pictures found favor mainly among the more wealthy artists, art lovers, and amateur photographers, groups that Ernest Lacan defined as a social elite, which also included leading representatives of the aristocracy and the French State.[14]

Fig. 19 Louis-Désiré Blanquart-Evrard, *Michelangelo's "Virgin" in the Cathedral of Notre Dame, Bruges,* c. 1852, Fotomuseum im Münchner Stadtmuseum

studio in the mid-nineteenth century to highlight both the modes of work and the interaction between painting and photography. Almost immediately after the public announcement of the first photographic processes, the centuries-old hierarchies in the arts became racked by crisis, and artists were forced to realign their aesthetic forms of expression. Paul Delaroche's often quoted claim, "Painting is dead, long live photography"— pronounced in 1839, the year of the introduction of the daguerreotype—brought the tension between photography and painting to a verbally dramatic head. Delaroche, however, was convinced not so much of the demise of painting but of the fact that photography would constitute an important aid for the artist. The photograph would serve as "an object of observation and study," and with this in mind Delaroche was the very first to recommend that his artist colleagues build up photographic "study collections which [they] could only acquire otherwise at the price of much time and effort, and still not of the same perfection, however great [their] talent might be."[10] If one can credit the contemporary sources, by 1855 photography had already made great inroads into artists' studios, first in France and England, in keeping with the technical development of the medium, and later in Germany and North America. In his 1854 essay "De l'influence de la photographie sur l'avenir des arts du dessin," in which he praised the photograph as a reconstructive "aide mémoire,"

Significantly, Blanquart-Evrard's first publication, the *Album photographique de l'artiste et de l'amateur,* was aimed at these circles. This publication, which documented all photography's areas of application in 1851, consisted of reproductions of famous artworks, such as paintings and sculptures by Raphael, Ghiberti, Michelangelo (fig. 19), Jan van Eyck, and Phidias, and architectural views of important religious buildings and archaeological monuments in Europe, India, and the Near East. Two years later, the series *Etudes photographiques* and *Etudes et paysages* were published in two installments, produced and distributed as photographs "after nature" especially for use by artists as pictorial models. The photographs, most of whose authors were not named, included views of trees, animal studies, still lifes, river landscapes, farmhouses, ruins, weather phenomena such as "effects of snow," or picturesque scenes of rural life composed as tableaux vivants in the style of the artists Jean-François Millet or Gustave Courbet (fig. 20). Of these *Etudes photographiques,* Lacan remarked that the photographs would be of outstanding service to artists, and the depictions would help people to "understand the different schools of landscape painting, the various manners of rendering foliage, masses or effects. . . . the least artistic eye would understand Th. Rousseau perfectly by studying the lovely 'Forêt' by M. Le Secq, just as one finds all the sentiment of Ruysdael in M. le vicomte Vigier's 'Saules,' so admirably true to life."[15]

Other albums published by Blanquart-Evrard were devoted to countries, such as Belgium, or cities, like Brussels or Paris, or to the countryside, such as that of the Pyrenees. These contained photographs of buildings and works of art that were already quite well known thanks to lithographs and that were now available in an authentic reproduction of their physical mass and proportions. In the course of the emerging tourist industry, these photographs, whose aesthetic was influenced by *veduta* painting and drawing of the eighteenth and nineteenth centuries, became available for sale to travelers as souvenirs.

## The Art of Reproduction

Most of the photographs, however, were reproductions of works of painting, sculpture, and graphic art, as is clearly illustrated by the albums *L'Art contemporain,* containing French painting; *L'Art réligieux. Architecture, Sculpture. Peinture,* with works by Raphael, Leonardo da Vinci, Anthony van Dyck, Annibale Carracci, Peter Paul Rubens, and Nicolas Poussin; *Dessins originaux et gravures célèbres, Mélanges photographiques;* and *Musée photographique. Oeuvre de Nicolas Poussin.* At the time, these publications constituted a minor sensation, something that can scarcely be understood today in view of the omnipresence of art in illus-

trated books and periodicals. Often the photographs reproduced the original work in facsimile format, so that original and reproduction looked remarkably alike, achieving a more authentic, less interpretative copy of the objects than had been possible with traditional reproduction media such as the lithograph or the copperplate print. At the same time, photography also made it possible to duplicate works of art that were privately owned and thus not easily accessible. Consequently, an artist's oeuvre could be studied in its entirety with the help of top-quality reproductions.

Interestingly enough, up until 1860 these photographic reproductions were mainly of rare drawings, etchings, and other valuable prints, while reproductions of paintings were not as common. The reason for this was the poor color sensitivity of the negative, which required the use of complicated filter techniques and chemicals when developing negatives or making prints to capture any of the coloristic subtleties of the originals. Yet whereas up until the 1880s the photographic reproduction of paintings was still a challenge to the photographer's skill, the reproduction of sculpture was already so perfected in the early years of photography that photographs of sculpture conjured up in viewers the illusion of having the three-dimensional particularity and materiality of the works right before their eyes.

In retrospect, the significance and practical value of photographic art reproductions for the reception of art can certainly not be overestimated. In anticipation of André Malraux's theses, put forward in his *Musée imaginaire,* the mid-nineteenth century already had at its disposal a widely available pictorial universe of works of fine art, which fundamentally altered the perception

Fig. 20 Humbert de Molard, *Landscape in Winter at Argenteuil,* c. 1850, Musée d'Orsay, Paris

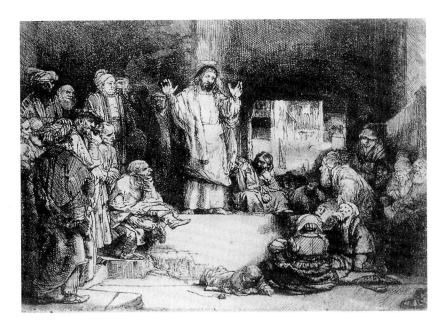

Fig. 21 Bisson Frères, *Reproduction of a Rembrandt Drawing/Etching,* c. 1853, Bibliothèque Nationale de France, Paris

and understanding of art, given that from then on it was possible to study a work irrespective of its location. What is more, artists sent photographs of their works to interested collectors, dealers, and museums, informing them about what they were producing. Applications to participate in exhibitions were also made with the help of photographic reproductions of relevant works. Thus it comes as no surprise that the photographic estates of nineteenth- and twentieth-century artists contain considerable numbers of art reproductions, as demonstrated by the archives of such contrary artistic natures as Lawrence Alma-Tadema and Pablo Picasso.

There can be no doubt that the centers of the trade in photographic reproductions of artworks were Paris and London, where until 1855 not only Blanquart-Evrard but other companies were trading in folio works. In Paris, for example, reproductions of Marcantonio Raimondi's copperplate engravings were being sold by Benjamin Delessert, and reproductions of Rembrandt's and Albrecht Dürer's prints by the Bisson brothers (fig. 21). As was the case with the purchase of illustrated books, the photographs could be acquired by subscription, either as individual prints or in installments from Parisian booksellers such as Roret, Charles Chevalier, and Lerebours et Secrétan or from the international picture traders Goupil et Vibert and Gide et Baudry in Paris or Colnaghi and Gambart in London. Just how far-ranging the influence exerted by the French picture trade was can be illustrated by the first folio work by the German photographer Alois Löcherer, who between 1854 and 1856 reproduced a total of fifty medieval engravings and drawings as photographic facsimiles with an accompanying text in French and under the French title *Copies photographiques.*[16]

Whereas in the early years the publications by Blanquart-Evrard and others still exuded an aura of exclusiveness, with the result that samples of these costly images were only rarely included in artists' archives, after the 1860s photographs became affordable for larger numbers of people. What were then acquired for archives were mass-produced prints in carte-de-visite, stereoscope, and *carte-de-cabinet* (larger-scale luxury size, suitable for hanging) formats. The stereoscope, developed by Charles Wheatstone (mirror stereoscope, 1838) and David Brewster (lens stereoscope), was particularly popular. By giving slightly different views of one and the same motif, it provided the illusion of three-dimensional vision. Alongside views of famous cultural and historic monuments, the wide view of the stereoscope included almost all forms of pictorial representation, from costume and genre studies, art reproductions, portraits, scenes from the world of work, landscapes, contemporary events, instantaneous photographs taken on lively boulevards, and still lifes, to pornographic nudes. As early as 1855, Parisian wholesalers such as Alexis and Charles Gaudin were trading more than five thousand different motifs by photographers such as the Bisson brothers, Baldus, Bilordeaux, Blanquart-Evrard, and Disdéri, available in batches of a dozen either as monochrome and hand-colored paper prints on cardboard or as glass and metal plates.[17] These motifs were also available via museums or by direct mail from the publishers of the works, who usually advertised their wares in such photography journals as *La Lumière.*

### "L'Etude d'après nature"— Photographic Nature Studies

Another important international distribution center for art reproductions and artists' studies of all kinds was the world exhibitions, at which the whole range of photography's applications were presented. Ideologically committed to the premise of progress, these expositions resembled universal picture archives, in which scientific and artistic photographs were exhibited on an equal footing. In view of the enormous numbers of visitors to these exhibitions (fig. 22; 6 million visitors were estimated in London in 1851, more than 30 million in Paris in 1900), these "parades of capitalism," as Friedrich Naumann called them,[18] represented an inexhaustible reservoir of possibilities for gathering information about the latest developments in this specific technology. The photography sections also sold those *études d'après nature* so highly praised by landscape painters in particular as true copies of nature, which gave rise to a veritable industry, providing studies of trees, plants, clouds, waves, animals, still lifes, and nudes. The first generation, up to about 1860, consisted mainly of photographers trained primarily as painters and graphic artists, like Charles Marville (fig. 23),

Gustave Le Gray, and Henri Le Secq, who captured worthy scenic outlooks in the forests of Fontainebleau and Barbizon, or Auguste Bellocq, Bruno Braquehais, and F.-A. Moulin, who specialized in photographs of nudes and genre scenes. The second generation, who dominated the commercial market from 1860 to 1890, included the photographers Charles Hippolyte Aubry (fig. 24), Charles Bodmer, Léon Cremière, Eugène Cuvelier, Constant Famin, Hermann Heidt, August Kotzsch, Josef Löwy, Charles-Guglielmo Marconi, A. Taupin, and Carl Teufel, to mention just a few, with their many and varied views. But numerous unknown photographers also came to the fore as purveyors of artists' studies, which they distributed either as

a private publishing venture or through the international art trade.[19]

The designation *étude d'après nature* to be found on the frames of many of these photographs characterizes the work as having something unfinished, subjective about it. In his study *Before Photography*, Peter Galassi pointed to the fact that landscape painting in the late eighteenth century had already anticipated not only the themes but also the aesthetics of early photographic artists' studies, so that photography ought to be evaluated not so much as the inventor of a new iconography but rather as the synoptic successor of painting.[20] The intrinsically photographic modes of representation that existed in painting before the invention of photography were unusual close-up views, an isolation and fragmentation of natural elements, a concentration on the depiction of fleeting meteorological phenomena such as clouds, sunrises, and sunsets, and a general preference for the common, unspectacular landscape motif. Drawings and paintings by John Constable, Caspar David Friedrich, J. M. W. Turner, Ferdinand Georg Waldmüller, and others bear ample witness to this. The photographic *études d'après nature,* therefore, are to be seen, above all, as a reflection of late romantic painting, which sought to render experiences of nature tangible and to immerse the viewer in vivid aspects of the landscape.

From a practical viewpoint, these photographic studies replaced the graphic folios of the eighteenth and nineteenth centuries, which contained an amalgam of lithographs and copperplate engravings of anatomical studies of humans and animals, landscapes and buildings, as full or partial views, and, above all, of decorative ornamental prints, floral ornaments, fabric patterns, or items of furniture and glassware dating from all centuries.[21] After the Great Exhibition in London in 1851, these pattern

Fig. 22 (top) Pierre Petit, *Interior View of the Exposition Universelle in Paris*, 1867, Dietmar Siegert, Munich

Fig. 23 (bottom, left) Charles Marville, *Study of the Sky,* Paris 1855, Gallery Rolf Mayer, Stuttgart

Fig. 24 (bottom, right) Charles Aubry, *Flowers,* 1864, Fotomuseum im Münchner Stadtmuseum

sheets underwent a revival as the demand for improving the quality of arts and crafts gained in momentum. They were used as teaching material in the training of craftspeople and artists at the polytechnics and art academies. Although these folios of drawn or painted decorative motifs were also in circulation in the second half of the nineteenth century, mostly as (chromo)lithographs, and blossomed in the period of historicism, photographs gradually came to represent serious competition. Of decisive importance here were not only an almost tangible closeness to nature and a realistic depiction but also a desire for authenticity.

### The Ideal and the Reality of the "Academies"

In the teaching of drawing, the study of photographs gradually replaced that of plaster casts or drawings after ancient sculptures. As drawing after a live nude model was usually restricted to a few hours, photographs of nudes gained in importance as inexpensive alternatives, making it possible to study nudes independently of art academies. Whether these "academies," as the nude photographs were called, favored the return of the live model in art[22] is not a question that can be answered definitively. In their striving for authenticity, some art professors, like the Munich animal painter Heinrich von Zügel, went so far as to bring live cattle into the art academy classrooms, where they were then at the disposal of the students for the purposes of drawing after nature (fig. 25).[23]

In the 1890s such art journals as *Die Kunst für Alle* or *Art Journal* provided an enormous wealth of photographic study models for artists. This market was dominated mainly by nude studies, most of which were collotypes, which could be produced quite cheaply.[24] In the German-speaking region alone between 1891 and 1914, more than thirty-five folio and large-format books of photographs of nude male and female models of all ages were published, clearly aimed at an artist clientèle under such titles as *Der Aktsaal. Ein Album für Maler, Bildhauer, Architekten, Akademiker und Kunsthandwerker* (1892) and *Der moderne Akt. Studienmappe für Künstler* (1903). Many of the photographs they contained were taken outdoors, articulating a demonstrative new consciousness of the human body, which under the aegis of the emerging German reform movement sought freedom from prevailing moral strictures. From the point of view of their iconography, these photographs were usually indebted to the canon of Western art and mythology: for example, female models were posed as Diana, warring Amazons, or embodiments of fertility. In France, Emile Bayard and A. Vignola published three special volumes entitled *L'Etude académique. Recueil de documents humains* (fig. 26), containing more than 1,650 studies of nude male and female models "after nature."[25] The sheer inexhaustible compendium of physical poses was the main focus of a regular industry, which disseminated well-printed books and almanacs on the artistic or anthropological nude in Europe and North America. Aesthetically, the appearance of these nude studies was very much indebted to the traditional studio style: nude models romped around with replicas of ancient sculptures in front of painted screens with romantic landscape and architectural motifs and

Fig. 25 Giraudon (ed.), *A Peasant Woman*, c. 1880, Musée d'Orsay, Paris

Fig. 26 A. Vignola, *Academic Studies*, 1903–5, Fotomuseum im Münchner Stadtmuseum

in poses from famous works of Western art, such as Jean-Dominique Ingres's *Odalisque,* Botticelli's *Spring,* Théodore Gericault's *Raft of the Medusa,* or Raphael's putti. As general prudery submitted the publication of nude motifs to strict legislation— in Germany, for example, for some years after 1900 the so-called Lex Heinze, or display window paragraph, prevented the public showing of nude motifs in painting, sculpture, and photography even in museums—the genitals of the female model were usually obscured by retouching, whereas the male's were draped artistically in veils. This later reworking lent the pictures an unreal aspect and made the models seem like sculptures made from stone or marble.

Presumably these "artistic" nude motifs, which strove so desperately to disassociate themselves in content and form from erotica by using "serious" presentations and expensive decorative designs, were aimed at average artists and sculptors and had very little attraction for the artistic avant-garde. All too evident was the will of the photographers to be "artistic," whereas artists like Degas or Bonnard rendered their visions of the unclothed body in much less artificial guises.

Along with nudes, the model studies most in demand were microphotographic enlargements of plants. A whole new morphological perception of nature was introduced by these organic "art forms of nature," a term taken from the title of the influential series of charts by Ernst Haeckel (fig. 27). Published between 1899 and 1904, they provided a standard for comparable photographic publications.[26] Haeckel had drawn views, cross sections, and stereometric representations of marine life, such as corals, jellyfish and algae, as symmetrical constellations and morphological comparisons to illustrate Darwin's theory of evolution. As the title of his work *Kunstformen der Natur* (Art forms of nature) already suggests, this was, not an objective reproduction of nature, but a subjective artistic interpretation or, to put it another way, a transformation of nature into the naturally beautiful. By contrast, the formal analysis of the invisible in microscopic photographs offered arts and crafts specialists, painters, and architects more objective information (fig. 28).[27]

## Structure and Content of the Photographic Archives

As of 1850 almost every stylistic trend in painting, irrespective of the genre, was influenced by photography. Portrait, architecture, and landscape painters "of any talent"—for whom according to

Fig. 27  Ernst Haeckel, *Thalamophora (Foraminifera),* Plate 2 from *Art Forms of Nature* (Leipzig and Vienna, 1904), engraving, Collection McGill University, Blackerwood Library of Biology, Montreal

Fig. 28  Wilson Alwyn Bentley, *Snowflake Crystals,* 1911–24, nos. 307, 427, 201, and 383, National Gallery of Canada, Ottawa

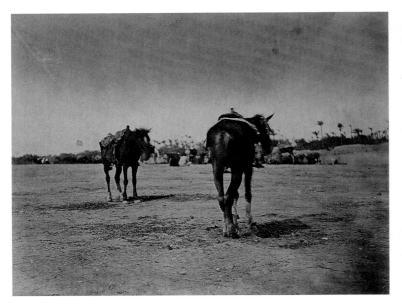

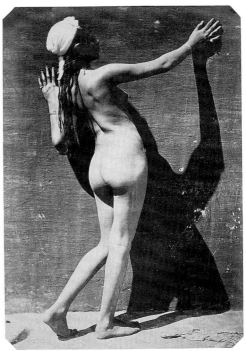

Gaston Tissandier in 1874 a photographic collection was "an inexhaustible source of useful instruction"[28]—availed themselves just as much of photography as did the artists of oriental exoticism, for example. However, if one examines the order that prevailed in the photographic archives that have survived in artists' estates more closely, only seldom will it be possible to identify the kind of differentiated structure and organization that characterized the archives of Alma-Tadema and Franz Lenbach.[29] Often these photographic holdings were a jumble of bought and received items, art reproductions, travel photographs, and private photographic documents, put away in the studio along with a chaotic mass of paraphernalia, including armor and furs. Views of the interiors of artists' studios in the last quarter of the nineteenth century provide evidence of this. A further, exemplary case is the estate of the Austrian painter Carl Friedrich Huber, whose photographic archive must have contained several hundred motifs, which have been widely dispersed.[30] During a sojourn in Egypt with Lenbach and Hans Markart in 1875–76, Huber had countless photographs taken or bought them from commercial photography studios (fig. 29). His archive contained photographic reproductions not only of his own works but also, and above all, views of decoration typical of Moorish and Coptic architecture, studies of camels, portraits of Egyptians, and nude studies of oriental women (fig. 30). On his return to his studio in Vienna, these photographic studies, along with other memorabilia such as palm fronds, leather poufs, weapons, stone fragments of buildings, and so forth, served to evoke the exotic world of the Orient, which Huber depicted in his paintings.

Another illustrative example of the genesis and structure of a photographic archive is the estate of the Italian stage set designer Mariano y Fortuny, who owned more than 1,500 original photographs (fig. 31), along with his objets d'art and paintings.[31] Fortuny did not regard the former highly as an art form; he simply collected photographs related to his personal preferences and as a stimulus for his work as a painter and textile and stage set designer. His archive embraced all photography's genres and fields of application: views of cultural monuments taken by such photographers as Alinari, Eugène Atget, Félix Bonfils, Samuel Bourne, Francis Frith, Giorgio Sommer, and George Washington Wilson in the Near East, Egypt, Italy, England, France, and India can be found alongside atmospheric landscape motifs, shots of plants, architectural details, sculptures, and nudes by photographers like Constant Famin, Vincenzo Galdi, Wilhelm von Gloeden, Guglielmo Plüschow, or Achille Quinet.

The oeuvre of Atget, the photographer "discovered" by the Parisian surrealists and designated the precursor of modernism, is also closely linked with the phenomenon of the artists' study. Atget, who advertised using the imprint "Documents pour artistes," sold his photographs to such artists as Maurice Utrillo and Georges Braque. Various Parisian museums and institutions, such as the Ecole des Beaux-Arts, the Bibliothèque Nationale, the Musée Carnavalet, the South Kensington Museum in London (today the Victoria & Albert Museum), and the library of the Kunstgewerbemuseums in Berlin (today the Kunstbibliothek) acquired hundreds of Atget's photographs of Paris for their collections. These were consulted mainly

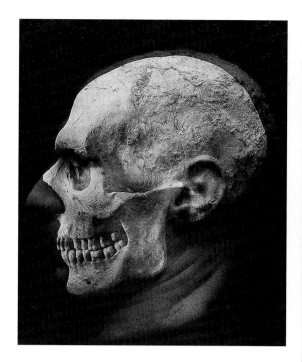

by artists, craftspeople, architects, and art histori-
ans, who estimated their documentary quality
highly without ascribing any particular value to
them as examples of art. Atget's photographs,
which were also valued as documents by people
involved in the preservation of historical monu-
ments (fig. 32), represent the final high point in
the career of the photographic artists' study in
the nineteenth century.[32]

"PROGRESS IS A STANDPOINT AND LOOKS
LIKE A MOVEMENT."—KARL KRAUS, 1909
But how did the transformation of the photo-
graphic model into the medium of painting take
place at the intellectual and practical levels? If
one calls to mind the creative process of making
art, then one might aptly describe the consecu-
tive working stages as those of seeing, photo-
graphing, remembering, drawing, or painting.
The photograph assumes the task of the filter,
the selective controller of a disparate pictorial
world, for only a few motifs out of several thou-
sand photographs were relevant for the indi-
vidual artist's work. Doubtless, photography
sharpened the artist's powers of observation
and perception vis-à-vis nature. At the same
time, the artist was intent on outdoing the
photographic reality, as the art theorist Ludwig
Pfau indicated: "This new invention compels the
artist to make greater efforts. For, if on the one
hand it forces him to exchange the foggy con-
structs of his studio imagination for a healthy
reality, so as not to be outstripped in matters of
fidelity by mechanical reproduction, on the other
hand it also forces him to heighten the ideal con-
tent of his depiction with the energetic stamp

Fig. 31 (top, left) Anonymous,
*Anatomic Study,* Mariano
Fortuny, Palazzo Fortuny,
Venice

Fig. 32 (top, right) Eugène
Atget, *St. Gervaise and Protaise
in Paris,* albumen print,
Mariano Fortuny, Palazzo
Fortuny, Venice

Fig. 33 (bottom) Anonymous
(Dr. Hermann Heidt), *Study of
a Nude Child,* c. 1880, Foto-
museum im Münchner
Stadtmuseum

of his individuality, so as to surpass photography and not fall into the same trap as it."[33]

Technically, a photograph could be transformed into a drawing with the help of a grid that subdivides the photographic model into equal-sized squares (fig. 33). Or else the model could be projected as a slide onto a canvas and the contours copied. *Photo-peinture,* invented in the mid-1850s, offered another possibility that involved using a sciopticon to project the selected motif onto a canvas covered with a photosensitive emulsion. Once the image had been fixed on the canvas, it was mounted on an easel and then painted over, a procedure used mainly in portrait painting to achieve as naturalistic a resemblance as possible.[34]

If one reviews the numerous accounts of the use of photography in nineteenth-century art, it soon becomes clear that what the purveyors of photographic studies praised most was the acceleration of the artistic working process. Some referred enthusiastically to the smaller number of hours required and the reduction in the mechanical part of the artist's work as a consequence of the use of photographs.[35] Photographs saved the portrait painter numerous sessions with the sitters, while art reproductions disseminated the artist's work to all corners of the earth in the shortest possible time—so go the arguments of the promoters. In the age of progress and accelerated transport and communication, through inventions such as the steam engine, telegraphy, and electricity, the technology of photography too was evaluated in terms of its economic efficiency. The photographic

artists' study became part of the principle of the division of labor that Taylorism had developed for a more rationalized world of work, in keeping with the catch phrases of "simplicity" and "speed." Photography, and in particular instantaneous photography, constituted the prerequisite for the mechanization of artistic production *and* perception, which Sigfried Giedion had described in his *Herrschaft der Mechanisierung* (Mastery of mechanization) as an essential feature of the emergence of modernism.[36]

## The Modernization of Photographic Techniques

The preconditions for the spread of photography were some groundbreaking technical developments that made photography easy even for untrained amateurs. The invention by the English doctor Richard Leach Maddox of the silver bromide gelatin dry plate in 1871, and its industrial manufacture as of 1878, made the process of taking photographs noticeably easier. The negative plates no longer needed to be covered with wet collodion long before exposure and then developed and fixed immediately after being exposed. Instead, they were now available ready-to-use. The exposure time for a shot had also been reduced to a fraction of a second, so that it was possible to capture sequences of movement (fig. 34) and contemporary events on film. Thanks to smaller negative plates, stereoscopy made the taking of so-called instantaneous photographs feasible in the 1850s.[37] However, not until the

Fig. 34 Ottomar Anschütz, *Storks,* 1886, Agfa Fotohistorama, Museum Ludwig, Cologne

experiments of Eadweard Muybridge, Etienne-Jules Marey, Albert Londe, and Ottomar Anschütz could the different phases in the movement of the human body be represented in individual images. The photographs by Anschütz and Muybridge enjoyed particular popularity. Muybridge presented them to prominent interested artists such as Auguste Rodin and Adolph Menzel during lecture tours in Berlin, London, Munich, and Vienna between 1889 and 1891.[38] "The numerous photographic sketches of people running, doves flying, etc., show the extent to which talented artists have recourse to photography when it is a matter of capturing fleeting phenomena in their total originality."[39]

Other technical improvements concerned the reproduction of color within the spectrum from red to orange, yellow, and green. On the traditional negative material these bright colors mostly appeared as black, while dark colors such as blue, indigo, or violet appeared as almost white. Hermann Wilhelm Vogel's discovery of eosin in 1873 and the development of the orthochromatic gelatin plate by Joseph Maria Eder in 1884 made it possible to achieve more authentic color reproduction. These improvements had positive effects for portrait and landscape photography, and the tonal values of paintings in photographs also became more realistic. About 1900 the realistic reproduction of the colors of the spectrum was also facilitated by the panchromatic silver bromide gelatin plate and three-tone photography. However, like Louis Lumière's autochrome (as of 1907), these color processes were technically complex and costly, with the result that they were only used by an elite and were of little significance to the artist-photographer.

Equally revolutionary developments were taking place in the field of camera construction. The large wooden cameras were being replaced by lighter hand-held cameras, which soon weighed less than a kilogram (2 pounds). These no longer required a tripod and could be used more spontaneously. Many of the camera types were magazine cameras that held a stock of up to twenty-four glass negatives or fifty film exposures.[40] Not only was it easy to change the negative magazines, but the fact that the acts of taking the photograph and chemically processing the plate or film were now separate also facilitated the use of the camera. Amateurs no longer had to retire to a darkroom. Instead, they could deliver their exposed negatives to a specialist laboratory and have prints made. In the 1880s and 1890s so-called detective and spy cameras became especially popular. These, in particular the most popular type, the round "C. P. Stirn's patented photographic spy camera," meant that a photograph could be taken secretly through a buttonhole, a tie, and so on. By no means was this type of camera used in forensic research, as the name might suggest. Instead, it appealed primarily to amateurs and dabblers because it was so functional, and it culminated in 1887 in the production of a spy camera called the "artist's camera."[41] Some of these cameras even had a pneumatic or mechanical remote shutter release, which enabled self-portraits to be taken both out- and indoors, as the compelling examples taken by Edvard Munch, August Strindberg, and Stanislav Witkievicz demonstrate. Camera lenses too, like Steinheil's antiplanet or the Zeiss, Goerz, and Voigtländer anastigmat, gained in speed, making them eminently suitable for instantaneous photographs of "lively scenes" in- and outdoors, while also solving the problem of missing depth of focus (figs. 35, 36). The technical developments outlined

Fig. 37 Ad. Baumann, *Franz von Stuck as Roman Emperor on the Occasion of the "Künstlerfest In Arkadien,"* Munich, 1898, Private Estate, Franz von Stuck, Munich

here were accompanied by a wealth of publications and handbooks on the use of photography for "tourists . . . and all those who take photographs . . . for pleasure."[42]

ARTISTS' PHOTOGRAPHS:
AN ICONOGRAPHY OF THE INCIDENTAL
In the late nineteenth century, photographic practitioners included artists, as the painter Karl Raupp, head of the nature class at the Munich art academy, pointed out in the journal *Kunst für Alle* in 1889:

> Those studies that the trade had on offer and that proved indispensable and profitable for the artist forced the photographic apparatus upon him. To produce photographs of nature independently for their own personal use and no longer be dependent on what was available to the general public was obviously all too plausible and practical for it not to become a mass phenomenon in art circles. . . . The apparatus is now a necessary part of the studio inventory. Out in the open, alongside the artist's umbrella, stands the camera, and if formerly the artist was only busy underneath

> the umbrella, now he just as frequently sticks his head under the black cloth to make a "setting." And when you enter a modern artist's studio, the chances are one hundred to one that the proprietor is in the darkroom, from where his muffled greeting and request for patience resounds. Artists who are not familiar with the photographic apparatus are already in the minority. By contrast, among many of the younger ones, including frequently mentioned names, it has already become their right-hand man, as it were. With its help, the work of art is pieced together in all its parts; the apparatus helps in preparing the draft for the painting, and guides and supports its completion through all its various phases.[43]

Raupp's description illustrates the high rate of acceptance photography enjoyed as a working tool, as a consequence of which corresponding publications such as *Photography for Artists* by Hector Maclean (Bradford, 1896) or *Photographie für Maler* by Julius Raphaels (Düsseldorf, 1899) provided instructions for taking photographs.

Interestingly enough, the way artists took photographs remained largely free of the aesthetics and ambitions of those artistically minded amateur photographers who, inspired by contemporary symbolist and plein-air painting around the turn of the century, pursued its recognition as an art form. Unimpeded by craft traditions and attempts to "ennoble" the photographic image by unusual positive techniques, the pictorial world of the artist-photographer was much closer to the aesthetics of snapshot photography than to the wilfully artistic aspirations of the pictorialists. They willingly accepted technically imperfect results, as one artist-photographer mentioned in 1892: "Even if, at worst, the resulting images are very unsatisfactory, if the exposure time was too short or long, if the object seems blurred for any reason, or if the vertical lines merge or fall apart because the camera was badly held, these photographic sketches still fulfill their function admirably, for in most cases all the artist or draftsman needs is an indicator, a hint, that comes to the aid of his memory, and even the worst photograph provides enough such cues."[44]

Just how reservedly some artists looked on pictorialist photography about 1900 is evident not least in the cool rejection of a Franz von Stuck or the satirical assessment of the Belgian artist Fernand Khnopff[45] as regards the artistic value of the medium. Largely independent of the aesthetic conventions of professional photography, artists captured their own views and preferences in photographic images that are astonishingly close to the style of snapshot and amateur photographers. Like these, the artist-photographer documented intimate realms, the studio, the apartment, sitters

from his or her circle of relatives or friends, leisure activities, travel, or other events in their lives, which were then occasionally included in their private photograph albums. Photographs of people, for example, were taken outside the protective veil of the photographer's studio—on the street, in the country, in private living quarters—and were thus not staged in any stereotypical manner. Unlike painting, the photography of artist-photographers recognized no hierarchy as regards the subject of the picture. The portrait, the nude, the still life, the landscape, the reproduction of a building or a work of art, all were photographed as equal in value. Aesthetically, too, there were no binding guidelines: the range of pictorial possibilities included anything from the panorama to the fragmentary view.

Needless to say, the instantaneous photograph taken in the private sphere brought with it a whole new iconography: incidental views, unsettled images, in other words, the iconography of the everyday, which at the same time was an expression of a modern awareness of life. "We want to fix what can be quickly seized and disappears quickly, to experience small sections of a stormy existence intensively!"[46] Like Karl Kraus, who in 1907 had claimed that "progress is an instantaneous photograph,"[47] Friedrich Naumann also understood instantaneous photography as an ideal medium for satisfying both individual needs and collective wishes. With instantaneous photography, the ideal medium for documenting contemporary history was born. Ultimately, history painting was made redundant by the direct, authentic shots of spectacular events typical of "illustration photography," a linguistic synonym for press photography.

Portraits of the artist, taken by the artist himself or herself or by a professional photographer, constitute a special section in the photographic archives that have been preserved. There has always been a demand for photographs of the artist's likeness. These were often presented as a sign of fellowship to artist colleagues, with a personally written dedication, or else they served more or less intentionally as an advertisement for the artist's person in the public domain. In such a case the portraits functioned as a media interface, which deliberately guided the public's opinion in a specific direction, as in the case of artists Stuck (fig. 37), Ferdinand Hodler, or Picasso, to mention just a few who in this way exerted an influence on the public status of their visual image, even adapting their appearance to it.[48]

Artists' photographic archives in the nineteenth century always have something of a "media wunderkammer" about them, gathering together everything that was available and could be depicted in photographs.[49] Photography provided a huge reservoir of mimetic copies of all the phenomena of nature and human civilization. And as photography came to be accepted as a universal and generally comprehensible pictorial language, reality could penetrate the pictorial world of art in fragments. It was that realistic moment, above all, that had such a long-term fascination, as is clear from the following statement by Henri Matisse: "Photographs will always be impressive because they show us nature, and all artists will find in them a world of sensations. . . . Photography should register and give us documents."[50] Critics who choose to regard this reference to photography as lacking in imagination and creativity may be countered with the arguments used by Max Liebermann in defence of Edouard Manet and the reproach that works by him such as *The Execution of the Emperor Maximilian of Mexico* were painted from photographs. Liebermann vehemently defended the artist's "sense of reality" by referring to the fact that the "imagination of an artist does not lie in the invention of a subject, but solely in the invention of the mode of realization."[51] What applied in the case of Manet was also valid for other artists. The artists' photographic archives that have survived usually contain a wealth of potential but often never realized paintings, representing an enormous reservoir held together by an invisible link: the artist's struggle to come to grips with reality by means of another, a second, nature: photography.

NOTES

1. Gleeson White, "Is the Camera the Friend or Foe of Art?" *Studio* 1, no. 3 (June 1893): 96.

2. Ibid., p. 102.

3. See "Der Kunstwerth der Photographie nach dem Urtheile moderner Meister der Malerei," *Gut Licht! Jahrbuch und Almanach für Photographen und Kunstliebhaber* (1896): 113–36.

4. Sadakichi Hartmann, "A Photographic Enquête," *Camera Notes* 5 (1901–2): pp. 233–38.

5. See Ulrich Pohlmann, "Alma-Tadema and Photography," in *Sir Lawrence Alma-Tadema,* ed. Edwin Becker (Amsterdam: Van Gogh Museum, 1996), pp. 111–24.

6. See *Photographies Barbizon d'hier et d'aujourdhui. La collection du peintre Théophile Chauvel au Musée d'Orsay* (Barbizon: Musée Municipale de l'Ecole de Barbizon, 1988).

7. *José Maria Sert Photographien* (Berlin: Georg Kolbe Museum, 1996).

8. See Ken Jacobson and Jenny Jacobson, *Etudes d'après nature: Nineteenth-Century Photographs in Relation to Art* (Essex: Petches Bridge, 1996), pp. 12 f.

9. The interrelation between painting and photography in the nineteenth and twentieth centuries has been examined in numerous scholarly publications. See, for example, Aaron Scharf, *Art and Photography* (Baltimore: Penguin, 1974); Van Deren Coke, *The Painter and the Photograph from Delacroix to Warhol* (Albuquerque: University of New Mexico Press, 1972); *Malerei nach Fotografie* (Munich: Münchner Stadtmuseum, 1970); Erika Billeter, ed., *Malerei und Photographie im Dialog von 1840 bis Heute,* Kunstmuseum Zürich (Bern: Benteli Verlag, 1977); Enno Kaufhold, *Bilder des Übergangs. Zur Mediengeschichte von Fotografie und Malerei in Deutschland um 1900* (Marburg: Jonas Verlag, 1986). In recent years the phenomenon of the artist's archive has been the object of particular attention, most notably in the exhibition and catalogue titled *Deep Storage: Collecting, Storing, and Archiving in Art,* ed. Ingrid Schaffner and Matthias Winzen (Munich and New York: Prestel, 1997).

10. Paul Delaroche, quoted in *Der Photograph* (1939): 174.

11. Pierre Caloine, "De l'influence de la photographie sur l'avenir des arts du dessin," *La Lumière,* April 29, 1854, pp. 65–66.

12. In 1855 just one advertisement in *La Lumière,* the leading trade magazine in France, mentioned more than 30 different texts by Belloc, Le Gray, Claudet, Disdéri, De Brébisson, Baldus, Gaudin, or Bertsch that were generally available for sale.

13. See Isabelle Jammes, *Blanquart-Evrard et les origines de l'édition photographique française. Catalogue raisonné des albums photographiques édités, 1851–1855* (Geneva: Droz, 1981), p. 65. See also "Blanquart-Evrard," in Anton Martin, *Handbuch der Photographie oder vollständige Anleitung zur Erzeugung von Lichtbildern auf Papier, Glas und auf Metall* (Vienna: C. Gerold, 1851), p. 254.

14. Ernest Lacan, "Esquisse physiologique. Du photographe amateur," *La Lumière,* February 26, 1853, p. 36.

15. Ernest Lacan, "Publications photographiques de M. Blanquart-Evrard," *La Lumière,* April 9, 1853, p. 57.

16. See Helmut Hess, "Copies photographiques," in *Alois Löcherer Photographien, 1845–1855,* ed. Ulrich Pohlmann (Munich: Schirmer/Mosel, 1998), pp. 140–53. On art reproduction in the nineteenth century, see Elizabeth Anne McCauley, *Industrial Madness: Commercial Photography in Paris, 1848–1871* (New Haven, Conn., and London: Yale University Press, 1994), pp. 265–300.

17. See *La Lumière,* September 22, 1855, p. 153. On stereophotography, see Denis Pellerin, *La Photographie stéréoscopique sous le second Empire* (Paris: Bibliothèque nationale de France, 1995).

18. Friedrich Naumann, "Die Kunst im Zeitalter der Maschine," *Der Kunstwart* 17, no. 20 (1904).

19. See Daniel Challe and Bernard Marbot, *Les photographes de Barbizon. La Forêt de Fontainebleau* (Paris: Editions Höebeke-Bibliothèque nationale, 1991); Ulrich Pohlmann, "'Etudes d'apres nature'. Barbizon und die französische Landschaftsphotographie von 1849 to 1875," in *Corot, Courbet und die Maler von Barbizon, "Les amis de la nature,"* ed. Christoph Heilmann, Michael Clarke, and John Sillevis (Munich and Berlin: Klinkhardt & Biermann, 1996), pp. 406–16, illustrations pp. 417–67; Jacobson and Jacobson (as in n. 8); Daniel Challe, *"Eugène Cuvelier oder die Legende vom Wald,"* in *Eugène Cuvelier* (Stuttgart: Graphische Sammlung, 1996).

20. Peter Galassi, *Before Photography: Painting and the Invention of Photography* (New York: The Museum of Modern Art, 1981).

21. See *Model Folios of the 19th and 20th Centuries* (Successor of the Historical Ornamental Engraving), auction cat. (Munich: Dietrich Schneider-Henn, June 13, 1996).

22. As represented by Carlo Bertelli and Guilio Bollati, *Storia d'Italia. L'Immagine Fotografica, 1845–1945* (Turin: G. Einaudi, 1979), 1: 79–83. Of interest is the question of how the photographed physiognomy of (modern) man in the nineteenth century either replaced the prototypes of the ancient ideal figures or melded with them.

23. See Helmut Bauer, ed., *Schwabing: Kunst und Leben um 1900* (Munich: Münchner Stadtmuseum, 1998), p. 33.

24. See *L'Art du nu au XIXe siècle—le photographe et son modèle* (Paris: Hazan, 1997).

25. A. Vignola, *L'Etude académique. Recueil de documents humains,* vols. 1–3 (Paris: Librairie d'Art Technique, 1904).

26. Ernst Haeckel, *Kunstformen der Natur* (Leipzig and Vienna, 1904; reprint, Munich and New York: Prestel, 1998). See contribution by Olaf Breidbach, "Kurze Anleitung zum Bildgebrauch," pp. 9–18.

27. See Martin Gerlach, *Formenwelt aus dem Naturreiche. Photographische Naturaufnahmen von M. Gerlach, Mikroskopische Vergrößerungen von H. Hinterberger* (Vienna and Leipzig: M. Gerlach, 1902–4?); H. Schenk, *Kristallformen,* with an introduction by Karl Schmoll gen. Eisenwerth (Stuttgart, ca. 1910). A later publication was the influential work by Karl Blossfeldt, *Urformen der Kunst. Photographische Pflanzenbilder von K. Blossfeldt,* ed. K. Nierendorf (Berlin: E. Wasmuth, 1928; English ed., 1929).

28. Gaston Tissandier, *Les Merveilles de la photographie* (Paris: Hachette, 1874), p. 294.

29. See J. A. Schmoll gen. Eisenwerth, "Lenbach und die photographie," in *Franz von Lenbach, 1836–1904* (Munich: Städtische Galerie im Lenbachhaus, 1987), pp. 63–97.

30. Part of the photographic estate, about 100 photographs, is now in the Fotomuseum im Münchner Stadtmuseum and the Dietmar Siegert Collection.

31. See *Mariano Fortuny Collezionista: Alinari, Atget, Bonfils, Laurent, Quinet, Sella* (Milan: Electa, 1983).

32. See Christine Kühn, *Eugène Atget, 1857–1927. Frühe Fotografien* (Berlin: Kunstbibliothek, 1998). It should also be noted that around the turn of the century extensive collections and archives of art and contemporary photographs were compiled in various museums in England, France, Germany, and Switzerland.

33. Ludwig Pfau, *Kunst und Gewerbe* (Stuttgart: Ebner und Seubert, 1877), 1: 264.

34. See E. Lamy, "Übermalen von Photographien auf Leinen," *Photographische Mitteilungen* 35 (1898): 250–52.

35. See *Reports by the Juries on the Subjects in the Thirty Classes into Which the Exhibition Was Divided* (London: Spicer Brothers, 1852), p. 244.

36. Sigfried Giedion, *Die Herrschaft der Mechanisierung* (Frankfurt am Main, 1987), originally published as *Mechanization Takes Command* (New York: Oxford University Press, 1948).

37. For example, the following items were captured in photographs by Hippolyte Macaire in Le Havre: "Sky, waves, fire and flames, effects of the sun and mirroring reflections on the ocean, as well as a moving coach, a person walking, a trotting horse, steamships with smoking chimneys and the spray caused by the paddles of the waterwheels." See "Des progrès et de l'avenir de la photographie," *La Lumière,* October 5, 1851, p. 138. See also *La Révolution de la photographie instantanée, 1880–1900* (Paris: Bilbiothèque nationale de France and Société française de photographie, 1996).

38. Muybridge presented his photographs by comparing them with the depiction of movement in paintings and drawings from the history of art. See "Edward Muybridge in Wien," *Photographische Rundschau* (1891): 235–36.

39. *Photographische Korrespondenz* 40 (1903): 40.

40. For example, in 1889 the Kodak company launched a handheld camera with a magazine containing 100 negatives. With the Kodak box, the exposure times varied from between 2 to 3 seconds outdoors, 20 to 40 seconds indoors in clear weather, and 1 to 2 minutes in cloudy weather.

41. *Photographische Rundschau* (1887): 311.

42. Quoted from Timm Starl, *Knipser: Die Bildgeschichte der privaten Fotografie in Deutschland und Österreich von 1880 bis 1980* (Munich: Keehler and Amelang, 1995), p. 33. This publication contains an extensive description of the fields of application and the aesthetic aspirations of snapshot photography.

43. Karl Raupp, "Die Photographie in der modernen Kunst," *Die Kunst für Alle* 4 (1889): 325f.

44. C. F. Hoffmann, "Die Photographie im Dienste der Kunst," *Photographische Rundschau* 6 (1892): 15. Similar statements are to be found in Carl Ernst Morgenstern, "Künstlerische Plauderei über Photographie," *Photographische Rundschau* 6 (1892): 219–24; Julius Raphaels, "Die Photographie für Maler," *Die Kunst für Alle* 12 (1897): 362f.

45. Franz von Stuck declared that "under no circumstances [was] a photograph to be regarded as a work of art," and that it was "nonsense to want to create any impression of an original work of art through photography." Quoted from "Der Kunstwerth der Photographie" (as in n. 3), p. 133; Fernand Khnopff, "Gehört die Photographie zu den schönen Künsten?" *Photographische Mitteilungen* 36 (1899): 128–33. See also the statements by Auguste Rodin, Gustave Geffroy, Théophile-Alexandre Steinlen, Alexandre Charpentier, Charles Cottet, Jules Chéret, Albert Bartholomé, Adolphe Willette, Jean-François Raffaëlli, Camille Mauclair, Francis Jourdain, Auguste Pointelin, Gabriel Mourey, and Henri Matisse in reaction to the survey in *Camera Work,* no. 24 (1908): 13–23.

46. Friedrich Naumann, "Die Kunst im Zeitalter der Maschine," *Der Kunstwart* 17, no. 20 (1904): 326.

47. Quoted in Timm Starl, "Geschoß und Unfall. Bewegung und Moment in der Fotografie um 1900," in Starl, *Im Prisma des Fortschritts. Zur Fotografie des 19. Jahrhunderts* (Marburg: Jonas Verlag, 1991), p. 83.

48. See Ulrich Pohlmann: "'Als hätte er sich selbst entworfen.' Die (Selbst-) Darstellung Franz von Stucks in Photographie, Malerei und Karikatur," in Jo-Anne Birnie-Danzker, Ulrich Pohlmann, J. A. Schmoll gen. Eisenwerth, eds., *Franz von Stuck und die Photographie: Inszenierung und Dokumentation* (Munich: Prestel, 1996), pp. 27–37; Anne Baldassari, *Picasso and Photography: The Dark Mirror* (Paris and Houston: Flammarion and Museum of Fine Arts, 1997); Jura Brüschweiler, *Ferdinand Hodler Fotoalbum* (Bern: Benteli, 1998).

49. It was possible to order catalogues from large photograph dealers either directly through their main branch or affiliates or through agencies and the international art trade, and even through museums. The distribution network included the bookbinders and picture traders Negesborn & Bowinkel and Alberto Detken in Naples, Joseph Spithöfer, Hermann Loescher, Edmondo Behle's, and Cook's travel agency in Rome, Degoix in Genoa, Carlo Ponti and Naya in Venice, J. Brecker in Florence, Ludwig Niernberger and Oscar Kramer in Vienna, Marion & Co., Ernest Gambart, and W. Day & Sons in London, etc. Initially the catalogues largely were without illustrations, but as of 1900 more and more of them were published with autotype illustrations.

50. Henri Matisse, quoted in "George Besson, Pictorial Photography—A Series of Interviews," *Camera Work,* no. 24 (1908): 22.

51. Max Liebermann, quoted in Fritz Hansen, "Photographie und Malerei," *Photographische Korrespondenz,* no. 607 (1911): 262.

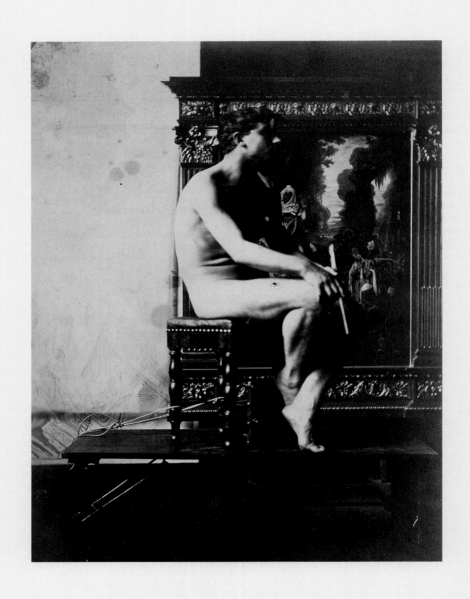

# Gustave Moreau

Paris 1826—1898 Paris

Born to a wealthy and supportive family, Moreau attended the
private studio of François-Edouard Picot, where he prepared for
the entrance exams to the Ecole des Beaux-Arts. More important
for him, though, was his friendship with Théodore Chassériau,
whose aesthetic exoticism laid the groundwork for Moreau's sub-
sequent explorations. A trip to Italy in 1857—58 was also very in-
fluential, acquainting Moreau with a wide range of ancient and
Renaissance art. His *Oedipus and the Sphinx* established his reputation
at the Salon of 1864. He exhibited there until 1869, when harsh
criticism from reviewers discouraged him; he returned to that
public forum in 1876, showing until 1880. He received the Le-
gion of Honor in 1875. Despite poor health, Moreau enlisted in
the National Guard during the Franco-Prussian War (1870—71)
but was dismissed after he contracted rheumatism. He showed
watercolors illustrating La Fontaine's fables at smaller venues
in the late 1880s, including a solo show at the Goupil Gallery
in 1886. In 1892 he began to teach at the Ecole des Beaux-Arts,
where he encouraged the individual talents of his students, among
them Henri Matisse and Georges Rouault. Reluctant to part with
his works, Moreau converted his house (which his parents had
bought for him) to become a museum after his death. He lived
with his mother until she died in 1884 and successfully kept her
in ignorance of his mistress, with whom he was involved from
1865 until the mistress's death in 1890. Moreau's paintings pre-
sent an almost dizzying surface, full of linear detail combined
with a somber though rich palette. His themes, drawn from the
Bible and mythology, such as Salome and Orpheus, emphasize
the unworldly, dreamlike aspect of their stories. The untraditional
aspect of his paintings is enhanced by his inclusion of elements
from exotic cultures, sometimes gleaned from photographs.

*Dorothy Kosinski*

# Picturing Poetry: Photography
# in the Work of Gustave Moreau

The extravagant accumulation of motifs and encrustation of rich and varied detail in Gustave Moreau's work create an exotic, even suffocating atmosphere that would seemingly preclude any role for photography. Similarly, one might imagine the camera to be an unthinkable intrusion of new technology into the carefully orchestrated environment of Moreau's house-museum, redolent with the heavy perfume of distant cultures. In recent years, however, art historians' "excavations" at the Musée Gustave Moreau have uncovered a surprisingly rich cache of photographs, painstakingly preserved and subsequently diligently obscured by Moreau's trusted secretary, Henri Rupp (cat. 9). Moreau's interaction with photography is, in fact, complex, functioning on at least three levels.[1] Photographs of elaborately posed nude models were staged amid partially or fully completed canvases in Moreau's atelier. These photographs were part of a multiphased working method by which Moreau composed his large-scale and intricate compositions.

In addition to these photographs, Moreau purchased photographs from various sources, including photographic agencies. Some were kept loose, others were bound in albums or were illustrations in publications. They include ethnographic and architectural views as well as animal studies. Images of Hercules, Apollo and Marsyas, Leda, and the Sphinx in Moreau's paintings were gleaned from photographic reproductions of gems and medallions from museums in Rome and published by Alfred Cadart in Paris in 1859. Furthermore, Moreau owned photographic reproductions of masterworks of the Italian Renaissance, Greek sculpture, and engravings by Rembrandt. Last, Moreau's innumerable works on paper include detailed drawings of fragments copied from

photographs that he did not own but had studied at exhibitions. Far from being incidental, these photographs—elaborately posed studio nudes, picture postcards, photographic albums —constitute a significant aspect of Moreau's visual repertoire, in addition to his vast library of myriad volumes adorned with engravings, plaster and bronze casts, prints, his own painted copies and sketches of the Renaissance masters, antique gems, and an array of studio props including tortoiseshell and swan's wing (fig. 38). Like so many artists of his generation, Moreau embraced photography as a compositional aid, as an aide-mémoire, but also as an avatar of remote places and culture, signifiers of the exotic. It is noteworthy, too, that Moreau, like other artists of this era, including Rodin, Khnopff, Rosso, and Stuck, occasionally reworked photographs of his compositions, thereby enfolding the photograph into an even more complex dialogue with the work of art, an intermedium, as it were, that defies easy classification in traditional hierarchies (cat. 4). Most significant, Moreau, "assembleur des rêves" (assembler of dreams), was an obsessive collector, a forager for images to be embraced and transformed within new constellations of signification. His dialogue with photographic material reveals what captivated his imagination. An examination of his ahistorical manipulation of the visual material makes clear the catholicism of his interests.

Cat. 4 (opposite) Gustave Moreau, *Venus out of Waves,* after 1866, retouched photograph, 5 × 3⅜ in., Musée Gustave Moreau, Paris

Fig. 38 Photo showing plaster casts from second-floor studio of Gustave Moreau, Museé Gustave Moreau, Paris

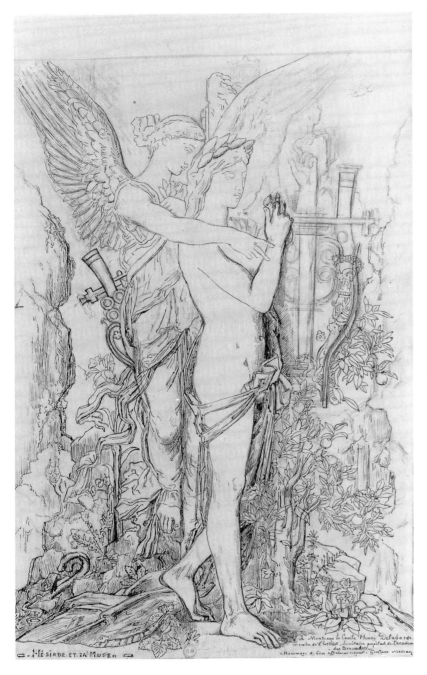

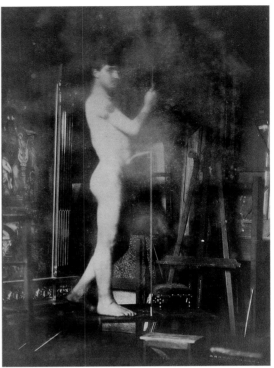

Cat. 3 Gustave Moreau,
*Hésiode and the Muse,* 1860,
pen and ink over pencil sketch
on paper, 19⅝ × 12⅝ in.,
Musée Gustave Moreau, Paris

Cat. 16 Henri Rupp, attrib-
uted, *Male Model Posing for
"Hésiode and the Muse,"* n.d.,
photograph affixed to card-
board, 9½ × 6⅞ in., Musée
Gustave Moreau, Paris

Moreover, as we shall see, the precise manner in
which he studied the photographs informs crucial
aspects of his style.

The batch of photographs of carefully posed
studio nudes was probably taken by Moreau's
assistant Rupp and subsequently inconspicuously
stored in a cardboard portfolio inscribed with his
initials. This later obfuscation is a manifestation
of the continued ambivalence about the status of
the photograph. No photographic equipment
has been discovered (as had been the case in the
house-museum of Khnopff), and it seems highly
unlikely that Moreau took the photographs him-
self. Although Rupp surely attended to the techni-
cal aspects of the project concerning camera and
darkroom, Moreau himself certainly orchestrated
the mise-en-scène, paying careful attention to
each nuance of the figures' poses. One discerns a
clarity or crispness in the photographic studies,
as though the goal were to achieve a degree of
gravitas or sculpturesque monumentality. There
are manifest and multiple connections between
the photographs and specific compositions, includ-
ing the *Argonauts, Pasiphae, The Poet and the Siren,
The Poet Voyager, Hésiode and the Muse* (cats. 3, 16),
and *Jupiter and Semele.* The resonance of the pho-
tographs in Moreau's oeuvre is amplified by the
fact that these constitute some of the principal
themes to which he repeatedly returned through-
out his career in many different versions of the
same composition. The contemplative pose of the
wandering poet and the defiant stance of Pasiphae

are both, for instance, based on atelier photographs (cats. 6, 8).

The function of the photographs in the working process is particularly interesting in the case of *The Argonauts.* Clearly, the poses of many of the individual figures had been determined already in an earlier phase of work. Moreau first sketched out the general compositional scheme in a wax maquette of the *Argo,* the Golden Fleece aloft, guarded by Jason (fig. 39). Modeling in wax, Moreau could work with ease and fluidity to establish the overall scheme of this complicated composition and to resolve the interaction of the many figures, analyzing the meaning and function of each figure's body position and response to the whole. The photographs, as it were, distilled or crystallized these results or decisions (cats. 11, 12, 13). The next phase of work consisted of finished drawings on blue paper after the photographs. In the various versions of the finished oil painting,

these details are once again obscured, rendered more generic, enveloped in a mantle of poetry (cat. 5).[2]

Sometimes the connection between finished work and these preparatory stages remains too close and injects a disturbing specificity into the finished work of art. The detailed rendering of the face, the carefully posed position of the melancholic poet in the *Wayfaring Poet* proves somehow irritating (cats. 2, 15). In 1908 Victor Segalen fiercely criticized the Mantegna-inspired horse that gazes sympathetically at the poet. It may be that Segalen was reacting to the awkward stiffness not only of the horse but of the poet as well (cat. 7). Typically, the drawing on blue paper is a precise rendering, which not only captures the general silhouette of the model but includes detailed facial expressions, even distinct elements such as hairstyles. The painting seems, in fact, a bizarre stylistic pastiche—contrasting the academically

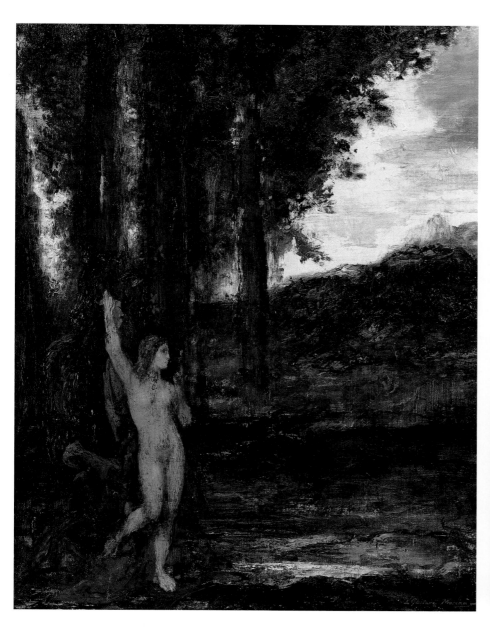

Cat. 6  Gustave Moreau, *Pasiphae,* c. 1890, oil on canvas, 31½ × 24¾ in., Musée Gustave Moreau, Paris

Cat. 8  Henri Rupp, attributed, *Female Model Posing for "Pasiphae,"* n.d., photograph affixed to cardboard, 9 × 4⅝ in., Musée Gustave Moreau, Paris

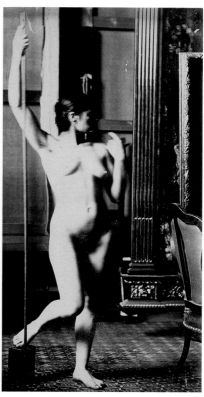

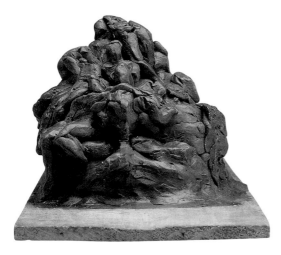

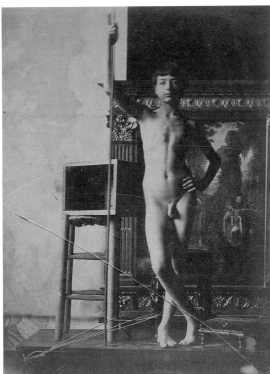

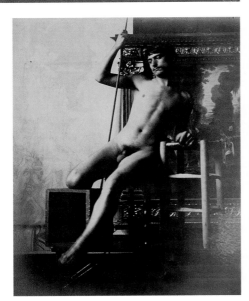

Fig. 39 (left, top) Gustave Moreau, wax model for *The Argonauts*, Museé Gustave Moreau, Paris

Cats. 11, 12, 13 (left, middle and bottom, and below) Henri Rupp, attributed, *Male Model Posing for "The Argonauts,"* n.d., photograph affixed to cardboard, 11¾ × 9⅜, 9⅜ × 6⅞, 9⅜ × 6¾ in., respectively, Musée Gustave Moreau, Paris

Cat. 5 (opposite) Gustave Moreau, *The Argonauts,* before 1885, oil on canvas, 18½ × 12⅝ in., Musée Gustave Moreau, Paris

inspired horse, the photographically based figure, and the astonishingly freely brushed, almost expressionistic landscape.[3]

Moreau collected photographs, some purchased from the Parisian photographic agencies Giraudon or Maison Martinet, for example. He owned albumen prints by Samuel Bourne and by Bourne and Charles Shepherd, who in 1867 had formed the company that came to dominate the market for picturesque views of India. Moreau's collection included views of elephants in India and others posed in the Jardin des Plantes photographed by Henri Dixon. His collection included ethnographic studies of India by a photographer now identified as Oscar Mallitte. Several of the English photographer Francis Frith's photographic studies of India, including both architectural details and ethnographic shots, are also to be found in Moreau's collection.[4] The fact that India and the Far East figure so prominently in Moreau's photo collection is noteworthy. These photographs are the sources for the Indian and oriental motifs in Moreau's finished paintings, which are juxtaposed to such disparate elements as those inspired by the Italian primitives and Roman sculpture, for instance.

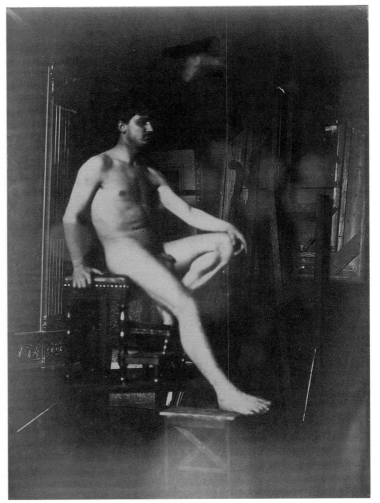

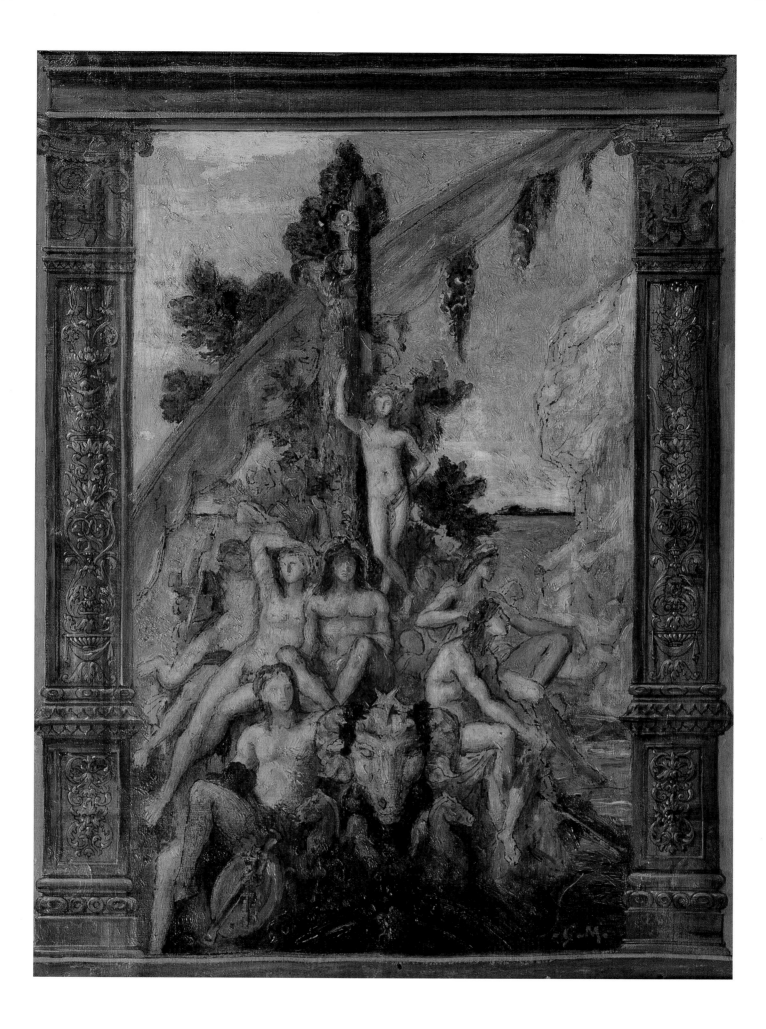

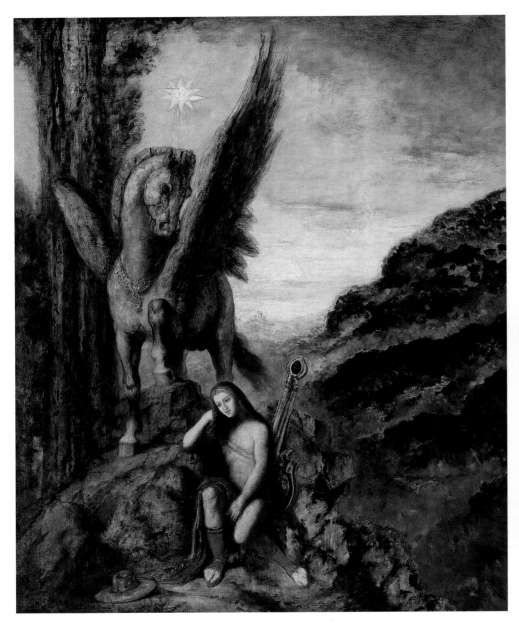

Cat. 7 Gustave Moreau,
*Wayfaring Poet,* 1891, oil on
canvas, 70⅞ × 57½ in., Musée
Gustave Moreau, Paris

Cat. 2 Gustave Moreau, *Study
for "Wayfaring Poet,"* n.d.,
pencil with white chalk on
bluish paper, 12⅜ × 8¼ in.,
Musée Gustave Moreau, Paris

Cat. 15 Henri Rupp, attrib-
uted, *Male Model Posing for
"Wayfaring Poet,"* n.d., photo-
graph affixed to cardboard,
9⅜ × 6⅞ in., Musée Gustave
Moreau, Paris

Fig. 40  Samuel Bourne,
*Ancient Brahmin and Temple,*
*Pillars, and Capitals, Album*
*of Photographs of India,*
73 albumen prints, Musée
Cernuschi, Paris

Fig. 41  Gustave Moreau,
*Study, Indian Architecture,*
pen, brown ink, graphite
on tracing paper, Museé
Gustave Moreau, Paris

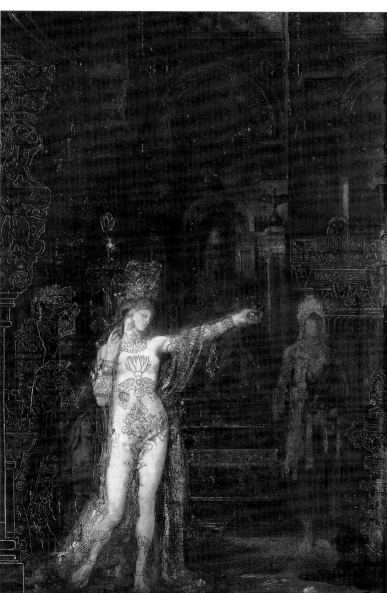

Fig. 42  Gustave Moreau,
*Salome Dancing, Salome*
*Tattooed,* oil on canvas,
Museé Gustave Moreau,
Paris

Fig. 43  Joseph Lawton,
*Entrance to Watte Dage,*
*Ceylon,* albumen print,
Musée Cernuschi, Paris

The photographs of India are more than sources for Moreau; they are implicated in the artist's syncretic vision of the cultural history of the world.

Perhaps the famous symbolist author, Joris-Karl Huysmans, captured the importance of India and the heterogeneity of Moreau's syncretic imagination most vividly. In his 1884 book *A rebours* (Against nature), Huysmans has his hero, Des Esseintes, describe his fascination with Moreau's Salome: "She belonged to the theogonies and the Far East." Salome was a symbol of the artist's evocative cultural-aesthetic syncretism: "The painter seemed to have wished to assert his intention of remaining outside the bounds of time, of giving no precise indication of race or country or period, setting as he did his Salome inside this extraordinary palace with its grandiose, heterogenous architecture, clothing her in sumptuous, fanciful robes, crowning her with a nondescript diadem like Salammbo's, in the shape of a Phoenician tower, and finally putting in her hand the sceptre of Isis, the sacred flower of both Egypt and India, the great lotus-blossom."[5] Huysmans stresses the Far Eastern aspects of Moreau's evocation of female power. He also astutely describes the inventive, ahistorical, a-archaeological blend of motifs that characterizes Moreau's paintings. Huysmans was by no means the first to celebrate Moreau's "Hindu" or "Indian" aura.[6] It is informative to plumb this aspect of Moreau's work and specifically to discover photography's role in his exotic brew of syncretism.

*Salome Dancing* (fig. 42) and *The Apparition* are two variations on this oft-repeated theme. Both versions are laden with accumulations of precise, archaeologically inspired, photographically derived detail. In *Salome Dancing* (called *Salome Tattooed*), a dazzling light emanates from the saint's hovering and blood-dripping head and illuminates the interior, which is richly adorned with linear ornamentation that seems etched in the paint surface. The temple's walls, columns, and arches are covered with grotesque faces, mythological beasts, and statues of eastern origin, evocative of non-Western cosmologies. Salome's jeweled attire recalls that of Indian deities. In the painting Moreau creates a tension between the brownish red crepuscular interior and the crisp linear decoration inscribed everywhere, even on the dancing Salome's body. She holds aloft a lotus, symbol in India of the powers of female sexuality. The orbs, snakes, and wings, by contrast, derive from Egypt, while the buckle of the bearded male figure is based on an Etruscan source. The intricate linear patterns replicate the densely etched metal surface of a reliquary or ceremonial object.[7]

Recent scholarship reveals a very specific source for the linear decoration at Salome's feet: an albumen print by Joseph Lawton of the engraved stone at the principal entrance to the Watte Dage temple in Ceylon (Sri Lanka) (fig. 43). Lawton had worked in Ceylon in the early 1860s, commissioned by the Committee on Ancient Architecture to document the most important ruins in that country.[8] Moreau worked closely with Lawton's photographs as well as those by Bourne and James Burgess in 1873, when their photographs were included in the section of the *Exposition des Beaux-Arts de l'Extrême Orient* in the Palais de l'Industrie devoted to the collection of Henri Cernuschi.[9] Moreau made innumerable detailed tracings and studies of photographs framed under glass or bound in albums (figs. 40, 41).[10]

Although China and Japan had clearly captured Cernuschi's attention and despite the fact that he and his traveling companion, Théodore Duret, had spent at least as much time in Indonesia and India as in China and Japan, they were relatively unimpressed with those cultures. Duret described India in disparaging terms. Asian cultures such as those of India and Indonesia were represented in the 1873 exhibition, not with art objects (as were China and Japan), but with extensive installations of photographs. Though these photographs of people, architectural monuments, and everyday scenes proved to be a disappointment for the general public, they were, as we have seen, of great interest to Moreau.[11] A close examination of Moreau's precise tracings and careful copies of these photographs offers crucial insight into his working methods and the essential and distinctive character of his finished works of art. His minutely detailed drawings of intricately carved architectural fragments not only reveal his intense interest in the photographs themselves. They also reveal themselves as the formal basis for the fine linear elements that play a major role in Moreau's major paintings. Through the intermediate step of transcription, the photographs function as inspiration for the delicate linear elements of his paintings, which form a counterpoint to the rich and fluid (and in his later compositions, almost abstract) brushwork of his oil paintings.

Moreau's obsessive fascination with detail contrasts dramatically with his flagrant disregard for cultural or historical coherence. The archaeological whole was apparently of no importance to him. Rather, in his exploration of the 1873 exhibition at the Palais de l'Industrie, bits and pieces from objects and photographs, from Japanese, Chinese, Indian, and Southeast Asian sources, are juxtaposed on a single sheet. One might argue that this method simply reflects Moreau's haste to record as much as possible, profiting from the morning hours when the exhibition was made available for study by artists. It seems clear, however, that these wild juxtapositions demonstrate something more significant, a syncretic vision, which creatively combined disparate cultures, informed by his confidence in a universal spiritual heritage.[12]

Moreau's particular interest in the photographs of India in Cernuschi's collection resonates with the broad fascination with the Far East and specifically with the increasing importance of India in that general area of study. Indeed, all of Europe seemed to have become intoxicated with India. The periodicals *Tour du monde* and *Magasin pittoresque* featured articles about India. Major books appeared: Eugène Burnouf's *Inde française* (1830), James Burgess's *Temples of Satrunjaya* (1869), and the richly illustrated *Civilisations de l'Inde* by Gustave Le Bon (1887). The fascination with India can, of course, be seen as another manifestation of "orientalism," which figures in the works of major authors including Chateaubriand, Gustave Flaubert, Victor Hugo, and Alfred de Vigny. It is important, too, to recall that the nineteenth century witnessed major translations and historical studies by Emile-Louis Burnouf, Alexandre Langlois, and Jules Michelet. The first chair in Sanskrit was established at the Collège de France in 1814 for the eminent scholar Antoine-Léonard de Chézy. Georg Friedrich Creuzer's influential encyclopedic study of world religions, *Symbolik und Mythologie der alten Völker,* first published in 1810, posits India as the primary source for the entire spiritual evolution of humankind. India figures centrally in many of the syncretic histories, mythographies, and comparative philologies that flourished during the nineteenth century.[13] Indeed, Moreau's fascination with photographic images of India cannot be dismissed as incidental but is clearly a central theme and telling symptom of a broad intellectual syncretism. Moreau's "archaeology," as Huysmans described the artist's indiscriminate borrowing of motifs from Greece, India, and Egypt, of symbols from Buddhism, Christianity, and Hinduism, was not scientific. His impulse was not to classify and separate. Rather, he wove together a variety of images, objects, and references, embracing diverse cultures and epochs, drawing too from different media such as photography, miniature painting, bronze sculpture, and oil painting. Moreau's aesthetic was informed by a ferocious appetite for details and the impulse to synthesize them into his complex, hallucinatory compositions.

NOTES

1. Geneviève Lacambre has pioneered these investigations. See her publications: *Maison d'artiste, maison-musée: L'exemple de Gustave Moreau* (Paris: Réunion des musées nationaux, 1987), catalogue by Lacambre; *L'Inde de Gustave Moreau* (Paris: Editions des musées de la Ville de Paris, 1997). See also *L'Art du nu au XIXème siècle* (Paris: Hazan, Bibliothèque de France, 1997).

2. See Lacambre, *Maison d'artiste, maison-musée,* pp. 38–42.

3. *Gustave Moreau symboliste* (Zurich: Kunsthaus Zürich, 1986), p. 140.

4. Lacambre, *L'Inde de Gustave Moreau,* p. 104.

5. Joris-Karl Huysmans, *Against Nature,* trans. Robert Baldick (Baltimore: Penguin Books, 1959), p. 66.

6. See Geneviève Lacambre, "Gustave Moreau, 'un Italien primitif ou quelque peintre hindou,'" in Lacambre, *L'Inde de Gustave Moreau,* pp. 33–38. R. van Heyms, article in *La Défense,* May 30, 1876; Emile Blavet, article in *Le Gaulois,* June 2, 1876; Judith Gautier, article in *Le Rappel,* May 19, 1881.

7. Julius Kaplan, *Gustave Moreau* (Los Angeles: Los Angeles County Museum of Art, 1974).

8. Lacambre, *L'Inde de Gustave Moreau,* p. 98, cats. 43 and 44.

9. See Michel Maucuer, "Gustave Moreau et les collections asiatiques d'Henri Cernuschi," in Lacambre, *L'Inde de Gustave Moreau,* pp. 39–47.

10. See Louis Mézin, "De l'usage inattendu d'un 'retour des Indes,'" in Lacambre, *L'Inde de Gustave Moreau,* pp. 11–14.

11. Moreau seemed to bring the same level of attention to these photographs as he had to the noted collection of Indian manuscripts bequeathed by Jean-Baptiste Gentil (1726–1799) to the Royal Library (Bibliothèque nationale) in 1778. Those albums of richly detailed gouache miniatures seemed to interest Moreau because of their compositional formulas, especially in the massing of figures and the general relationship of figures to landscape. His notebooks record careful study of faces, gestures, costumes, animals, instruments, and fantastic architectural elements.

"Ce qui frappe en effet par dessus tout dans la civilisation hindoue, c'est le caractère qu'on lui découvre d'un état qui est resté celui de l'enfance, combiné cependant avec tous les signes de la décrépitude." Théodore Duret, *Voyage en Asie* (Paris, 1874), p. 281, as quoted in Maucuer, "Gustave Moreau et les collections asiatiques d'Henri Cernuschi," p. 42.

12. See Dorothy Kosinski's long discussion of Moreau's interest in mythology and archaeology, and specifically his *Vie de l'Humanité* in the context of nineteenth-century syncretism, in "Orpheus: Das Bild des Künstlers bei Gustave Moreau," in *Gustave Moreau symboliste* (as in n. 3), pp. 43–69.

13. See Dorothy Kosinski, *Orpheus in Nineteenth-Century Symbolism* (Ann Arbor, Mich., and London: UMI Research Press, 1989), esp. chap. 2.

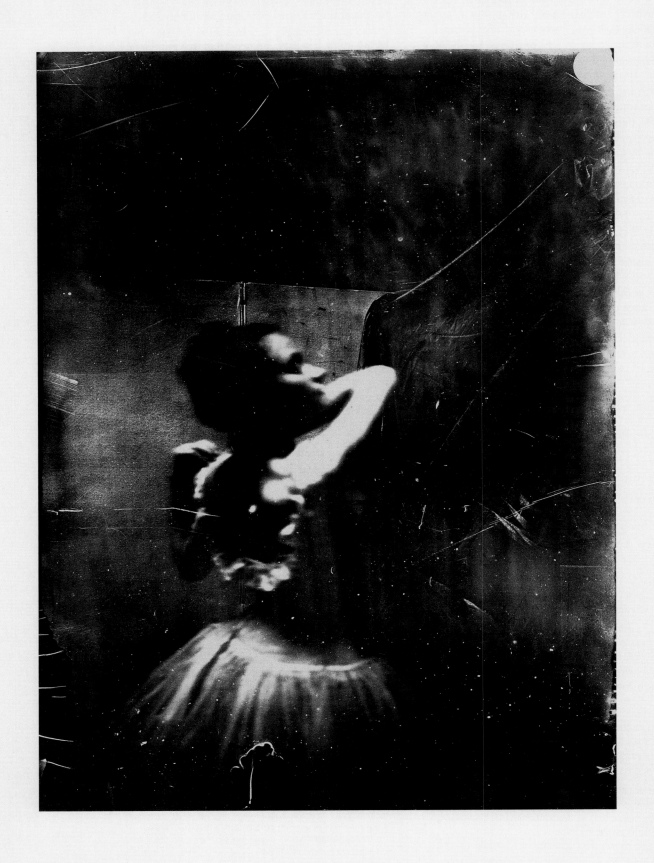

# Edgar Degas

Paris 1834—1917 Paris

Degas's classicist training—he studied with Louis Lamothe, a follower of Jean-Dominique Ingres—and his reverence for the old masters inform all of his art. A lifelong student, he approached his subjects with a spirit of inquiry and drew, sculpted, and photographed to better understand what he saw. By 1856, after a classical education at Paris's most prestigious lycée (high school) and brief study at the Ecole des Beaux-Arts, Degas was in Italy, where he stayed with family. There he met Gustave Moreau in 1858; they traveled to Pisa and Siena. An early desire to succeed at the Salon prompted Degas to produce large history paintings. He alternated work on these with portraits, a constant in his oeuvre through the 1870s. Contemporary urban life replaced history as a subject at the end of the 1860s, and exhibitions independent of the Salons became Degas's preferred venues. His alliance with Claude Monet, Camille Pissarro, and Pierre-Auguste Renoir was based on shared interests in contemporary subjects and technical innovation and a desire to be free of governmental strictures. Degas came to be associated with subjects that described or implied motion—racehorses, dancers, laundresses, and bathers. Visiting family, he spent five months in New Orleans and made several trips to Italy in the 1870s. He worked in all media: monotypes and etchings, *essence* (paint whose oil has been blotted out and thinned with turpentine), sculptures in wax (he cast only one in plaster during his lifetime), pastels, and photographs. Within each category he experimented, for example, working pastels with a brush for new effects. Afflicted with weak eyes his whole life, Degas found pastels and wax easier to work with as his eyesight worsened. In his later years he reworked the subjects that had interested him earlier, finding new ways to express the human and animal body in motion.

Fig. 44 Edgar Degas, *Dancer Adjusting Her Shoulder Strap,* late 1895 or 1896, gelatin dry plate negative, Bibliothèque nationale de France, Paris

*Elizabeth C. Childs*

# Habits of the Eye: Degas, Photography, and Modes of Vision

*One sees as one wishes to see.*
—Edgar Degas

For Degas the camera was a useful agent of modern vision. The photographer's powers of selecting and framing a view, of isolating the noteworthy in a scene of haphazard detail, appealed to the omnivorous eye of this naturalist. For an artist who aspired to read the temperament of an era through a posture, a gesture, or the mere curve of a back,[1] the photograph bore a synecdochical relation to the social world. And that relation emerged in both his painting and his photography. If at times Degas seems to have viewed the world as if through a camera, he also came to make photographs that often reiterated the formal structures of his paintings. Over the course of his career, his recourse to the two media intertwined, with photography informing his work in painting and vice versa (fig. 44). And his interests here also coalesced with his experiments in sculpture, printmaking, and pastel. In spite of Degas's intense flurry of activity as a photographer in 1895, there is never an extended phase of his mature career in which his artistic project is exclusively photographic, sculptural, or painterly. Rather, his interests in these media were coextensive and complementary.

Degas did not formulate his artistic vision by working in any single medium. One discerns the same reductive impulse, the same astute powers of observation, and the same ingenious patterns of composition in his work separated by twenty years or more. A comparison between his painting *Place de la Concorde* of c. 1876 and his photograph of a street scene of the mid-1890s (figs. 45, 46) makes the case for the consistency of his discerning eye. In the canvas the urbane printmaker vicomte Lepic strides across a wide expanse of plaza, his thin umbrella marking the vector of his purposeful stroll. His two daughters at his side move in a contrary direction yet echo him in their calculated and elegant nonchalance. Through the family's telling gestures and expressive bodies, Degas captured the passage of social habit from one generation to the next—a biological and sociological process of sustained interest to him. In his later photograph of a street scene, probably made in 1895, we once again find Degas's cross-generational observation of gesture and pose reinforced by his composition. The wide expanse of sidewalk is cut by the sharply receding line of a diagonal shadow, thrusting three figures into sunlight. First, an observer on the far left, detached and watchful, a surrogate for the photographer himself (and, by extension, the viewer), pauses to take in a view of the gathering. The crowd collected near the building falls into shadow except for the figure of one woman at the edge, whose light-colored gown draws the light. Her gesture of moving her right hand to her right ear is doubled by the small girl in the center foreground; with her ribboned waist, tight street shoes, and fancy hat, the girl emulates, probably unconsciously, the posture and gesture of the mature woman in the light dress, marking out a social path on which the girl has already embarked by virtue of both her class and the mandates of feminine decorum. In what might otherwise be a banal scene of a casual crowd, Degas's eye discovers essential human habits—the cool acts of observation, the unconscious postures of emulation, the reflexive movement of the body in public spaces. His camera, like his canvases, probes the information of the particular to reveal the character of physical and social states of being.

Fig. 45 Edgar Degas, *Street Scene,* c. 1895, gelatin silver print, The Museum of Modern Art, New York, Gift of Paul F. Walter

Fig. 46 Edgar Degas, *Place de la Concorde, Vicomte Lepic and His Daughters,* c. 1876, oil on canvas, The State Hermitage Museum, St. Petersburg

73

Fig. 47 (top) Anonymous, *Portrait of Edgar Degas,* c. 1860–65, photograph printed from glass negative, Bibliothèque nationale de France, Paris

Fig. 48 (bottom, left) Edgar Degas, *Princess de Metternich,* 1861, oil on canvas, National Gallery, London

Fig. 49 (bottom, right) André Adolphe-Eugène Disdéri, *Prince and Princess de Metternich,* c. 1860, carte de visite, Bibliothèque nationale de France, Paris

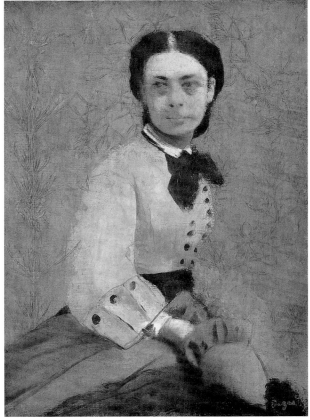

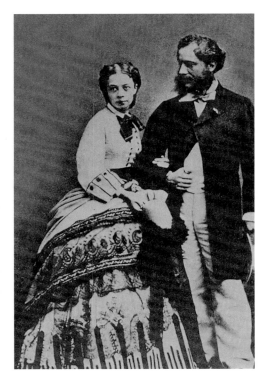

Born in 1834, Degas came of age as photography itself did. His initial interest in the medium no doubt grew from his incessant attraction to portraiture. As a young man, he shared in the general mania for small cartes de visite, the calling cards that included a small studio portrait photograph. Through the inexpensive and popular carte de visite, one could know the world as a repertoire of costumes, staged poses, frozen smiles, studio props, and stylish accessories. An album of these small photographs constituted a substitute studio, filled with visages of models both familiar and anonymous. Degas collected the cartes de visite of friends and participated in the fad by having himself photographed several times (fig. 47). These early cartes de visite feature him as poised, stylish in bow tie and top hat, but generally thin-faced and vulnerable in appearance. His own painted self-portraits (such as that of 1863 in the Calouste Gulbenkian Museum, Lisbon) of the same time aggrandize this image, turning him into the exceedingly dapper, confident, and elegant dandy we more easily associate with the modernist reputation of this artist. Degas, intrigued but never enslaved by the factual, did not paint every iota of information offered by a photograph, even when the subject was one he knew most intimately— himself. On perhaps the earliest occasion when he took his subject directly from a photographic source, in the portraits of the Prince and Princess de Metternich (figs. 48, 49) he not only cut through the prosaic ensemble of facts in the studio photograph to liberate an essential form and expression, but he also freely transformed details of cloth, color, and background, declaring even in this early

painterly exercise his independence from the often frozen language of the body in early photography. Degas excised from this carte de visite the entire figure of the prince. This transforms the princess's pose from that of a passive woman, leaning into the supporting arm of her escort, to that of a forceful and attractive individual, her body seeming to stride forward as she twists her head back to gaze past the viewer. It is an expressive portrait of an aristocrat known to the artist only through her photograph. Degas here joins his generation in using the photograph to claim a privilege of visual access to the circles of an elite whose images circulated widely through the popular carte de visite; he owned portraits of theater celebrities and the imperial family.[2] Later on, at the other end of the social spectrum, he collected photographs of women ironing, a subject of numerous evocative paintings.[3] Thus, collecting at least some examples of popular photography allowed Degas the vicarious pleasures of both hobnobbing and slumming, as they expanded his repertoire of modern social types across all boundaries of class.

Photography encouraged Degas to probe modern perceptions of time, sequence, and motion. As art historians have long been aware, Degas encountered in the 1870s some of the most advanced photographic experiments of his time.[4] In 1872 the photographer Eadweard Muybridge analyzed the movement of bodies, both human and animal, using stop-action photography. His compelling analyses of bodies in motion permitted the careful dissection of sequences the human eye experiences more conceptually than perceptually: Muybridge unveiled the secrets of the body's habits, a project that naturally appealed to Degas, who wanted to expose the very memory of muscle as it performs endless repetitions of motion. Muybridge's experiments were published in *La Nature* and *L'Illustration* in France in 1878, the latter accompanied by an article by Etienne-Jules Marey, a French scientist who was conducting similar trials. Marey lectured on these experiments in Paris in 1881, and Muybridge's photographs became easily available in 1887 with the international publication of his stop-action photographs in *Animal Locomotion.*[5]

Whether at lectures or in a bookshop, it is clear that during the late 1880s Degas familiarized himself with these studies of motion. In several drawings of about 1887–90, Degas copied the horses and jockeys caught in profile by Muybridge's camera.[6] These stop-action studies trumpeted the progress of the camera as a tool of depersonalized measurement, of science, of the culture of modern time reduced to infinitely repeatable elements. New information inspired new visualization of motion. For example, generations of artists from George Stubbs to Théodore Gericault had imagined that a galloping horse moved

in such a way that all four legs were fully extended when off the ground. Muybridge's photography now clarified that at full gallop, a horse's four feet indeed leave the ground only when they are all tucked under its body. Crisp new observations of motions unveiled physical processes previously apprehended by the human eye only as an incoherent blur. In wax sculptures Degas molded fifteen original statues of horses (these were cast in bronze posthumously, as in cat. 34).[7] He also turned to sculpture as an apt medium for examining the human body in its full range of motion—a woman stretching at the bath, a dancer performing a demanding arabesque. The artist never exhibited these sculptures during his lifetime; rather, they represent a private studio art, a series of puzzle solutions that document an artist's turning back obsessively to worry over how a mass of bones, muscles, and flesh actually manages to carry through a motion determined by a brain: these are thought pieces made into three dimensions. Often the same information gleaned from the stop-action photograph circulates in both the two- and three-dimensional work of Degas (cats. 29, 34; fig. 50). It little matters which Degas created first, the sculpture or the pastel. Rather, it is intriguing to imagine the photograph as a stop-action concept, migrating into Degas's studio (perhaps in a book, perhaps in a journal article, perhaps simply in the exceptional visual memory of the artist) and forming a complement to the artist's own sketches of horses. His knowledge of stop-action photographs did not circumscribe Degas with visual minutiae he felt obliged to emulate. Rather, these photographs liberated him, giving him a confidence to mark out an animal's essential motions, to lift out a characteristic action of the horse from the burden of the many details the eye can gather but that the mind suppresses as it organizes vision into concept or into a series of events. Paradoxically, the precinematic photograph (the stop-action study) helped Degas reaffirm one of painting's oldest conceits—the static representation of movement in a single moment in time. Yet with Degas that single moment, as inessential and contingent as it may seem, still implies a continuum of both time and space.

Throughout the years of the group shows of the impressionists (1874–86), Degas the painter coexisted with a growing visual culture of photography in Paris. In 1885 he showed an interest in conceiving and directing a few photographic group portraits of friends. In Dieppe he worked with the local photographer Walter Barnes to make group portraits of the Halévy family and to construct a photographic parody of Ingres's *Apotheosis of Homer,* in which Degas, sporting an emphatically modern top hat and walking stick, staged himself as a deflated, urbane version of Homer.[8] Subsequent to these diverting excursions

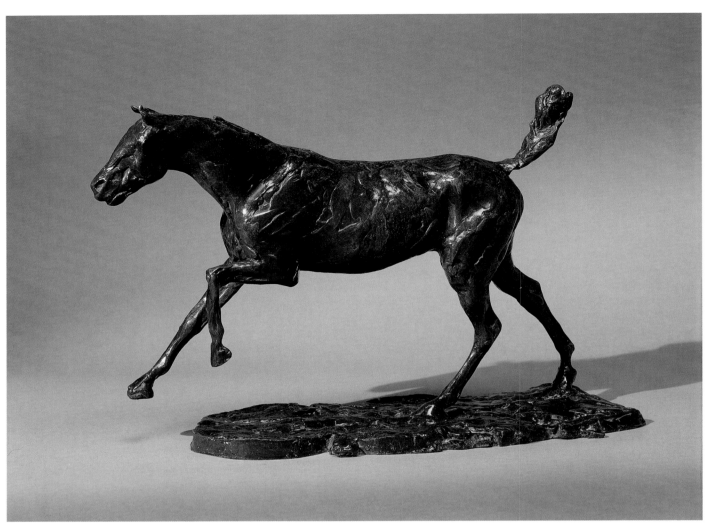

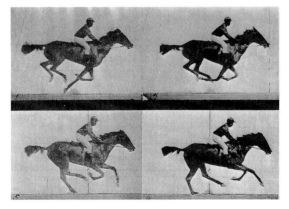

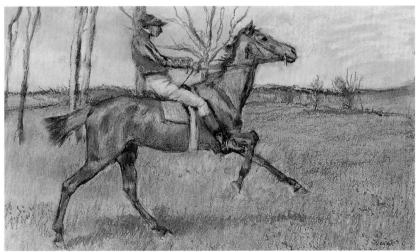

Cat. 34 (top) Edgar Degas,
*Horse Galloping on Right Foot,*
cast sometime between 1920
and 1932, bronze, 11⅞ × 18¼ in.,
Anonymous Collection, Dallas

Cat. 29 (bottom, left)
Eadweard Muybridge, *Animal
Locomotion, Horse and Rider
at Full Speed,* Plate 626, detail,
1887, collotype, Gernsheim Col-
lection, The Harry Ransom Hu-
manities Research Center, The
University of Texas at Austin

Fig. 50 (bottom, right) Edgar
Degas, *The Jockey,* 1888, pastel,
Philadelphia Museum of Art

into photography, Degas began to make photographs himself sometime in the spring of 1894. These first efforts, as in much of his painting thirty years earlier, were in his beloved genre of portraiture. He appears to have started in his own studio, where he made a few photographic portraits of close friends. Then, in the summer of 1895, Degas took an amateur camera with him on a trip to Monts-Dore, a village in the Dordogne, where he went in search of a mountain cure for his bronchitis.[9] Over the next year he plunged into teaching himself photography, making studies of landscape scenes, using models posed as bathers or dancers in the studio, and making numerous portraits of friends in domestic interiors. His avid passion for the medium soon wore itself out; he had largely abandoned photography by the end of 1896. Today only forty-four vintage prints or negatives survive; references to another two dozen emerge if one carefully scans Degas's letters.[10] Accounts by friends suggest that even more existed in his studio at the time of his death.

Given the whirlwind intensity of the artist's use of the medium some forty years into his prolific career, the simple question emerges: Why photography, and why only as late as 1895? With an artist as complex as Degas, there can be no simple answer. But several issues converged at that time to encourage him in this direction. A first explanation is external: the technology had become inexpensive and widely available by the 1890s. As the artist had reached the age of sixty-one, convenience is not to be discounted. Degas frequented a photographic supply store run by Guillaume Tasset that was located just around the corner from the artist's studio.[11] Degas favored one of the new hand-held cameras, intended for amateurs, but he preferred the slow technology of glass plates rather than the new, faster roll film. Perhaps the photograph was the latest agent of his recurring passion for extracting form from darkness. By the 1890s he had worked through the challenges of etching and ink drawing; in 1876 he had started exploring the power of monotype to register dramatic contrasts of dark and light. He brazenly mixed materials: some monotypes were even printed on the backs of blank daguerreotype plates he had lying about the studio. If photography was the "pencil of nature," as it had been called at the time of its discovery,[12] it seemed natural that as ambitious a draftsman as Degas should eventually work his way around to trying it.

Reasons of physical health are perhaps also related to the timing of Degas's venture into photography. As Richard Kendall has so carefully documented, Degas's sight was greatly affected throughout his career by a moderate myopia.[13] He also suffered increasingly from photophobia (an intolerance to bright light), a blurring of parts of the visual field, and a blind spot in his right eye that resulted after about 1870 in essentially monocular vision. In the 1890s Degas starts to refer in his letters to the deterioration of his eyesight. In 1896, a year when he had been actively making photographs, he wrote poignantly: "I have not done badly as regards work, without much progress. Everything is long for a blind man, who wants to pretend that he can see."[14] As Kendall has argued, the condition of photophobia may well have contributed to Degas's general hostility to plein-air painting and to his marked preference to subjects he could view in the studio.[15] Plein-air painting held no attraction for him; in 1882 he once described the brilliance of daylight as "more Monet than my eyes can stand."[16] In the early 1890s one oculist prescribed for him darkened spectacles that had a small slit over one eye to modulate light. Given how preoccupied Degas became with the problems of sight, we might speculate that the camera was for him an attraction as a reliable apparatus of vision, as a machine that could in a sense produce vision for him, and through which the visible world could be controlled and made accessible. He used the camera to probe his darker world: night skies, dark studios, or interior scenes lit only by a reading lamp. It is not that Degas used the camera as a surrogate pair of eyes; his artistic production from the 1890s is too varied and too prolific to suggest that he had in any way given up on his powers of sight. After all, he continued to make quite beautiful art until about 1912. Rather, the camera may have offered him in the 1890s some brief compensation for his uneven and troubled powers of sight, providing a visual respite from the task of hard looking, some mechanical aid to the problems of seeing, as well as an increased confidence in his control of visible world.

These are important motivations. But Degas's quickened passion for photography cannot be fully explained by technological convenience and by the limitations of aging eyes. He shared with his generation a passion for the particular personal truths of keepsake photographs, the "thereness" of the familiar facts recorded in a family photograph. His emotions were particularly swayed by the photographs of his sister Marguerite De Gas Fevre, who was first separated from him by her move to Buenos Aires in 1889 and then by her death in 1895. On the occasion of her departure from France, he arranged to have a set of amateur camera equipment sent to her, so they could have "an infallible way of having something" of each other.[17] Her absence was to be filled with photographic evidence of her presence at a distance. In 1895–96 Degas developed a passion for making photographic portraits of his friends. While he might still use pastel or paint to transform a studio model into a dancer or a bather, in 1895 he relied greatly on the medium of the gelatin silver print to render expressively the features of his closest

Cat. 26 Edgar Degas,
*Self-Portrait in Front of His
Library,* c. 1895, gelatin silver
print mounted to board,
4⅝ × 6⅝ in., The Fogg Art
Museum, Harvard University
Art Museums, Cambridge,
Massachusetts

friends. Degas did not develop his own prints, but he was closely involved in directing Tasset (his friend and supplier of camera equipment) how to print, crop, and enlarge his favorite negatives.

With photography Degas also returned to another of his favorite subjects—himself. He made several self-portraits in his home (cat. 26), in which we are unaware of his right hand that probably operates a cable release outside the frame of the print. His pose is one of effete nonchalance; his eyes never engage the viewer directly, as if he could not bear to face the eye of the camera. Rather, he gazes to the side, his slightly arched eyebrows suggesting a state of distracted pensiveness. His whitened hair and beard join his crisp shirt and starched cuff as starbursts of light illuminating an otherwise shadowed interior. In the room behind him, murky shadows swathe book spines and the vague outline of a portrait bust. Such evocativeness that begs comparison with works by Eugène Carrière or Odilon Redon departs dramatically from the precise detail of his cluttered and brightly lit naturalist portraits of earlier decades, such as *Edmond Duranty* of 1879 (The Burrell Collection, Glasgow, Scotland). This contrast drives home Degas's distance from the detail of his portraits in the impressionist era, and suggests his affiliation with the more essentializing aesthetic of the symbolists.

The clear majority of Degas's photographs are portrait studies of friends, made in their homes, his apartment, or his studio.[18] In 1895–96 the camera became an active accessory to many of Degas's important friendships, particularly with the Halévy family. In two curious photographs Degas achieves by accident a startling effect of disembodied heads, floating like specters in front of his wall of framed artwork (cats. 23, 24). Here we have a rich, firsthand account of what Degas's friends typically endured after a dinner party, when the artist often insisted that they pose for a group portrait. Degas not only orchestrated but forcefully commanded the scene be arranged according to his will. Daniel Halévy wrote about such an occasion on December 28, 1895: "The *duty* part of the evening began. We had to obey Degas's fierce will, his artist's ferocity. At the moment all his friends speak of him with terror. If you invite him for the evening, you know what to expect: two hours of military obedience. . . . When [Mlle. Henriette Taschereau] did

Cat. 23 Edgar Degas, *Group Portrait (Henriette Taschereau, Mathilde Niaudet, Jules Taschereau, Sophie Tascherau-Niaudet, and Jeanne Niaudet)*, December 28, 1895, gelatin silver printing-out print, 3¼ × 4⅜ in., The deLIGHTed eye, London–New York

Cat. 24 Edgar Degas, *Group Portrait (Mathilde and Jeanne Niaudet, Daniel Halévy, Henriette Taschereau; Ludovic Halévy, and Élie Halévy)*, December 28, 1895, gelatin silver printing-out print, 4⅜ × 3¼ in., The deLIGHTed eye, London–New York

not follow his orders to suit him, he grabbed her by the nape of the neck and posed her as he wished. He seized hold of Mathilde and turned her face toward her uncle. Then he stepped back and exclaimed happily, 'Let's go.' The pose was held for two minutes—and then everything was repeated."[19]

At this sitting, Degas's preoccupation with forcing the poses he sought preempted his attention to technical detail; he accidentally double-exposed two negatives. The resulting images pleased him enough that he not only kept the negatives but had them printed repeatedly. The prints are haunting in their unnerving dislocation of space and in the incoherent relations between the sitters. One is reminded of the double-exposures of nineteenth-century spirit photographs, in which emanations emerge in an otherwise rational world.[20] Heads of individuals float and imitate the partial head and figures framed on the wall, making ever more ambiguous the distinction between the artifice of art and the weighted realities of the everyday. These layered, partial images expand conventional boundaries of both time and space, and share the contemporary symbolist value of nuance and suggestion over the explicitness of rational fact. But it is possible that Degas also enjoyed these photographs as studio artifacts that began in a determined fashion yet ended as unexpected records of his process of thought. In that sense, these photos are like sketchbook pages: private exercises in which the artist mulls over a subject repeatedly, sometimes rotating the page and laying down new studies in a contrary direction. One such example is a roughly contemporary sheet of four self-portrait drawings by the young Henri Matisse (fig. 51) in which the artist drew face upon face, in a process of generating the most expressive rendering of his own visage. In the case of Degas, the double-exposure plates permanently transcribe the sequence of his actions both as director of the scene and as maker of the photograph. These photographs expose doubly, recording both his subjects and himself as creator.

Perhaps Degas's most renowned photograph (or at least the recipient of some of the most elaborate analysis) is a powerful double portrait of two friends, the impressionist painter Renoir and the symbolist poet Stéphane Mallarmé (cat. 25).[21] To achieve the photograph, Degas demanded that his friends pose for fifteen minutes under the light of nine kerosene lamps.[22] Renoir folds himself back into a dark brocade divan; Mallarmé, eyes cast down, leans heavily against the wall. Their bodies intersect at the corner of the mantelpiece and at the right lower edge of the framed mirror—at the very center of the composition. Studied harmonies of value lock figures and architecture together in a carefully balanced grid of light and dark. The photograph is both a portrait of these two friends and a double self-portrait—the camera itself is visible in the mirror reflection, as is the body of Degas, who takes the picture. Degas's face, however, is eclipsed by a brilliant reflection, and he becomes an anonymous agent of the act of representation, which is then echoed in an infinite regress of mirrors behind him. Degas constructs here a complex layering of levels of representation that, at the very least, contrasts the fully visible lens of the camera with the illegible blur of the artist's face. Without attempting to draw too literal a conclusion from this play of mirrors, we may at least think of this photograph as an essay on intersecting modes of vision: Renoir, the arch impressionist, is firmly engaged in an act of looking, and the camera reciprocates; Degas aligns himself with Mallarmé, the master of suggestion and nuance, as they both deflect any direct gaze, as Degas uses the machine to take the picture. The relative positions of the four reiterate these pairings. Degas, like Mallarmé, stands above and to the side of the lower "eyes"— those of the camera in the reflection and of the seated Renoir in the salon. Into this dialogue of direction and diversion, Degas inserts the mirror surface as analogue to both camera lens and picture plane, sharply drawing our attention to the artifice of his composition. The frame of the mirror, like a picture frame, sets off Degas and his apparatus both as producers (of the image we look at) and as a subject for art itself: man and camera are locked into the corridor of infinitely receding reflections of the mirror frame. So compelling is this detail within the overall photograph that we

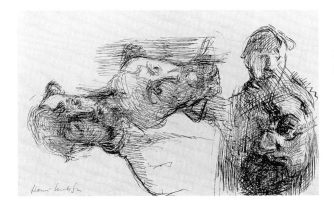

Fig. 51 Henri Matisse, *Four Self-Portraits*, c. 1898–99, pen and ink on paper, Paris, Private Collection

Cat. 25 (opposite) Edgar Degas, *Portrait of Renoir and Mallarmé in the Salon of Julie Manet*, 1895, gelatin silver print, 15⅛ × 11⅜ in., Musée Départemental Stéphane Mallarmé, Vulaines-sur-Seine

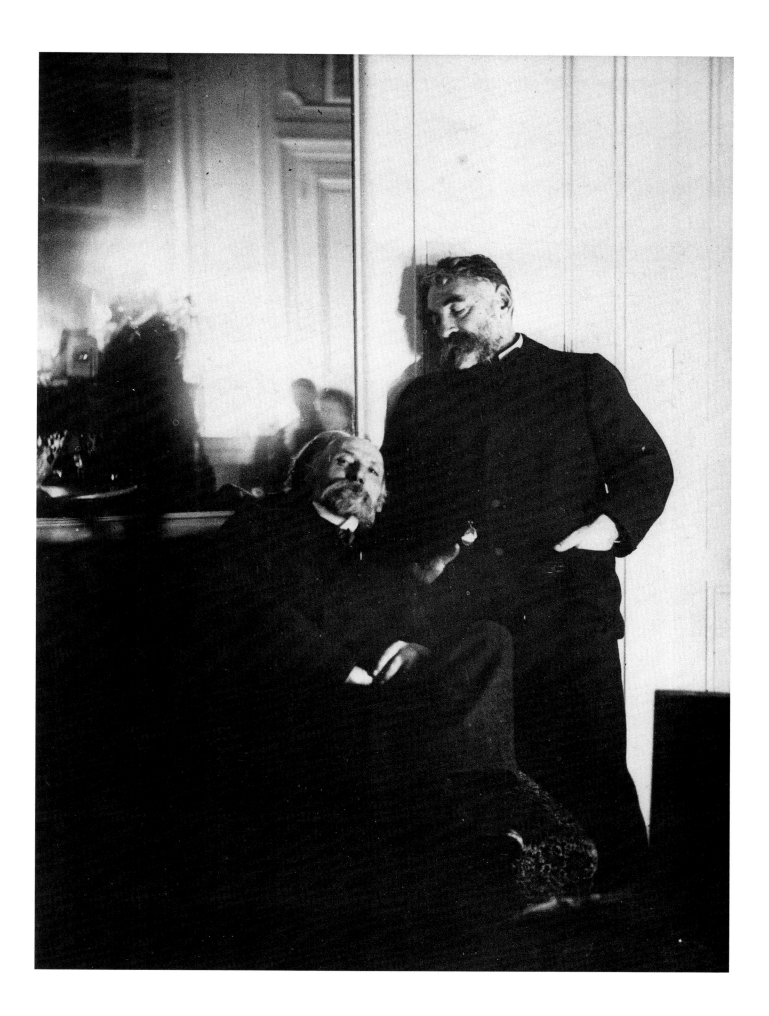

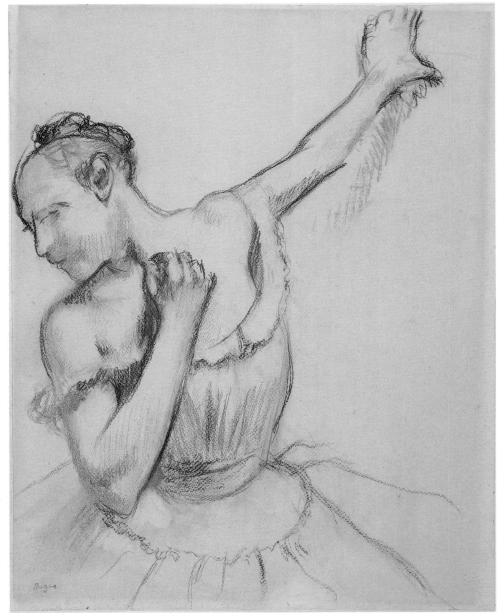

Top, left to right:

Fig. 52 Edgar Degas, *Dancer, Arm Outstretched,* late 1895 or 1896, gelatin dry plate negative, Bibliothèque nationale de France, Paris

Fig. 53 Edgar Degas, *Dancer, Adjusting Her Shoulder Strap,* late 1895 or 1896, gelatin dry plate negative, Bibliothèque nationale de France, Paris

Fig. 54 Edgar Degas, *Dancer, Adjusting Both Shoulder Straps,* late 1895 or 1896, gelatin dry plate negative, Bibliothèque nationale de France, Paris

Cat. 17 (bottom) Edgar Degas, *Dancer (Adjusting Her Shoulder Strap),* n.d., red and black chalk on paper, 19⅝ × 15½ in., The Israel Museum, Jerusalem

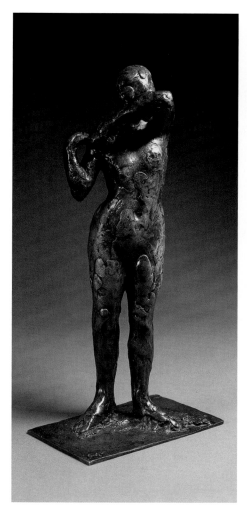

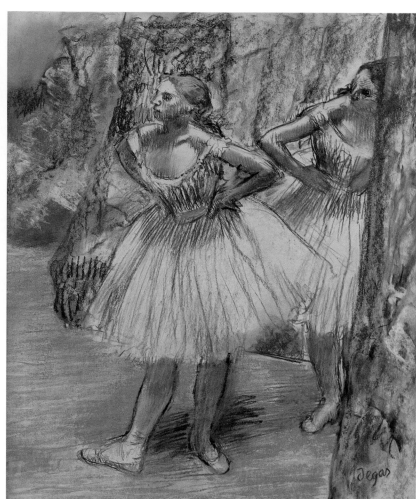

easily reverse the conventional roles of the sitter and artist and discover that Renoir is the viewer of Degas and his camera, rather than vice versa. Such a relation implies that what we view here are not just individuals (although their identities as close friends are known), but the consciousness of viewing itself.

These portrait photographs were discrete works of art within Degas's oeuvre and did not inspire him to make related works in paint or pastel. Other photographic studies of models in the studio, however, generated forms that Degas recirculated into his painted and graphic work of the 1890s. Notable among these are a series of three photographs of ballet dancers, which survive in brilliantly colored vintage negatives (figs. 52, 53, 54). Each has been partially "solarized," in that the photographer allowed the gelatin dry-plate negatives to be selectively developed and fixed, so that the image reads as both negative and positive.[23] The visual effect is compelling for its admixture of levels of reality (positive/negative) and as in the portrait of Renoir and Mallarmé, Degas self-consciously inserts traces of his own action and decision in the image. While it is possible someone else may have produced the negatives, Degas at

the very least orchestrated the poses of the models.[24] The dancer turns, reaches, stretches, adjusts her straps—all gestures typical of Degas's interrogation of the dancer's body in motion. These precise poses appear in numerous paintings, pastels, and sculptures of the period (cats. 19, 21). In one pastel drawing (cat. 17), Degas closely emulates the photograph, copying even the contour of the shadow cast by the model's left arm as she rests it on the studio screen. He adds a bow at the waist but otherwise keeps the contours of the ballet costume as seen in the photograph. Yet for all of the correspondence between these images, there are subtle differences: the model in the photograph poses with grace and delicacy, and her slipping right shoulder strap reveals a sinuous, even sensual, curve of arm and breast. Degas undercuts the studied grace of this female form and infuses his drawn dancer with slightly more robustness and awkwardness. He even pushes back the dancer's hair over an excessively receding hairline to expose the skull and the raw contours of the woman's head. The result is a dancer whose massive left hand, muscled shoulder, thick neck, and muzzlelike mouth suggest the challenge of training any ordinary body to observe conventions

Cat. 21 Edgar Degas, *Dancer Adjusting Her Shoulder Strap,* c. 1890–1900, bronze, 13¾ in., Fridart Foundation

Cat. 19 Edgar Degas, *Dancers,* 1890, charcoal and pastel on paper, 25⅝ × 21¼ in., Courtesy of Galerie Daniel Malingue

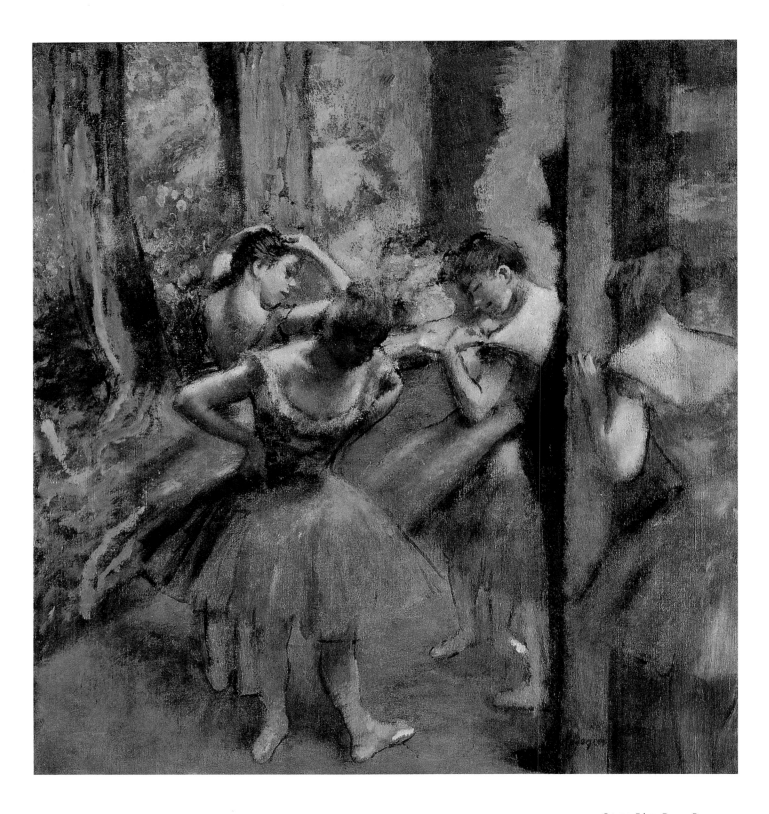

Cat. 20 Edgar Degas, *Dancers, Pink and Green*, 1890, oil on canvas, 32⅜ × 29¾ in., The Metropolitan Museum of Art, New York

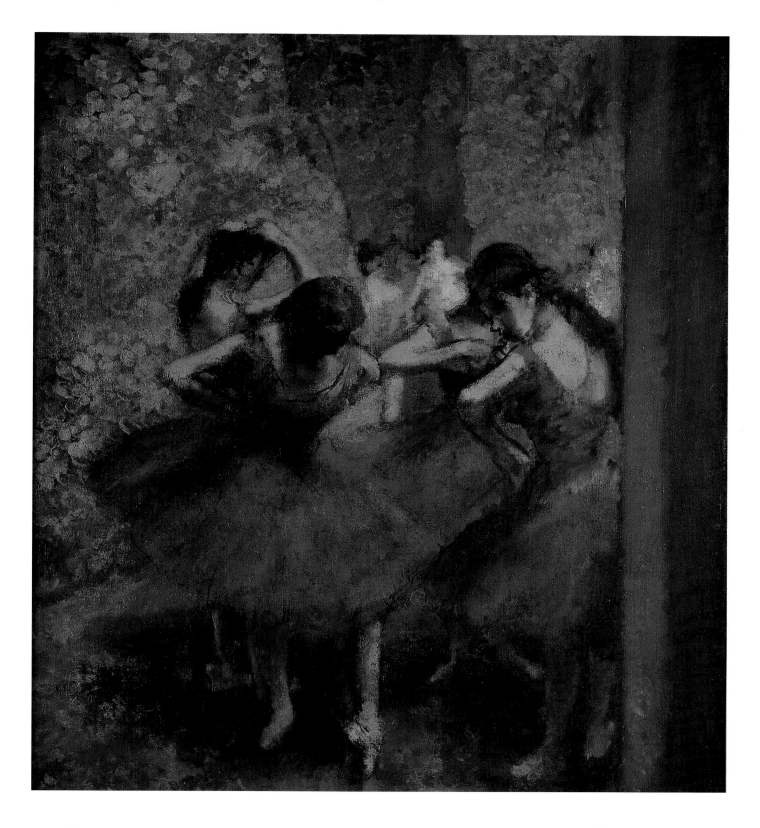

Cat. 22 Edgar Degas, *Blue Dancers,* c. 1893, oil on canvas, 33½ × 29¾ in., Musée d'Orsay, Paris

Fig. 55 (top) Edgar Degas, *View of Saint-Valery-sur-Somme,* c. 1896–98, oil on canvas, The Metropolitan Museum of Art, New York

Cat. 27 (bottom, left) Edgar Degas, *The Bathers,* 1895–97, pastel and charcoal on tracing paper mounted on gray board, 42¹⁵⁄₁₆ × 43¾ in., Dallas Museum of Art

Fig. 56 (bottom, right) Edgar Degas, *Nude (Drying Herself),* late 1895 or 1896, gelatin silver print, J. Paul Getty Museum, Los Angeles

of grace and balletic form. Numerous large oils of the late 1890s (cats. 20, 22) reiterate Degas's compulsion to expose the tensions inherent in preparing the body for performance: the final illusion is consistently less intriguing to Degas than the labors and ritual of motion that go into constructing it. The studio photographs of the ballet participate in, but do not determine, Degas's visualization of these dancers' bodies.

As Malcolm Daniel has observed, we may well know only a very small percentage of Degas's photographic oeuvre.[25] Two photographs of nudes, probably taken by Degas in his studio about 1895, are tantalizing hints of what may have been a larger body of photographs he made of nudes stretching, drying their bodies, and dressing (fig.

56).[26] In the study of a nude putting on her stockings, Degas captures the awkward compression of the model's body, the folds of her flesh, the gesture of her reaching arms. At the time that he examined this topos of the private rituals of the body in photography, he also returned in several large pastels to scenes of monumental bathers spilling across a generalized landscape. In one pastel (cat. 27), female torsos bend, stretch, and unfold, as if tracing in one scene a continuous narrative of a mythic female body caught, like Sisyphus, in a perpetual cycle of exerting and relaxing the body.

While the majority of Degas's photography focused on the human figure, he did occasionally venture into that staple of Impressionism, the landscape, yet his initial engagement with photographing the landscape shares far more with symbolist tendencies of the 1890s. In August 1895, on his trip to Monts-Dore, he attempted dozens of negatives of moonlit landscapes. He wrote back to Tasset, desperate for advice on how to photograph at night.[27] Degas later acknowledged the ambition of his experiments: "What I want is difficult—the atmosphere of lamps or moonlight."[28] Although moonlit photographs from Monts-Dore do not survive, we can imagine they share the evocative quality of Degas's monotypes. No doubt they echoed the subtle tonal harmonies of Whistler's nocturnes and anticipated the moody naturalism of the slightly later pictorialist photographers.[29]

It is often tantalizing to speculate about lost work and little-known episodes. Lest we remain too secure in the obvious conclusion that Degas's greatest passion in photography was for his exercises in portraiture, it is worth considering a proposal made by Richard Kendall.[30] Degas traveled to Saint-Valéry-sur-Somme in Picardy in 1898 and

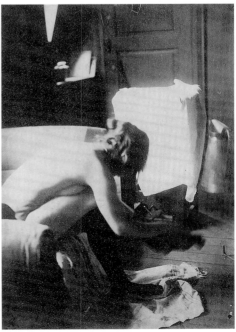

there produced fifteen little-known oil paintings and pastels. Most of the oils feature the small houses and rooftops of the village and were executed with no preparatory drawings. Some images combine multiple points of view into one expansive scene (fig. 55). Here Degas has combined two points of view of the village in a continuous panorama, one in which the two noncontiguous views of the town are conjoined abruptly in the painting, resulting in a juncture visible in a sharp vertical line at the left of the picture. Kendall has proposed that Degas probably drew two separate views of the scene, perhaps recorded in photographs that he himself took but that have not survived. If Degas did use photography as a stimulus for creating such a painterly collage, he has integrated into his

pictorial space the cinematic view implicit in Muybridge's stop-action photography.

For Degas the camera played an essential but syncopated role in his artistic life. Photography was alternatively an agent of humor and parody, the keeper of precious personal memory, the crucible for examining his own aging face, the vehicle by which he could seize the model or landscape afresh in his imagination. Like his wax sculptures, his own photographs remained the largely private art of a private man. Small and obsessive, they are intensely expressive of the activity of observing the familiar. They tease out from his personal world compelling observations on the rituals of the body and the habits of the eye.

NOTES

Epigraph:

As quoted in Daniel Halévy, *My Friend Degas,* ed. and trans. Mina Curtiss (London: Hart-Davis, 1966), p. 58.

For help with aspects of research for this essay, and for the Degas section of the exhibition, I wish to thank Richard Kendall, Theodore Reff, and George Shackelford. We owe special thanks to Malcolm Daniel, who most generously helped us locate several Degas photographs for this exhibition. I also thank John Klein for his helpful comments on a draft of this essay.

1. Degas followed the naturalist goal to discern both individual character and the temperament of a society through the careful study of the body. See the writings of Edmond Duranty, notably "Sur la physiognomy," *Revue libérale,* July 25, 1867, pp. 499–523.

2. Eugenia Parry, "Edgar Degas's Photographic Theater," in *Edgar Degas, Photographer,* ed. Malcolm Daniel (New York: The Metropolitan Museum of Art, 1998), p. 59.

3. Marcel Guérin, *Dix-neuf Portraits de Degas par lui-même* (Paris, 1931).

4. Key accounts are in Charles Millard, *The Sculpture of Edgar Degas* (Princeton, N.J.: Princeton University Press, 1976), pp. 99–102; and Jean Sutherland Boggs et al., *Degas* (New York: The Metropolitan Museum of Art, 1988), pp. 459–63.

5. Boggs, *Degas,* p. 375.

6. In particular, see *Horse with Jockey in Profile,* c. 1887–90, red chalk on white paper (Museum Boijmans-van Beuningen, Rotterdam), illustrated in ibid., cat. 279. See also fig. 257 on same page (location of original unknown). Degas copied both from Muybridge's *Annie G. in Canter,* in *Animal Locomotion,* vol. IX, plate 621, nos. 5, 11.

7. The most important recent study of the horse sculptures is Daphne Barbour and Shelley Sturman, "The Horse in Wax and Bronze," in Jean Sutherland Boggs, *Degas at the Races* (Washington, D.C.: National Gallery of Art, 1998), pp. 180–207.

8. Parry, "Edgar Degas's Photographic Theater," pp. 52, 61.

9. Malcolm Daniel, "The Atmosphere of Lamps or Moonlight," in *Edgar Degas, Photographer,* ed. Daniel, pp. 17–19.

10. For the most complete catalogue to date of these images, see Malcolm Daniel, "Catalogue raisonné and Census of Known Prints," in *Edgar Degas, Photographer,* ed. Daniel, pp. 125–39.

11. Theodore Reff, "Degas chez Tasset," in *Edgar Degas, Photographer,* ed. Daniel, pp. 75–81.

12. By Samuel F. B. Morse, describing the early daguerreotypes: "Nature has taken the pencil into her own hands." William Henry Fox Talbot used the same metaphor in the title of his book *The Pencil of Nature* (1844–46). See Mary Warner Marien, *Photography and Its Critics: A Cultural History, 1839–1900* (New York: Cambridge University Press, 1997), p. 4.

13. All comments regarding the state of Degas's vision are drawn from Richard Kendall, "Degas and the Contingency of Vision," *Burlington Magazine* 130 (March 1988): 180–97.

14. Marcel Guérin, ed., *Lettres de Degas* (Paris, 1945), p. 199, as quoted in ibid., p. 194.

15. Ibid., p. 178.

16. Guérin, *Lettres de Degas,* p. 70, as quoted in ibid., p. 192.

17. Daniel, "The Atmosphere of Lamps or Moonlight," pp. 21, 22, 29.

18. See Antoine Terrasse, "Portraits: Painting and Photography," in *Degas Portraits,* ed. Felix Baumann and Marianne Karabelnik (London: Merrell Holberton, 1994), pp. 302–14.

19. Daniel Halévy, quoted in Daniel, "The Atmosphere of Lamps or Moonlight," pp. 31–32.

20. Spirit photographs, first made in Boston in the 1860s, were produced by double exposures to create a contrived image of a ghost, aura, or astral projection. These photographs generally introduced this "proof" of the spirit world into a scene of the "normal," tangible, material world. Mucha and Munch sometimes used spirit photographs as preparatory studies. See Ulrich Pohlmann, "The Dream of Beauty, or Truth Is Beauty, Beauty Truth: Photography and Symbolism, 1890–1914," in *Lost Paradise: Symbolism in Europe* (Montreal: The Montreal Museum of Fine Arts, 1995), p. 446 n. 79.

21. See Carol Armstrong, "Reflections on the Mirror: Painting, Photography, and the Self-Portraits of Edgar Degas," *Representations* 22 (spring 1988): 108–41; also Douglas Crimp, "Positive/Negative: A Note on Degas's Photographs," *October* 5 (1978): 89–100.

22. Paul Valéry, quoted in Carol Armstrong, *Odd Man Out: Readings of the Work and Reputation of Edgar Degas* (Chicago: University of Chicago Press, 1991), p. 238.

23. Daniel, *Edgar Degas, Photographer,* pp. 136–37.

24. These negatives are generally accepted to be by Degas, although the evidence of their authorship rests only on the poses of the models and on the discovery of these negatives in Degas's studio at the time of his death.

25. Daniel, *Edgar Degas, Photographer,* p. 43.

26. The other photograph of a nude drying herself is in the J. Paul Getty Museum, Los Angeles (84.XM.495.2).

27. Daniel, *Edgar Degas, Photographer,* p. 23.

28. Recounted by Daniel Halévy in his journal, November 4, 1895, as quoted in Daniel, *Edgar Degas, Photographer,* p. 24.

29. For example, see Edward Steichen, *The Pond—Moonlight* of 1904, reproduced in Maria Hambourg, ed., *The Waking Dream: Photography's First Century* (New York: The Metropolitan Museum of Art, 1993), p. 201.

30. Richard Kendall, *Degas Landscapes* (New Haven, Conn., and London: Yale University Press, 1993), chap. 9, esp. pp. 266–67. Kendall reinforced the importance of this episode in Degas's engagement with photography, in personal communications with the author, 1998.

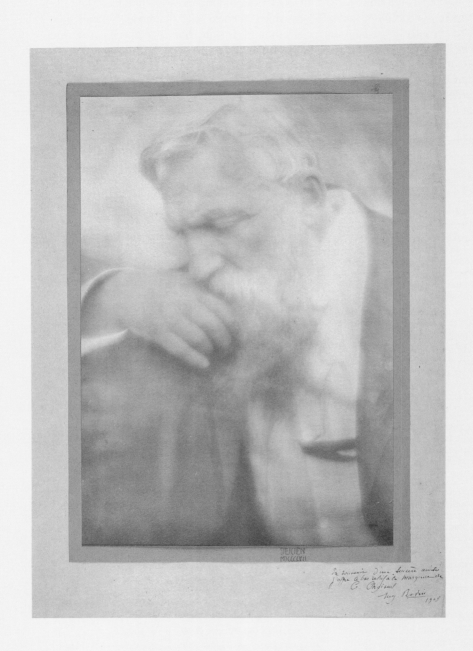

*En souvenir d'une sincère amitié*
*j'offre ce bas relief à la Marquise de*
*C. Chaffanel*
*Aug Rodin*
*1908*

# Auguste Rodin

PARIS 1840–1917 MEUDON

From unpromising beginnings, Rodin became the most famous sculptor of his time. His training was practical rather than academic, for he was never admitted to the Ecole des Beaux-Arts, working instead as an assistant doing routine tasks for decorative sculptors, especially Ernest Carrière-Belleuse. From 1871 to 1877 Rodin worked in Brussels and Antwerp on various decorative and monumental projects, assisting other sculptors. In the winter of 1875–76 he made an important two-month trip to Italy, where he saw works by Michelangelo and other Renaissance artists that would inform his subsequent output. His first success came in the Salon of 1877 with *The Age of Bronze,* although its extreme naturalism caused some to say it was cast from life. In 1880 he received the commission to create great doors for a projected museum of decorative arts. This project, *The Gates of Hell,* which was inspired by Dante's *Inferno,* occupied him for twenty years, and though he issued single figures from the complex (*The Thinker, Eve, Adam*), he never saw the whole cast in bronze. He received more and more commissions for portraits and monuments, including those to the Burghers of Calais, Victor Hugo, and Honoré de Balzac. In 1889 he and Claude Monet shared a show at the Galerie Georges Petit, and his fame was confirmed. The following year, for the Exposition Universelle, he set up a separate retrospective exhibition at the place de l'Alma. Rodin's creativity was largely confined to the nineteenth century, yet demand for portraits, replicas, and reductions caused him to employ many assistants. He made meticulous arrangements to control his legacy, authorizing the Musée Rodin (which the French state accepted as a gift in 1916) to issue up to twelve bronze casts of his sculptures. The expressive freedom and emotional intensity of Rodin's figures, whether in drawings or sculptures, were unparalleled in his day.

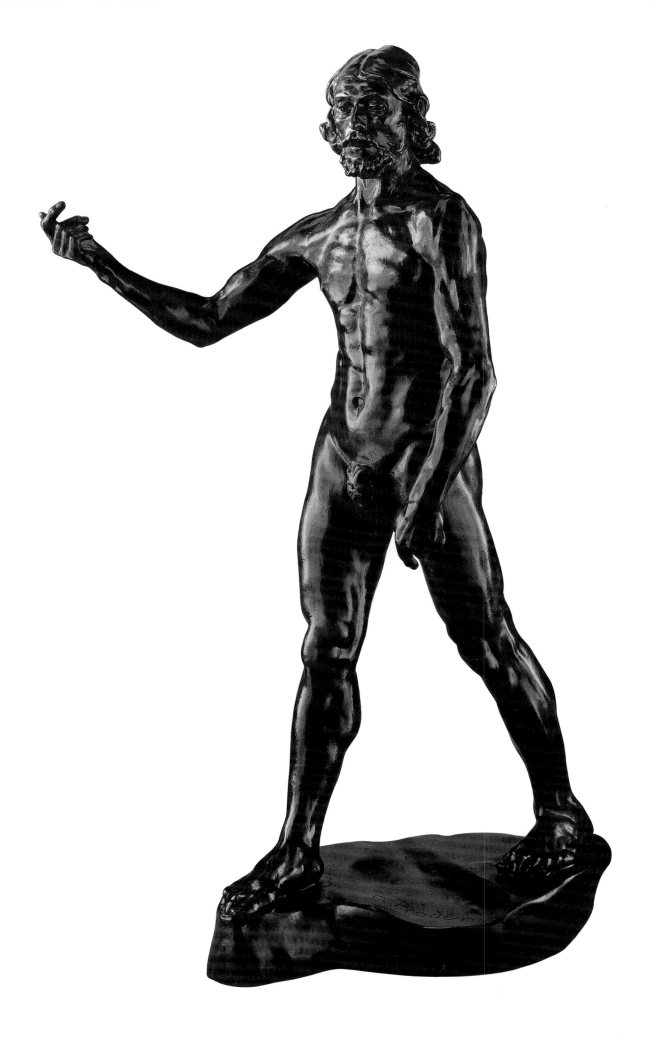

# Jane R. Becker

# Auguste Rodin and Photography:
# Extending the Sculptural Idiom

Auguste Rodin's relationship to photography was sensitive. The sculptor professed his distaste for the medium on more than one occasion. It was despite himself that Rodin turned more and more often to the aid of photography as the years wore on. His hesitancy when approaching the camera, as borne out by the fact that the artist appears never to have taken any photographs himself, was related to his fear of scientific progress. Slowly, Rodin turned to photography as a means to document and publicize his work. These practical uses gave way to more creative ones for the camera's product. Soon, Rodin began to use photography as a tool in altering works and as a source for new hybrid constructions. This trajectory ended with the artist's acceptance of photography as a valid art form.

From the outset the sculptor made several statements about the artlessness of photography. Documentary photography was for him a subject that neither required the interpretative faculties of its creator nor called on the emotions of its viewers; as such, it could not be considered high art.[1] This rational, nonemotive quality of photography was something that Rodin noted even in his "Testament" later in life: "Mere exactitude, of which photography and *moulage* [life casting] are the lowest forms, does not inspire feelings."[2] In a letter to the mayor of Calais in January 1889, he wrote, "Many cast from nature, that is to say, replace an art work with a photograph. It is quick but it is not art."[3] Here, he equated photography with casting from life (of which he was notoriously accused with his *Age of Bronze* and deliberately fought) in their respective inabilities to move beyond the act of recording. The sculptor also did not believe that photography could dig under the skin of a subject to reveal the human soul. In his book *L'Art* (1911), based on a series of conversations with Paul Gsell in which the sculptor laid out the tenets of his art, Rodin said, "If the artist only reproduces superficial features as photography does, if he copies the lineaments of a face exactly, without reference to character, he deserves no admiration. The resemblance which he ought to obtain is that of the soul; that alone matters; it is that which the sculptor or painter should seek beneath the mask of features."[4]

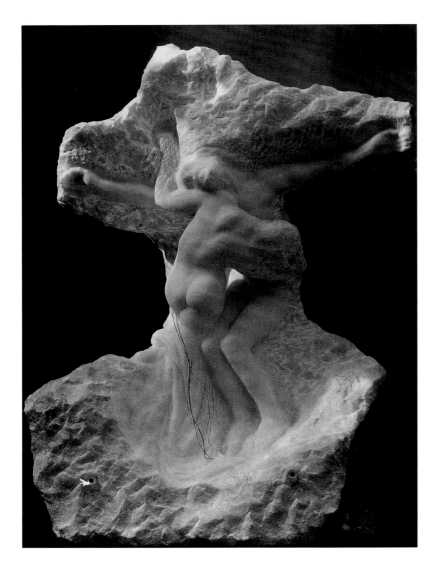

Rodin's distrust of the instantaneous photography of Etienne-Jules Marey and Eadweard Muybridge specifically related to his glorification of the role of movement in art. In fact, *L'Art* devoted an entire chapter to the subject. In it, he attributed the illusion of life in art to two qualities: good modeling and movement.[5] Rodin used his own sculpture *St. John the Baptist* as an example of how the artist is more faithful to the idea of movement than the photography of his contemporaries Marey and Muybridge. When he asked Gsell what he had noticed about instantaneous photographs of walking figures, Gsell replied, "That they never seem to advance. Generally, they seem to rest motionless on one leg or to hop on one foot."[6] Rodin agreed, pointing to the effectiveness of his *St. John* by comparison, and declared:

> *If, in fact, in instantaneous photographs, the figures, though taken while moving, seem suddenly fixed in mid-air, it is because, all parts of the body being reproduced exactly at the same twentieth or fortieth of a second, there is no progressive development of movement as there is in art. . . . It is the artist who is truthful and it is photography which lies, for in reality time does not stop, and if the artist succeeds in producing the impression of a movement which takes several moments for accomplishment, his work is certainly much less conventional than the scientific image, where time is abruptly suspended.[7]*

Rodin even used the phrase "the scientific image" to describe photography in this last sentence, betraying his distaste for photography as a form of scientific "progress."

The artist's attitude toward science was clear. He was suspicious of science and industry's claims to progress and blamed them for many of the ills of the time:

> *We are constantly being told that we live in an age of progress, an age of civilization. That is perhaps true from the point of view of science and mechanics; from the point of view of art it is wholly false. Does science give happiness? I am not aware of it; and as to mechanics, they lower the common intelligence. Mechanics replace the work of the human mind with the work of a machine. That is the death of art. It is that which has destroyed the pleasure of the inner life, the grace of that which we call industrial art—the art of the furniture-maker, the tapestry-worker, the goldsmith. It overwhelms the world with uniformity.[8]*

Finally, Rodin's lack of interest in taking photographs himself is revealing, for it shows the distance that the artist chose to keep between himself and the photographic image. This fact also places him apart from most of the other artists in this exhibition. Unlike his sometime friend and rival Medardo Rosso, who reveled in taking photographs of his own works to better present them to the public, Rodin shied away from the lens. Unlike his contemporaries Edgar Degas and Alphonse Mucha, he chose not to experiment with photography outside the atelier either. Françoise Heilbrun suggested that it was precisely because they (and others such as Pierre Bonnard and Edouard Vuillard) were artists that these figures were among the first to experiment with photography.[9] But because of his distrust of technology, Rodin had no desire to release the mechanical shutter.

Slowly, though, the French sculptor found practical value in photography. Lacking any photographs of the writer Honoré de Balzac, for example, Rodin used photographs of men from Balzac's native Touraine region as physiognomic types from which to cull Balzacian features. These head-shots served, then, as inspiration for Rodin's work in plaster. He also used photographic likenesses of Jules Bastien-Lepage, Barbey d'Aurevilly, and the American robber baron Edward H.

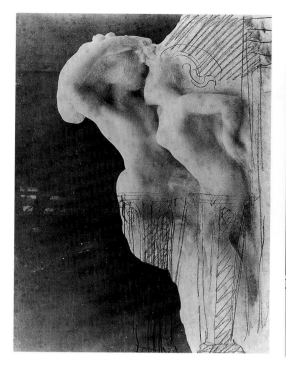

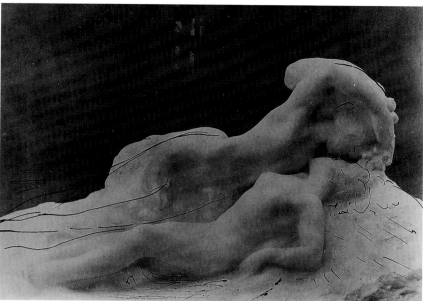

Harriman for his portraits of them. Rodin referred to these portrait photographs despite his low estimation of photography's ability to capture a sitter's soul. It must be said, however, that Rodin was reluctant to make portraits from photographs and did so only very rarely. Occasionally he used a photograph of a model to stand in for the model when sculpting in between posing sessions. In 1878, while working on his sculpture *St. John,* he began the practice of having photographers come to record the changing states of the plaster in its late stage. These documentary photographs were an updated version of *estampages,* prints made of works in progress. In fact, the eminent Rodin scholar Albert Elsen asserted that Rodin may have been the first sculptor to use photography to record and edit works in progress.[10]

Rodin's desire to document the stages of change in his work gave way to a recognition of the value of photography for publicity. Rodin was the first to organize the dissemination of his work by photography, so that amateurs and critics alike might have access to his sculpture beyond its actual physical presence.[11] The publication of these photographs expanded public knowledge of his work and encouraged discussion as well. When Rodin included photographs alongside his sculptures at the Musée Rath in Geneva in 1896, he was using the medium to exhibit more works than the space would allow, not to provide additional images of the same subjects.[12] Photography thereby enhanced his international reputation. It is no coincidence that this exhibition, which Rodin shared with his painter friends Eugène Carrière and Puvis de Chavannes, was the moment he chose to start showing photographs with his sculpture.

Photography brought his work closer to the two-dimensional work of his peers, particularly that of Carrière. We will return to this point below.

The 1896 exhibition was a turning point in Rodin's relationship to photography. It marked the beginning of his recognition of the form's broader uses. This was the medium in which he would be able to make multiple reproductions of his work at a low cost. From that point on, he would always exhibit roughly as many photographs as sculptures. Next, photography became a tool in his process of altering works and their bases. Two-dimensional reproductions of his works allowed the sculptor critical distance from his creations. Rodin often inscribed notes and sketched revisions of works onto the photographs themselves, yielding evidence of his working method. For example, Jacques-Ernest Bulloz's photograph of *Christ and Mary Magdalene* (fig. 57), a late marble work of 1903, has graphic marks on the surface from Rodin's hand that show his desire to shift the placement of the Magdalene's marble leg so that she might seem more firmly rooted in the marble "earth." In two photographs of his *Young Girl Kissed by a Phantom* (figs. 58, 59), Rodin's notations reveal his contemplation of adding legs to the phantom and wings to the woman, as well as his wish to attend more to the contours of the figures and to consider the possibility of shifting to a vertical orientation (to turn the figures into caryatids for an architectural cycle). He often corrected the gesture of a movement or a drapery fold. In the inscriptions on photographs of his *Monument to Claude Lorrain* at Nancy, he made notes for changes to the work's base—changes that he wished for after the fact.

Fig. 58 Photographer unknown, *Young Girl Kissed by a Phantom,* salt print with ink drawing, Musée Rodin, Paris

Fig. 59 Photographer unknown, *Young Girl Kissed by a Phantom,* salt print with ink drawing, Musée Rodin, Paris

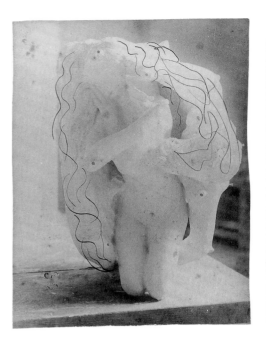
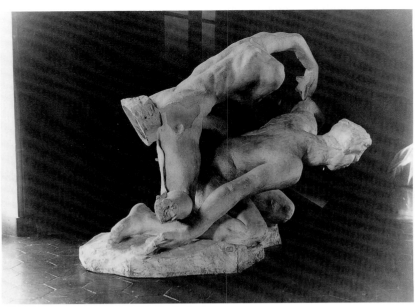

New hybrid forms erupted out of these scribbled-on photographs that led to entirely new works of art. In these cases, photographs served as starting points for multiple new constructions. For example, Charles Bodmer's photograph of *Psyché-Printemps* (fig. 60), which dates from before 1890, was transformed with a few scrawls from a horizontally conceived work into a vertically oriented one.[13] At the same time, the overarching male figure was eliminated and replaced by a long, loose hairstyle that envelops the female figure. A photograph by Bulloz, a hybrid conglomeration of Rodin's *Tragic Muse* from his *Monument to Victor Hugo* and one of the sons from *Ugolino and His Sons* (fig. 61), provides the only evidence that Rodin conceived of integrating the two sculptures in this fashion. This example of *marcottage,* or assemblage of two disparate elements within a sculptor's oeuvre to create a new unity, was daring; it brought together a headless, armless figure with another fragmented form. It was so daring, perhaps, that Rodin did not pursue the composition beyond this experiment captured by the camera.

The photograph served as intermediary, too, between the sculptor and draftsmen or engravers, who used the images as models for press illustrations. This service was important, because the technique of photographic reproduction had not become fast and cheap enough to appear in most daily newspapers until 1904. Early on, Rodin himself traced in lead pencil and steel point on the backs of these photographs or squared off the images to create quick drawings of his works for reproduction in the press. This was a common practice at the time, as is evidenced by the journalist Arsène Alexandre's note to Rodin of 1889: "I need a rough pen-drawing from you, very

simple, of your *Eve.* You have a lot of great photographs; it is sufficient that you make one for me from them, a very expressive sketch. I need it for Wednesday morning at the latest."[14]

Photographers were treated no better than *praticiens* in Rodin's studio, workers who did the initial carving in marble, sized works to larger formats, and completed other tasks that were considered by artists to be without creative input. When photographers disobeyed Rodin's directions and asserted too much artistic control, Rodin quickly shunted them aside. Rodin's wariness of the photographic process led him to place sometimes severe limitations on his photographers. Even while he pursued hybrid constructions via the photograph, the sculptor enforced various checks and balances on the output of the photographers with whom he worked. He reserved the creative act for himself.

Working with the photographers Bodmer, Charles Michelez, and Victor Pannelier, Rodin decided on the angle of the shot as well as the lighting and the background; in fact, he preferred his photographers to use the same light source he had used when modeling the works. His letters tell us as much.[15] His wash and pencil marks on the proofs show us his editing of the photographs as well as of the works themselves, as we have seen. In addition, by the 1890s all prints had to be approved by the master before being published. To assure that no photographer would use prints in ways beyond his wishes, Rodin had the glass plate destroyed if he disliked an image. His relationship with Eugène Druet, the bistro owner and amateur photographer who became Rodin's primary photographer for much of the late 1890s and into the first decade of the twentieth century, was fraught with tension because of Rodin's controlling in-

stincts. He required the photographer to place his own signature on the glass plates. In his contract with Druet of 1900, Rodin even reserved the right to forbid the sale of any photographs he found to be "insufficiently artistic."[16]

Druet definitely made sacrifices for his *maître* and for acceptance in the sphere of "high" art.[17] He used silver gelatin paper, which produced prints with grayish, murky light. His choices of material, light (magnesium lighting), and viewpoint created somewhat subjective visions of Rodin's oeuvre that often integrated their subjects with the environment, as in his photograph of Rodin's *Balzac, mi-corps* (cat. 53).[18] In 1899 the critic Fagus noted that Druet's photographs of Rodin's sculptures, such as his *Pensée* (fig. 62), brought a new pictorial slant to the sculptor's works, making one react to them as "Un Carrière! . . . Un Rembrandt! . . . Un Vinci!"[19] Similarly, the Belgian critic André Fontainas found similarities between Druet's images and Carrière's, and he attributed Rodin's attraction to the photographs to "something misty and delicate that makes one almost think of the harmonious and profound art of Eugène Carrière."[20] The dark atmospheric qualities found in some of Druet's photographs were heightened further in the later photography of Rodin's works by the British team of Stephen Haweis and Henry Coles and by Edward Steichen.[21]

It took the technique of Haweis and Coles to get Rodin to cede some authority over the camera's products. The very medium in which Haweis and Coles worked, gum bichromate, required that Rodin yield artistic control to this pair. While it had existed for about forty years before, Rouille-Ladêveze reintroduced the gum bichromate process in 1894. This process was, in fact, prized for the high degree of artistic control it gave the photographer over the final print.[22] Altering the amount of contrast in the print could be minutely controlled by the artist-photographer, just as re-coating and reexposing the print could deepen tonalities in selected areas. Coles, a chemist by trade, took care of the technical aspects of their work, whereas Haweis was a painter who turned to photography as an alternative course for his artistic inclinations. It was Emilia Cimino, a some-time translator for Rodin, who introduced this British pair to Rodin in 1903.

That the sculptor liked the misty, sfumato effects of so many of Haweis and Coles's works only increased the photographers' relative autonomy. In fact, Rodin never once opposed placing his name on their prints. Rodin liked the hazy impressionistic effects of prints like *Crouching Woman* (cat. 71), *Meditation,* and *Toilette of Venus* (all 1903–4) because they reminded him of the equally two-dimensional yet highly modeled paintings of his friend Carrière. These photographs and Steichen's later images like *Balzac, Midnight* (cat. 103) were steeped in the symbolist aesthetic

that Rodin shared in his marble sculptures with Carrière and, later, with such pictorialist photographers as Alvin Langdon Coburn and Gertrude Käsebier. Works like Haweis and Coles's *Meditation* (figs. 63, 64, 65) closely approximate the elements of strong contrast, mistiness, and scratching into the reproductive plate found in such of Carrière's pieces as his lithograph *Rodin Sculpting* (fig. 66).[23] Rodin's closeness to Carrière and his oeuvre must have led him to a fuller appreciation of Haweis and Coles's purposeful effects in the gum bichromate process.[24] The Carrièresque pictorial effects that Haweis and Coles produced only increased Rodin's respect for their photography as an expressive form. In fact, Rodin, sensing that these two artists needed to become acquainted, introduced Haweis to Carrière; Haweis became Carrière's pupil during the last few months of Carriere's life.[25]

Having created some two hundred photographs for Rodin from 1903 to 1904, Haweis and Coles broke up. They, like many of Rodin's other photographers, had endured difficult contract terms that hardly ever allowed them to make a profit on their work, all so that they might attain fame and fortune through their connection to *le Mâitre.*[26] Haweis returned to painting and etching, spending some months in the South Pacific and several years in Florence with his wife, the poet and painter Mina Loy; it is not known what became of Coles.[27] In a year this pair had been able to capture Rodin's complete enthusiasm; in an article of 1904, the sculptor called their photographs as admirable as those of Steichen, and he compared their portrait of him to a Tintoretto.[28] As Hélène Pinet has noted, the irony is that just when Rodin released control of the photographic process, he began to recognize photography as a work of art.[29]

Rodin's experience with Steichen's photography was another lesson in accepting the photograph as a form of art. Steichen's interest in photography grew naturally out of his painting, which was called "Whistleresque" by critics of the period.[30] Steichen's painting and his photography before arriving in Paris (and after) influenced his approach to photographing sculpture. William Innes Homer explained, "For years, he found these two media inseparable, and his photography would not have developed as it did if he had not gone through the experience of painting."[31] For early photographs like *Woods in Rain, Milwaukee* (fig. 68) and *The Pool—Evening, Milwaukee* (fig. 69), Steichen would often throw the lens out of focus, kick the tripod, or even spit on the lens to achieve blurred Corot-like effects that he was pursuing in his painting at the same time. Still back in Milwaukee, Steichen saw photographs of Rodin's *Balzac* in a newspaper and vowed he would meet the sculptor one day.[32] In fact, the photographer later attributed his desire to go to Paris to seeing this work.

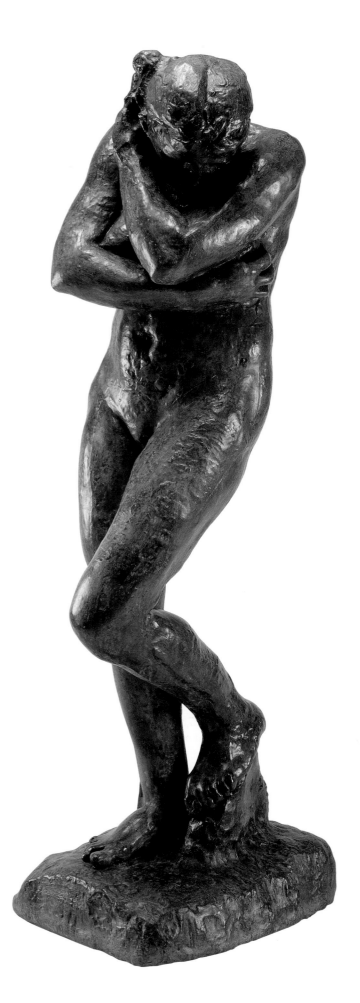

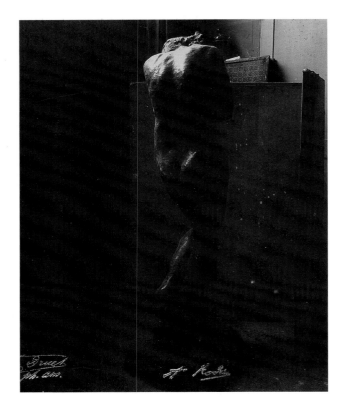

Cat. 87 Auguste Rodin, *Eve,*
1881 (cast before 1932), bronze,
68 × 17¼ × 25½ in., The Patsy
R. and Raymond D. Nasher
Collection

Cat. 66 Eugène Druet, *"Eve,"*
n.d., albumen print, 11⅝ ×
9⅛ in., Musée Rodin, Paris

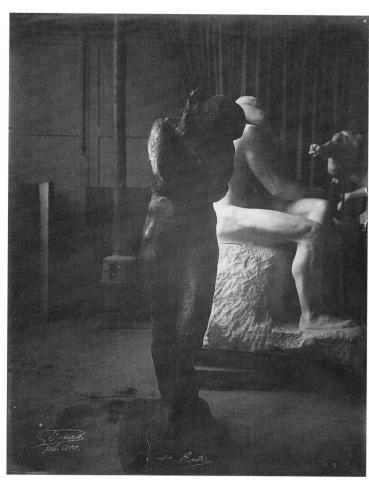

Cat. 59  Eugène Druet, *"Eve" in Front of the Marble "The Kiss,"* n.d., gelatin silver print, 15¾ × 11⅞ in., Musée Rodin, Paris

Cat. 56  Eugène Druet, *"Eve" in Front of "The Gates of Hell,"* n.d., gelatin silver print, 15⅝ × 11¾ in., Musée Rodin, Paris

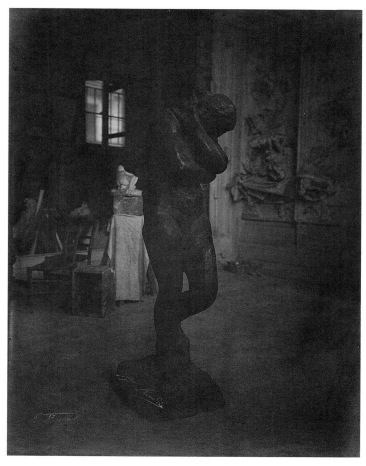

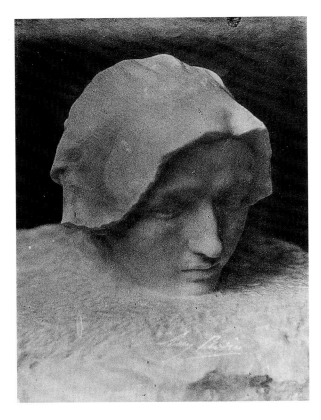

Fig. 62 Eugène Druet, *La Pensée,* before 1900, gelatin silver print, whereabouts unknown

Cat. 53 (opposite) Eugène Druet, *"Balzac, Half-Length," in the Studio,* n.d., gelatin silver print, 15¾ × 11¾ in., Musée Rodin, Paris

Steichen arrived in France in May 1900 and almost immediately went to see Rodin's exhibition at the place de l'Alma. Rodin was a great inspiration for Steichen, certainly, but theirs was an immediate kinship of the artistic spirit. Steichen wrote to Alfred Stieglitz that the first time Rodin went through his portfolio he "took *my hand in big silence.*"[33]

In that portfolio was *Self-Portrait with Brush and Palette* (fig. 67) that presented a pictorial approach to photography like that of Haweis and Coles and reminiscent of Carrière's paintings and lithographs. It also clearly showed the photographer's desire to be accepted as an artist and to elevate photography to high art. Steichen later gave prints of his *Pool—Evening, Milwaukee* and *Self-Portrait with Brush and Palette* to Rodin as gifts. When Steichen was introduced to Rodin by the Norwegian painter Fritz Thaulow, he immediately asked if he might photograph the sculptor. Rodin took a liking to the young man and his work and told him to visit as often as he liked. So he did —Steichen went to Rodin's atelier once or twice a week for a year. Out of these first sittings came *Portrait of Rodin next to "The Thinker," "Monument to Victor Hugo" in the Background* (cat. 97). To achieve the effect of silhouetting Rodin against the background of his two works, Steichen had to use two negatives and combine them, as the studio was packed with sculptures and he owned only one lens at the time (a rapid rectilinear lens, not the wide-angle lens necessary to get the full composition). This was, then, a very deliberate and

time-consuming image to create. Steichen drew on the symbolist concept of synthesis in combining the two images to arrive at a more sharply defined third.[34] In his autobiography, Steichen reported that Rodin was elated by the image.[35]

Rodin was a great influence on the young Steichen, especially in the experience of photographing the *Balzac* outdoors in Meudon at night. Steichen thought that the *Balzac* plaster looked too chalky in daylight; it was Rodin's suggestion to take the pictures outdoors in moonlight as he had seen it the night before, and Steichen agreed.[36] Rodin wanted to see the *Balzac* as a silhouette stood up against the sky, so that one might experience it as a synthetic gestalt. Steichen photographed for two whole nights, from sunset to sunrise, varying the exposure time from fifteen minutes to one hour.[37] Steichen's photographs such as *"The Silhouette, 4 A.M."* (cat. 102) provided a controlled distant view of the sculpture, which Rodin appreciated.

Rodin specifically related value to the kind of epiphany he had from looking at objects from a distance, as a silhouette against the half-light beyond, as in Steichen's photographs.[38] He often spoke of finding "la grande ligne" of his subjects.[39] Camille Mauclair claimed that from the *Balzac* one gained a complete lesson on simplicity of modeling and the subordination of details to a silhouette.[40] Rodin was so taken with the results of Steichen's all-night session that he gave Steichen three bronzes in appreciation (evidence of their artist-to-artist relationship) and made certain that

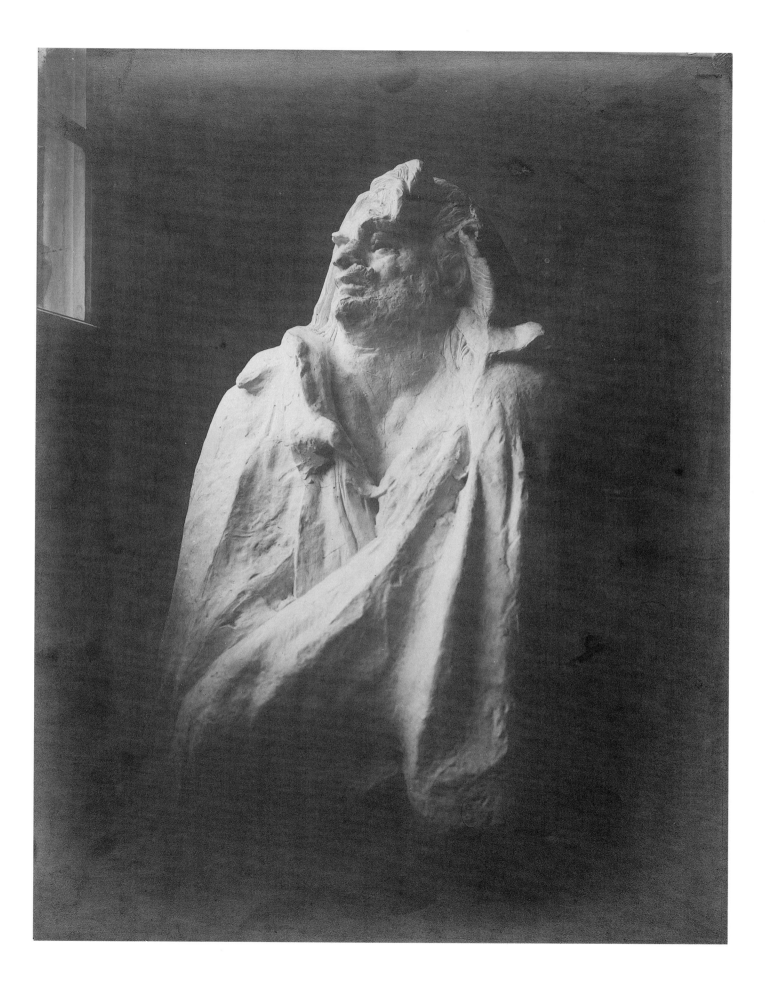

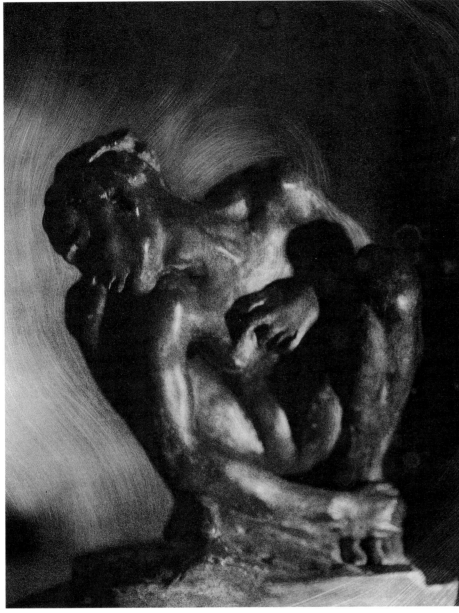

Top:

Cat. 71 Stephen Haweis and Henry Coles, *"Crouching Woman,"* 1903–4, carbon print, 8⅝ × 6⅝ in., Musée Rodin, Paris

Bottom, left to right:

Fig. 63 Stephen Haweis and Henry Coles, *Meditation,* 1903–4, gum bichromate print, Musée Rodin, Paris

Fig. 64 Stephen Haweis and Henry Coles, *Toilette of Venus,* 1903–4, gum bichromate print, Musée Rodin, Paris

Fig. 65 Stephen Haweis and Henry Coles, *Meditation,* c. 1904, gum bichromate print, Musée Rodin, Paris

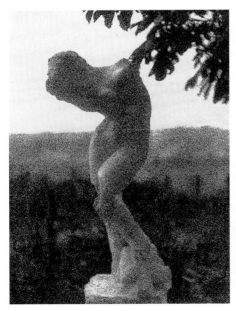
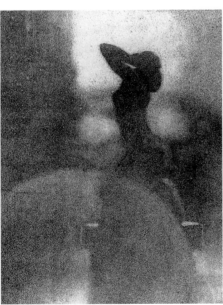
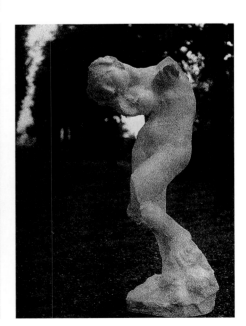

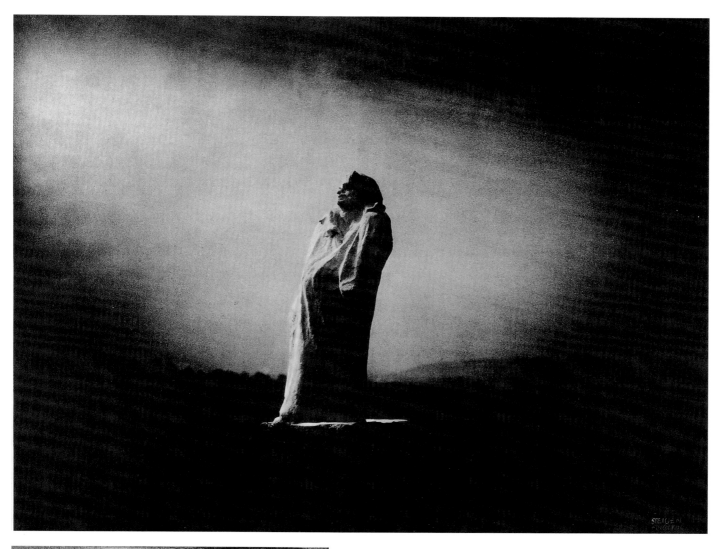

Cat. 103 Edward Steichen,
*Balzac, Midnight,* c. 1908 /
printed 1940s, gelatin silver
print, 11 × 14 in., Los Angeles
County Museum of Art

Fig. 66 Eugène Carrière,
*Rodin Sculpting,* 1900, litho-
graph, Private Collection,
Paris

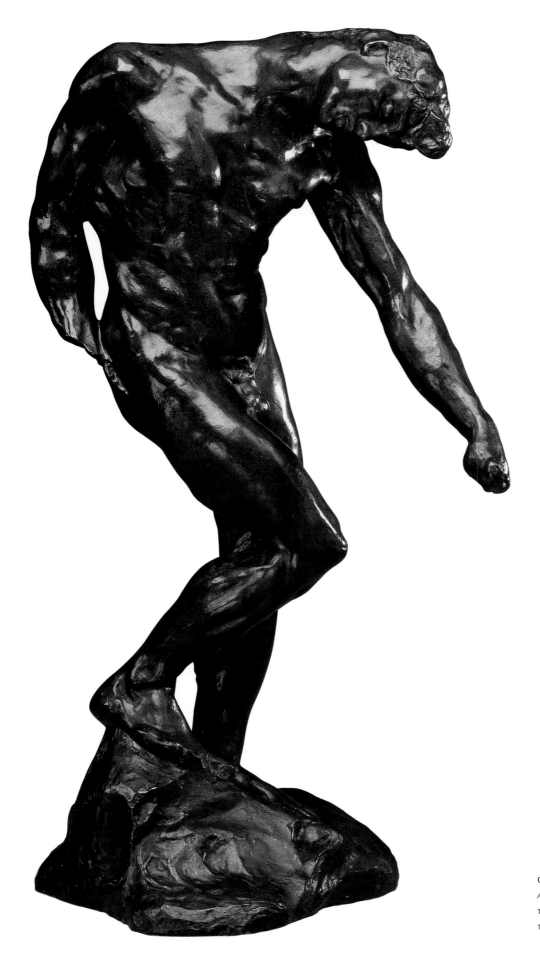

Cat. 86 Auguste Rodin, *Shade, Adam from "The Gates of Hell,"* 1880, bronze, 38⅛ × 20¾ × 12¼ in., Dallas Museum of Art

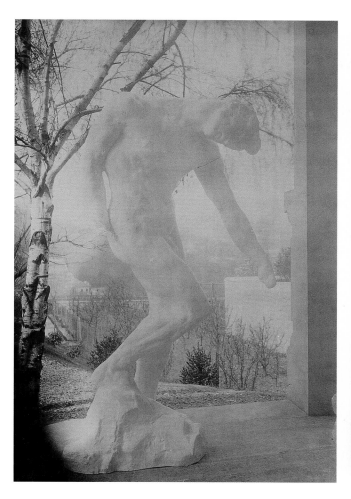

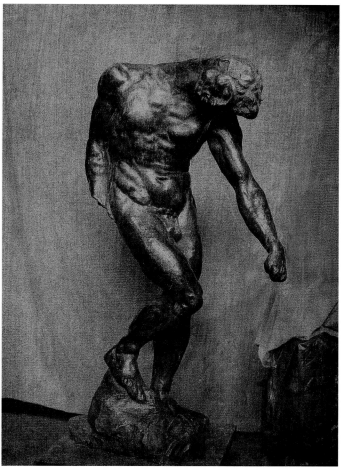

Cat. 35 (top, left) Anonymous, *"The Shade,"* c. 1907, albumen print, 6½ × 4½ in., Musée Rodin, Paris

Cat. 77 (top, right) Jean-François Limet, *"The Shade,"* n.d., gum bichromate print, 14½ × 10¼ in., Musée Rodin, Paris

Cat. 40 (bottom) Jacques-Ernst Bulloz, *"The Large Shade" in the Garden,* n.d., gelatin silver print, 14 × 9⅞ in., Musée Rodin, Paris

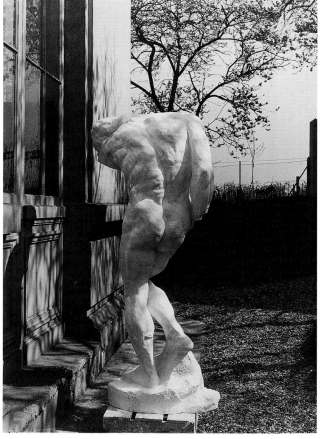

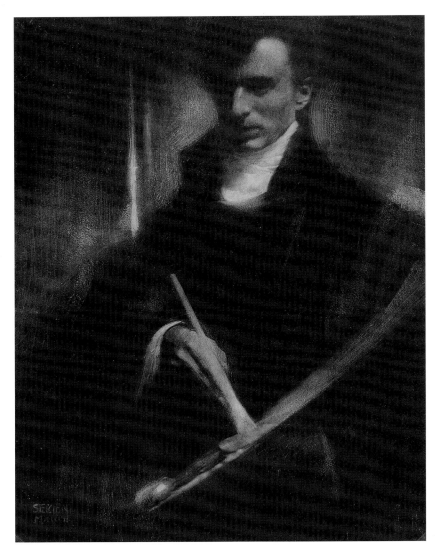

the young American photographer got proper royalties for his work.

Still, Steichen's work confirmed Rodin's own inclinations about the *Balzac.* The notion of silhouetting the work against the sky was Rodin's; it was magically achieved by Steichen and was perfectly in line with both artists' conceptions. In his autobiography, Steichen reported: "The prints seemed to give him more pleasure than anything I had ever done. He said, 'You will make the world understand my *Balzac* through these pictures. They are like Christ walking in the desert.'"[41] This last observation about his work seemed to strike Rodin only when he saw the photographs of it. Steichen's work, then, was an inspiration for Rodin as well. It also was an enlightenment to the public more generally. Writing in *Camera Work* in 1909 of Steichen's prints of the *Balzac,* Charles H. Caffin noted that "its silence renders audible the footfall of incorporeal presences: the shadow seems to be the substance."[42]

Rodin and Steichen were mutual influences. Through the process of working together, Rodin learned to accept Steichen as a great artist. Though only twenty-two, Steichen was paid in advance by the sculptor, who trusted him unlike any of his other photographers. Other *praticien*-photographers were paid only on completion of their jobs and according to strict contractual stipulations. In an interview in *Camera Work* in 1908, Rodin finally allowed that Steichen had made him appreciate photography as an art form:

Fig. 67 (top) Edward Steichen, *Self-Portrait with Brush and Palette,* 1901, gum bichromate print, The Art Institute of Chicago

Fig. 68 (bottom, left) Edward Steichen, *Woods in Rain, Milwaukee,* c. 1898, platinum print, The Metropolitan Museum of Art, New York

Fig. 69 (bottom, right) Edward Steichen, *The Pool— Evening, Milwaukee,* 1899, platinum print, The Metropolitan Museum of Art, New York

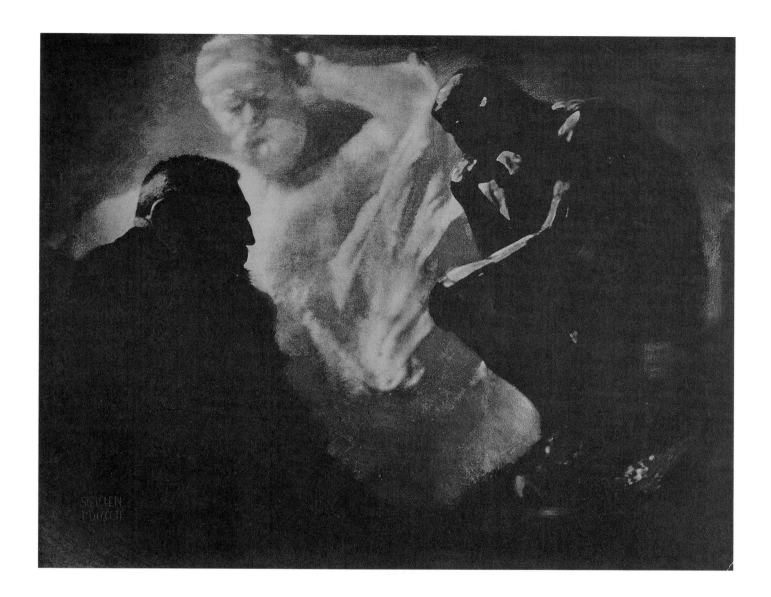

Cat. 97 Edward Steichen,
*Portrait of Rodin next to "The
Thinker," "Monument to Victor
Hugo" in the Background,* 1902,
carbon print with engraving?,
10¼ × 12⅜ in., Musée Rodin,
Paris

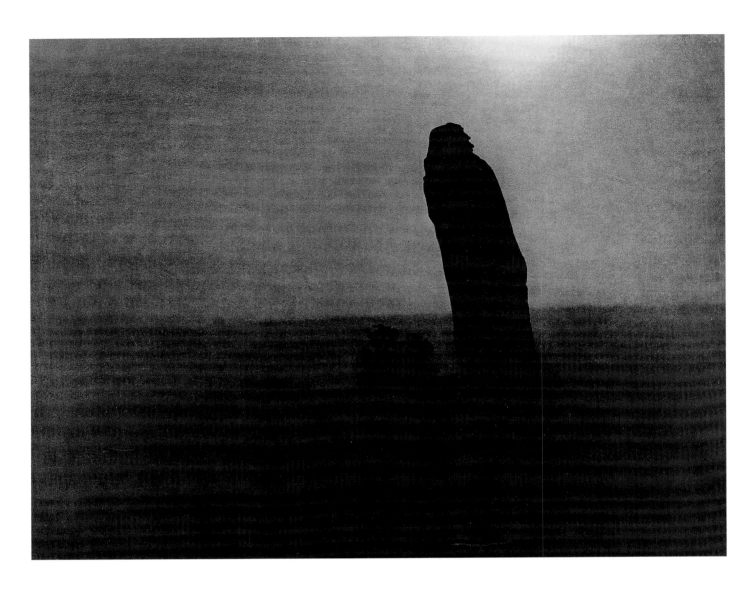

Cat. 102 Edward Steichen,
*The Silhouette, 4 A.M., Meudon,*
1908 / printed 1940s, gelatin
silver print, 10¾ × 13⅝ in.,
Los Angeles County Museum
of Art

*I believe that photography can create works of art, but hitherto it has been extraordinarily bourgeois and babbling. No one ever suspected what could be gotten out of it; one doesn't even know today what one can expect from a process which permits of such profound sentiment, and such thorough interpretation of the model, as has been realized in the hands of Steichen. I consider Steichen a very great artist and the leading, the greatest photographer of the time. Before him nothing conclusive had been achieved. . . . I do not know to what degree Steichen interprets, and I do not see any harm whatever, or of what importance it is, what means he uses to achieve his results. I care only for the result, which however, must remain always clearly a photograph. It will always be interesting when it be the work of an artist.*[43]

For his part, Steichen made the grand gesture of naming his daughter Kate Rodina Steichen, after her godfather. He also went back to New York to promote Rodin's art at Stieglitz's 291 gallery.

Rodin's encounter with photography took a steep learning curve. His path ended with the late embrace of photography in the hands of Steichen. With the aid of photography, Rodin was able to go further in his emphasis on painterly sculpture, like his friend Carrière's sculptural painting. It was often through photography's aid that Rodin was most able to synthesize his goals for a particular work. Steichen's photographs of the *Balzac* are the ultimate example of this point. While Rodin's impact on the photographers who worked with him is clear, photography gave Rodin a fresh perspective from which to reconsider his works and to experience unforeseen effects.[44] The exhibition and publication of photographs of his sculptures also gave him the opportunity to educate the public about his work. This worked so well that photographs were sometimes the only objects that sold in Rodin's exhibitions.[45] In these ways and with what Kirk Varnedoe has called a "fruitful lack of concern for conventional hierarchies and boundaries within the field of artistic endeavor,"[46] Rodin extended the sculptural idiom with photography's help. He, in turn, found new respect for the medium.

Cat. 95 Auguste Rodin, *Study for "The Monument to Balzac,"* c. 1897 (cast 1974, marked 6), bronze, 44½ × 17¼ × 15 in., The Patsy R. and Raymond D. Nasher Collection

Cat. 93  Auguste Rodin,
*Republican Balzac,* c. 1892,
bronze, 42½ × 19⅝ × 14⅝ in.,
Collection Fondation Pierre
Gianadda, Martigny,
Switzerland

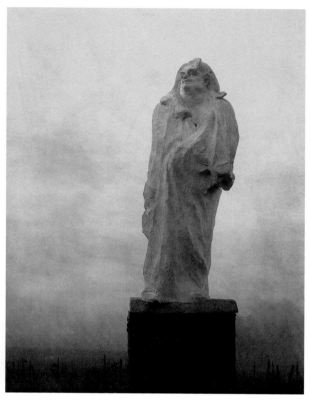

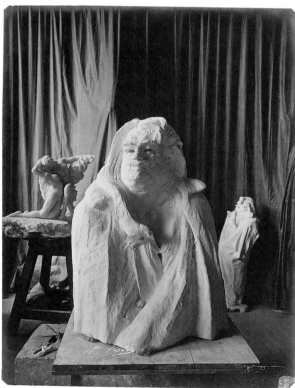

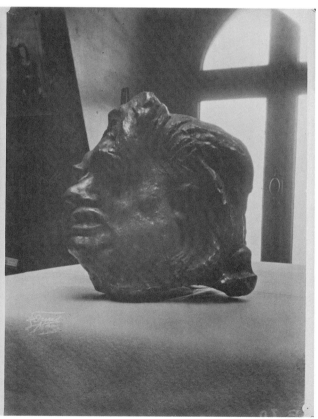

Cat. 46 (top, left) Jacques-Ernst Bulloz, *"Monument to Balzac" at Meudon,* n.d., carbon print, 10⅜ × 8¼ in., Musée Rodin, Paris

Cat. 43 (top, right) Jacques-Ernest Bulloz, *"Monument to Balzac" at Meudon,* n.d., carbon print with gray-green tint, 10⅝ × 8 in., Musée Rodin, Paris

Cat. 57 (bottom, left) Eugène Druet, *"Balzac, Half-Length,"* n.d., gelatin silver print, 15 × 11⅛ in., Musée Rodin, Paris

Cat. 63 (bottom, right) Eugène Druet, *"Head of Balzac,"* n.d., gelatin silver print, 15⅝ × 11¾ in., Musée Rodin, Paris

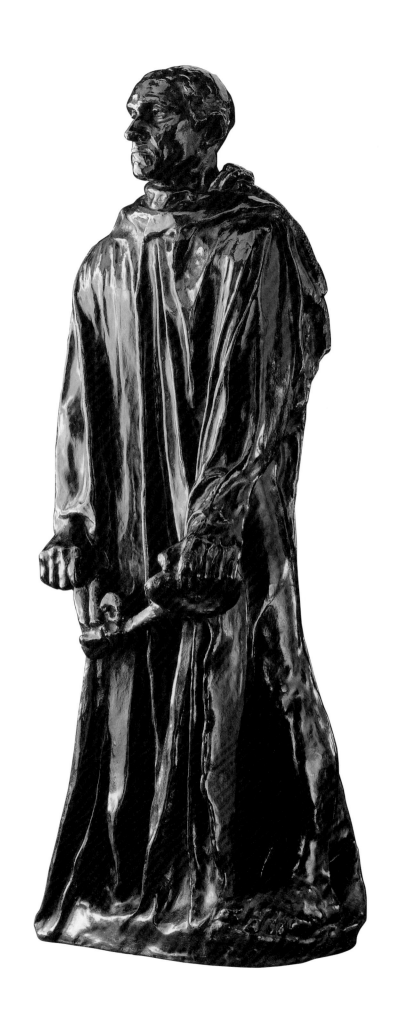

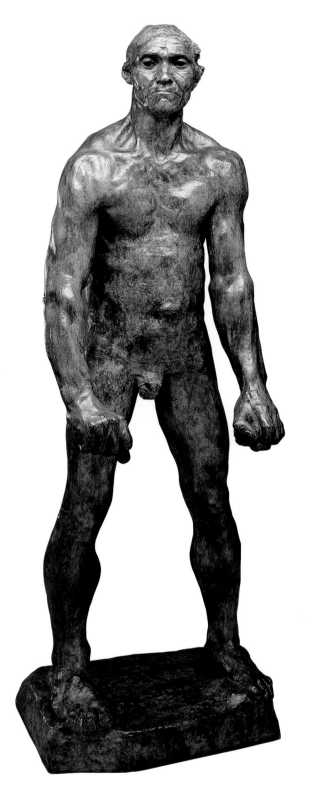

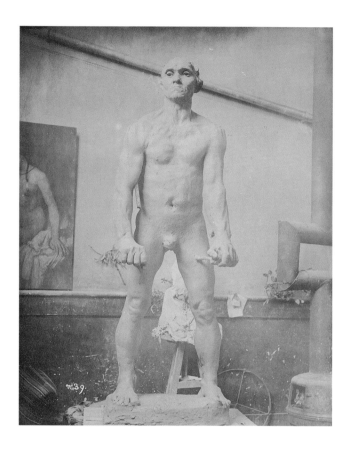

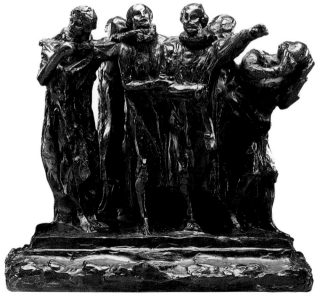

Clockwise from top left:

Cat. 37 Karl-Henri (Charles) Bodmer, *"Jean d'Aire, Nude," in the Studio,* c. 1886, albumen print, 9⅞ × 7⅜ in., Musée Rodin, Paris

Cat. 91 Auguste Rodin, *Jean d'Aire,* 1886, bronze, cast in the early 20th century, 81 × 28 × 24 in., Dallas Museum of Art

Cat. 89 Auguste Rodin, *The Burghers of Calais, First Maquette,* fall 1884, bronze, 23½ × 14¾ × 12⅝ in., Iris & B. Gerald Cantor Foundation, Los Angeles

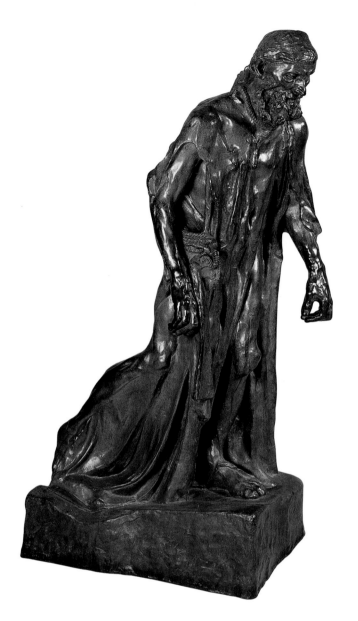

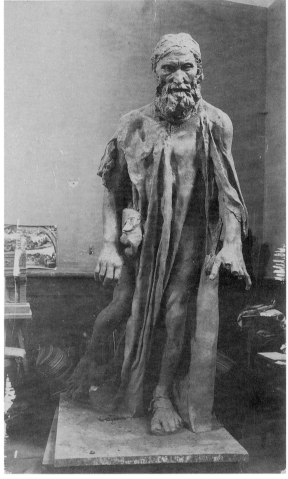

Cat. 92 Auguste Rodin,
*Eustache de St.-Pierre,*
c. 1886–87, cast 1983, bronze,
85 × 30 × 48 in., Brooklyn
Museum of Art

Cat. 81 Victor Pannelier,
*"Eustache de St.-Pierre" in the
Studio,* c. 1886, albumen print,
13¾ × 8 in., Musée Rodin,
Paris

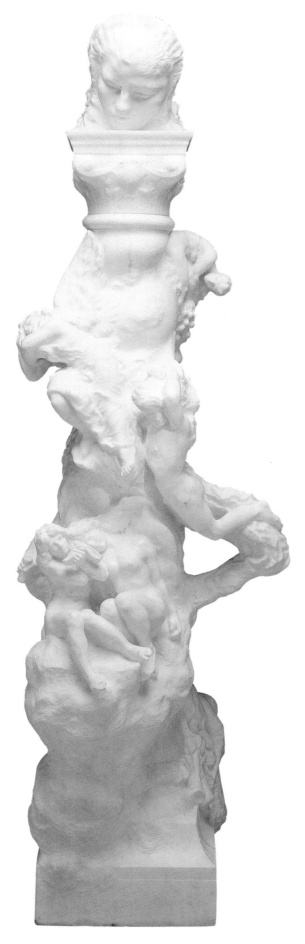

Cat. 94 (left) Auguste Rodin, *The Poet and the Contemplative Life (The Dream of Life),* 1896, marble, 72¼ × 20½ × 23¾ in., Dallas Museum of Art

Cat. 67 (right, top) Eugène Druet, *"The Dream of Life,"* *at the Salon of the Société* *Nationale des Beaux-Arts,* 1897, gelatin silver print, 15⅝ × 11⅜ in., Musée Rodin, Paris

Cat. 69 (right, bottom) D. Freuler, *"The Dream of Life"* *at the Société Nationale des* *Beaux-Arts,* 1897, salt print, 10⅞ × 4¼ in., Musée Rodin, Paris

NOTES

I am grateful to Lisa Rotmil for her help in editing this essay.

1. Albert E. Elsen, *In Rodin's Studio: A Photographic Record of Sculpture in the Making* (Ithaca, N.Y.: Cornell University Press, 1980), p. 11.

2. Rodin, "My Testament," quoted in ibid.

3. Letter from Rodin to mayor of Calais, January 1889, quoted in ibid.

4. Auguste Rodin, *Rodin on Art and Artists: Conversations with Paul Gsell,* trans. Romilly Fedden (New York: Dover, 1983), p. 54. Originally published as Rodin, *L'Art,* ed. Paul Gsell (Paris: Editions Grassett and Fasquelle, 1911).

5. Ibid., p. 32.

6. Ibid., p. 33.

7. Ibid., pp. 33–34.

8. Rodin in his notebook, reprinted in Judith Cladel, *Rodin: The Man and His Art,* trans. S. K. Star (New York: The Century Co., 1918), p. 206.

9. Françoise Heilbrun, "Artists as Photographers," trans. Madonna Deverson, in *Paris in the Late Nineteenth Century* (Canberra, New South Wales: National Gallery of Canberra, 1996), p. 108.

10. Elsen, *In Rodin's Studio,* p. 13. Similarly, Hélène Pinet claimed that sculptors before Rodin were not really interested in photography. See Pinet, "La Sculpture, la photographie et le critique," in *Sculpter-photographier photographie-sculpture,* ed. Michel Frizot and Dominique Paini (Paris: Marval, 1993), records of proceedings from a colloquium organized at the Musée du Louvre by the Service Culturel, November 22–23, 1991, p. 90.

11. Ibid.

12. The photographs on view included images of his bust of Victor Hugo, *The Gates of Hell, The Kiss, Ugolino, Orpheus and Eurydice, Claude Lorrain* (seven details as well as the entire composition), *Mme Vicuña,* and *The Burghers of Calais* (front and two side views, and an image of the inauguration of the work). None of these sculptures were on view in Geneva. See Alain Beausire, *Quand Rodin exposait* (Paris: Editions Musée Rodin, 1988), pp. 125–26. It is unclear whose idea it was originally for Rodin to include photography with his sculptures in 1896 at the Musée Rath.

13. Charles Bodmer specialized in photographing works of art and had his main office in Barbizon. Rodin used him primarily in the early 1880s. On Bodmer, see Kirk Varnedoe, "Rodin and Photography," in *Rodin Rediscovered,* ed. Albert E. Elsen (Washington, D.C.: National Gallery of Art, 1981), pp. 210–13. On the photograph of *Psyché-Printemps,* see Hélène Pinet, "Les Photographes de Rodin," *Photographies* (Paris), no. 2 (September 1983): 44.

14. "J'ai besoin d'un croquis de vous à la plume, très simple de votre *Eve.* Vous avez quantité de grandes photographies, il suffit de m'en faire vous-même un calque bien expressif, j'en ai besoin pour mercredi matin au plus tard." Letter from Arsène Alexandre to Rodin, 1889, quoted in Pinet, "Les Photographes de Rodin," p. 41.

15. Hélène Pinet, "Rodin and Photography," in Catherine Lampert, *Rodin: Sculpture and Drawings* (London: Hayward Gallery, 1986), p. 241.

16. "M. Rodin aura toujours le droit d'interdire la vente de photographies qui lui paraitraient insuffisament artistiques." Quoted in Varnedoe, "Rodin and Photography," pp. 216 and 223 n. 2.

17. In fact, the sculptor's restrictions caused Druet to argue with Rodin and precipitated a break in their relations in 1900 at the time of Rodin's one-man show at the place de l'Alma. This break was not permanent, however, as Rodin seems to have supported Druet in his venture to open an art gallery and photography studio in 1903.

18. On Druet and Rodin, see Varnedoe, "Rodin and Photography," pp. 203–8, 215–24; Pinet, "Les Photographes de Rodin," pp. 47, 49, 55; Hélène Pinet, *Rodin sculpteur et les photographes de son temps* (Paris: P. Sers, 1985), pp. xxiii–xxvi, 150–51, 153–56; Claude Anet, "La Photographie de l'oeuvre de Rodin," *La Revue blanche,* June 1, 1901, pp. 216–17; Claude Keisch, "Photographien von E. Druet," in *Auguste Rodin: Plastik Zeichnungen Graphik* (Berlin: Staatliche Museen zu Berlin, 1979), pp. 251–52; and *Eugène Druet, 1868–1916,* essays by Hélène Pinet and Anne Ganteführer (New York: Sander Gallery, 1993).

19. Fagus, "Ses Collaborateurs," *La Revue des beaux-arts et des lettres,* January 1899, p. 13.

20. André Fontainas, in *Le Mercure de France,* July 1901, quoted in Pinet, "Les Photographes de Rodin," p. 56.

21. Steichen changed the spelling of his first name from Eduard to Edward in 1918.

22. Michael Hiley explained, "The fact that what was seen as its 'artistic' potential had not been developed before 1894 points to the switch in the concerns of photographers during these years, away from photographic definition and towards artistic effect." Hiley, "The Photographer as Artist: A Turn-of-the-Century Debate," *Studio International* 190, no. 976 (July–August 1975): 7.

Paper coated with gum arabic, water, pigment, and potassium (or ammonium) bichromate solution was dried and exposed to sunlight or ultraviolet light under a negative. The gum arabic would harden in proportion to the light received, due to its union with the bichromate. What did not harden could be washed away, leaving a highlighted area. On the gum bichromate process, see Gordon Baldwin, *Looking at Photographs: A Guide to Technical*

*Terms* (Malibu, Calif.: J. Paul Getty Museum, in association with British Museum Press, 1991), p. 51.

23. This was a study for the poster that Carrière made to advertise Rodin's private exhibition at the pavillion de l'Alma during the Exposition Universelle of 1900.

24. On Rodin and Carrière, see my discussions in Becker, "'Only One Art': The Interaction of Painting and Sculpture in the Work of Medardo Rosso, Auguste Rodin, and Eugène Carrière, 1884–1906," Ph.D. diss., Institute of Fine Arts, New York University, 1998; and "Carrière et Rodin," in Rodolphe Rapetti et al., *Eugène Carrière, 1849–1906* (Strasbourg: Editions de la Réunion de Musées Nationaux, 1996), pp. 45–47.

25. Carrière died of throat cancer in 1906. Haweis was also the *massier* (student in charge) in Alphonse Mucha's class in Paris for a time and exhibited at the Salon des Beaux-Arts and the Salon d'Automne. See Stephen Haweis's preface to *Pictures Painted by Stephen Haweis in the South Sea Islands. Melanesia, Polynesia* (New York: Berlin Photographic Company Galleries, 1915), p. 4.

26. The contract required that their prints sell at ten francs to pay Rodin's royalty and still make a profit. Their prints, which sold for less than ten francs, had to be sold through Bulloz. Bulloz charged them 1.50 francs to put Rodin's stamp on the prints. On the contract, see Elsen, *In Rodin's Studio,* p. 15, and Varnedoe, "Rodin and Photography," p. 239.

27. On Stephen Haweis's painting career, see Amelia Dorothy Defries, "The Oil Paintings of Stephen Haweis," *International Studio* 57 (January 1916): lxxix–lxxxii; *Pictures Painted by Stephen Haweis;* and C. H. B., "Watercolors by Stephen Haweis," *Bulletin of the Detroit Institute of Arts* 2, no. 1 (October 1920): 4–6. On his relationship with Mina Loy, see Loy, *The Last Lunar Baedeker,* ed. Roger L. Conover (Highlands, N.C.?: The Jargon Society, 1982), pp. lxiv–lxv.

28. Clipping from the *Pall Mall Gazette,* January 21, 1904, in the archives of the Musée Rodin, Paris, mentioned in Pinet, "Les Photographes de Rodin," in *Rodin,* ed. P. Gassier (Martigny: Fondation Pierre Gianadda, 1984), p. 44.

29. Ibid., pp. 44–45.

30. A. E. Gallatin, "The Paintings of Eduard J. Steichen," *International Studio,* no. 40, supplement. XL–XLIII (April 1910): XL.

31. William Innes Homer, "Eduard Steichen as Painter and Photographer, 1897–1908," *American Art Journal* 6, part 2 (November 1974): 45.

32. In his autobiography, Steichen wrote, "When I saw it [*Balzac*] reproduced in the Milwaukee newspaper, it seemed the most wonderful thing I had ever seen. It was not just a statue of a man; it was the very embodiment of a tribute to genius. It looked like a mountain come to life. It stirred up my interest in going to Paris, where artists of Rodin's stature lived and worked." Steichen, *Steichen: A Life in Photography* (New York: Harmony Books and The Museum of Modern Art, 1985), chap. 2, n.p.

33. Steichen to Stieglitz, c. 1900, Alfred Stieglitz Archive, Beinecke Rare Book and Manuscript Library, Yale University, quoted in Ruth Butler, *Rodin: The Shape of Genius* (New Haven, Conn., and London: Yale University Press, 1993), p. 405. See also Penelope Niven, *Steichen: A Biography* (New York: Clarkson Potter, p. 110, for an account of this encounter.

34. Dennis Longwell, *Steichen: The Master Prints, 1895–1914, the Symbolist Period* (New York: The Museum of Modern Art, 1978), p. 16.

35. Steichen, *Steichen: A Life in Photography.*

36. On Rodin's having seen the work in moonlight the night before, being struck by it, and asking Steichen to replicate the effect, as well as on Steichen's interest in the moonlight idea because of similar issues he was exploring in his paintings, see Steichen's typescript "Photographing Rodin's *Balzac,*" in "Balzac by Rodin in MOMA Garden" file, Steichen Collection of material on Rodin and Brancusi, Steichen Archive, The Museum of Modern Art, New York. On Steichen's own attraction to this time of day for artistic creation, see also Hélène Pinet, "'Il est là, toujours, comme un fantôme,'" in *1898: Le "Balzac" de Rodin* (Paris: Musée Rodin, 1998), pp. 199, 201–2.

37. On Steichen's photography of Rodin's Balzac, see ibid., pp. 195–204, esp. 198–99.

38. See Camille Mauclair, "L'Art de M. Auguste Rodin," *La Revue des revues* 25, 2d trimestre (June 15, 1898): 597–98.

39. Quoted in ibid., p. 607.

40. Ibid., p. 604.

41. Steichen, *A Life in Photography,* chap. 4. Here, Rodin was making a reference to the criticism of his work and the "Balzac affair," the scandal that swirled around the work on its appearance at the Salon of 1898 and its subsequent rejection from the Société des Gens de Lettres.

42. Charles H. Caffin, "Prints by Eduard J. Steichen—of Rodin's 'Balzac,'" *Camera Work,* no. 28 (1909), reprinted in Alfred Stieglitz, *Camera Work: The Complete Illustrations, 1903–1917* (Cologne: Benedikt Taschen Verlag, 1997), p. 484.

43. Quoted in George Besson, "Pictorial Photography: A Series of Interviews," *Camera Work,* no. 24 (October 1908): 14.

44. Elsen, *In Rodin's Studio,* p. 26.

45. For example, at the Haagsche Kunstkring in the fall of 1899. See John Sillevis, "Rodin's First One-Man Show," *Burlington Magazine* 137, no. 1113 (December 1995): 837.

46. Varnedoe, in Elsen, ed., *Rodin Rediscovered,* p. 207.

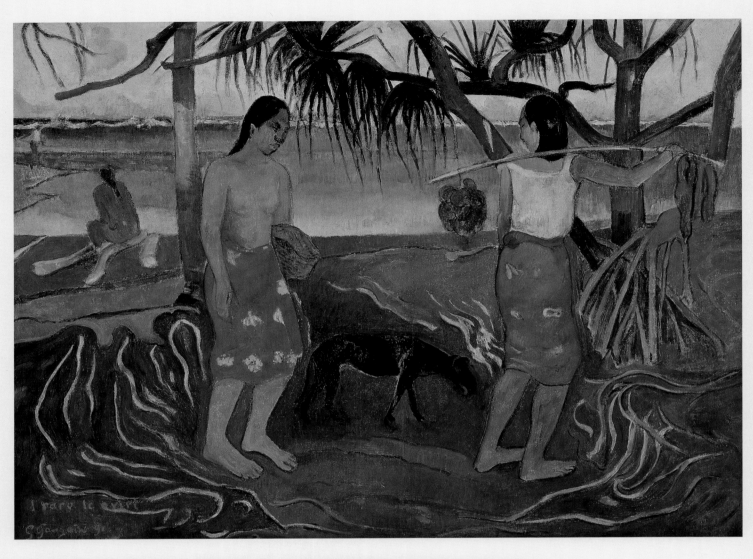

# Paul Gauguin

PARIS 1848–1903 ATUONA, MARQUESAS ISLANDS

Cat. 124  Paul Gauguin, *Under the Pandanus (I raro te oviri)*, 1891, oil on canvas, 26½ × 35¾ in., Dallas Museum of Art

Cat. 142  Charles Spitz, attributed, *Fruit Carriers on Raiatea*, c. 1900, vintage postcard, 3⅛ × 6½₆ in., Christian Beslu, Tahiti

Gauguin's childhood spent in Peru and his years in the merchant marine and navy accustomed him to a life outside French middle-class conventions. A job as a stockbroker in Paris in the 1870s allowed him to collect contemporary (impressionist) painting and to paint as an amateur. He became friendly with Camille Pissarro and showed with him and his colleagues in four of their eight group shows. A stock market crash in 1883 cost Gauguin his job, and he was forced to sell his collection. In 1886, seeking a culture simpler than the one in Paris, he went to Brittany. In Pont-Aven a group of artists gathered around him, attracted by his new style of painting, which broke from descriptive, naturalistic modes by using a flattened picture space and areas of un-modulated color, often outlined with black, to achieve expressive and symbolic ends. In 1887–88 Gauguin went to Panama and Martinique, and in 1888 he spent a short, ultimately unsettling time with the mentally fragile Vincent van Gogh in Arles. Searching for a still more primitive culture, he made his first trip to the South Seas in 1891. He was very productive in Tahiti, where he made some of his best paintings, woodcuts, and sculptures. He was back in Paris in 1893—sick and out of money—but returned to Tahiti in 1895, thanks to an inheritance. In 1901 Gauguin moved to the Marquesas Islands, where he died in 1903. The force of his art caused many artists to change the course of their own output. His interest in the physical artifacts of primitive cultures (tempered by a thorough knowledge of Western culture back to the Greeks) and Japanese prints, and his expressionism and mysticism, ally his art to much of that produced at the turn of the last century. His posthumous fame was guaranteed by an exhibition of his work at the 1906 Salon d'Automne.

*Elizabeth C. Childs*

# Paradise Redux: Gauguin, Photography, and Fin-de-Siècle Tahiti

Paul Gauguin's escape from Paris to the South Seas in 1891 is the classic episode of modernist primitivism. His pursuit of what he termed the life of a "savage" in the tropics may seem to be a simple tale of fin-de-siècle antimodernism—the ultimate act of individualism brought on by disillusionment with mass culture and urban modernity.[1] Like most Europeans of his era, Gauguin arrived in Polynesia expecting a "pure" or "authentic" paradise, frozen in some vague, mythic past. What he encountered was the dynamic culture of a modern colonial Tahiti. Gauguin's mission was primitivist retreat, but he never fully abandoned either the artistic or the technological culture of the France he left behind. Gauguin's identity in Polynesia was a cultural hybrid—part French (both bohemian artist and sailor) and part Polynesian. He created an idiosyncratic, avant-garde identity in the margins between the worlds of the Parisian *métropole* and the Tahitian village. For Gauguin that liminal position in the colonial world was a stimulating and creative space, if not always a serene one. By focusing on the unfolding role the photographic image played in his exoticism, this essay examines a key aspect of the impact of colonial experience on Gauguin's primitivism.

Gauguin's position in the debate over the value of photography to art was, like that of many fellow symbolists, contradictory. On the one hand, he dismissed photography as a medium that was mechanical and unexpressive, claiming that only academic masters like Jean-Louis-Ernest Meissonier who cared about precise anatomical detail could learn from it.[2] Its technical character seemed to preclude aesthetic play, subjective judgment, and individual imagination, all of which were central to the symbolist credo. He shared the symbolist generation's general disdain for technology: "Machines have come, art has fled, and I am far from thinking photography can help us."[3] For Gauguin, as for Baudelaire, seemingly objective photographic "truths" could never surpass the beauties created by the imagination: "Color photography is going to tell us the truth. What truth? The true color of the sky, of a tree, of all of material nature. What then is the true color of a centaur, a minotaur, or a chimera, of Venus, and of Jupiter?"[4] In spite of such contentions, Gauguin was clearly in awe of the speed and mimetic powers of photographic technology: "I will tell you that photography will be the most faithful work of art when it renders color, which will soon be possible. And you would like to have an intelligent man, working for months, to produce the same illusion of reality by an ingenious small machine."[5] Our contemporary understanding of photography as an agent of subjectivity that always somehow bears the mark of its maker and its time was an insight that Gauguin never had.[6] Nonetheless, he recognized that the photograph is not transparently factual but has an independent agency capable of stimulating the viewer. This modern machine had its uses, even for a "civilized savage," as Gauguin sometimes called himself.[7]

In an era of fin-de-siècle colonialism the medium of photography provided Gauguin with a crucial element of control and visual privilege. The photograph assumed three important roles for him during his Polynesian sojourn: it was a convenient and affordable document to facilitate communication with the avant-garde community in Paris; it was a stimulating vehicle of art reproduction that allowed him to construct a *musée imaginaire* (imaginary museum) on the walls of his Tahitian studio; and it was an ethnographic source that authenticated the appearance and culture of

Cat. 119  Paul Gauguin, *Still-Life with Horse's Head,* c. 1886, oil on canvas, 19¼ × 15 in., Bridgestone Museum of Art, Ishibashi Foundation, Tokyo

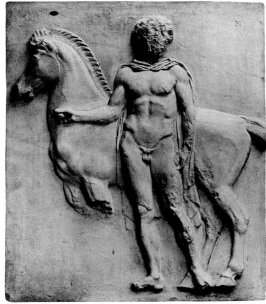

Cat. 121 Paul Gauguin, *In the Vanilla Grove: Man and Horse*, 1891, oil on canvas, 28¾ × 36¼ in., Solomon R. Guggenheim Museum, New York

Cat. 110 Anonymous, *Detail of Standing Youth and Horse on Slab N of the Parthenon*, 1868, 16 × 12¾ in., from *Les Frises du Parthenon* by C. Yriarte, Minneapolis Public Library

the Other in the colonial sphere. Photography also offered Gauguin a surrogate world of "authentic" native experience in a colonial Tahiti that had disappointed him in its heterogeneity and modernity. Ethnographic and travel photography could stabilize and reify a perishing exotic world that was, to his European eye, in a tragic and inevitable stage of dissolution in the wake of imperialism.[8] Photography was one tool of European progress that Gauguin chose not to leave behind.[9]

Gauguin's engagement with photography was a logical extension of his polymathic interests. At the center of the avant-garde's reevaluation of the role of traditional easel painting, he strove for innovation in every medium: he devised new ceramic glazes, resurrected the woodcut, and painted directly on rough burlap. For him it was routine to reconsider the potential of his materials and to juxtapose unusual combinations of motifs. It was also in his nature to seek out the intriguing object. In the course of his Polynesian career, Gauguin became an avid collector of photographs, just as he had been a keen collector of impressionist painting when his income had permitted.[10]

While we cannot confirm that Gauguin made photographs himself, his ownership of a camera in at least three stages of his career and his friendships with at least three colonial photographers suggest that he was knowledgeable about the medium in the 1890s and probably experimented with it. Between 1895 and 1901 he also probably took some of the photographs that are now attributed to his friend Henri Lemasson.[11]

In all, at least fifty works of art Gauguin created in Polynesia—paintings, sculptures, drawings, prints, and illustrated manuscripts—are informed by his appropriation of poses or motifs taken from his large collection of photographic reproductions of art and from ethnographic photographs of indigenous people of Oceania. Gauguin collected art reproductions through his career. He covered the walls of his Paris studio with reproductions of Japanese prints and of works by Manet and Puvis de Chavannes. During his Breton period (1886–90), Gauguin did not rely on photographic sources for his compositions of peasants or landscapes. But as he prepared to leave for Tahiti in 1891, he declared to Odilon Redon his plan to take a "whole little world of friends" in his collection of art reproductions and drawings: these images would be his comrades, with whom he could "chat" every day.[12] Even at the end of his career in Hivaoa, his little *musée imaginaire,* still continued to play an important part in his studio life (fig. 70). In Polynesia he worked in an isolation from fellow artists unknown to him in his career in either Brittany or Paris. Photographs provided him with a surrogate art community.

Fig. 70 (top) Louis Grelet, *Tohotaua,* photographed in Gauguin's studio in Hivaoa, Marquesas Islands, 1901. Visible on back wall are reproductions of Hans Holbein, *Woman and Child;* Puvis de Chavannes, *Hope;* Edgar Degas, *Harlequin;* and a photograph of a Buddha from the Borobudur sculptures

Cat. 112 (bottom, left) Anonymous, *Fragment of Parthenon Frieze,* c. 1880–89, photograph, Private Collection, Tahiti

Cat. 137 (bottom, right) Paul Gauguin, *Three Native Women (Study for "The Call"),* 1902–3, traced monotype in black ink, squared, on a sheet of brown paper, 17⅛ × 12 in., Museum of Fine Arts, Boston

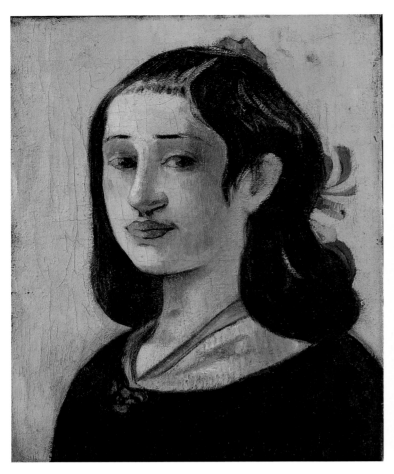 

 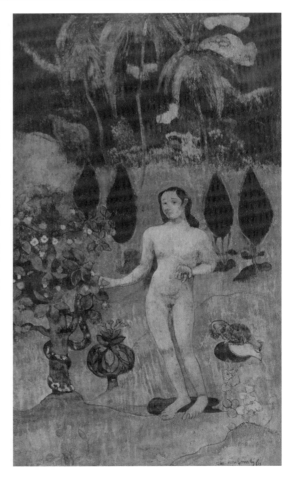

But Gauguin's interest in photography is not just a reflection of the loss of his artistic cohort in France. It offers us a key to his exploration of issues of memory, time, and space. These concerns emerge in Gauguin's art well before his departure for Tahiti in 1891. An early still life of 1886, dating from his brief experimentation with neo-impressionist technique, illustrates the eclectic nature of his exoticism. *Still Life with Horse's Head* (cat. 119) is an exotic pastiche of decorative Japanese fans, a Japanese doll, and a cast replica of the head of a horse from the Parthenon displayed against patterned French wallpaper. On a table at the base of the composition lies an open photograph album, its thick gilt-edged pages offering a sampling of photographs whose illegibility, in conjunction with the Japanese and Greek artifacts hovering above it, invites the viewer to muse over recollection and the fantasy of travel and the exotic.

Photographs first emerge as sources for figures in Gauguin's paintings just prior to his departure for Tahiti. In a portrait he painted in 1890 of his mother, he relied on a thirty-year-old photograph to guide his construction of an ideal image of her at a youthful age he could imagine but had never known in life (cat. 120, fig. 71). At about the same time, Gauguin exoticized his mother as Eve, conjuring a fantastic tropical scene that fuses the artist's reference to his own family history with an archetypal female symbol of human origins (fig. 72). In calling on memories of one he had known so intimately, but who had been lost to him since her death in 1867, Gauguin drew on two photographic sources. He grafted his mother's youthful head, taken from the family photograph, onto a sensuous nude body configured in a pose lifted from a photograph of the stone reliefs of the ancient ninth-century Javanese temple at Borobudur (cat. 118). Thus, in this period just prior to his departure for Polynesia, Gauguin began to employ photographs both as mediating filters of personal memory and as referents to idealized exotic locales.

Travel and relocation in the colonial world fueled Gauguin's artistic energies. When Gauguin traveled to Martinique in 1887, he claimed, "It was only there that I felt like my real self."[13] The search for one's "real self" in the course of travel to an "authentic" exotic locale is a hallmark of fin-de-siècle exoticism. Gauguin was a disgruntled romantic individual who reveled in his own alienation from urban, bourgeois culture. He longed to recuperate —and reinvent himself—in an exotic sphere. Europe's vision of exotic paradise promised more, however, than it could deliver. As Chris Bongie has observed, in the fin-de-siècle "the exotic necessarily becomes, for those who persist in search of it, the sign of an aporia—a constitutional absence at the heart of what had been projected as a possible alternative to modernity."[14] What Gauguin sought was utopia, pure and simple. He wrote to fellow

artist Emile Bernard of founding a "Studio of the Tropics," where they could "live in freedom and practice art. Without needing money, you will find an assured existence in a better world."[15] Gauguin's exotic vision grew decidedly colonial: by the end of 1890 he was convinced that "out there," in the colonies, he could renew both his energies and his art.

In 1889 the spectacular Exposition Universelle in Paris gave Gauguin the idea of immigration to the French colonies. The fair touted France at the zenith of her commercial and creative vigor and celebrated the promises of science and industry. In the Palais des Arts Libéraux, a large retrospective (fig. 73) canonized the history of photography, a rapidly developing technology that after just half a century now seemed "already quite old thanks to the progress it has made."[16] The era of the portable tourist camera had arrived: the new portable camera promised amateurs the benefits of modern convenience in making their own visual records.[17] Photography also figured prominently at the Exposition Universelle at the Palais des Colonies in exhibits that proclaimed the success of France's imperial campaigns (figs. 74, 75). Scenic photographs of Tahiti were so appealing that visitors frequently stole them, ripping them from the wall as illicit souvenirs. Travel photos made the exotic world both accessible and subservient to the desires of tourism and immigration, providing instant gratification for urban voyagers who spent a day, and a vicarious fantasy life, in the simulacrum of the exotic.

Gauguin's many trips to the colonial exhibition resulted in a few minor drawings based on the architectural exhibits, notably the reproduction of the Cambodian temple Angkor Wat.[18] But of lasting importance to his developing primitivism was his exposure to the prepackaged ideology of colonialism and to collectible photographs of exotic works of art. The photographs Gauguin

Cat. 120 (oppposite, top left) Paul Gauguin, *Portrait of the Artist's Mother*, 1890, oil on canvas, 16⅛ × 13 in., Staatsgalerie Stuttgart

Fig. 71 (opposite, top right) Anonymous photograph of Gauguin's mother, Aline Chazal, original not located; reproduced in Malingue, *Gauguin*, 1948, p. 19

Cat. 118 (opposite, bottom left) Anonymous, *Relief on Temple at Borobudur, Java*, detail, *Top register: The Tathagat Meets an Ajiwaka Monk on the Benares Road*, c. 1889, albumen photograph, 9¼ × 11½ in., Private Collection, Tahiti

Fig. 72 (opposite, bottom right) Paul Gauguin, *Exotic Eve*, 1890, Private Collection, whereabouts unknown

Fig. 73 (above) J. Kuhn, *Exhibition of the History of Photography, Exposition Universelle, 1889,* albumen print, Bibliothèque Historique de la Ville de Paris, Paris

Intérieur du Palais central des Colonies.

Fig. 74 E. H., ed., *Palais des Colonies, Exposition Univer-selle, Paris,* 1889, albumen print mounted on board, Courtesy Photographic Archives, National Gallery of Art, Washington, D.C.

Fig. 75 Anonymous photographer, *Interior of the Palais central des Colonies,* engraving, from F. G. Dumas and L. de Fourcaud, *Revue de l'Exposition Universelle* (Paris: Ludovic Baschet, 1890), p. 90, Courtesy Photographic Archives, National Gallery of Art, Washington, D.C.

acquired at the colonial exhibition shared the same seductive aura of authenticity that appealed to him in the displays. In writing to Bernard, he collapsed the distinctions between the Asian referents, the entertainment of the performance, and the photographic reproductions he had acquired: "You missed something in not coming the other day. In the Java village there are Hindu dances. All the art of India can be seen there, and it is exactly like the photos I have."[19]

The colonial fair also promoted shopping. Most visitors in 1889 bought replicas of the icon of the future and of progress: miniature Eiffel Towers were the most popular souvenir of the fair. In buying photographs of ancient and exotic sculpture (cats. 117, 118), Gauguin acquired the opposite, modern souvenirs of a vanishing world of ancient, handcrafted religious art. He carried these photographs, along with his many reproductions of European paintings, to Tahiti in 1891. These images inspired Gauguin for more than a decade; even in his last years in the Marquesas he mined them for poses. Gauguin's attraction to the photographic art reproduction lay in its infinite flexibility. The reduction of hue to variations of black and white, and even of three-dimensional surfaces to a glossy flat picture, homogenized a highly diverse group of objects into a single reservoir of visual ideas. The photographs also distanced both the authorship and the authority of the original object. Although Gauguin had never been an artist shy of "plagiarizing" the work of another whose art he admired,[20] the use of photographs served to neutralize or even naturalize his acts of borrowing pictorial ideas from the world encyclopedia of art.

The full scope of Gauguin's *musée imaginaire* will never be known, because his photographic collection survives only in small part. But there are two photographs of relief sculptures from Borobudur (see again cats. 117, 118) that proved to be fertile ground for Gauguin's Tahitian oeuvre. Gauguin circulated his favorite poses and gestures, often with only slight variation, in several compositions. For example, devout women with hands clasped in the Borobudur reliefs reappear as the prayerful attendants in *We Greet Thee, Mary (Ia Orana Maria)* (The Metropolitan Museum of Art, New York), as well as in several related works (cats. 125, 131, 133, 135). The merchant in *The Arrival of Maitrakanyaka at Nadana* (see again cat. 118), which first inspired the pose of Gauguin's exotic Eve, reappears in *The Delightful Land (Te Nave Nave fenua)* of 1892 (Ohara Museum of Art, Kurashiki, Japan) and related works (cats. 126, 127, 133). The seated women in *Delectable Waters (Te pape nave nave)* (cat. 132) in the lower right foreground reiterate details of the crowded frieze of seated attendants in the Borobudur reliefs. Seated Javanese Buddhas preside in many Tahitian works (cats. 130, 134). In turning often to such Javanese sources, Gauguin based his image of present-day Tahiti on the art of an ancient culture from which he erroneously believed the modern Polynesians were descended.[21]

Given Gauguin's isolation from art museums while living in Polynesia, it is not surprising that he would create a gallery of world art in his studio to stimulate his imagination. Yet he turned to photography in local contexts as well. He used

Cat. 118 Anonymous, *Relief on Temple at Borobudur, Java (Top register: The Tathagat Meets an Ajiwaka Monk on the Benares Road; bottom register: Merchant Maitraknayake Greeted by Nymphs),* c. 1889, albumen photograph, 9¼ × 11½ in., Private Collection, Tahiti

Cat. 117 Anonymous, *Relief at Temple of Borobudur, Java (Top register: The Assault of Mara; bottom register: Scene from the Bhallatiya-Jakata),* c. 1889, albumen photograph, 9½ × 11⅜ in., Private Collection, Tahiti

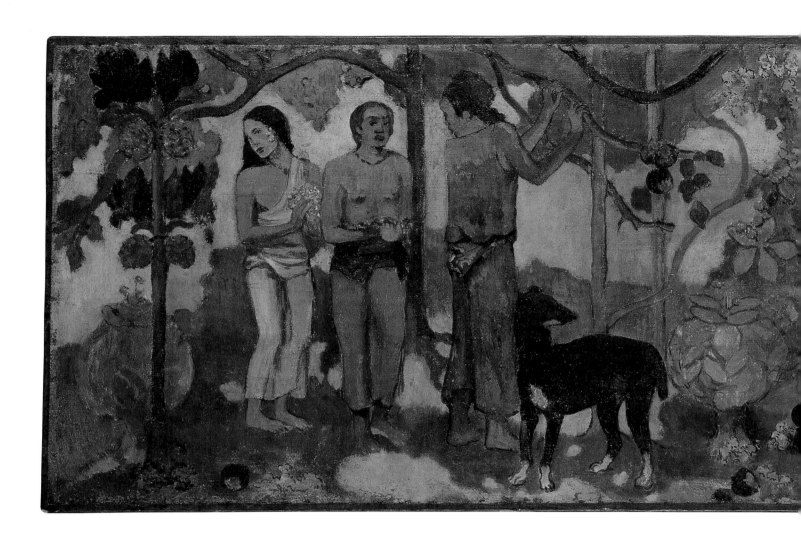

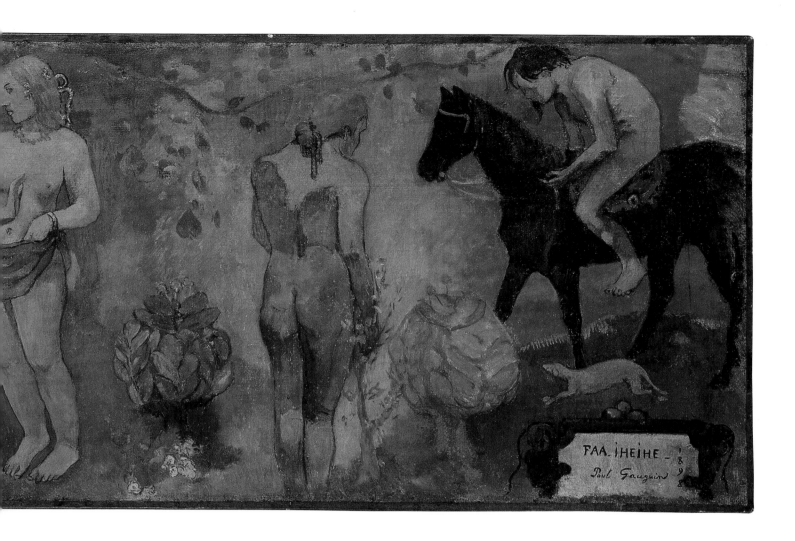

Cat. 133  Paul Gauguin,
*Tahitian Pastorale (Faa Iheihe),*
1898, oil on canvas, 21¼ ×
66¾ in., The Tate Gallery,
London

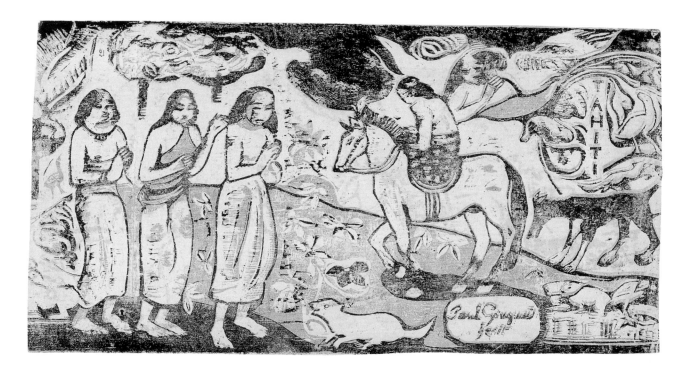

Cat. 135 Paul Gauguin,
*Change of Residence*, c. 1899,
woodcut printed in ochre and
black on thin Japanese tissue
pasted to ivory wove paper,
6½ × 11⅞ in., The Art Institute
of Chicago

Cat. 118 Anonymous, *Relief
on Temple at Borobudur, Java
(Top register: The Tathagat
Meets an Ajiwaka Monk on the
Benares Road)*, c. 1889, albu-
men photograph, 9¼ × 11½ in.,
Private Collection, Tahiti

ethnographic photographs of Polynesians to
negotiate his own social position as what James
Clifford has termed an "ethnographic liberal," or
an ironic participant in native culture who culti-
vates an image of marginality at a conscious re-
move from all colonial authority.[22] In his final year
in the Marquesas, Gauguin used photography to
mark himself as a bohemian and libertine. He
boldly displayed pornographic photographs of
North African women to irritate the morally self-
righteous colonists in his community. He con-
cluded that "if you hang up a little indecency on
your door, you will always get rid of the honest
people, the most intolerable people God ever
created."[23] But at the same time Gauguin was
provoking the ire of local Catholics with his soft-
core porn show, he was using a constructed, West-
ern image of the exotic body to do it.[24] There is
considerable irony here in the idea of Gauguin's
deploying an orientalist's view of the exotic
woman to critique Western notions of modesty
and propriety.

Gauguin also used photography to maintain
his attenuated relationship with the avant-garde
in France. In letters to fellow artists, he included
photographs of himself, of his art, and of his hut
in paradise. In this sense his practice anticipates
ethnographers' use of photographs in the twenti-
eth century to authenticate the author's experi-
ence as well as his text.[25] Gauguin sent photo-
graphs as proof of his having "gone native." One
such document is the only known photographic
record of any of Gauguin's residences in Poly-
nesia (fig. 77), which he sent to Georges-Daniel
de Monfreid in 1896.[26] Gauguin also occasionally
sent colonial photographs to France to reinforce

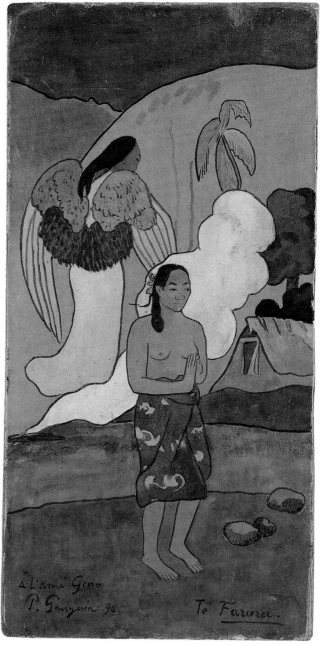

Cat. 131  Paul Gauguin, *We Greet Thee, Mary (Ia Orana Maria)*, c. 1894, watercolor monotype, printed in blue, black, and red, 13⅜ × 7⅛ in., Rijksmuseum, Amsterdam

Cat. 125  Paul Gauguin, *The Annunciation (Te Faruru)*, 1892, oil and gouache on paper, mounted on cardboard, 17⅛ × 8⅛ in., Museum of Fine Arts, Springfield, Massachusetts

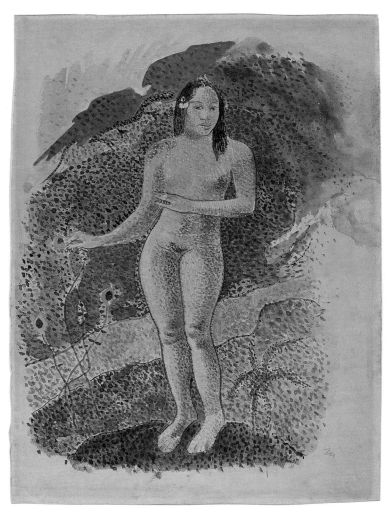

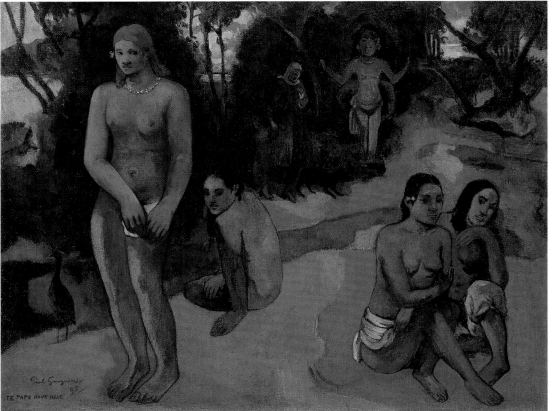

Cat. 127 (top, left) Paul Gauguin, *Reworked Study for "Delightful Land,"* 1892 (reworked 1894), charcoal and pastel drawing, 36¼ × 21⅝ in., Des Moines Art Center Permanent Collections

Cat. 126 (top, right) Paul Gauguin, *The Delightful Land (Te Nave Nave fenua),* 1892, brush and gouache on wove paper, 15¾ × 12⅝ in., Musée de Grenoble

Cat. 132 (bottom) Paul Gauguin, *Delectable Waters (Te pape nave nave),* 1898, oil on canvas, 29⅛ × 37½ in., National Gallery of Art, Washington, D.C.

his aesthetic agenda among his fellow symbolists. Invoking the popular concept of synaesthesia, he wrote about the powerful effects of "hearing" the music of a photograph of seated Tahitian women that he sent to a French friend in 1895. He praised the image for its "barbarous" and "primitive" rhythms and for the pleasing "music" the scene created.[27] Gauguin concluded his letter with the lament, "Ah, the dream, how easy it is to believe it is real," suggesting that the photograph offered him reassurance and confirmation of an exotic world he sought but had not found.

In facing the loss of the "authentic" old Tahiti he had expected, Gauguin often took refuge in the image of a "true" Polynesia as codified by ethnographic photography. Living in and near Papeete, Gauguin had easy access to Papeete's colonial photographers, whose businesses flourished in response to a growing tourist market and demands for travel illustration. These photographs included scenes of the modern city of Papeete; formal portraits of white colonists and affluent Tahitians; rural landscape and village scenes (cats. 104, 106, 108); and ethnographic studies of native "types" (cat. 115) posed in controlled settings. Of these four genres it was the ethnographic fictions, the frozen images of a premodern Tahiti that most interested Gauguin, and that he used as the basis of numerous works of art. Ethnographic photography of the fin de siècle both categorized and subjugated non-European peoples. These images are generally characterized by the deemphasis or elimination of contemporary details that identify the subject as a member of a dynamic, changing culture; the adoption of a stock repertoire of poses designed to display, measure, and objectify exotic bodies; and a vacuous, disinterested facial

Cat. 130 Paul Gauguin, *The God (Te Atua)*, c. 1894, woodcut on boxwood printed by embossing or gaufrage with traces of brown ink from an earlier impression, 8⅛ × 13⅝ in., The Art Institute of Chicago

Cat. 134 Paul Gauguin, *Buddha*, 1898–99, woodcut on long grain plank, printed in black on ivory Japanese tissue, 11½ × 8¾ in., The Art Institute of Chicago

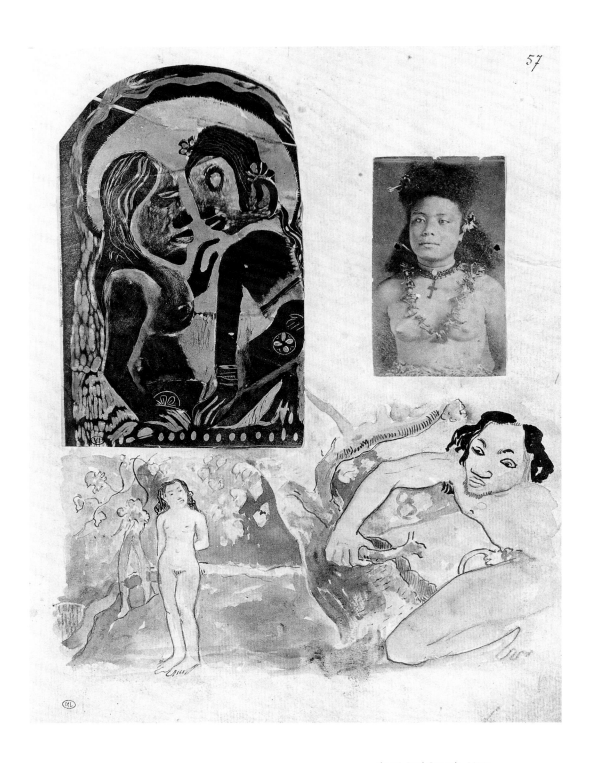

Fig. 76 Paul Gauguin, Manu-
script page from *Noa Noa*,
1893–97, photograph, water-
color, and woodcut on paper,
Département des Arts Gra-
phiques, Musée du Louvre,
Paris

expression that relieved the Western viewer of a
direct psychological encounter with an individual.

Gauguin used actual ethnographic photo-
graphs as collage elements in one instance—in his
*Noa Noa,* an illustrated version of his fictionalized
narrative of his first Tahitian trip. Between 1893
and 1896 Gauguin copied his text into a bound
album and illustrated many pages with a heterog-
enous collage of images that included photographs,
woodcuts, drawings, rubbings, watercolors, mono-
types, and reproductions of his own art. For ex-
ample, Gauguin attached to one page a woodcut
of an encounter between a male and a female
deity, probably Hina and Tefatou (fig. 76).[28] On
the same page his watercolor depicts two more
mythic male and female personages drawn from
Tahitian mythology: a scene from the narrative of
Hiro, god of thieves, who rescues a virgin impris-
oned in an enchanted forest guarded by giants.
Gauguin infuses this heroic scene with an undeni-
able eroticism: as the passive captive watches,
Hiro grabs a phallic branch of the tree in a gesture
that is as much a surrogate act of self-stimulation
as it is the movement of the barrier between him-
self and the virgin. In such a display of sexualized
male action and female passivity, the single photo-
graph of the Polynesian woman glued to the upper
right corner of the page plays an ambivalent role.
She is at once the empirical evidence of a real
photographic referent—the exotic woman whom
Gauguin encountered Out There—and the imag-
ined subject of the amorous fantasies of the viewer.
Her bare chest and grass skirt position her in the

Fig. 77 Jules Agostini,
*Gauguin's House and Studio
in Punaaiua,* 1896, albumen
print sent by Gauguin to
Georges-Daniel de Monfreid,
November 1896

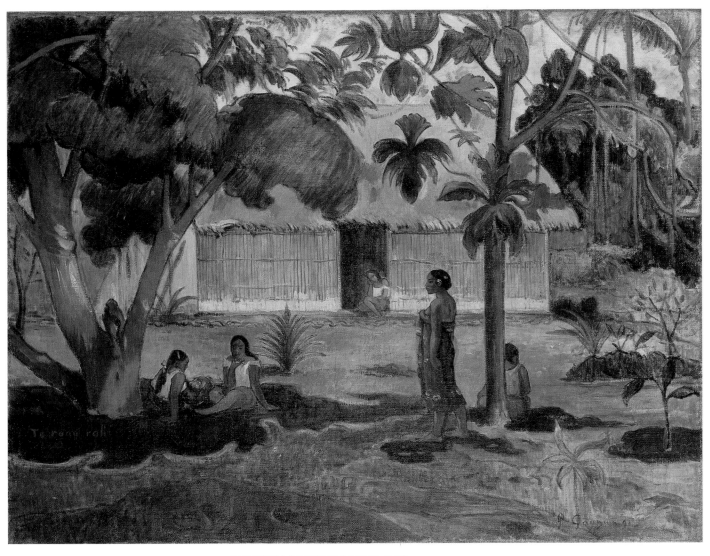

Cat. 122 Paul Gauguin,
*The Large Tree (Te raau rahi),*
1891, oil on canvas, 29⅛ ×
36½ in., The Cleveland
Museum of Art

Cat. 104 After a photograph
of c. 1890 by Charles Spitz,
*Tahiti: Indigenous Dance,* n.d.,
vintage postcard, 3½ × 5½ in.,
Christian Beslu, Tahiti

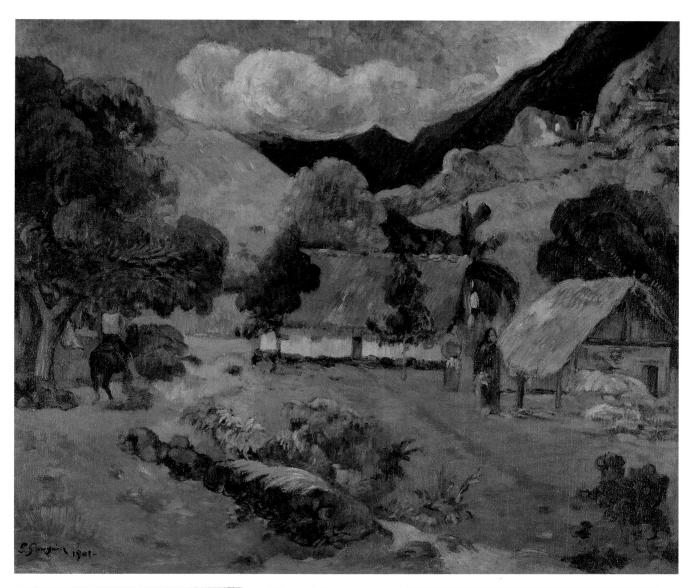

Tahiti — Case indigène

CASE CANAQUE TAHITI.

Cat. 136 (top) Paul Gauguin, *Landscape with Three Figures,* 1901, oil on canvas, 26½ × 30½ in., Carnegie Museum of Art, Pittsburgh

Cat. 106 (bottom, left) Anonymous, *Tahiti: An Indigenous Hut,* n.d., vintage postcard, 5½ × 3½ in., Christian Beslu, Tahiti

Cat. 108 (bottom, right) Anonymous, *Tahiti: An Indigenous Hut,* n.d., vintage postcard, 3½ × 5½ in., Christian Beslu, Tahiti

Clockwise from top left:

Cat. 139  Henri Lemasson, *Half-Tahitian Woman,* c. 1895, albumen print, Centre des Archives d'Outre-Mer, Aix-en-Provence

Cat. 111  Anonymous, Reproduction of Corot's *The Letter,* c. 1865–70, Arosa auction catalogue, c. February 25, 1878, collotype, National Gallery of Art Library, Washington, D.C.

Fig. 79  Charles Spitz, *Tahitian Woman,* c. 1890, albumen print, whereabouts unknown

Fig. 78  Charles Spitz, *Tahitian Woman,* c. 1890, albumen print, Private Collection, Tahiti

Cat. 123 (opposite)  Paul Gauguin, *Melancholic (Faaturuma),* 1891, oil on canvas, 37 × 26⅞ in., The Nelson-Atkins Museum of Art, Kansas City, Missouri

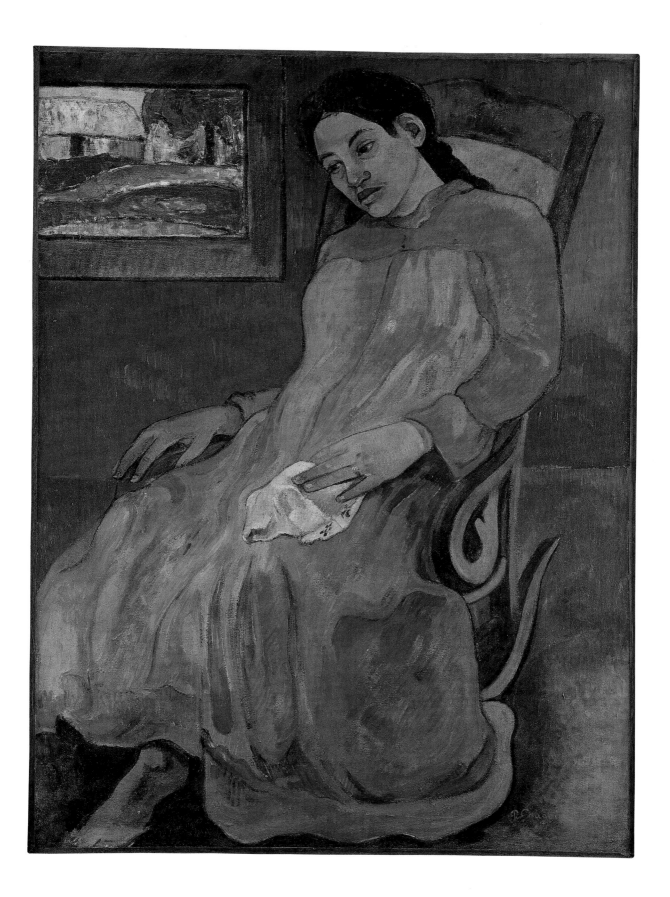

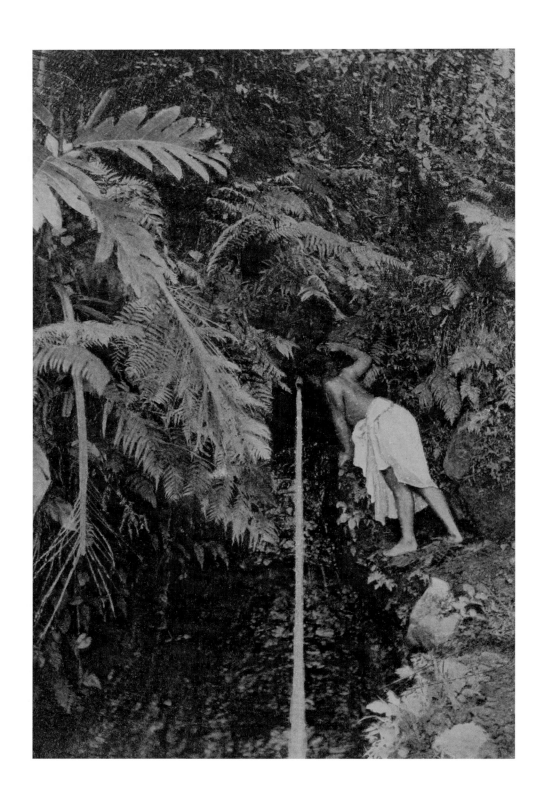

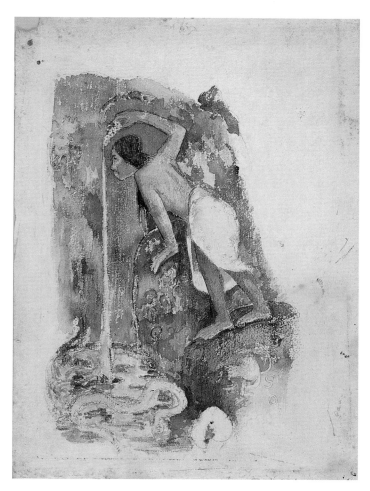

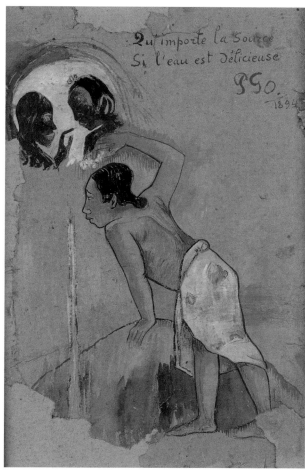

realm of traditional culture; yet her Christian necklace also relocates her in the present, in the mixed realities of colonialism. She inhabits the boundaries between the realms of the experienced and the desired: she is Gauguin's feminized allegory of modern Tahiti. Such photographs, affixed to the pages of a travel album, are the artist's precious fragments torn from a perishing world. Surrounded by Gauguin's watercolors and woodcuts, they emerge as flashes of a palpable reality that give substance to the dream.

Connections between Gauguin's paintings and colonial photography are often very subtle. Many landscapes that depict Tahitians at rest in front of their houses restate the conventions of ethnographic cliché. One such example is *Te fe'au Rahu* (The Large Tree) (cat. 122). This picture, while echoing the static monumentality of Georges Seurat's urban modernism, also intersects the image of rural Tahiti developed in colonial photography (see cat. 104). Gauguin's placement of Tahitians in the land, frozen in a slice of daily routine, resonates with the photographer's calculated scattering of "typical" villagers in front of their hut. Yet to observe this common ground between Gauguin's composition and the style of the colonial photograph is not to reduce the paint-

ing to a mere exercise of formulas. Gauguin's figures repose with grace, and the interspersed color harmonies of the foliage and background evidence the skilled vision of the painter. The photographs inform, but do not determine, the artist's decisions.

A mood of nostalgia and sober contemplation is common to many of Gauguin's depictions of contemporary Tahitians. Such views far outnumber the few pictures that depict vigorous physical action, such as dancing, washing, or working. Gauguin's Tahiti, like that of the novelist Pierre Loti, was one of languorous and sensual repose. The passive, melancholic woman in his paintings bears an intriguing relation to the typology of the contemplative Tahitian woman in colonial photography. For example, Gauguin's canvas *Faaturuma* (cat. 123), which he exhibited in Paris in 1893 with the French title *La Bodeuse* (The Melancholic or Sulking Woman) is imbued with reverie and melancholia. This canvas, like most of Gauguin's Tahitian production, results from a hybrid of his French and Polynesian experience. The brushwork owes a clear debt to Cézanne, and the pose echoes the collapsing posture of the figure in Corot's *Letter*, known to Gauguin through a collotype reproduction he took to Tahiti of this Corot

Cat. 115 (opposite) Anonymous, *Samoan at a Waterfall*, 1888, colored gillotage reproduction of an albumen print, 6¹⁄₁₆ × 6⅛ in., Christian Beslu, Tahiti

Cat. 128 Paul Gauguin, *Mysterious Water (Pape Moe)*, 1891–93, watercolor on cream paper, 13⅞ × 10⅛ in., The Art Institute of Chicago

Cat. 129 Paul Gauguin, *Mysterious Water, the Moon and the Earth (Pape Moe, Parau Hina Tefatou)*, 1894, watercolor, gouache, brush and black ink on irregular tan paper laid down on board, 15¾ × 10⅛ in., Edward Tyler Nahem, Fine Art, New York, and John Berggruen Gallery, San Francisco

painting once owned by his godfather, Gustave Arosa (cat. 111). But Gauguin's choice also reverberates with his experience of modern visual culture in Tahiti, and the significance of the nostalgic woman increases when the Gauguin painting is also compared with the colonial photographs of the contemplative *tahitienne.* Like the women in Lemasson's and Charles Spitz's photographs (cat. 139; figs. 78, 79), Gauguin's *tahitienne* is sadly modern—she inhabits a cultural borderland that synthesizes the Tahitian and the European, as she sits in a tropical garden in her "Mother Hubbard" gown. She wears the mantle of Europe's fin-de-siècle nostalgia for an idealized past.

*Faaturuma*'s listless, mournful woman joins a pervasive Western discourse on the enervated Tahitian. This idea emerges in the era's travel literature, such as the account of the American historian Henry Adams, who described the Tahitians of 1891 as "still, silent, rather sad in expression . . . the melancholy of it quite oppresses me."[29] These literary and visual texts illustrate the ideology of a "fatal impact" theory of colonization. This viewpoint maintains that in the wake of Polynesia's contact with Europe, a process of "civilization" was inevitable, resulting not only in modernization but in the gradual decline of local culture and the ultimate destruction or degeneration of a pure "race."[30] Such a view, however imbued with regret and nostalgia about the impending destruction, fails to acknowledge that native communities usually adapt and thrive in new syncretic forms. Nostalgia appropriates the modern and the future as the exclusive domains of the observer, not the observed. Thus exoticist themes of reverie and regret do not innocently circulate within the spheres of sentimentality or in the seemingly neutral environment of the artist's studio. In accepting such loss as inevitable, painter and photographer alike align themselves with the colonialist agenda of France.

The colonial photograph also served Gauguin as the basis of some of his most mythic constructions of an edenic Tahiti. Gauguin lifted the central motif and composition of *Pape Moe (Sacred Waters)* (Private Collection, Zurich) and related studies from a photograph taken by an anonymous photographer in Samoa and sold in Tahiti by Spitz (cats. 115, 128, 129).[31] These works provide a point of departure for Gauguin's hyperbolic tale recounted in *Noa Noa* of the magical transformation of a Tahitian princess into an eel. Gauguin imbues the foliage with animistic transformation: the drinking figure looks up to meet the gaze of a fish that emerges from the contours of rock and foliage. To the left of the fish, an embryo-like human figure uncurls within the rock also to confront the drinker. The scene both invokes Tahitian cosmology and provides an analogue for the artistic

processes of invention and imagination so revered by the symbolists.

But what of the relationship between the Samoan photograph and Gauguin's mythic scene at the waterfall? There are the superficial formal connections: Gauguin has clearly copied the thin stream of water, a few distinctive forms of vegetation, and the pose of the drinker. We could try to explain Gauguin's deference to the photograph as a method of verifying authentic Polynesian costume and scenery (the deviation of the plain Samoan *lava lava* wrap from the printed Tahitian *pareu* may have seemed to him even more "primitive"). Or we might surmise that Gauguin found in the image an exotic variant of a familiar European topos that aligned the feminine with nature, as typified by scenes of women at waterfalls recurrent in nineteenth-century French painting from Ingres to Courbet. A third interpretation locates Gauguin's attraction to the image within its own intrinsic ambiguities. The face of the figure is hidden in the photograph; the hair is either short or curled up around the neck; both the body and the costume of the figure could belong to either a Polynesian man or woman. Gauguin's adoption of an androgynous figure perhaps reflects his open appreciation of Polynesia as a realm where European gender stereotypes are relaxed and sexual identity is more mutable.[32]

But as an ethnographic photograph this image has a more general appeal for the primitivist. It is a seemingly transparent filter of culture that functions in stopped time, not real time. In viewing it, the European can push the exotic subject back into a historical fantasy of a frozen past, where it becomes a precious object of Western study and salvage. The viewer can then also recall that distanced and voiceless Other back from the static past into a coextensive present, in which the living source of the scene is recognized still to exist. That Gauguin often escaped to this mediating image-world constructed by the camera suggests that he found in ethnographic photography a comforting articulation of his vision of Tahiti as it should have been.

In tracing the role of photography in Gauguin's work, we discover the rich intersection of modernist primitivism with the photographic repertoire of the fin de siècle. The commercial art reproduction opened an array of world art to Gauguin's symbolist imagination. The imagery of modern colonial photography, which Gauguin discovered on his arrival in Papeete, confirmed the Tahiti of his fantasy and expectations. The medium of photography facilitated Gauguin's exoticism, at once affirming and filtering his two Tahitis: the mythic one he sought, and the modern one in which he lived and produced his art.

NOTES

This essay derives from research for my book: Childs, *In Search of Paradise: Painting and Photography in Fin-de-Siècle Tahiti* (Berkeley and Los Angeles: University of California Press, forthcoming). Some of the research was conducted under the auspices of a grant from the Florence Gould Foundation, administered by the Department of Art, Princeton University.

1. For an interdisciplinary approach to primitivism, see Elazar Barkan and Ronald Bush, *Prehistories of the Future: The Primitivist Project and the Culture of Modernism* (Stanford, Calif.: Stanford University Press, 1995), esp. the introduction.

2. Paul Gauguin, *Oviri, écrits d'un sauvage,* ed. Daniel Guérin (Paris: Gallimard, 1974), p. 158.

3. Ibid., p. 158.

4. Ibid., p. 174.

5. Quoted in Sophie Monneret, *L'Impressionisme et son époque* (Paris: Robert Laffont, 1987), n.p.

6. On documentary photography of works of art, see Mary Bergstein, "Lonely Aphrodites: On the Documentary Photography of Sculpture," *Art Bulletin* 74, no. 3 (September 1992): 475–98.

7. Gauguin, *Oviri,* pp. 178 and 11.

8. On fin-de-siècle exoticism in the context of imperialism, see Chris Bongie, *Exotic Memories: Literature, Colonialism, and the Fin de Siècle* (Stanford, Calif.: Stanford University Press, 1991), chap. 1.

9. On the relationship between photography and the discourses of modernism and progress, see Mary Warner Marien, *Photography and Its Critics: A Cultural History, 1839–1900* (New York: Cambridge University Press, 1997), chap. 2.

10. On Gauguin's art collection, see Merete Bodelsen, "Gauguin the Collector," *Burlington Magazine* 112, no. 810 (September 1970): 590–615.

11. Gauguin collected some photographs by the Papeete photographer Charles Spitz on his first trip to Tahiti. Gauguin met Henri Lemasson and Jules Agostini, two amateur French colonial photographers, on his return to Tahiti in 1895. They traveled together to Bora-Bora and around Tahiti itself (Henri Lemasson, "La Vie de Gauguin à Tahiti," *Encyclopédie de la France et d'outremer* [February 1950]: 19). After moving to the Marquesas in 1901, Gauguin befriended a colonial photographer, Louis Grelet, who lived in Fatu Hiva. Grelet took many photographs of the artist at work in his studio-home, but these were lost in a shipwreck (Bengt Danielsson, oral communication, 1991).

12. Gauguin to Redon, as quoted in Richard Brettell et al., *The Art of Paul Gauguin* (Washington, D.C.: National Gallery of Art, 1988), p. 214.

13. Letter to Charles Morice, 1890, quoted in ibid., p. 60.

14. Bongie, *Exotic Memories,* p. 22.

15. Gauguin to Bernard, 1890, letter in Maurice Malingue, ed., *Paul Gauguin: Letters to His Wife and Friends,* trans. Henry Stenning (Cleveland: World Publishing Company, 1949), p. 139, no. 102.

16. Louis Gonse, "L'Histoire retrospective du travail," in *Revue de l'Exposition universelle de 1889* (Paris: Librairie d'Art, 1889), p. 124.

17. See *L'Illustration,* August 13, 1889, p. 171.

18. See Douglas W. Druick and Peter Zegers, "Le Kampong et la pagode: Gauguin à l'exposition universelle de 1889," in *Gauguin: Actes du colloque Gauguin, Musée d'Orsay 11–13 janvier 1989* (Paris: Ecole du Louvre, 1991), pp. 101–42.

19. Letter of March 1889, in Malingue, ed., *Paul Gauguin: Letters to His Wife and Friends,* p. 118, no. 81.

20. See Richard Field, "Plagiaire ou créateur?" in *Paul Gauguin: Génies et réalités* (Paris: Editions du Chêne, 1986), pp. 115–30.

21. See Jehanne Teilhet-Fisk, *Paradise Reviewed: An Interpretation of Gauguin's Polynesian Symbolism,* Studies in the Fine Arts, The Avant-Garde, no. 31 (Ann Arbor, Mich.: UMI Research Press, 1983).

22. James Clifford, "Power and Dialogue in Ethnography," in *The Predicament of Culture: Twentieth-Century Ethnography, Literature, and Art* (Cambridge, Mass.: Harvard University Press, 1988), p. 79.

23. He probably acquired these photographs in Port-Said at the Suez Canal, on his return to Tahiti in 1895. See Gauguin, *Oviri,* p. 316.

24. While it is impossible to determine which particular photographs Gauguin bought in Port-Said in Egypt, the genre of quasi-pornography that he acquired is reproduced in Malek Alloula, *The Colonial Harem,* trans. Myran Godzich and Wlad Godzich (Minneapolis: University of Minnesota Press, 1986).

25. See Chelsea Miller Goin, "Malinowski's Ethnographic Photography: Image, Text, and Authority," *History of Photography* 21, no. 1 (spring 1977): 67–73, esp. 67.

26. Letter 31, February 1898, *The Letters of Paul Gauguin to Georges-Daniel de Monfreid,* trans. Ruth Peilkovo (New York: Dodd, Mead and Co., 1922), p. 95.

27. Unpublished Gauguin letter, quoted by Théophile Briant in *Le Goeland,* March 1, 1938.

28. I follow here the identification of these two figures in a related drawing, as discussed by Teilhet-Fisk, *Paradise Reviewed,* pp. 58–59 and ill. 20.

29. Henry Adams, in Worthington Ford, ed., *The Letters of Henry Adams* (New York: Houghton Mifflin, 1930), pp. 466–67.

30. See Nicholas Thomas, "Partial Texts: Representation, Colonialism, and Agency in Pacific History," *Journal of Pacific History* (Canberra) 25, no. 2 (December 1990): 139–58.

31. The negative was made by 1887; an albumen print from it is preserved in the album compiled in that year by R. Gallop (collection, State Library of New South Wales, Sydney).

32. A discussion of Gauguin's writings and paintings in the context of the homosexuality of the Tahitian *mahu* is developed by Stephen Eisenman, *Gauguin's Skirt* (London: Thames and Hudson, 1997), chap. 2.

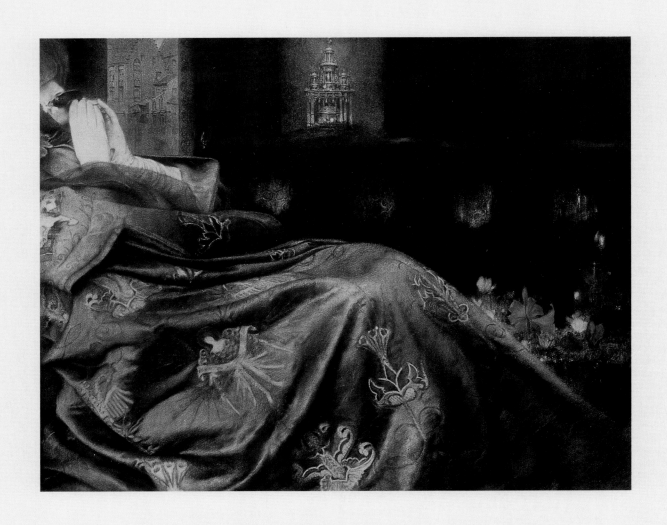

# Fernand Khnopff

NEAR TERMONDE, BELGIUM 1858—1921 BRUSSELS

Khnopff's wealthy family moved to Brussels at the end of 1864. He abandoned the study of law for art, having already become enamored of literature, especially the French writers Charles Baudelaire, Gustave Flaubert, and Charles-Marie-René Leconte de Lisle. Visits to Paris at the end of the 1870s acquainted him with the work of Delacroix, Ingres, Rembrandt, Rubens, and the masters of the Venetian Renaissance. Also in Paris, at the Exposition Universelle of 1878, he discovered the work of the British Pre-Raphaelite artists and of Alfred Stevens and Gustave Moreau. Quitting the Belgian Académie des Beaux-Arts in 1879, Khnopff began his career with a ceiling commission and showings at various venues in Brussels, to generally lukewarm reviews. In October 1883 he was a founding member of Les XX, an international, progressive artists' group that held exhibitions and sponsored lectures until its dissolution in 1893. His paintings, often with a subject taken from literature or inspired by music, have a dream-like, static quality, as if the figures have been frozen in place. This quality also characterizes his portraits of Brussels' high society. His literary interests intensified, and he entered the circle of the symbolist writers Joséphin Péladan, Georges Rodenbach, and Emile Verhaeren. Fluent in English, Khnopff exhibited in London at the prestigious New and Grafton galleries, wrote for the London-based journal *The Studio* (1894–1914), and in the 1890s became close friends with Edward Burne-Jones, George Watts, Frederic, Lord Leighton, William Holman Hunt, and Dante Gabriel Rossetti. In addition to using photographs, he experimented with polychrome sculpture. His work was seen widely throughout Europe, from London to Munich and Vienna. In 1900 he designed a house for himself that was to be "a votive chapel of a personal and complex aesthetic." After the turn of the century Khnopff exhibited widely and continued to write and lecture prolifically.

Cat. 153 Fernand Khnopff, *In the Past (D'autrefois)*, 1905, vintage print with pastel on paper, 8⅜ × 11⅛ in., Musées Royaux des Beaux-Arts de Belgique, Brussels

*Dorothy Kosinski*

# The Gaze of Fernand Khnopff

The gaze—looking, being seen, not being seen, sight obscured, direct glance, indirect perception —dominates Fernand Khnopff's work, indeed, simultaneously constitutes theme and form, process and substance.[1] Khnopff's iconography repeatedly includes mirrors; mirroring surfaces of water; reflected objects; windows; riveted, staring eyes; veiled eyes; or averted eyes. He chooses, moreover, for many of his works a round or ocular, specular format. The eye of the photographic apparatus, too, reveals itself as a crucial, even defining, device. His work is a contemplation of the ontology of image making, an effort to define the role of perception and the visual arts between essence and phenomenon.

Khnopff's self-consciousness or self-scrutiny is consonant with the essence of the symbolist idealist aesthetic, embracing a Neoplatonic (or Schopenhauerian) model by which the work of art reveals in its pure forms a higher reality.[2] For many artists of his generation, and certainly for Khnopff, this ideal often emerged in the context of mysticism, occultism, or Wagnerism—that is, spheres of interest that carried specific iconographic contexts. However, just as Symbolism cannot be defined stylistically, so it transcends themes and subject matter. Symbolism is the communication of a higher reality through the intrinsic expressive vocabulary of the art form.

A direct, penetrating, even unsettling gaze literally fills many of Khnopff's works. In *The Blue Curtain* (fig. 81), for instance, the face is radically cropped by the edges of the composition. The visage is further obscured by the superimposition of strips of brilliant blue and black material at the left and right edges, veiling much of the face. These vertical stripes emphasize the geometry of the highly idealized face—the emphatically vertical

Fig. 80 (opposite) Unknown, *Fernand Khnopff in Front of His "Altar,"* photograph, Musées Royaux des Beaux-Arts de Belgique, Archives de l'Art contemporain, Brussels

Fig. 81 Fernand Khnopff, *The Blue Curtain,* 1909, colored pencil and pastel on paper, Private Collection, Brussels

nose, the horizontal "bands" of eyes and thin, pre-
cise lips, the neck swathed in black, the gray bodice
below. One eye is veiled, rendered inert, mysteri-
ously withdrawn. The revealed eye, wide open, is,
in contrast, bright, glistening, even alarming in its
clarity. It fixes (like a nail) the patterns of flat geo-
metric areas and seems to pierce (like an arrow)
the subtle flatness of the soft pastel surface.

The glistening orb of this aggressive eye is
placed at the very top edge of the drawing, alert-
ing us to a pictorial device greatly favored by
Khnopff. He audaciously manipulates the edges
of his composition. Frequently, the figure is trun-
cated by the image's edges, to be seen only as a
fragment (fig. 82). This concerted fragmenting of
the figure seems to draw on the cropping of casual
photography and serves to dramatize the subject.
In Khnopff's case, because of his obsessive the-
matization of the eye(s), the cropping is a means
to intensify the gaze.

Khnopff also relegates his subject to the very
edges of the work, thereby embracing a void as the
dominant aspect of the composition. In *Nevermore*
(cat. 150), for example, the female figure—heavily
draped, with wreathed head—is pushed to the left
side of the roundel, her body leaning against an
ornately decorated vertical fragment, her right
arm draped along the bottom edge of the roundel.
The figure is pushed to the edges, granting the
most area to a near emptiness here adorned with
a tenuously inscribed quotation from Edgar Allan
Poe, "Nevermore." This void is the manifestation
of the "nonvision" of the woman's closed eyes, the
nonmanifestation of her inner world, of thoughts
and dreams not revealed. The lens of Khnopff's
observation is turned on a subject that defies de-
piction. *Marguerite Posing with Her Hands Covering
Her Face* (cat. 143) may be taken as an inverse cor-
ollary of *Nevermore.* Here, although the wreathed
and draped woman is posed at the center of the

round composition, her hands obscure her face
and especially her gaze, thereby effectively obviat-
ing the subject. The thematic heart of the compo-
sition is, with this gesture, rendered void.

This interaction of edges and void is central,
too, to the dramatically hieratic gesture of draped
female and mask in the *Secret* (cat. 152), and espe-
cially in the preparatory drawn and photographic
studies for it (cat. 151). The mask (a frequent prop
in Khnopff's world) is suspended at left, while
the somber priestess sits at right. Her bare arm
reaches across a void at the center of the compo-
sition, a physical manifestation of the magnetic
tension between the female (her head separated
from her body by a dramatic swath of black cloth)
and her near-double in the inert mask.

Khnopff rendered overt this mirrorlike con-
frontation when he atypically framed *Secret* to-
gether with *Reflection,* of about 1902 (fig. 83).[3] The
juxtaposition of figure and landscape, of round
and horizontal formats is startling. Common to
both images is the dramatic mirroring, especially
the line between the two. *Secret-Reflection* is an
almost programmatic exploration of image/repre-
sentation, mirror/reflection. In the tondo framed
at top, the artist's sister, Marguerite, the priestess
of the artist's realm, is "reflected" in the mask
modeled after her own face. In the work framed
beneath, the back of the Hospital of St. Jean in
Bruges is reflected in the mirrorlike surface of the
canal. A photograph was the intermediary be-
tween reality and representation of both images.
"Reality" had, in each case, already been qualified:
Khnopff's private atelier-theater was the stage for
the *Secret;* Khnopff's memory, the Belgian poet
Georges Rodenbach's famous text, *Bruges-la-Morte,*
and photographic illustrations by the Belgian
photographer E. Neurdein were the mirrors of the
*Reflection* of Bruges. The gesture of the gloved
hand toward the lips of the mask in one picture
and, in the other, the cropping of the edifices,
allowing the water to fill and muffle the composi-
tion, are synaesthetic devices, hermetic symbols
of silence and mystery.

In a body of work dominated by mirrors and
mirroring, there are remarkably few actual por-
traits and a specifically noteworthy absence of self-
portraits.[4] The absence of "self" as image-subject
contrasts at least superficially with Khnopff's
motto inscribed on an art altar that he designed
for his aesthetic temple-home: "On ne a que soi"
(One has only oneself) (fig. 80). The coolly ideal-
ized, staring androgynous visage that dominates
his oeuvre is often depicted close to mirrors, ca-
ressing, cheek to cheek, a face almost indistin-
guishable from its own. The significance of the
androgyne may be sought in the artist's own bi-
sexuality or as an expression of the symbolist
idealistic aesthetic.[5] The author-painter absents
himself from his narcissistic mirror, which reflects

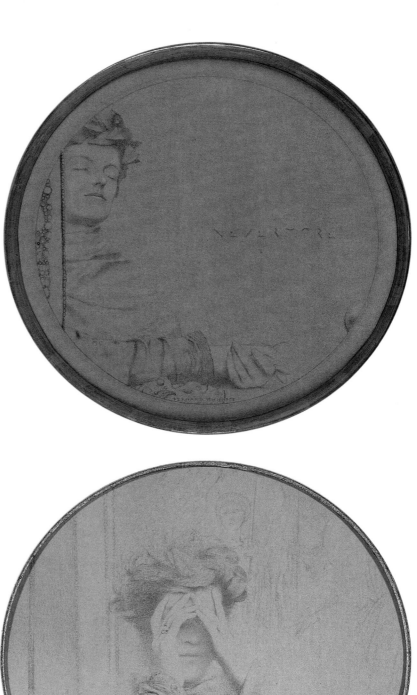

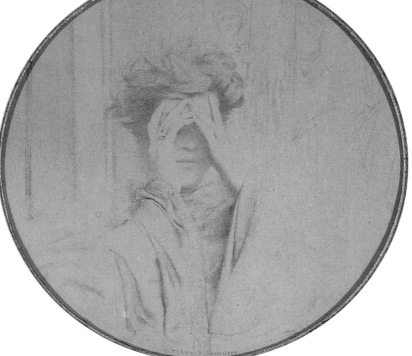

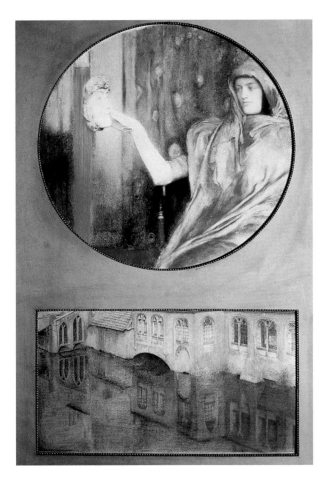

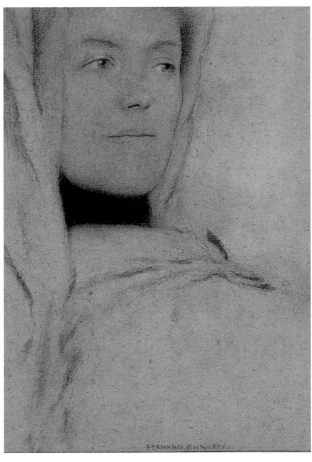

Fig. 83 Fernand Khnopff,
*Secret-Reflection,* c. 1902, pastel
on paper, colored pencil on
paper, Groeningemuseum,
Stedelijk Museum voor
Schone Kunsten, Bruges

Cat. 154 Fernand Khnopff,
*The Black Collar (Le Col Noir),*
c. 1906, charcoal and pastel on
cardboard, 13⅜ × 10⅛ in.,
Courtesy of Patrick Derom
Gallery, Brussels

instead his androgynous avatar-ideal. This eradi-
cation of self from the work of art brings to mind
Stéphane Mallarmé's dictum (Mallarmé was
Khnopff's favorite poet) concerning the silencing
of the poet's voice: "The pure work of art implies
the elocutionary disappearances of the poet who
cedes initiative to words, through the friction of
their mobilized inequality; they are illuminated by
reciprocal reflections like a virtual train of flames
or gems, replacing the perceptible respiration of
ancient lyric genius or the personal enthusiasm
that directs the phrase."[6]

The works depicting Khnopff's sister, Mar-
guerite, could only be inaccurately described as
portraits, and can perhaps best be characterized as
another form of the absent self. She is costumed,
posed, transformed into the actress on Khnopff's
personal stage, performing the ritual acts at the
direction of the artist-hierophant (cats. 146, 147).
These tableaux vivants were subsequently photo-
graphed, either by Khnopff himself or under his
supervision, and the photographic prints later
became the basis for other works.[7] In this way the
artifice of the stage is compounded by the inter-
jection of an additional level of unreality—the
photograph—between representation and reality.[8]
Khnopff (perhaps inspired by Schopenhauer)
suggests that no reality exists—merely representa-
tion. The photograph protects Khnopff from the

subject matter of his own contrivance and allows
him to reappropriate and reassemble "reality," no
matter how fictive, into an aesthetic realm of meta-
physics. In perhaps his most audacious manipula-
tion of photography, *Memories* (cat. 148; fig. 84),[9]
in which Marguerite is seven times depicted in
the guise of a tennis player, the medium allows
him a multiplication that is neither spatially nor
temporally successive and certainly not narrative,
but rather a simultaneous juxtaposition of distinct,
not contradictory, *perçus.* Khnopff makes no effort
(even while altering the setting of the figures) to
smooth out the edges between them and seems to
exploit the "fatality" of the photograph, as explored
by Roland Barthes in his *Camera Lucida.*[10]

This pastiche technique, especially when it
involves photographic images, may provide a
clue to the mysterious background of *I Lock the
Door upon Myself* (fig. 85),[11] an elusive environment
of flat rectangular screens and circular mirrors-
apertures, all secured by a vague geometry of
frames or edges. These illogically unrelated pas-
sages, each with distinct spatial definition and
texture, defy attempts to recompose them into a
logical-readable arrangement of walls, mirrors,
doors, windows, and so forth. The juxtaposition of
the riveting stare of the Pre-Raphaelesque beauty
with the spatially ambiguous—even abstract—
passages is, in fact, a hallmark of Khnopff's work

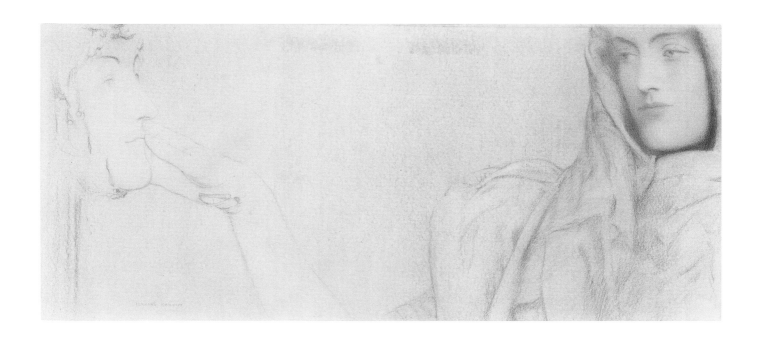

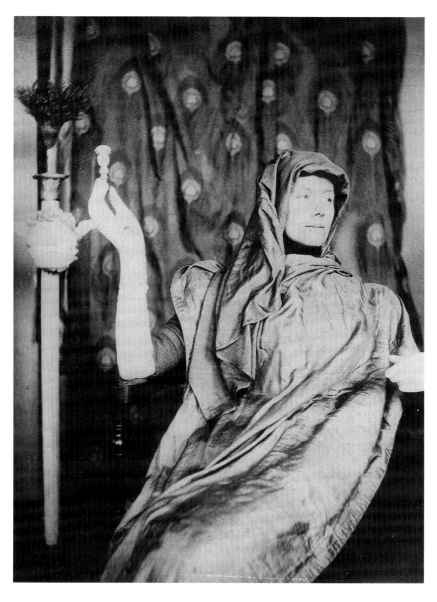

Cat. 152  Fernand Khnopff,
*Study for "Secret,"* c. 1902,
charcoal, pencil, and pastel on
paper, 6¼ × 14 in., Collection
of Peter Marino, New York

Cat. 151  Fernand Khnopff,
*Marguerite Posing for "Secret,"*
c. 1902, photograph, 9⁷⁄₁₆ ×
7³⁄₁₆ in., Musées Royaux des
Beaux-Arts de Belgique,
Brussels

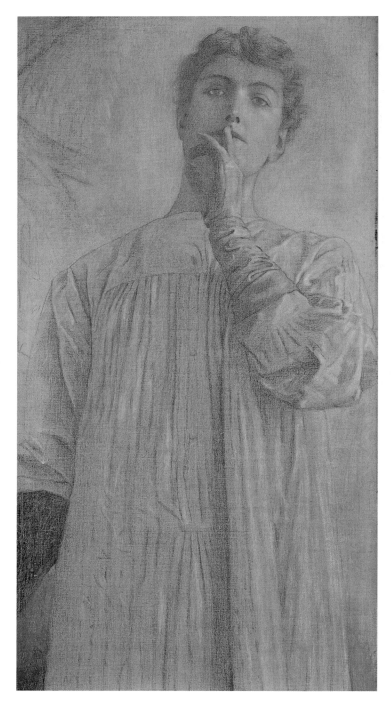

Cat. 147 Fernand Khnopff,
*Du Silence,* c. 1890, pastel on
paper, 34½ × 17⅜ in., Musées
Royaux des Beaux-Arts de
Belgique, Brussels

Cat. 146 Fernand Khnopff,
*Marguerite Posing for "Du
Silence,"* 1890, photograph,
9⁷⁄₁₆ × 7¼ in., Musées Royaux
des Beaux-Arts de Belgique,
Brussels

generally.[12] Might not the ambiguous background
plane be compared with the vast and unreadable
screenlike background of Courbet's 1855 *Studio*—
a pastiche, therefore, of images (photographic or
otherwise) from within Khnopff's own oeuvre? If
we see this as Khnopff's painting of *his* studio, into
which he retreats and locks the door on himself
(as, in reality, he worked and lived in his aesthetic
temple on the avenue des Courses in Brussels),
then we are confronted again with the substitution
of the androgynous Other for the artist himself.
This figure's staring but inward-turned gaze is that
of the artist-Narcissus, transformed and absorbed
in the reflection that is a representation in a world
of images of his own making.

The reappropriation of images from within
his own oeuvre is most dramatic in Khnopff's
curious collaboration with the noted portrait pho-
tographer Alexandre.[13] Khnopff commissioned him
to reproduce photographically several of his works,
which he would then retouch and transform with
passages of colored pastels and chalks and grace
with his own signature (cats. 145, 149). The con-
cept of the original work of art is dramatically
called into question as Khnopff allows its multi-
plication through mechanical reproduction and
its subsequent reanimation or rebirth at his own
hand, emphasizing the almost indistinguishable
character of the passages of pastel and the surface
of the platinum print.[14] As he confronts his own
work of art a second time, he multiplies and con-
fuses his roles as observer, conceptualist, inter-
preter, image maker. Khnopff, consistent with the
contemporaneous polemic about the unacceptabil-

ity of photography as an art form, fiercely dismissed the importance of photography in his art.[15] But perhaps this dissimulation was inspired less by an unwillingness on his part to admit to having availed himself of this modern device than by the necessity of maintaining the purity of the metaphysical work (as Mallarmé had intoned) of mystery, suggestion, and impenetrability. It may seem ironic to find photography, normally associated with realism, associated here with the mystical attitude articulated with characteristic theatricality by the Rosicrucian Sâr Péladan: "Artist you are Priest!" The initiate does not, however, unveil the hermetic truth. The alchemist similarly will not reveal the secrets of his laboratory-darkroom. Khnopff shields himself from our gaze and will not allow himself to be seen looking—a gesture essential to the ontological purity of picture making.[16]

Neurdein's photographs that accompanied the 1892 edition of Georges Rodenbach's novel *Bruges-la-Morte* functioned as far more than mere aides-mémoire for Khnopff's finely detailed depictions of the city (fig. 87) (an environment he had not seen since his sojourn there as a child). Rather, they, along with Rodenbach's text, are crucial to Khnopff's probing examination of reality and representation.[17] Khnopff's depictions are based on his "memories" or mental images brought into focus by the photographs, themselves positive prints of negative images that were reflections of the phenomenon of the cityscape, a city in itself a

Cat. 148  Fernand Khnopff, *Marguerite Posing for One of the Tennis Players*, c. 1890, photograph, 9⅜ × 4¼ in., Musées Royaux des Beaux-Arts de Belgique, Brussels

Fig. 84  Fernand Khnopff, *Memories*, 1889, pastel on paper on canvas, Musées Royaux des Beaux-Arts de Belgique, Brussels

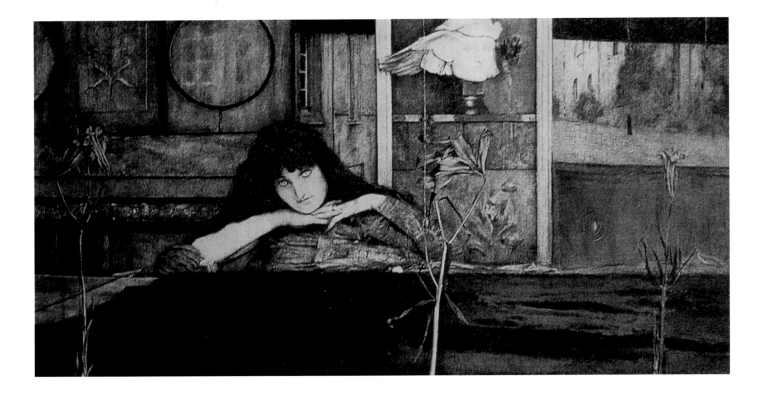

construction, artificially protected from modernization. "Reality" becomes as impalpable or elusive as the mosaic of gently undulating reflections in Khnopff's depictions, and Bruges exists only as a reflection in Khnopff's looking-glass construction of representations.

In Rodenbach's novel, mirrors and mirroring —elaborate descriptions of the canals and reflective pools of the city; looking glasses; spy mirrors; and, most important, the central uncanny, mirror-like resemblance of the female characters—are at once motif, theme, symbol, and structure. The very structure of the book has been likened to a diptych whose "hinge" is the resemblance between the protagonist Hugue's dead wife, "La Morte," and her double, the dancer-actress Jane Scott. Between the two mirroring leafs of the diptych, the widower's mourning becomes obsession; the wife's death is transformed into her double's murder; Ophelia— La Morte is transformed into Medusa—Jane Scott the Femme Fatale.[18] It is Rodenbach's mirror structure rather than the facile plot about grief, obsession, and murder that is pertinent here and that would have fascinated Khnopff. His frontispiece for the 1892 edition (fig. 86) captures the central theme and mythic core of the book (what Gaston Bachelard called the "Ophélisation of an entire city"[19])—the total identification of Bruges and the dead wife, "La Morte"—and yet is inconsequential in the context of the important body of his depictions of Bruges. The somber aura of Rodenbach's

Bruges surely corresponded to Khnopff's own melancholic reverie. But more significant was Rodenbach's fusion of subject and structure, which mirrored Khnopff's own search for symbolic form in structure.

The real secret of these highly introverted, self-reflective images is, however, the absence of the artist from his own narcissistic mirror (his art about art making), his obfuscation of self (with the substitution of the androgynous Other) and of process (his engagement with photography, for instance), shielded from our gaze. This tension, which transcends any specific iconographic program, is invested instead in the form and substance of the work of art. The iconographic cedes to images of intrinsic symbolic significance. Khnopff's self-conscious contemplation of his own creative process finds mythic expression in the gaze of Narcissus (and, it would seem, of Orpheus), and yet the allegorical figure (like Khnopff himself) does not appear. Khnopff's work is symbolist in its move from metaphor to metonymy. He gazes into the mirror (his art) with an intensity by which the image of self is totally absorbed or made invisible —Mallarmé's metaphysician-poet's elocutionary disappearance; or Maurice Blanchot's gaze of Orpheus,[20] simultaneous inspiration and self-destruction in the creative act; or the Marcusian-Freudian oceanic oneness with the libidinous subject—moving ambiguously among reality, reflection, and representation.[21]

Fig. 87  Fernand Khnopff,
*Memories of Bruges, Entrance
to the Beguinage,* 1904, pastel
on paper, The Hearn Family
Trust, New York

Fig. 86  Fernand Khnopff,
*Bruges-la-Morte,* 1892, pencil
and ink on cardboard, Private
Collection, frontispiece for
Georges Rodenbach, *Bruges-
la-Morte* (Paris, 1892)

Cat. 145  Fernand Khnopff,
*With Verhaeren. An Angel,*
c. 1889, vintage photograph,
10 × 5⅞ in., Musées Royaux
des Beaux-Arts de Belgique,
Brussels

Cat. 149  Fernand Khnopff,
*Head of a Young English Girl,*
1898, hand-colored photo-
graph, 11¼ × 9 in., Ronny Van
de Velde, Antwerp, Belgium

## NOTES

1. This essay is in large part a reprint of an essay published in *Source* 11, *Essays in Honor of Gert Schiff* (spring–summer 1992): 26–33.

2. Concerning Schopenhauer and Khnopff, see Reinhold Heller, "The Art Work as Symbol," in *Fernand Khnopff and the Belgian Avant-Garde* (New York: Barry Friedman, 1983), pp. 10–15; Françine-Claire Legrand, *Le Symbolisme en Belgique* (Brussels: Laconti, 1971), pp. 74–75. Robert L. Delevoy, "Rêve, mort, et volupté," in *Fernand Khnopff*, with catalogue raisonné by Catherine de Croës and Gisèle Ollinger-Zinque (Brussels: Editions Lebeer-Hossmann, 1979), deals creatively with many of the essential issues of Khnopff's oeuvre, including the role of photography. See also Delevoy, *Symbolists and Symbolism* (Geneva: Editions Skira, 1978), pp. 173–75. The basic and thorough monographic analysis of Khnopff is J. W. Howe, *The Symbolist Art of Fernand Khnopff* (Ann Arbor, Mich.: UMI Research Press, 1982).

3. de Croës and Ollinger-Zinque, catalogue raisonné, p. 333, nos. 378a, 378b.

4. One notes the relatively minor self-portraits: ibid., nos. 8, 18, 46, 144, 469, 597, 598.

5. See Delevoy, "Rêve, mort, et volupté," pp. 157–94; William Olander, "Fernand Khnopff; 'Art or the Caresses,'" *Arts* (June 1977): 126–31; Françine-Claire Legrand, "Das Androgyne und der Symbolismus," in *Androgyn-Sehnsucht nach Vollkommenheit* (Berlin: Neuer Berliner Kunstverein, 1986), pp. 75–112; Dorothy Kosinski, *Orpheus in Nineteenth-Century Symbolism* (Ann Arbor, Mich., and London: UMI Research Press, 1989), pp. 49–73.

6. Stéphane Mallarmé, "Variations sur un sujet," in *Oeuvres complètes* (Paris: Pléiade, Galllimard, 1945), p. 366; first published in *La Revue Blanche* (1985). Douglas Crimp explores the relevance of Mallarméan vocabulary to the eradication of self in the famous photograph by Degas of Mallarmé, his family, and Renoir (1895) in "Positive-Negative—a Note on Degas' Photographs," *October* 5 (summer 1978): 89–100.

7. Charles de Maeyer, "Fernand Khnopff et ses modèles," *Bulletin des Musées Royaux des Beaux-Arts de Belgique* 1–2 (1964): 43–55; Delevoy, "Rêve, mort, et volupté," pp. 118–39; Gisèlle Ollinger-Zinque, "Fernand Khnopff et la photographie," in *Art et Photographie/Kunst en Camera* (Brussels: Europalia 80/Belgique 150, 1980), pp. 19–23; Günter Metken, "Khnopffs Modernität," in *Fernand Khnopff, 1858–1921* (Hamburg: Kunsthalle, 1980), pp. 33–47, esp. 44–47.

8. In Roland Barthes, *Camera Lucida,* trans. Richard Howard (New York: Farrar, Straus & Giroux, 1981), pp. 31–32, death constitutes the connection between photography and theater. "Photography is a kind of primitive theater, a kind of *Tableau Vivant,* a figuration of the motionless and made-up face beneath which we see the dead."

9. de Croës and Ollinger-Zinque, no. 131, pp. 248–49; Howe, *Symbolist Art of Fernand Khnopff,* pp. 79 ff.; L. D. Morrissey, "Exploration of Symbolic States of Mind in Fernand Khnopff's Work of the 1880s," *Arts* (February 1979): 88–92.

10. See Barthes, *Camera Lucida,* concerning the "fatality of the photograph" (p. 6), its "ratification of what is represented"; its confrontation, "immobilization of time" (p. 91); "Photography . . . produces death while trying to preserve life" (p. 92). Delevoy, "Rêve, mort, et volupté," p. 136, discusses the role of photography in Khnopff's work, citing Maurice-Jean Lefebve, *L'Image fascinante et le surréal* (Paris: Plon, 1965), pp. 118–19, who (apparently prior to Barthes) pointed to the hallucinatory quality of the photograph, a connection between the photograph and death.

11. de Croës and Ollinger-Zinque, no. 174, pp. 263–64. See L. D. Morrissey, "Isolation of the Imagination: Fernand Khnopff's *I Lock the Door upon Myself,*" *Arts* (December 1978): 94–97; S. Burns, "A Symbolist Soulscape: Fernand Khnopff's *I Lock the Door upon Myself,*" *Arts* (January 1981): 80; Günter Metken, "In sich Vergraben—Zu einem Bild von Fernand Khnopff," in *Wunderblock—eine Geschichte der Modernen Seele* (Vienna: Wien Festwochen, 1989), pp. 433–39, esp. 438.

12. Heller, "The Art Work as Symbol" (as in n. 2), notes this characteristic of Khnopff's work.

13. Albert-Edouard Drains (1855–1925); see Ollinger-Zinque, "Fernand Khnopff et la photographie" (as in n. 7), p. 22.

14. Khnopff demonstrated an almost fetishistic attention and experimental attitude to medium. Consider, for example, his patient working of unusually large pastels.

15. Fernand Khnopff, "Is Photography among the Fine Arts?" *Magazine of Art* 23 (1899): 157 ff., and idem, "A propos de la photographie dite d'art," *Annexe aux Bulletins de la Classe des Beaux-Arts (1915–1918)* (1919): 93–99. Concerning the contemporaneous polemic about the status of photography, see Ollinger-Zinque, "Khnopff et la photographie"; see also Crimp, "Positive-Negative" (as in n. 6), 93, no. 7.

16. Barthes, *Camera Lucida,* p. 111, considers the photographic look: "How can we look without seeing? One might say that the Photograph separates attention from perception and yields up only the former." Note Khnopff's relatively traditional *Listening to Schumann* (1883; de Croës and Ollinger-Zinque, no. 52, p. 219), in which the averted gaze, eyes and face shielded by the hand to avoid seeing and to avoid being seen, is meant to enhance, one assumes, auditory concentration. The raised hand creates tension, turns us away, and allows us to hear or feel the concentrated listening (the symbolist synaesthetic ideal). The mirror on the background wall further amplifies the manipulation of looking but not seeing. See Jean Claire, *Méduse* (Paris: Gallimard, 1989), chap. 9, "L'Évidence de Narcisse," esp. p. 166, concerning the "disappearance" of the photographer and his apparatus by means of a setup of mirrors. This brings us back to Crimp's analysis of Degas's "disappearance" in his photograph of Mallarmé and Renoir (see n. 6, above).

17. These photographs were high-quality prints of delicately modulated grays, emphasizing a mysteriously silent environment of canals and medieval architecture untouched by nineteenth-century reality. There is an interesting contrast between these photographs illustrating Rodenbach's *Bruges* and those photographs from the 1850s and later that were used as a social critique of the modern urban environment (see, for example, the works of Henry Mayhew, John Thomson, Jacob Riis, Lewis Hine). Note in this regard that Rodenbach was among those who sought to protect medieval Bruges from efforts to modernize the port. See J. Howe, "Fernand Khnopff's Depiction of Bruges: Medievalism, Mysticism, and Socialism," *Arts* (December 1980): 126–31.

18. See Joyce Lowrie, "Ophelia Becomes Medusa—Reversals and Ambiguity in Georges Rodenbach's *Bruges-la-Morte,*" in *Georges Rodenbach: Critical Essays,* ed. Philip Mosley (Cranbury, N.J., London, and Mississauga, Ontario: Associated University Press, 1996).

19. Gaston Bachelard, *L'Eau et les rêves* (Paris: José Corti, 1942), p. 121.

20. Maurice Blanchot, *The Gaze of Orpheus,* preface by Geoffrey Hartman, trans. Lydia Davis (Barrytown, N.Y.: Station Hill Press, 1981).

21. Concerning Orphic or narcissistic fusion with the subject, see Kosinski, *Orpheus* (as in n. 5), pp. 200 ff. and 345 nn. 40–47. That book traces, during 1911 and 1912, the gradual disappearance of the allegorical or metaphorical image of Orpheus but the continued significance of Orphic themes in works of pure abstraction. Note p. 64, which cites Mallarmé ("Proses diverses") regarding the Orphic function of the poet. One notes in this regard Jacques Le Rider, *Modernité viennoise et crises de l'identité* (Paris: Presses Universitaires de France, 1990), esp. chap. 4, "Narcisse." See p. 90 regarding the Orphic/cosmogenic/narcissistic qualities of Jugendstil ornament. Also see Claire, *Méduse* (as in n. 16), p. 168.

# Medardo Rosso

Turin 1858–1928 Milan

Rosso was a sculptor of astonishing originality. By the time
he was expelled from the Accademia di Brera in Milan in 1883
for agitating for more liberal instruction, he had already made
important sculptures. He took his subjects from everyday life
(examples are *Unemployed Singer* and *Kiss under the Lamppost*) and ren-
dered them in a way to suggest the interaction of objects and the
surrounding atmosphere. Rosso went to Paris briefly in 1884,
but exactly what he did there cannot be documented; he may have
worked in Jules Dalou's studio and met Edgar Degas and Auguste
Rodin. In the late 1880s his sculpture was seen in exhibitions in
London, Paris, and Venice. Rosso moved to Paris in 1889 and
continued to sculpt portraits, single figures, and groups in con-
temporary settings, sometimes incorporating real objects. In
his search to replicate fleeting visual impressions in three dimen-
sions, he created an innovative medium: he dipped plaster casts
in wax, sometimes repeatedly, and added wax to the form, so that
each version of the sculpture, despite sharing the identical plas-
ter cast, was unique. He and Rodin were admirers of each other
until Rodin exhibited his *Balzac* in 1898; after Rosso detected
traces of his own work in Rodin's, the relationship grew more
distant. Rosso's sculptures were exhibited and bought for muse-
ums all over Europe (in large degree thanks to the support and
mediation of his Dutch patroness, the painter Etha Fles). Rosso
frequently exhibited photographs he had taken of his work along
with the sculptures themselves; like Constantin Brancusi, he
wanted to give the viewer the optimal visual experience. Fre-
quently hospitalized throughout his life for illnesses and treat-
ment after accidents, he died after an operation to amputate his
leg after his foot had been injured by glass photographic plates.

Cat. 191 (top left)  Medardo
Rosso, *Baby at the Breast
(Enfant au sein)*, 1889, bronze,
12⅝ × 16½ × 16⅛ in., Museo
Rosso, Barzio

Cats. 194, 193, 199, 197, 198, 195
(clockwise from top right)
Medardo Rosso/Photographer
Unknown, *Baby at the Breast*,
after 1889, vintage photo-
graph, various dimensions,
5⅜ × 7¼ to 5⅜ × 8⅜ in.,
Museo Rosso, Barzio

*Jane R. Becker*

# Medardo Rosso: Photographing
# Sculpture and Sculpting Photography

*In short, I cannot allow other photographs to be taken. I want those of mine and no others. I also believe these are the best. I don't want any others. Thank the director. . . . Also thank the photographer. But I don't want his, I want only my own.*

—Medardo Rosso

The Italian sculptor Medardo Rosso was an innovator in whatever medium he touched. Whether working in wax over plaster or in paint over photographic prints, the Milanese-trained sculptor searched beyond traditional artistic techniques. When it came to photography, Rosso had specific ends in mind. He used photography as an integral part of his working method and as a prime conveyor of the points he was trying to make about the possibilities for sculpture. Those ends grew to incorporate the use of photography as an expressive form in and of itself.

Rosso took his own photographs of his sculptures and directed others who photographed them, unlike his rival Auguste Rodin, who only did the latter. Like Rodin, though, he exhibited these photographs alongside his sculptures in public. Rosso always had a clear trajectory in mind for his work, even when frustrated along the way. His experimental techniques were sources of both satisfaction and disappointment. He fell into photography to emphasize specific elements of his sculpture; what he conveyed, finally, was an interchangeability of artistic media that startled his contemporaries.

It is difficult to determine who created many of the photographic images that remain in the collection of the private Museo Rosso in Barzio, Italy. While many have notations made in Rosso's own hand or have been altered in some peculiar

way that only he could have contemplated, others sit in files alongside them unmarked and unsigned. Most of this collection of photographs has never been published before. In her recent exhibition catalogue, Gloria Moure attributed all of the photographs that she exhibited in Santiago de Compostela as being from the hand of Rosso.[1] The truth is, though, that we cannot be so certain that all of the works in Barzio are by Rosso. In fact, in Moure's own catalogue, the Rosso scholar Luciano Caramel specifically wrote, "Contrary to what is often groundlessly asserted, it is not clear whether Rosso personally took the photographs. Thus, they should be attributed to an anonymous photographer, although it is clear that Rosso, as did Rodin, directed the photographer to prevent the betrayal of his quest, thus arranging the framing, distance and lighting."[2] A few examples by professional photographers have been mixed in with Rosso's photographs over the years. In addition, Rosso altered many photographs taken by others after they were in print form. For these reasons, it seems most expedient to refer to the entire group of photographs as being by "Rosso/Photographer unknown," that is to say, taken, directed, or altered by Rosso in collaboration with other unidentified photographers.

Although Rosso began to photograph works like his *Impressions of an Omnibus* (cat. 190) during his early period in Milan, and some works—like this one, destroyed in 1887—were known only through photographs during the sculptor's lifetime, Rosso intensified his photographic efforts in his later years. By 1889 in Paris he was using photographs of his works to promote and advertise his own cause to such major nineteenth-century figures as the naturalist writer Edmond de Goncourt.[3] It was probably because of his dissatisfaction with

159

MEDARDO ROSSO. - LA PORTINAIA.   (1883)

others' photography of his works that Rosso took
up the medium. Of photographers, Rosso wrote to
the director of the Galleria Ricci-Oddi in Piacenza,
"I have never known *worse criminals than photog-
raphers.* [They are] extremely irresponsible. . . .
Enormous enemy of seeing—because it limits—
because it is objective—Denial of our state of
mind = of the infinite. . . . Photography as an inven-
tion is a great thing—but for seeing it is the worst
evil."[4] Because he saw photography as too close to
the objective realm, Rosso was not able to leave
his prints alone. He began to alter his photographs
to promote the very subjectively chosen "optimal"
perspective from which the viewer should observe
his works.

From the different states of photographs that
Rosso either took or directed in his studio, we can
trace his interest in photography as a separate art
form. At the same time, his cropping and drawing
over photographs were specific devices adopted
not only to highlight particular viewpoints for his
sculptures but also to emphasize light and spatial
effects he sought for his sculptures. That Rosso
applied experimental techniques to photography
is not surprising, given his penchant for innova-
tion in sculptural media. He rebelled against the
traditions of statuary by using wax and plaster for
final versions of works, not just for modeling. His
use of wax over plaster was a technical advance
that picked up where ancient methods left off.[5]
Rosso was attracted to wax's fluidity, malleability,
responsiveness to the touch, and translucency in
creating effects of movement and light. He used
the substance for the first time in 1883, the year
of his expulsion from the Accademia di Brera in
Milan and a period of extreme rebellion for him.[6]
There were no immediate precedents for his use
of wax in nineteenth-century Italy. This initiation

into the use of wax occurred long before he met
Edgar Degas, his friend and a closet fellow wax
sculptor, in 1889.[7] In bronze and plaster, too,
Rosso pushed the materials to new heights of
suggestiveness with homemade "tricks" during
casting, the incorporation of chance occurrences
(such as granulation built up during the casting
process), unusual patinas, and a return to bronz-
ing, an ancient technique of patinating plasters.[8]
The use of alternative media as well as unortho-
dox modeling techniques had a long history in
this artist's oeuvre. As implied by the timing of
his initiation into wax, for Rosso experimental
techniques had associations of defiance and
independence.

In cropping, masking, abrading, and painting
or drawing over various photographs, Rosso was
literally sculpting the photographic form. The
purpose of these interventions always was to bet-
ter control the image and the way it was seen.
He cropped many of the photographs to irregular
shapes to enforce a particular point of view. For
example, *The Concierge (La Portinaia)* (cat. 177)

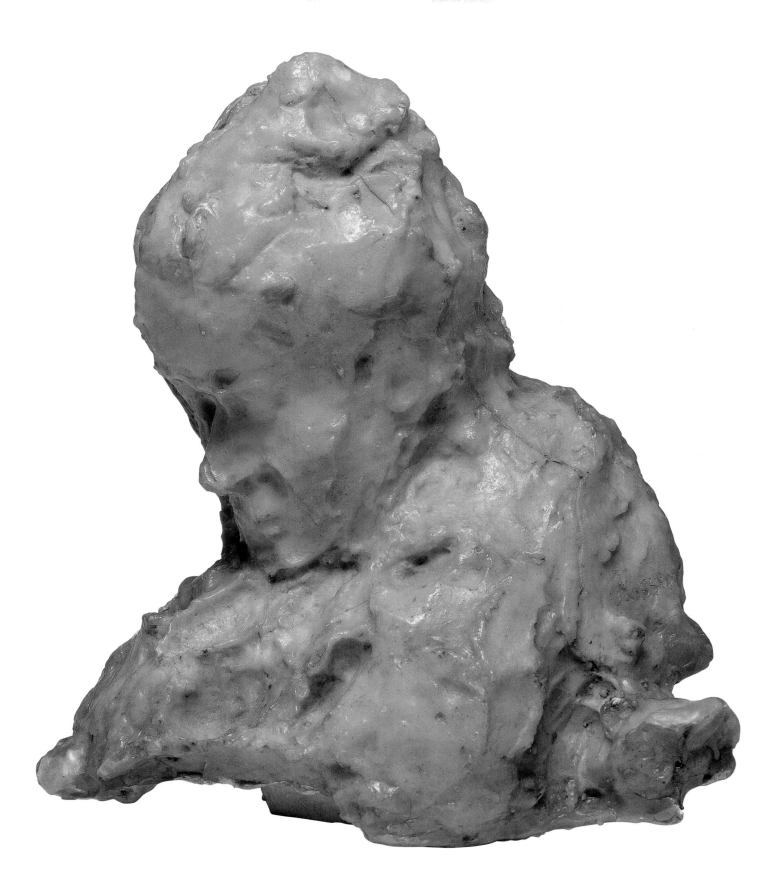

Cat. 168  Medardo Rosso,
*The Concierge (La Portinaia),*
c. 1883–84, wax over plaster,
15 × 13⅜ × 7¹⁄₁₆ in., The Patsy R.
and Raymond D. Nasher
Collection

has been slashed on a diagonal at the right side to emphasize the downturned pose of Rosso's Milanese concierge as well as the angle from which the viewer could best appreciate this work. A chunk of a photographic print of *The Golden Age* (Aetas aurea) (fig. 88), Rosso's sculpture of his wife and young child that he produced in several media, also has been snipped out at the top right. In cropping the photograph in this manner, Rosso makes the viewer focus on the diagonal on which this sculpture was composed as well as the closeness of the faces of mother and child. From the point of view that Rosso imposed, Giuditta Rosso's face appears to merge with that of her son Francesco. Similarly, the bottom left corner has been cut away in a photograph of *Impressions on a Boulevard, Lady with a Veil* (fig. 89), which, from the evidence of the curvature of the top contour of the work depicted and the placement of the lumps in the wax, appears to be an image of the wax version of this work at the Galleria d'Arte Moderna Ca' Pesaro. The angle from which the photograph was taken enforces a point of view slightly to the right and below this figure. The cropping of the photograph reinforces the artist's conception of viewing this veiled woman as a quickly glimpsed impression in the street. As Marina Vaizey has noted, Rosso wanted to suggest momentary appearance with his sculptures; therefore, he needed to control how they were seen.[9] Rosso even made these kinds of revisions to photographs after they had been published in periodicals.

Cropped photographs of the sculptor's late work *Behold the Child (Ecce Puer)* (fig. 90), whether presented frontally or slightly from the right side,

again compel the viewer to observe the image of this young boy from strictly imposed angles. These photographs are also purposefully out of focus. This effect echoes the blurred vision that Rosso promoted in the original sculptures as well.[10] In other photographs of *Ecce Puer* (cats. 156, 157; figs. 90, 91) from the 1910s and 1920s, Rosso presented the glow of light on this face as a vibrating flash. He used photography here to emphasize the fall of light on the surface of the sculpture; light seems to emanate from this apparitional face itself. The image of the eight-year-old child Alfred William Mond fleetingly peeping from behind a curtain at the people gathered in his family's London

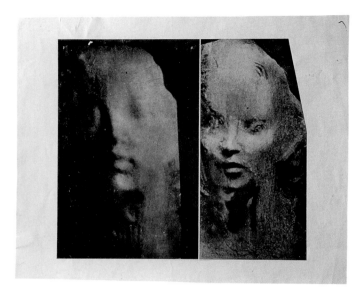

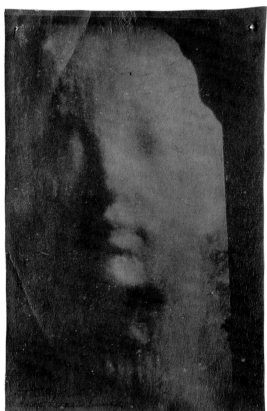

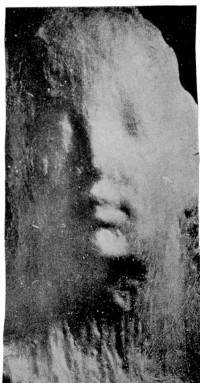

Fig. 90 (top, left) Medardo Rosso/Photographer Unknown, *Photograph of Rosso's Ecce Puer,* Museo Rosso, Barzio

Fig. 91 (top, right) Medardo Rosso/Photographer Unknown, *Photographs of Rosso's Ecce Puer,* Museo Rosso, Barzio

Cat. 156 (bottom, left) Medardo Rosso/Photographer Unknown, *Behold the Child (Ecce Puer),* n.d., vintage photograph, 5¼ × 3¼ in., Museo Rosso, Barzio

Cat. 157 (bottom, right) Medardo Rosso/Photographer Unknown, *Behold the Child,* n.d., vintage photograph, 5½ × 2¼ in., Museo Rosso, Barzio

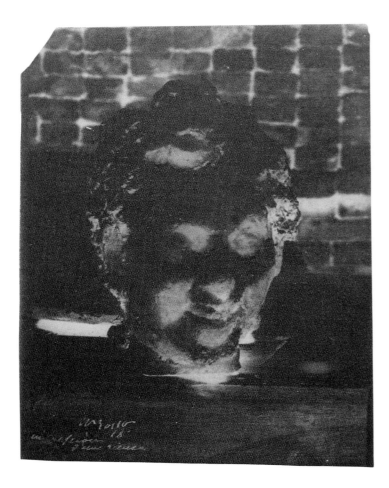

Fig. 92 (top, left) Medardo Rosso/Photographer Unknown, *Original Photographic Plate for Rosso's "Grande Rieuse,"* Museo Rosso, Barzio

Fig. 93 (top, right) Medardo Rosso/Photographer Unknown, *Original Photographic Plate for Rosso's "Bambino alle Cucine Economiche,"* Museo Rosso, Barzio

Fig. 94 (bottom, left) Medardo Rosso/Photographer Unknown, *Original Photographic Plate for Rosso's "Portrait of Henri Rouart,"* Museo Rosso, Barzio

Cat. 203 (bottom, right) Medardo Rosso/Photographer Unknown, *Laughing Woman (La Grande Rieuse),* after 1890, photograph, 5¾ × 3½ in., Museo Rosso, Barzio

drawing room captured Rosso instantaneously.[11] In the photographic version of the portrait (even more than in the original sculpture itself), boy and curtain meld into dematerialized light itself. With this kind of diaphanous presentation of his sculpture reproduced in periodicals of the period, Rosso was able to further his cause against the permanent monumentality traditionally associated with statuary.[12]

Rosso also controlled the fall of light on his photographs by masking or touching up the photographic plates, as in *Laughing Woman (La Grande Rieuse)* (fig. 92) and *Bambino alle cucine economiche* (fig. 93), where applications of a translucent pink substance guide the depth of penetration of shadows for the final print. Rosso's own signature and scrawl of notes about the work appear on the very plate reproduced as figure 92. Some of these interventions were the cause of Rosso's return to the actual sculptures for revisions.

Rosso painted and drew on some of the photographs to unite his sculptures further with the two-dimensional pictorial mode to which he had now literally transposed them. An original photographic plate for *Portrait of Henri Rouart* (fig. 94) and a photograph of the head of *La Grande Rieuse* (cat. 203; the latter again with Rosso's signature and notes) demonstrate how the sculptor manipulated the backgrounds by sketching on those areas

of the print itself. In this manner, he conveyed not only a sense of the importance of the space around the sculptures but also the literal closeness of three- and two-dimensional artistic statements.

Rosso also abraded the surfaces of some of his photographic prints to activate spatial areas and to make them equal in power to the matter they envelop. For example, in a photograph of his now destroyed life-size sculpture *Impression on the Boulevard, Paris Night* (cat. 161), the dark space between the figures has been scratched away, creating a light-toned pocket of air that is as strong compositionally as the figures themselves. Depicting three figures in the place Clichy in Paris at night, the work distinctly divided the space between two groups composed of the woman who rushes away from us at right and the couple farther in the distance at left (cat. 160). The woman at right with her head cast down moves so quickly that her mantle billows in the wind, as the train of her dress fans out on the pavement below. Beyond her, a man supports a bonneted woman as they walk slowly, his arm around her waist. Rosso very deliberately sought

an image of receding figures at night, when the square became more deserted. The space in which these figures move is doubly activated in catalogue 161; beside the effects of wind on the figures' outer garments, we see space highlighted in and of itself in a very modern vein. Matter and space interact so that the viewer can forget the material nature of each; Rosso said, "What is important for me in art is to make people forget matter."[13] The sculptor refused to consider a form without its environment, and his abrasions of spatial areas in the photographs prove this point. That Rosso aimed at a unique perspective for *Paris la nuit* is emphasized, too, in the photographs, which vary the rear viewpoint only slightly.

In all of these photographs, Rosso determined the proper distance from which the object should be viewed, and he imposed that distance on the viewer. This followed his own dictum, "My work must be looked at like a painting, from optical distance, where it recomposes itself with the collaboration of your retina."[14] The artist was painfully aware of the viewer's role, and he wished to dominate it as much as possible.

Rosso employed photography as a tool in challenging Baudelaire's diatribe from his criticism of the Salon of 1846, "Why Sculpture Is Boring." The critic accused sculpture of being vague and less controllable than painting because it exhibited too many planar sides at once. He emphasized sculpture's vulnerability to the viewer's shifting position in relationship to the work:

> It is in vain that the sculptor attempts to enforce a unique point of view; the spectator, who turns around the figure, can choose one hundred different points of view, except the correct one, and it often happens that an accident of light, an effect of a lamp, discovers a beauty that is not the one the artist had in mind, which is humiliating for the artist. A painting is only what it wants to be; there is no way of viewing it other than in its light. Painting has only one point of view; it is exclusive and despotic.[15]

Rosso directly responded to Baudelaire's summons with an assured sense of his goals for sculpture. Despite the poet's claims that sculpture could not enforce a unique point of view, Rosso made certain that his sculptures and his photographs of them did.

Photography became a part of Rosso's working method, helping him to control the viewer's place in relationship to the sculptures and allowing him a means to revisit his sculptures for later adjustments. Rosso was so fanatical about enforcing a one-point perspective for works that, when Edmond Claris visited the artist's studio in 1900, Rosso proceeded to place his visitor at the exact point in the room from which he himself had

viewed his model. Only then did he reveal the portrait that he had made of her and ask Claris for his impressions; when Claris's evocations of what he saw agreed with the sculptor's own impressions of his model, he was happy.[16] Similarly, Rosso controlled the viewing conditions for clients visiting his studio. His friend the French poet Jehan Rictus wrote in his diary in 1889:

> Rosso selling a cast to a bourgeois is astonishing to watch. It is a truly unforgettable comic scene. He takes the unfortunate Michet, he turns the guy's nose to the wall, telling him to stay in that penitent posture until he tells him to turn back around. Then, he goes to a big Norman trunk that conceals the work that he wants to sell to him. He opens a door latch, plunges in the chest, pulls out from it a morsel of green or black plush cotton accordingly, sets it out, drapes it on a wooden chest, or a stool, then quickly runs to the window, sets the atelier curtains in motion for illumination, *for* lighting. *And if the fidgety bourgeois risks opening an eye during these preparations, Rosso vehemently enjoins him not to move, this in addressing him in the familiar form: "For Christ's sake, don't turn around." Finally after a half hour of entreaties and injunctions, Rosso, having situated the wax [sculpture] that he wants to sell on the pedestal adorned with a plush cotton cloth, declares: "And now look!"*[17]

Rosso's letters to his friend the painter Carlo Carrà show that, much later, he was equally obsessive about controlling the publication of photographic reproductions of his works. In February 1926 Rosso wrote, "Dear friend please show me all photographs before publication—as we had agreed. That is, never publish them without my approval— It's important to me. . . . Anyway it avoids errors even if [made] with good will."[18] Here, the sculptor was insisting on choosing the photographs to be included in an article on him in *L'Ambrosiano*, a Milanese newspaper. The artist's need to control the viewer's relationship to his sculpture was relentless.

Rosso used photography to promote an interchange between three-dimensional and two-dimensional art. This interchange was based on the notion that making the observer forget the material in which the work was made allowed for enlightened viewing. Rosso explained, "One does not walk around a statue any more than one walks around a painting, because one does not walk around a figure to receive an impression from it. . . . If it is conceived in this way, art is indivisible. There is not the realm of painting on the one hand and that of sculpture on the other."[19] This statement of the unity of the arts was reliant on the idea of a fixed one-point perspective.[20]

As with his own painterly sculpture, his friend and rival Rodin's marble sculptures, and Rodin's great friend Eugène Carrière's monochrome sculptural paintings, Rosso chose to confuse the boundaries between the arts further by photographing his sculptures and then altering those photographs with painterly interventions. Rosso loved the fact that when Degas was presented with a photograph of Rosso's *Impressions of an Omnibus* (see cat. 190), the painter had mistaken the subject of the photograph for a painting.[21] Rosso was elated at that confusion, not because his trickery had worked, but because it reflected so well on the question of the unity of the arts, a question he held most dear. Rosso had been successful; he had made Degas "forget" the material in which the work was made.

Increasingly, Rosso turned to photography as an expressive art form. Through his methodical reliance on photography to state his case about sculpture's potential, Rosso began to see the artistic potential of the photographic medium itself. Photography became for him more than the "interpretations and meditations on [his] work, [the] diary without words, [the] visual record, [the] journal through photographic images, which lets us see through the artist's eyes his own creation," which Marina Vaizey claimed it was.[22] Photographs like those of his *Ecce Puer* (cats. 156, 157; figs. 90, 91) and *Jewish Child (Bambino Ebreo)* (cats. 221, 222, 223) helped the artist to return to his original impression of the chosen subject. They galvanized his creative impulses for new versions of the same works.

Unlike Degas or Rodin (except at the very end of his life), Rosso manipulated photography as an art form in itself. Of photography, Françoise Heilbrun noted that "the abolition of the hierarchy in the arts at the turn of the century allowed artists to legitimately explore this form of expression."[23] Rosso's sense of freedom before the various artistic media was rooted in his training in Milan at the time of the Scapigliatura and flourished in Paris, where symbolist circles embraced the cross-fertilization of the arts. The degree of liberty Rosso felt before the various media was exceedingly rare; it led him to alter completed photographic prints, creating unique works of art out of a medium conceived as reproductive. Also, unlike Degas or Alphonse Mucha, for example, Rosso never seems to have taken photographs outside the studio. This fact reinforces the idea that the artist used photography as a part of his working process and toward specific aesthetic ends. Sculpture remained his first love.

Rosso also exhibited photographs alongside his sculptures, in part to expand the works on view and in part to spite Rodin after feeling slighted by him when Rodin exhibited his *Balzac* in the Salon of 1898 (and again, after Rodin's 1900 exhibition at the place de l'Alma).[24] The Italian sculptor took the

unusual step of exhibiting photographs of Rodin's works next to his own sculptures and photographs of his own works. At the 1904 Salon d'Automne, Rosso placed photographs of Rodin's *Balzac* (1891–98), *Despair* (c. 1890), *Crouching Woman* (1880–82), and *Head of Sorrow* (by 1882) on the wall to accompany photographs of his own works and his sculptures in cases below (figs. 95, 96). He also placed a copy he had made after Michelangelo's *Madonna* next to his original works as well. On the mount for one of these prints (fig. 95), Rosso scrawled in Italian, "Confronto al Salon, Parigi," or "Confrontation at the Salon, Paris." He wanted the Salon visitor to compare and contrast the two artists' work, so that Rosso's achievements could be seen to be greater than those of Rodin. Again, in 1909, Rosso created such a photographic confrontation in pages that he designed and laid out for *Il caso Medardo Rosso* (figs. 97, 98), a book by his friend the critic Ardengo Soffici. This was a rivalry that was, to a large degree, only imagined and one-sided on Rosso's part. Rosso was so obsessed by the idea that he had been rebuffed and wronged by his former friend Rodin that he wasted valuable time in the public eye to make his point through photographic means. Here, certainly, is another extremely unusual application that Rosso made of photography.

For Rosso photography was a means to an end as well as an end in itself. Still, it did not supersede his production in sculpture. Unlike Moure,

who proclaimed photography Rosso's only successful medium—"There can be no doubt that this was the only medium in which Rosso achieved the vital effect he sought"[25]—I do not think that photography was Rosso's only successful medium. Rather, it was a powerful tool the artist used to convey the interchangeability of the arts he envisioned. Robert Taplin recently noted the photographic quality of Rosso's sculptures: "to contemporary eyes many of Rosso's works call to mind the evocative qualities of a blurred or damaged photo, mysteriously realized in three dimensions."[26] Rosso extended this tension between the two-dimensional and the three-dimensional in his later photographs of the same subjects.

Two ironies about Rosso's relationship to photography remain. Some of his greatest masterpieces in sculpture have been destroyed (most during his own lifetime), and photography has become our only way of appreciating works like his *Impressions of an Omnibus, Impression on the Boulevard, Paris Night,* and *Portrait of Dr. Fles* (fig. 99). Finally, the artist was so enamored of the photographic process that it was the cause of his death. Rosso died from complications that ensued from an accident while developing photographs. He dropped a photographic plate on his foot and had several toes and then his leg amputated when his heart gave out in 1928. Rosso never finished with his pursuit of photography. Unfortunately, it finished him.

Figs. 97, 98 (top and middle)
Medardo Rosso, *Photographic
Confrontation with Rodin and
Michelangelo,* from Ardengo
Soffici, *Il caso Medardo Rosso*
(Florence, 1909)

Fig. 99 (bottom) Medardo
Rosso/Photographer Un-
known, *Photograph of Rosso's
Portrait of Dr. Fles,* Museo
Rosso, Barzio

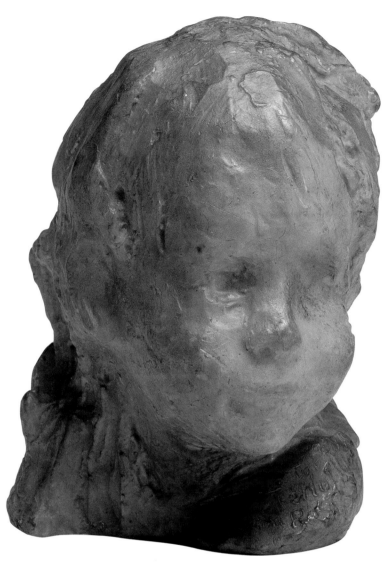

Cat. 220 (top, left) Medardo Rosso, *Jewish Child (Bambino Ebreo),* c. 1892–93 (cast 1900–1914), wax over plaster, 8⅝ × 7 × 5⅞ in., The Patsy R. and Raymond D. Nasher Collection

Cat. 222 (top, right) Medardo Rosso/Photographer Unknown, *Jewish Child,* after 1892, vintage photograph, 4⅛ × 2¼ in., Museo Rosso, Barzio

Cat. 223 (bottom, left) Medardo Rosso/Photographer Unknown, *Jewish Child,* after 1892, vintage photograph, 4 × 2⅜ in., Museo Rosso, Barzio

Cat. 221 (bottom, right) Medardo Rosso/Photographer Unknown, *Jewish Child,* after 1892, vintage photograph, irregular dimensions, c. 9½ × 6⅛ in., Museo Rosso, Barzio

Cat. 216 (left, top) Medardo Rosso/Photographer Unknown, *Child in the Sun (Bambino al sole),* after 1892, photograph, 7 × 5⅛ in., Museo Rosso, Barzio

Cats. 218, 217 (left, middle and bottom) Medardo Rosso/Photographer Unknown, *Child in the Sun,* after 1892, vintage photograph, 4⅝ × 2⅞ in. and 6¼ × 4¼ in., Museo Rosso, Barzio

Cat. 215 (right, top) Medardo Rosso/Photographer Unknown, *Child in the Sun,* after 1892, vintage photograph, 5¾ × 4⅛ in., Museo Rosso, Barzio

Cat. 214 (right, bottom) Medardo Rosso/Photographer Unknown, *Child in the Sun,* c. 1892, wax over plaster, 13¾ × 9⅜ × 7½ in., Private Collection

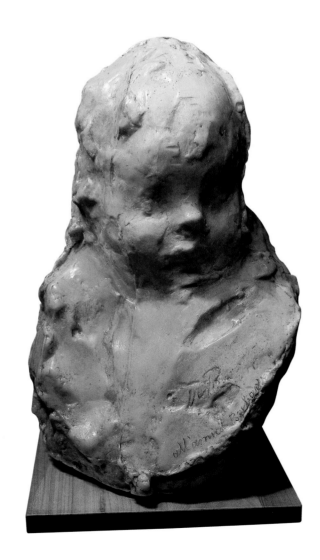

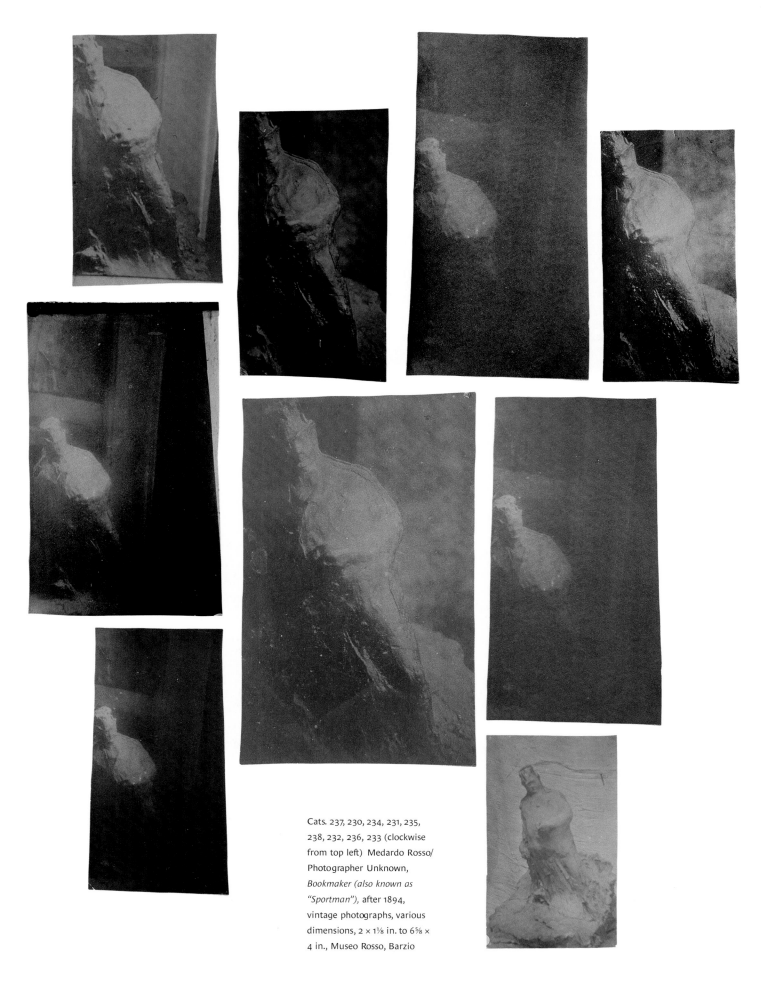

Cats. 237, 230, 234, 231, 235,
238, 232, 236, 233 (clockwise
from top left) Medardo Rosso/
Photographer Unknown,
*Bookmaker (also known as
"Sportman"),* after 1894,
vintage photographs, various
dimensions, 2 × 1⅛ in. to 6⅝ ×
4 in., Museo Rosso, Barzio

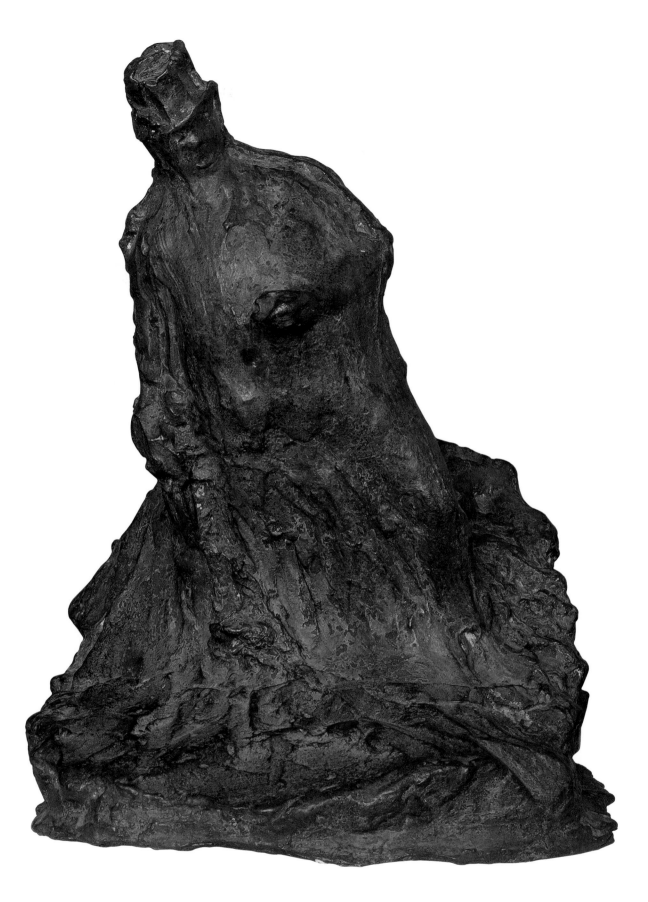

Cat. 229 Medardo Rosso,
*Bookmaker (also known as
"Sportman"),* 1894, bronze,
17⅜ in., Museum Moderner
Kunst Stiftung Ludwig, Vienna

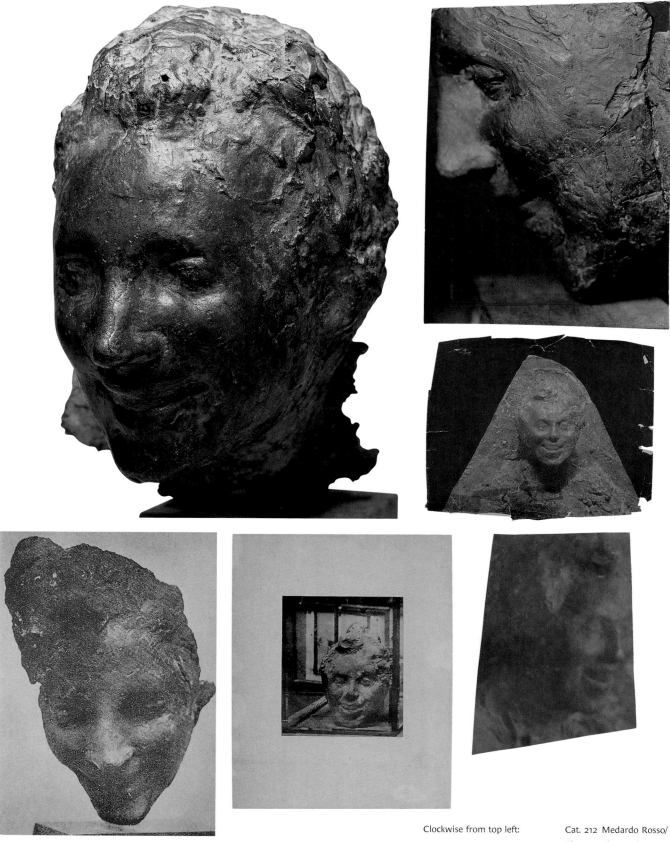

Clockwise from top left:

Cat. 200  Medardo Rosso, *Laughing Woman (La Rieuse)*, 1890, bronze with gold patina, 13½ × 10 × 11 in., Private Collection

Cat. 212  Medardo Rosso/ Photographer Unknown, *Laughing Woman (La Rieuse)*, after 1890, vintage photograph, 4¾ × 3¼ in., Museo Rosso, Barzio

## NOTES

Epigraph: Medardo Rosso, letter to Carlo Carrà, [November 1926], translated into English in Gloria Moure, ed., *Medardo Rosso* (Santiago de Compostela: Centro Galego de Arte Contemporánea, 1996), p. 299.

1. Ibid, see list of reproductions, pp. 317–25.

2. Luciano Caramel, "Identity and Current Relevance of Medardo Rosso," in ibid, p. 106.

3. See Rosso, letter to Felice Cameroni, Paris, September 20, 1889, in ibid, p. 274.

4. Rosso, letter to Ricci Oddi [director of the Galleria Ricci-Oddi in Piacenza], March 22, 1927, translated in ibid, pp. 295–96.

5. Centuries before, Romans had used beeswax to create the masks of their ancestors. In addition to ancestor portraits, wax sculptures have been used in funeral ceremonies, votive practices, and witchcraft throughout the centuries.

6. Rosso was expelled from the Accademia for leading a protest against the lack of anatomical sketching from live models and for having insulted and beaten a student who refused to sign a petition supporting his position.

7. Degas and Rosso met when Rosso exhibited at the Galerie Georges Thomas, and Degas's collector-friend Henri Rouart bought a sculpture by Rosso that Thomas had put in the window. Most of Degas's wax figurines were not discovered and cast into bronze until after his death in 1917.

8. One of Rosso's tricks during casting was to take a gold ring from his finger and throw it into the molten metal to give the bronze finer highlights. See Margaret Scolari Barr, *Medardo Rosso* (New York: The Museum of Modern Art, 1963), p. 70, n. 80.

9. Marina Vaizey, *The Artist as Photographer* (London: Sidgwick and Jackson, 1982), p. 97.

10. On Rosso's, Rodin's, and Eugène Carrière's harnessing of blurred vision, see Jane R. Becker, "'Only One Art': The Interaction of Painting and Sculpture in the Work of Medardo Rosso, Auguste Rodin, and Eugène Carrière, 1884–1906," Ph.D. diss., Institute of Fine Arts, New York University, 1998, esp. chaps. 4 and 5.

11. The sculptor had been staying with the Mond family to do the portrait, commissioned by the boy's father, Emil Mond. The one stipulation that Emil Mond had made was that the boy was not to pose for the sculptor, but that Rosso should visit the Mond home to find an appropriate moment or subject. Rosso struggled to find either. The moment he saw the boy mischievously look out from behind that curtain, he knew he had found his subject. The title of the work means "behold the boy."

12. On Rosso's use of photography to combat sculptural monumentality, see Robert Taplin, "The Fleeting Image," *Art in America* 86, no. 1 (January 1998): 71. For Rosso's views on light, see Becker, "Only One Art," chap. 2, esp. pp. 70–71.

13. Rosso, response to Edmond Claris, in Claris, *De l'impressionnisme en sculpture* (Paris: Editions de la Nouvelle Revue, 1902), p. 51. Translated in Linda Nochlin, ed., *Impressionism and Post-Impressionism, 1874–1904: Sources and Documents* (Englewood Cliffs, N.J.: Prentice-Hall, 1966), p. 78.

14. "Mon ouvrage doit être regardé comme un tableau, à la distance optique, où il se recompose avec la collaboration de votre rétine." Quoted in Louis Vauxcelles, "Medardo Rosso," preface to Rosso retrospective in *Salon d'Automne, Catalogue des Ouvrages de Peinture, Sculpture, Dessin, Gravure, Architecture et Art Décoratif* (Paris: Grand Palais des Champs-Elysées, 1929), p. 331 (my translation).

15. "C'est en vain que le sculpteur s'efforce de se mettre à un point de vue unique; le spectateur, qui tourne autour de la figure, peut choisir cent points de vue différents, excepté le bon, et il arrive souvent, ce qui est humiliant pour l'artiste, qu'un hasard de lumière, un effet de lampe, découvrent une beauté qui n'est pas celle à laquelle il avait songé. Un tableau n'est que ce qu'il veut; il n'y a pas moyen de le regarder autrement que dans son jour. La peinture n'a qu'un point de vue; elle est exclusive et despotique." Charles Baudelaire, "Pourquoi la sculpture est ennuyeuse," *Salon de 1846* (1846), reprinted in Baudelaire, *Ecrits esthétiques* (Paris: Union Générale d'Editions, 1986), p. 177 (my translation).

16. Claris, *De l'impressionnisme en sculpture,* p. 26.

17. "Rosso vendant une reproduction à un bourgeois est étonnant à voir. C'est une vrai scène de comédie inoubliable. Il prend l'infortuné Michet, il le tourne le nez dans la muraille lui enjoignant de rester dans cette posture de pénitence jusqu'à ce qu'il lui dise de se retourner. Puis il va à un grand bahut normand qui recèle l'oeuvre qu'il veut lui vendre. Il ouvre un battant de porte, plonge dans le bahut, en retire un morceau de peluche vert ou noir selon, le dispose, le drape sur une caisse en bois, ou une selle, puis vite court à la fenêtre, fait jouer les rideaux de l'atelier pour *l'éclairage, la lumière*. Et si le bourgeois inquiet risque un oeil vers ces préparatifs, Rosso véhémentement lui enjoint de ne pas bouger, ce en le tutoyant: 'Per Christo, ne te retourne pas.' Enfin après une demi-heure d'adjurations et de recommendations, Rosso ayant situé la cire qu'il veut vendre sur le piédestal orné d'une peluche déclare: 'Et maintenant régarde!'" Jehan Rictus, diary entry, May 12, 1889, quoted in Giovanni Lista, *Medardo Rosso: Destin d'un sculpteur, 1858–1928* (Paris: L'Echoppe, 1994), pp. 152–53 (my translation). Here, Rictus also captured Rosso in a typical instance of peppering his French speech with Italian.

18. Rosso, letter to Carlo Carrà, [February 1926], translated in Moure, ed., *Medardo Rosso,* p. 297.

19. Rosso, response to Claris, in Claris, translated in Nochlin, ed., *Impressionism and Post-Impressionism,* p. 79.

20. Rosso had inherited his cross-disciplinary interests from the Scapigliatura Milanese art movement, active from the 1860s until the 1880s. The idea of the unity of the arts circulated among the *scapigliati* from as early as the 1860s.

21. Camille de Sainte-Croix recounted this tale in "Medardo Rosso," *Mercure de France* (Paris) 17, no. 75 (March 1896): 391.

22. Vaizey, *The Artist as Photographer* (as in n. 9), p. 104.

23. Françoise Heilbrun, "Artists as Photographers," trans. Madonna Deverson, in *Paris in the Late Nineteenth Century* (Canberra, New South Wales: National Gallery of Australia, 1996), p. 108.

24. On the interrelations of Rosso and Rodin and on the *Balzac* affair, see Becker, "Only One Art," chap. 1.

25. Moure, "Medardo Rosso: The Contemporary Turning Point in Sculpture," in Moure, ed., *Medardo Rosso,* p. 47.

26. Taplin, "The Fleeting Image" (as in n. 12), p. 69.

---

Cat. 201 Medardo Rosso/ Photographer Unknown, *Laughing Woman (La Grande Rieuse),* after 1890, vintage photograph, 2⅜ × 8¹⁵⁄₁₆ in., Museo Rosso, Barzio

Cat. 209 Medardo Rosso/ Photographer Unknown, *Laughing Woman (La Grande Rieuse),* after 1890, vintage photograph, irregular dimensions, c. 3½ × 3⅞ in., Museo Rosso, Barzio

Cat. 204 Medardo Rosso/ Photographer Unknown, *Laughing Woman (La Grande Rieuse),* after 1890, vintage photograph, 8⅝ × 6⅝ in., Museo Rosso, Barzio

Cat. 213 Medardo Rosso/ Photographer Unknown, *Laughing Woman (La Rieuse),* after 1890, vintage photograph, 5¹⁵⁄₁₆ × 3⅝ in., Museo Rosso, Barzio

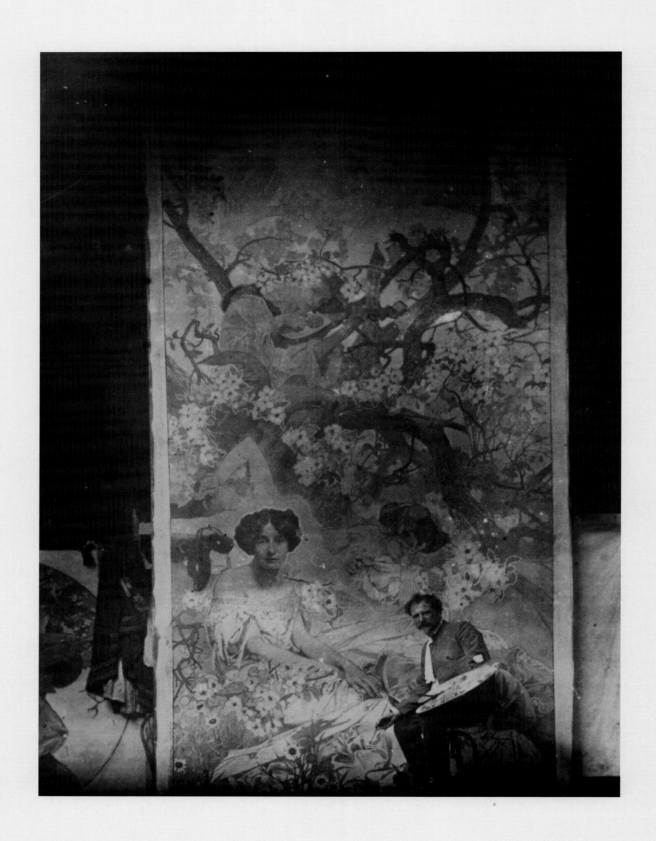

# Alphonse Mucha

IVANČICE, MORAVIA 1860–1939 PRAGUE

Cat. 277 Alphonse Mucha, *Self-Portrait with Easel in Front of "Comedy,"* New York, 1908, modern print from original glass plate negative, Mucha Trust

In 1882 Mucha met Count Khuen Belasi, who commissioned the artist to decorate his castle at Emmahof. Khuen went on to sponsor Mucha's study at the Munich Academy of Arts (1885–87) and at the Académies Julian and Colarossi in Paris (1887–89). Mucha began to work as an illustrator, creating advertising posters characterized by large-scale female figures, hypnotically flowing lines, and a sure sense of decorative backgrounds. He met and became friendly with the important figures in the Parisian art world of the 1890s, including the Nabis, Gauguin, and Rodin. He was catapulted to fame by his poster for the actress Sarah Bernhardt, depicting her in her role in the play *Gismonda,* which appeared in 1895. In 1897 he had two solo exhibitions, in Paris and Prague. An active teacher since 1892, Mucha was asked by the city of Paris to propose reforms in art education, and taught in the United States, in Chicago, New York, and Philadelphia; these American posts assured him a steady income. The commission to decorate the Bosnia-Herzogovina pavilion at the Exposition Universelle of 1900 prompted a research trip to the Balkans, where he was inspired to paint a grand cycle, *The Slav Epic.* Popular in the United States, Mucha found a patron for *The Slav Epic* in the Chicago Slavophile industrialist and philanthropist Charles Crane. Mucha also decorated theaters, designed costumes, and painted portraits in the United States. Mural work and decorative panels occupied him in Prague and New York in the first decade of the century. At the beginning of the second decade, he moved to Prague and worked on *The Slav Epic,* along with commissions for Czech postage stamps and banknotes. By 1928 *The Slav Epic* cycle was complete and given to the Czech people and the city of Prague. In 1936 Mucha was honored with a retrospective exhibition at the Jeu de Paume in Paris.

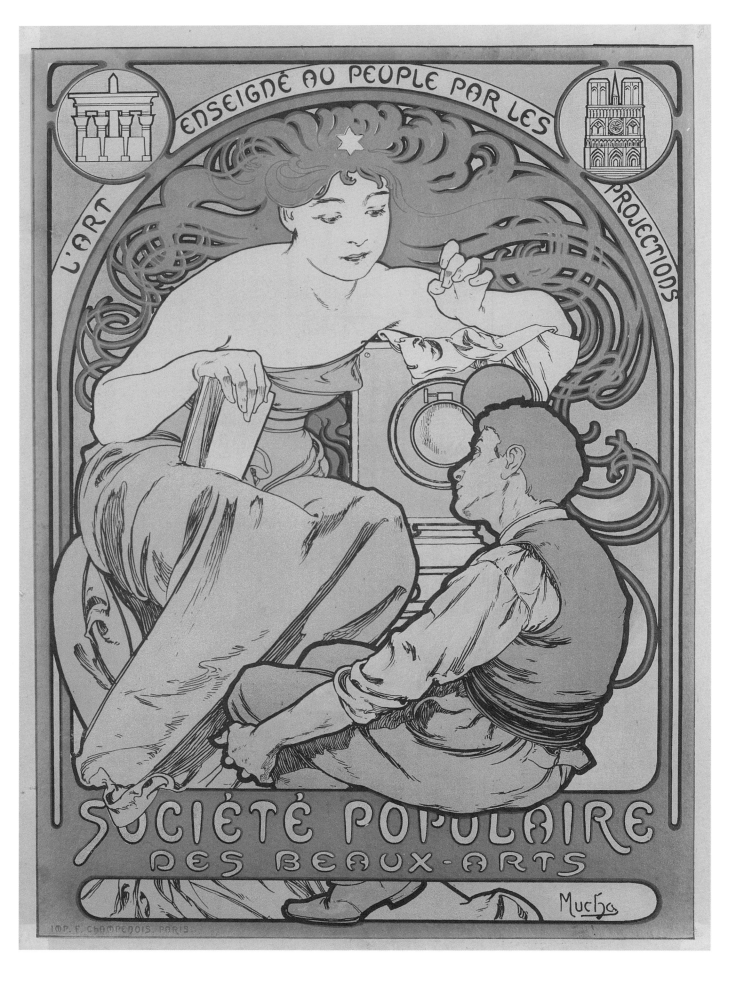

*Jack Rennert*

# Mucha and Photography

Toward the end of 1894 the reigning queen of the French stage, Sarah Bernhardt, decided to reprise one of her previous popular successes, *Gismonda,* to open at the Théâtre de la Renaissance soon after the New Year. To publicize it, she put in a rush order with her printer for a poster that had to be on all Paris billboards and street-corner kiosks by January 1.

This put the printer in a quandary. All his regular designers were taking their Christmas vacations; the only man available was Alphonse Mucha, the Czech graphic craftsman who had arrived in Paris some years before and had been steadily gaining a reputation as a conscientious book illustrator and occasional poster artist. Reluctantly, with the prestige of his shop on the line, the printer assigned the job to Mucha.

Mucha produced a striking, unusual vertical design showing the actress in a pose of regal splendor, with every detail of her richly ornate costume meticulously worked out, and a background simulating ornamental tiles. The printer was reluctant to show what he considered needless extravagance to the client, but Miss Bernhardt loved it; in fact, she immediately requested that Mucha design her future poster orders. In fact, she arranged to meet him and had him design some jewelry and costumes for her as well.

Overnight, the humble, obscure, journeyman graphic designer basking in the superstar's favors became the toast of the art world; the nascent decorative style he used, which eventually became known as Art Nouveau, was for a time known in Paris as *le style Mucha.* The artist signed a contract with the printer-agent F. Champenois and found himself immersed in an avalanche of orders for posters, calendars, and decorative panels for a variety of clients (cat. 245).

The increased workload created a problem for Mucha, an exceptionally conscientious artist who always strove for the highest level of craftsmanship. He was known to agonize for days over the exact tilt of a subject's head, the way light played on every fold of a dress, or the position of a hand. Working with models was a large expense for him, as he had them hold poses for hours while he caught every nuance.

At this crucial point, photography came to Mucha's rescue. He began to take pictures of his models, so that once he had the pose right, he could work on his image at his leisure. He had already discovered photography earlier as a young man in Vienna about 1880, but hitherto it had been just a hobby. Now, however, it became a tool of his trade, and he even set up a darkroom to develop his work.

At the end of the 1890s photography had already been around for more than sixty years. Just arriving on the market were hand-held cameras using nitrate-based film advanced by means of sprockets, and motion pictures made their appearance in the middle of the decade. Mucha, in fact, befriended the Lumière brothers, whose factory made photography products, and enthusiastically followed their pioneering foray into motion-picture projection at the end of 1895.

For the kind of pictures used by Mucha and other artists at this time, however, the preferred technique still involved gelatin and silver bromide glass negatives—and it was these as well as many contact prints made from them that constitute the bulk of Mucha's photo archive discovered by his son Jirí in the artist's estate decades later. Oddly enough, although Mucha had become in the course of his lifetime a fairly competent photographer, he apparently never came to consider

Cat. 245 Alphonse Mucha, *Société Populaire des Beaux-Arts,* 1897, color lithograph, 24¼ × 18 in., Courtesy of Posters Please, Inc.

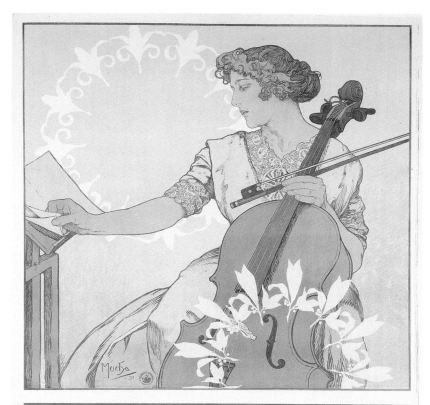

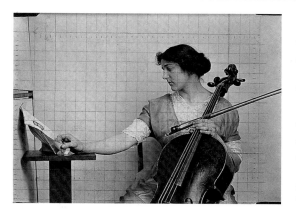

Cat. 292 Alphonse Mucha, *Zdenka Cerný*, 1913, color lithograph, 74½ × 43⅜ in., Courtesy of Posters Please, Inc.

Cat. 293 Alphonse Mucha, *Zdenka Cerný. Study for the Poster,* Chicago 1913, vintage print retouched with pencil and ink, 5⅛ × 7 in., Mucha Trust

the artistic aspect of photography and treated the pictures he took merely as a convenient tool of his craft. Most of them were found with lines and grids drawn on them, which facilitated the accuracy of re-creating the image in the drawing, and some were mounted on cardboard for easier handling (cats. 292, 293). There are repetitive pictures of a model with slight variations of a given pose, or of several models assuming the same pose. In a number of photos, especially those taken later in his studio in Prague, we find groupings of people in costumes enacting scenes for Mucha's artistic bequest to his homeland, the re-creation of dramatic scenes from the history of the Slavic tribes of Eastern Europe in a series of huge canvases titled *The Slav Epic.*

This does not mean, however, that Mucha limited himself to photography connected with his graphic designs. For an artist who, like many of his generation, regarded photography as artistically meaningless, he left behind an astonishing quantity of family portraits, scenes from his travels, and casual snapshots of one type or another— more than virtually any other artist of the period. This is mostly due to the fact that although many painters or graphic designers became intrigued by photography in this era, most of them stayed with it for only a brief period, whereas Mucha remained an avid shutterbug for the rest of his life (he died in 1939; cats. 283, 286, 288, 289).

Among Mucha's earliest preserved photos are street scenes of Vienna from the early 1880s, taken when he worked there as a young man for a firm of theatrical set decorators. The earliest known photo he used in his work is a posed picture of a young boy holding a palette; it was taken in Paris in 1892, and Mucha used it in two of the twelve panels of a calendar he designed for the Lorilleux ink company the following year. Other photographs from this period were used in Mucha's illustrations for a book on German history by Seignobos—one of the projects he took on in his early years in Paris when he found it hard to eke out a meager living. In addition, there is evidence that the use of photography for painters and graphic designers, especially young, struggling artists who could not afford to pay for lengthy or repeated sittings of professional models, was at this time being taught at most art academies—including the Académies Julian and Colarossi, where Mucha studied and taught after moving to Paris.

During his lean years in Paris, he sometimes took pictures of other struggling members of the art colony who came to commiserate with him. There exist photographs taken in Mucha's studio in 1893 of his friend Paul Gauguin, wearing no trousers, and Anna, the native girl he brought to France from one of his travels in the South Seas and whom he always introduced as Javanese but who actually turned out to have come from Ceylon (today's Sri Lanka; cats. 241, 242). When he had

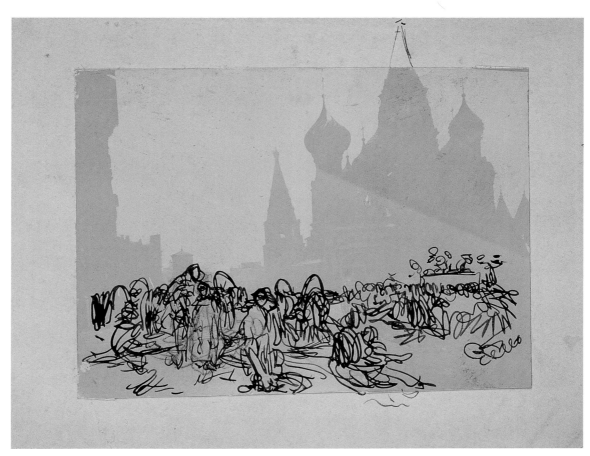

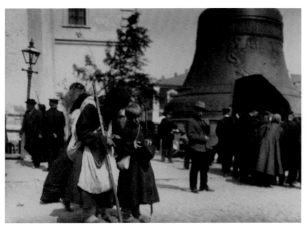

Cat. 288 (top) Alphonse
Mucha, *Red Square,* Moscow,
1913, vintage print on card,
retouched with pen and ink,
2¾ × 4 in. (print), Mucha Trust

Cat. 286 (middle, left)
Alphonse Mucha, *Man and
Boy, Red Square,* Moscow,
1913, modern print from
original glass plate negative,
Mucha Trust

Cat. 289 (middle, right)
Alphonse Mucha, *Three Men
in Red Square,* Moscow, 1913,
modern print from original
glass plate negative, Mucha
Trust

Cat. 283 (bottom) Alphonse
Mucha, *Family Group, Red
Square,* Moscow, 1913, modern
print from original glass plate
negative, Mucha Trust

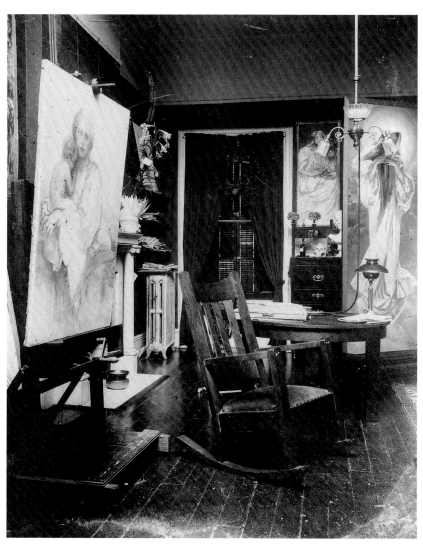

no money to pay models, Mucha evidently had no
qualms about asking friends, particularly mem-
bers of the Czech art colony in Paris among whom
he had many contacts, to pose for various scenic
illustrations and other minor graphic work in
which he was involved.

Mucha's use of models' photographs is rather
haphazard. There are poses taken with a specific
purpose in mind, which we can trace to the fin-
ished design without any trouble. But here is
also a large number of poses that may have been
taken on speculation, as they cannot be readily
connected with any known project of his. At the
other end of the spectrum, there are poses that
were apparently used more than once (cats. 253,
259, 269, 294). For example, a photo of a woman
leaning forward seems to have served for a poster
advertising Mucha's own exhibition at La Plume
gallery in 1897 as well as for the *Emerald* panel in
his set of *Precious Stones* in 1900.

Going through the photo archives, the artist's
son Jirí identified pictures used on every type of
project his father ever undertook. Obviously, most
are connected with posters and major paintings
such as *The Slav Epic* series, but Mucha also took
pictures to work from when he did book illustra-
tions, magazine covers, portraits, decorations, and
even minor graphic vignettes like menus or sta-
tionary design. Jirí traced some pictures to his
father's two textbooks on style, *Documents Décora-
tifs* (1902) and *Figures Décoratifs* (1905); to the
proposed decor for the Bosnia-Herzegovina pavil-
ion at the 1900 World's Fair; to the interior design
for the German Theater in New York, which Mucha

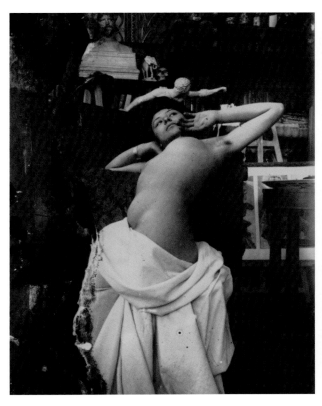
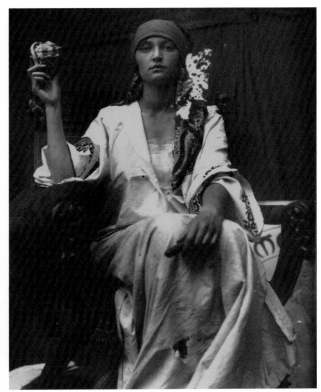
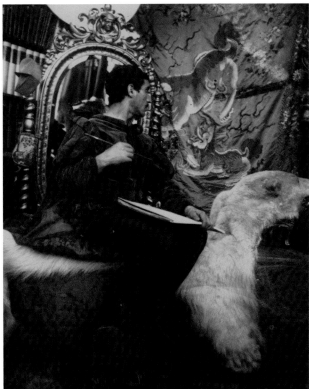
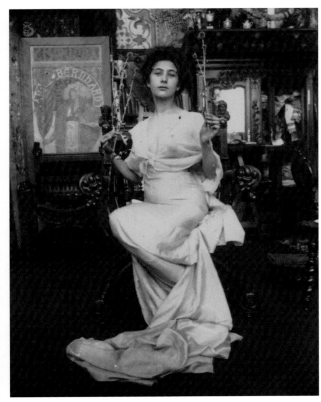

Cat. 269 (top, left)
Alphonse Mucha, *Model Posing in Mucha's Studio*, rue du Val de Grâce, Paris, c. 1902, modern print from original glass plate negative, Mucha Trust

Cat. 294 (top, right)
Alphonse Mucha, *Study for 50 Crown Banknote of the Republic of Czechoslovakia*, Prague, 1919, modern print from original glass plate negative, Mucha Trust

Cat. 253 (bottom, left)
Alphonse Mucha, *Model Posing in Mucha's Studio*, rue du Val de Grâce, Paris, c. 1898, modern print from original glass plate negative, Mucha Trust

Cat. 259 (bottom, right)
Alphonse Mucha, *Model Posing in Mucha's Studio*, rue du Val de Grâce, Paris, c. 1899, modern print from original glass plate negative, Mucha Trust

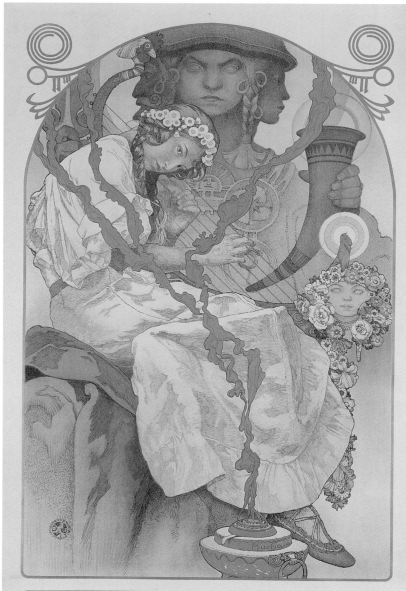

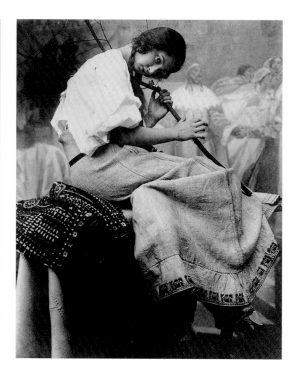

„SLOVANSKÁ EPOPEJ"
HISTORIE SLOVANSTVA V OBRAZÍCH
~ ALFONSE MUCHY ~
VYSTAVENO OD 1. ČERVNA DO 30. ZÁŘÍ 1930
VE VELKÉ DVORANĚ VÝSTAVNÍHO PALÁCE
V BRNĚ·
POD PROTEKTORÁTEM
MĚSTSKÉ RADY BRNĚNSKÉ
DENNĚ OTEVŘENO OD 8.—18. HOD.

prepared during his stay in the United States—to virtually all the artist's varied oeuvre.

Jiří himself recollected posing for his father for some photos that were used in his commercial work. When his son was only six years old, Mucha made him a model for the January 1922 New Year's cover drawing for *Hearst's International* (cat. 296; fig. 100). Jiří represented the New Year, while the Old Year is shown, not in the traditional guise of Father Time, but rather as a mature woman, so that the design allegorically represents the young generation taking over from the older one. Daughter Jaroslava, born in 1909, also modeled for her father's camera on various occasions. She is the young woman in the poster announcing the opening of the exhibition of *The Slav Epic* series of monumental paintings (cats. 302, 304). The pose in the poster is taken from one of these historic re-creations, *The Oath under the Linden Tree.*

For some projects Mucha used photographs of close friends, possibly as thanks for services rendered. In the poster for the Czech insurance company Slavia, the girl who presumably represents the embodiment of Slavic virtues is, ironically, an American socialite—Josephine Crane, the daughter of the industrial tycoon Charles Crane. The choice of model is explicable when it is known that Crane supported Mucha financially, allowing him to indulge in his major project, *The Slav Epic,* without needing to worry about making a living (cat. 299).

A poster from Mucha's Czech period, for the ballet and pantomime *Princess Hyacinth* by the composer Oskar Nedbal, features a design taken from a portrait of the actress who created the role on stage, Andula Sedláčková. She later became one of the first major stars to emerge from the early Czech film industry (cat. 279).

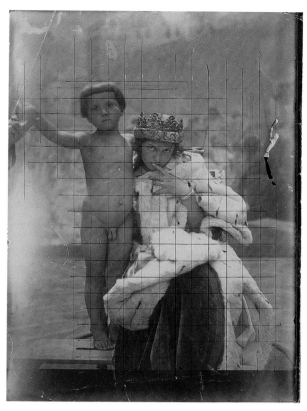

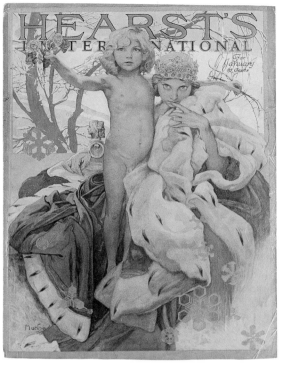

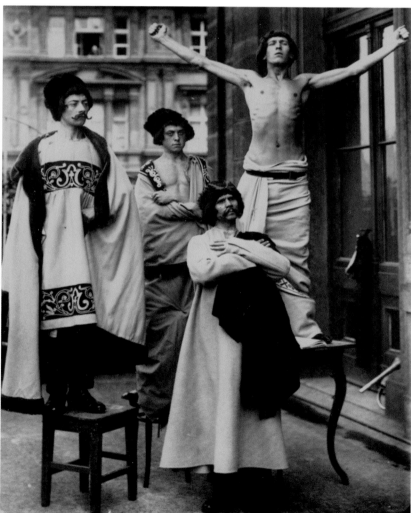

Cat. 304 (opposite, left) Alphonse Mucha, *The Slav Epic,* 1928, color lithograph, 72¼ × 31⅞ in., Courtesy of Posters Please, Inc.

Cat. 302 (opposite, right) Alphonse Mucha, *The Artist's Daughter, Jaroslava, as Model for the Poster Announcing the Opening of the Slav Epic,* 1927, vintage print, Collection of Jack Rennert

Cat. 296 (top, left) Alphonse Mucha, *The Artist's Son and Daughter, Jirí and Jaroslava. Study for the Cover of "Hearst's International," January 1922,* New York, 1921, vintage print retouched with pen and ink, 7 × 5⅛ in., Mucha Trust

Fig. 100 (top, right) *Cover of "Hearst's International," January 1922,* 1921, color print, Collection of Robert Allen Haas, Kansas City, Mo.

Cat. 299 (bottom) Alphonse Mucha, *Study for the Slav Epic Canvas "Apotheosis of the Slavs,"* *1926,* Prague, c. 1924, modern print from original glass plate negative, Mucha Trust

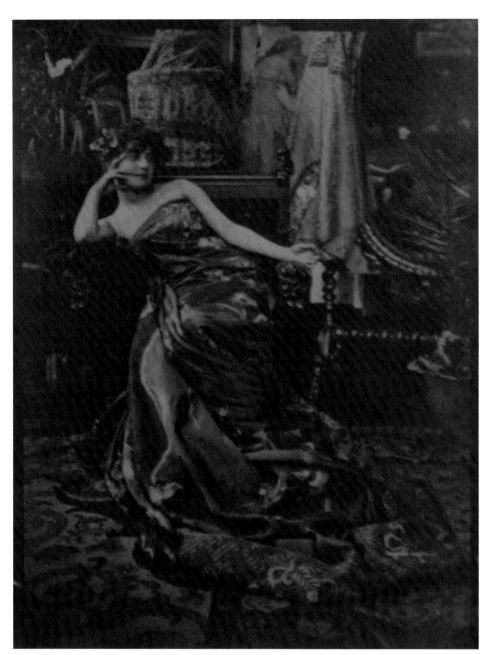

Cat. 247 Alphonse Mucha, *Study for "Iris" from "The Flowers," 1898*, rue du Val de Grâce, Paris, 1897, vintage print, 7 × 5⅛ in., Mucha Trust

Cat. 279 (opposite) Alphonse Mucha, *Princess Hyacinth*, 1911, color lithograph, 49½ × 32⅞ in., Courtesy of Posters Please, Inc.

In some cases, it appears that Mucha composed a design from more than one photograph, using either different poses of the same model or different models. In the photo study for the *Morning Star* panel in Mucha's decorative set *Stars,* we see a nude woman with one arm raised high, the other trailing by her side. The finished design has the woman raising her arm only to her forehead; the other arm's position is also entirely different. We may assume that another picture was taken in the corrected pose. This may be true even if we do not have the proof, as the photo archive as it stands today is by no means the complete record of Mucha's photographic work.

We may discern a similar difference between the original pose and the completed design in two magazine covers Mucha executed from pho-

tographs. In the study for the April 1910 cover of *L'Habitation Pratique,* the model has her arms stretched forward; in the actual drawing she has them clasped at the hip (cats. 257, 258, 271). In the case of the January 1905 cover of *Wiener Chic,* not only are the hands placed entirely differently from the way they are in the photo, but now the girl has also acquired wildly buoyant tresses meandering in all directions. Such restless hair happens to be one of Mucha's most easily identifiable trademarks, an expression of Art Nouveau's trend toward excessive ornamentation, but practically speaking, it would have been next to impossible to locate models with such hair, so artistic license came into play (cats. 245, 249).

Another composite can be seen in Mucha's own textbook on Art Nouveau design, *Documents*

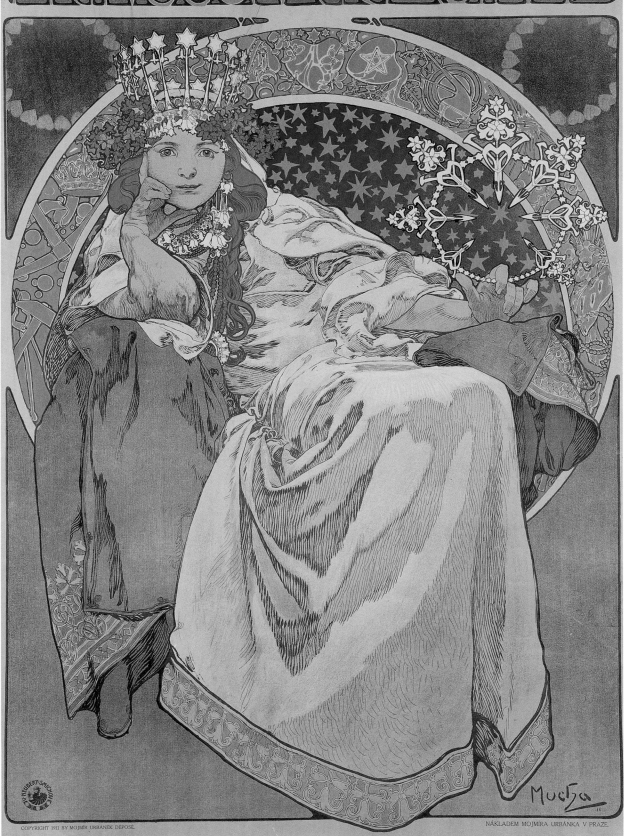

PRINCEZNA HYACINTA

NÁKLADEM MOJMÍRA URBÁNKA V PRAZE.

Mucha

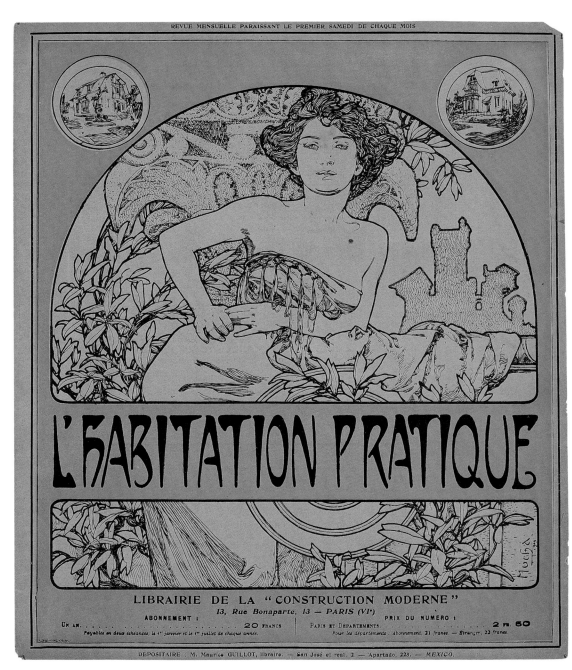

Cat. 271 (top) Alphonse Mucha, *Cover of "L'Habitation Pratique" (April 1910)*, 1903, lithograph, 13½ × 12½ in., Courtesy of Posters Please, Inc.

Cat. 257 (bottom, left) Alphonse Mucha, *Model Posing in Mucha's Studio*, rue du Val de Grâce, Paris, c. 1899, modern print from original glass plate negative, Mucha Trust

Cat. 258 (bottom, right) Alphonse Mucha, *Model Posing in Mucha's Studio*, rue du Val de Grâce, Paris, c. 1899, modern print from original glass plate negative, Mucha Trust

Cat. 249 (opposite) Alphonse Mucha, *Cover of "Wiener Chic" (January 1905)*, 1898, monochrome lithograph, 14¾ × 10⅞ in., Courtesy of Posters Please, Inc.

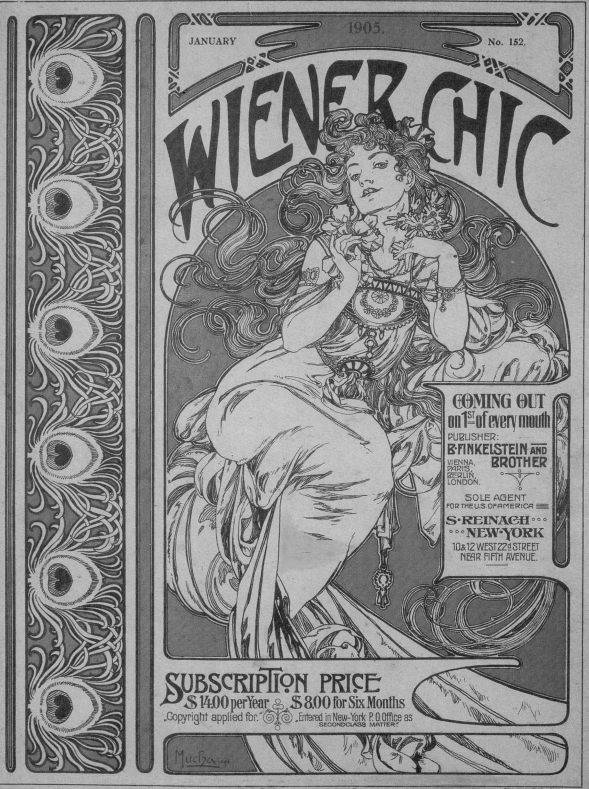

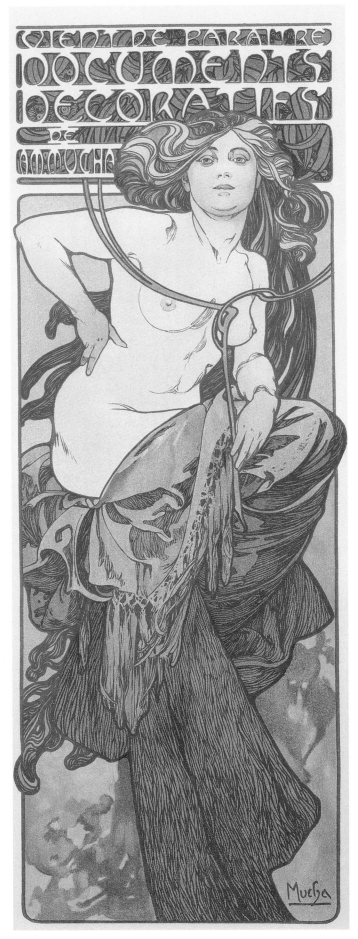

*Décoratifs.* One of the plates in it is a fully executed poster design, showing how the book's publication might be advertised (in reality, Mucha designed a different poster for the purpose). The study of a model with hand on hip who posed for the mock poster is readily identifiable, but she posed for it fully dressed, whereas in the design she is seminude. Was there another camera session with the same subject? Or did Mucha take the torso from one of the many nude photos he had at his disposal (cats. 261, 268)?

The book also contains an example of Mucha's practice of using a design more than once. In 1899 Mucha used the photo of a seated model for a design meant for the cover of a catalogue of the 1900 World's Fair; although in the end, it appeared only on a menu for one of the banquets held in conjunction with the exposition. That same drawing appears in the style book as an example of a properly executed design. Mucha simply removed the ornamental frame with the number *1900* on it and substituted a flower motif.

Another example of Mucha's flexibility can be seen in the *Summer* panel from the 1896 decorative set *Seasons* (cat. 244). To catch the precise expression of indolence he wanted, suggesting the summer doldrums, he evidently took pictures of a least two models in the half-averted leaning pose he was trying to capture. But both of them are normally dressed, whereas the finished design shows the girl in a flimsy off-the-shoulder garment revealing her bare back and most of her legs. Most likely there was another photo used for the body, and quite possibly still another one for the face.

Faces, in fact, seem to be one feature that Mucha most consistently altered in the designs he

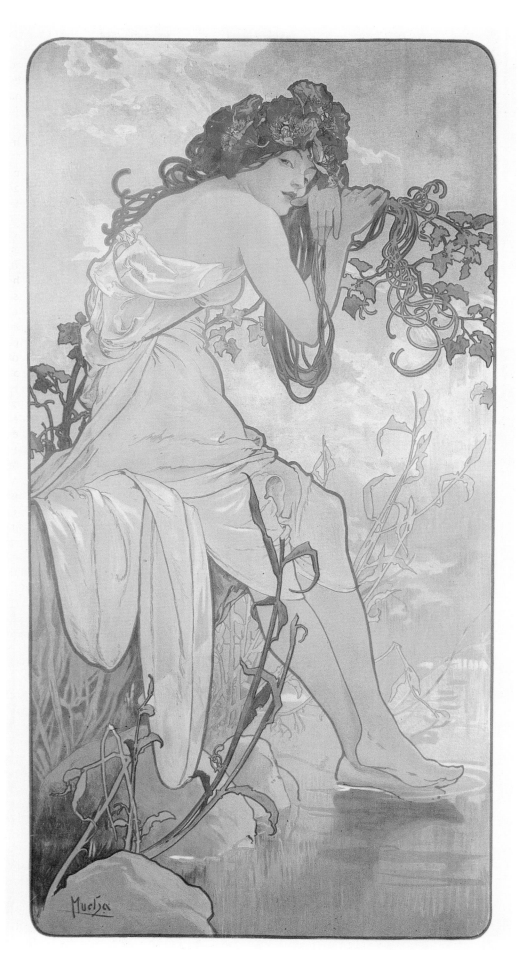

Cat. 268 (opposite, left)
Alphonse Mucha, *Cover Plate for "Documents Décoratifs,"* 1902, lithograph, 18⅛ × 13 in., Courtesy of Posters Please, Inc.

Cat. 261 (opposite, right)
Alphonse Mucha, *Study for the Design for the Menu of the Official Banquet of the Exposition Universelle, Paris, 1900* (later adapted for Plate 1 of *Documents Décoratifs* [1902] and the cover of *Paris Illustré* [December 1903]), rue du Val de Grâce, Paris, c. 1899, vintage print, 4¾ × 3⅝ in., Mucha Trust

Cat. 244  Alphonse Mucha, *Summer (panel from "The Seasons"),* 1896, color lithograph, 40½ × 21¼ in., Courtesy of Posters Please, Inc.

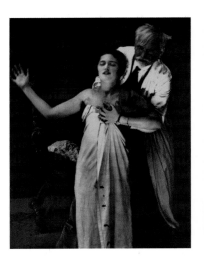

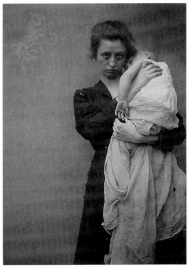

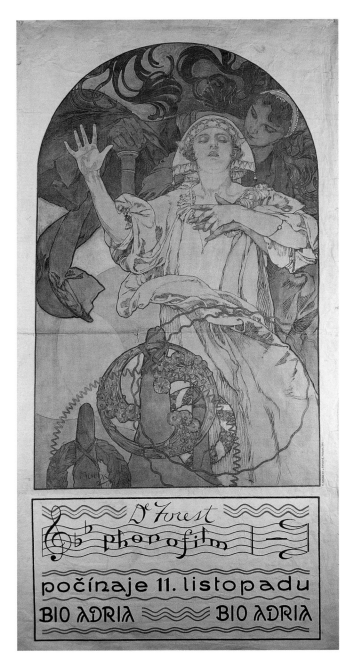

made from photographs. He needed the models mainly for the correct alignment of the body and limbs, but the models who posed for him rarely had the soft, sensitive facial features he wanted. Mucha's ideal woman had a face of classic, luminous beauty that is rarely, if ever, found in nature; she represented the Victorian concept of woman as an unattainable object of admiration and awe placed on a pedestal. Hence, Mucha refined the faces of his models to fit the images he was trying to convey.

Comparing Mucha's design with the photos from which he worked gives us useful insight into the artistic process. It is clear that no photograph was ever slavishly copied; it represented only a point of departure from which inspiration takes over. With his meticulous attention to detail, Mucha certainly used the pictures to check things such as the precise position of fingers on a hand holding something—often a stumbling block for even otherwise competent artists—as well as for a correct perspective and spatial relations between people and objects. Beyond that, the heart of every design is an expression of the artist's soul.

Among the many casual photographs Mucha took during his life, particularly those from his travels in Russia and elsewhere, there are some quite effective compositions worthy of being included in his artistic legacy. Granted that he never intended to create any photographic artwork intentionally, we can conclude that his artist's eye could not help but compose scenes we might call inspired. Almost totally overlooked in his self-assessment as an artist, photography nevertheless remains a part of his total achievement.

Mucha will remain celebrated as a superior and profoundly influential poster designer of the belle époque of Paris in the 1890s, a cocreator of the Art Nouveau movement and its most successful exponent. But for those who wish to grace some of the sources of his inspiration, the photographic legacy he left behind is worth a closer look.

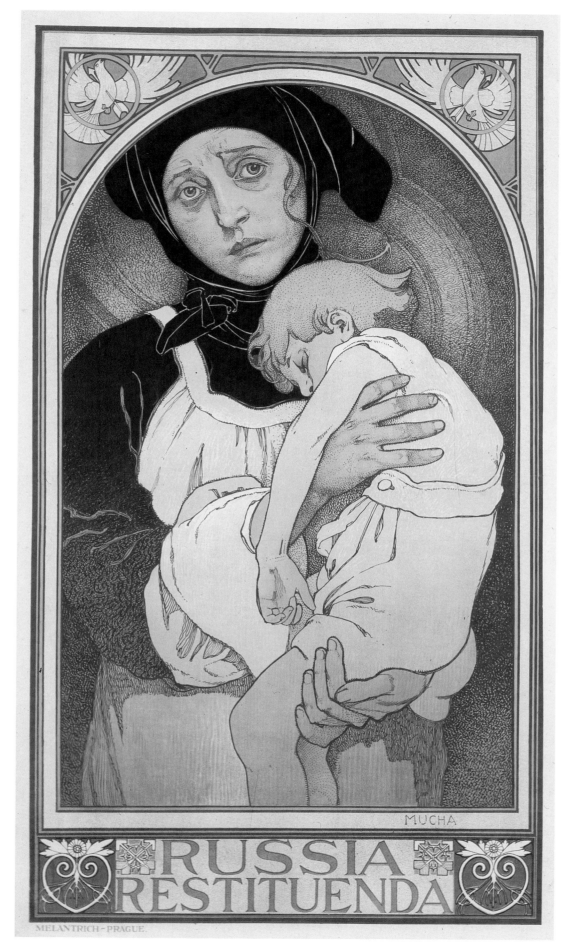

Cat. 301 (opposite, top left)
Alphonse Mucha, *Mucha and His Daughter, Jaroslava, Posing for the Poster "DeForest Phonofilm, 1927,"* Prague, c. 1926, modern print from original glass plate negative, Mucha Trust

Cat. 297 (opposite, top right)
Alphonse Mucha, *Study for "Russia Restituenda" (1922)*, Prague, c. 1921, vintage print, 7 × 5⅛ in., Mucha Trust

Cat. 303 (opposite, bottom)
Alphonse Mucha, *DeForest Phonofilm,* 1927, color lithograph, 60½ × 30 in., Courtesy of Posters Please, Inc.

Cat. 298 Alphonse Mucha, *Russia Restituenda,* 1922, color lithograph, 31⅜ × 18 in., Courtesy of Posters Please, Inc.

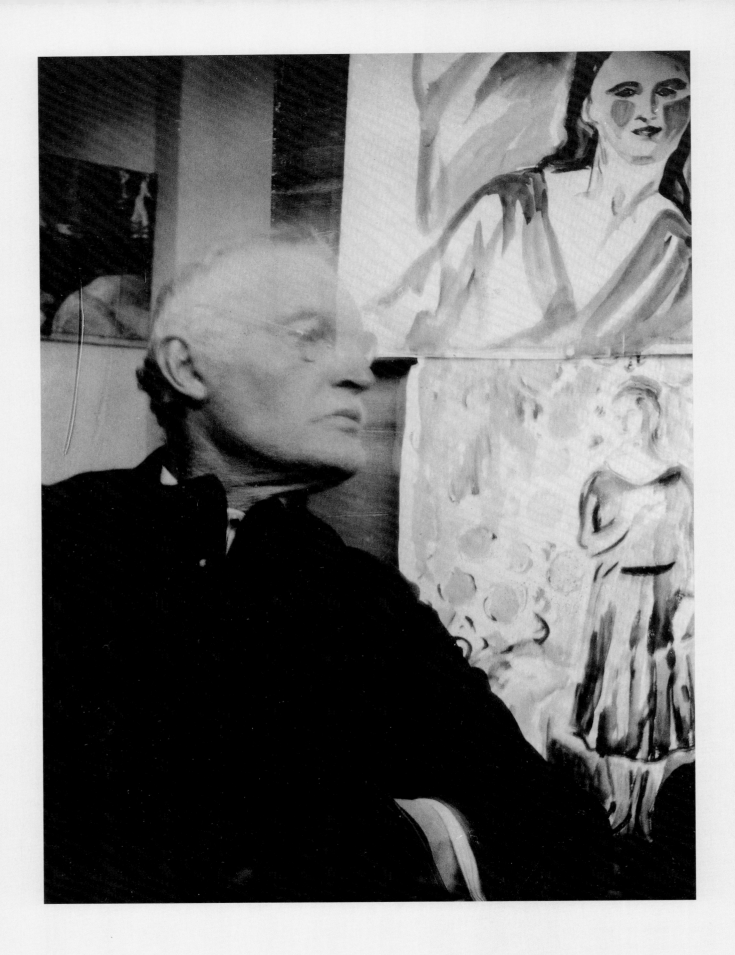

# Edvard Munch

LØTEN, HEDMARK 1863–1944 OSLO

Munch was able to overcome his poor health and unsettled child-
hood (his mother and older sister both died of tuberculosis, and
his father was zealously pious) to create profoundly moving, if
unsettling, highly influential paintings and prints. From the be-
ginning of his career, his paintings featured subjects of deeply
personal, often sexual content. After brief visits to Paris in 1885,
1889 (when he saw the work of Paul Signac, Georges Seurat, and,
most important for him, Paul Gauguin), and 1891, he lived
mainly in Berlin from 1892 to 1909. The unfettered subjects of
his work shown at the Verein Berliner Künstler in 1892 caused
the members to close the show to forestall further scandal; Munch
became famous as a result of the controversy. Shortly thereafter,
he produced his first prints; his woodcuts are especially forceful,
taking advantage of the grain of the wood. Contriving to work
despite hospitalizations for illness (partially if not largely caused
by drinking), Munch's works were seen in exhibitions in Germany
and Paris, and his illustrations appeared in periodicals across
Europe. A house at Åsgårdstrand, bought in 1897, and its seaside
location offered escape from the city during the summer months.
He envisioned a large cycle of works, *The Frieze of Life*, "a poem of
life, love, and death." Many of his most famous paintings—*The
Scream, Puberty, Jealousy*—were meant to constitute this series. He
was in demand as a portraitist by German bankers, industrialists,
and aristocrats. After a complete nervous breakdown in 1908 in
Copenhagen, Munch returned permanently to his native Nor-
way. He won a competition to paint murals for the auditorium
of Oslo University; they were unveiled in 1916. His palette and
subject matter brightened considerably after his illness until the
1920s, when Munch again made his inner torments visible. He
nonetheless maintained an active exhibition schedule in both
Europe and the United States until his death.

Cat. 328b  Edvard Munch,
*Self Portrait with Glasses in
Front of Two Watercolors*, 1930,
gelatin print, 4⅛ × 3⅛ in.,
Munch-museet, Oslo

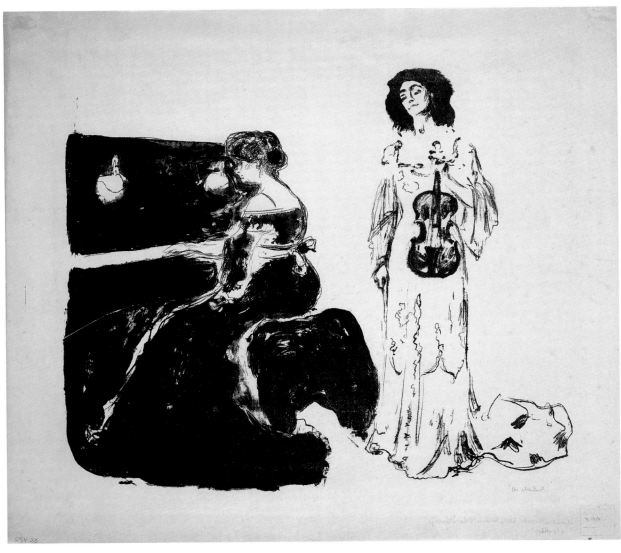

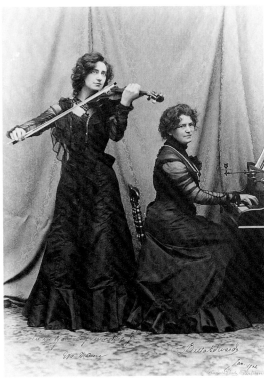

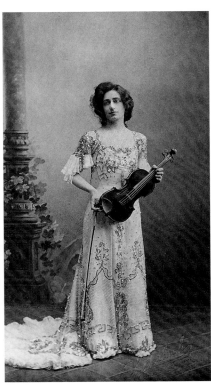

*Dorothy Kosinski*

# Edvard Munch and Photography

Edvard Munch, like so many of his contemporaries, seemed compelled to dismiss photography as a tool of realism: "The camera cannot compete with painting so long as it cannot be used in heaven and hell."[1] Yet, as Arne Eggum has so thoughtfully explored, Munch is not interested in visionary renderings of heaven and hell. Rather, the subject of his art is the depths and heights of his own psychic and emotional-moral terrain. Munch essentially demanded from painting and photography an art that reached not beyond, but within: "an art which touches and grips one's own heart's blood."[2]

Munch's career embraces several portraits of notable contemporary figures famous in the realms of theater, literature, philosophy, and psychology, and photography played a role in each case. In 1896 Munch produced lithographic and etched versions of a portrait of the French symbolist poet Stéphane Mallarmé (figs. 101, 102). Clearly based on Paul Nadar's noted photograph of 1895, Munch created an image of emotional serenity and otherworldliness, removed from the descriptive details—shawl, pen, writing materials—included in Nadar's work. Similarly, in his lithograph of Henrik Ibsen, Munch uses a well-known official photographic portrait of the playwright as the basis for his expressive and intensified interpretation.

Munch's lithographic portrait of the violinist Eva Mudocci and the pianist Bella Edwards is also inspired by at least two photographs of the artists but transforms these official portraits into a depiction of visual intensity and psychological depth (cats. 307, 313, 329). Unlike the photograph, which shows both women's faces, in Munch's double portrait the visage of the pianist is totally obscured. On the other hand, the face of Mudocci is defined with a few powerful calligraphic marks. Munch invests the outlines of the figures and the areas

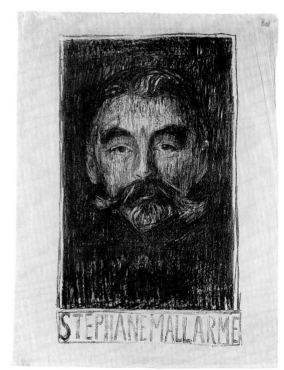

Cat. 313 (opposite, top) Edvard Munch, *The Violin Concert,* 1903, lithograph, 18⅝ × 21½ in., Munch-museet, Oslo

Cat. 329 (opposite, bottom left) Harald Patz, *Eva Mudocci and Bella Edwards,* 1902, gelatin print, 17½ × 11¾ in., Munch-museet, Oslo

Cat. 307 (opposite, bottom right) L. Forbech, *Eva Mudocci with Her "Emiliano d'Oro,"* c. 1902, gelatin print, 6⅛ × 3¼ in., Munch-museet, Oslo

Fig. 101 Edvard Munch, *Stéphane Mallarmé,* 1896, lithograph, Munch-museet, Oslo

Fig. 102 Paul Nadar, *Stéphane Mallarmé,* 1895, photograph, Fotografika, Museet, Stockholm

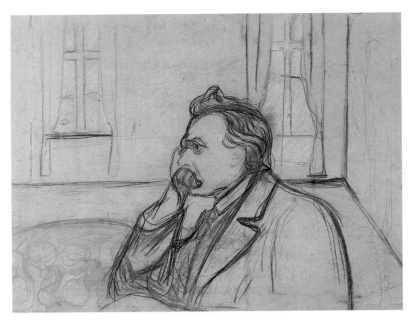

Cat. 317 (right) Edvard Munch, *Study for "Portrait of Friedrich Nietzsche,"* 1905, crayon and charcoal on cardboard, 28¾ × 39¾ in., Munch-museet, Olso

Cat. 318 (below) Edvard Munch, *Friedrich Nietzsche,* 1905–6, oil and tempera on canvas, 78¾ × 51⅛ in., Munch-museet, Oslo

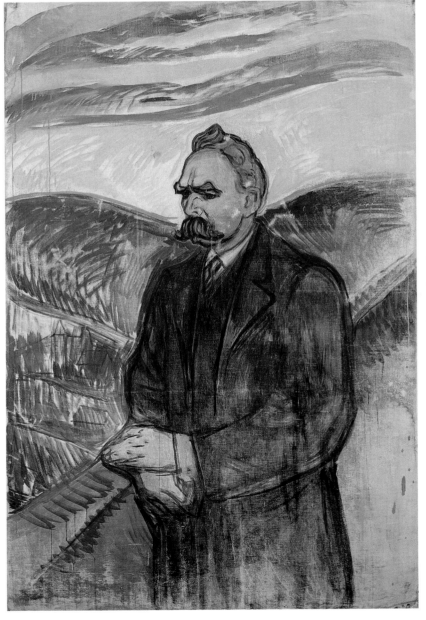

Above:

Fig. 103 Unknown, *Friedrich Nietzsche and His House in Weimar,* postcard

Fig. 104 Hans Olde, *Friedrich Nietzsche,* 1899, modern reprint from original negative, Goethe- und Schiller Archiv, Weimar

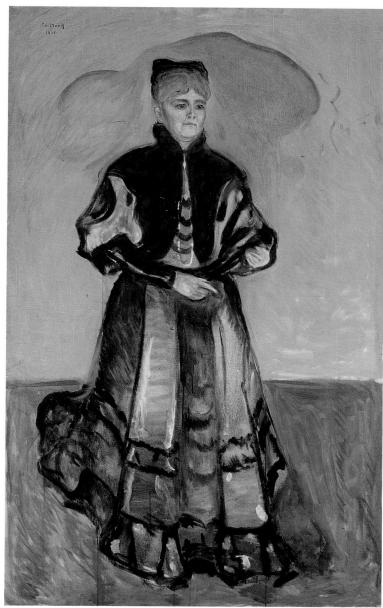

they define with an abstract, graphic power. The figure of Edwards, for instance, in a dark gown, is entirely subsumed into the dark shape of her piano. Munch's powerful manipulation of shape and sinuous outline serves to create a complete fusion of the woman and her instrument. The double portrait is built on the contrast of the dark shape of the seated woman-piano and the tall, erect violinist in a white gown, who gazes directly out at us, the audience. She clutches her violin before her, as though, having just completed her performance, she reveals the instrument to the audience. The hourglass shape of the violin, held at waist height, seems to parallel the form and structure of the woman's body. Munch eradicates any sense of communication or emotional rapport between the two musicians, establishing instead a sense of counterpoint between two artists of contrasting personalities, each totally consumed or defined by their music.

Munch's work with the musicians was apparently fraught with difficulty. They became so impatient with the progress of his work that they demanded that he remove from their room at the Hotel Sans Souci in Berlin all of his painting and lithographic paraphernalia. The 1903 lithograph entitled *Salome* depicts the painter's own visage enveloped in the copious tresses of Mudocci. Inspired once again by the official formal photograph of the musicians, Munch substitutes his own head for Mudocci's Stradivarius, establishing thereby a psychologically morbid parallel between himself as St. John the Baptist and Mudocci as his

Cat. 330 Unknown, *Elisabeth Förster-Nietzsche,* c. 1905, collodion print, 5⅞ × 4 in., Munch-museet, Oslo

Cat. 319 Edvard Munch, *Elisabeth Förster-Nietzsche,* 1906, oil on canvas, 64½ × 39¾ in., Munch-museet, Oslo

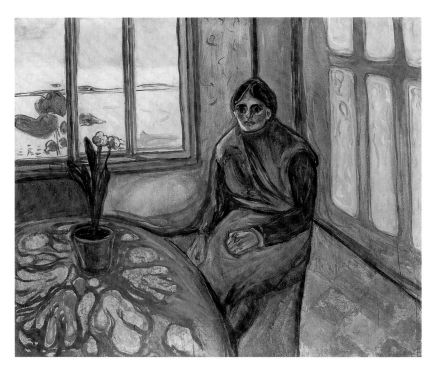

Fig. 105 Edvard Munch, *Melancholy*, 1899, oil on canvas, Munch-museet, Oslo

Salome. Munch's once intense feelings—"one day I will bathe my sick soul in your music"[3]—have been transformed with disappointment or jealousy.

Munch likewise transforms photographic snapshots or portrait studies into paintings of monumental size and psychological importance in his likenesses of Friedrich Nietzsche and his sister, Elisabeth Förster-Nietzsche (cat. 319). Both portraits, dating from 1905–7, were commissioned by the well-known Swedish arts patron Ernest Thiel. Munch's rendering of the philosopher's visage in a preparatory study (cat. 317) is unmistakably based on an 1882 picture postcard showing Nietzsche's house in Weimar and a small profile of the writer in a roundel (fig. 103). Munch's pastel sketch of the philosopher depicts him seated, head in hand, at a round table. The articulations of that table's surface, but also the configuration of the composition generally, are strikingly similar to the 1899 painting entitled *Melancholy,* a portrait in fact of Munch's mentally ill sister, Laura (fig. 105). Here, the surface of the table is articulated like a section of the brain, a sign or visualization of looking within, of probing the inner chemical-physical and psychological reality of the unbalanced young woman. This painting is evidence of Munch's interest in psychology, his belief in picturing altered states or subjective vision. Munch's painting seems to be based on Hans Olde's photograph of Nietzsche from 1898–99, mentally ill and confined to an asylum, the basis too for an etching published in Paris in 1900, the year of Nietzsche's death (fig. 104). Munch, however (according to his desire to create a symbolist portrait that goes beyond realism), paints an overlifesize portrait, a

brooding, solemn figure at the parapet of a veranda overlooking an undulating, mountainous landscape, evoking the environment in which Nietzsche composed *Zarathustra.* Thiel was thrilled with the portrait, which he felt successfully embodied "the man" and the "prophet."[4] Similarly, the portrait of Nietzsche's sister, which is clearly based on a snapshot taken in Weimar (cat. 330), endows her with enormous dignity and power, appropriate to her valued roles as student, biographer, and head of the Nietzsche archive in Weimar.

Despite Munch's stated misgivings about the medium, photography emerged for him as a field of experimentation and exploration. Munch's relationship to the camera began in Berlin early in 1902, when he purchased a small Kodak. His excitement with the new apparatus is apparent in correspondence from that year to his aunt, Karen Bjølstad, in which he included two photographs. The photographs he eagerly produced between 1902 and 1908 and later between 1927 and 1932 have a quality that far exceeds the casual snapshot or preparatory study. Instead, this corpus includes many photographs characterized by distortions and intensifications that carry an intense psychological force. Double exposures or blurred or multiplied silhouettes are accidents that Munch willingly accepted, apparently enjoying the similarity, for instance, with the spirit photographs (supposed records of seances and apparitions) that fascinated him and his contemporaries. His photographs are charged with the excitement of capturing the invisible, the hunt for a reality beneath the surface.

With his own camera in hand, Munch seems to have become intensely involved in this medium, producing self-portraits, portraits of colleagues (Albert Kollmann, the occultist, for example), records of his exhibition at Blomquist in Kristiania in 1902, and shots of his family (especially his aunt, Karen, and sister Inger). In 1904 he made more self-portraits, posing nude in the garden or in his house in Åsgårdstrand. His 1906–7 self-portraits and shots of his model Rosa Meissner in Warnemünde are also characterized by an experimentation with optical distortions, accepting "accidents" caused by movements played out in front of the open lens. In 1908–9 Munch made extraordinarily innovative photos of himself while in a private clinic headed by Dr. Daniel Jacobson, where he was undergoing therapy following a stroke and being treated for alcoholism.

Eggum is surely correct in saying that Munch's experimentation with photography was not programmatic. Rather, he delighted in the accidents attendant on his photographic explorations, exploiting the long exposure times to incorporate movement, atmosphere, and ambiguity into the image (cats. 320, 322; fig. 106). He was especially fascinated with lighting effects and

Cat. 322 (top, left) Edvard Munch, *Self-Portrait Sitting on a Trunk I,* c. 1906, gelatin print, 3½ × 3¾ in., Munch-museet, Oslo

Fig. 106 (top, right) Edvard Munch, *Self-Portrait on a Trunk in His Studio at Lützow-strasse 82,* Version II, collodion print, Munch-museet, Oslo

Cat. 320 (bottom) Edvard Munch, *Self-Portrait in a Room on the Continent I,* probably 1906, gelatin print, 3½ × 3½ in., Munch-museet, Oslo

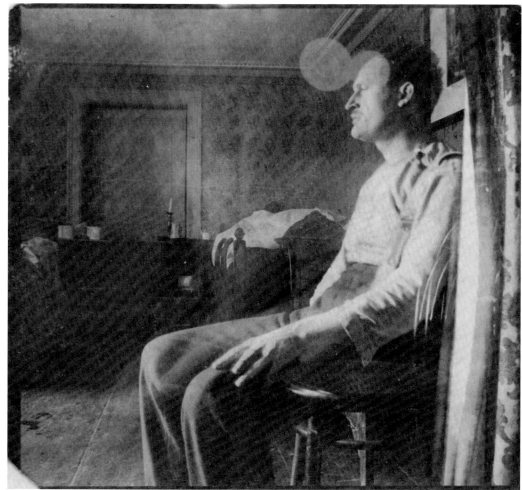

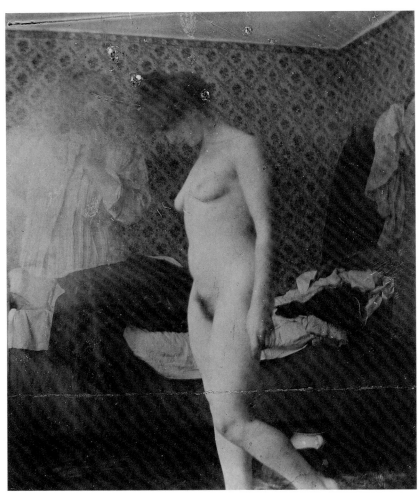

played with covering the lens with a black felt hat, with moving in front of the lens, with incorporating his shadow into the composition. The 1907 photograph of his model Rosa Meissner, shot in a hotel room in Warnemünde in 1907, includes at the upper left a ghostly and ambiguous image of another woman (cat. 324). Presumably this is Rosa's chaperon-sister, Olga. The foggy, suggestive rendering of this figure is the result of her moving during the exposure of the film. Whether such effects were intentional is debatable; however, there are compelling resemblances to the spirit photographs that interested Munch, the playwright August Strindberg, and so many others by the 1880s. Rosa's sister Olga resembles the phantomlike apparitions conjured by mediums and purportedly captured on film (fig. 107). In the related painting, the apparition is deleted and Rosa's pose is further exaggerated. The nude woman seems physically oppressed by the room, bowed down by a ceiling that is too low and by the animated pattern of the wallpaper. The theme of emotional anxiety is underlined by the painting's title, *Weeping Girl.* Munch was intrigued by this figure, producing several related painted versions (cats. 325, 326) and a bronze in 1909–14. One can only speculate what impact the photo made on these subsequent works and specifically the significance of the deletion of the second figure. Olga's absence is analogous to the hovering presence of

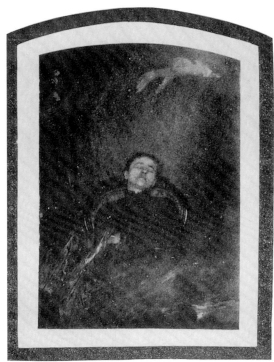

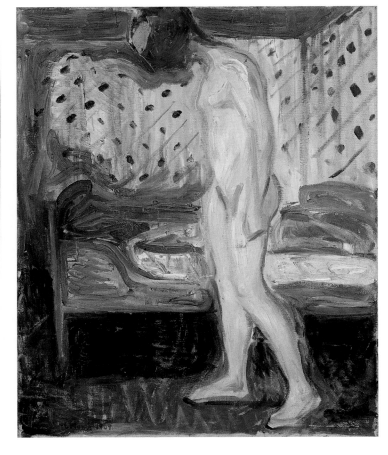

Cat. 324 (opposite, top)
Edvard Munch, *Portrait of
Rosa Meissner in the Ware-
münde Studio (Weeping Girl)*,
1907, tinted gelatin print,
3⅜ × 2⅞ in., Munch-museet,
Oslo

Fig. 107 (opposite, bottom
left) N. Wagner, *Transcen-
dental Photography*, 1881,
from A. Aksakow, *Animismus
und Spiritismus* 1 (1890):
plate 5

Cat. 326 (opposite, bottom
right) Edvard Munch, *Weep-
ing Girl*, 1909, oil on canvas,
34⅞ × 28⅜ in., Westfälisches
Landesmuseum für Kunst und
Kulturgeschichte, Münster

Cat. 325 Edvard Munch,
*Weeping Girl*, 1907, oil on
canvas, 47⅝ × 46⅞ in.,
Munch-museet, Oslo

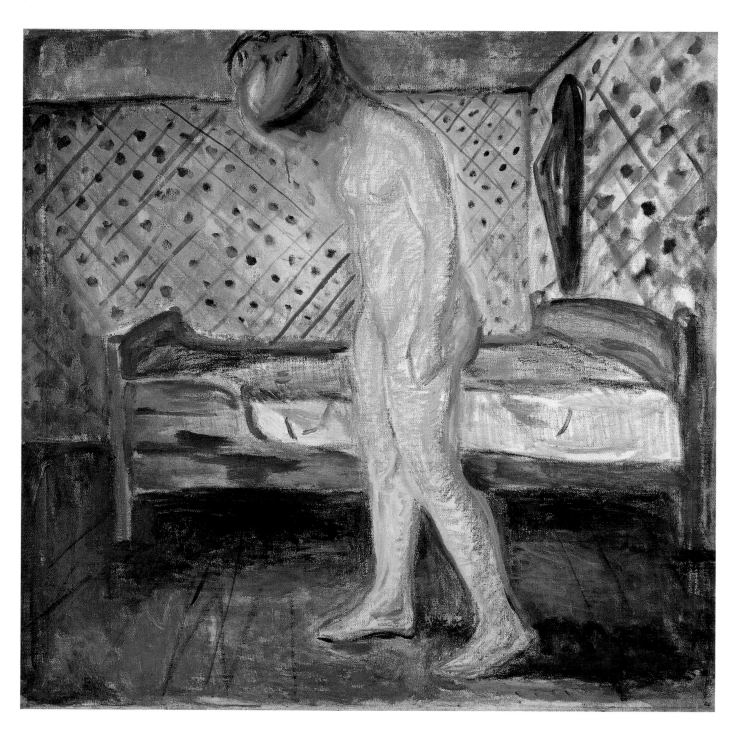

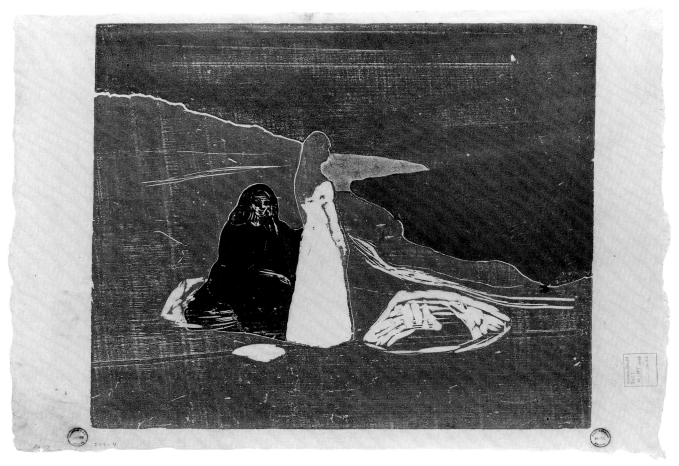

Fig. 108 Edvard Munch, *Two Women on the Beach,* 1898, woodcut, Munch-museet, Oslo

Fig. 109 Edvard Munch, *Aunt Karen and Sister Inger in Front of Olaf Ryes Platz 2 and 4,* 1902, gelatin print, Munch-museet, Oslo

the almost disembodied head in *Jealousy,* 1895 (coll. Rasmus Meyers, Bergen), the visage of the jealousy-ravaged man who seems to imagine the wayward dallyings of his "Eve." In another photo, of Munch's aunt and his sister Inger, he emphasizes a continuous sinuous silhouette encompassing both figures posed outside their house in a stark street (fig. 109), an impression reinforced by the bare expanse of stone step that fills the lower third of the photograph. The two women seem to be drawn together into a single dark-colored entity, a formal device that echoes the stylization of figures in many of his prints and paintings, an exaggeration that heightens the psychological quality of withdrawal, or turning inward, of isolation from the surrounding environment (fig. 108).

It is essential to examine in detail the number of photographic self-portraits that relate in turn to painted depictions of Munch's own face and body. His famous *Self-Portrait with Cigarette,* 1895, was clearly inspired by the dramatically lighted and mysteriously staged 1886 photographic self-portrait that Strindberg had used as a visiting card (figs. 110, 111).[5] Strindberg's portrait is dramatic in its frontality, the subject's eyes riveted on the camera. He is clad in coat, top hat, with one hand gloved, the other dramatically lighted against his somber garb. Munch's painting (though more casual in pose) exploits this dramatic emphasis of head and hand. Munch's expression—eyebrows arched, eyes wide—seems almost strained with fierce scrutiny, intense observation, and self-awareness.

It is manifest that photographs were never a simple means of reportage for Munch and are always more than simple narrative fragments of his life. Rather, he characterized them as his "destiny" pictures.[6] As exemplified in his monumental *Frieze of Life* series, exhibited at the Secession in Berlin in 1902, Munch was preoccupied with fundamental life-and-death rhythms that marked his own existence. The central fact of Munch's existential drama was the loss of part of a finger on his left hand in September 1902, the result of a gunshot wound sustained during a lover's quarrel with Tulla Larsen. This traumatic

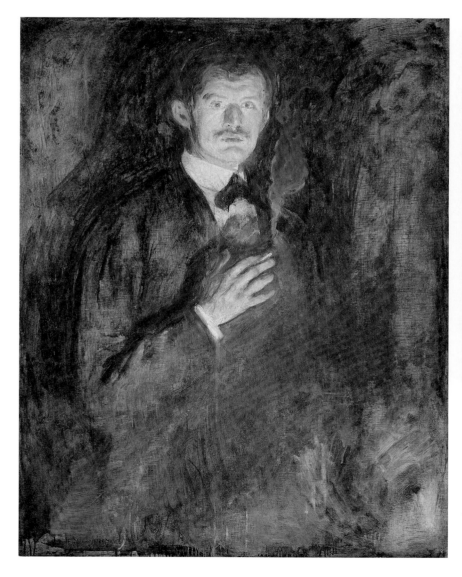

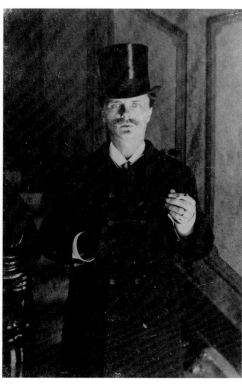

Fig. 110 Edvard Munch, *Self-Portrait with Cigarette,* 1895, oil on canvas, National Gallery, Oslo

Fig. 111 August Strindberg, *Self-Portrait,* 1886, albumen print, Munch-museet, Oslo

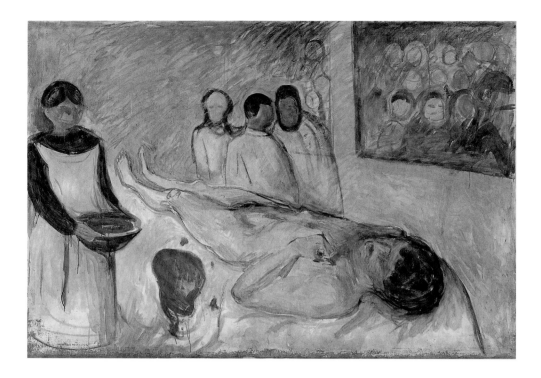

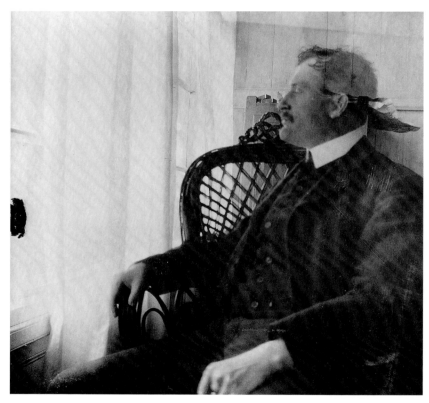

Fig. 112 Edvard Munch, *The Operation,* 1902, oil on canvas, Munch-museet, Oslo

Fig. 113 Edvard Munch, *Self-Portrait on the Veranda of Am Strom 53,* 1907, modern print from original negative, Munch-museet, Oslo

incident, and the resultant maiming injury, became the obsessive focus in the artist's life work and was undoubtedly a catalyst for his breakdown in 1908. Munch's distress over the disfigurement of his hand was extraordinarily intense; he transformed the loss of his finger into a sign of the collision of Eros and Thanatos, love and death.[7] These themes of passion and violence are the essential subjects, of course, of his major paintings of this period—*Love and Psyche* (1907), and two versions of *The Death of Marat* (1907), and *Murderess/Still Life* (1902). (The femme fatale is generally one of Munch's primary symbolist themes, as witnessed in *The Dance, The Vampire,* or *Ashes.*) Munch depicts himself during the operation to remove the bullet—a brutal image of the naked body as a landscape form (1902)—that communicates shame in front of the consulting physicians and the sea of faces in the gallery picture-window (fig. 112). The mangled hand figures in several photos (fig. 113) over the next several years (1906–9), fueling the idea that Munch is morbidly fascinated with the injury. There is a dramatic difference between the 1895 *Self-Portrait with Cigarette,* based on the Strindberg carte de visite, and the 1903 *Self-Portrait in Hell* (fig. 114)—which relates to nude photos of Munch posing in Åsgårdstrand (cat. 314). In the earlier work, as we have seen, the artist's hand and face are emblems of vitality, the most forceful parts of the artist-dandy's intense but self-confident portrayal. In the later work, by contrast, the artist's nude body seems vulnerable, seemingly rigid with anxiety or dread. Notably, his hands are not merely obscured but almost entirely cut off by the lower edge of the

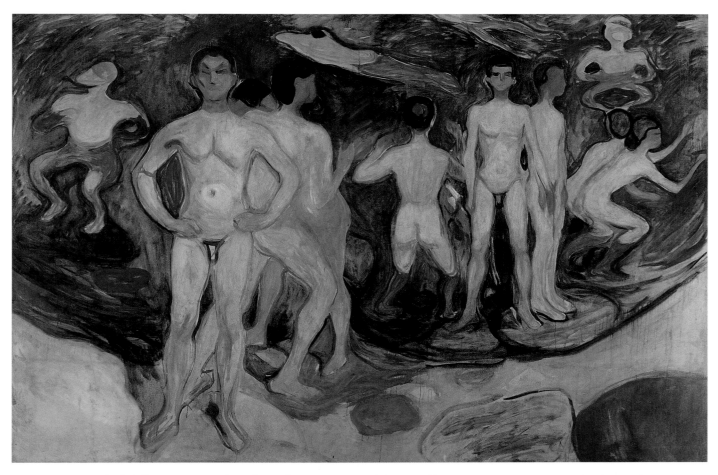

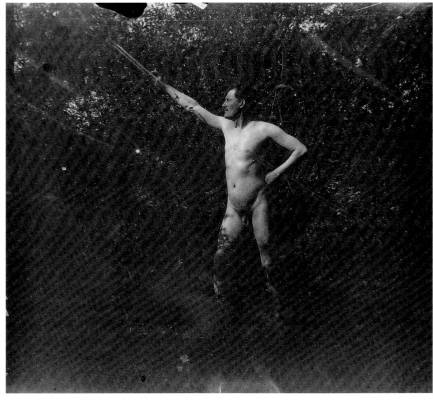

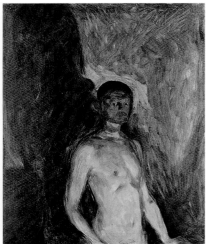

Cat. 315 (top) Edvard Munch,
*Bathing Men,* 1904, oil on
canvas, 76⅜ × 114⅛ in.,
Munch-museet, Oslo

Cat. 314 (bottom, left)
Edvard Munch, *Nude Self-
Portrait at Åsgårdstrand,*
1903, gelatin print, 3⅜ ×
3¼ in., Munch-museet,
Oslo

Fig. 114 (bottom, right)
Edvard Munch, *Self-Portrait
in Hell,* 1903, oil on canvas,
Munch-museet, Oslo

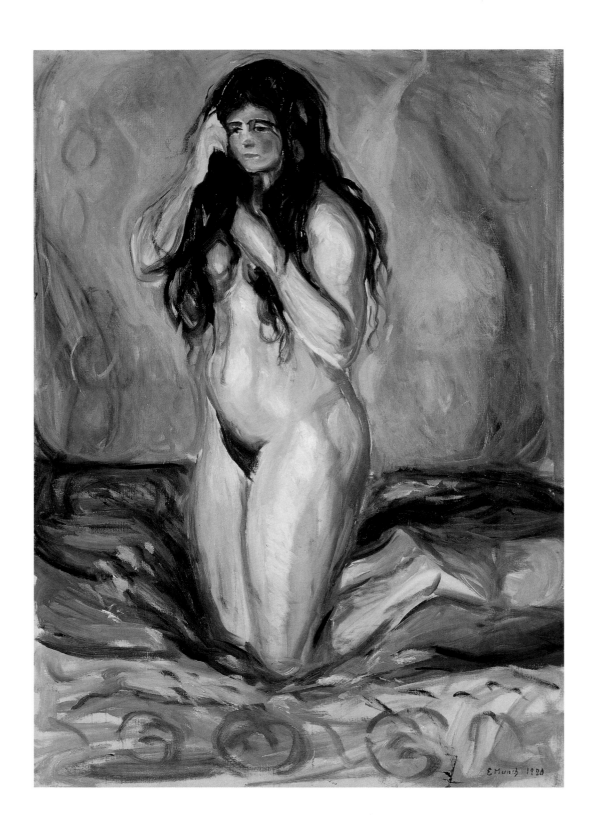

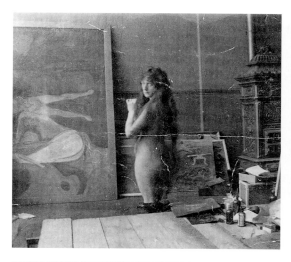

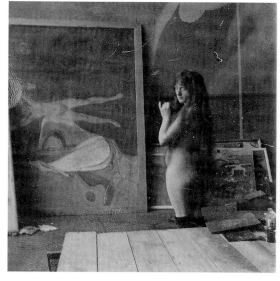

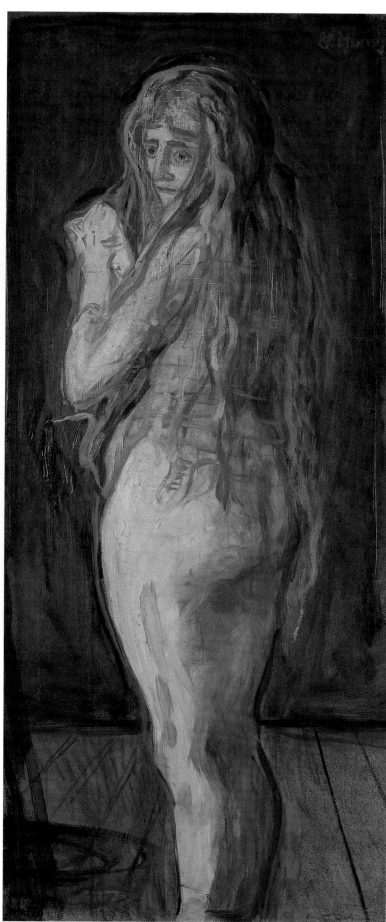

Cat. 327 (opposite) Edvard Munch, *Female Nude (Anna),* 1920, oil on canvas, 59⅛ × 41½ in., Sarah Campbell Blaffer Foundation, Houston

Cat. 310 (left, top) Edvard Munch, *Model in Munch's Studio, Berlin, Version I,* 1902, collodion print, 3⅜ × 3¼ in., Munch-museet, Oslo

Cat. 311 (left, bottom) Edvard Munch, *Model in Munch's Studio, Berlin, Version II,* 1902, collodion print, 3⅝ × 3½ in., Munch-museet, Oslo

Cat. 312 (right) Edvard Munch, *Nude with Long Red Hair,* 1902, oil on canvas, 47¼ × 19⅝ in., Munch-museet, Oslo

canvas. The signifiers of self in the earlier portrait are eradicated in this disturbing self-portrayal.

This richly symbolic and highly suggestive group of "destiny photographs" cannot, however, be fully understood solely by means of biographical context or as evidence of individual formal experimentation. Indeed, experimentation, or the willingness to accept unorthodox potential in the photograph, may be linked, for example, to the innovations of other Scandinavian artists. Strindberg, for instance, was extraordinarily precocious in his painting technique, lathering a palette-knife load of pigment on canvas to create totally abstract "landscapes" that reflect an interior psychological state more than they describe a place. In the realm of photography, Strindberg created photograms utilizing passive or direct photographic techniques, for instance, capturing the growth of crystals as liquids congealed (crystallizations) and the starry heavens (celestographs), uninterpreted images of microcosm and macrocosm. The author was inordinately preoccupied with his photographic works, and his experiments may well have inspired Munch in the spontaneous exploration of accident in his photographs. Munch himself invites us to consider these works as symptoms of an entirely redefined notion of what constitutes the nature of vision, of its subjectivity, of its essence as the result of electrochemical processes in the body. Vision and optics were no longer viewed as predictable, rational, objective phenomena. As Jonathan Crary has made so transparent in his publication on vision in the nineteenth century, the diagrammatic clarity of the camera obscura is supplanted by a much more ambivalent, ambiguous model.[8] Curiously, Munch takes refuge in or finds sustenance in photography when his faculties are impaired (his "destiny" photos are tied to a profound psychological and emotional breakdown; his return to photography in 1927 seems pinned to a further impairment of his sight when a blood vessel in his right eye ruptured (cats. 328a, 328b). This physical problem, which gave rise to profoundly disturbing visual distortions, unleashed another suite of photographic self-portraits, which couple unclear vision and compromised vision of self. The new notion of optics readily coincides with dysfunction, just as it embraced the traces of the supernatural or the accidental.

NOTES

1. Quoted in Arne Eggum, *Munch and Photography* (Newcastle upon Tyne: The Polytechnic Gallery, 1989), p. 59.

2. Quoted in ibid., p. 58.

3. Arne Eggum, *Munch und die Photographie* (Wabern-Bern: Benteli-Werd Verlags, 1991), p. 84.

4. Ibid., p. 96.

5. Eggum, *Munch and Photography,* pp. 36–37.

6. Ibid., p. 46.

7. Ibid., pp. 38–40.

8. Jonathan Crary, "Techniques of the Observer," in *Techniques of the Observer: On Vision and Modernity in the Nineteenth Century* (Cambridge, Mass., and London: MIT Press, 1990).

Cat. 328a  Edvard Munch,
*Self Portrait in Profile in Front of "Youth on Beach" and Watercolors, made during eye disorders,* 1930, gelatin print, 4⅜ × 3¼ in., Munch-museet, Oslo

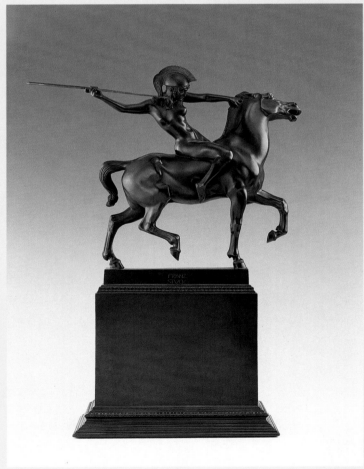

# Franz von Stuck

TETTENWEIS, LOWER BAVARIA 1863–1928 MUNICH

As a youth Stuck was known for his drawings, especially his caricatures. He studied in Munich first at the School of Arts and Crafts, where he learned the practical aspects of his craft. His drawings for the portfolio *Allegorien und Embleme* (1882–84) brought him renown, and he continued to supply illustrations and caricatures for important Austrian and German books and magazines until 1901. Stuck's paintings are frequently decorative (he often used gold paint and gold frames) and allegorical, featuring mythological and ideal subjects, such as Innocence, Sin, and fighting fauns. The paintings are marked by both eroticism and comedy, their figures having a heavily corporeal presence. Straddling the nontraditional and established art worlds, Stuck was a founding member of the avant-garde Munich Secession and a professor at the School of Fine Arts. He won a medal at the World's Columbian Exposition in Chicago in 1893 and in 1905 was elevated by the Bavarian crown to the aristocracy (hence the *von* in his name). In 1897 he married the American Mary Lind-paintner, with whom he raised his daughter from a previous relationship. The Villa Stuck, built in a Pompeiian style after his designs, was erected in Munich in 1898; furniture for the house, also after his designs, won a gold medal at the Exposition Universelle in Paris in 1900. A well-liked man and important artist, he received many official decorations and honors from governments and art associations across Europe, including a room dedicated to his works in the 1909 Venice Biennale, and more personal tributes, such as the torchlight procession through the streets of Munich on his fiftieth birthday. His work in sculpture necessitated the building of a special studio in 1914. After 1919 Stuck seldom exhibited paintings, finding that his vision was no longer in style. Instead, he made sculptures in bronze of figures extracted from his paintings.

Cat. 333 Edward Steichen, *Portrait of Franz von Stuck with the Spear-Throwing Amazon,* c. 1901, platinum print, 6 × 8 in., Nachlass Franz von Stuck Privatbesitz

Cat. 337 Franz von Stuck, *Amazon,* 1897, bronze, 14⅛ in., Private Collection

*Dorothy Kosinski*

# From Camera to Canvas:
# The Aesthetic Theater
# of Franz von Stuck

Franz von Stuck used photographs as the basis
for some of his early, magisterial symbolist com-
positions. An idealized photographic portrait of a
young girl, by Carl Teufel, is the basis for Stuck's
1889 *Innocence,* a work that radiates untainted
purity. If the lily branch is a residual allusion to
the Virgin of Christian iconography, the painting
is largely devoid of specific traditional symbolic
content. Rather, the young woman's large, glisten-
ing brown eyes, full red lips, and pale, regular fea-
tures embody the promise and innocence of her
youth. Similarly, the monumental composition
*Guardian of Paradise,* also dated 1889, is based in
part on a photographic study (cats. 334, 335). In
this case, the photograph was likely taken by Stuck
himself, in his studio. At lower left, a small prepa-
ratory study of the painting is propped up on the
floor, indicating that the general theme of the work
has already been developed. Apparently, however,
Stuck found the process of posing and photograph-
ing the model in the midst of painting an essential
aid, preparatory to continuing with the full-scale
version of the canvas. One suspects that it is pre-
cisely this intervention that enabled Stuck to in-
vest his guardian figure with such robust physicality
—a poignant counterpoint to the luminescent
impasto that surrounds him and dominates the
composition.

    Surely Stuck's use of photography is crucial
in the artist's determined efforts to be the director
of his own elaborate mise-en-scène, in which he
himself takes center stage as sovereign artist—
artist-prince, as it were—of the Munich art world.
His goal, as we shall see, was to claim a position
of preeminence, to be acclaimed artistically and
socially influential, in addition to being the head
of a wealthy and elegant family. The setting for
this egocentric and self-referential tour de force

Cat. 335 (opposite) Franz von
Stuck, *Guardian of Paradise,*
1889, oil on canvas, 98⅝ ×
66 in., Museum Villa Stuck,
Munich

Cat. 334 Franz von Stuck,
*Study for "The Guardian of
Paradise,"* c. 1889, albumen
print, 9⅜ × 6¼ in., Münchner
Stadtmuseum, Graphik- und
Plakatsammlung

was the neoclassical-Jugendstil villa he commissioned in 1898. Stuck's wife and daughter were co-opted into this elaborate theater piece, playing the roles of muse, dancer, Greek woman, Velázquez-inspired Infanta, Pallas Athena. In photography, Stuck discovered a powerfully useful tool in the articulation of this elaborate construct, his personal "total work of art."

Because the center of this biographical-aesthetic universe was the artist himself, a logical starting place is his many self-portraits as well as the photographic portrait studies that were made by an array of photographers.[1] Indeed, photographic portraits between 1901 and 1908 by the Americans Edward Steichen, Frank Eugene, and Alvin Langdon Coburn confirm Stuck's international fame (cat. 333). Stuck's many self-portraits are severe, even hieratic in their stylization. He favors a profile stance, evoking Renaissance precedents. As in almost all of Stuck's oeuvre, the outline or silhouette has an important presence, informed with a linear crispness and sometimes the precision of a bas-relief. This crucial characteristic is, as we shall see, derived in part from the transfer of the outline of forms from enlarged photographs via a transfer process. *Self-Portrait in the Studio* from 1905 (fig. 115) exemplifies this stylization. The idealization of the self-portrayal is further amplified by the depiction of the Renais-sance-classical studio interior with its friezes, the ornate gilded, coved ceiling, and, moreover, by the picture's elaborate gilt frame of Stuck's design—decorated with pilasters and sinuous Minoan-like decorations and prominently bearing his stylized name. The artist's image is imbued with the weight of tradition; his bearing and dress exude elegance and refinement. His determined, unwavering stare at the depicted canvases communicates an unflag-ging, even heroic artistic determination, yet Stuck's self-portraits intentionally obfuscate or mask the inner self. Psychological veracity is beside the

point in the artist's elaborately constructed, nar-cissistic universe.

Several photographs have been preserved of Franz von Stuck and his wife, Mary Lindpaintner, at an artists' costume ball in 1898, just a year after their marriage (cat. 332). The couple is dressed in Roman costume of togas and laurel wreaths. Their self-conscious and stiff stylization makes these photographs seem ludicrous to today's eyes and, in fact, inspired derision from the noted contem-porary critic Julius Meier-Graefe.[2] Nonetheless, these photos were the basis for paintings and, moreover, cannot be dismissed as curiosities, because they are entirely consonant with Stuck's larger agenda of continuously augmenting his own elaborate mythologizing.

Stuck's unique use of photographs is thrown into relief by comparing it to the photographic explorations of contemporaneous artists. The strenuous control of every detail, the concentra-tion on an artificial construct demanding costumes, props, and scenery is light years away from Pierre Bonnard's or Edouard Vuillard's casual snapshots of their everyday, familiar surroundings. Stuck's dialogue with photography is devoid of the intro-spective, self-analytical, psychologically fraught

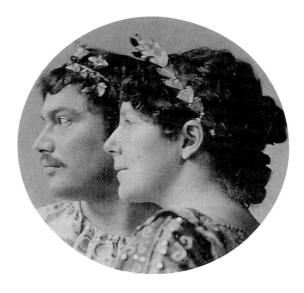

essence of the photographic experiments of Edvard Munch, for instance.[3] In comparison to Stuck's output, the absence of self-portraits in the oeuvre of Gustave Moreau renders that art-ist faceless, his work devoid of self-promotion.

Stuck furthered his self-promotion with his involvement in the commercial distribution of reproductions of his works through an ongoing contractual relationship with the prestigious Munich-based international art photography firm Franz Hanfstaengl. This lithography firm, founded by Hanfstaengl in 1833, soon embraced the 1839 invention of photography as its central medium.[4]

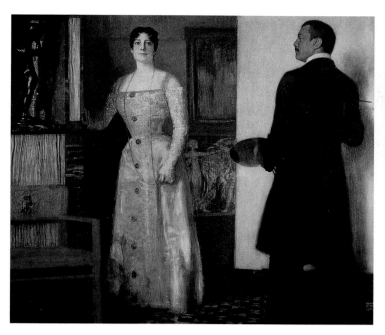

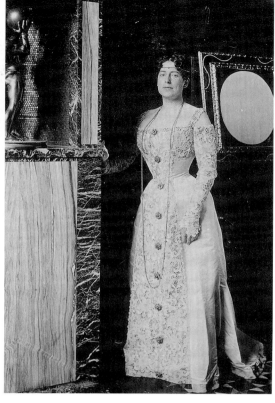

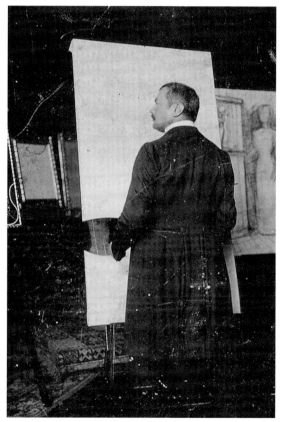

Stuck was friends with Hanfstaengl's son, Edgar, who took over the enterprise. Hanfstaengl purchased the rights to photographs of works of art, which were printed in a deluxe format, with the highest attention paid to detail, and distributed to art galleries and art publishers in exchange for lavish sums of money. Handsome albums of Stuck's works appeared in 1898 and 1909. Often these high-quality photographic reproductions were presented framed in exhibitions, contributing to the perception of their value and decorative presence. The decorative power inherent in every aspect of Stuck's works—informed by his own attention to setting, framing, clarity of composition, and strength of color—ensured the forcefulness of these photo reproductions. Stuck's ready collaboration with Hanfstaengl reveals his keen appreciation of the market potential of photography and an eagerness to exploit its potential of increasing his fame and the notoriety of his already celebrated works.

Because of their importance as models, one must carefully consider how wife, Mary, and daughter, Mary, functioned within Stuck's self-centered universe. One is left to speculate how the new bride accommodated herself to the imposing villa, in which each room was adorned with an elaborate altar devoted to the art and aesthetics of the master of the house. Stuck's new wife, Mary Lindpaintner, was purportedly a great beauty, but her image is radically subsumed into the greater purpose of Stuck's aesthetic mission. In the monumental *Self-Portrait of the Artist and His Wife in the Artist's Studio* (cats. 339, 340; fig. 116), Mary is indeed very beautiful, years shaved away through idealization. She is regal in stature and appropriately adorned as the partner, muse, and model of the great artist. Somehow, however, it is the

Fig. 116 (left) Franz von Stuck, *Franz and Mary Stuck in the Artist's Studio,* 1902, oil on canvas, Private Collection

Cat. 340 (right, top) Franz von Stuck, *Study for "Franz and Mary von Stuck in the Artist's Studio" (Mary),* February 1902, set of 4 gelatin silver prints on matting, 4⅛ × 3⅛ in., 4⅛ × 3¼ in., 6⅝ × 4¼ in., 6½ × 3⅞ in., Münchner Stadtmuseum, Graphik- und Plakatsammlung

Cat. 339 (right, bottom) Franz von Stuck, *Study for "Franz and Mary von Stuck in the Artist's Studio" (Franz),* February 1902, gelatin silver print, 6⅛ × 3⅞ in., Münchner Stadtmuseum, Graphik- und Plakatsammlung

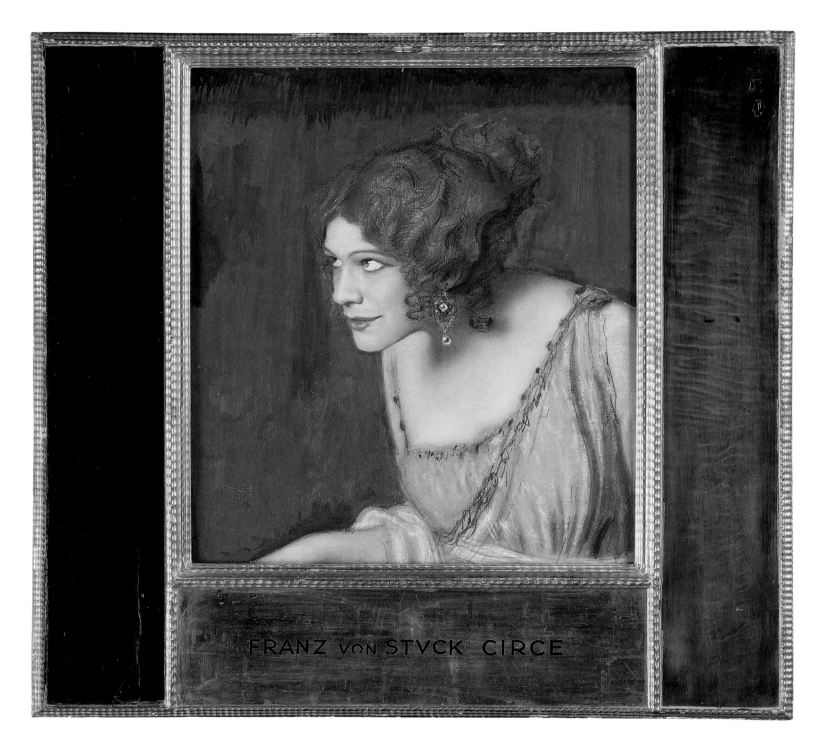

FRANZ von STVCK CIRCE

Cat. 346  Franz von Stuck,
*Tilla Durieux as Circe,*
c. 1912–13, mixed media
on paper, 21 1/16 × 18 1/4 in.,
Private Collection

Cat. 345 (opposite, bottom)
Attributed to Mary or Franz
von Stuck, *Study for "Tilla
Durieux as Circe,"* c. 1912–13,
gelatin silver print, 15 1/2 ×
11 5/8 in., Museum Villa Stuck,
Munich

painter himself, garbed in an elegant black frock coat, against an as-yet-white, empty canvas, who dominates the composition. One can argue that wife Mary—with all her noble bearing and personal beauty—is still but a prop among others, such as the statue of the Athlete, the "serpentine dancers," even Stuck's award-winning red velvet chair.[5]

The role of Mary, Stuck's daughter, is particularly interesting, in that the artist seemed especially to favor her as a model, repeatedly photographing her in straight portraits or in variously-posed roles—Infanta, Greek woman, dancer (cats. 341, 342, 343). The forthright intensity of many of these photographs and paintings allows us to consider them as real portraits. With the photographic studies of Mary, we come perhaps as close as possible to peeking into the psychological behind-the-scenes truth of Stuck's world. Perhaps the child's directness can pierce the role-playing, or alternatively, the girl, because of her youth, is especially able at playacting.

Several biographical facts intensify this psychologically inflected inquiry. Mary was the product of Stuck's liaison with Anna Maria Brandmair, born just one year before Stuck's marriage to Mary Lindpaintner. Curiously, Stuck and his bride adopted this child, although the twelve- and thirteen-year-old children of Lindpaintner's previous marriage (she was widowed) were not allowed to live in Stuck's newly completed villa.[6] It is hardly farfetched to speculate that these details reveal faults in Stuck's carefully constructed artistic world.

These particular facts are further complicated by the yet open question of authorship: Did Mary or Franz von Stuck take many of the photographs? Did Mary take the photographs of Stuck's daughter? Is Mary Lindpaintner an accomplice in Stuck's idealization, ennobling him in the atelier, endowing him with the attributes of prince or caesar?[7] There is evidence that Mary knew how to use Stuck's glass-plate camera and that she too worked

Cat. 341 (left) Attributed to Mary or Franz von Stuck, *Mary in Velázquez Costume,* 1908, gelatin silver print, 11⅝ × 15¾ in., Museum Villa Stuck, Munich

Cat. 342 (middle) Attributed to Mary or Franz von Stuck, *Mary as a Greek,* 1910, gelatin silver print, 15¾ × 11¾ in., Museum Villa Stuck, Munich

Cat. 343 (right) Attributed to Mary or Franz von Stuck, *Mary as a Greek,* 1910, gelatin silver print, 15⅝ × 11⅝ in., Museum Villa Stuck, Munich

Cat. 347 Franz von Stuck,
*Crucifixion of Christ (Kreuzi-
gung Christi),* 1913, distemper
on canvas, 74¾ × 65 in.,
Museum der bildenden
Künste, Leipzig, Germany

in the cellar darkroom.[8] As Jo-Anne Birnie Danzker suggests, the attribution of the numerous photographs would specifically offer an important clue about the highly charged and dramatically theatrical eroticism that plays out so importantly in Stuck's sadoerotic images *(Sin, Kiss of the Sphinx, Salomé)* and depictions of powerful female figures *(Amazon* and *Athena).* The photographic studies of the actress Tilla Durieux in her role as Circe von Calderón are a case in point (cats. 345, 346). In one pose the actress leers ominously, her head inclined, her eyes cast upward, her visage endowed with the aura of a woman possessed. In another photograph, the actress's forceful and dynamic stage presence radiates—her eyes glisten, her glance is sharp, her lips parted as though on the verge of speech.

Stuck himself frequently posed with forceful energy and unself-conscious abandon for various photographic studies for specific paintings. He apparently harbored ideas about the poses of each figure but even more specifically the intended psychological tenor required, and clearly was convinced that he alone could best communicate the desired emotion as well as the specific posture and gesture. The various studies for *Crucifixion I* and *II* (cats. 331, 347) demonstrate how he accumulated elements that make up the overall composition and gradually amplified the significance of each directed stare and calculated pose. This late crucifixion is a highly dramatic and expressive interpretation of the moment of Christ's death. His limp body is brilliantly illuminated by a white, unearthly light. The rest of the painting is bathed in an eerie blue. The sun, however, is a dull blood-red orb. Aspects of the canvas are highly simplified—for instance, the crosses of the two robbers are shown as massive, looming shadows, without distracting details. At least three preparatory photographs

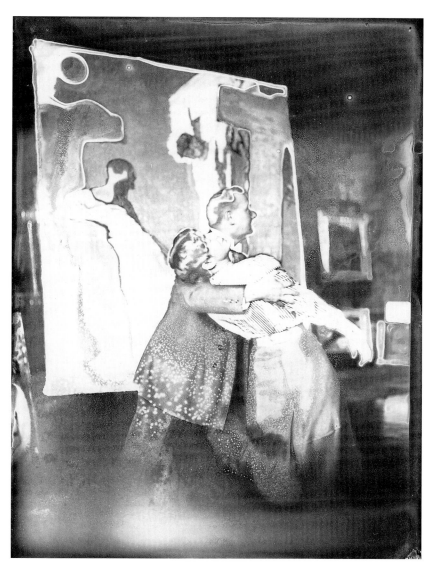

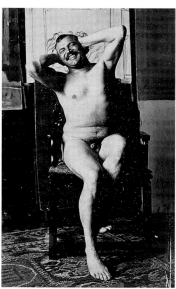

Cat. 331 (top) Anonymous, *Study for "Kreuzigung Christi,"* c. 1913, modern print from original negative, 7⅛ × 5⅛ in., Fotomuseum im Münchener Stadtmuseum

Fig. 117 (bottom, left) Attributed to Mary Stuck, *Von Stuck Posing for "Battle of the Sexes,"* c. 1905, gelatin photographic print, Estate Franz von Stuck

Fig. 118 (bottom, right) Attributed to Mary Stuck, *Von Stuck Posing for "Dissonance,"* c. 1905, gelatin photographic print, Estate Franz von Stuck

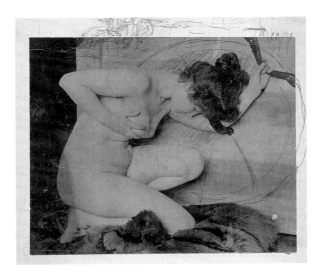

Fig. 119  Franz or Mary von Stuck, *Photograph of Model Posing for "Wounded Amazon,"* with Overdrawing by Stuck, c. 1904, gelatin print, Estate Franz von Stuck

exist, revealing the attention Stuck gave to the poses of the mourning figures of John and Mary. The photographs in fact show the as-yet-unfinished canvas in the artist's studio, backdrop to the staged figures of Stuck himself, once with his daughter, once with his wife, posing for the miserable, swooning couple. These photographs are precious evidence of the integral function of the photographic medium in Stuck's resolution of some of his most powerful, monumental canvases. Stuck throws himself fully into a fighting stance in his studies for *Battle of the Sexes* (fig. 117). In the remarkable study for *Dissonance* (fig. 118), Stuck plays directly to the camera with an exuberance and playful enthusiasm. In their athletic forcefulness and psychological immediacy, the photographic studies for many of the paintings far exceed simple studio preparations.

He also engaged with the photograph on another, technical level, drawing over the photographic image, changing and refining aspects of the composition. This is evident, for instance, in photographic studies for *Wounded Amazon* (fig. 119), in which Stuck manipulated the position

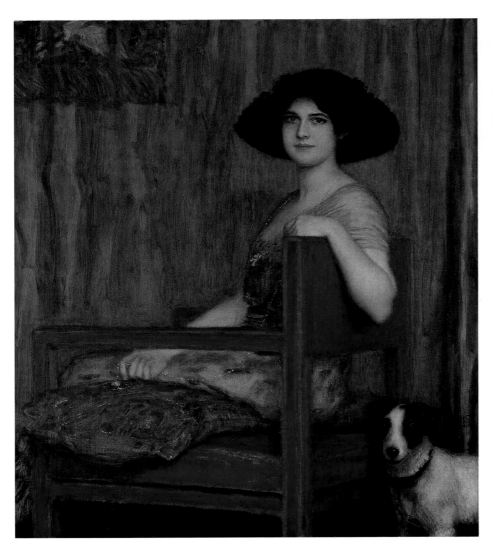

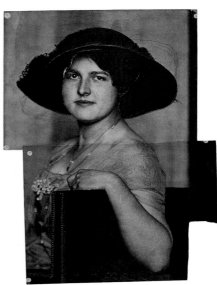

Cat. 348 (above) Attributed to Mary or Franz von Stuck, *Mary with a Dark Hat,* 1915, gelatin silver print, 22⅞ × 17⅜ in., Museum Villa Stuck, Munich

Cat. 349 (left) Franz von Stuck, *Mary in a Red Chair,* 1916, oil on canvas, 42⅛ × 36¾ in., Nachlass Franz von Stuck Privatbesitz

of the female's arm and how the hand grasps the oversized shield, calculating how the body of the Amazon, coiled in on itself with pain, relates to the curve of the massive shield. Indeed, this juxtaposition of white, softly modeled body and the overpowering form of the intensely colored shield is the focus of the work of art, and Stuck perceptively refines this crucial relation between figure and object. In *Mary with a Dark Hat* (cat. 348), pencil lines indicate the artist's deliberations about the exact contours of the broad-brimmed hat. Furthermore, in this photographic print we see evidence, in the form of sharply incised lines, of how the photograph formed the basis of the finished oil, and especially for the design of the composition's broad ornamental areas (cat. 349).

Stuck apparently scratched the surface of the photograph, transferring the image with a sharp instrument (pencil or needle) onto the canvas, using a type of carbon paper tacked below. This transfer technique allowed him to engrave the hard-won facial or body gestures directly into the painting. Stuck gives his attention to fine details but most clearly to the powerful silhouettes of the figures. Another clear example of this technique is apparent in Stuck's manipulation of the photograph of Mary's daughter, Olga Lindpaintner, of about 1903 (fig. 120). The photographic print has been deeply incised with a sharp instrument. The embossed lines on the reverse are covered with the traces of the carbon paper that was layered between it and the canvas. Stuck, in revisiting the beautiful photograph of the young woman, emphasized the silhouette, concentrating on the outlines and certain adornments in the hair, investing the image with an arabesque energy.

Stuck's dialogue with photography was many layered. He orchestrated the scenes, creating elaborate tableaux vivants, choosing costumes and backdrops. He deftly directed the actors, establishing precisely the required pose and eliciting the desired emotion. He played on both sides of the lens—effective actor and talented cameraman. He also developed (with Mary) the prints in the darkroom, producing images of high quality. Stuck was apparently at ease with all aspects of the technology and did not hesitate to incorporate photography into almost all the different phases of his work. Photography emerges as an essential tool in Stuck's elaboration of narrative detail, as well as in his orchestration of decorative, reductive patterns, an integral element, therefore, of Stuck's masterful Jugendstil oeuvre.

Fig. 120  Mary or Franz von Stuck, *Olga Lindpaintner*, c. 1903, gelatin print, Museum Villa Stuck

### NOTES

1. See Ulrich Pohlmann, "'Als hätte er sich selbst entworfen,' Die (Selbst-)Darstellung Franz von Stuck in Photographie, Malerei und Karikatur," in *Franz von Stuck und die Photographie* (Munich: Museum Villa Stuck; Prestel, 1996), pp. 27–37.

2. Julius Meier-Graefe, *Entwicklungsgeschichte der modernen Kunst* (Stuttgart: J. Hoffman, 1904), p. 710.

3. See Pohlmann, "'Als hätte er sich selbst entworfen,'" p. 36, comparing Stuck's self-portrayals with those by Edvard Munch, Arnold Schönberg, Leon Spilliaert, August Strindberg, and Stanislaw Ignacy Witkiewicz (Witkacy).

4. See Helmut Hess, "Stuck und Hanfstaengl—Künstler und Verleger," in *Franz von Stuck und die Photographie*, pp. 116–26, for an in-depth analysis of the reproductions of Stuck's most famous works.

5. Jo-Anne Birnie Danzker et al., "Franz von Stuck und die Photographie," in *Franz von Stuck und die Photographie*, pp. 9–15.

6. Ibid., p. 12.

7. Ibid., pp. 12–13; see also J. A. Schmoll gen. Eisenwerth, "Photographische Studien zur Malerie Franz von Stucks," in ibid., pp. 16–26.

8. Birnie Danzker, "Franz von Stuck und die Photographie," p. 9.

# Félix Vallotton

LAUSANNE 1865–1925 PARIS

Vallotton moved in 1882 from his native Switzerland to Paris and studied at the free Académie Julian. He remained close to Switzerland throughout his life, vacationing there annually and sending paintings to exhibitions. He made his first wood-cuts, marked by extreme contrasts of large areas of black and white in 1891, after seeing Japanese prints in 1890. By 1892 he was affiliated with the Nabis and the next year began a lifelong friendship with Edouard Vuillard. Thadée Natanson's journal *La Revue blanche* was an important outlet for Vallotton's prints in the mid-1890s, and Vallotton also contributed illustrations to books and periodicals in France, Germany, Great Britain, and the United States. In 1899 he married Gabrielle Rodrigues-Henriques, a wealthy widow with three children; the following year he became a naturalized French citizen. Like many other artists at the turn of the twentieth century, Vallotton worked in different media (bronze sculptures) and wrote art criticism (for the *Gazette de Lausanne,* 1890–97) and plays, some of which were produced. With Vuillard, among others, in 1903 he founded the Salon d'Automne as an alternative to both the official Salon and the Salon des Indépendants; he exhibited there annually. In 1910 he had his first solo show at the Galerie Druet. Too old to enlist in World War I, he was for a short time a stretcher carrier and then visited the front to gather material for the article "Art and War." His paintings—whether portraits, nudes, domestic interiors, or composed landscapes—like his prints, are characterized by large areas of unmodulated color, which establish rhythms of darks and lights across the surface. His nudes in particular, with their sinuous outlines, reveal, within their close study of the work of Jean-Dominique Ingres, his own hard-edged realism.

Cat. 358 Félix Vallotton, *The Laundry Woman, The Blue Room (La Lingère, Chambre bleue),* 1900, tempera on board laid on canvas, 19⅝ × 31½ in., Dallas Museum of Art

*Eik Kahng*

# Félix Vallotton's
# Photographic Realism

Little has been published regarding the role of photography in the strange realism of Félix Vallotton. What little we know through his correspondence and journals seems to indicate the artist's enthusiasm for the camera. There is no evidence of any wariness on his part as to the future "discovery" of his strong interest in photography.[1] However, as in the case of the French realist Gustave Courbet,[2] the defenders of Vallotton's critical legacy have been slow to highlight the artist's involvement with the photographic medium. Very few of Vallotton's extant photographs have been published, and when photographs have been linked with specific paintings,[3] the nature of the interrelationship between photograph and painting has remained largely intuitive rather than historically substantiated. Even more so than in the case of Edouard Vuillard, factual information as to Vallotton's history as a photographer has remained sketchy at best. We do know that, like Pierre Bonnard and Vuillard, his fellow Nabis and lifelong friends, the Swiss artist seems to have reveled in the possibilities of the Kodak camera. Like those of Vuillard and Bonnard, Vallotton's photographs exhibit many of the same themes and formal effects the artist explored in his paintings. However, the unique visual characteristics of the Kodak photograph have an obvious stylistic affinity with Vallotton's peculiar brand of realism in a way that they do not in the cases of Bonnard and Vuillard.

The art of the Swiss-born artist Vallotton remains something of an enigma for American audiences, partially because of the limited exposure it has received in the twentieth century as compared with the oeuvres of the better-known Bonnard or Vuillard. The first and last major exhibition devoted to Vallotton in the United States was presented by the Yale University Art Gallery in 1991. Usefully, this exhibition attempted to represent the plenitude of the artist's long career, rather than dwelling on the more familiar episode of his youthful experiments as a card-carrying Nabi. Like that of Henri de Toulouse-Lautrec, Vallotton's graphic work tends to overshadow his achievements as a painter, even though he obviously privileged the traditional medium of oil paint. Equally adept as an incisive portraitist, perceptive landscape and still-life painter, and ambitious history painter, Vallotton possessed undeniable technical facility, as was amply demonstrated in the 1991 exhibition. However, like those of Bonnard and Vuillard, Vallotton's mature style is often less familiar than his radical symbolist works of the 1890s, when his subject matter, abstract compositional methods, and daring use of bold color most closely resembled the works of his fellow Nabis. For example, the Dallas Museum's *The Laundry Woman, The Blue Room* of 1900 (cat. 358) is closely related to the intimate interiors of both Vuillard and Bonnard. The dry touch, theatrical lighting, arbitrary palette, and domestic theme are characteristic of the work of the Nabis during these years. This is the Vallotton who has habitually been remembered, despite the fact that he went on to develop a highly individual artistic vision that has little in common with these early paintings. The greater importance given to the Nabi moment is made explicit in the major exhibition devoted to the symbolists held at the Kunsthaus Zürich and the Grand Palais in Paris in 1993–94, in which Vallotton was, of course, included. That exhibition was defined by the transitional two-year period of 1888–1890, a reminder of the extremely fecund but brief period of efflorescence of the Nabi movement in general.

The alienness of Vallotton's art is not only a consequence of his limited exposure outside Europe. As has always been recognized, there is a singular allusiveness to Vallotton's painting that sets him apart from the other Nabis—an allusiveness born of his idiosyncratic range of pictorial reference. As a Swiss artist active in the Parisian art world at the turn of the century, Vallotton retained an allegiance to his own heritage, apparent in his frequent citation of the great masters of the Northern European tradition.[4] Vallotton's earliest paintings clearly reflect his admiration for Cranach, Dürer, Holbein, and Vermeer among others, which was then merged with a predictable avant-garde inclination toward the exotic look of Japanese art. The vivid but unmodulated quality of his use of color can be related to the eighteenth-century Swiss realist Etienne Liotard, whose work Vallotton must have known, and can also be seen as empathetic to the planar realism of Henri Rousseau. At the same time, Vallotton's investment in avant-garde painting in Paris is very clear. Like Courbet, Degas, and Manet before him, Vallotton strove to infuse the iconography of past art with the contemporaneity of the present, thereby fulfilling a modernist agenda of disruptive, even

insolent effrontery. Although never far from the technical facility gleaned from his youthful apprenticeship to the academic painters Jules Lefebvre and Gustave Boulanger, Vallotton employed his mastery of the great tradition as a means of questioning its very legitimacy. It was toward this end that the photograph seems to have functioned for Vallotton as a particularly useful tool.

Vallotton's invitation to the art-historical game of visual citation and influence is quite calculated. Take, for example, *Portrait of Gabrielle Vallotton Seated in a Rocking Chair* (cat. 353). The subject is typical of seventeenth-century Dutch genre painting. A woman—in this instance, Vallotton's recent bride, Gabrielle—is shown gazing mildly at the viewer, her busy fingers automatically continuing to work at the knitting she holds in her lap. The close perspective, the full frontality of Gabrielle's calm regard, the smile frozen on her lips, all might be said to compare closely with a seventeenth-century precedent such as Vermeer's *Lady Writing,* now in the National Gallery of Art, Washington, D.C. (fig. 121). However, as usual, one cannot help but suspect Vallotton's intention in so obviously clothing his wife in the idealized role of Vermeer's peaceful maids. The irony of Gabrielle's

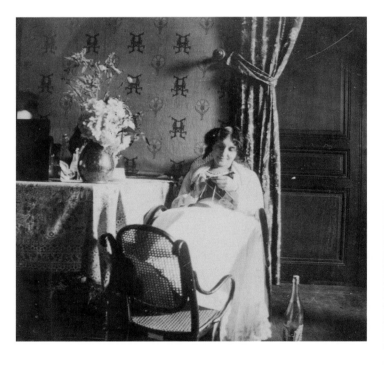

Cat. 357 Félix Vallotton, *Gabrielle Vallotton Knitting in a Rocking Chair,* c. 1899–1902, modern facsimile, 3½ × 3½ in., Archives Jacques Rodrigues-Henriques

Fig. 122 Johannes Vermeer, *The Lacemaker,* c. 1669–70, oil on canvas mounted on panel, Musée du Louvre, Paris

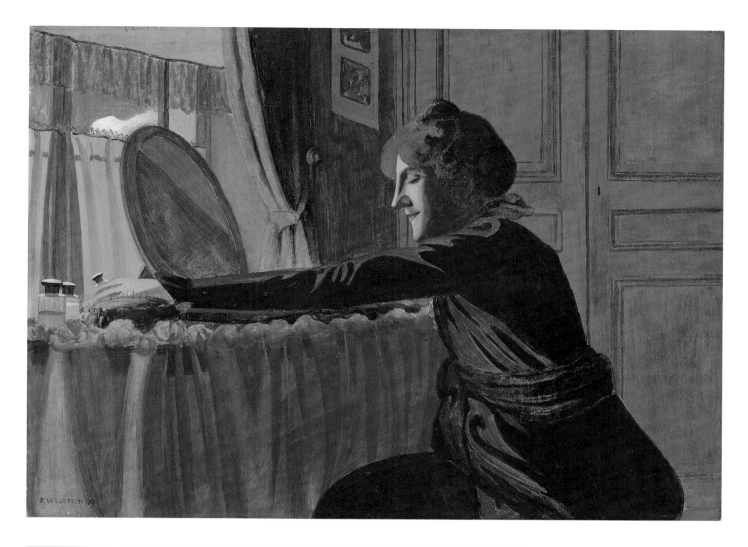

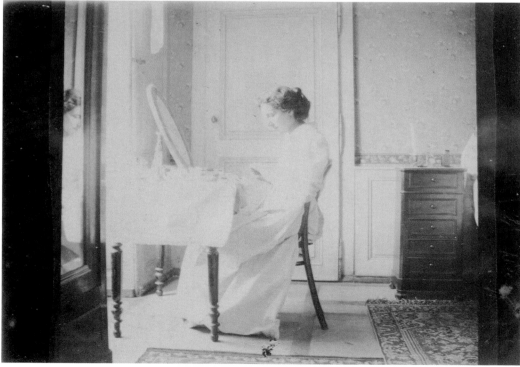

Cat. 356  Félix Vallotton, *Madame Vallotton at Her Dressing Table,* 1899, tempera on cardboard, 22⅝ × 30¾ in., Kunsthaus Zurich

Cat. 359  Félix Vallotton, *Gabrielle Vallotton Manicuring Her Nails,* 1901, modern facsimile, 3½ × 4¾ in., Archives Jacques Rodrigues-Henriques

womanly affectation as an industrious housewife cannot have been lost on the artist's friends. After all, Gabrielle, who was the daughter of the influential dealer Alexandre Bernheim,[5] was Vallotton's ticket to the kind of bourgeois home life that had been the very target of his graphic and painted satires of the 1890s. Does Vallotton depict Gabrielle smiling benevolently, or is that more of a smirk? Is she caught in an incidental moment of true daily life, or is she dressed up as a Vermeer at the bidding of her self-apologetic husband?

A photograph taken by Vallotton of Gabrielle in a similar pose makes the allusion to seventeenth-century Dutch precedents even more clearly (cat. 357). The stiff wings of hair enframing Gabrielle's downcast face call to mind Vermeer's *Lacemaker* (fig. 122), as does the flood of light from an unseen window. Isabelle de la Brunière and Philippe Grapeloup-Roche have implied that the photograph, taken sometime between 1899 and 1902, when the Vallottons resided in an apartment on the rue Milan in Paris, must have predated the painting. There is no way of verifying this assumption. The vast differences in perspective, decorative pattern, and still-life objects would seem to belie any direct correspondence between photo and painting. However, comparison with the photograph does reveal how in the painting Vallotton has in fact adapted, rather than literally copied, the simplification of form created by the stark contrasts of the black-and-white Kodak snapshot, thereby securing the effect of photographic authenticity. For example, the sharp contrast be-

tween overexposed, illuminated areas in the photograph, as compared with the strong outline of the chair in the foreground, is very similar to the curved line of the chair against the simplified expanse of Gabrielle's gown in the painting. The photographic clarity of incidental details, such as the regular pattern of the textured cloth wall covering, or the glass surface of the bottle at Gabrielle's side, is translated in the painting into competing visual foci. There is an unaccountable coloristic clarity in the description of the chrysanthemums behind Gabrielle's relatively obscured visage, in the blob of black yarn that seems to float on the table, and in the crisp, energetic outlines of the flower-sprigged pillow erupting from the slow curve of her shoulder.

Similarly, comparison between a photograph of Gabrielle filing her nails at her makeup table (cat. 359) and a painting of a similar subject (cat. 356) yields many of the same points. Here the photograph is, again, replete with references to seventeenth-century Dutch genre painting. Light floods into the room from an unseen window at the left. Gabrielle sits, absorbed in her mundane task of grooming, oblivious to the camera. A mirror, another element common to the domestic interiors of Vermeer, underscores the analogy between camera and mirror as reflexive records of a transient reality seen from a subjective point of view. The overt differences between photograph and painting, again, cast some doubt as to any necessary dependence between the two. The painting moves the viewer closer to the sitter. The reflection in the mirror is more visible to the viewer, and Gabrielle is shown as though reaching for one of the ointment bottles on her vanity table. However, the same exaggeration of simplified areas of light and dark as recorded by the light-sensitive Kodak camera can be seen in the painting. In the painting the folds of Gabrielle's gown are harshly modeled, as is her prominent nose, in a way that effects the same simplifications of form of the photograph.

The resultant tension between photographic-like specificity and art-historical pastiche is at the heart of Vallotton's ironic realism. Many of the same points can be made in studying side by side the photograph by Vallotton of Gabrielle seated before a fireplace (cat. 354) and the painting called *Madame Vallotton and Her Niece Germaine Aghion* (cat. 355). Here the correspondences between photo and painting are in some respects precise. The exact position of Gabrielle's body in the photograph is duplicated in the painting, as are such details as the tiled fireplace and the vase of flowers on the mantel. More important, Vallotton has again adapted the schematization incidental to the harsh chiaroscuro produced by the Kodak camera to effect the look of an objective photograph in the painting. This seeming objectivity is then made to

Cat. 354 Félix Vallotton, *Gabrielle Vallotton Seated before a Fireplace*, 1899, modern facsimile, 3½ × 3½ in., Archives Jacques Rodrigues-Henriques

Cat. 355 (opposite) Félix Vallotton, *Madame Vallotton and Her Niece Germaine Aghion*, 1899, oil on cardboard, 19⅜ × 20¼ in., The Art Institute of Chicago

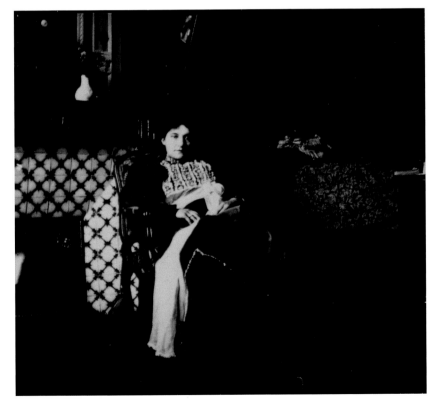

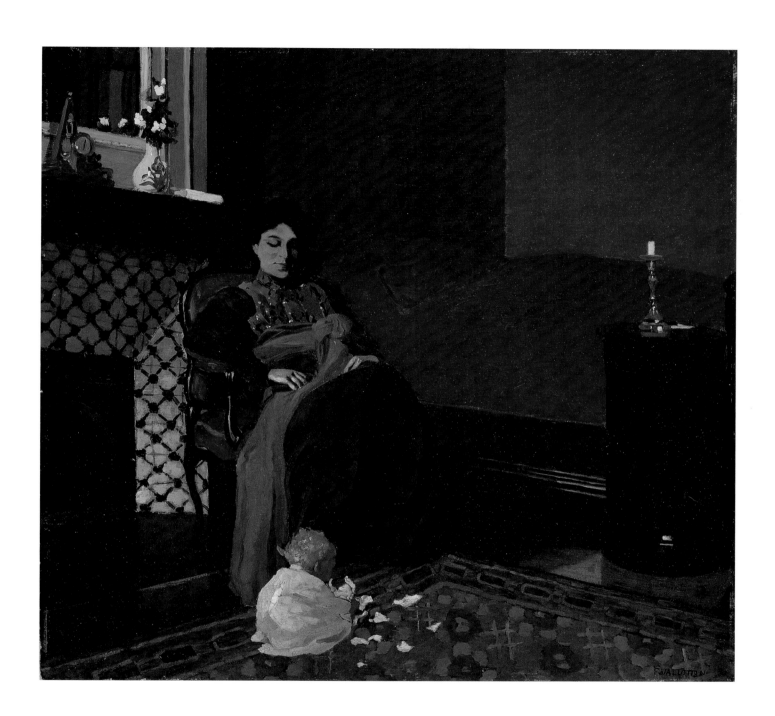

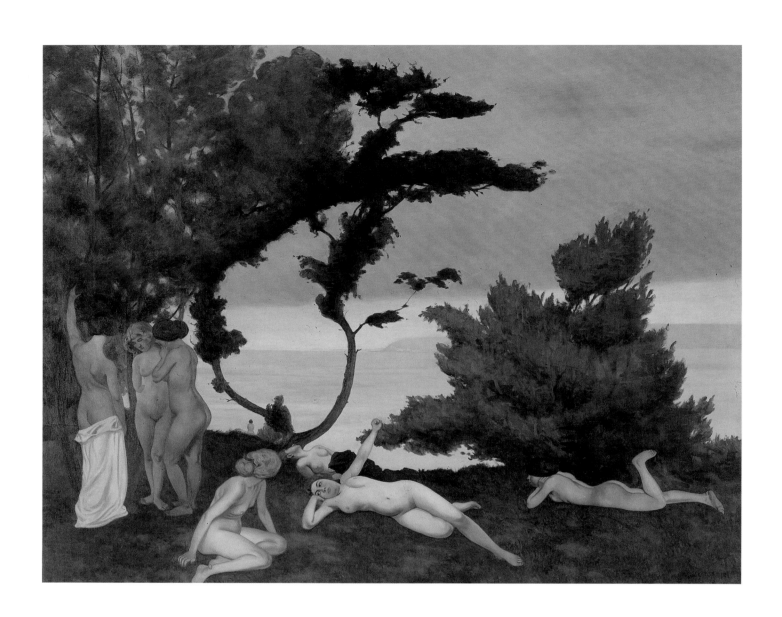

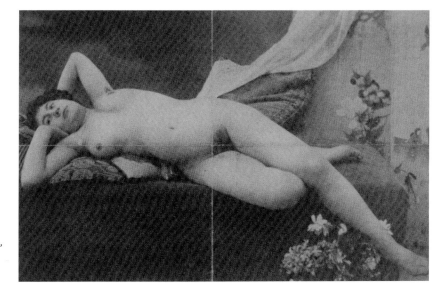

Cat. 360 (opposite) Félix Vallotton, *Summer (Bathers in Repose),* 1912, oil on canvas, 79⅛ × 98⅝ in., Musée cantonal des Beaux-Arts de Lausanne, Switzerland

Fig. 123 Anonymous, *Nude Model,* from *"Academic Studies"* (1908), photograph

coexist with the typically symbolist suggestiveness of the scene: the prominent candle to the far left of the composition, the addition of a crouching child on whom Gabrielle gazes serenely as the infant inexplicably shreds a piece of paper into bits, the blood red of the enormous bed looming behind. This interior in red resonates with an implied, if ambiguous, symbolic meaning. It is as though Vallotton has taken one of Mary Cassatt's impressionist scenes of mother and child and made it unsettlingly resistant to any comfortable message of motherly affection.

Like Courbet, who was a devoted painter of the female body, Vallotton also used the stock daguerreotypes of the nude intended as photographic substitutes for the live model.[6] In such pastoral idylls as *Summer* (cat. 360), the tension between real and ideal is deliberately left out in the open. Vallotton's piecemeal method of composition is confirmed when we compare the central bather with outstretched arm to an anonymous photograph published in 1908 in the book *Academic Studies* (fig. 123). Vallotton has obviously adapted this specific body for his composition, retaining its unidealized tubular rotundity and individualized specificity, while inventing the oddly extended left arm as a kind of abstract fulcrum for the composition as a whole. As it did to Courbet, the photographic *académie* must have appealed to Vallotton's realist sensibilities in that it records mercilessly, not the suave, elegant, impossibly clean bodies of Jean-Dominique Ingres's *Turkish Bath* (Musée du Louvre, Paris), but the true

variety of the female form in all its unsanitized particularity. In such photographic sourcebooks of the female nude, real bodies are inserted into the erotic poses of the painted odalisque, thereby theatricalizing the tension between artifice and reality that was already a part of Vallotton's ambitions in paint. Again, Vallotton manipulates the look of the photograph to retain the indices of photographic verism in the painting. The exaggerated shadows of the photograph are retained in the painted version of the centralized nude, so that the underside of her belly and the sharp V of her clamped thighs are emphasized. The modeling of each body is distinct from the others, creating a scatter effect not unlike that seen in the utopian pastorals of Puvis de Chavannes. In Vallotton's updated version of the pastoral, the conventional identification between female body and landscape is undone. These "real" bodies seem to float in an airless abstraction, exposing the mythical conceit of woman and nature as childish make-believe.

We know from his letters that Vallotton shared Vuillard's delight in the ease with which the camera could capture the natural landscape.[7] The port of Honfleur on the Normandy coast was a favorite motif, which he recorded in both photographs and paintings. As though anticipating the invention of the zoom lens, the painting *Boats in the Port of Honfleur, Evening Effect* (cat. 361) brings the viewer closer to the motif recorded in a photograph (cat. 352), taken by the artist on one of his frequent jaunts to the old port. Again, despite the common subject, there is no reason to believe that

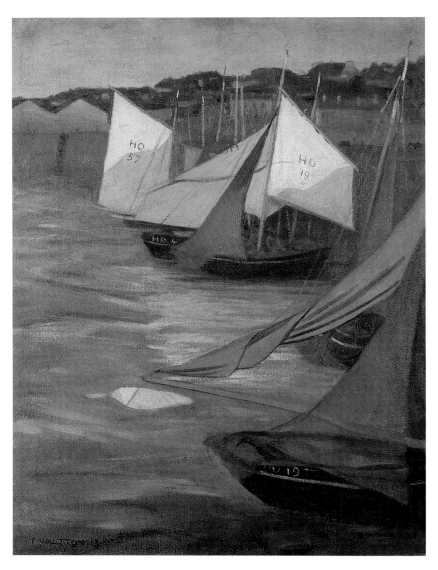

there is any direct correspondence between photo and painting. And yet, the painting does pick up the abstract patterning of the black-and-white photo, which transforms the flaccid sails of the boats into shards of crisscrossing diagonals. In the painting the sails are further simplified, with sharply delineated shadows that serve to flatten them into geometric shapes. As in the photo, the foreground element is abruptly cropped by the right edge of the canvas. The perspective, as in the woodblock prints of Hokusai and Hiroshige, remains blatantly ununified, with a rapid recession of objects established through their relative upward placement in the composition. In this instance it would seem that photograph and painting do not bear any direct dependence on one another. As in the case of Vuillard, comparison of photographs and paintings of like subject matter cannot substantiate any assumed priority between photograph and painting. Rather, the photograph confirms the consistency of the artist's thematic and pictorial interests, where the artist could discover compositional devices that he also employed in his painted compositions.

These few published examples of Vallotton's work as a photographer raise more questions than they answer. As in the case of Vuillard, no firm conclusions can be drawn without recourse to all of Vallotton's extant photographs. It is to be hoped that the eventual publication of the catalogue raisonné, along with the extant photos preserved in the Vallotton family archives, will help to clarify those specific cases in which photographs and paintings are clearly intertwined.[8]

Cat. 361 Félix Vallotton, *Boats in the Port of Honfleur, Evening Effect,* 1913, oil on canvas, 28¾ × 21¼ in., Private Collection, Switzerland

Cat. 352 Félix Vallotton, *The Old Port of Honfleur at Low Tide,* n.d., modern facsimile, 3½ × 3½ in., Archives Jacques Rodrigues-Henriques

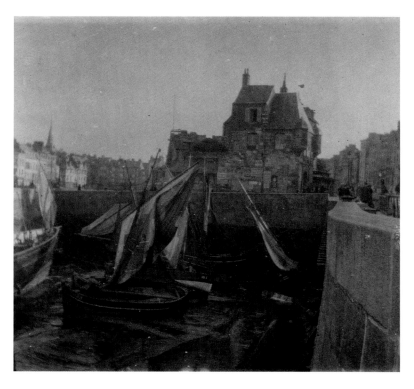

NOTES

1. See, for example, John Klein, "Portraiture and Assimilation of the 'very singular Vallotton,'" in Sasha M. Newman, *Félix Vallotton: A Retrospective* (New Haven, Conn.: Yale University Art Gallery; New York: Abbeville Press, 1991), p. 275 n. 14. He points out several instances in Vallotton's diary where the artist noted the use of photographs as direct models for painted portraits.

2. For a recent discussion of the role of photography in the work of Courbet, see Dominique de Font-Réauix, "Courbet et la photographie: L'exemple d'un peintre réaliste, entre vérité et réalité," in *L'Art du nu au XIXe siècle, le photographe et son modèle* (Paris: Bibliothèque nationale de France, 1997), pp. 84–91. Font-Réauix comments on the reluctance on the part of Courbet's earliest defenders to acknowledge the actual importance of photography in his work, most likely as a means of shoring up the controversial painter's critical reputation as an inventive genius (pp. 85–86).

3. See Isabelle de la Brunière and Philippe Grapeloup-Roche, "La Photographie au service de la peinture," in *Félix Vallotton* (Saint-Tropez: L'Annonciade Musée de Saint-Tropez, 1995), pp. 30–43. This essay was also published as "Vallotton and the Camera: Art and the Science of Photography," *Apollo* 99 (June 1994): 18–23.

4. For more on this subject, see Rudolf Koella, "Vallotton und die altdeutsche Kunst," in *Félix Vallotton* (Munich: Hirmer Verlag, 1995), pp. 11–26.

5. Vallotton married Gabrielle Rodrigues-Henriques on May 10, 1899. From then on, as Vallotton surely realized would be the case, his financial security was assured. Gabrielle was the widowed mother of three children, ranging in age from seven to fifteen. Vallotton's marriage to Gabrielle also signaled the end of his relationship with the working-class seamstress Hélène Chatenay, with whom he had lived since 1892. Hélène died alone and poor in 1910.

As Sasha M. Newman has observed, Vallotton's marriage to Gabrielle meant that "three of Vallotton's most important youthful contacts were abruptly disrupted: Charles Maurin, Hélène Chatenay, and *La Revue blanche* itself in 1903" (introduction to *Vallotton,* p. 36.) Charles Maurin, a French artist who was a student and then professor at the alternative Académie Julian, had introduced the youthful Vallotton to the radical society of bohemian Paris as well as to the expressive possibilities of the woodcut.

6. See, for example, the daguerreotypes reproduced on pp. 15–17 in *Malerei und Photographie im Dialog: Von 1840 bis Heute* (Bern: Beuteli Verlag, 1977).

7. See the letters from Vuillard to Vallotton excerpted in Brunière and Grapeloup-Roche, "Vallotton and the Camera" (as in n. 3), pp. 19–20.

8. A useful avenue of inquiry, which cannot be treated in the space of this brief essay, would be the use of photographs as direct models for portraits. This is an area that might be explored in the cases of the mature portraiture of Bonnard and Vuillard as well.

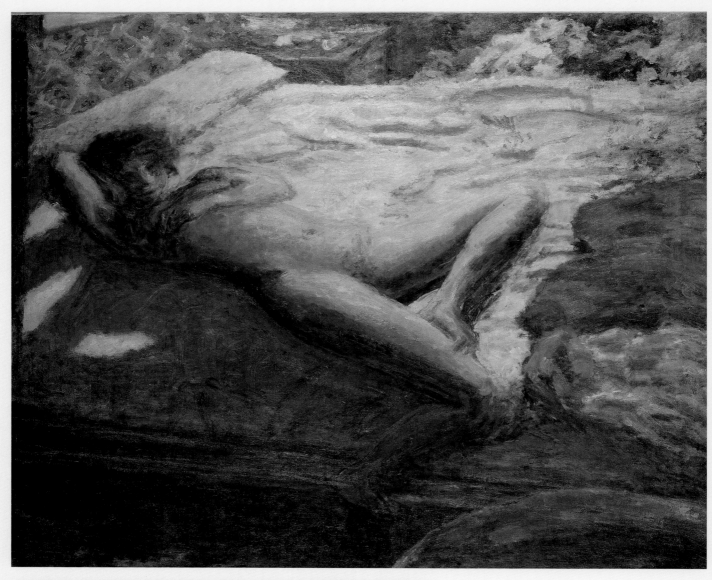

# Pierre Bonnard

FONTENARY-AUX-ROSES, NEAR PARIS 1867–1947 LE CANNET

Attracted to painting early on, Bonnard nonetheless attended law school. While there, in 1887 he enrolled at the Académie Julian and was admitted to the Ecole des Beaux-Arts. The Académie Julian was more decisive for Bonnard. Some of its members, including Paul Sérusier, Maurice Denis, and Bonnard, formed a group called the Nabis, taking their name from the Hebrew word for "prophets," reflecting their search for spiritual meaning in their art. Paul Gauguin's work, which Bonnard saw in a small exhibition at the Café Volpini in June 1889, confirmed his interest in nonnaturalistic art at this time. In 1890 he became involved with nontraditional theater and publishing ventures, and for several decades designed posters, theater sets, stained glass, puppets, book illustrations, and decorative panels. In 1893 he met Maria Boursin, who called herself Marthe de Méligny. She first modeled for him and then became his wife. Her face and figure remain virtually unchanged over the years in the almost four hundred paintings in which she appears, a constant reminder of youth. Bonnard exhibited regularly at the Salon des Indépendants and the Salon d'Automne, at prestigious commercial galleries in Paris, and in international exhibitions. After the turn of the century he began to travel, visiting Spain, Holland, London, northern Africa, and the northern coast of France. Beginning in 1909, he made annual trips to the South of France, where in 1926 he bought a villa, Le Bosquet, at Le Cannet. He had a series of apartments in Paris but considered his home to be Le Bosquet. Throughout his life Bonnard's imagery, whatever the medium, was largely domestic, showing interiors, nudes, and garden scenes. His early interest in bold outlines and colors, inherited from Gauguin and Japanese prints, gave way to a more modulated, even pastel palette and softened contours.

Cat. 378  Pierre Bonnard, *L'Indolente*, c. 1899, oil on canvas, 37⅞ × 41⅜ in., Private Collection

Cat. 380  Pierre Bonnard, *Marthe Lying on Her Back, with Her Left Leg Bent*, 1899–1900, Paris, vintage print on albumen paper, 1½ × 2 in., Musée d'Orsay, Paris

*Eik Kahng*

# The Snapshot as *Vanitas:*
# Bonnard and His Kodak

*Untruth is cutting out a piece of nature and copying it.*

—notation by Pierre Bonnard,
January 22, 1934

Pierre Bonnard has been hailed as one of the greatest colorists of the early twentieth century. In the ceaseless narration of modernism, Bonnard has even been seen as the generational successor to Claude Monet and Pierre-Auguste Renoir, whose impressionism served to inspire his somewhat delayed investment in the colorist's agenda. And yet Bonnard was also fascinated with a medium at that time entirely devoid of color—photography. As recorded by his friend and fellow Nabi Edouard Vuillard, Bonnard and his camera were a familiar sight (cat. 409). Most of Bonnard's extant photos date from the 1890s, when the Kodak camera was a fashionable accoutrement of the middle class. He would record the fleeting smile of his nephew Charles Terrasse as a child, dancing out of the sheer delight of his own nudity (cat. 371), or the faceless silhouette of his longtime lover and eventual wife, Marthe Bonnard, née Maria Boursin (cat. 388). Although very few of these images, as has been remarked so emphatically by Michel Terrasse,[1] have a simple, one-to-one relation to paintings or sculptures, such photos are nevertheless of a piece with Bonnard's endeavors in his favored medium of painting. But the relation between photography and painting in the oeuvre of Bonnard is not one of straightforward empathy between the two media. Rather, the contradictions between the two seem to have attracted the artist to the possibilities of photography.

Consider the pure colorism of painting versus the monochromy of photography (then restricted to black and white); or the temporal specificity of the snapshot versus the atemporality of a painting, its location in linear time confused by the unrecorded hours of labor that we know went into its execution; or the explicitly empirical quality of a photograph and the decidedly ideational intent of Bonnard's project in paint. Remarkably, despite these apparent contradictions, the photographic work of Bonnard still exudes the same transcendence of time as his most elusive paintings. The artist knowingly capitalized on the inevitably allegorical effect of the photograph as snapshot, in which the fleeting moment is transformed through mechanical reproduction into its opposite: an eternally fixed image of life stilled in time, the modern counterpart of the painted *vanitas.* Conversely, Bonnard's paintings often create the illusion of the momentary, of a lived moment captured in time, even though the worked surface and overt compositional contrivance attest to the canvas's decidedly nonimitative nature.

Bonnard's photography has never attained the same status as his work in painting or sculpture. In fact, there is a distinct wariness, it would seem, in the effort to distinguish Bonnard's lack of ambition as a "serious" photographer as compared with his evident devotion to the traditional medium of painting.[2] Not surprisingly, the hundred or so photographs preserved by the Bonnard-Terrasse family were considered worthy of independent exhibition only recently with the organization by the Musée d'Orsay of an exhibition devoted to these photographs in 1987 upon their bequest in reserve.[3] Bonnard himself may have intentionally discouraged posterity's consideration of his photographic work as the aesthetic equivalent of his paintings. Perhaps, like Gustave Moreau and so many other artists marked by the nineteenth century's suspicion of photography, he even feared

that the existence of these photos might detract
from his reputation as an ideationist who would
never resort to the mimetic literalness of such
an outwardly empirical, reproductive medium.
There is, however, no clear documentary evidence
of Bonnard's attitude toward his experiments in
photography.[4] We have only the photographs
themselves.

One clear commonality between Bonnard's
photography and his paintings is the intimacy
of his chosen subjects. As in the paintings, the
photos record Bonnard's nieces, nephews, close
friends, domestic servants, and, of course, Marthe.[5]
The outside world of public, urban spaces or pic-
turesque, foreign landscapes rarely appears in
Bonnard's photos. Instead, we are given the privi-
leged view of a voyeur peering into the enclosed,
domestic sphere of Bonnard's home life. The large
majority of Bonnard's photos are taken outside
(probably because of the limitations of the instant
camera he preferred).[6] The outdoor sites pictured
are obviously common areas of recreational use,
either just outside the Terrasse family home at
Grand-Lemps, or nearby destinations, regularly
visited, such as a grove of fruit trees (cat. F).

If we accept the common interpretation of
Bonnard's project in paint as the Proustian one of
nostalgia,[7] how then do Bonnard's photographs
figure into this reading? That Bonnard worked
exclusively with the instant Kodak camera is sig-
nificant. Ever since its invention in 1890, the afford-
able, hand-held camera had been transforming into
the stuff of nostalgia the spontaneous moments
of familial interaction it records. The familiarity
of the domestic scenes captured by Bonnard's
Kodak has to do with their evasion of the profes-
sional photographer's preoccupation with the
formal sites of particular identity. Likeness, if one
can speak of such a concern when it comes to the
objective lens of the camera, is rarely an aim of
Bonnard's eye. With the exception of the self-
portrait, a genre Bonnard explored exclusively
through painting, face-to-face confrontation be-
tween sitter and viewer is rarely to be found in
Bonnard's art. Rather, the family and friends
imaged by Bonnard on film, as in his paintings,
are frequently captured in the midst of an activity
that underscores the sitters' unself-consciousness
while being viewed. For example, in the series of
photos of the Terrasse children at play in the water
(cats. 392, 393), as in the amateur photos of any
family album, the children are entirely unposed.
The decentralized area of focus, occasional blurri-
ness caused by movement, the defamiliarization of
people and things through unexpected croppings,
all work to proclaim a casual instantaneity very
different from the calculated disposition of the
conventional photographic portrait. Even in the
case of the seated figure of Marthe on the porch of
the Bonnard residence, Ma Roulotte (fig. 124), light
and texture garner all of our attention. We can
hardly make out the shadowy features of Marthe's
face, her eyes transformed into eerie pools of dark-
ness beneath the brim of her skull-hugging hat.

What are we to make of Bonnard's apparent
disregard of his photographs? That he did not
consider them as works of art, to be valued in the
same way as his paintings, is evident in their lack

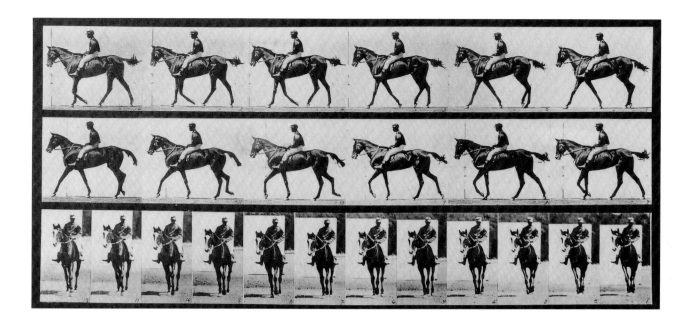

of preservation.[8] They were, as has been pointed out,[9] precious (and in this sense somewhat banal) records of the happy first years of his sister's marriage into the Terrasse family or erotic mementos of the heady days of his young relationship with his lover, Marthe. It is true that Bonnard did not make use of photography as an easy substitute for his painted compositions. Very rarely can one point to any direct correspondence between extant photos and works of art in other media. But, as Bonnard's photographs also attest, the new medium of photography held a great deal of potential for his own ambitions in painting. It is almost as if the apparatus of the camera held out the utopian possibility of achieving his stated goal of remaining faithful to that "first idea" of the

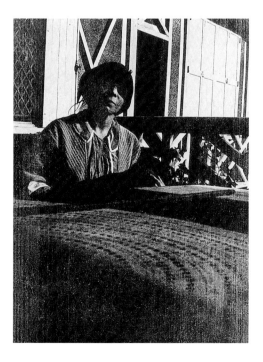

motif, before his embodied gaze grew ever more confused by the distraction of sustained looking.

Again, the new advantages of the instant Kodak camera must be recognized as the basis of Bonnard's attraction to photography. Just as Bonnard avoided conventional composition by deliberately banishing from his mind any preconceived overall structure of a given painting, so too did the snapshot ensure that known compositions would not be accidentally replicated. As opposed to the older technology of the stationary camera, the hand-held Kodak enabled Bonnard to capture, without further meditation, a split second of lived reality. With no need for arrangement and self-conscious posing, the Kodak also "invented" compositions all by itself. Although Bonnard did not stage such blind images in the way that Vuillard is recorded to have done,[10] by its very nature, the instant camera surpasses the expectations of the photographer-viewer. As Eadweard Muybridge's famous stop-action photos of a horse at full gallop so dramatically established, the camera could exceed the parameters of human sight (cat. 29), capturing images too fleeting for the eye to perceive. One cannot help but suspect that Bonnard must have found such images inspirational, for they achieve the impossible: they capture a millisecond of experience that the viewer himself can never fully grasp. In this sense, then, Bonnard's photographs, like his paintings, are always deliberate evasions of known formulas, of images seen before. They are like melodies that have, quite self-consciously, never been hummed before. The nonsense or sense that such "accidental" inventions denote is at the very heart of Bonnard's oeuvre.

We can only imagine Bonnard's delight when he first glimpsed a sequence of photos such as the remarkable images of Marthe, resplendent in her uninhibited nudity like Eve in the Garden of

Cat. 29  Eadweard Muybridge, *Animal Locomotion, Horse and Rider at Full Speed,* Plate 626, 1887, collotype, 16⅞ × 22⅛ in., Gernsheim Collection, The Harry Ransom Humanities Research Center, The University of Texas at Austin

Fig. 124  Pierre Bonnard, *Marthe Seated on the Terrace of "Ma Roulotte" Veronnet,* c. 1910–15, vintage print, Musée d'Orsay, Paris

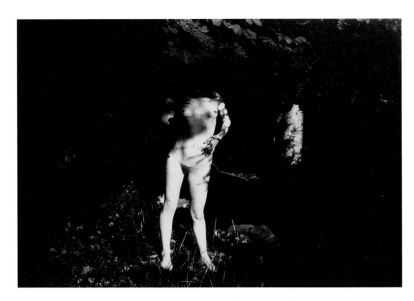

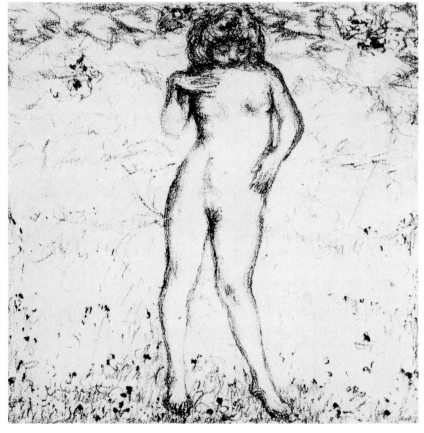

Cat. G  Pierre Bonnard, *Marthe Standing in the Sunlight,* 1900–1901, Montval, modern countertype, Musée d'Orsay, Paris

Cat. 391  Pierre Bonnard, *Chloe Bathing, from "Daphnis and Chloe,"* 1902, lithograph, 15 × 13 in. (mat size), The Metropolitan Museum of Art

Paradise (cats. 388, G). The poignancy we cannot help but feel in regarding such private moments of Bonnard's early years with Marthe is the same poignancy that saturates Bonnard's paintings of the nude Marthe. This is especially so in the case of the late paintings of her bathing, in which the physical reality of her aging, imperfect flesh is suppressed through the sheer force of memory.[11]

The occasional recurrence in multiple paintings and lithographs of the peculiar poses struck by Marthe in these photos (e.g., cats. 378, 380, 387, 390, 391, G)[12] does not derive from the artist's literal copying of these photographic images as the model for later compositions. Such a tactic would run counter to everything we know of Bonnard's working method. As reported by the artist's relatives and friends, Bonnard's approach to his art was explicitly anti-impressionist. The motif, once glimpsed, was never allowed to continue to bombard the artist's vision while painting. The quick sketches scribbled on Bonnard's calendar are those of an artist who used drawing as a necessarily partial record of visual perception. Such thumbnail sketches are the drawn equivalent of the snapshot, their rapidity impelled by the artist's consciousness of the immediately deteriorating memory of a split second in lived time. Drawings such as these were never "copied" into large-scale, painted compositions. At best, they must have functioned as mnemonic devices meant to reinvigorate the artist's inner memory of a visual plenitude now lost. In this regard, Bonnard's fascination with the snapshot is understandable, for in revisiting each infallible photographic image of a past moment in time, the psychology of remembrance is once again set into motion. For the viewer for whom a photograph is outward testimony to an embodied experience, the associations of the past, present, and future inevitably entwine themselves around the photograph. Each reexamination of the image readjusts the viewer's relationship to his or her own past as constantly revised in the present. In this sense, a personal photograph is not merely an objective record of a single moment. The visual experience of the photographic image itself shifts perpetually through the density of signification that accrues with repeated looking. To some extent, the photographic image even erodes one's ability to reconstitute the past without reference to it. The photographic image, now etched in the mind of the viewer through repeated study, is thus ripped free of its temporal specificity, to be endlessly recycled in the imagination, either consciously or unconsciously.

One wonders, then, how to understand the relationship between photographic image and painting in the rare instances where there are overt resemblances in composition, texture, or lighting. Take, for example, Bonnard's painted self-portrait, dated to 1889 (cat. 362), most likely on the basis of

« Elle a, ta chair, le charme sombre
Des maturités estivales,
Elle en a l'ambre, elle en a l'ombre;

« Ta voix tonne dans les rafales,
Et ta chevelure sanglante
Fuit brusquement dans la nuit lente. »

Cat. 387 Pierre Bonnard, *Illustration for Paul Verlaine's "Parallèlement,"* 1900, book, 11¾ × 10⅛ × 1¼ in., Special Collections, Dallas Public Library

Cat. 390 Pierre Bonnard, *Photograph Taken by Marthe: Pierre Bonnard Viewed from the Back,* 1900–1901, Montval, modern print from original negative, Musée d'Orsay, Paris

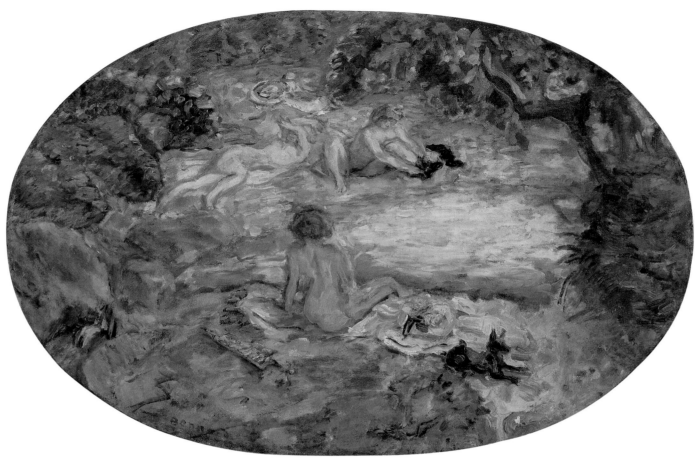

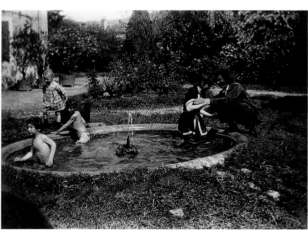

Cat. 395 (top)  Pierre Bonnard, *Bathers in a Park,* c. 1908, oil on canvas, 26 × 28½ in. (oval), Sarah Campbell Blaffer Foundation, Houston

Cat. E (bottom, left)  Pierre Bonnard, *Charles, Robert, and Jean Terrasse,* summer 1899, Grands-Lemps, modern countertype, Musée d'Orsay, Paris

Cat. 373 (bottom, right)  Pierre Bonnard, *Charles, Robert, Jean, Andrée, and Claude Terrasse,* summer 1899, Grand-Lemps, modern print from original negative, Musée d'Orsay, Paris

an anonymous photographic portrait of Bonnard of that year (fig. 126). Despite the obvious disparity of the palette and brushes included in the painting, it is difficult to believe that the photograph does not underlie the painting. The almost catatonic expression of wide-eyed paralysis, the peculiar streakiness of the unintelligible background, and the sharp line of shadow beneath the right eye cannot be incidental similarities between photo and painting. Perhaps, in this earliest of Bonnard's twelve self-portraits, the artist did experiment with using a photograph as a direct model.

However, in the later self-portrait with beard of about 1920 (cat. 396), no such clear-cut correlations are to be had. Although the tilt of the head, the prominence of the right ear, and the wrinkled brow are shared features, the imprecise focus of the gaze in the painting creates a greater feeling of vulnerability than does the gaze in the photo (fig. 125). It is more likely that in this case we have an example of Bonnard's using a vivid, but necessarily imperfect, recollection of a photograph as a point of departure for a painting. However, the pictorial translation of that recollection is obviously not indebted to the literal look of the black-and-white photograph. The violent swags of color that threaten to engulf the artist's blurred features

achieve Bonnard's symbolist aim of direct, emotional expression, and the photograph is only one piece of the visual fodder that fed its invention.

However, a trace of heightened self-reflexivity is evident in this self-portrait that does seem to derive from the photograph. There, Bonnard's typically unsmiling face is turned toward the photographer-viewer, as though he has just been interrupted, and has turned to respond to his interlocutor. The upraised eyebrows and resultant lines in the forehead are a reflexive action of the moment caught by the camera. The result is an exaggeration of a temporal dislocation that is inherent to the snapshot. A fleeting expression of attentiveness as entrapped for a split second in the muscles of the face is now frozen into an image of perpetual stillness. The cumulative effect of the photo is only a variation on the same temporal contradiction we find in Johannes Vermeer's *Girl with a Pearl Earring* (fig. 127). Nevertheless, Bonnard's adaptation of his own expression as caught by an unknown photographer is testament to the role of the photograph as modern *memento mori* in his experimentation in the traditional genre of self-portraiture. When one compares *Self-Portrait with Beard* to Gustave Courbet's early self-portrait, *Man Mad with Fear* (fig. 128),

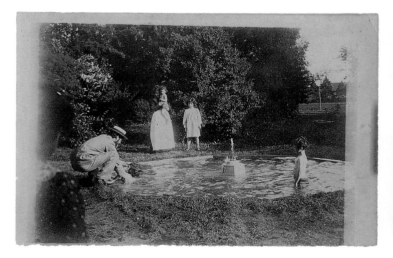 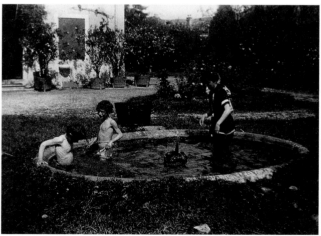

Cat. 375  Pierre Bonnard, *Pierre Bonnard by the Side of the Pool Playing with Renée, while a Nursemaid Holds Robert, and Charles and Jean Terrasse Sit in the Pool (Andrée Terrasse Is Cropped at the Left),* summer 1899, Grand-Lemps, vintage print on albumen paper, 2¼ × 3 in., Musée d'Orsay, Paris

Cat. 372  Pierre Bonnard, *Charles, Jean, and Andrée Terrasse,* summer 1899, Grand-Lemps, modern print from original negative, Musée d'Orsay, Paris

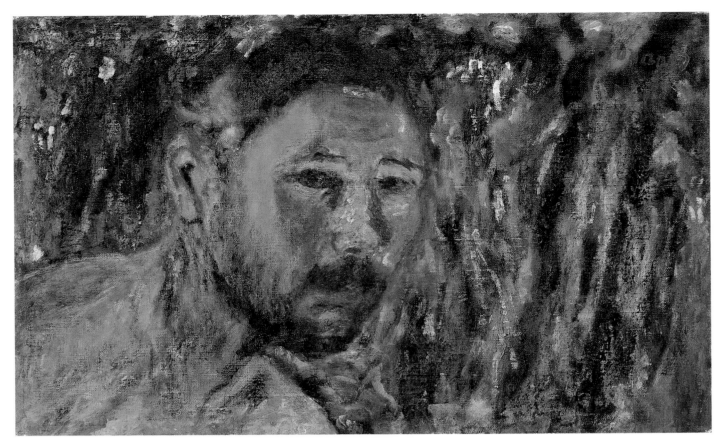

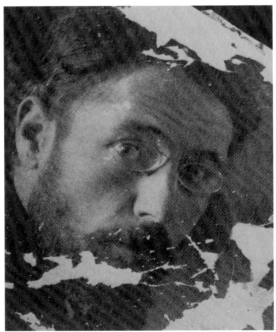

Cat. 396 (top) Pierre Bonnard, *Self-Portrait with Beard (Portrait de l'artiste)*, c. 1916–20, oil on canvas, 11⅝ × 18 in., Private Collection

Fig. 125 (bottom, left) Anonymous, *Portrait of Bonnard*, 1920, photograph, Private Collection

Fig. 126 (bottom, right) Anonymous, *Portrait of Bonnard*, c. 1889, photograph, Private Collection

Cat. 362 (opposite) Pierre Bonnard, *Self-Portrait*, c. 1889, oil on board, 8⅜ × 6¼ in., Private Collection

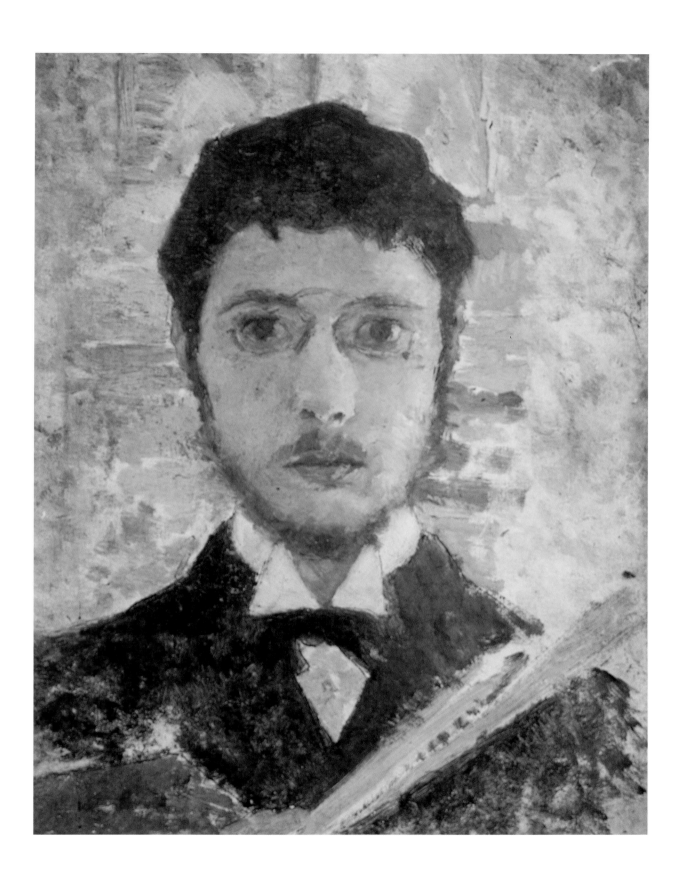

Fig. 127 Johannes Vermeer, *Girl with a Pearl Earring*, c. 1665–66, oil on canvas, Royal Cabinet of Paintings Mauritshuis, The Hague

Fig. 128 Gustave Courbet, *Man Mad with Fear,* 1843?, oil on canvas, Nasjonal-galleriet, Oslo

one realizes the degree to which Bonnard has profited from the snapshot's ability to record effortlessly even the most transitory of facial expressions. The theatricality of Courbet's facial expression, as he strains to maintain his features in a wide-eyed stare of self-inspection at the moment he has just leapt off an imaginary cliff, gives satiric form to the artist's ultimate inability to both paint and view himself at the same time. Our own modern imperviousness to the wonders of photography makes this image an especially telling comparison, since Courbet cannot have known that he has anticipated precisely the kind of stop-action image Muybridge would make possible some forty years later. By contrast, there is an unmistakable authenticity to Bonnard's *Self-Portrait with Beard,* born of the artist's melancholic awareness of the eternal belatedness of embodied vision, now exposed by the superhuman shutter speed of a camera lens. Bonnard's knowing assimilation in his paintings of the formal effects made possible by the instant snapshot anticipates a similar phenomenon in the postmodern era. For it is this same analogy between the limitations of embodied vision and the specific effects of mechanical reproduction that generates the desolate self-alienation we find in the digital realism of Chuck Close (fig. 129).

Fig. 129 Chuck Close, *Self-Portrait*, 1997, oil on canvas, 102 × 84 in., photograph by Ellen Page Wilson, courtesy of PaceWildenstein

## NOTES

We gratefully acknowledge the invaluable collaboration of the Musée d'Orsay.

Epigraph: As quoted by Antoine Terrasse in "Bonnard's Notes," in *Bonnard: The Late Paintings* (Washington, D.C., and Dallas: The Phillips Collection and the Dallas Museum of Art, in association with Thames and Hudson, 1984), p. 69.

1. Michel Terrasse, *Bonnard, du dessin au tableau* (Paris: Imprimerie Nationale Editions, 1996), p. 118.

2. In nearly every account of Bonnard's photography thus far, this assertion recurs. For example, in the introduction to Françoise Heilbrun and Philippe Néagu, *Pierre Bonnard: Photographs and Paintings* (Paris: Philippe Sers, 1987), it is immediately pointed out that "although Bonnard had no artistic ambitions as a photographer, he nevertheless demonstrated in this area the force and originality of his special powers of observation and reflection" (p. 7).

3. Several of Bonnard's photographs of Marthe were exhibited more recently in *Paris in the Late Nineteenth Century* (Canberra, New South Wales: National Gallery of Australia, 1996.)

4. The only documented evidence of Bonnard's attitude toward photography was reported by his friend Jacques Salomon in an article he published in 1963 and republished in 1966. Jacques Salomon and Annette Vaillant, *Vuillard et son Kodak* (London: Lefevre Gallery, 1966). Salomon mentions Bonnard's perturbation at the new possibilities offered by color photography in the course of a conversation with Vuillard.

5. For a succinct list of the cast of characters appearing in Bonnard's photographs, see Heilbrun and Néagu, *Bonnard: Photographs and Paintings,* pp. 14–15.

6. Ibid., pp. 9–10.

7. The often drawn parallel between Bonnard and Proust is a leitmotif of the literature on Bonnard. See, for example, Jean Clair's essay "Bonnard ou l'espace du miroir," in which he

muses on Bonnard's legacy as perceived by posterity: "The trajectory of a Bonnard, by contrast [to Picasso], similar to the one followed by Proust in literature at the same moment, would be aimed at the experience of Time." (Le démarche d'un Bonnard, à l'opposé, semblable à celle qu'même instant Proust effectuait en littérature, aura été tournée vers l'expérience du Temps.) (*La Nouvelle Revue Française,* no. 176 [March 1967]: 511.) See also the essay published by Michel Makarius, "Bonnard et Proust: Les Couleurs du temps retrouvé," *Cahiers du Musée nationale d'art moderne* 13 (1984): 110–13.

8. This is a point made by Jean-François Chevrier in his essay "Bonnard and Photography," in *Bonnard: The Late Paintings,* p. 88.

9. Ibid., pp. 92–94.

10. See Salomon (as in n. 4) on Vuillard's habit of taking pictures with his Kodak without looking through the viewfinder.

11. As Sarah Whitfield has established, Marthe suffered from tubercular laryngitis. In France a hydropathic regimen was often the prescribed treatment, which largely explains her habit of constant bathing. After decades of constant attention to the demands of her delicate health, Marthe died in 1942 at seventy-three. In such late paintings as *Nude in the Bath* of 1936 (Musée du Petit Palais, Paris), the naked body floating in the water is clearly not that of a woman in her late sixties.

12. See, for example, the sketches reproduced in Terrasse, *Bonnard, du dessin au tableau,* pp. 290–91. The most explicit examples of these crossovers are the transposition of figures from photographs to lithographs in the illustrations Bonnard produced for Paul Verlaine's *Parallèlement* (see cats. 387, 390, on p. 243) and Longus's *Daphnis et Chloë* (see cats. 391, G, on p. 242), executed between 1899 and 1902. For a brief discussion of Bonnard's illustrations for *Parallèlement,* see Kathryn Weir, "The Advent of the Beautiful Book," in *Paris in the Late Nineteenth Century,* pp. 134–35.

# Edouard Vuillard

CUISEAUX, SAÔNE-ET-LOIRE 1868–1940 LA BAULE, NEAR SAINT-NAZAIRE

Cat. 405 Edouard Vuillard, *Interior with Women Sewing (L'Aiguillée)*, 1893, oil on canvas, 16⅜ × 13⅛ in., Yale University Art Gallery, New Haven, Collection of Mr. and Mrs. Paul Mellon

Vuillard's family moved to Paris in 1897, where his mother supported the family as a seamstress, particularly after the father's death in 1884. In the same year Vuillard enrolled at the Lycée Condorcet. There he met Maurice Denis, Aurélien Lugné-Poë, and Ker-Xavier Roussel, who was to become his closest friend and brother-in-law. At the Académie Julian he met Paul Sérusier and Pierre Bonnard and joined the group called the Nabis. Like Bonnard, Vuillard became involved in the theater through the agency of Lugné-Poë, who had become an actor and manager. Posters, programs, and set designs complemented Vuillard's interest in painting as decoration. Out of his theatrical work grew a steady production of domestic decorative panels and overdoors. Vuillard's first exhibition took place at the offices of Thadée Natanson's journal *La Revue blanche;* many commissions came to Vuillard from Natanson himself and his friends and colleagues. The subject matter of Vuillard's paintings—domestic life, portraits—shows a deep attachment to home, family, and friends (he lived with his mother until her death in 1928). He exhibited with the Nabis from 1891 until 1899, when the members of the group drifted apart. In 1897 he visited Venice and Florence, a trip that was the first of many to foreign destinations. After 1900 his paintings became more naturalistic, less densely patterned, and more spacious, and he began to explore the genre of landscape. Until the end of his life Vuillard painted decorative panels, increasingly for such public buildings as the Palais de Chaillot in Paris and the Palais des Nations in Geneva. He was given a large retrospective exhibition at the Musée des Arts Décoratifs in 1938, one year after he became a member of the Institut de France, where his archives, including his photographs, are preserved.

*Eik Kahng*

# Staged Moments in the Art of Edouard Vuillard

The photographs of Edouard Vuillard have yet to enjoy the same degree of exposure as Pierre Bonnard's. And yet Vuillard's investment in photography was recognized long before that of his artistic ally and longtime friend. In 1966 the Lefevre Gallery in London dignified Vuillard's photographs with a small exhibition. It was for this modest showing that Jacques Salomon composed a short essay that is the inevitable starting point for all subsequent discussions of Vuillard's photographs:

> *Vuillard owned a camera, a Kodak. It was an ordinary model, one of the bellows type. It was part of Vuillard's household. Its place was on the sideboard in the dining room. Sometimes, during a conversation, Vuillard would go to get it and resting it on some furniture or even the back of a chair, oblivious of its view finder, would point the lens in the direction of the image he wished to record: he would then give a brief warning, "Hold it please" and we could hear the clic . . . clac of the time exposure. The camera was then returned to its place, and Vuillard walked back to his seat. When the number 12 appeared on the little red window of the camera, Vuillard took it to his usual supplier, close to where he lived in the Rue de Clichy, to have it reloaded. The printing of the film was then entrusted to his mother. Sitting by the window overlooking the square, doing some embroidery, she watched the frame exposed to the light and when it was time she proceeded to the "fixing" in a soup plate.*[1]

This essay is telling in several respects: first, it relates in anecdotal form an eyewitness account of Vuillard's habit of interrupting conversation, so that he might make use of his portable Kodak camera to commemorate the atmosphere of his society.[2] Invariably, Vuillard's photos picture persons from his intimate circle: whether family (cat. 400) or patrons and friends (cat. 416). However, these photos are not portraits in any conventional sense. For they give equal, if not more, weight to the environment that envelops Vuillard's cast of characters. Like a stage director whose pride resides as much in the scenery as in the actors, Vuillard's subject in his photography, as in his painting, is not so much the individuals depicted as it is the interplay of his sitters with their environment, as if the external world must necessarily reverberate with the interior world of feeling. Even when constructing an implied narrative or psychological exchange between multiple figures, as in the photograph of the Vuillard family at table, it is the setting, the decor (in the Nabi sense) that electrifies relations among the players. The inanimate objects and patterned walls engulf the body, as if the room emanated the psychic energy of its inhabitants, thereby becoming the only site of action, where feeling itself qualifies as a type of action. "The subject of any work is an emotion simple and natural to the author."[3] In Vuillard's world sentiment is the only action to be found.

In French the verb *sentir* (to feel) is ambivalent in a way that is particularly apt when considering the brand of Symbolism developed by Vuillard. *Sentir* means "to sense," "to feel," and "to understand." In the philosophical tradition that is Vuillard's inheritance, perception is ambiguously defined by the conundrum posed by the indivisibility of that which is outside and that which is internal to the subject. In this respect, it is the same dialectic between subject and object that encompasses both the radical subjectivism of the Nabi movement as well as Vuillard's eventual

Cat. 421 (top) Edouard Vuillard, *Interior*, c. 1902, oil on cardboard, 20 × 26½ in., Dallas Museum of Art

Cat. 400 (bottom, left) Edouard Vuillard, *The Vuillard Family at the Table*, n.d., vintage print, 3¼ × 3⅜ in., Archives Salomon, Paris

Cat. 416 (bottom, right) Edouard Vuillard, *Misia and Thadée Natanson*, c. 1899, modern print from original negative, Archives Salomon, Paris

return to sensory experience as the basis of his painting. Of course, Vuillard arrived at his realization of empirical experience as the necessary point of departure for his art only with difficulty. As is so often recounted in the literature on the artist, with Paul Sérusier's *Talisman* (Musée d'Orsay, Paris) shimmering in his mind, in 1890 ("l'année de Sérusier," as Vuillard called it in his journal) Vuillard struggled with Maurice Denis's symbolist mantra: "Remember that before a painting is a battle horse, a female nude, or some other anecdotal thing, it is essentially a flat surface covered with colors, assembled in a certain order."[4] Although Vuillard was to reject naturalism in the impressionist sense, neither did he fully embrace Denis's programmatic refusal of objective description as a legitimate aim for painting. Whether the everyday sights of his mother's workshop (cat. 405) or the heavily patterned apartment of his family, friends, and patrons (cats. 401, 403), Vuillard painted what he knew from experience. However, for Vuillard, like his fellow Nabis Bonnard and Vallotton, empirical experience far exceeded the simple physiological act of visual observation. To sense the world inevitably implied the inner process by which embodied sensation interlocks with emotion and is immediately saturated by the work of recollection. For Vuillard, photography was yet another means by which the internalization of sense experience might be explored.

Salomon's description of Vuillard's photographic method also touches on another intriguing aspect of his interest in the new medium. As Elizabeth Wynne Easton has explored in her crucial essay published in 1994, Vuillard quite consciously embraced the accidental nature of the Kodak. The limited technology of the hand-held Kodak camera meant that the artist had no way of previewing the image fixed by the camera at any given moment. In the 1890s there was no viewfinder on the camera through which to anticipate

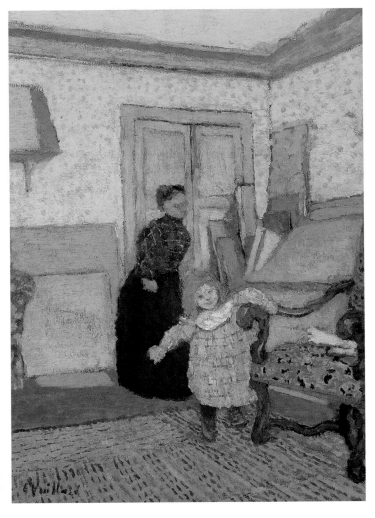

Cat. 401 Edouard Vuillard, *The First Steps (Les Premiers Pas)*, late 1890, oil on canvas, 20⅜ × 14¾ in., Dallas Museum of Art

Cat. 403 Edouard Vuillard, *Interior*, 1892, oil on cardboard mounted on canvas, 10¼ × 20 in., The Phillips Collection, Washington, D.C.

the final product. Usually the camera would be braced against the body at stomach height, with only an arrow at the top of the camera to give a rough idea of the camera's center of focus.[5] The inherent unpredictability of the camera was, according to Salomon's account, further enhanced by Vuillard's physical distance from it when taking a picture. By "resting it on some furniture or even the back of a chair," Vuillard would have had an even less precise idea of the resultant composition. As "part of Vuillard's household," the camera, it would seem, was allowed to take on its own point of view, as though its own monocular eye deserved to be respected.

And yet, at the same time, Vuillard's artistic gaze is everywhere apparent in his photographs. As Gloria Groom has rightly pointed out,[6] there is nothing accidental about the formal rhyming we find in Vuillard's photograph of Misia Natanson, standing beside a sideboard in one of the rooms of the eccentric apartment that she shared with her husband, Thadée (fig. 130), on the rue Saint-Florentin. With characteristic calculation, Vuillard calls attention to the resemblance between Misia's elaborate lace collar and the faience displayed directly to her left. The decorative unity of the composition, enhanced by the graphic black-and-white tonality of the photographic medium, is matched by the thematic consistency of the composition. Misia's very body is as busily engulfed by the dizzying patterns of her voluminous dress as are the papered walls of her apartment. The inclusion of the right edge of Vuillard's painting *The Embroidery* of 1895 (The Museum of Modern Art, New York) adds yet another layer of reference to the union of form and content. The manual production of decorative fabrics is made present by a painting whose own creation as a decorative surface is thereby likened to the métier of sewing.

There is, then, a tension between Vuillard's acquiescence to the chance effects of his Kodak camera and the artist's knowing anticipation of the composition that will result, despite the supposedly "blind" nature of its production. A clear example of the highly artificial nature of Vuillard's photography is the striking resemblance between his photographic portrait *The Vuillard Family at the Table* (cat. 400) and the paintings of the same subject from some years earlier (fig. 131). In the several paintings of this subject, Vuillard positions himself as he does in the photograph, as a figure lurking in the doorway behind the table, as though eavesdropping on an intimate conversation from which he is excluded. The artist's physical distance from the camera, as described by Salomon, is dramatized in this example. One must presume that such compositional echoes between later photographs and earlier paintings confirm the artist's deliberate orchestration of his photographs. The haphazardness of the camera was thus balanced

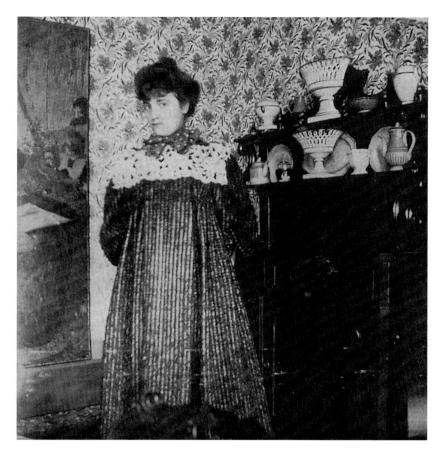

Fig. 130  Edouard Vuillard, *Misia Natanson*, c. 1897, modern reprint, Archives Salomon, Paris

Fig. 131  Edouard Vuillard, *Family of the Artist (L'heure du dîner)*, c. 1889, oil on canvas, The Museum of Modern Art, New York, gift of Mr. and Mrs. Sam Salz and an anonymous donor

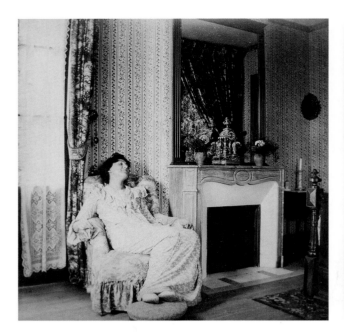

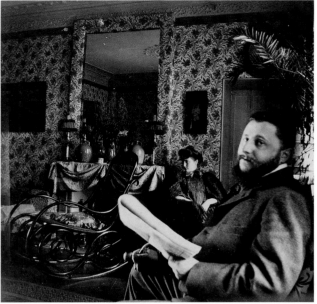

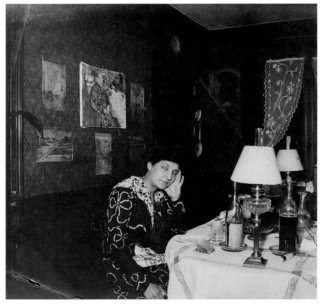

Cat. 420 (top, left) Edouard
Vuillard, *Lucie Hessel on a
Chaise,* 1901–3, vintage print,
3⅜ × 3⅜ in., Archives Salo-
mon, Paris

Cat. 406 (top, right) Edouard
Vuillard, *Misia and Thadée
Natanson,* c. 1897–98, modern
print from original negative,
4 × 4 in., Archives Salomon,
Paris

Cat. 419 (bottom) Edouard
Vuillard, *Vuillard's Apartment,
rue Truffant,* c. 1899–1901,
modern print from original
negative, 4 × 4 in., Archives
Salomon, Paris

against the artist's ability to project accurately his
own inner vision onto the lens of his apparatus.

The staged quality of Vuillard's photographs is
only an extension of the same quality in his paint-
ings. Unlike Bonnard, who delighted in the fleeting
moments he could capture instantly through the
new technology of the hand-held Kodak camera,[7]
Vuillard had much less interest in such sponta-
neous effects.[8] According to Salomon's account,
Vuillard would preface his picture taking with the
polite command, "Hold it please," a phrase that
would seem to belong to the olden days of the
glass-plate camera used by Edgar Degas. The ono-
matopoeia of Salomon's "clic . . . clac" well ex-
presses the lethargic sound of a camera limited to
one shutter speed and one f-stop.[9] The natural flow
of conversation and bodily expression would have
had to come to a self-conscious halt, as Vuillard's

subjects waited patiently for the camera to per-
form its function. The resultant awareness of be-
ing viewed is a feature shared by all of Vuillard's
photos, whether of single sitters (cat. 419) or of
several people (cat. 406). Even when the sitter's
gaze is averted, as in the photograph of Lucie
Hessel on a chaise (cat. 420), one senses that
Mme Hessel's entire body is tensed to Vuillard's
watchful gaze. There is nothing candid about her
position. Her bent knees are swung to the side to
produce an uncomfortable angle that is reiterated
by the curved relief in the fireplace and the pro-
jecting face of the clock on the mantel.

The difference between the individual artis-
tic ambitions of Bonnard and Vuillard is as pal-
pable in their respective photographs as it is in
their paintings. While both artists have been
habitually described as *intimistes* because of the

highly personal nature of their subject matter (so often family or friends or each other), this term connotes something quite different in each case. If Bonnard was attracted to the instantaneous effects made possible by the new technology of the Kodak, Vuillard had much less interest in the momentary or fleeting impressions he might have captured with the instant camera. Bonnard took most of his photographs in the plentiful light of day, so that he might take full advantage of the Kodak's ability to capture the most transient of spontaneous actions (cat. 368). By contrast, Vuillard often shunned this innovative aspect of the hand-held camera, taking many of his photographs indoors. The absence of diffuse light demanded that his subjects remain perfectly still, as they waited self-consciously for the slow "clic . . . clac" of the shutter to release them from their suspended animation. In this sense, Bonnard and Vuillard were diametrically opposed in their working methods when it came to the Kodak.

This obvious contrast in their photographs is also carried out in their respective paintings. Although the two artists shared the same dedication to their daily environments as the natural subject for their paintings, they had radically different ambitions. Bonnard's interior scenes, like his photographs, are entirely personal. They depict the most mundane of domestic moments, whether the day-to-day rituals of his lover and eventual wife, Marthe, bathing or the unexceptional interaction of family members seated at the family table. The particularity of individuals is habitually less important than the universal sensation of recollection, of experience lived in embodied time that is Bonnard's symbolist aim. However, it is the facticity of the image as remembered experience that enables Bonnard to express the essential universality of his message. The ultimately allegorical effect of his paintings as modern-day *vanitas* depends on the authenticity of their origin as transient moments in the life of the artist, now fixed in paint as tributes to the inexorable passage of time. To regard Bonnard's paintings is to immerse oneself in his domestic environment, with which the artist was obsessed as the natural subject for his elegies to the everyday.

By contrast, Vuillard's paintings seem oddly unspontaneous and self-consciously staged. What may appear at first to be a portrait of a moment as it might have been experienced in real time, quickly becomes on further examination a highly theatrical orchestration of shapes and patterns. Take, for example, the painting known as *Mother and Child* of 1899 (cat. 414). The woman in blue has been identified as Misia, although this identification is superfluous to the meaning of the painting. Vuillard's obvious lack of interest in capturing the particularity of individual likeness is apparent in his choice to picture Misia from behind, with only

the simplified circle of her hair, gathered in a loose chignon at the top of her head, fully visible to the viewer. Instead, an iconic sense of woman and child is evoked through the juxtaposition of Misia and the infant Mimi, who was the firstborn of her half brother Cipa. Nearly every surface of the room is engulfed in pattern, from the upholstery of the chaise to the folding screen behind it, to the busy floral pattern of the papered walls. The woman appears to be supporting the infant with outstretched arms in an unsteady upright position. The child's doll-like face is reduced to a few blobs of paint: two blue dabs for the eyes, two rosy circles for cheeks, and a black slash of a mouth. The chaise is warped upward toward the viewer, as though tilted up by the weight of the sitter at its left edge. This downward point of view is contradicted by the sharp profile of the cobalt blue urn atop its tripod stand. The cacophony of patterned surfaces further flattens the space of the image, creating the illusion of the viewer's suffocatingly close proximity to the scene.

Comparison to a photograph by Vuillard of Misia, posed on a chaise (cat. 407) in what appears to be the same room depicted in *Mother and Child,* offers an interesting example of possible cross-fertilization between photograph and painting. Instead of simply transposing the photographic composition captured by his Kodak into his colorful rendition of the same corner of the Natansons' apartment, Vuillard appears to have selectively adapted certain formal elements of the photo in the subsequent painting. Although the painting pictures Misia in an entirely different guise, in a different position and with the chaise angled toward the viewer, it reiterates the sharply cropped ledge in the lower left-hand corner of the photograph. In the painting this sharp diagonal is established by the tilted lower edge of the chaise, which is punctuated by a black streak that both exaggerates its angularity and seems to float atop the

Cat. 368 Pierre Bonnard, *Robert Terrasse,* 1898, Noisy-le-Grand, modern print from original negative, 9½ × 12⅝ in., Musée d'Orsay, Paris

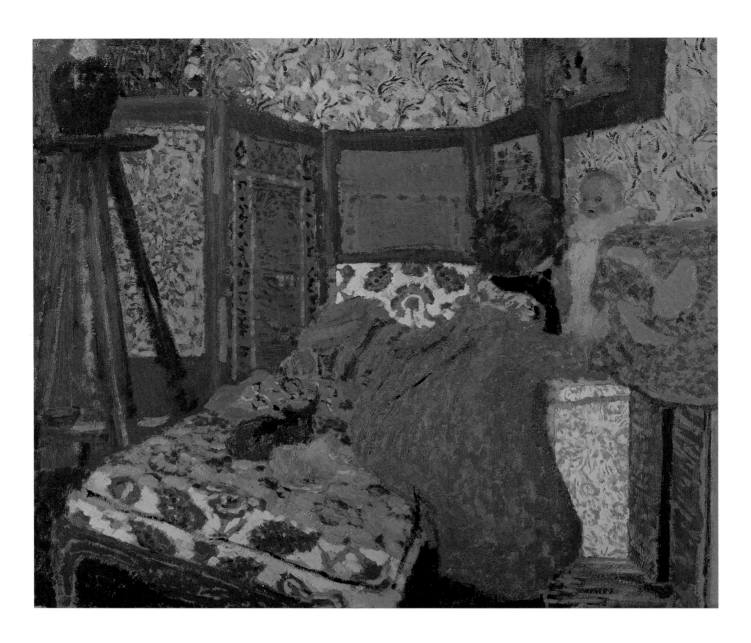

Cat. 414 Edouard Vuillard,
*Mother and Child,* 1899, oil
on cardboard, 20 × 23 in.,
Glasgow Museums; Art
Gallery & Museum,
Kelvingrove

patterned upholstery fabric. Did the photograph, although not a direct model for the painting, serve as partial inspiration for the peculiar compositional organization of the canvas? Or is this, as Elizabeth Wynne Easton has noted, simply another example of the consistency of Vuillard's inevitable formal rigor whether in his photographs or in his paintings? Whatever the case, it is clear that both photograph and painting reveal Vuillard's highly premeditated sense of compositional design, where representional description is always harnessed to the canvas or photographic surface as abstract pattern.

The Glasgow *Mother and Child* has a provocative connection to another photograph by Vuillard (cat. 417). In a photograph dated to about 1899, the cabinet-sized canvas is shown inserted into the molding of a mantel, above a mirror of exactly the same dimensions. Romain Coolus (the playwright and, like Vuillard, a member of the Natansons' inner circle) is shown as though deep in thought,

head in hand, reading a book. In a vertiginous gesture of circular reference, the patterned wallpaper of the Natansons' apartment is imaged by three different means: as registered by the lens of the camera on the wall of the bedroom; as imitated in paint by Vuillard in *Mother and Child;* and in the mirror reflection of the opposite wall. The temporal priority between painting and photograph is again brought into question, this time by the photograph of Misia, propped up against the mirror and tucked into the compartments of a man's toiletry set. As in the photograph, Misia is pictured from behind; as in the painting, her abundant hair forms a dark circular cloud.

Even more infrequently than in the case of Bonnard's Kodak snapshots, Vuillard's photographs are hardly ever straightforward models for subsequent paintings. Rather, the photographs often share many of the same compositional devices employed by the paintings. Thus, as Easton remarked,[10] Vuillard's photograph of his little niece, Annette Roussel as a child, sprawled on a dirt path with the pointed silhouette of Vuillard's own shadow cropped at the lower edge (cat. 398), shares a similar subject and use of silhouette with the San Francisco *At the Window* of about 1900 (cat. 418). Since precise dating of photograph and painting is impossible, there is no way to know which preceded the other. Moreover, Vuillard's inclusion of a confessional shadow occurs in other photographic compositions, such as *Bonnard, Roussel (Seated on the Ground), Renée, and a Little Girl* (cat. 410). However, this is beside the point, as the photos and painting also differ radically in overall design. Rather, this comparison well demonstrates Vuillard's attraction to like formal methods of compositional and thematic organization in both media. The recurrence of the black silhouette in such earlier paintings as *Interior with Women Sewing* of 1893 (cat. 405) or *Woman in an Interior* of 1891–92 (cat. 404) and in such later canvases as *At the Window* leads one to postulate that Vuillard deliberately sought such effects in his photographs. It is unlikely that the photos led him to discover by chance such devices, which he later adapted for use in his paintings.

The full breadth of Vuillard's achievements as a photographer has yet to become known and will only be recognized once the nearly one thousand photographs preserved in the Archives Salomon have finally been exhibited and published. Also unresolved is the extent to which the medium of photography may have served as another means of artistic exchange between Vuillard, Bonnard, Félix Vallotton, and Ker-Xavier Roussel. Some of Vuillard's photographs document the time shared by these artists in each other's company, for example, Vuillard's photograph of Bonnard photographing Renée (cat. 409), his photograph of Bonnard tickling Renée (cat. 411), or *Around the*

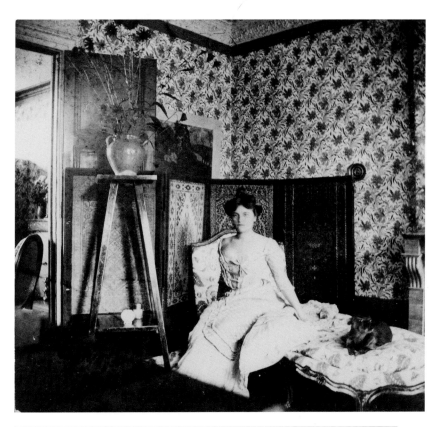

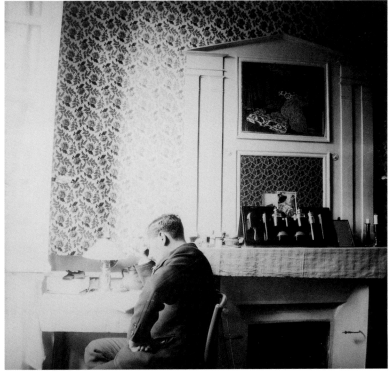

Cat. 407 Edouard Vuillard, *Misia Natanson,* 1898, vintage print, 3⅜ × 3⅜ in., Archives Salomon, Paris

Cat. 417 Edouard Vuillard, *Natanson Country House with Romain Coolus,* c. 1899, vintage print, 3½ × 3½ in., Archives Salomon, Paris

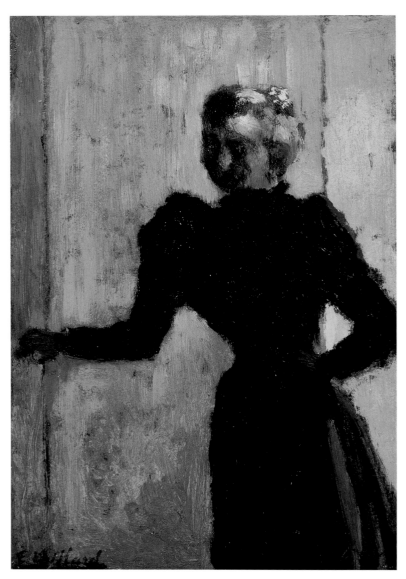

*Table* (cat. 408). One wonders if Bonnard's own affectionate photographs of the Terrasse children at play (cats. 363, 367, 385, 386) may have inspired Vuillard to paint such canvases as *The First Steps* (cat. 401), which is unusual for the artist in that it attempts to depict a figure in motion. The overt sentimentality of such an innocent subject with so much childish appeal is certainly unlike most of Vuillard's habitually stilted visions of domestic life.

Unlike Bonnard, whose photographic output waxed in the 1890s and then waned over the course of the rest of his long career, Vuillard continued to practice photography throughout his maturity. One suspects that when Vuillard's photographic oeuvre is at last revealed in its entirety, he will take his rightful place as one of the early masters of what is now termed "fine art" photography. An image like *Amfréville: View from a Window* (cat. 397)[11] clearly announces the spare beauty achieved by the likes of André Kertész,[12] where the specialized medium of black-and-white photography is no longer a mere preparatory study for a subsequent painting but rather an independent artistic expression in its own right.

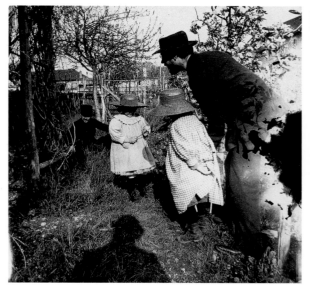

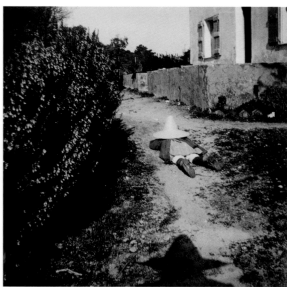

Cat. 402 Edouard Vuillard, *Portrait of the Artist's Grandmother,* 1891–92, oil on canvas, 25⅝ × 21¼ in., Hirshhorn Museum and Sculpture Garden, Smithsonian Institution

Cat. 418 Edouard Vuillard, *At the Window,* c. 1900, oil on board, 18⅞ × 24½ in., San Francisco Museum of Modern Art

Cat. 404 (opposite, top) Edouard Vuillard, *Woman in an Interior,* c. 1892, oil on canvas, 8¹⁵⁄₁₆ × 5⅞ in., Collection Foundation Pierre Gianadda, Martigny, Switzerland

Cat. 410 (opposite, bottom left) Edouard Vuillard, *Bonnard, Roussel (Seated on the Ground), Renée, and a Little Girl,* spring 1899, Grand-Lemps, modern print from original negative, Musée d'Orsay, Paris

Cat. 398 (opposite, bottom right) Edouard Vuillard, *Annette Roussel,* n.d., modern print from original negative, Archives Salomon, Paris

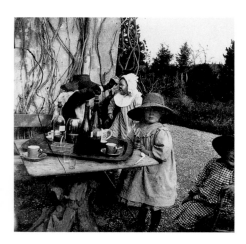
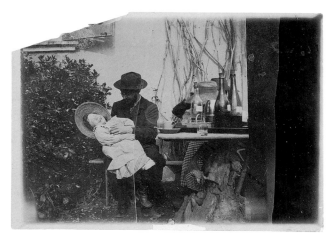
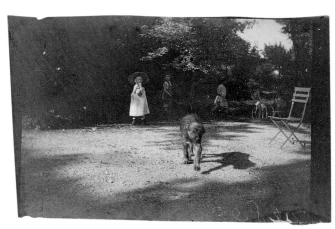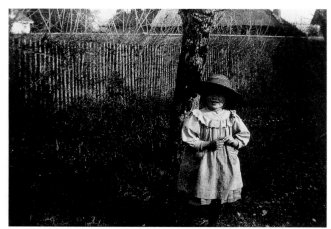

Opposite, clockwise from top left:

Cat. 409 Edouard Vuillard, *Bonnard Photographing Renée; Roussel and an Unidentified Child,* spring 1899, Grand-Lemps, modern print from original negative, Musée d'Orsay, Paris

Cat. 415 Edouard Vuillard, *Roussel, Madame Mertzdorff, and Renée,* spring 1899, Grand-Lemps, modern print from original negative, Musée d'Orsay, Paris

Cat. 408 Edouard Vuillard, *Around the Table: Bonnard (?) Holding Renée, Madame Mertzdorff, a Little Girl, and a Servant Holding Vivette,* spring 1899, Grand-Lemps, vintage print on albumen paper, 3¼ × 3⅜ in., Musée d'Orsay, Paris

Cat. 386 Pierre Bonnard, *Renée Looking at Pierre Bonnard,* spring 1900, Grand-Lemps, modern print from original negative, Musée d'Orsay, Paris

Cat. 413 Edouard Vuillard, *Madame Eugène Bonnard, Misia and Ida Godebska,* spring 1899, Grand-Lemps, vintage print on albumen paper, 3⁷⁄₁₆ × 3½ in., Musée d'Orsay, Paris

Cat. 385 Pierre Bonnard, *Renée Looking at Edouard Vuillard,* spring 1900, Grand-Lemps, modern print from original negative, Musée d'Orsay, Paris

Cat. 367 Pierre Bonnard, *Renée (?) Hugging a Dog,* 1898, Noisy-le-Grand, modern print from original negative, 11¼ × 15⅛ in., Musée d'Orsay, Paris

Cat. 411 Edouard Vuillard, *Bonnard Tickling Renée,* spring 1899, Grand-Lemps, vintage print on albumen paper, 3¼ × 3½ in., Musée d'Orsay, Paris

Cat. 363 Pierre Bonnard, *The Family Dog Approaches the Camera while the Terrasse Children Look On,* 1898, Noisy-le-Grand, modern print from original negative, 11¼ × 15⅜ in., Musée d'Orsay, Paris

Cat. 397 Edouard Vuillard, *Amfréville: View from a Window,* n.d., vintage print, 3½ × 3½ in., Archives Salomon, Paris

## Notes

1. Jacques Salomon and Annette Vaillant, *Vuillard et son Kodak* (London: Lefevre Gallery, 1966), p. 2.

2. As Elizabeth Wynne Easton has observed, Salomon's published description of Vuillard's use of the Kodak cannot be applied directly to the photographs done before Salomon's marriage to the artist's niece in the 1920s. See Easton, "Vuillard's Photography: Artistry and Accident," *Apollo* 99 (June 1994): 17 n. 1. However, given the equally contrived appearance of earlier photographs, it is not unlikely that Vuillard practiced something of the same technique in his early photographs of interior scenes. It is clear, however, that the apparatus referred to by Salomon as "of the bellows type" is a model that was not developed until 1917. See ibid., 17 n. 9. We do not know what types of cameras Vuillard used during the first two decades of his activity as a photographer. Many questions pertaining to Vuillard's habits as a photographer, as well as to the dating of extant photographs, remain unresolved. The imminent publication, under the direction of Dominique de Font-Réauix, in collaboration with Antoine Salomon, of the Vuillard photographs in the Archives Salomon, Paris, should lead to the full documentation of Vuillard's history as a photographer.

3. Quoted in Elizabeth Wynne Easton, *The Intimate Interiors of Edouard Vuillard* (Washington, D.C.: Smithsonian Institution Press for the Museum of Fine Arts, Houston, 1989), p. 19, Vuillard's journal, carnet 2, p. 30 verso, March 1891.

4. Maurice Denis, "Définition du néo-traditionnisme," *Art et critique* (August 1890), reprinted in *Du symbolisme au classicisme* (Paris: Hermann, 1964), p. 1.

5. See Easton, "Vuillard's Photography," p. 12.

6. Gloria Lynn Groom, *Edouard Vuillard, Painter-Decorator: Patrons and Projects, 1892–1912* (New Haven, Conn.: Yale University Press, 1993), p. 84.

7. See my essay on Bonnard's photographs in this volume.

8. According to Dominique de Font-Réauix, about one-third of Vuillard's photographs, preserved in the Archives Salomon, were taken indoors.

9. Easton, "Vuillard's Photography," p. 11.

10. Ibid., p. 16.

11. This photograph was reproduced in the catalogue for the 1991 exhibition *Vuillard: A National Touring Exhibition from the South Bank Centre* (London: South Bank Centre, 1991), no. 111. It appears on page 70, opposite a black-and-white reproduction of a painting by Vuillard called *Game of Draughts at Amfréville* of 1906. The implication of this juxtaposition seems to be, once again, that there is a relation between the two compositions, obvious in the common aerial point of view and theme of recreational park activities. However, the text does not discuss the nature of this relationship, thereby avoiding the problematic question of temporal priority between photograph and painting. No date is given for the photograph, which would seem to suggest that the date of the photograph has yet to be determined.

12. André Kertész was born in 1894 in Budapest. His photographs of Paris and New York have won him worldwide fame as one of the most sophisticated avant-garde photographers of the twentieth century. See, for example, *André Kertész: Of Paris and New York* (Chicago: The Art Institute of Chicago; New York: The Metropolitan Museum of Art, in association with Thames and Hudson, 1985).

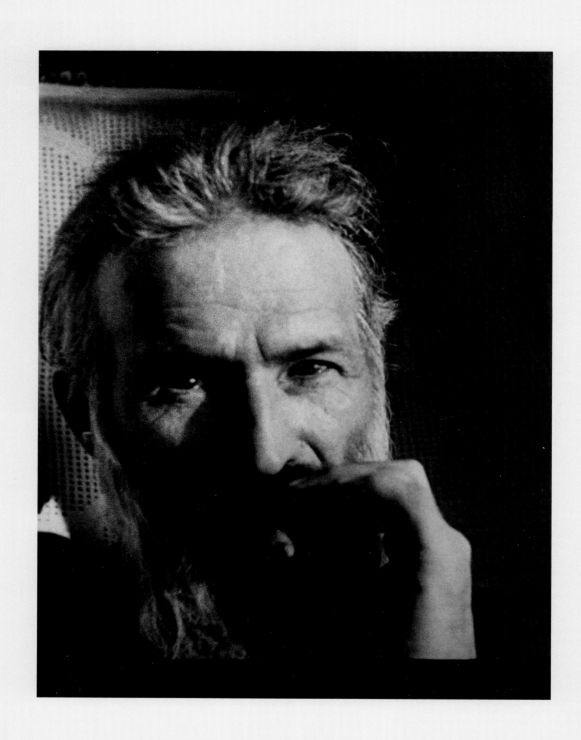

# Constantin Brancusi

HOBITZA, GORJ, ROMANIA 1876–1957 PARIS

At age eleven, Brancusi (Brâncuşi in Romanian) left home. He studied sculpture at the National School of Fine Arts in Bucharest and at the School of Arts and Crafts in provincial Craiova. In 1902, after winning prizes and medals for his student work, he received his fine arts degree. Two years later Brancusi moved to Paris, and in 1905 he enrolled at the Ecole des Beaux-Arts, studying with the sculptor Antonin Mercié. Soon his works were shown in the Salon d'Automne (1906) and in the Salon des Indépendants (1910). In 1907 he left the Ecole des Beaux-Arts and met Auguste Rodin. Recognizing and perhaps not wanting to compete with Rodin's enormous influence, Brancusi began to make sculptures by direct carving, a method Rodin did not practice. Brancusi's works are characterized by forms so simplified as to be almost abstract, their sensuous shapes often enhanced by meticulously smooth surfaces, whether the sculptures are made from stone, marble, or bronze. Shown in the United States at the Armory Show (1913) and Alfred Stieglitz's Photo-Secession Gallery (Brancusi's first solo show, 1914), his works were eagerly amassed by the American collectors John Quinn and Walter and Louise Arensberg. His first retrospective exhibition took place in the United States in 1955–56 at the Solomon R. Guggenheim Museum in New York and the Philadelphia Museum of Art. Wanting to control the presentation of his sculptures in publications and in installations, he started in 1914 to take photographs of them himself, capturing what he deemed their correct aura and angle of view. The special bases Brancusi made for his sculptures further controlled the way they were seen. The iconic forms of his work lent themselves to public-scale monuments, such as those to World War I heroes at Tîrgu Jiu, Romania (*Endless Column, Gate of the Kiss,* and *Table of Silence,* 1937–38), and an unrealized project for a temple on a private estate in India. In 1952 he received French citizenship; he bequeathed the studio he occupied from 1916 to 1957 and its contents to the French state.

Cat. 440 Constantin Brancusi, *Self-Portrait,* c. 1922–23, gelatin silver print, 7½ × 5½ in., Didier Imbert Fine Art, Paris

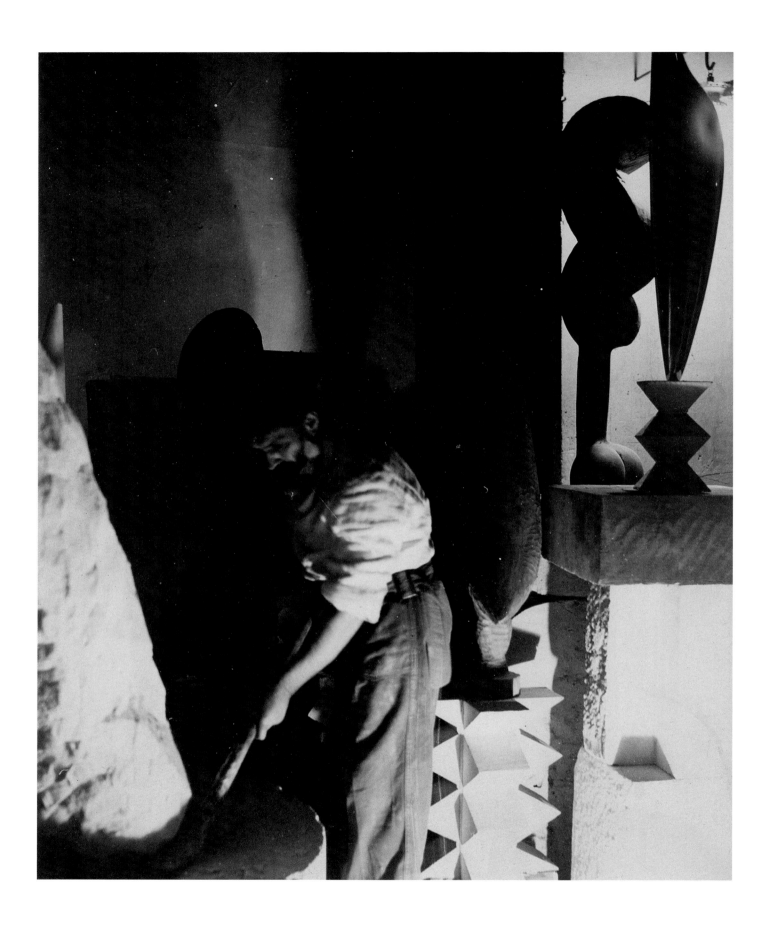

*Elizabeth A. Brown*

# Brancusi's Photographic In-sights

Photography played a peculiar and complicated role in Constantin Brancusi's career. The camera served as an intercessor between the artist and his sculptures, providing him the opportunity to make repeated "portraits" of favorite works and to create pictures out of the controlled disorder of his studio. Never a professional or trained photographer, Brancusi disregarded such technical standards as printing squarely on the sheet or focusing precisely, let alone such theoretical considerations as maximizing depth of field or printing the full frame. He worked with whatever camera was at hand, producing negatives in at least nine formats; he used a movie camera, but only to produce stills. He jury-rigged negative holders and carved backgrounds out of emulsions. His enlargements and copy prints were improvised and offhand, so that these images seem willed into existence instead of being crafted.

This aesthetic is very different from the masterful perfection that characterizes Brancusi's sculpture. Whereas subtlety, finish, and execution all speak from the figures and objects the sculptor produced, his photographs function differently: although we now see them as fascinating and compelling images, their haphazard and casual appearance suggests that Brancusi wanted them seen transparently, not as objects in their own right but as transmitters of images. Photographs were included in at least one of his major mid-career exhibitions, but there is no suggestion that he wished them to be considered works of art or even thought of their sale.[1]

The bank of images Brancusi left in various states of completion is not a random grab bag but rather a storehouse of data, as readable as someone's letters or journals. Just like writing, the photographs comment on whatever issue was at hand.

Some graze lightly against what seem to be crucial subjects, others probe deeply and repeatedly into an interest, an obsession. Unlike letters, which are written until they are sent, Brancusi sometimes added to his visual commentary, returning again and again to a classic expression of *Sleeping Muse,* for example (cat. 423). Whereas the marble itself has one sort of existence, goes out into the world, interacts with others, and (potentially) returns, the photograph constitutes a sort of utterance, a definition as well as a likeness. Like the perfect choice of words, this image was often ready to hand. The sculptor gave prints of it to such friends as Edward Steichen and published the image at least eleven times.

This historical event of *use*—the ways Brancusi employed a photograph—provides an extraordinary angle of inquiry into the artist's career, intentions, and development. Fairly strict lines can be drawn between the numerous negatives he (probably) shot and the far fewer images he printed: these might occur as images in books, catalogues, and magazines printed during his lifetime, or the photographic print itself might still survive. There are around twelve hundred prints in the Fonds Brancusi, the material transferred to the Musée National d'Art Moderne, Paris, after the artist's death.[2] Over the past fifteen years perhaps another two hundred have surfaced. Since they were never commodities during Brancusi's life, the photographs "in circulation" either had been given to friends and acquaintances or resurfaced from the archives of publications. This trail of function is also richly significant, tracing relationships and associations that might otherwise remain conjecture.

In this way we can examine the photographs that worked for Brancusi, the ones he liked. One

Cat. 439 Constantin Brancusi, *Self-Portrait (Artist Carving "The Seal"),* c. 1922, gelatin silver print, 13⅜ × 10⅝ in., Didier Imbert Fine Art, Paris

267

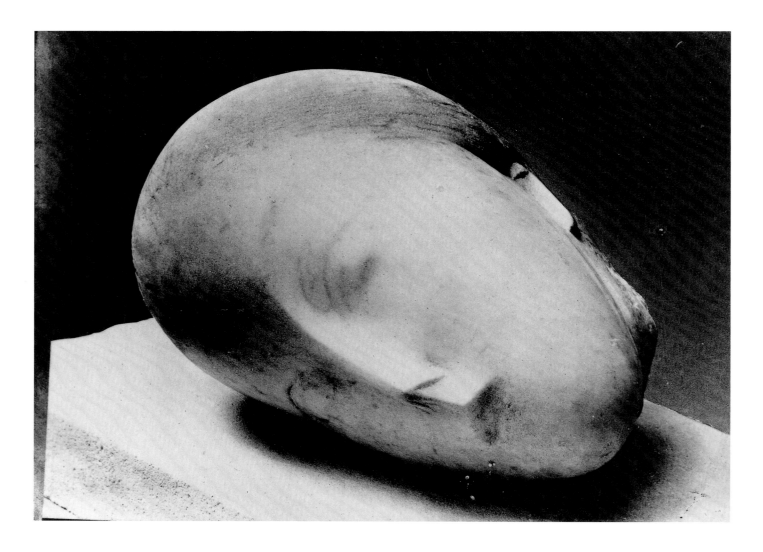

such photograph depicts his first *Mlle. Pogany* (cat. 437). There are numerous prints, dating from the late teens until the end of the artist's life: jewel-like contact prints preserving the fine detail of a 24-by-18-centimeter glass plate and glossy enlargements up to 50-by-40 centimeters. The photographic image represents a significant modification of the subject—a marble sculpture carved in 1912—and heralds the changes that characterize versions II and III, which reduced the gestalt to a closed ovoid. This suggests that one factor in conceiving this image was to experiment with "recarving" the sculpture conceptually. In the same way an individual will examine her reflection, shifting her chin to make her nose seem a little shorter or squinting slightly to soften an outline, the artist manipulated the concrete reality of a sculpture by the specific way he looked at it. An active process of vision, this photographic view, along with others in Brancusi's corpus, makes a new image by will, by an act of apperception.

A similar example can be found in the devel-opment of *Princess X* (fig. 132), which evolved out of an unsuccessful carving known as *Woman Regarding Herself in a Mirror* or simply *Portrait.* Two photographs preserve this lost figure, one shot from the left shoulder, which demonstrates the unresolved masses of coiffure. The other, from the right, finds a point of view that begins to reduce the volumes to a series of simplified ovoids: face, shoulder, cap of the skull, ponytail (fig. 133). Working with this photograph in positive and negative prints actually helped Brancusi prefigure the generalized suggestive forms that would notoriously scandalize viewers of the 1920 Salon des Indépendants. This pair of images is the most extreme example of Brancusi's employing photography in his intellectual working process. The photographic view of *Portrait* allowed him to perform a dry run on the radical recarving that would ultimately reveal *Princess X.* Later prints of the image such as the pair reproduced here permitted Brancusi to demonstrate visually how his progressive abstraction actually worked.

Indeed, carving was the basic activity of Brancusi's art practice: he revealed rather than indicated; uncovered rather than limned. Distinguished by seductive rhythms and sensitive color, his drawings and paintings are "primitive" and childlike, as schematic as his verbal communications. Neither matched the workings of his mind. But photography provided a two-dimensional medium that could be conceptualized fully in the round. Brancusi worked out his ideas by carving, whether cutting away a plaster mass, aged oak, or hollows in space. Photography allowed him to create pictures as well as objects by taking away, excavating images by manipulating lights and casting shadows.

Often Brancusi used a photograph to assert how his sculptures should be seen. His straightforward images of *The Kiss* (cat. 438) emphasize the unity of form achieved in direct carving, yet assert all the visual clues by which the sculpture represents two distinct figures. This clean and simple photograph seems to have appealed to Brancusi, because he shot several versions in the same fashion (see cat. 428). Sometimes he eschews one viewpoint of a given subject or encourages another: all his images of *Princess X* approach the figure from its right side, a more naturalistic viewing, whereas museum photographers invariably prefer the odd viewpoint from the left shoulder, with a flipperlike arm.

The artist's photographs furthermore provide visual correlatives for emotional responses. Light shining off gleaming bronzes is one such device, which equates polish with inspiration (see cat. 430).

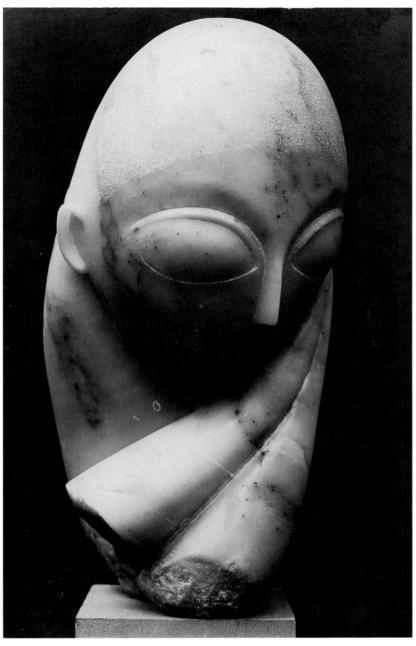

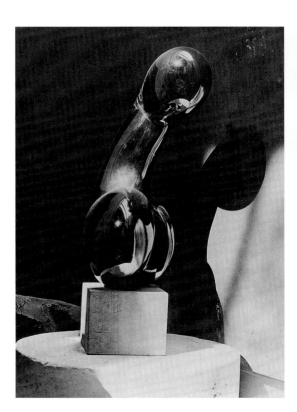

Cat. 437 (top) Constantin Brancusi, *Mlle. Pogany I (Marble)*, before 1921, gelatin silver print, 8⅞ × 7 in., Mayor Gallery, London, and David Grob

Fig. 132 (bottom, left) Constantin Brancusi, *Princess X*, 1916, gelatin silver print, Centre Georges Pompidou, © Musée National d'Art Moderne, Paris

Fig. 133 (bottom, right) Constantin Brancusi, *Woman Regarding Herself in a Mirror*, gelatin silver print, Centre Georges Pompidou, © Musée National d'Art Moderne, Paris

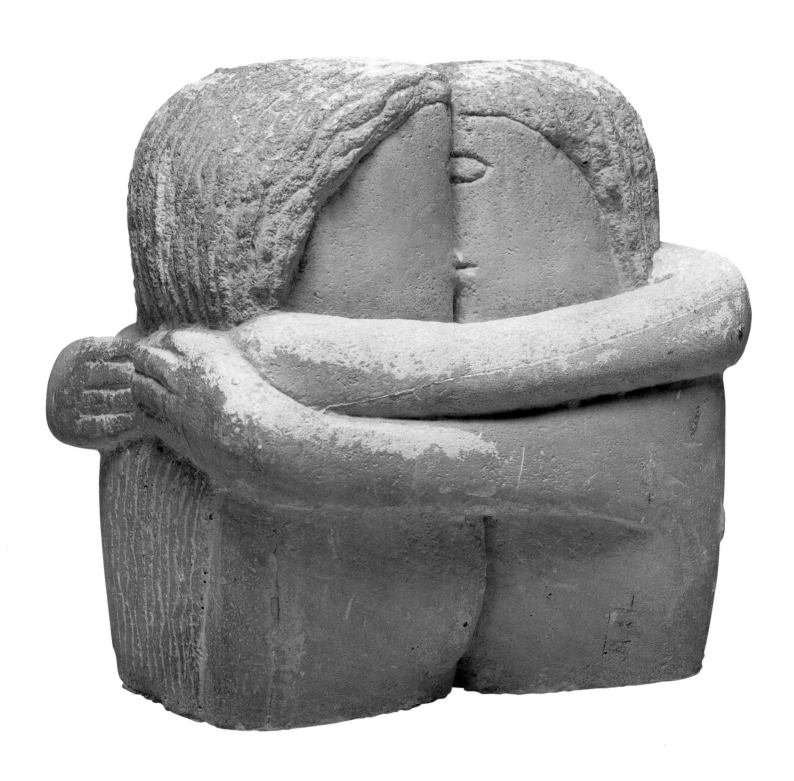

Cat. 425 (opposite)
Constantin Brancusi, *The Kiss,*
c. 1907–8 (cast before 1914),
plaster, 11 × 10¼ × 8½ in.,
The Patsy R. and Raymond D.
Nasher Collection

Cat. 428  Constantin Brancusi,
*The Kiss,* c. 1918–23, gelatin
silver print, 9¾ × 7 in.,
Didier Imbert Fine Art, Paris

Cat. 438  Constantin Brancusi,
*The Kiss,* c. 1921, gelatin silver
print, 19¾ × 15⅝ in., Indiana
University Art Museum

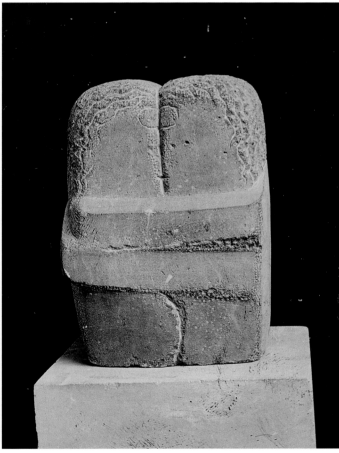

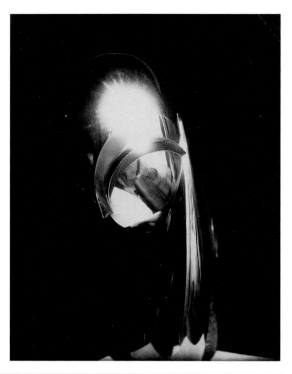

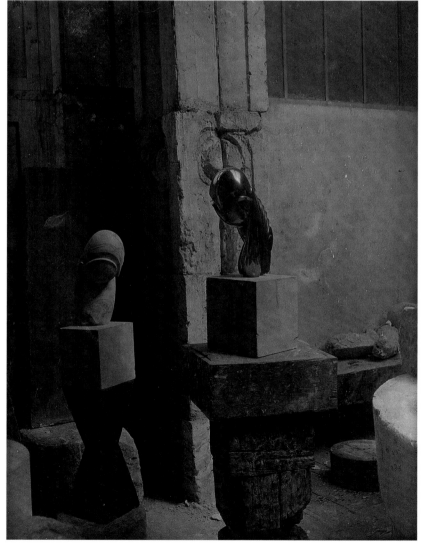

Another is to adopt old-master codes of seeing in the round, providing more than one aspect in the same picture. Two viewings of *Mlle. Pogany II,* marble and bronze at different angles of vision, serve to seize or possess the subject more completely (cat. 437). A third, more subtle, and less provable device is Brancusi's use of sculptures literally as surrogates: in some of the photographs "figures" stand in for the viewer, in others they subrogate the artist himself. Thus in *Studio: Eve with Newborn* (fig. 134), the way *Eve* gazes at *Newborn* suggests a viewpoint we should emulate; in *View of the Studio with the Crocodile,* the crocodile's position stands in for that of the photographer.[3]

On the other hand, Brancusi's photographs frequently complicate our reading of a sculpture. Some of the best known represent not a single sculpture, but innumerable pieces woven into the fabric of a site—the artist's studio—which I argue elsewhere becomes one of the earliest instances of installation as art.[4] Whereas Brancusi has been discussed as the producer of refined, closed objects, the photographs suggest instead a definition of sculpture as additive and inclusive, often resisting final definition. Images of the *Newborn* (fig. 134) and of *Mme. L.R.* (cat. 434) present temporary combinations: in each case, the deeply sculptured pedestal supplies a lower body for the fragmentary figure it supports, whereas these bases (in fact, the same base elements in each case) are no longer connected to the figures.[5] Brancusi generated a wide stock of pedestal components, whether intended as stools, socles, or abstract sculptures, which he employed in exhibiting and photographing named sculptures. Some, such as the variegated wood carving occasionally identified as "Chien du garde," ended up as a permanent portion of the sculpture (*The Chief,* Solomon R. Guggenheim Museum, New York). Others, although published as part of an assemblage, remained independent in the artist's studio on his death and form part of the ensemble presented by the Centre Pompidou today. Nonetheless, several of the most austere works retain their composite bases, which enable them to oscillate between a reading as abstract and another as figural. A classic example is the marble *Beginning of the World* (cat. 429), profoundly abstract if we focus on the marble "figure," whereas the whole ensemble can be read as a body, with the reflective disk signifying shoulders and the vertical elements stacking like torso and legs.

The way in which Brancusi used his photographs to teach a manner of seeing, the visual approach he desired from his viewers, provides insight into certain issues surrounding his art. One involves asymmetry, the life-giving irregularities he built into each perfect-seeming object. For example, *The Fish,* reputedly as regular as the tang of a knife, actually inscribes an S-curve.

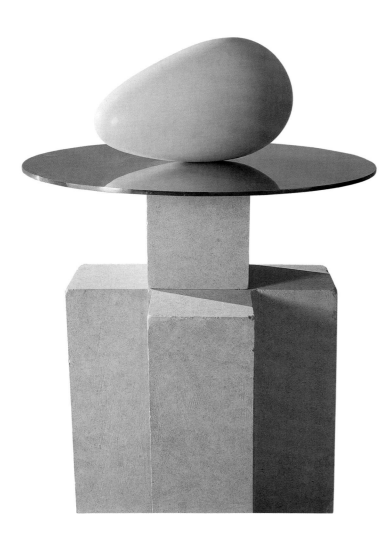

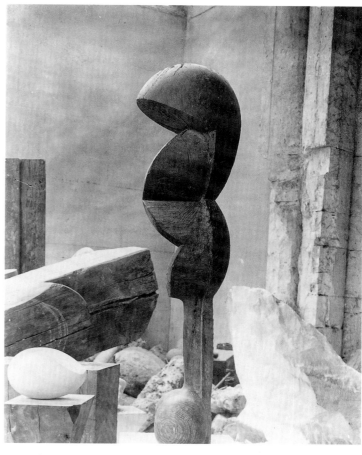

Cat. 429 (left) Constantin Brancusi, *Beginning of the World,* c. 1920, marble, metal, stone, 30 × 20 × 20 in., Dallas Museum of Art, Foundation for the Arts Collection

Fig. 134 (right, top) Constantin Brancusi, *Studio: Eve with Newborn,* 1919, gelatin silver print, Centre Georges Pompidou, © Musée National d'Art Moderne, Paris

Cat. 434 (right, bottom) Constantin Brancusi, *View of the Studio with Portrait of Mme. L.R.,* c. 1920, gelatin silver print, 9 × 6⅞ in., Mayor Gallery, London, and David Grob

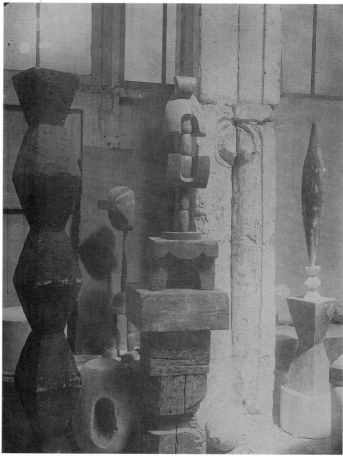

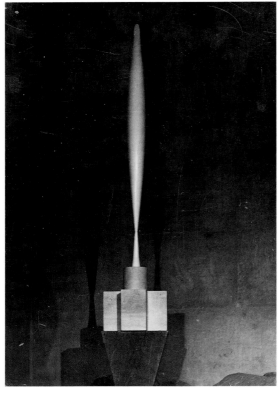

Cat. 445  Constantin Brancusi,
*Bird in Space,* c. 1925, gelatin
silver print, 11¾ × 7¹³⁄₁₆ in.,
Indiana University Art
Museum

Cat. 450  Constantin Brancusi,
*View of the Studio with "Leda"
and "Fish,"* after 1934, gelatin
silver print, 11¾ × 9⅜ in.,
Mayor Gallery, London, and
David Grob

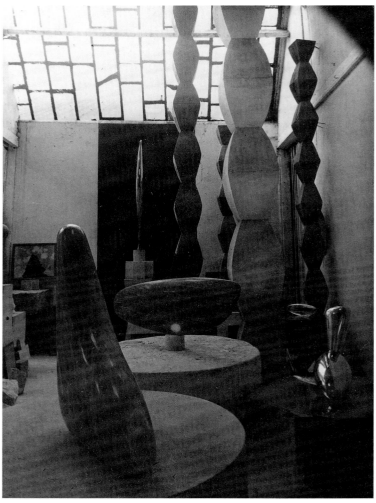

When *The Large Fish* is seen head-on, it creates the illusion of swimming toward the viewer. Brancusi published such a point of view enacted by *Leda, Socrates,* and other sculptures in his studio: *View of the Studio with "Leda" and "Fish"* (cat. 450), for instance, shows the monumental *Fish* nose-to-nose with a small-scale bronze version. Similarly, the minute but endless differences between contour, profile, and three-quarter view of *Bird in Space* contradict its status as the epitome of rigorous abstraction.[6] This point is made by a photographic device Brancusi invented, using two light sources to provide three views: those of the sculpture itself and the distinct, clear silhouettes it casts to each side (cat. 445).

One might have expected Brancusi's photographs to speak of abstraction, the streamlined *moderne* of gleaming new machinery.[7] Instead, time after time these pictures assert the humanity of the sculptures, or something equivalent, a personal quality, a suggestion of agency or vitality. Photographs of *Newborn* and *Sleeping Muse* (notably cat. 423) feature those details that make an egg into a face: an edge of a brow, shadows defining an eye socket, the expression of a mouth. This crucial grip on representation is the very subject of *The Newborn II* and *Head of a Sleeping Child* (cat. 441), which justifies the ovoid's evolution through naturalistic observation. Despite the abrupt fragmentation of both sculptures and the way the rough column base eliminates any notion of context, their juxtaposition encourages that they be read as heads, not as objects. Brancusi found capacious interest in exploring this edge between abstraction and representation, returning frequently to rephotograph *Newborn, Sleeping Muse,* and *Little Bird* (another truncated ovoid). In contrast, there were subjects he never engaged photographically, perhaps because they resisted being characterized by the camera's lens.

The only "Brancusi photo" that celebrates the nonrepresentational is one image of *Beginning of the World,* the unveiling of the egg as the birth of modernity (fig. 135), and that turns out to have been made by Edward Steichen. This theatrical showcasing of *The Beginning of the World* seems to be the sole image Brancusi wholeheartedly adopted from another photographer.[8] Having produced his own counterproof negative *(contretype),* using thumbtacks to hold Steichen's print securely at the right viewpoint (a detail that identifies Brancusi's hand), he reprinted this image several times. Thus he could provide photographs of his most austere work to Theo van Doesburg, László Moholy-Nagy, Carola Giedion-Welcker, and others as needed.[9]

This example brings up another rule with exceptions: Brancusi's proscription against other photographers. Several contemporaries recount his rejection of specific images made by professionals

Cat. 441 Constantin Brancusi, *The Newborn II* (c. 1920) and *Head of a Sleeping Child* (1916–20), c. 1923, gelatin silver print, 9¼ × 11¾ in., Mayor Gallery, London, and David Grob

Fig. 135 Edward Steichen, *Constantin Brancusi's "The Beginning of the World,"* *c. 1926*, gelatin silver print, Musée national d'art moderne, Centre national d'art et de culture Georges Pompidou, Paris

or his refusal to admit a photographer into his studio. On the other hand, he maintained extended friendships with several photographers: Steichen, for whom he carved his first site-specific *Endless Column,* Man Ray, and Charles Sheeler. The latter made several images used in a 1922 article in *Vanity Fair,* one of which Brancusi contretyped and reused for his exhibition catalogue at the Brummer Gallery in 1926.[10] Brancusi also owned photographs that Man Ray had shot in his studio, although the only images he reused from Man Ray derive from a portrait session in the early 1930s.[11] Curiously, in *Self Portrait,* his autobiography, Man Ray claims to have taught Brancusi photography. The chronology does not support this contention: Man Ray did not arrive in Paris until 1921, after Brancusi had made and published a group of twenty-four photographs in the literary and arts journal *Little Review.*[12]

Making photographs grew in significance from important to crucial within the intense relationship Brancusi maintained with John Quinn in the seminal years after World War I. Quinn, perhaps the preeminent New York collector of modern art in the 1910s, discovered Brancusi in the Armory Show—where his art made nearly as big a splash as Duchamp's *Nude Descending a Staircase.* The following year Quinn bought the *Mlle. Pogany* from the Little Gallery of the Photo-Secession; the exhibition had been arranged by the expatriate Steichen, who supported himself in part by doing such long-distance work for Alfred Stieglitz. Working through interlocutors for a few years, the two men established a (relatively) regular correspondence in 1917, which continued until 1923.[13] Quinn died in 1924 and his collection was dispersed; Duchamp brokered the deal by which no Brancusi went to public sale. Many of the thirty-four pieces Quinn had owned went back to Brancusi's studio, although these always remained "for sale," intermittently pitched by Duchamp, Henri-Pierre Roché, or occasionally Man Ray. Brancusi never had a formal gallery. Duties such as providing information or pictures were generally fulfilled by the artist himself, although it seems that his friends helped to negotiate sales, at first probably by establishing the contacts and conducting the negotiations, later apparently putting more effort into persuading the artist to part with another of his "children."

Quinn's death represented many transitions for Brancusi. His photographs appeared in more public and semipublic venues, particularly in the new cultural magazines. This is also probably the moment when Brancusi grew more retentive. He began to resist letting go of any sculptures other than the Quinn collection he was storing, avoiding sales and even new visitors; by the later 1930s he was producing "surrogates" of any objects that did depart. Personal accounts report his refusing sales, even declining visitors; one possibly apocryphal family was advised to have their nubile daughter knock at his door. In 1947 he acquiesced to three purchases by the Musée National d'Art Moderne; later he played hard to get with the Guggenheim, only completing their purchases in 1953. Gradually, plaster casts replaced *Seal, Large Fish, Sorceress,* and other figures in the artist's studio, filling in their precise positions in the ensemble that Brancusi constructed, explicated, and photographed as his final work of art.[14]

Photographs sometimes functioned as these surrogates, particularly when the subject was site-specific. Numerous views of the studio show large photographic prints of Brancusi's first site-specific work, the *Endless Column* in Voulangis, made for Steichen. After 1934 framed images of *Endless Column* in Tîrgu Jiu appear (fig. 136); proofs of these images are piled on a pedestal element in the foreground of another studio view. Photographs of lost works or pieces Brancusi sold early in his career also peopled his studio, such as his *Ecorché* (cat. 422) and an image of the very early *Wisdom of the Earth,* which the artist seems to have reshot from a newspaper photograph. However different in scale, material, and presence from their referent, these images seem nonetheless to indicate the missing sculptures, like memorial photographs of departed relatives hanging on the living room wall.

Brancusi's photographs are highly subjective, even quirky objects, tackling big and slippery themes such as procreation, desire, and transcendence. Extended photographic meditations on *Newborn* explore a deeply emotional relationship, sometimes tender and sometimes fiercely celebratory, one that might even be read as an abstracted but extended fantasy of paternity. Western art norms represent the feminine with smooth, soft forms and rounded curves; is it two steps or only one to the stereotype of woman as vessel and as object of desire? In contrast, the distinctive Brancusis with a rough finish are either identified as male subjects or more generalized in gender—the *Kiss* portrays both man and woman; *Socrates* and *Plato* are well-known male subjects; *Chimera* and the *Endless Column,* while not explicitly gendered, inevitably suggest the masculine. In subjects named for women (besides *Mlle. Pogany* and *Mme. L.R.,* these include *Nancy Cunard, Portrait of Mrs. Meyer, White Negress* and *Blond Negress, Sorceress* [cat. 426], *Princess X,* and *Leda*), Brancusi explored many nuances of desire, intimacy, passion, and fear, consulting his unconscious to devise fantastic form. A sensual, tightly closed silhouette characterizes each, an embrasure of form that we can see progressively enacted in the three versions of *Mlle. Pogany.* Each depends on smoothly rounded form, ideal for the high polish that became his hallmark.

Cat. 422 (top, left) Constantin
Brancusi, *View of the Studio
with l'Ecorché,* c. 1901, gelatin
silver print, 11⅝ × 9⅜ in.,
Didier Imbert Fine Art, Paris

Cat. 453 (top, right)
Constantin Brancusi, *Endless
Column at Tîrgu Jiu,* c. 1938,
gelatin silver print, 11¾ ×
9⅜ in., Indiana University
Art Museum

Fig. 136 (bottom) Constantin
Brancusi, *View of the Studio,*
1945, gelatin silver print,
Centre Georges Pompidou,
© Musée National d'Art
Moderne, Paris

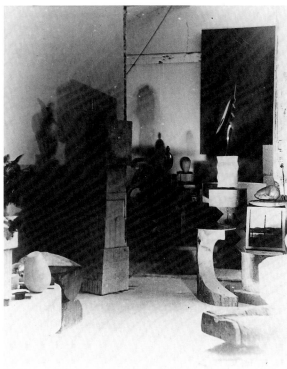

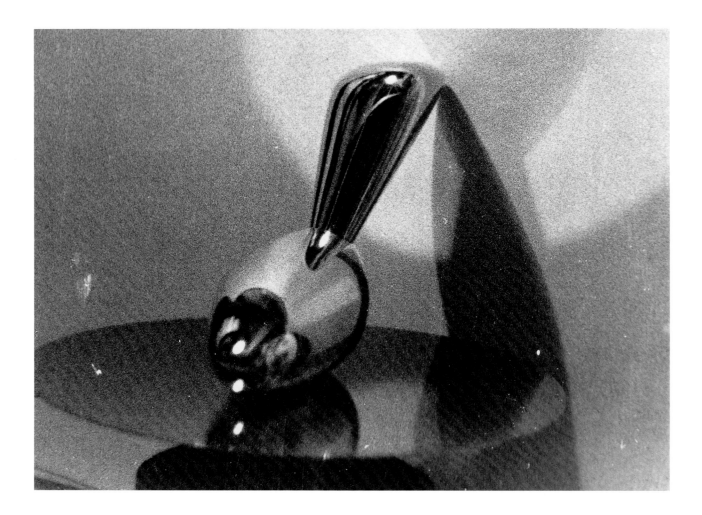

All the stylistic devices Brancusi invented, the
tenuous engineering of *Bird in Space* or the ex-
traordinary machinelike perfection of his polished
metal works, might argue for a cool aesthetic, one
that might emphasize his technical virtuosity. The
ritualized refinement of his sculptures, particularly
the obsessive devotion of polishing for weeks at a
time,[15] enact a sensual as well as an actual mani-
festation of the affect. The readable subjects and
explicit titles—nearly all of which can be traced
back to the artist's direct invention—argue some-
thing more personal and intimate. Biographic
readings, however, never seem to work. There is
no evidence, for example, of an erotic relationship
between Brancusi and Margit Pogany, although
he continued to reinvent her image for decades.
I would argue that the sculpture, rather than the
woman, was at the core of his romantic cathexis.

Brancusi's photographs are varied in formal
construction, scale, mood, and technique. Nearly
all have a single consistency: they persistently
reintroduce life back into the subject. However
abstracted a head or figure might have become,
in its author's photographs it moves or speaks. In
contrast to contemporary photographers, such as
Paul Strand, whose modernist images of cameras
and cars glory in the machined perfection of
manufactured equipment, Brancusi envisioned

his high polish as another tool for bringing in life
force. Whereas professional photographers take
great pains to eliminate their reflections from such
objects, his intention was precisely the opposite:
to explore and exploit the penetrability of the fig-
ure. His photographs of mirror-polished bronzes
endow the sculptures with myriad reflections that
imply internal attributes of the subject. In *Leda
in Flight* (cat. 449) the lower half of the figure in-
scribes a regular hollow, as if revealing a womb
within the body. Images of mirror-finished heads
such as *Mlle. Pogany II* and *Blond Negress* utilize
reflections differently, revealing a squadron of
persons occupying the volume of the head. Most
of the recognizable sculptures in these images can
be read as distinct surrogates for the artist himself.
In the example of *Blond Negress* (fig. 137) we can
read the standing figure of the artist and his large-
scale view camera amid a squadron of attenuated
sculptures, including *Sorceress.* The bright reflec-
tions and sharp lines of this image contrast with
the penumbrous shadows and mysterious instabil-
ity of *White Negress* (cat. 442), the marble version
of the same composition.

Other images of metal works exploit the
reflectivity of the material to suggest something
ineffable, a spark of life, a glimpse of emotion.
Brancusi first devised his explosive light device

in portraying *Bird in Space* in its first mirror-finished incarnation (fig. 138):[16] that the negative is cracked attests to how frequently he printed and used it. In subsequent series, similar, highly affective explosions herald the appearance of *Newborn* or several versions of *Bird in Space* in polished metal. In extended photographic series of *Endless Column* at Tîrgu Jiu, the shifting cloud-scape provides another set of objective correlatives for his intense emotional responses, whether it is reflected in the metal facets of the structure or remains in the background (cat. 453).

Visitors to Brancusi's studio reported that their experience felt theatrical. The artist would lead a guest from one work to another, whisking away dropcloths at strategic moments to catch a ray of light or to reveal a rotating base. The effect was to produce a series of unique perceptions, as if to introduce each sculpture on its own merits. In exhibition or in publication, his photographs function in the same way to showcase the personality of *Sorceress* or *Princess X.* The affective devices Brancusi invented in his photographic practice,

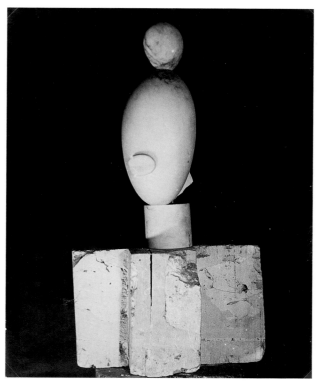

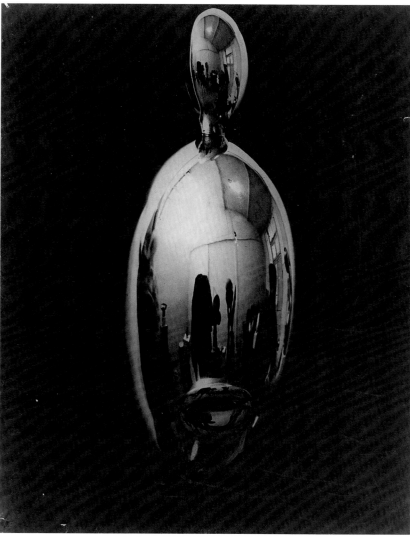

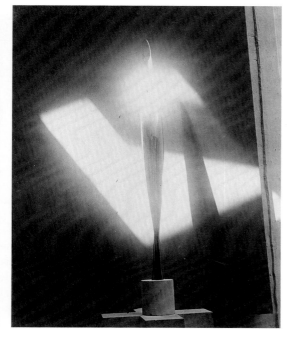

Cat. 442 (top) Constantin Brancusi, *White Negress,* c. 1923, gelatin silver print, 11½ × 9¼ in., Courtesy of Zabriskie Gallery, New York

Fig. 137 (bottom, left) Constantin Brancusi, *Blond Negress,* 1926, gelatin silver print, Centre Georges Pompidou, © Musée National d'Art Moderne, Paris

Fig. 138 (bottom, right) Constantin Brancusi, *Bird in Space,* 1927, gelatin silver print, Centre Georges Pompidou, © Musée National d'Art Moderne, Paris

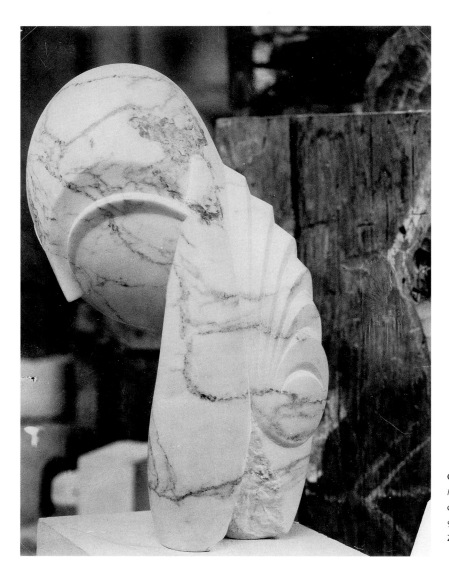

Cat. 431  Constantin Brancusi,
*Mlle. Pogany II, Profile View,*
c. 1920, gelatin silver print,
9⅛ × 6¾ in., Courtesy of
Zabriskie Gallery, New York

like his sculptural innovations, help to animate his art, to make his object—virtually—live.

Brancusi had definite ideas about what his art could do and how it needed to be seen. He determined ways to control audience receptions at the same time he was learning to use the camera, so that his intellectual process and his self-presentation developed in parallel tracks. Photography provided the medium by which Brancusi interacted with others—his contemporaries, his patrons, and his critics. At the same time it enabled an inner dialogue, a means for discerning his own reactions and perceptions and for fixing them in concrete visual form. Much of the mystique that has grown up around the figure of the lone mystic from exotic Romania can be understood as a marketing strategy; although his self-portraits also show him interrogating his self-image, they serve primarily to romanticize the figure of the artist (cats. 439, 440, 443, 444, 448). Unlike comparable

images by Edgar Degas, Edvard Munch, and others featured in the present exhibition, however, these self-portrait images never crossed the line into Brancusi's subject matter. They remained more or less practical, while his images of individual sculptures or groups of objects take on the personal interpretation associated with portraits of human subjects in other artists' work. Brancusi's desire remained caught up with the near-abstract subjects of his own creation. It was to his own invention of a "Mlle. Pogany" who consisted of self-multiplying curves (cat. 431), to the oscillating single/double form of *The Kiss,* or to the origins of life in an egg that he was compelled to return, both in the production of new sculptures and in the generation of photographic images. In the art of Brancusi, archetypal modernist, there remains that symbolist core, the pervasive belief in elusive meanings and the persistent search for universal truths.

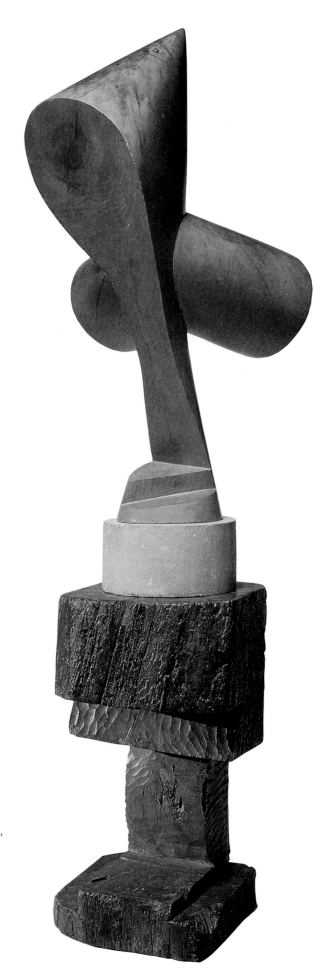

Cat. 426 Constantin Brancusi,
*The Sorceress,* 1916–24, maple
with two-part base of lime-
stone and oak, 38¼ × 18⅝ ×
18½ in., The Solomon R.
Guggenheim Museum,
New York

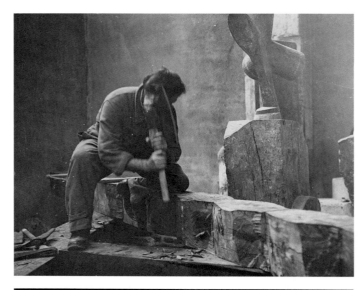

Clockwise from top left:

Cat. 443 Constantin Brancusi, *Self-Portrait (Artist Seated, Carving the "Endless Column"),* c. 1924, gelatin silver print, 9⅜ × 11⅞ in., Didier Imbert Fine Art, Paris

Cat. 444 Constantin Brancusi, *Self-Portrait Working on the "Endless Column,"* c. 1924, gelatin silver print, 7⅛ × 9 in., Didier Imbert Fine Art, Paris

Cat. 448 Constantin Brancusi, *Self-Portrait,* c. 1933–34, gelatin silver print, 15⅝ × 11¾ in., Didier Imbert Fine Art, Paris

Cat. 424 Constantin Brancusi, *The Prayer,* c. 1907, gelatin silver print, 11⅜ × 9 in., Didier Imbert Fine Art, Paris

Cat. 432 (opposite) Constantin Brancusi, *Studio with Polaire,* c. 1920, gelatin silver print, 15 × 12 in., Camera Works, Inc.

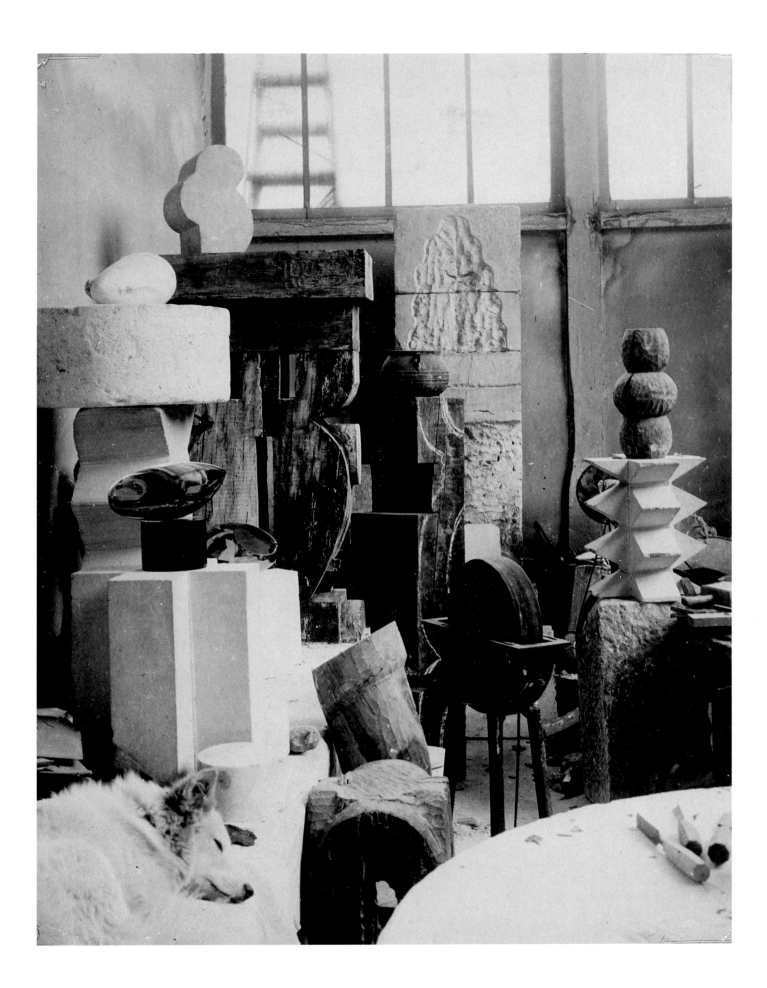

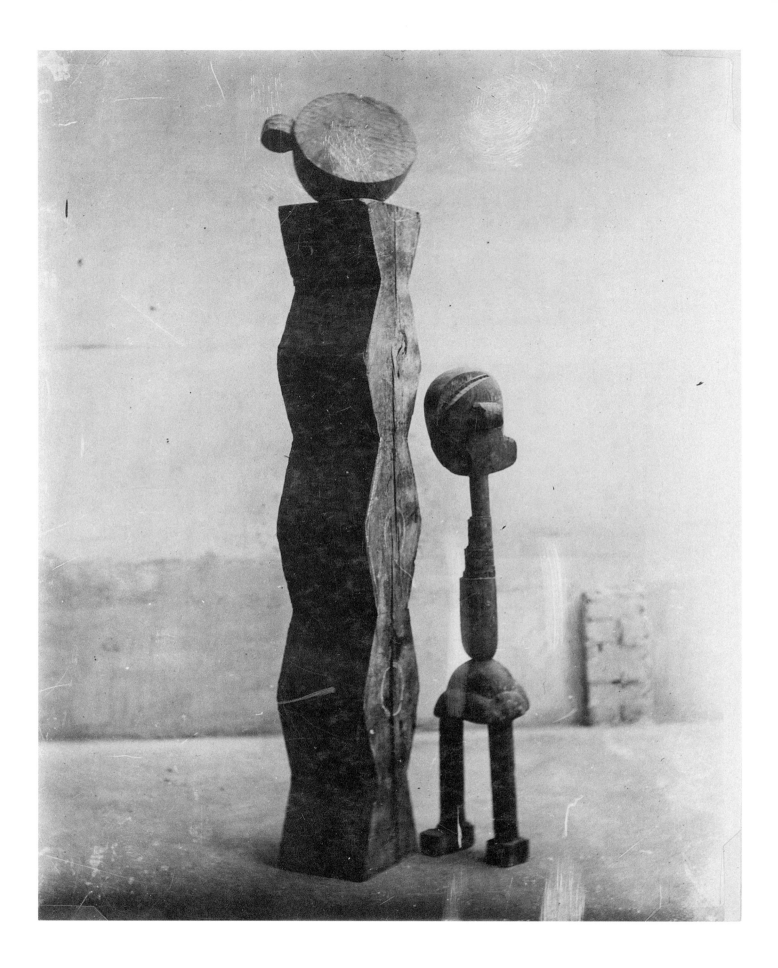

## NOTES

1. At least one photograph—of *The Chief*—was shown in Brancusi's first large-scale solo exhibition at the Joseph Brummer Gallery, New York, held November 17–December 15, 1926, which the artist attended. It can be seen in the background of an installation view shot by Yasuo Kuniyoshi, who worked as a professional photographer to earn his living. The photograph is nowhere mentioned in Brancusi's notes for the exhibition, let alone its catalogue. At least two photographs were included in Brancusi's second exhibition at the same gallery, held November 17, 1933–January 13, 1934, which the artist did not attend. Marcel Duchamp, a good friend of the artist and his sometime dealer/representative, installed the exhibition and indicated on a floor plan he drew for Brancusi the positions of "photo écorché" (cf. cat. 422) and "photo Colonne" (cat. 453). The latter represented a view in situ of the monumental *Endless Column* Brancusi had carved in the Voulangis garden of Edward Steichen (variously dated 1920 and c. 1926). In both cases the photographs represent sculptures important to the artist's development and self-image, which could not be included in any showing, the former lost, the latter essentially site-specific.

2. For an account of materials in the Fonds Brancusi of the Musée National d'Art Moderne, Centre Pompidou, and analyses of their use, see Elizabeth A. Brown, "Through the Sculptor's Lens: The Photographs of Constantin Brancusi," Ph.D. diss., Columbia University, 1989, pp. 7–14.

3. The latter is reproduced in Marielle Tabart and Isabelle Monod-Fontaine, *Brancusi Photographer,* trans. Kim Sichel (Paris: Musée National d'Art Moderne; Agrinde Publications, 1997), no. 42.

4. Elizabeth A. Brown, "L'Atelier méta(mor)phorique," in Michel Frizot and Dominique Païni, eds., *Sculpter-Photographier/Photographie-Sculpture,* Actes du colloque organisé au Musée du Louvre, November 22–23, 1991 (Paris, 1991), pp. 41–56.

5. The photograph of *Newborn II* (marble) is published in the exh. cat. of the Brummer Gallery, 1926, as no. 16 (where it is used to reproduce the base), and Tabart and Monod-Fontaine, *Brancusi Photographer,* no. 60.

6. This version of *Bird in Space,* purchased by Steichen and imported to the United States, touched off the landmark court case *U.S. Customs Authority v. Constantin Brancusi.* Although the first trial found for the plaintiff, agreeing with a customs official that the object could be taxed as scrap metal, Brancusi and his defenders won on appeal, which provided a legal definition of artistic invention. Steichen's account of the controversy was published after Brancusi's death: "Brancusi vs. United States," *Herald Tribune* (Paris), December 25, 1963, p. 5. See also Brown, "Through the Sculptor's Lens," pp. 49 and 259–60.

7. In this regard, it is useful to recount the anecdote of Brancusi's visiting the exhibition of aerial locomotion at the Grand Palais

in 1912 with two of his closest friends—Marcel Duchamp and Fernand Léger. Viewing one stand, Duchamp is said to have challenged Brancusi: "Who could do better than that propeller. Could you make that." Anecdote reprinted in Gladys Fabre, "The Modernist Spirit in Figurative Painting—From Modernist Iconography to a Modernist Conception of Plastic Art," in *Léger and l'Esprit Moderne* (Paris: Musée d'Art Moderne de la Ville de Paris, 1982), p. 149.

8. I have not been able to trace the circumstances of this "collaboration." An original Steichen print is catalogued in the Fonds Brancusi as ph 326a. All other prints, including those used for numerous lifetime publications, were produced from Brancusi's *contretype:* they are all distinguished by the sunken quality of the detail within the grain, especially at the top edge where the source was inscribed "frontispiece of catalogue," not in Brancusi's hand. The image was used as the frontispiece of the 1926 Brummer Gallery catalogue.

9. Theo van Doesburg, "Constantin Brancusi," *De Stijl* 7, nos. 79–84 (1927): 81–86, as "Sculpture pour aveugles (1926)" (p. 82). László Moholy-Nagy, *Von Materiel zu Arkitektur* (Munich: Bauhausbücher, 1929), p. 99, same identification. Carola Giedion-Welcker first published the image in her survey, *Modern Plastic Art* (Zurich: Verlag Dr. H. Girsberger, 1937), with the correct title and date: "Le commencement du monde, 1924" (p. 99).

10. Jeanne Robert Foster, "New Sculptures by Constantin Brancusi: A Note on the Man and the Formal Perfection of His Carvings," *Vanity Fair* 63 (May 1922): 68, 124. Sheeler's image of *Newborn* remained Brancusi's only photograph of the first marble version, which was included in the exhibition as not for sale, see Brummer Gallery, no. 5.

11. See Brown, "Through the Sculptor's Lens," pp. 87–88.

12. *Little Review* 1, no. 1 (autumn 1921): plates unpaginated. Maybe Man Ray taught him how to use enlargement equipment. The illustrations used by Ezra Pound probably came from large-format contact prints—8 × 10 cm glass plates printed directly on top of the paper—that required less equipment, although paradoxically produced his most precisely detailed prints. Cf. cat. 423.

13. Department of Special Collections, New York Public Library, archives Quinn's complete correspondence.

14. Numerous visitors who recorded their experience recounted a similar tour of the artist's studio, as I have described in Brown, "Through the Sculptor's Lens," pp. 285–92. See also Brown, "L'Atelier méta(mor)phorique," pp. 52–54.

15. Peggy Guggenheim, *Out of This Century: Confessions of an Art Addict* (London: Andre Deutsch, 1979), p. 212.

16. See *Little Review* (as in n. 12), unnumbered (17th plate) and Brummer Gallery, no. 20.

Cat. 427 Constantin Brancusi, *The Child in the World: Mobile Group,* c. 1917–20, gelatin silver print, 11¾ × 9⅛ in., Camera Works, Inc.

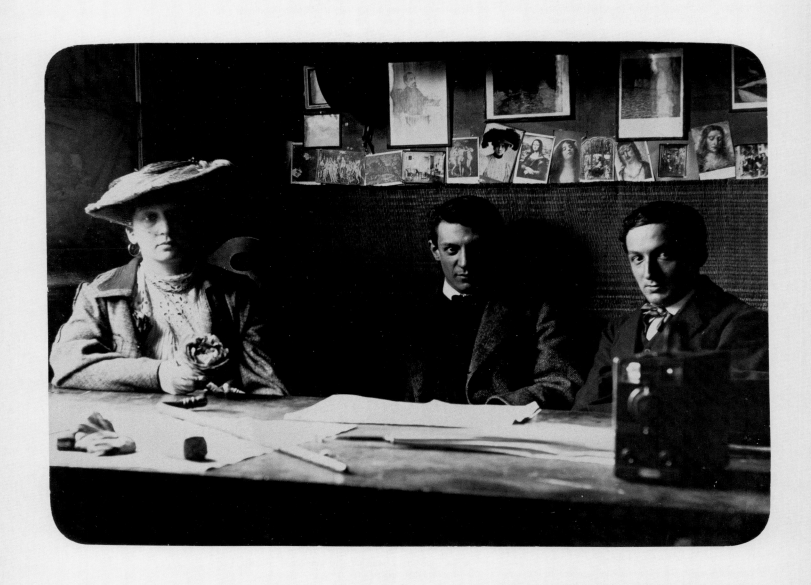

# Pablo Picasso

MÁLAGA 1881–1973 MOUGINS

Picasso's precocious talent was encouraged by his father, José Ruiz, a painter and drawing instructor. By 1900 and his first trip to Paris, Picasso had already absorbed a wide range of influences, including the old masters he saw at the Prado. He moved between Barcelona and Paris until 1904, producing pictures of people on society's margins, rendered with a pervasive melancholy (called his Blue Period). In 1904 he settled permanently in Paris and began to concentrate on acrobats and performers, reflecting his lifelong interest in the theater and characterized as his Rose Period. Aesthetically restless, Picasso was a constant innovator. In 1907 he painted *Les Demoiselles d'Avignon* (The Museum of Modern Art, New York), whose fragmented forms departed radically from convention. With Georges Braque he developed the various permutations of cubism, which definitively ended the tradition of one-point perspective and painting seen as a single moment in time. A classicism expressed in naturalistically modeled and monumental figures entered his work in the 1920s, perhaps as a result of a trip to Italy. It alternated with an expressionism, which deformed and distorted the human figure in sometimes comic, often violent ways. The expressive force of Picasso's art may be said to be concentrated in *Guernica*, his poignant condemnation of fascism and war. He made sculptures out of almost anything that was at hand, from metal scraps to bicycle seats. Recurring themes include portraits, the Minotaur or bull, the artist in the studio, and reprises of the old masters. Staggeringly prolific, in addition to paintings (at times enhanced with real objects) and sculptures, he made prints (both individual, in suites, and to illustrate books), collages, and ceramics (after 1946, when he lived mainly in the South of France). Perhaps the most famous artist of the twentieth century, Picasso lived a life full of friends, wives, children, and mistresses, deriving inspiration for his art from his always varying domestic situation and his self-consciousness as an artist.

Cat. 507   Joan Vidal Ventosa, *Portrait of Fernande Olivier, Pablo Picasso, and Ramón Reventós,* 1906, gelatin silver print, 6⅛ × 8⅛ in., Musée Picasso, Paris

*Anne Baldassari*

# Picasso 1901–1906: Painting in the Mirror of the Photograph

In the early years of this century, Pablo Picasso undertook the pictorial journey that would lead him from the fauve colorism of his exhibition at Ambroise Vollard's gallery in the spring of 1901 to the monochrome phase of his Blue and Pink Periods. My analysis of the complex role played by Picasso's use of the photographic medium from that time on led me to describe the relationship between painting and photography by reference to the dark mirror.[1] This reference, however, is much more than a metaphor; Picasso's ways of using photography give modern form to the "jugement du miroir," as advocated by Renaissance treatises.[2] The use of the dark mirror, a small mirror usually made of black glass,[3] was still common practice in the studios of the nineteenth century, where it could often be found alongside the camera obscura and the camera lucida. As explained in a treatise from 1829, the dark mirror "facilitates the percep-

tion of the relationship between the different tones/colors and facilitates the comparison between nature or the object to its image in a painting. In addition, the errors of the chiaroscuro are more visible when they are presented in a dark mirror, which, by lessening the brilliant aspect that nature can have, allows a better appreciation of the quality of the respective tones."[4] This description enables us to better understand why Edouard Manet would choose to judge the quality of his paintings by looking at them with a "little dark mirror."[5] "I prefer to go suddenly from light to dark rather than accumulate things that the eye does not see and which not only weaken the vitality of the light but attenuate the coloring of the shadows, which should be underscored."[6] The principle referred to by Manet—a painting made with light and shadow—is close to Picasso's pictorial project developed during the first years of this century.

 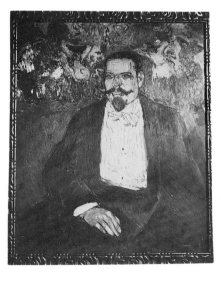

Cat. 483 (opposite) Pablo Picasso, *Self-Portrait in the Studio,* 1901, gelatin silver print (superimposition), 4¾ × 3½ in., Archives Picasso, Musée Picasso, Paris

Cat. 481 Pablo Picasso, *"Portrait of Gustave Coquiot" in Progress I,* 1901, gelatin silver print, 4⅝ × 3½ in., Archives Picasso, Musée Picasso, Paris

Cat. 482 Pablo Picasso, *"Portrait of Gustave Coquiot" in Progress II,* 1901, gelatin silver print, 4⅞ × 3¾ in., Archives Picasso, Musée Picasso, Paris

Elsewhere I have established how his pictorial approach ran parallel to his own experiences making photographs and to his collecting diverse photographic images of reproductions of works of art, ethnographic postcards, or regional photos. This would then be a true work of reflection, in the double sense of reflection and analytic meditation, in that the photographic tool enabled Picasso to operate in the world of appearances, on his own work and on the work of the great masters.

Photographic prints that remained in Picasso's possession throughout his lifetime demonstrate that early on he was in the habit of photographing his works during the course of their execution. A painting typical of his colorism of 1901, *Portrait of Gustave Coquiot* is recorded in three consecutive stages of execution (cats. 481, 482, 483).[7] These photographs document the progress of the painting and, no doubt, contributed to the refinement of the composition. Similarly, photographs of other canvases of this period make it possible to identify the changes he made after taking such photographs (for example, cat. 478).[8]

With these works the style of the Blue Period emerges gradually: painting in unmodulated colors, dense outlines, a fading of the chromatic contrast. The photographic record that accompanies this change has the effect of reducing colors to a simple gradation of values, the equivalent of a monochrome brown-gray. The means by which these photographs could have contributed to the radicalization of a new pictorial vocabulary is alluded to in a conversation the artist had with

Christian Zervos in 1935: "It would be very interesting to document with photos, not the stages of a painting but its metamorphosis. We would be able to see then which path the mind takes to realize its dreams." In the same statement, Picasso progresses from a wish expressed in the conditional to relating a real experience: "What is truly interesting is to observe that the painting does not change in its essence, that the initial vision remains intact, contrary to appearances. I often see a light and a shadow. Once I have put them in the painting, I do all I can to 'break them' by adding a color that has the opposite effect. I realize, once the painting is photographed, that what I had introduced to correct my first vision has disappeared and that in the end the image given by the photo corresponds to my first vision, before I had willfully added the changes." Picasso here goes beyond granting photography the task of recording a work in progress; he literally confers on photography the "very interesting" power of restoring the original scheme of a work, as if the "medium" gives back to him the uniqueness of his "first vision."[9] In 1901–2 the photographic documentation of work in progress helped Picasso to free his painting of a color uselessly "added" to get back to the essence of his project: "I see a light and a shadow."

During this period the dialogue between painting tending toward the monochrome and the expressive palette specific to the photographic medium deepens. After the toning experiments developed by the photographic pictorialists of 1890–1910, the picture postcard and then cinematographic projections[10] rendered banal the perceptive experience of monochrome images graduated in cold or warm tints. In this context, the discovery of a cyanotype[11] print in the Picasso archives has great importance. Dating from the turn of the century, it depicts a young man standing before the wall of a studio. The third dimension is barely suggested by the slight wrinkle of an architectural sketch or the pleats of a fan. This cyanotype bears a strong resemblance to several portraits of young men in profile in front of a background of solid color[12] and most especially to the drawing depicting the poet Carles Casagemas, which accompanied his funeral notice in *Catalunya artística*.[13] The link between photography and the artist's new manner of painting is also obvious in two important works of 1903–4, portraits of Sebastià Junyent[14] and Jaime Sabartès,[15] both of which can be linked to studio photos of their models. A nineteenth-century ethnographic portrait (cat. 470) could also have inspired the recurring motif found in the years 1901–3 of people with arms crossed tightly across their body.[16] This singular posture by which the native seems to protect himself from the lens of the camera can be found in *Portrait of a Man (Blue Portrait)* (cat. 494)

Cat. 470 Paul Emile Miot, *Gougou, Prince of the Mic-Macs,* 1859, albumen print pasted onto cardboard, 5¾ × 4⅜ in., Archives Picasso, Musée Picasso, Paris

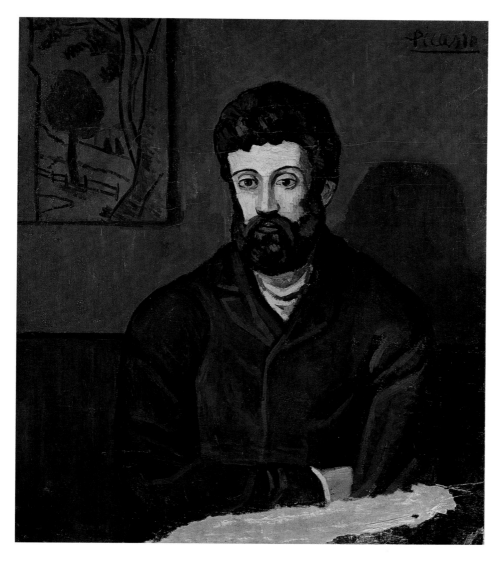

Cat. 494 Pablo Picasso, *Portrait of a Man (Blue Portrait)*, 1902–3, oil on canvas, 36⅝ × 30¾ in., Musée Picasso, Paris

Cat. 493 Pablo Picasso, *Portrait of a Bearded Man*, 1902–3, pen and India ink on paper, 6⅝ × 5¼ in., Musée Picasso, Paris

as well as in several preparatory studies (cat. 493),[17] which, even when depicting figures at full length, retain a visual trace of this atypical photographic pose and framing. The best example remains that of the large canvas from 1903, *The Soler Family*,[18] which transposes a simple studio photo[19] into a parody of Edouard Manet's *Luncheon on the Grass.* Picasso borrows that painting's classically pyramidal composition but remains true to the photographic alignment of his models on a single plane. This nonperspectival effect is further accentuated by color limited to a few traces and by a solid blue background. In a paradoxical manner, such a painting borrows from the photographic "resemblance" as much as it systematizes pictorial processes that are deliberately anti-illusionist: subjects reduced to pallid cutouts, flat superimposition of figures, and a monochrome abstraction.[20]

Several gouaches dating to Picasso's trip to Holland at the beginning of 1905 announce the style of the Rose Period. *Dutch Woman*[21] has similarities to a nineteenth-century photo depicting a young woman with a straw hat:[22] one notes the same inclination of the head, faraway expression

Clockwise from top left:

Fig. 139  Pablo Picasso, *Woman with a Fan,* 1905, oil on canvas, National Gallery of Art, Washington, D.C.

Cat. 508  C. & G. Zangaki, *Two Bicharine Sisters,* Egypt, 1860–80, albumen print, 11 × 8¼ in., Archives Picasso, Musée Picasso, Paris

Cat. 463  Anonymous, *Berber Woman,* Algeria, 1860–80, albumen print, 9½ × 6⅞ in., Archives Picasso, Musée Picasso, Paris

Cat. 501  Pablo Picasso, *Study for "La Toilette,"* 1906, watercolor and pencil on paper, 9½ × 6½ in., Private Collection

Cat. 500  Pablo Picasso, *Study for "La Toilette,"* 1906, charcoal on paper, 24 × 15¾ in., The Alex Hillman Family Foundation

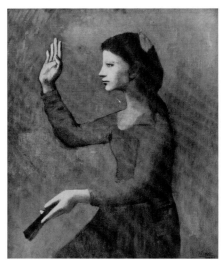
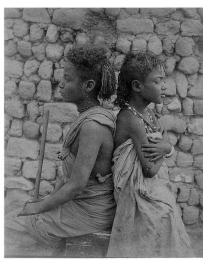

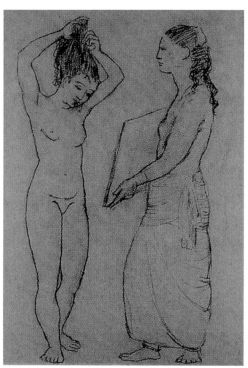
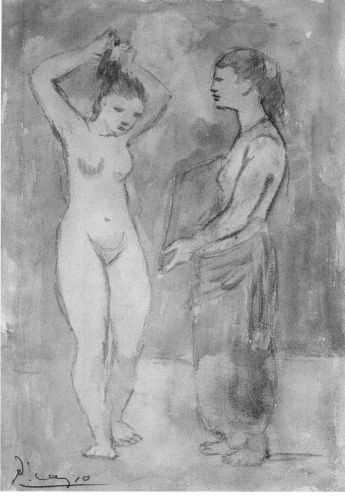

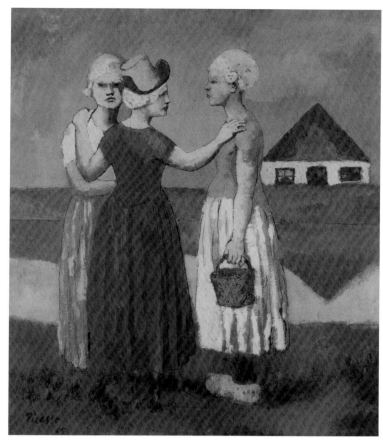

Fig. 140 (top) Pablo Picasso, *Three Dutch Women,* 1905, gouache on cardboard, Centre Georges Pompidou, © Musée Nationale d'Art Moderne

Bottom, left to right:

Fig. 141 Anonymous, *Portrait of a Girl with Cap,* c. 1880, albumen print, Archives Picasso, Musée Picasso, Paris

Fig. 142 Anonymous, *Portrait of a Girl,* c. 1880, albumen print, Archives Picasso, Musée Picasso, Paris

Fig. 143 Anonymous, *Portrait of a Girl,* c. 1880, albumen print, Archives Picasso, Musée Picasso, Paris

of the face, and ample shoulders and breasts. The gouache *Three Dutch Women* (fig. 140)[23] brings together in a landscape female portraits based on three prints of the same series (figs. 141, 142, 143).[24] There are also Orientalist photos in the Picasso Archives dating back to 1880–90, taken for the most part in Egypt. It is possible to trace the means by which several of these photos enriched Picasso's work during this first classic period of 1905–6. We have observed the strong relationship between *Woman with a Fan* (fig. 139)[25] or *La Toilette* (cats. 500, 501)[26] and the image of two young Nubian women, posing back to back (cat. 508).[27] Some archaizing paintings, such as *The Two Brothers*[28] and *Two Youths*[29] (cat. 503), could very well have been inspired by a photo of young naked

boys taken by Guglielmo Plüschow (cat. 505),[30] with which they share many similarities in pose and composition. The ocher tonality of this period, often described as the subjective reflection of the area of Gosol,[31] also merits comparison with the sepia tone of these old prints. Far more than a simple imitative transcription, Picasso combines these photographic sources with other references —the Greek kouroi or Jean-Dominique Ingres's *Turkish Bath,* creating meaningful assemblages of these images. He seems to open himself in these to a kind of "suspended attention," allowing himself to embrace visual suggestions that a realist would have missed.

Picasso's relation with the masterworks of the great painterly tradition plays out mainly through

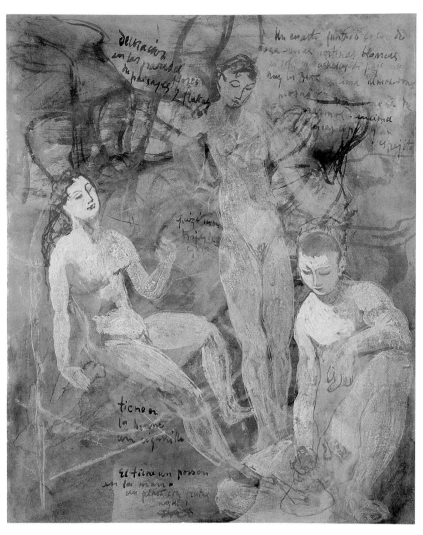

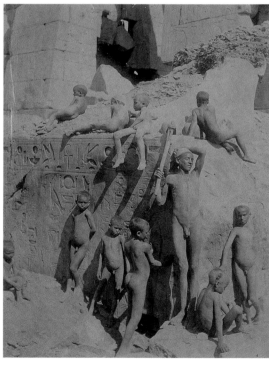

Cat. 502 Pablo Picasso, *Three Nudes,* 1906, gouache, water-color over pencil on paper, 24¾ × 19 in., The Alex Hillman Family Foundation

Cat. 505 Gugliemo Plüschow, *Naked Youths, Karnak,* 1896, albumen print, 8½ × 6⅜ in., Archives Picasso, Musée Picasso, Paris

Cat. 503 (opposite) Pablo Picasso, *Two Youths (Les Adolescents),* 1906, oil on canvas, 61¾ × 46⅛ in., Musée National de l'Orangerie, Paris

the mediation of photographic reproductions. William Rubin has emphasized that "this simultaneous accessibility of all historical sources, which sets the modern period off from any other, is encapsulated in the oeuvre of Picasso."[32] But in this manner, medium and message blend their effects. Through photography Picasso submitted his own works and those of the great masters to the same parameters (of format and bichromy). Picasso was able to engage in a visual dialogue whereby his painting in progress directly confronts the painting of the past. This hypothesis, which has been only touched on before,[33] finds corroboration in a newly discovered portfolio in the Picasso Archives of old albumen prints of Italian, Spanish, French, Flemish, and English masterworks.[34] A preliminary inventory of this collection suggested the topics explored in this essay. We know that such reproductions were available at the end of the nineteenth century relatively inexpensively and that they were sold by the piece, at the discretion of the collector (see Ulrich Pohlmann's essay in this volume). The photographic studios of Alinari in Florence, Braun in Paris, Laurent in Madrid, or Anderson in Rome published and dispersed them throughout the entire continent. For Picasso this portfolio undoubtedly played the role of an "imaginary museum" whereby photography, much like the role of the etchings of Marcantonio Raimondi for Edouard Manet,[35] participated directly in the elaboration of a modern vision of painting. In such a repertoire of themes and stylistic references, painting reveals itself only under the strong influence of the photographic code. Change of scale, uniformity of formats, framing of details, reduction of the chromaticism of sepia monotints as well as the caption, signature of the publishers, and presentation in passe-partout mats impose a mode of "technical reproduction" whereby the paintings circulate only as images. At the beginning of the twentieth century, the advent of the postcard and illustrated editions further augmented this phenomenon. In a photo taken in 1906 in Barcelona (cat. 507), Picasso, Fernande Olivier, and Ramón Reventós pose in El Guayaba, the studio of Joan Vidal Ventosa; behind the group, in neat rows, we see many postcards reproducing works by Botticelli, Leonardo, Cranach, or Rubens alongside reproductions of impressionist works and the studio photo of *la belle Otéro.*[36] In assembling this portfolio of fragile large-format albumen prints, Picasso participated in a practice of elite art lovers going back to about 1870.[37] The vision of the artist was attracted as much by his interest in the works of art as by the already obsolete methods of their photographic reification. If these paintings in photos lose their essence, their scale, their color, "the here and now of the artwork,"[38] the aura linked to this uniqueness, it seems that this very demystification of painting through photography

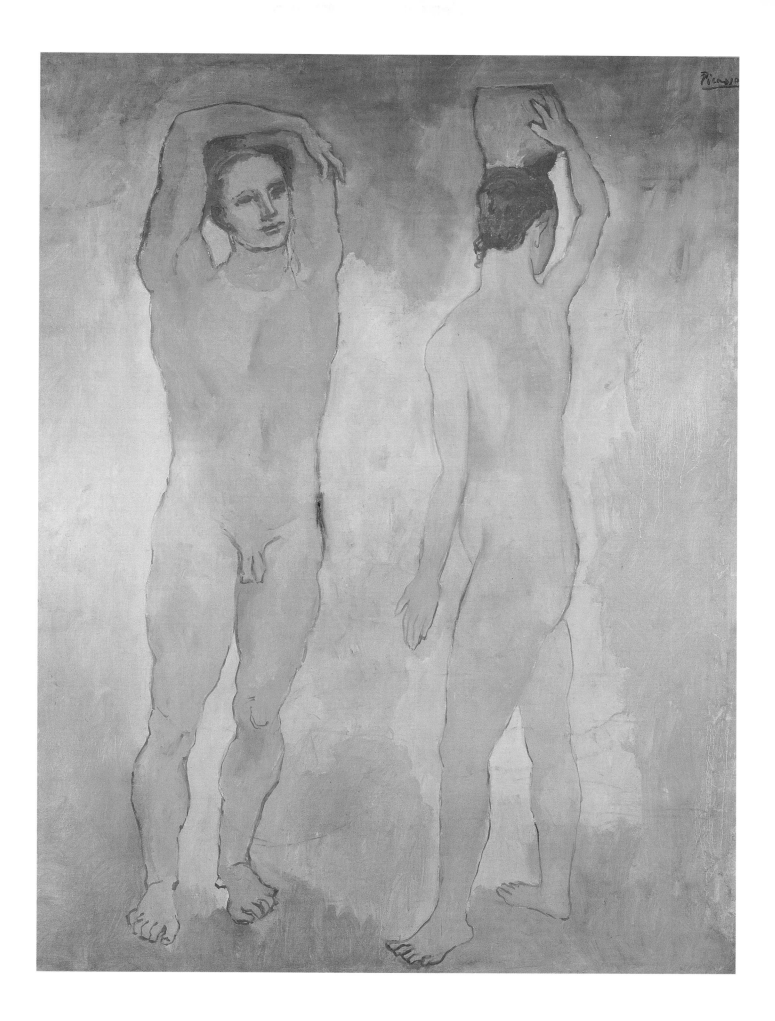

provoked in Picasso an intense creative excitement. Prosaically pinned to the frame of the easel, the reproduction participates by proximity in the painting in progress. "Pinned paper" before its cubist incarnation, "image en abîme" as a reference for the pictorial production, it becomes an integral part of the painting, which in turn borrows from it motif, composition, chromaticism, play of light and shadow.

The portfolio contains two old photos, one anonymous (cat. 464), the other published by Anderson (cat. 459), reproducing two different views of *The Burial of Count Orgaz,* a painting by El Greco that Picasso had discovered in Toledo as early as 1897 and that he would see again during his trip to Madrid in 1901. The Anderson photo shows the entire picture, giving a full view of the architectural archway that frames the altarpiece in the church of Santo Tomé in Toledo. The other reproduction provides a close-up of the central scene of the painting. "In the foreground, Saint Augustine and Saint Stephen, clothed in rich vestments, bend to lift in their arms the lifeless body of Lord Orgaz, decked in his Flemish armor. Behind them, standing in tight rows, are about thirty noblemen, priests and monks, almost all clothed in black, forming a sort of frieze from one end of the painting to the other."[39] The noticeable fading and the many holes in the photo are evidence of its

prolonged presence on the wall of the studio. In France, as in Spain, the art of El Greco saw an immense resurgence of interest, especially among the symbolists and the modernists of the last decade of the nineteenth century. The principal forces behind this movement were the painters Santiago Rusiñol and Ignacio Zuloaga. It is not, therefore, surprising to find references to El Greco in Picasso's portraits from as early as 1899[40] and throughout his work as late as the 1950s.[41] One can clearly see a reference to El Greco in the painting from the fall of 1901, *Evocation* (cat. 479),[42] which depicts the funeral of Carles Casagemas, who had committed suicide in February of that year. Surrounded by grieving women, foreshadowing the women draped in dark blue of 1901 and 1902, the painter-poet is wrapped in a shroud similar to that of Count Orgaz. An array of female nudes, representing a kind of profane allegory, occupies the space above, which El Greco had reserved for his celestial scene. A pencil drawing, *Study for "Evocation"* (cat. 484),[43] had explored an unusual depiction of this apotheosis: as three young men bend over the body of the artist lying on the floor, a female nude muse-anima seems to rise above him. The source for this figure could be the angel in El Greco's work, who crosses the space separating earth and heaven to carry the soul of the dead. The detail photo shows only the legs of the angel

floating above the faces of the noblemen. Cropped in this manner, these limbs emerge from a background of broken and pale drapery. The indeterminability of their owner's gender had provoked in Picasso an image of woman in which spirituality and eroticism are subtly condensed. In the upper part of *Evocation,* this nude woman embraces Casagemas, taken to heaven on a white horse, lamented by prostitutes in colored tights. Here Picasso borrows from the popular art of ex-votos, reinvesting its sequential narrative with the rupture of different planes—earth and sky—belonging to El Greco's composition. This spatial and temporal caesura is materialized in the discordance between the two photographic reproductions. Their superimposition would have subsequently guided the elegiac study for *Evocation* as well as the marked parody of the final painting.

The influence of El Greco has also been linked to the important 1902 painting, *Two Sisters* (fig. 144).[44] From Barcelona, Picasso wrote to the poet Max Jacob that he was working on a painting with "a Saint Lazare prostitute and a mother."[45] However, this work is not inspired solely by memories of visits to the Parisian prison for women. It has been suggested[46] that Picasso may have transposed into the world of Parisian prostitutes El Greco's *Visitation,* a painting that was commissioned for the Oballe chapel of the church of San Vicente in Toledo.[47] The resemblance between the two paintings lies in the treatment of the two

Cat. 484 (top) Pablo Picasso, *Study for "Evocation,"* 1901, pencil on the back of a reproduction, 16⅜ × 11⅜ in., Musée Picasso, Paris

Fig. 144 (bottom, left) Pablo Picasso, *Two Sisters (L'Entrevue),* oil on canvas, Hermitage Museum, Leningrad

Cat. 479 (bottom, right) Pablo Picasso, *Evocation (Burial of Casagemas),* 1901, oil on canvas, 59 × 35⅜ in., Musée de l'Art Moderne de la Ville de Paris

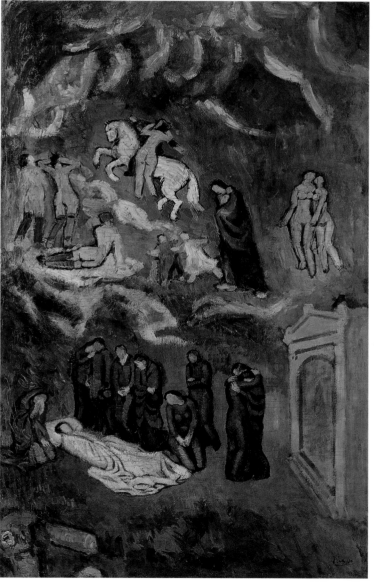

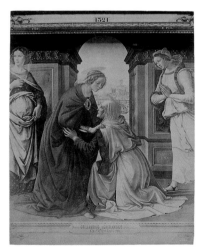

Cat. 455 (top) Alinari, *Domenico Ghirlandaio's "Birth of St. John the Baptist" in the Church of Santa Maria Novella, Florence, Italy,* 1870–80, albumen print, 7½ × 9⅞ in., Archives Picasso, Musée Picasso, Paris

Cat. 486 (middle, left) Pablo Picasso, *Study for "Two Sisters (L'Entrevue),"* 1901–2, pencil on paper, 17¾ × 12⅝ in., Musée Picasso, Paris

Cat. 487 (middle, right) Pablo Picasso, *Study for "Two Sisters (L'Entrevue),"* 1901–2, pen and black ink on the back of a reproduction of Michel-Lévy's "Le Couvert" in *L'Art français,* 13⅝ × 10⅝ in., Musée Picasso, Paris

Cat. 471 (bottom) J. Muhn, *Photograph of the Painting "The Visitation" by Ghirlandaio,* 1860–80, albumen print, 10⅞ × 8¼ in., Archives Picasso, Musée Picasso, Paris

bodies enveloped in a blue-green drapery from which only the hands emerge. One also notes the motif of the lateral opening, which, in Picasso's work, seems to evoke the rounded effect of the architecture in which was inscribed the composition *en tondo* of El Greco.[48] Picasso's knowledge of this painting remains, however, hypothetical.[49]

Perhaps another visual reference was provided by a print by Alinari, preserved in the Picasso archives, which reproduces *The Birth of Saint John the Baptist* by Domenico Ghirlandaio (cat. 455).[50] The repeated folds, the partial cutting of the photograph, as well as the pieces (with the exception of one) of the photo that Picasso has kept like parts of a puzzle, are evidence of his interest in this image. In the upper part, rectilinear cutouts invert the geometric perspective of the fresco. The lower part has been detached along an irregular line that covers the female figures in the foreground, child, nurse, servants, and members of the family of the commissioners, as if Picasso wanted to examine these motifs out of their context. The female couple at the right of the fresco, representing Lucrezia Tornabuoni and her lady-in-waiting, have particular resonance in *L'Entrevue* and its preparatory studies (cats. 486, 487). The two full-length figures, one young, one old, would seem to have been borrowed from Ghirlandaio, especially the treatment for the leg, wrapped in drapery with two folds, and in one of the studies[51] in which the hieratic pose is emphasized by the "archaistic"[52] fluted folds of the dress. Picasso had, however, reversed the position of the two figures. The direction of Lucrezia Tornabuoni's legs is inverted as if in a mirror, and for the younger figure, the painter had repeated the bold movement of the foot of Ghirlandaio's servant carrying the fruit. The image is therefore constructed as if the artist had flipped over the Alinari photo and slid the lower part to the left. One also notes that in the fresco, the faces of the two women are framed against the dark rectangle of a door, just as in Ghirlandaio's *Visitation* in which Saint Elizabeth welcomes the Virgin Mary in front of the full arch of a window. (Picasso had a reproduction of this work, too, in his portfolio; cat. 471.) This spatial motif, which symbolizes the house of Zacharia, site of the meeting of the two women (Luke 1:40) as well as the birthplace of John (Luke 1:57), constitutes a link between these two works and the *Visitation* by El Greco. It could also have inspired the particular setting in *L'Entrevue.* Other similarities can be discerned between the art of Ghirlandaio as Picasso approached it via photography and the paintings of his Blue Period. One thus recognizes the gesture of the extended arms of the servant at the left, just as in the drawing *L'Offrande.*[53] In the fresco of Santa Maria Novella we see the wet nurse, painted against the background of the heavy folds of Saint Elizabeth's garment. This motif of cloth, draped,

knotted, pleated, recurs in Picasso's numerous variations of mother and child, and sleeping or crouched women, for example in the *Crouching Woman and Child* (cat. 478).[54] With such works, Picasso inaugurates a new and original pictorial vocabulary, whereby, in a metonymic manner, the canvas seem to crinkle, ruffle, and wrinkle, demonstrating a disconcerting three dimensionality. The brown tones of the Alinari photo correspond to the monochromy of blues characteristic of that period. We could continue this quest for visual resonances where the chromaticism of the two Florentine photos and the gestures of Ghirlandaio's frescoes are diffused through an entire chain of works leading from Picasso's maternity scenes of 1901 to the portrait of women from the Saint Lazare prison, to the great symbolist work of 1903, *La Vie*.[55]

But in the end the essence of this masterwork leads us back to the photo of another El Greco, *Christ Bidding His Mother Farewell* (cat. 465).[56] This old albumen print in the Picasso archives bears evidence of its repeated use, so frequently pinned down that its corners were eventually torn off. This El Greco was known only to specialists[57] and only left the high altar of the San Vincente church in Toledo in 1961 when it was transferred to the Museo de Santa Cruz. In contrast to the reproductions of *The Burial of Count Orgaz,* this photo is not like those commonly available to art collectors. The painting was photographed in the sacristy, perhaps during restoration.[58] It is placed on a plain wooden chair, used as a makeshift easel. Behind it an armoire for the religious vestments, the edge of a baroque frame, and the upper part of a crucifix are visible. This improvised setting recalls the

way that Picasso will photograph his works in his studios of the Bateau-Lavoir (fig. 145), boulevard de Clichy, or rue Schoelcher.[59] The haphazard installation and the poor state of the painting make the El Greco seem abandoned, while at the same time the photograph is evidence of a curiosity sufficient to have elicited such a visual record. In any case, in its uniqueness the image caught Picasso's attention, who, in our opinion, would find in it the visual material for a series of studies and canvases leading up to *Life* (fig. 146).

El Greco's painting, uniting Christ and the

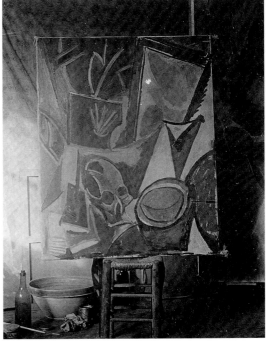

Cat. 478 (top) Pablo Picasso, *"Crouching Woman and Child" in Progress,* 1901, gelatin silver print, 5⅜ × 4⅜ in., Archives Picasso, Musée Picasso, Paris

Cat. 465 (bottom, left) Anonymous, *"Christ Bidding His Mother Farewell" by El Greco,* 1870–80, albumen print, 8⅜ × 6⅞ in., Archives Picasso, Musée Picasso, Paris

Fig. 145 (bottom, right) Pablo Picasso, *"Composition with Skull" in the Bateau-Lavoir Studio,* Paris, summer 1908, gelatin silver print, Private Collection

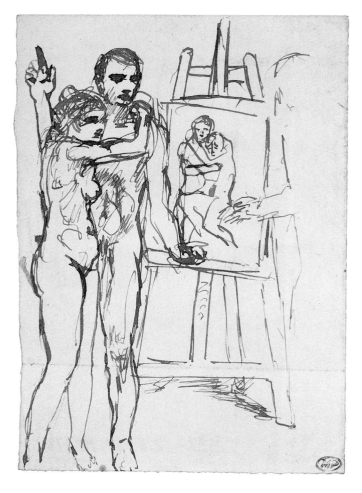

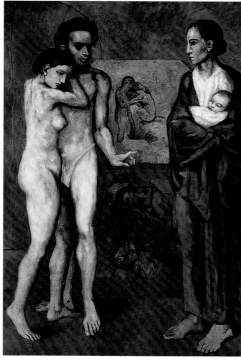

Cat. 496  Pablo Picasso, *Study for "Life" (Etude pour "La Vie")*, 1903, pen and brown ink on paper, 6¼ × 4⅜ in., Musée Picasso, Paris

Fig. 146  Pablo Picasso, *Life*, 1903, Barcelona, oil on canvas, Cleveland Museum of Art

Virgin Mary as in a double portrait, shows great iconographic boldness. José Camón Aznar notes that it depicts, not the farewell scene before the passion of Christ,[60] but another apocryphal episode, the apparition of the resurrected Christ to his mother.[61] Ignacio de Loyola made this episode the subject of one of his "spiritual exercises,"[62] and several pictorial interpretations are known.[63] "With this painting, for the first time, a painter executes a true psychological painting. For the first time we see a pure dialogue between two souls."[64] Unlike the other paintings of the same subject by El Greco, all with a wider format whereby the figures are farther from each other,[65] here the two bodies meld in one drapery. The hands are superimposed to form a complex pictogram, a flutter of wings,[66] expressing the meaning of the painting.[67] The spiritual tension of such an exchange eliminates all physical distance between the son and his mother. The gesture of farewell and the imminent separation are paradoxically materialized in a kind of incomplete embrace, as if Christ and the Virgin Mary wanted to "melt into each other's eyes."[68] In this way El Greco injects this filial farewell with something of the aspect of the *Noli me tangere,* when the resurrected Christ appears to Mary Magdalene and keeps her physically away from him, saying: "Do not touch me as I have not yet joined the Father" (John 20:17), signifying the imminence of his divine ascent. Forbidden sensuality, a renunciation of the world, is echoed in the photo with the image of the crucified. A similar scene is then played out between Christ and the two Marys, the Mother and the prostitute, united at the time of the ultimate separation as well as at the foot of the crucifixion.[69] It would appear that Picasso was affected by the same ambiguous interpretation and that he conferred both levels of reading on *Life.* Preparatory to this work, several drawings with the theme of the Embrace show a similar symbolic tension (figs. 147, 148).[70] The embrace of the two women, one old and one young, which had been the theme of the *L'Entrevue,* progressively retreats and leaves center stage to these couples, whereby the woman on the right—the Saint Elizabeth of the *Visitation*—is transformed into the figure of a male protector. In the first studies (cat. 496), Picasso himself plays this masculine role,[71] his right hand gesturing like Christ pointing to the heavens, as his other hand is turned to reveal the painting in the background. A young woman, pregnant like the Virgin in the *Visitation,* embraces his neck. Later the masculine role will be given back to Casagemas (fig. 146), evoking his destiny and his legend: incapable of satisfying his lover, Germaine, he has tried to kill her and then committed suicide in front of her.[72] Chaste man opposes feminine submission with violence. Christ, nonvirile, retreats from the realm of the senses. The allegorical double portrait of

Fig. 147 (top, left) Pablo Picasso, *Study for "The Embrace,"* early 1903, pencil on paper with scraping, Musée Picasso, Paris

Fig. 148 (top, right) Pablo Picasso, *Female Nude next to a Sketchy Figure,* Barcelona, 1902, pen and wash on paper, Museu Picasso, Barcelona

Cat. 495 (bottom, left) Pablo Picasso, *Crucifixion and Couples Embracing,* 1903, pencil and blue crayon on paper, 12½ × 8⅝ in., Musée Picasso, Paris

Fig. 149 (bottom, right) Pablo Picasso, *Seated Male Nude with Crossed Arms,* 1902, pen, brown ink, tinted wash with scraping on oval paper cut-out, Musée Picasso, Paris

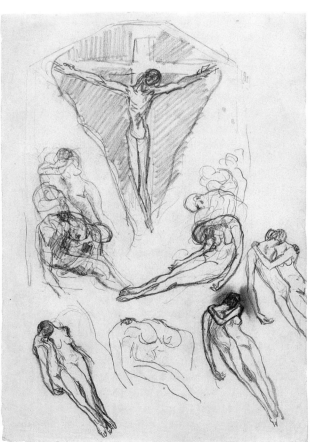

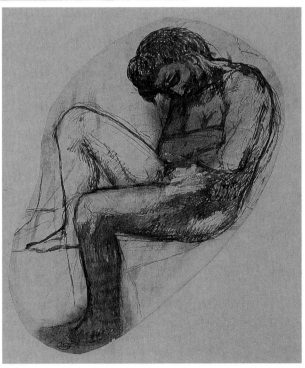

Cat. 457 Alinari, *Detail of "The Adoration of the Magi" by Leonardo da Vinci,* 1870–80, albumen print, 9⅞ × 7¼ in., Archives Picasso, Musée Picasso, Paris

Fig. 150 Pablo Picasso, *Head of a Woman Crying Out,* January 1903, pen, brown and black ink on paper, Musée Picasso, Paris

Germaine and Casagemas shares this ambiguous sexual identity, which was part of the mystery of El Greco's painting: their faces so similar and their hands intertwined, the Virgin and Christ resemble one another, twin figures in the symmetry of a mirror. The thematic and iconographic relationships that link *Life* to the painting by El Greco are also matched by a homology of the setting and the way it is framed in the photo. Picasso organizes his composition like a metaphoric space that puts real and fictive on the same plane and exposes the ambiguity of pictorial representation. Hence, as if taken from the Toledo painting, the Christ-like couple Casagemas/Germaine move to the foreground in the "real" space of Picasso's painting. The easel in the background evokes the haphazard setting in the photo of the El Greco painting and fills a position analogous to that of the crucifix: the easel can be identified as the tool of the crucifixion, the painter is the crucified, the painting, agony.[73]

Rather than the embrace of two lovers, the imaginary painting "in progress" set on this easel would depict a pietà in which the woman holds the body of her son. At the right of *Life,* Saint Elizabeth has become a mother holding her child in her cloak. At the bottom is another painting: a man alone, abandoned, returns to the fetal position to die (fig. 149). The cycle of life is also that of the work's progress: iconographic exchanges, demonstration, permutation of the levels of representation or reading.

William Rubin recently published his conviction that a deep artistic kinship exists between Picasso and Leonardo da Vinci.[74] Beyond the stylistic parallels developed by Rubin, this theory, "at first glance, far fetched or irrelevant,"[75] can be illustrated with two details of *The Adoration of the Magi* by Leonardo reproduced by Alinari and found in Picasso's portfolio. Here, exceptionally, the photographic monochromy corresponds with the painting's "color" (cats. 456, 457). The large sketch, made by Leonardo in 1481 for the San Donato monastery in Scopeto, is in an overall brown, greenish, or black wash, whereby flat, solid areas are left in reserve. The modeled quasi-monochrome of the forms evokes the grisaille of the altar panels, where the registers of painting and sculpture are superimposed in a most ambiguous manner. Here, the language of the painting and the code specific to its reproduction overlap each other fortuitously, as if to give Picasso access to this "photographic color" of Leonardo's work. By looking closely at drawings from 1902–3, we can see how carefully he studied details of *The Adoration of the Magi.* Their themes as well as their tenebrist style have previously been read as a reference to the *Massacre of the Innocents* or *The Rape of the Sabines* by Nicolas Poussin.[76] But a study in black ink, wash, and brown ink[77] is a stunning interpretation of the head of an old man at the center of Leonardo's figural group. It follows precisely the overall structure—uncovered head, deep eye socket, and dark, bushy eyebrows, line of the nose, ears, and chin. The head that in Leonardo's painting inclines toward the floor is tilted upward, accentuating even more the darkness of the mouth, transforming its expression into a scream of stunned stupefaction (fig. 150).[78] This visual rotation seems to be a direct result of the isotropy of the setting of the photographic print, whereby, isolated from the rest of the composition, it can be oriented in any direction. In his studies of screaming figures with raised arms of that period (cats. 489, 490),[79] Picasso seems to have utilized hands that in Leonardo's painting actually belong to two of the old men to serve as the reaching arms of the figures. In a larger sense, Picasso invests the whole flurry of curiosity, astonishment, and emotion surrounding the mother and her child into the panic of these imploring and escaping women. On the technical side, in his transcription of the head of

Cat. 456 (top, left) Alinari, *Detail of "The Adoration of the Magi" by Leonardo da Vinci,* 1870–80, albumen print, 7⅝ × 9⅞ in., Archives Picasso, Musée Picasso, Paris

Cat. 489 (top, right) Pablo Picasso, *Mother and Child,* 1902, pen and black ink on paper, 10¼ × 8 in., Musée Picasso, Paris

Fig. 151 (middle, left) Pablo Picasso, *Head of a Bearded Man,* Paris, January 1903, pen on paper, Museu Picasso, Barcelona

Fig. 152 (middle, right) Pablo Picasso, *Study of a Head Looking Upwards,* Paris, December 1902, black pencil on yellow paper "pois chiche," Museu Picasso, Barcelona

Cat. 490 (bottom) Pablo Picasso, *Nude Woman Imploring the Heavens,* 1902, pen, brown ink and tinted wash

the old man (fig. 150), Picasso's graphic virtuosity condenses the wash drawing of the central part of *The Adoration of the Magi* with the chiaroscuro drawing with shadows of its lateral areas. Through this monochromatic exercise, with photography as the intermediary, Picasso captures the dramatic expressiveness of Leonardo and confirms the deep affinity linking the two artists that Rubin accurately identified as their fundamental light-dark approach to painting: "Picasso remains closer to Leonardo's essentially draftsmanly and tonal model than the colorist tradition in twentieth-century modernism; in many pictures, Picasso deliberately lets the tonal underdrawing show through or remain uncovered, as if to remind us that the color—however beautiful or poetic—is an 'add-on' to the determining light-dark matrix. A black-and-white photograph of a canvas by Picasso gives us a fairly clear understanding of the painting's construction, since it is primarily the rightness of the light-dark values that accounts for the coherence of the pictorial scaffolding."[80]

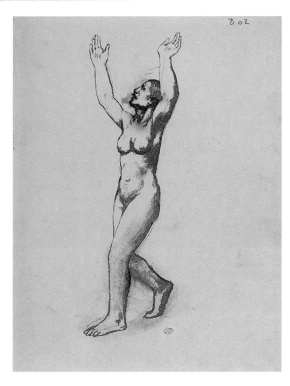

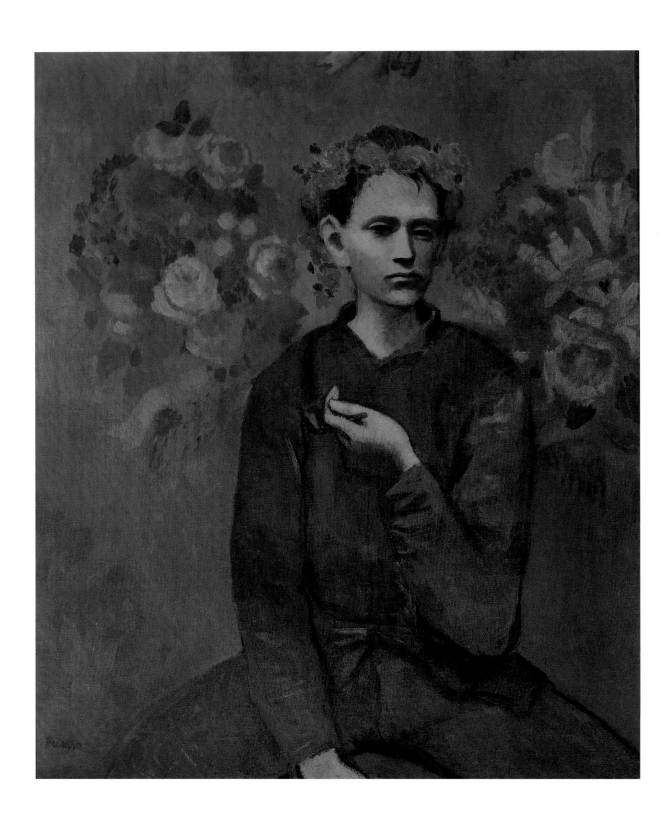

A final juxtaposition can be established between a print by Anderson of the Botticelli tondo, *Madonna and Child with St. John the Baptist and a Chorus of Angels* in the Borghese Gallery (cat. 458),[81] and a painting by Picasso dating from 1905, *Boy with a Pipe* (cat. 498).[82] The two colors at the ends of the chromatic spectrum are juxtaposed here. The cold blue, almost purple, has nothing in common with the cobalt and Prussian blues of *Evocation* and *Life.* Its pink does not exactly evoke the faded Tyrian shades that symbolize his Rose Period. It is a precursor of the scorched palette of the summer of 1906 in Gosol. The indigo and the orange tones interpenetrate, lowering the contrast where the complementary colors seem to cancel one another out. At the compositional focus, as much chromatic as spatial, the face and hand of the child are described with a pale sepia, expressly photographic. This odd pictorial treatment could be a direct result of the Anderson print and specifically the yellowing of the photo on albumen paper of the angelic figures surrounding Botticelli's Virgin. By this coloring and the softened modeling of the features, *Boy with a Pipe* recalls more specifically the angels with downcast eyes, one placed at the left of the group to the right, the other at the center of the left group. The crown of roses worn by the latter, the bunches of lilies, and the bouquets that close the space of the tondo would thus have given their luxuriant decorative vocabulary to this reading by Picasso of Botticelli's painting.

Furthermore, the twisted gesture of the boy holding the pipe evokes the especially contorted position of the hands of the Virgin and her companions. The transposition of these elements confers an indefinable allegorical character to the portrait of the young adolescent in a workman's shirt. At the tension of the chromatic spectrum toward pink or toward blue corresponds a contradiction between the sacred and the profane, the mystical and the trivial, the sublime and the realistic. As is so often the case in Picasso's work, this visual source is probably not exclusive. A diffuse relationship seems to exist between the melancholic adolescent figures of 1905[83] and an array of studio portraits of boys and adolescents that Picasso collected. From one series to the other, one can identify the partial similarities of gestures, the pose of the legs or the hands, of looks, of accessories, and elements of the decor. But above all, when observed in its entirety, this ensemble of old photos is animated by a slow choreography whereby a mythic adolescence is incarnated in one and the same body (cat. 460). With the monotint of their brown-pink colors softened by the matte gouache, the harlequins from the same period as *Boy with a Pipe* participate directly in the emotional and chromatic universe of these pocket-sized photo portraits. Focused on the face, in half- or full-length pose, the bodies no longer claim their individuality. Their distinctive signs fade in a painting that has become blurred at the moment of transcription. These would be portraits by default, what remains when identity has disappeared: a dark modeling of the eye, a distant indifference, an emblematic gesture, whose meaning has long ago been lost. The ancient ritual of the photographic pose would open on nothingness: paintings, fragments of the same enigma where, as in the troubling contemplation of the dark mirror, the presence of the subject ends up disappearing: "The blackness, the longer one gazes into it, ceases to be black, but becomes a queer silver-blue, the threshold to secret visions."[84]

Cat. 498 (opposite) Pablo Picasso, *Boy with a Pipe,* 1905, oil on canvas, 43¼ × 32 in., Greentree Foundation, New York

Cat. 458 Anderson, *Photograph of "Madonna and Child with St. John the Baptist and a Chorus of Angels" by Botticelli in the Borghese Gallery, Rome,* 8 × 10⁵⁄₁₆ in., Archives Picasso, Musée Picasso, Paris

Cat. 460 Anonymous, *Carte de Visite Portrait of a Boy,* n.d., albumen print, 4⅛ × 2½ in., Archives Picasso, Musée Picasso, Paris

## NOTES

The references to the works of Picasso refer to the comprehensive catalogue by Christian Zervos (Z) and to the book by Pierre Daix and Georges Boudaille, *Picasso, 1900–1906: Catalogue raisonné de l'oeuvre peint* (Neuchâtel: Editions Ides et Calendes, 1966) (D-B). The inventory numbers of the Picasso Museum in Paris and the Picasso Museum in Barcelona will be referred to respectively by the following initials: MP and MPB.

1. My research on Picasso's works and photography was based on the study of the photographic archives of the artist preserved at the Musée National Picasso in Paris and can be found in three catalogues published by the Réunion des musées nationaux: Baldassari, *Picasso Photographe, 1901–1916* (1994); *Picasso et la Photographie: "A plus grande vitesse que les images"* (1996); and *Le Miroir noir, Picasso sources photographiques, 1900–1928* (1997). A synthesis in English of these texts is given in Baldassari, *Picasso and Photography: The Dark Mirror,* trans. Deke Dusinberre (Paris: Flammarion, 1997).

2. Leon Battista Alberti (*De la peinture, de pictura* [1435], French translation, J. L. Schefer [Paris: Macula Dédale, 1995], p. 195) comments: "It is remarkable that any mistake in painting is accentuated in the mirror." Furthermore, Leonardo da Vinci (*Le Traité de la peinture* [1490], French translation, André Chastel [Nancy: Berger-Levrault, 1987], p. 151) asks: "Why do we see a painting better in a mirror than without it?"

3. The photograph of a painter's dark mirror dating back to the eighteenth century is published by Léon Aulen and Roger Padiou, *Les Miroirs de bronze anciens, symbolisme et tradition* (Paris: Guy Trédaniel Editeur, 1982), p. 620.

4. M. Paillot de Montabert, *Traité complet de la peinture* (Paris: Bossange, 1829), vol. 9, p. 634.

5. Antonin Proust, *Edouard Manet: Souvenirs* (Paris: Librairie Renouard and H. Laurens, 1913), pp. 40–41. This quotation is about the execution of *The Spanish Singer* (The Metropolitan Museum of Art, New York) of 1861. Aaron Scharf (*Art and Photography* [Harmondsworth: Penguin, 1974], pp. 61–66) notes the sharp contrast in Manet's painting, which could have been influenced by photographs of his time in which artificial lighting and the low sensitivity of the negative eliminated the majority of half-tones.

6. Proust, *Edouard Manet,* pp. 31–32.

7. Z I, 84; D-B V, 64. In one of the photographs the canvas is presented on an easel, already signed. An earlier version of the painting appears in the background of the photo *Self-Portrait in the Studio.* In another photo, where the painting is framed, new changes affect the background or accentuate the contours.

8. Same thing for *Buveuse d'absinthe* (Z I, 100; D-B VI, 25; see *Le Miroir noir,* fig. 8): the photo shows an unsigned version where

the splash of white on the bottle is missing and where the background appears more intense. Furthermore, one notes an accentuation of the dark tones on the bottle in *L'Apéritif* (Z I 96; D-B VI, 24), where the feet of the dancer are repainted in the background of *La Gommeuse* (Z I, 104; D-B VI, 18). *Femme au chignon* (Z I, 96; D-B VI, 23) still has the signature "Picasso Ruiz." The latter name has been repainted. *Femme accroupie et enfant* (fig. 23) (Z I, 115; D-B VI, 30) was photographed before the signature and could possibly have been modified after the photo was taken.

9. Christian Zervos, "Conversation avec Picasso," *Cahiers d'Art,* nos. 7–10 (1935): 173–78.

10. On the usage of cinematographic film, tinted or faded at the turn of the century, see Paolo Cherchi Usai, *Le nitrate mécanique (1830–1928): La couleur en cinéma,* ed. Jacques Aumont (Paris: Mazotta, Cinémathèque Française, 1995), pp. 95–109, which notes the blue tint of the celestial scenes of *The Motorist* by Robert Williamson Paul in 1906.

11. The property of certain iron salts to give a blue tint to proofs had been noted by Sir John Herschell as early as 1842.

12. One thinks particularly of *Portrait of Ramon Suriñach Senties* (Barcelona, 1900, not in Zervos; see *Picasso and Photography,* fig. 23). Suriñach was a young Catalan writer whose "sinister fables of madmen and paupers are in the same dark vein" as the painting of Nonell or Picasso at the beginning of the century, according to Alexander Cirici Pelicer (*El Arte modernista catalan* [Barcelona: Ayma, 1951], p. 59). See, too, portraits of Sebastià Junyer Vidal (Z XXI, 114), Antonin Busquets Punset (Z XXI, 165), or Angel Fernandez de Soto (Z XXI, 123; D-B I, 22).

13. Z VI, 241. February 28, 1901. According to Pierre Daix, *La Vie de peintre de Pablo Picasso* (Paris: Le Seuil, 1977), p. 47, we know that Picasso later confided that "I started painting in blue when I thought about Casagemas's death."

14. MPB 110.018; see *Le Miroir noir,* figs. 24 and 25.

15. Z VI, 653, D-B X, 11; see *Le Miroir noir,* figs. 22 and 23.

16. Specifically, *Buveuse d'absinthe, Femme aux bras croisés* ( Z I, 105 and Z VI, 543; D-B VII, 7), *Homme en bleu* (Z I, 142; D-B VIII, 1; MP 5), *Les Pauvres au bord de la mer* (Z I, 208; D-B IX, 6). Since the publication of my book *Picasso and Photography,* I have been able, thanks to Françoise Heilbrun, to identify this photo as the portrait of one of the last "princes" of the Mic-Mac tribe, taken in 1859 by the French sailor Paul-Emile Miot, who may have been the first person to take photos in that region of Nova Scotia. Note from Françoise Heilbrun and Philippe Néagu in Jean Starobinski, *Largesse,* collection Parti pris (Paris: Réunion des musées nationaux, 1994), pp. 201–2.

17. A sketch (Z I, 165), a crayon (Succ. 352R), and an ink (Z IV, 454; MP 453). The pose with the arms crossed is associated with a bearded face, which may come from another visual source. Picasso might have indicated that *Portrait of a Man (Blue Portrait)* was a madman from Barcelona, work mentioned on p. 215, but he also added that "the models stay but the artists move on."

18. Z I, 203 and 204; D-B IX, 23. A friend of Picasso, Soler was a tailor in Barcelona. Picasso is said to have painted the portrait in payment for some clothing.

19. Identified in 1994 in the will of the artist, this photo was published and commented on for the first time in *Picasso photographe, 1901–1906*, p. 19.

20. The ultimate fate of the *La Famille Soler* gives one reason to ponder its formal ambiguity. The commissioner obtained permission from Picasso to give the painting a landscape setting painted by Sebastià Junyer Vidal comparable to the background of the Manet painting . But when in 1913 Kahnweiler bought back the painting, Picasso decided to restore the background, after having attempted to insert the figures in a cubist composition.

21. Z I, 260; D-B XIII, 1.

22. The hypothesis remains open that a model had posed nude for the artist; see John Richardson, *Vie de Picasso,* vol. 1, *1881–1906* (Paris: Chêne, 1992), p. 381.

23. Z I, 261; D-B XIII, 2.

24. See *Le Miroir noir,* figs. 38–41. These photographic close-ups seem to have been joined together according to the circular arrangement of the characters, which we can observe in other drawings of the trip to Holland (MP 1855, 4R and 5R).

25. Z I, 308; D-B XIII, 14.

26. Z I, 325; D-B XV, 34.

27. This photo is signed Zangaki. Of Greek nationality, the brothers C. and G. Zangaki published, starting in 1870, numerous photos of Egypt, the Sudan, and the Red Sea.

28. Z VI, 720; D-B XV, 8; MP 7.

29. Z I, 324; D-B XV, 11.

30. Photographer settled in Italy, Plüschow was, as the baron von Gloeden, a specialist of the nude with an antique/Greek theme. See Ulrich Pohlmann, *Guglielmo Plüschow (1892–1930): Ein Photograph aus Mecklenburg in Italien* (Munich, 1995). According to Pohlmann (p. 9), Plüschow traveled and stayed in Egypt in 1896–97. The presence of this photo in the artist's archive was not known by Robert Judson Clark and Marian Burleigh-Motley ("News Sources for Picasso's Pipes of Pan," *Arts Magazine* 55 [October 1980]), which made a connection between the photos of von Gloeden and *La Flute de Pan* (1932, Z V, 141; MP 79). At the same time that I published for the first

time the photo of Plüschow (*Le Miroir noir,* pp. 62–64, fig. 54), Robert Rosenblum ("Picasso in Gosol: The Calm before the Storm," in *Picasso: The Early Years, 1892–1906* [Washington, D.C.: National Gallery of Art, 1997], pp. 271–73) hypothesized a strong influence of the photos of Plüschow and von Gloeden on the masculine classicizing figures of the Gosol period, most notably in *Les Adolescents.*

31. Theodore Reff ("Themes of Love and Death in Picasso's Early Work" [1973], reprinted in *Picasso in Retrospect* [New York: Harper & Row, 1980], p. 26) speaks of new tones, "not spiritual like the blue, nor sentimental like the pink, but warm luminous and natural like the ochre earth of Gosol itself."

32. William Rubin, "Modernist Primitivism, an Introduction" in *"Primitivism" in Twentieth-Century Art* (New York: The Museum of Modern Art, 1985), p. 10.

33. Baldassari, *Picasso and Photography,* p. 22.

34. The photos, dating for the most part to 1870–90, make up a simple montage with triangular corner pockets on different kinds of paper. They could have come from diverse sources and collected at different dates.

35. On the borrowings of the *Déjeuner sur l'herbe* from the etching of Marcantonio's *Jugement de Paris* by Raphael, see Françoise Cachin and Charles S. Moffett, *Manet* (Paris: Réunion des musées nationaux, 1983), p. 168.

36. On *la belle Otéro,* see Richardson, *Vie de Picasso* (as in n. 22), p. 201.

37. Picasso also kept a thousand pocket-size portraits from the last century, anonymous and generic visual material, which many times up until 1920 were for him a source of invention. See examples dating back to, respectively, 1901 (*Le Miroir noir,* figs. 16–19), 1909 (Baldassari, *Picasso and Photography,* figs. 65 and 66), and 1919 (ibid., figs. 180–85).

38. Walter Benjamin, "L'Oeuvre d'art à l'ère de sa reproductibilité technique" (1936), republished in *Essays,* vol. 2, *1935–1940* (Paris: Bibliothèque médiations, Denoël Gonthier, 1971), p. 90.

39. Maurice Barrès, *Greco ou le secret de Tolède* (1911; reprint, Paris: Le Club Francais du Livre, 1953), p. 6. This photo is a detailed view of the original work of the Santo Tomé church. We must remember that there is a copy of only the bottom part of *The Burial of Count Orgaz* sometimes attributed to the son of El Greco, Jorge Manuel, painted for the Jesuit monastery in Toledo. This copy was in the Real Academia of San Fernando in Madrid until its transfer to the Prado in September 1901. It is highly probable that Picasso saw this painting during his academy years, 1897–98, or perhaps as early as 1895 during his first trip to Madrid with his father.

40. Besides the portrait *"a la Greco"* (Barcelona, 1899), Pierre Daix (*Dictionnaire Picasso* [Paris: Collection Bouguins, Robert Laffont, 1995], p. 416) mentions the mannerist treatment of the hands, notably in *Le Bock* (Z I, 97; D-B VI, 19), *Portrait of Mateu de Soto* (Z I, D-B VI, 21), or *L'Apéritif* (Z I, 98; D-B VI, 24).

41. See esp. *Portrait d'un peintre d'après le Greco,* February 22, 1950.

42. *L'Evocation (L'Enterrement de Casagemas),* Z I, 55, D-B VI, 4.

43. Z VI, 356; MP 442.

44. Z I, 163; D-B VII, 22.

45. This letter is reproduced in Baldassari, *Picasso and Photography,* fig. 20.

46. See Daix, *Dictionnaire Picasso,* p. 304; and Richardson, *Vie de Picasso,* pp. 222–23.

47. This painting is considered to be one of the last that El Greco painted in 1613–14. Today it is in the Dumbarton Oaks collection (Washington, D.C.) after having belonged to the Fogg Art Museum (Cambridge, Mass.). It does not seem to have been known by specialists of the time, as it is not mentioned in any texts by Jose Alvarez Lopera (*De Cean a Cossio, la fortuna del Greco en el siglo XIX* [Madrid: Fundacion Universitaria Espanola, 1987]), Manuel B. Cossio (*El Greco* [Madrid, 1908]), Paul Lafond (*Le Greco, Essai sur sa vie et sur son oeuvre* [Paris: E. Sansot, 1906]), or Hugo Rehrer (*Die Kunst des Greco* [Munich: Hugo Schmidt, 1914]). To the best of my knowledge, it was not reproduced until 1937 by M. Legendre and A. Hartman (*El Greco* [Paris: Editions Hyperion]).

48. This formal equivalence is even stronger in the study *Les Deux Soeurs* (Z VI, 436; D-B VII, 4), where the arch towers high over the two figures.

49. Daix (*Dictionnaire Picasso,* pp. 304 and 416) supposes that Picasso could have seen the painting in the San Vicente church during his trip to Toledo in 1901. However, Harold E. Wethey (*El Greco and His School,* 2 vols. [Princeton, N.J.: Princeton University Press, 1962) indicates that, for reasons unknown, *The Visitation* was never installed on the ceiling of the Oballe chapel but was placed in the church of Santa Clara in Daimiel. Had Picasso gone to this place some 120 kilometers south of Toeldo during his 1901 trip? Could Daimiel be "this nearby village, the name of which I cannot recall," where, according to Richardson (*Vie de Picasso,* p. 178), Picasso had gone during that trip and from where he brought back "some paintings of a church whose steeple makes me think of Nonell"? A topographic verification should be made regarding the nonidentified landscapes visible in the works of 1901, Z XXI, 308; D-B V, 49; Z XXI, 240; D-B V, 50; and Z VI, 363, D-B V, 51.

50. This fresco is one of the series made in 1486–90 for the Tornabuoni chapel in Santa Maria Novella in Florence.

51. Z VI, 435; D-B VII, 6.

52. Daix, *Dictionnaire Picasso,* p. 304.

53. Z XXI, 357; D-B VII, 1.

54. Z I, 115; D-B VI, 30.

55. Z I, 179; D-B IX, 13; The Cleveland Museum of Art.

56. c. 1595, Museo de Santa Cruz, Toledo. This title, *La Despedida de Cristo y la Virgen,* is the one mentioned by Cossio in his monograph (p. 325); it is mentioned again by Wethey (no. 70), Paul Guinard (*Tout l'oeuvre peint de Greco* [Paris: Flammarion, 1971], no. 62 d), and Fernando Marias (*Greco, Biographie d'un peintre extravagant* [Paris: Adam Biro, 1997], p. 202).

57. According to the guide of the Museo de Santa Cruz (1987 ed., p. 145), the painting was mentioned as early as 1829 by Avecedo, *Los Tesoros toledanos. El Museo Parroquial de San Vicente.* In 1845 José Amador de los Rio (*Toledo pintoresca o descripción de sus célebres monumentos,* republished in facsimile [Barcelona: Al Albir, 1976], p. 172) speaks of it as "from the hand of El Greco," "and worthy of the interest of art lovers." One sees therein "an undeniable proof of his 'unbridled craziness.'" In 1908 the monograph of Cossío confirmed its presence in the top part of the principal retable of San Vicente but considers it an old copy of the original (pp. 325 and 591); it also mentions (p. 325) two other copies, one in the convent at San Pablo Ermitano in Toledo (fig. 52bis, today at The Art Institute of Chicago) and the other belonging to the royal collection of Romania. In 1950 José Camón Aznar (*Dominico Greco* [Madrid, 1950]) counted (p. 1368) five or six different versions, considering the San Vicente version to be an old copy, dating to 1580; he mentions it as being in "Museo Iglesia de San Vicente." The guides of the Museo de Santa Cruz (1962–1987 eds.) indicate as provenance the "parish of Saint Nicolas," which was probably the church San Vicente was attached to when it was transformed into a diocesan museum.

58. The guide of the Museo de Santa Cruz (1987 ed., p. 145) points out that the painting has undergone "an extensive restoration."

59. See, for example, Baldassari, *Picasso and Photography,* figs. 78 or 160. In these photos taken by Picasso, the photographic contiguity of the canvas, the studio environment, and at times of other works gives a context to the painting, helps the "reading" of the painting, and, as has been demonstrated, was for the artist the source of new visual ideas. See the examples dating to 1908 in the Bateau-Lavoir, 1909 at Horta, or 1913, boulevard Raspail, analyzed in Baldassari, *Picasso and Photography,* pp. 80 and 116.

60. On the pictorial iconology of this farewell scene before the passion, see Mauro Lucco, in *Lorenzo Lotto, 1480–1557* (Paris: Réunion des musées nationaux, 1998), pp. 121–24.

61. José Camón Aznar (p. 420, as in n. 57) uses the title *La Aparición de Cristo resucitado a la Virgen.* This interpretation is justified by the gesture by which the Virgin "touches with her hand the arm of Christ to convince herself that it is real."

62. Ignacio de Loyola (*Exercices spirituels,* French trans. by Pierre Jennesseaux [Paris: Arléa, 1991], p. 206) proposes as one of his "contemplations" the moment when "the resurrected Savior appears in the flesh to his blessed mother."

63. Emile Mâle notes several other pictorial interpretations of this theme, notably by Guercino, Jacques Stella, and Alessandro Allori. See Mâle, *L'Art Religieux après le Concile de Trente* (Paris: Librairie Arnand Colin, 1932), pp. 358–59.

64. Camón, p. 422.

65. Notably, the two versions at The Art Institute of Chicago and at the Museum Boijmans Van Beuningen, Rotterdam, *Tout l'oeuvre peint de El Greco* (as in n. 56), no. 62 c.

66. "Winged hands of El Greco, one of the rare artists who show that hands can say more than words"; Miguel de Unamuno, 1914, quoted in ibid., p. 13.

67. According to Camón (p. 424), "With one hand Christ points to the sky toward his glory and destiny, the other hand stretched, sad, opens in a gesture of filial comprehension in a sweet palpitation. The hands of the Virgin are a mixture of maternal instinct and faith in the chosen one. One hand rests on her chest in a semiecstasy underscoring the loveliness of the look and the submission of the character. The other touches Christ's wrist to convince herself that his return is real, the corporeal reality of the apparition."

68. Cossio, p. 325.

69. In 1845 José Amador de los Rio (p. 172) wrote that the painting "appears to depict the appearance of Jesus to his mother or the Magdalene." Recalling that the Fathers of the Church often interpreted the passage in John where Christ appears to Mary Magdalene as referring to a meeting with his mother, Jean Guitton (*La Vierge Marie* [Paris: Editions Minting, 1949], p. 63) wrote: "One can retain the hypothesis for consideration that each, the apparition to Mary and to Mary Magdalene had the same rhythm, an element of surprise, a quest, a vision, a recognition, a desire to touch, a retreat from Christ, an announcement of the Ascension and a message to the Apostles, who were considered the brothers of the Lord, or the sons of his mother."

70. Z I, 162; D-B 11, and Z I, 161; D-B IX, 12, and MPB 110.483.

71. Z VI, 534; D-B IX, 4; MP 473.

72. See Daix, *Dictionnaire Picasso,* pp. 164–65; and Richardson, *Vie de Picasso,* pp. 178–81.

73. On this perception by Picasso of the artistic work as agony/torment: "one can really suffer and skin himself alive without any pressure from anyone," quoted in Helène Parmelin in *Picasso dit* (Paris: Gonthier, 1966), p. 98.

74. William Rubin, "Reflections on Picasso and Portraiture," in *Picasso and Portraiture: Representation and Transformation* (New York: The Museum of Modern Art, 1996), pp. 12–109.

75. Ibid., p. 90.

76. Richardson, *Vie de Picasso,* p. 254.

77. Z VI, 539; MP 470.

78. Also, dating from the preceding month, other studies in pen showing faces in profile with mouth open (MPB 110.529 and fig. 152, MPB 110.530) present a Leonardesque mannerism of expression that could have been borrowed from each of the figures surrounding the old men in the painting. An ink drawing (fig. 151, MPB 110.544R) also merits close comparison to the bearded figures visible in the two shots by Alinari.

79. Notably, Z XXI, 360, MP 458; fig. 36, Z VI, 412, MP 457; Z VI, 515, MP 464.

80. Rubin, "Reflections," p. 94.

81. Similar in composition to the *Madonna of the Pomegranate* (Museo degli Uffizi, Florence), this painting is generally considered to be a studio work.

82. Z I, 274, D-B XIII, 13.

83. Besides *Le Garçon à la pipe,* see Z I, 262, D-B XIII, 12; Z VI, 686, D-B XIII, 15, and D-B XIII, 16; Z I, 273, D-B XIII, 8, and Z I, 294, D-B XIII, 19; Z I, 294, D-B XIII, 20; Z I, 294, D-B XIII 20; and Z I, 216, D-B XIII, 10.

84. Truman Capote, *Music for Chameleons* (New York: Random House, 1979), p. 8. Saying that he had held a mirror Gauguin took on his trip to Martinique in 1887, the author writes: "the object in Madame's drawing room is a black mirror. It is seven inches tall and six inches wide. It is framed within a worn black leather case that is shaped like a book. Indeed, the case is lying open on a table, just as though it were a deluxe edition meant to be picked up and browsed through; but there is nothing there to be read or seen—except the mystery of one's own image projected by the black mirror's surface before it recedes into its endless depths, its corridors of darkness" (p. 7).

# Checklist of the Exhibition

This checklist is organized chronologically by the artists' dates of birth. Each section is organized alphabetically by title and therein chronologically. Works without date (n.d.) are listed first. Every care has been taken to indicate accurately the medium of the photographic prints. An asterisk precedes facsimile prints (*). Modern reprints are listed separately in Appendix A, on p. 322.

## GUSTAVE MOREAU
(1826–1898)

Cat. 1 Gustave Moreau, *Study after a Photograph for "Wayfaring Poet,"* n.d.
Pen and ink with charcoal, 13⅜ × 8¼ in., 34.7 × 21.1 cm
Musée Gustave Moreau, Paris, Des. 3759

Cat. 2 Gustave Moreau, *Study for "Wayfaring Poet,"* n.d.
Pencil with white chalk on bluish paper, 12⅜ × 8¼ in., 31 × 21 cm
Musée Gustave Moreau, Paris, Des. 3760 (ill. p. 66)

Cat. 3 Gustave Moreau, *Hésiode and the Muse,* 1860
Pen and ink over pencil sketch on paper, 19⅝ × 12⅝ in., 50 × 32 cm
Musée Gustave Moreau, Paris, Des. 860 (ill. p. 62)

Cat. 4 Gustave Moreau, *Venus out of Waves,* after 1866
Retouched photograph, 5 × 3⅜ in., 12.7 × 8.7 cm
Musée Gustave Moreau, Paris (ill. p. 60)

Cat. 5 Gustave Moreau, *The Argonauts,* before 1885
Oil on canvas, 18½ × 12⅝ in., 47 × 32 cm
Musée Gustave Moreau, Paris (ill. p. 65)

Cat. 6 Gustave Moreau, *Pasiphae,* c. 1890
Oil on canvas, 31½ × 24¾ in., 80 × 63 cm
Musée Gustave Moreau, Paris (ill. p. 63)

Cat. 7 Gustave Moreau, *Wayfaring Poet,* 1891
Oil on canvas, 70⅞ × 57½ in., 180 × 146 cm
Musée Gustave Moreau, Paris (ill. p. 66)

Cat. 8 Henri Rupp, attributed, *Female Model Posing for "Pasiphae,"* n.d.
Photograph affixed to cardboard, 9 × 4⅝ in., 23 × 11.8 cm
Musée Gustave Moreau, Paris, Inv. 16016 (ill. p. 63)

Cat. 9 Henri Rupp, attributed, *Male Model Posing for "The Argonauts,"* n.d.
Photograph affixed to cardboard, 9¼ × 6⅞ in., 23.6 × 17.4 cm
Musée Gustave Moreau, Paris, Inv. 16026 (ill. p. 58)

Cat. 10 Henri Rupp, attributed, *Male Model Posing for "The Argonauts,"* n.d.
Photograph affixed to cardboard, 9 × 6¾ in., 23 × 17.2 cm
Musée Gustave Moreau, Paris, Inv. 16027

Cat. 11 Henri Rupp, attributed, *Male Model Posing for "The Argonauts,"* n.d.
Photograph affixed to cardboard, 11¾ × 9⅜ in., 29.8 × 23.8 cm
Musée Gustave Moreau, Paris, Inv. 16028A (ill. p. 64)

Cat. 12 Henri Rupp, attributed, *Male Model Posing for "The Argonauts,"* n.d.
Photograph affixed to cardboard, 9⅜ × 6⅞ in., 23.8 × 17.4 cm
Musée Gustave Moreau, Paris, Inv. 16030B (ill. p. 64)

Cat. 13 Henri Rupp, attributed, *Male Model Posing for "The Argonauts,"* n.d.
Photograph affixed to cardboard, 9⅜ × 6¾ in., 23.8 × 17.3 cm
Musée Gustave Moreau, Paris, Inv. 16034 (ill. p. 64)

Cat. 14 Henri Rupp, attributed, *Male Model Posing for "The Argonauts,"* n.d.
Photograph affixed to cardboard, 8⅞ × 6⅞ in., 22.5 × 17.5 cm
Musée Gustave Moreau, Paris, Inv. 16035

Cat. 15 Henri Rupp, attributed, *Male Model Posing for "Wayfaring Poet,"* n.d.
Photograph affixed to cardboard, 9⅜ × 6⅞ in., 23.7 × 17.5 cm
Musée Gustave Moreau, Paris, Inv. 160234 (ill. p. 66)

Cat. 16 Henri Rupp, attributed, *Male Model Posing for "Hésiode and the Muse,"* n.d.
Photograph affixed to cardboard, 9½ × 6⅞ in., 24 × 17.4 cm
Musée Gustave Moreau, Paris, Inv. 16033 (ill. p. 62)

## EDGAR DEGAS
(1834–1917)

Cat. 17 Edgar Degas, *Dancer (Adjusting Her Shoulder Strap),* n.d.
Red and black chalk on paper, 19⅝ × 15½ in., 50 × 39.5 cm
The Israel Museum, Jerusalem (ill. p. 82)
*Dallas venue*

Cat. 18 Edgar Degas, *Trotting Horse, the Feet Not Touching the Ground,* c. 1881
Bronze, 8⅝ in., 22 cm
Fine Arts Museums of San Francisco, Gift of Jay D. McEvoy in memory of Clare C. McEvoy and partial gift of the Djerassi Art Trust (ill. p. 1)

Cat. 19 Edgar Degas, *Dancers,* 1890
Charcoal and pastel on paper, 25⅝ × 21¼ in., 65.2 × 54 cm
Courtesy of Galerie Daniel Malingue (ill. p. 83)
*San Francisco venue*

Cat. 20 Edgar Degas, *Dancers, Pink and Green,* 1890
Oil on canvas, 32⅜ × 29¾ in., 82.2 × 75.6 cm
The Metropolitan Museum of Art, H. O. Havermeyer Collection, Bequest of Mrs. H. O. Havemeyer, 1929 (ill. p. 84)
*San Francisco and Dallas venues*

Cat. 21 Edgar Degas, *Dancer Adjusting Her Shoulder Strap,* c. 1890–1900
Bronze, 13¾ in., 35 cm
Fridart Foundation (ill. p. 83)

Cat. 22 Edgar Degas, *Blue Dancers,* c. 1893
Oil on canvas, 33½ × 29¾ in., 85 × 75.5 cm
Musée d'Orsay, Paris; Gift of Dr. and Mrs. Albert Charpentier, 1951 R.F. 1951-10 (ill. p. 85)
*San Francisco and Dallas venues*

Cat. 23 Edgar Degas, *Group Portrait (Henriette Taschereau, Mathilde Niaudet, Jules Taschereau, Sophie Tascherau-Niaudet, and Jeanne Niaudet),* December 28, 1895
Gelatin silver printing-out print, 3¼ × 4⅜ in., 8.3 × 11.2 cm
The deLIGHTed eye, London–New York (ill. p. 79)
*San Francisco venue*

Cat. 24 Edgar Degas, *Group Portrait (Mathilde and Jeanne Niaudet, Daniel Halévy, Henriette Taschereau; Ludovic Halévy, and Élie Halévy)*, December 28, 1895
Gelatin silver printing-out print, 4⅜ × 3¼ in., 11.1 × 8.3 cm
The deLIGHTed eye, London–New York
(ill. p. 79)
*Dallas venue*

Cat. 25 Edgar Degas, *Portrait of Renoir and Mallarmé in the Salon of Julie Manet*, 1895
Gelatin silver print, 15⅛ × 11⅜ in., 38.5 × 29 cm
Musée Départemental Stéphane Mallarmé, Vulaines-sur-Seine, Inv. 985-114-1 (ill. p. 81)

Cat. 26 Edgar Degas, *Self-Portrait in Front of His Library*, c. 1895
Gelatin silver print mounted to board, 4⅝ × 6⅝ in., 11.9 × 16.7 cm
The Fogg Art Museum, Harvard University Art Museums, Cambridge, Massachusetts, Richard and Ronay Menschel Fund for the Acquisition of Photographs, P1997.42 (ill. p. 78)

Cat. 27 Edgar Degas, *The Bathers*, 1895–97
Pastel and charcoal on tracing paper mounted on gray board, 42¹⁵⁄₁₆ × 43¾ in., 109 × 111 cm
Dallas Museum of Art, The Wendy and Emery Reves Collection (1985.R.24) (ill. p. 86)
*San Francisco and Dallas venues*

Cat. 28 Eadweard Muybridge, *Animal Locomotion, Horse and Jockey Walking*, Plate 580, 1887
Collotype, 18⅜ × 23⅝ in., 47.2 × 60.1 cm
Gernsheim Collection, The Harry Ransom Humanities Research Center, The University of Texas at Austin

Cat. 29 Eadweard Muybridge, *Animal Locomotion, Horse and Rider at Full Speed*, Plate 626, 1887
Collotype, 16⅞ × 22⅛ in., 56.1 × 43 cm
Gernsheim Collection, The Harry Ransom Humanities Research Center, The University of Texas at Austin
(ill. pp. 76, 241)

Cat. 30 Eadweard Muybridge, *Animal Locomotion, Horse and Rider with Derby Jump*, Plate 636, 1887
Collotype, 19⅛ × 24 in., 48.5 × 61 cm
Gernsheim Collection, The Harry Ransom Humanities Research Center, The University of Texas at Austin
(ill. front endsheet)

Cat. 31 Eadweard Muybridge, *Animal Locomotion, Woman in Flowing Dress Dancing (Turning)*, Plate 187, 1887
Collotype, 18⅛ × 23¾ in., 46.2 × 60.2 cm
Gernsheim Collection, Harry Ransom Humanities Research Center, The University of Texas at Austin

Cat. 32 Eadweard Muybridge, *Animal Locomotion, Woman in Flowing Dress Dancing (Profile)*, Plate 188, 1887
Collotype, 19⅛ × 24 in., 48.6 × 61.1 cm
Gernsheim Collection, Harry Ransom Humanities Research Center, The University of Texas at Austin

Cat. 33 Eadweard Muybridge, *Animal Locomotion, Woman Picking up a Ball*, Plate 204, 1887
Collotype, 19 × 24 in., 48.2 × 61 cm
Gernsheim Collection, The Harry Ransom Humanities Research Center, The University of Texas at Austin

Cat. 34 Edgar Degas, *Horse Galloping on Right Foot*, cast sometime between 1920 and 1932
Bronze, 11⅞ × 18¼ in., 30.2 × 46.3 cm
Anonymous Collection, Dallas
(ill. p. 76)

## AUGUSTE RODIN
(1840–1917)

Cat. 35 Anonymous, *"The Shade,"* c. 1907
Albumen print, 6½ × 4½ in., 16.5 × 11.3 cm
Musée Rodin, Paris (Ph 2094)
(ill. p. 103)
*Bilbao venue*

Cat. 36 Karl-Henri (Charles) Bodmer, *"Jean d'Aire, Nude," in the Studio*, c. 1886
Gelatin silver print, 9⅞ × 7½ in., 25 × 19 cm
Musée Rodin, Paris (Ph 323)
*Bilbao venue*

Cat. 37 Karl-Henri (Charles) Bodmer, *"Jean d'Aire, Nude," in the Studio*, c. 1886
Albumen print, 9⅞ × 7⅜ in., 25 × 18.8 cm
Musée Rodin, Paris (Ph 956)
(ill. p. 111)
*San Francisco venue*

Cat. 38 Karl-Henri (Charles) Bodmer, *"Jean d'Aire, Nude," in the Studio*, c. 1886
Albumen print, 9¾ × 7⅜ in., 24.9 × 18.7 cm
Musée Rodin, Paris (Ph 3282)
*Dallas venue*

Cat. 39 Jacques-Ernst Bulloz, *"The Large Shade" in the Garden*, n.d.
Gelatin silver print, 14 × 10 in., 35.6 × 25.3 cm
Musée Rodin, Paris (Ph 302)
*San Francisco venue*

Cat. 40 Jacques-Ernst Bulloz, *"The Large Shade" in the Garden*, n.d.
Gelatin silver print, 14 × 9⅞ in., 35.5 × 25 cm
Musée Rodin, Paris (Ph 969)
(ill. p. 103)
*Dallas venue*

Cat. 41 Jacques-Ernst Bulloz, *"Monument to Balzac" at Meudon*, n.d.
Carbon print with gray-green tint 10⅝ × 8¼ in., 26.9 × 20.9 cm
Musée Rodin, Paris (Ph 972)
*Bilbao venue*

Cat. 42 Jacques-Ernst Bulloz, *"Monument to Balzac," at Meudon*, n.d.
Carbon print with brown tint, 14 × 10 in., 35.5 × 25.3 cm
Musée Rodin, Paris (Ph 974)
*San Francisco venue*

Cat. 43 Jacques-Ernst Bulloz, *"Monument to Balzac" at Meudon*, n.d.
Carbon print with gray-green tint, 10⅝ × 8 in., 27 × 20.2 cm
Musée Rodin, Paris (Ph 973) (ill. p. 109)
*Dallas venue*

Cat. 44 Jacques-Ernest Bulloz, *"Monument to Balzac" at Meudon*, n.d.
Gelatin silver print with sepia tint, 15 × 11 in., 38.2 × 28 cm
Musée Rodin, Paris (Ph 1197)
*Dallas venue*

Cat. 45 Jacques-Ernest Bulloz, *"Monument to Balzac" at Meudon*, 1908
Carbon print, 14 × 9¾ in., 35.7 × 24.8 cm
Musée Rodin, Paris (Ph 1508)
*Dallas venue*

Cat. 46 Jacques-Ernst Bulloz, *"Monument to Balzac" at Meudon*, n.d.
Carbon print, 10⅜ × 8¼ in., 26.4 × 21 cm
Musée Rodin, Paris (Ph 2698)
(ill. p. 109)
*Bilbao venue*

Cat. 47 Jacques-Ernst Bulloz, *"Monument to Balzac" at Meudon*, n.d.
Carbon print, 13⅞ × 9⅞ in., 35 × 25.2 cm
Musée Rodin, Paris (Ph 2894)
*Bilbao venue*

Cat. 48 Jacques-Ernst Bulloz, *"Monument to Balzac" at Meudon*, n.d.
Brown carbon print with green tint, 10⅜ × 8¼ in., 26.5 × 20.8 cm
Musée Rodin, Paris (Ph 3118)
*San Francisco venue*

Cat. 49 Jacques-Ernst Bulloz, *"Monument to Balzac" at Meudon*, n.d.
Carbon print with green tint, 14⅛ × 10½ in., 35.9 × 26.6 cm
Musée Rodin, Paris (Ph 3122)
*San Francisco venue*

Cat. 50 Alvin Langdon Coburn, *Portrait of Rodin with Blurred Contours*, 1906
Platinum print, 11⅜ × 8¾ in., 28.8 × 22.3 cm
Musée Rodin, Paris (Ph 537)
*Bilbao venue*

Cat. 51 Alvin Langdon Coburn, *Portrait of Rodin Wearing a Black Cap*, 1906
Platinum print, 11¼ × 8⅝ in., 28.5 × 22 cm
Musée Rodin, Paris (Ph 882)
*San Francisco venue*

Cat. 52 Eugène Druet, *"Eve,"* n.d.
Gelatin silver print, 15¼ × 11¼ in., 38.6 × 28.5 cm
Musée Rodin, Paris (Ph 287)
*Bilbao venue*

Cat. 53 Eugène Druet, *"Balzac, Half-Length," in the Studio*, n.d.
Gelatin silver print, 15¾ × 11¾ in., 40 × 30 cm
Musée Rodin, Paris (Ph 949)
(ill. p. 99)
*San Francisco venue*

Cat. 54 Eugène Druet, *"Monument to Balzac" in the Studio*, n.d.
Aristotype, 15¼ × 11⅝ in., 38.6 × 29.4 cm
Musée Rodin, Paris (Ph 950)
*Dallas venue*

Cat. 55 Eugène Druet, *"Eve" in Front of "The Gates of Hell,"* n.d.
Gelatin silver print, 15¾ × 11¾ in., 40 × 30 cm
Musée Rodin, Paris (Ph 1409)
*Bilbao venue*

Cat. 56 Eugène Druet, *"Eve" in Front of "The Gates of Hell,"* n.d.
Gelatin silver print, 15⅝ × 11¾ in., 39.6 × 29.8 cm
Musée Rodin, Paris (Ph 1527)
(ill. p. 97)
*Dallas venue*

Cat. 57 Eugène Druet, *"Balzac, Half-Length,"* n.d.
Gelatin silver print, 15 × 11⅛ in., 38 × 28.3 cm
Musée Rodin, Paris (Ph 2137)
(ill. p. 109)
*Bilbao venue*

Cat. 58 Eugène Druet, *"Eve,"* n.d.
Gelatin silver print, 15¾ × 11¾ in., 39.9 × 29.8 cm
Musée Rodin, Paris (Ph 2416)
*San Francisco venue*

Cat. 59 Eugène Druet, *"Eve" in Front of the Marble "The Kiss,"* n.d.
Gelatin silver print, 15¾ × 11⅞ in., 40 × 30 cm
Musée Rodin, Paris (Ph 2417) (ill. p. 97)
*San Francisco venue*

Cat. 60 Eugène Druet, *"Eve" in the Studio*, n.d.
Gelatin silver print, 15¾ × 11¾ in., 40 × 29.8 cm
Musée Rodin, Paris (Ph 2827)
*Dallas venue*

Cat. 61 Eugène Druet, *"Balzac, Half-Length," in the Studio*, n.d.
Gelatin silver print, 12⅜ × 9¾ in., 31.4 × 24.8 cm
Musée Rodin, Paris (Ph 2910)
*Dallas venue*

Cat. 62 Eugène Druet, *"Monument to Balzac" in the Studio*, n.d.
Gelatin silver print, 15⅝ × 11¾ in., 39.6 × 30 cm
Musée Rodin, Paris (Ph 3147)
*San Francisco venue*

Cat. 63 Eugène Druet, *"Head of Balzac,"* n.d.
Gelatin silver print, 15⅝ × 11¾ in., 39.6 × 29.8 cm
Musée Rodin, Paris (Ph 3151)
(ill. p. 109)
*Bilbao venue*

Cat. 64  Eugène Druet, *"Eve,"* n.d.
Gelatin silver print, 15⅜ × 10⅞ in.,
39 × 27.5 cm
Musée Rodin, Paris (Ph 3909)
*Bilbao venue*

Cat. 65  Eugène Druet, *"Eve,"* n.d.
Gelatin silver print, 15¾ × 11¹¹⁄₁₆ in.,
40 × 29.7 cm
Musée Rodin, Paris (Ph 3920)
*San Francisco venue*

Cat. 66  Eugène Druet, *"Eve,"* n.d.
Albumen print, 11⅝ × 9⅛ in.,
29.5 × 23.3 cm
Musée Rodin, Paris (Ph 3926)
(ill. p. 96)
*Dallas venue*

Cat. 67  Eugène Druet, *"The Dream
of Life,"* at the Salon of the Société
Nationale des Beaux-Arts, 1897
Gelatin silver print, 15⅝ × 11⅝ in.,
39.8 × 29.5 cm
Musée Rodin, Paris (Ph 5571) (ill. p. 113)
*San Francisco venue*

Cat. 68  Eugène Druet, *"The Dream
of Life"* at the Société Nationale des
Beaux-Arts, 1897
Gelatin silver print, 15 × 11¼ in.,
38.2 × 28.5 cm
Musée Rodin, Paris (Ph 5572)
*Bilbao venue*

Cat. 69  D. Freuler, *"The Dream of Life"*
at the Société Nationale des Beaux-Arts,
1897
Salt print, 10⅞ × 4¼ in., 27.5 × 10.8 cm
Musée Rodin, Paris (Ph 2246)
(ill. p. 113)
*Dallas venue*

Cat. 70  D. Freuler, *"The Dream of Life,"*
n.d.
Salt print, 10⅛ × 3⅞ in., 25.7 × 10 cm
Musée Rodin, Paris (Ph 5597)
*Dallas venue*

Cat. 71  Stephen Haweis and Henry
Coles, *"Crouching Woman,"* 1903–4
Carbon print, 8⅝ × 6⅝ in., 22.1 × 17 cm
Musée Rodin, Paris (Ph 297)
(ill. p. 100)
*Dallas venue*

Cat. 72  Stephen Haweis and Henry
Coles, *"Crouching Woman,"* 1903–4
Gum bichromate print, 8⅞ × 6⅞ in.,
22.5 × 17.5 cm
Musée Rodin, Paris (Ph 964)
*San Francisco venue*

Cat. 73  Stephen Haweis and Henry
Coles, *"Crouching Woman,"* 1903–4
Carbon print, 8⅞ × 6⅝ in.,
22.6 × 16.8 cm
Musée Rodin, Paris (Ph 4349)
*Bilbao venue*

Cat. 74  Gertrude Käsebier, *Rodin in
Profile,* 1905
Gum bichromate print, 8⅝ × 6¼ in.,
22 × 16 cm
Musée Rodin, Paris (Ph 241)
*Dallas venue*

Cat. 75  Jean-François Limet,
*"The Large Shade,"* n.d.
Gum bichromate print with orange
tint, 15⅜ × 10⅛ in., 39 × 25.6 cm
Musée Rodin, Paris (Ph 1585)
*San Francisco venue*

Cat. 76  Jean-François Limet,
*"The Shade,"* n.d.
Gum bichromate print, 14⅝ × 9⁵⁄₁₆ in.,
37.3 × 23.7 cm
Musée Rodin, Paris (Ph 5078)
*Bilbao venue*

Cat. 77  Jean-François Limet,
*"The Shade,"* n.d.
Gum bichromate print, 14½ × 10¼ in.,
36.7 × 26.1 cm
Musée Rodin, Paris (Ph 5079)
(ill. p. 103)
*Dallas venue*

Cat. 78  Charles Michelez, *"Saint John
the Baptist,"* with *"Bellone"* and *"Man
with a Broken Nose,"* c. 1881
Albumen print, 13⅛ × 8¾ in.,
33.5 × 22.2 cm
Musée Rodin, Paris (Ph 662) (ill. p. 91)
*San Francisco venue*

Cat. 79  Charles Michelez, *"Saint John
the Baptist,"* with *"Bellone"* and *"Man
with a Broken Nose,"* c. 1881
Albumen print, 8⅞ × 6 in.,
22.5 × 15.3 cm
Musée Rodin, Paris (Ph 667)
*Dallas venue*

Cat. 80  Charles Michelez, *"Saint John
the Baptist,"* with *"Bellone"* and *"Man
with a Broken Nose,"* c. 1881
Albumen print, 13⅜ × 8⅞ in.,
34.5 × 22.5 cm
Musée Rodin, Paris (Ph 959)
*Bilbao venue*

Cat. 81  Victor Pannelier, *"Eustache
de St.-Pierre"* in the Studio, c. 1886
Albumen print, 13¾ × 8 in.,
35 × 20.2 cm
Musée Rodin, Paris (Ph 318) (ill. p. 112)
*San Francisco venue*

Cat. 82  Victor Pannelier, *"Eustache
de St.-Pierre"* in the Studio, c. 1886
Albumen print, 14 × 7⅝ in.,
35.7 × 19.4 cm
Musée Rodin, Paris (Ph 3281)
*Dallas venue*

Cat. 83  Victor Pannelier, *"Eustache
de St.-Pierre"* in the Studio, c. 1886
Albumen print, 13¾ × 7⅞ in.,
34.8 × 20.1 cm
Musée Rodin, Paris (Ph 3283)
*Bilbao venue*

Cat. 84  Auguste Rodin, *Small Head
of Jean des Fiennes,* n.d.
Bronze, 3 × 2⅞ × 3 in., 7.7 × 7.2 × 7.5 cm
Collection Fondation Pierre Gianadda,
Martigny, Switzerland

Cat. 85  Auguste Rodin, *St. John the
Baptist Preaching Nr. 6,* 1878
Bronze, Musée Rodin cast 6/12, 1966,
31½ × 19 × 9½ in., 80 × 48.3 × 24.1 cm
Los Angeles County Museum of Art,
Gift of B. Gerald Cantor Art Foun-
dation (M.73.108.12) (ill. p. 90)

Cat. 86  Auguste Rodin, *Shade, Adam
from "The Gates of Hell,"* 1880
Bronze, 38⅛ × 20¾ × 12¼ in.,
96.8 × 52.7 × 31.1 cm
Dallas Museum of Art, Gift of Mr. and
Mrs. Eugene McDermott (1964.77)
(ill. p. 102)

Cat. 87  Auguste Rodin, *Eve,* 1881
(cast before 1932)
Bronze, 68 × 17¼ × 25½ in.,
172.7 × 43.8 × 64.8 cm
The Patsy R. and Raymond D. Nasher
Collection (ill. p. 96)
*San Francisco and Dallas venues*

Cat. 88  Auguste Rodin, *Crouching
Woman,* 1882
Bronze, 37½ × 25 × 22 in.,
95.3 × 63.5 × 55.9 cm
Los Angeles County Museum of Art,
Gift of the B. Gerald Cantor Art
Foundation (M.73.108.4)

Cat. 89  Auguste Rodin, *The Burghers
of Calais, First Maquette,* fall 1884
Bronze, 23½ × 14¾ × 12⅝ in.,
59.7 × 37.5 × 32.1 cm
Iris & B. Gerald Cantor Foundation,
Los Angeles (ill. p. 111)

Cat. 90  Auguste Rodin, *Jean d'Aire,*
1884–86
Bronze, 18½ × 6½ × 5⅝ in.,
47 × 16.5 × 14.6 cm
Los Angeles County Museum of Art,
Gift of the B. Gerald Cantor Art
Foundation (M.73.110.4) (ill. p. 110)

Cat. 91  Auguste Rodin, *Jean d'Aire,*
1886
Bronze, cast in the early 20th century,
81 × 28 × 24 in., 205.7 × 71.1 × 61 cm
Dallas Museum of Art, Given in
memory of Louie N. Bromberg and
Mina Bromberg by their sister Essie
Bromberg Joseph (1981.1) (ill. p. 111)

Cat. 92  Auguste Rodin, *Eustache de
St.-Pierre,* c. 1886–87, cast 1983
Bronze, 85 × 30 × 48 in.,
215.9 × 76.2 × 121.9 cm
Brooklyn Museum of Art, Gift of Iris
and B. Gerald Cantor (87.106.2)
(ill. p. 112)

Cat. 93  Auguste Rodin, *Republican
Balzac,* c. 1892
Bronze, 42½ × 19⅝ × 14⅝ in.,
108 × 50 × 37 cm
Collection Fondation Pierre Gianadda,
Martigny, Switzerland (ill. p. 108)

Cat. 94  Auguste Rodin, *The Poet and
the Contemplative Life (The Dream of
Life),* 1896
Marble, 72¼ × 20½ × 23¾ in.,
183.5 × 52.1 × 60.3 cm
Dallas Museum of Art, The Wendy and
Emery Reves Collection (1985.R.64)
(ill. p. 113)
*Dallas venue*

Cat. 95  Auguste Rodin, *Study for
the "Monument to Balzac,"* c. 1897
(cast 1974, marked 6)
Bronze, 44½ × 17¼ × 15 in.,
113 × 43.8 × 38.1 cm
The Patsy R. and Raymond D. Nasher
Collection (ill. p. 107)
*San Francisco and Dallas venues*

Cat. 96  Edward Steichen, *Portrait of
Rodin in Front of "The Hand of God,"*
n.d.
Pigment or oil print? 8¼ × 6¼ in.,
21 × 16 cm
Musée Rodin, Paris (Ph 215)
*Bilbao venue*

Cat. 97  Edward Steichen, *Portrait of
Rodin next to "The Thinker," "Monument
to Victor Hugo" in the Background,* 1902
Carbon print with engraving?
10¼ × 12⅝ in., 26 × 32.2 cm
Musée Rodin, Paris (Ph 217) (ill. p. 105)
*Dallas venue*

Cat. 98  Edward Steichen, *Portrait of
Rodin (Left Hand on His Beard),* 1907
Platinum print, 14 × 9⅝ in.,
35.5 × 24.5 cm
Musée Rodin, Paris (Ph 238) (ill. p. 88)
*Dallas venue*

Cat. 99  Edward Steichen, *Portrait of
Rodin (Left Hand on His Beard),* 1902
Pigment or oil print? 8 × 6⅛ in.,
20.3 × 15.5 cm
Musée Rodin, Paris (Ph 243)
*San Francisco venue*

Cat. 100  Edward Steichen, *Portrait
of Rodin ("The Hand of God" in the
Background),* 1901
Platinum print, 8⅛ × 6⅛ in.,
20.7 × 15.7 cm
Musée Rodin, Paris (Ph 244)
*San Francisco venue*

Cat. 101  Edward Steichen, *Portrait of
Rodin Seated on a Chair ("The Hand
of God" in the Background),* 1901
Gum platinum print? 8⅛ × 6¼ in.,
20.5 × 16 cm
Musée Rodin, Paris (Ph 253)
*Bilbao venue*

Cat. 102  Edward Steichen, *The
Silhouette, 4 A.M., Meudon,* 1908 /
printed 1940s
Gelatin silver print, 10¾ × 13⅝ in.,
27.3 × 34.6 cm
Los Angeles County Museum of Art,
Gift of the B. Gerald Cantor Art
Foundation (M.87.74.3) (ill. p. 106)

Cat. 103  Edward Steichen, *Balzac,
Midnight,* c. 1908 / printed 1940s
Gelatin silver print, 11 × 14 in.,
27.9 × 35.6 cm
Los Angeles County Museum of Art,
Gift of the B. Gerald Cantor Art
Foundation (M.87.74.4) (ill. p. 101)

**PAUL GAUGUIN**
(1848–1903)

Cat. 104 After a photograph of c. 1890 by Charles Spitz, *Tahiti: Indigenous Dance,* n.d.
Vintage postcard, 3½ × 5½ in., 8.9 × 14 cm
Christian Beslu, Tahiti (ill. p. 134)

Cat. 105 Anonymous, *Tahiti— A Banana Carrier,* n.d.
Vintage postcard, 3½ × 5½ in., 8.9 × 14 cm
Christian Beslu, Tahiti

Cat. 106 Anonymous, *Tahiti: An Indigenous Hut,* n.d.
Vintage postcard, 5½ × 3½ in., 14 × 8.9 cm
Christian Beslu, Tahiti (ill. p. 135)

Cat. 107 Anonymous, *Tahiti: An Indigenous Hut,* n.d.
Vintage postcard, 3½ × 5½ in., 8.9 × 14 cm
Christian Beslu, Tahiti

Cat. 108 Anonymous, *Tahiti: An Indigenous Hut,* n.d.
Vintage postcard, 3½ × 5½ in., 8.9 × 14 cm
Christian Beslu, Tahiti (ill. p. 135)

Cat. 109 Anonymous, *Tahiti: In the Countryside,* n.d.
Vintage postcard, 5½ × 3½ in., 14 × 8.9 cm
Christian Beslu, Tahiti

Cat. 110 Anonymous, *Detail of Standing Youth and Horse on Slab N of the Parthenon,* 1868
From *Les Frises du Parthenon* by C. Yriarte
16 × 12¾ in., 40.6 × 32.4 cm
Minneapolis Public Library (ill. p. 120)

Cat. 111 Anonymous, reproduction of Corot's *The Letter* (c. 1865–70)
Arosa auction catalogue, c. February 25, 1878
Collotype
National Gallery of Art Library, Washington, D.C. (ill. p. 136)

Cat. 112 Anonymous, *Fragment of Parthenon Frieze,* c. 1880–89
Photograph
Private Collection, Tahiti (ill. p. 121)

Cat. 113 Anonymous, *Frieze below the Stage of the Theater of Dionysus, Athens, 54–68 B.C.,* c. 1880–89
Albumen photograph
Private Collection, Tahiti

Cat. 114 Anonymous, *Scene from the Dacian Wars: Supply Ships on the Danube River (Fragment of a Trojan Column),* c. 1880–89
Albumen photograph
Private Collection, Tahiti

Cat. 115 Anonymous, *Samoan at a Waterfall,* 1888
Colored gillotage reproduction of an albumen print, 6¹⁄₁₆ × 6⅛ in., 15.4 × 15.6 cm
Christian Beslu, Tahiti (ill. p. 138)

Cat. 116 Anonymous, *Fragment of Egyptian Wall Painting of a Banquet Scene. Tomb of Nebamun, 1400 B.C.,* c. 1889
Albumen photograph, 8⅞ × 11⅛ in., 22.6 × 28.2 cm
Private Collection, Tahiti

Cat. 117 Anonymous, *Relief at Temple of Borobudur, Java,* detail *(Top register: The Assault of Mara; bottom register: Scene from the Bhallatiya-Jakata),* c. 1889
Albumen photograph, 9½ × 11⅜ in., 24.3 × 29 cm
Private Collection, Tahiti (ill. p. 125)

Cat. 118 Anonymous, *Relief on Temple at Borobudur, Java (Top register: The Tathagat Meets an Ajiwaka Monk on the Benares Road; bottom register: Merchant Maitraknayake Greeted by Nymphs),* c. 1889
Albumen photograph, 9¼ × 11½ in., 23.5 × 29.3 cm
Private Collection, Tahiti (ill. pp. 122, 125, 128)

Cat. 119 Paul Gauguin, *Still-Life with Horse's Head,* c. 1886
Oil on canvas, 19¼ × 15 in., 48.9 × 38.1 cm
Bridgestone Museum of Art, Ishibashi Foundation, Tokyo (ill. p. 118)
*Dallas and Bilbao venues*

Cat. 120 Paul Gauguin, *Portrait of the Artist's Mother,* 1890
Oil on canvas, 16⅛ × 13 in., 41 × 33 cm
Staatsgalerie Stuttgart (ill. p. 122)

Cat. 121 Paul Gauguin, *In the Vanilla Grove: Man and Horse,* 1891
Oil on canvas, 28¾ × 36¼ in., 73 × 92 cm
Gift of Justin K. Thannhauser Collection, 1978, Solomon R. Guggenheim Museum, New York (ill. p. 120)
*Dallas and Bilbao venues*

Cat. 122 Paul Gauguin, *The Large Tree (Te raau rahi),* 1891
Oil on canvas, 29⅛ × 36½ in., 74 × 92.8 cm
© The Cleveland Museum of Art 1999, Gift of Barbara Ginn Griesinger (1975.263) (ill. p. 134)

Cat. 123 Paul Gauguin, *Melancholic (Faaturuma),* 1891
Oil on canvas, 37 × 26⅞ in., 94 × 68.3 cm
The Nelson-Atkins Museum of Art, Kansas City, Missouri (Purchase: Nelson Trust) 38-5 (ill. p. 137)
*Dallas venue*

Cat. 124 Paul Gauguin, *Under the Pandanus (I raro te oviri),* 1891
Oil on canvas, 26½ × 35¾ in., 67.3 × 90.8 cm
Dallas Museum of Art, Foundation for the Arts Collection, gift of the Adele R. Levy Fund, Inc. (ill. p. 116)

Cat. 125 Paul Gauguin, *The Annunciation (Te Faruru),* 1892
Oil and gouache on paper, mounted on cardboard, 17⅛ × 8⅛ in., 43.5 × 20.6 cm
Museum of Fine Arts, Springfield, Massachusetts, The James Philip Gray Collection (ill. p. 129)

Cat. 126 Paul Gauguin, *The Delightful Land (Te Nave Nave fenua),* 1892
Brush and gouache on wove paper, 15¾ × 12⅝ in., 40 × 32 cm
Musée de Grenoble (ill. p. 130)
*Dallas venue*

Cat. 127 Paul Gauguin, *Reworked Study for "Delightful Land,"* 1892 (reworked 1894)
Charcoal and pastel drawing, 36¼ × 21⅝ in., 92.1 × 54.9 cm
Gift of John and Elizabeth Bates Cowles; Des Moines Art Center Permanent Collections, 1958.76 (ill. p. 130)

Cat. 128 Paul Gauguin, *Mysterious Water (Pape Moe),* 1891–93
Watercolor on cream paper, 13⅞ × 10⅛ in., 35.4 × 25.6 cm
The Art Institute of Chicago, gift of Mrs. Emilu Crane Chadbourne, 1922.4797 (ill. p. 139)
*Dallas venue*

Cat. 129 Paul Gauguin, *Mysterious Water, the Moon and the Earth (Pape Moe, Parau Hina Tefatou),* 1894
Watercolor, gouache, brush and black ink on irregular tan paper laid down on board, 15¾ × 10⅛ in., 40 × 25.8 cm
Edward Tyler Nahem, Fine Art, New York, and John Berggruen Gallery, San Francisco (ill. p. 139)

Cat. 130 Paul Gauguin, *The God (Te Atua),* c. 1894
Woodcut on boxwood printed by embossing or gaufrage with traces of brown ink from an earlier impression, 8⅛ × 13⅝ in., 20.6 × 34.6 cm
The Art Institute of Chicago, Joseph Brooks Fair Collection, 1940.1074 recto (ill. p. 131)
*San Francisco and Dallas venues*

Cat. 131 Paul Gauguin, *We Greet Thee, Mary (Ia Orana Maria),* c. 1894
Watercolor monotype, printed in blue, black, and red, 13⅜ × 7⅛ in., 34 × 18 cm
Rijksmuseum, Amsterdam (ill. p. 129)
*Dallas and Bilbao venues*

Cat. 132 Paul Gauguin, *Delectable Waters (Te pape nave nave),* 1898
Oil on canvas, 29⅛ × 37½ in., 74 × 95.3 cm
Collection of Mr. and Mrs. Paul Mellon, © 1998 Board of Trustees, National Gallery of Art, Washington, D.C. (ill. p. 130)

Cat. 133 Paul Gauguin, *Tahitian Pastorale (Faa Iheihe),* 1898
Oil on canvas, 21¼ × 66¾ in., 54 × 169.5 cm
The Tate Gallery, London, Presented by Lord Duveen, 1919 (ill. pp. 126–27)
*Dallas venue*

Cat. 134 Paul Gauguin, *Buddha,* 1898–99
Woodcut on long grain plank, printed in black on ivory Japanese tissue, 11½ × 8¾ in., 29.3 × 22.2 cm
The Art Institute of Chicago, Print Sales Miscellaneous Fund, 1947.687 (ill. p. 131)
*San Francisco and Dallas venues*

Cat. 135 Paul Gauguin, *Change of Residence,* c. 1899
Woodcut printed in ochre and black on thin Japanese tissue pasted to ivory wove paper, 6½ × 11¹⁄₁₆ in., 16.4 × 30.1 cm
The Art Institute of Chicago, The Albert H. Wolf Memorial Collection, 1939.322 (ill. p. 128)
*San Francisco and Dallas venues*

Cat. 136 Paul Gauguin, *Landscape with Three Figures,* 1901
Oil on canvas, 26½ × 30½ in., 67.3 × 77.5 cm
Carnegie Museum of Art, Pittsburgh; Presented through the generosity of Mrs. Alan M. Scaife, 1963 (ill. p. 135)
*Dallas venue*

Cat. 137 Paul Gauguin, *Three Native Women (Study for "The Call"),* 1902–3
Traced monotype in black ink, squared, on a sheet of brown paper, 17⅛ × 12 in., 43.5 × 30.5 cm
Museum of Fine Arts, Boston, Otis Norcross Fund, 1956 (56.106) (ill. p. 121)

Cat. 138 Isidore van Kinsbergen, *Shiva, Mid-Java, 9th Century,* negative 1863–67 (print 1872)
Albumen print, 12¾ × 9⅝ in., 32.5 × 24.5 cm
Kern Institute, Leiden, The Netherlands

Cat. 139 Henri Lemasson, *Half-Tahitian Woman,* c. 1895
Albumen print
Centre des Archives d'Outre-Mer, Aix-en-Provence (ill. p. 136)
*San Francisco venue*

Cat. 140 Charles Spitz, attributed, *Raiatians Returning with Provisions*
Albumen print
Centre des Archives d'Outre-Mer, Aix-en-Provence
*San Francisco venue*

Cat. 141 Charles Spitz, attributed, *Banana Carriers,* c. 1890
Albumen print glued to carton paper, 4 × 5⅜ in., 10.3 × 13.7 cm
Hamilton Library, University of Hawaii at Monoa

Cat. 142 Charles Spitz, attributed, *Fruit Carriers on Raiatea,* c. 1900
Vintage postcard, 3⅛ × 6¹⁄₁₆ in., 7.9 × 15.4 cm
Christian Beslu, Tahiti (ill. p. 116)

## FERNAND KHNOPFF
(1858–1921)

Cat. 143  Fernand Khnopff, *Marguerite Posing with Her Hands Covering Her Face,* n.d.
Pencil and pastel on paper, c. 6¼ in.,
16 cm diameter
Courtesy of Patrick Derom Gallery, Brussels (ill. p. 147)

Cat. 144  Fernand Khnopff, *The Offering,* n.d.
Drypoint etching, 11⅜ × 7⅞ in.,
29 × 20 cm
Galerie Claude van Loock, Brussels

Cat. 145  Fernand Khnopff, *With Verhaeren. An Angel,* c. 1889
Vintage photograph, 10 × 5⅞ in.,
25.5 × 15 cm
Musées Royaux des Beaux-Arts de Belgique, Brussels (ill. p. 154)

Cat. 146  Fernand Khnopff, *Marguerite Posing for "Du Silence,"* 1890
Photograph, 9⁷⁄₁₆ × 7¼ in.,
23.9 × 18.4 cm
Musées Royaux des Beaux-Arts de Belgique, Brussels (ill. p. 150)

Cat. 147  Fernand Khnopff, *Du Silence,* c. 1890
Pastel on paper, 34½ × 17⅜ in.,
87.8 × 44.3 cm
Musées Royaux des Beaux-Arts de Belgique, Brussels (ill. p. 150)

Cat. 148  Fernand Khnopff, *Marguerite Posing for One of the Tennis Players,* c. 1890
Photograph, 9⅜ × 4¼ in.,
23.8 × 10.8 cm
Musées Royaux des Beaux-Arts de Belgique, Brussels  (ill. p. 151)

Cat. 149  Fernand Khnopff, *Head of a Young English Girl,* 1898
Hand-colored photograph, 11¼ × 9 in.,
28.5 × 23 cm
Ronny Van de Velde, Antwerp, Belgium (ill. p. 154)

Cat. 150  Fernand Khnopff, *Nevermore (La Rêveuse),* c. 1900
Pencil and pastel on paper, 6 in.,
15.2 cm in diameter
Courtesy of Patrick Derom Gallery, Brussels  (ill. p. 147)

Cat. 151  Fernand Khnopff, *Marguerite Posing for "Secret,"* c. 1902
Photograph, 9⁷⁄₁₆ × 7³⁄₁₆ in.,
23.9 × 18.2 cm
Musées Royaux des Beaux-Arts de Belgique, Brussels  (ill. p. 149)

Cat. 152  Fernand Khnopff, *Study for "Secret,"* c. 1902
Charcoal, pencil, and pastel on paper
6¼ × 14 in., 16 × 35.5 cm
Collection of Peter Marino, New York (ill. p. 149)

Cat. 153  Fernand Khnopff, *In the Past (D'autrefois),* 1905
Vintage print with pastel on paper,
8⅝ × 11⅛ in., 21.8 × 28.3 cm
Musées Royaux des Beaux-Arts de Belgique, Brussels (ill. p. 142)

Cat. 154  Fernand Khnopff, *The Black Collar (Le Col noir),* c. 1906
Charcoal and pastel on cardboard,
13⅜ × 10⅛ in., 34 × 25.7 cm
Courtesy of Patrick Derom Gallery, Brussels  (ill. p. 148)

## MEDARDO ROSSO
(1858–1928)

Cat. 155  Medardo Rosso/Photographer Unknown, *Behold the Child (Ecce Puer),* n.d.
Vintage photograph, 5½ × 3½ in.,
14 × 8.9 cm
Museo Rosso, Barzio (E 5)
*San Francisco venue*

Cat. 156  Medardo Rosso/Photographer Unknown, *Behold the Child (Ecce Puer),* n.d.
Vintage photograph, 5¼ × 3¼ in.,
13.4 × 8.2 cm
Museo Rosso, Barzio (E 6) (ill. p. 164)
*San Francisco venue*

Cat. 157  Medardo Rosso/Photographer Unknown, *Behold the Child (Ecce Puer),* n.d.
Vintage photograph, 5½ × 2¼ in.,
14 × 5.7 cm
Museo Rosso, Barzio (E 8) (ill. p. 164)
*San Francisco venue*

Cat. 158  Medardo Rosso/Photographer Unknown, *Impression on the Boulevard, Paris Night,* n.d.
Vintage photograph, 3½ × 5½ in.,
9 × 13.5 cm
Museo Rosso, Barzio (Z 1)
*Bilbao venue*

Cat. 159  Medardo Rosso/Photographer Unknown, *Impression on the Boulevard, Paris Night,* n.d.
Vintage photograph, 2¾ × 4⅜ in.,
7 × 11.1 cm
Museo Rosso, Barzio (Z 2)
*Bilbao venue*

Cat. 160  Medardo Rosso/Photographer Unknown, *Impression on the Boulevard, Paris Night,* n.d.
Vintage photograph, 3⅞ × 5¼ in.,
10 × 13.4 cm
Museo Rosso, Barzio (Z 3) (ill. p. 166)
*Bilbao venue*

Cat. 161  Medardo Rosso/Photographer Unknown, *Impression on the Boulevard, Paris Night,* n.d.
Vintage photograph, 2¾ × 4 in.,
7 × 10.2 cm
Museo Rosso, Barzio (Z 6) (ill. p. 166)
*Bilbao venue*

Cat. 162  Medardo Rosso/Photographer Unknown, *Impression on the Boulevard, Paris Night,* n.d.
Vintage photograph, irregular dimensions, c. 3.9 × 2.2 in., 9.9 × 5.5 cm
Museo Rosso, Barzio (Z 9)
*Bilbao venue*

Cat. 163  Medardo Rosso/Photographer Unknown, *Impression on the Boulevard, Paris Night,* n.d.
Vintage photograph, 4¼ × 2 in.,
10.8 × 5.1 cm
Museo Rosso, Barzio (Z 10)
*Bilbao venue*

Cat. 164  Medardo Rosso/Photographer Unknown, *Impression on the Boulevard, Paris Night,* n.d.
Vintage photograph, 3¾ × 1⅞ in.,
9.5 × 4.8 cm
Museo Rosso, Barzio (Z 11)
*Bilbao venue*

Cat. 165  Medardo Rosso/Photographer Unknown, *Impression on the Boulevard, Paris Night,* n.d.
Vintage photograph, 5⅜ × 2¾ in.,
13.7 × 6.9 cm
Museo Rosso, Barzio (Z 12)
*Bilbao venue*

Cat. 166  Medardo Rosso/Photographer Unknown, *Impression on the Boulevard, Paris Night,* n.d.
Vintage photograph, 7 × 3⅝ in.,
17.8 × 9.3 cm
Museo Rosso, Barzio (Z 14)
*Bilbao venue*

Cat. 167  Medardo Rosso/Photographer Unknown, *Impression on the Boulevard, Paris Night,* n.d.
Vintage photograph, 4⅝ × 3½ in.,
11.9 × 8.9 cm
Museo Rosso, Barzio (Z 15)
*Bilbao venue*

Cat. 168  Medardo Rosso, *The Concierge (La Portinaia),* c. 1883–84
Wax over plaster, 15 × 13⅜ × 7¹⁄₁₆ in.,
38.1 × 34 × 17.9 cm
The Patsy R. and Raymond D. Nasher Collection (ill. p. 161)
*San Francisco and Dallas venues*

Cat. 169  Medardo Rosso/Photographer Unknown, *The Concierge (La Portinaia),* after 1883
Vintage photograph, 5.4 × 2.7 in.,
13.6 × 6.8 cm
Museo Rosso, Barzio (N 2)
*San Francisco venue*

Cat. 170  Medardo Rosso/Photographer Unknown, *The Concierge (La Portinaia),* after 1883
Vintage photograph, irregular dimensions, 5¼ × 2⅝ in., 13.5 × 6.8 cm
Museo Rosso, Barzio (N 3)
*Dallas venue*

Cat. 171  Medardo Rosso/Photographer Unknown, *The Concierge (La Portinaia),* after 1883
Vintage photograph, 6¾ × 3⅝ in.,
17.3 × 9.3 cm
Museo Rosso, Barzio (N 8) (ill. p. 160)
*Dallas venue*

Cat. 172  Medardo Rosso/Photographer Unknown, *The Concierge (La Portinaia),* after 1883
Vintage photograph, irregular dimensions, c. 5⅜ × 3⅛ in., 13.8 × 7.8 cm
Museo Rosso, Barzio (N 10) (ill. p. 160)
*Dallas venue*

Cat. 173  Medardo Rosso/Photographer Unknown, *The Concierge (La Portinaia),* after 1883
Vintage photograph, 5¼ × 2⅜ in.,
13.3 × 6 cm
Museo Rosso, Barzio (N 15)
*Dallas venue*

Cat. 174  Medardo Rosso/Photographer Unknown, *The Concierge (La Portinaia),* after 1883
Vintage photograph, 4¾ × 2⅜ in.,
12.1 × 6.2 cm
Museo Rosso, Barzio (N 16)
*Dallas venue*

Cat. 175  Medardo Rosso/Photographer Unknown, *The Concierge (La Portinaia),* after 1883
Vintage photograph, 5 × 2⅜ in.,
12.7 × 6 cm
Museo Rosso, Barzio (N 17)
*Dallas venue*

Cat. 176  Medardo Rosso/Photographer Unknown, *The Concierge (La Portinaia),* after 1883
Vintage photograph, 5¼ × 2⅜ in.,
13.4 × 6.2 cm
Museo Rosso, Barzio (N 18)
*Dallas venue*

Cat. 177  Medardo Rosso/Photographer Unknown, *The Concierge (La Portinaia),* after 1883
Vintage photograph, 5⅝ × 3½ in.,
14.3 × 8.8 cm
Museo Rosso, Barzio (N 19) (ill. p. 160)
*San Francisco venue*

Cat. 178  Medardo Rosso/Photographer Unknown, *The Concierge (La Portinaia),* after 1883
Vintage photograph, 3⅞ × 1⅝ in.,
9.9 × 4.2 cm
Museo Rosso, Barzio (N 21)
*San Francisco venue*

Cat. 179  Medardo Rosso/Photographer Unknown, *The Concierge (La Portinaia),* after 1883
Vintage photograph, 3¼ × 1⅜ in.,
8.2 × 3.5 cm
Museo Rosso, Barzio (N 22) (ill. p. 160)
*San Francisco venue*

Cat. 180  Medardo Rosso/Photographer Unknown, *The Concierge (La Portinaia),* after 1883
Photograph, 4⅜ × 2⅜ in., 11.2 × 5.9 cm
Museo Rosso, Barzio (N 23)
*San Francisco venue*

Cat. 181  Medardo Rosso/Photographer Unknown, *The Concierge (La Portinaia),* after 1883
Vintage photograph, 5⅝ × 3¾ in.,
14.3 × 9.5 cm
Museo Rosso, Barzio (N 24)
*San Francisco venue*

Cat. 182  Medardo Rosso/Photographer Unknown, *Impressions of an Omnibus,* c. 1883–84
Vintage photograph, 5⅞ × 4¼ in.,
14.9 × 10.9 cm
Museo Rosso, Barzio (Y 3)
*Dallas venue*

Cat. 183  Medardo Rosso/Photographer Unknown, *Impressions of an Omnibus*, c. 1883–84
Vintage photograph, 5½ × 4 in., 14 × 10.3 cm
Museo Rosso, Barzio (Y 13)
*Dallas venue*

Cat. 184  Medardo Rosso/Photographer Unknown, *Impressions of an Omnibus*, c. 1883–84
Vintage photograph, 4½ × 3¾ in., 11.4 × 9.4 cm
Museo Rosso, Barzio (Y 14) (ill. p. 158)
*Dallas venue*

Cat. 185  Medardo Rosso/Photographer Unknown, *Impressions of an Omnibus*, c. 1883–84
Vintage photograph, 3⅝ × 3 in., 9.3 × 7.5 cm
Museo Rosso, Barzio (Y 17) (ill. p. 158)
*Dallas venue*

Cat. 186  Medardo Rosso/Photographer Unknown, *Impressions of an Omnibus*, c. 1883–84
Vintage photograph, 3⅜ × 2⅛ in., 8.7 × 5.3 cm
Museo Rosso, Barzio (Y 21)
*Dallas venue*

Cat. 187  Medardo Rosso/Photographer Unknown, *Impressions of an Omnibus*, c. 1883–84
Vintage photograph, 2¼ × 2⅝ in., 5.6 × 6.8 cm
Museo Rosso, Barzio (Y 45)
*Dallas venue*

Cat. 188  Medardo Rosso/Photographer Unknown, *Impressions of an Omnibus*, c. 1883–84
Vintage photograph, 3½ × 4¼ in., 8.8 × 11.4 cm
Museo Rosso, Barzio (Y 47)
*Dallas venue*

Cat. 189  Medardo Rosso/Photographer Unknown, *Impressions of an Omnibus*, c. 1883–84
Vintage photograph, 3 × 7 in., 7.7 × 17.7 cm
Museo Rosso, Barzio (Y 52)
*Dallas venue*

Cat. 190  Medardo Rosso/Photographer Unknown, *Impressions of an Omnibus*, c. 1883–84
Vintage photograph, 7¼ × 9⅝ in., 18.5 × 24.6 cm
Museo Rosso, Barzio (Y 58) (ill. p. 158)
*Dallas venue*

Cat. 191  Medardo Rosso, *Baby at the Breast (Enfant au sein)*, 1889
Bronze, 12⅝ × 16½ × 16⅛ in., 32 × 42 × 41 cm
Museo Rosso, Barzio (ill. p. 156)

Cat. 192  Medardo Rosso/Photographer Unknown, *Baby at the Breast (Enfant au sein)*, after 1889
Vintage photograph, 3¾ × 2⅞ in., 9.5 × 7.3 cm
Museo Rosso, Barzio (M 1)
*Dallas venue*

Cat. 193  Medardo Rosso/Photographer Unknown, *Baby at the Breast (Enfant au sein)*, after 1889
Vintage photograph, 5⅜ × 7¼ in., 13.7 × 18.3 cm
Museo Rosso, Barzio (M 4) (ill. p. 156)
*Dallas venue*

Cat. 194  Medardo Rosso/Photographer Unknown, *Baby at the Breast (Enfant au sein)*, after 1889
Vintage photograph, 5⅜ × 7½ in., 13.8 × 19 cm
Museo Rosso, Barzio (M 5) (ill. p. 156)
*Dallas venue*

Cat. 195  Medardo Rosso/Photographer Unknown, *Baby at the Breast (Enfant au sein)*, after 1889
Vintage photograph, 6⅞ × 5 in., 17.5 × 12.8 cm
Museo Rosso, Barzio (M 6) (ill. p. 156)
*Dallas venue*

Cat. 196  Medardo Rosso/Photographer Unknown, *Baby at the Breast (Enfant au sein)*, after 1889
Vintage photograph, 7⅝ × 6⅛ in., 19.4 × 15.4 cm
Museo Rosso, Barzio (M 12)
*San Francisco venue*

Cat. 197  Medardo Rosso/Photographer Unknown, *Baby at the Breast (Enfant au sein)*, after 1889
Vintage photograph, 5⅜ × 8⅛ in., 13.8 × 20.5 cm
Museo Rosso, Barzio (M 13) (ill. p. 156)
*San Francisco venue*

Cat. 198  Medardo Rosso/Photographer Unknown, *Baby at the Breast (Enfant au sein)*, after 1889
Vintage photograph, 6⅝ × 7⅞ in., 16.9 × 20 cm
Museo Rosso, Barzio (M 14) (ill. p. 156)
*San Francisco venue*

Cat. 199  Medardo Rosso/Photographer Unknown, *Baby at the Breast (Enfant au sein)*, after 1889
Vintage photograph, 5⅜ × 8⅝ in., 13.8 × 22 cm
Museo Rosso, Barzio (M 15) (ill. p. 156)
*San Francisco venue*

Cat. 200  Medardo Rosso, *Laughing Woman (La Rieuse)*, 1890
Bronze with gold patina, 13½ × 10 × 11 in., 34.3 × 25.4 × 27.9 cm
Private Collection (ill. p. 174)
*Dallas and San Francisco venues*

Cat. 201  Medardo Rosso/Photographer Unknown, *Laughing Woman (La Grande Rieuse)*, after 1890
Vintage photograph, 2⅜ × 8¹⁵⁄₁₆ in., 6.2 × 22.7 cm
Museo Rosso, Barzio (C 1) (ill. p. 174)
*San Francisco venue*

Cat. 202  Medardo Rosso/Photographer Unknown, *Laughing Woman (La Rieuse)*, after 1890
Vintage photograph, 6½ × 6⅞ in., 16.6 × 17.4 cm
Museo Rosso, Barzio (C 2)
*Dallas venue*

Cat. 203  Medardo Rosso/Photographer Unknown, *Laughing Woman (La Grande Rieuse)*, after 1890
Photograph, 5¾ × 3½ in., 14.6 × 9 cm
Museo Rosso, Barzio (C 6) (ill. p. 165)
*Dallas venue*

Cat. 204  Medardo Rosso/Photographer Unknown, *Laughing Woman (La Grande Rieuse)*, after 1890
Vintage photograph, 8⅝ × 6⅝ in., 22 × 17 cm
Museo Rosso, Barzio (C 7) (ill. p. 174)
*Dallas venue*

Cat. 205  Medardo Rosso/Photographer Unknown, *Laughing Woman (La Rieuse)*, after 1890
Vintage photograph, 5 × 3 in., 12.8 × 7.5 cm
Museo Rosso, Barzio (C 8)
*San Francisco venue*

Cat. 206  Medardo Rosso/Photographer Unknown, *Laughing Woman (La Rieuse)*, after 1890
Vintage photograph, 4⅝ × 2½ in., 11.9 × 6.5 cm
Museo Rosso, Barzio (C 9)
*Dallas venue*

Cat. 207  Medardo Rosso/Photographer Unknown, *Laughing Woman (La Rieuse)*, after 1890
Vintage photograph, irregular dimensions, c. 2¾ × 1⅝ in., 7 × 4.1 cm
Museo Rosso, Barzio (C 10)
*Dallas venue*

Cat. 208  Medardo Rosso/Photographer Unknown, *Laughing Woman (La Rieuse)*, after 1890
Vintage photograph, 3⅞ × 2¾ in., 9.8 × 7 cm
Museo Rosso, Barzio (C 11)
*Dallas venue*

Cat. 209  Medardo Rosso/Photographer Unknown, *Laughing Woman (La Grande Rieuse)*, after 1890
Vintage photograph, irregular dimensions, c. 3½ × 3⅞ in., 8.8 × 10 cm
Museo Rosso, Barzio (C 12) (ill. p. 174)
*San Francisco venue*

Cat. 210  Medardo Rosso/Photographer Unknown, *Laughing Woman (La Rieuse)*, after 1890
Photograph, 4¼ × 2 in., 10.9 × 5.2 cm
Museo Rosso, Barzio (C 13)
*San Francisco venue*

Cat. 211  Medardo Rosso/Photographer Unknown, *Laughing Woman (La Rieuse)*, after 1890
Vintage photograph, 2¼ × 1½ in., 5.6 × 3.8 cm
Museo Rosso, Barzio (C 14)
*San Francisco venue*

Cat. 212  Medardo Rosso/Photographer Unknown, *Laughing Woman (La Rieuse)*, after 1890
Vintage photograph, 4¾ × 3¼ in., 11.3 × 8.3 cm
Museo Rosso, Barzio (C 15) (ill. p. 174)
*San Francisco venue*

Cat. 213  Medardo Rosso/Photographer Unknown, *Laughing Woman (La Rieuse)*, after 1890
Vintage photograph, 5¹⁵⁄₁₆ × 3⅝ in., 13.5 × 9.3 cm
Museo Rosso, Barzio (C 18) (ill. p. 174)
*San Francisco venue*

Cat. 214  Medardo Rosso, *Child in the Sun (Bambino al sole)*, c. 1892
Wax over plaster, 13¾ × 9⅜ × 7½ in., 35 × 24 × 19 cm
Private Collection (ill. p. 171)
*Bilbao venue*

Cat. 215  Medardo Rosso/Photographer Unknown, *Child in the Sun (Bambino al sole)*, after 1892
Vintage photograph, 5¾ × 4⅛ in., 14.7 × 10.5 cm
Museo Rosso, Barzio (T 1) (ill. p. 171)
*Bilbao venue*

Cat. 216  Medardo Rosso/Photographer Unknown, *Child in the Sun (Bambino al sole)*, after 1892
Photograph, 7 × 5⅛ in., 17.8 × 12.9 cm
Museo Rosso, Barzio (T 2) (ill. p. 171)
*Bilbao venue*

Cat. 217  Medardo Rosso/Photographer Unknown, *Child in the Sun (Bambino al sole)*, after 1892
Vintage photograph, 6¼ × 4¼ in., 16 × 10.9 cm
Museo Rosso, Barzio (T 3) (ill. p. 171)
*Bilbao venue*

Cat. 218  Medardo Rosso/Photographer Unknown, *Child in the Sun (Bambino al sole)*, after 1892
Vintage photograph, 4⅝ × 2⅞ in., 11.9 × 7.2 cm
Museo Rosso, Barzio (T 4) (ill. p. 171)
*Bilbao venue*

Cat. 219  Medardo Rosso/Photographer Unknown, *Child in the Sun (Bambino al sole)*, after 1892
Vintage photograph, irregular dimensions, c. 3³⁄₁₆ × 1½ in., 8.1 × 3.9 cm
Museo Rosso, Barzio (T 6)
*Bilbao venue*

Cat. 220  Medardo Rosso, *Jewish Child (Bambino Ebreo)*, c. 1892–93 (cast 1900–1914)
Wax over plaster, 8⅝ × 7 × 5⅞ in., 22 × 17.8 × 14.9 cm
The Patsy R. and Raymond D. Nasher Collection (ill. p. 170)
*San Francisco and Dallas venues*

Cat. 221  Medardo Rosso/Photographer Unknown, *Jewish Child (Bambino Ebreo)*, after 1892
Vintage photograph, irregular dimensions, c. 9½ × 6⅛ in., 24 × 15.5 cm
Museo Rosso, Barzio (S 3) (ill. p. 170)
*Dallas venue*

Cat. 222  Medardo Rosso/Photographer Unknown, *Jewish Child (Bambino Ebreo)*, after 1892
Vintage photograph, 4⅛ × 2¼ in., 10.6 × 5.8 cm
Museo Rosso, Barzio (S 8) (ill. p. 170)
*Dallas venue*

Cat. 223 Medardo Rosso/Photographer Unknown, *Jewish Child (Bambino Ebreo),* after 1892
Vintage photograph, 4 × 2⅜ in., 10.1 × 6 cm
Museo Rosso, Barzio (S 10) (ill. p. 170)
*Dallas venue*

Cat. 224 Medardo Rosso, *Impressions on a Boulevard, Lady with a Veil,* 1893
Plaster, 35⅞ × 31½ × 13¾ in., 91 × 80 × 35 cm
Openluchtmuseum voor Beeldhouwkunst Middelheim, Antwerp (ill. p. 163)

Cat. 225 Medardo Rosso/Photographer Unknown, *Impressions on a Boulevard, Lady with a Veil,* after 1893
Vintage photograph, irregular dimensions, c. 4 × 3¼ in., 10.1 × 8.3 cm
Museo Rosso, Barzio (G 11)
*Bilbao venue*

Cat. 226 Medardo Rosso/Photographer Unknown, *Impressions on a Boulevard, Lady with a Veil,* after 1893
Vintage photograph, 5⅝ × 3¾ in., 14.2 × 9.5 cm
Museo Rosso, Barzio (G8)
*Bilbao venue*

Cat. 227 Medardo Rosso/Photographer Unknown, *Impressions on a Boulevard, Lady with a Veil,* after 1893
Vintage photograph, irregular dimensions, c. 3¾ × 3⅛ in., 9.4 × 8 cm
Museo Rosso, Barzio (G 25) (ill. p. 162)
*Bilbao venue*

Cat. 228 Medardo Rosso/Photographer Unknown, *Impressions on a Boulevard, Lady with a Veil,* after 1893
Vintage photograph, 2⅛ × 3⅜ in., 5.3 × 8.7 cm
Museo Rosso, Barzio (G 9)
*Bilbao venue*

Cat. 229 Medardo Rosso, *Bookmaker (also known as "Sportman"),* 1894
Bronze, 17⅜ in., 44 cm in height
Museum Moderner Kunst Stiftung Ludwig, Vienna (ill. p. 173)

Cat. 230 Medardo Rosso/Photographer Unknown, *Bookmaker (also known as "Sportman"),* after 1894
Vintage photograph, 3½ × 2 in., 9 × 5 cm
Museo Rosso, Barzio (D 2) (ill. p. 172)
*Bilbao venue*

Cat. 231 Medardo Rosso/Photographer Unknown, *Bookmaker (also known as "Sportman"),* after 1894
Vintage photograph, 5¾ × 2⅞ in., 14.5 × 7.3 cm
Museo Rosso, Barzio (D 3) (ill. p. 172)
*Bilbao venue*

Cat. 232 Medardo Rosso/Photographer Unknown, *Bookmaker (also known as "Sportman"),* n.d.
Vintage photograph, 5¾ × 3½ in., 14.5 × 8.8 cm
Museo Rosso, Barzio (D 4) (ill. p. 172)
*San Francisco venue*

Cat. 233 Medardo Rosso/Photographer Unknown, *Bookmaker (also known as "Sportman"),* after 1894
Vintage photograph, ½ × 2½ in., 1.4 × 6.5 cm
Museo Rosso, Barzio (D 5) (ill. p. 172)
*Bilbao venue*

Cat. 234 Medardo Rosso/Photographer Unknown, *Bookmaker (also known as "Sportman"),* after 1894
Vintage photograph, irregular dimensions, c. 3⅞ × 2⅛ in., 10 × 5.3 cm
Museo Rosso, Barzio (D 8) (ill. p. 172)
*Bilbao venue*

Cat. 235 Medardo Rosso/Photographer Unknown, *Bookmaker (also known as "Sportman"),* after 1894
Vintage photograph, irregular dimensions, c. 5 × 2½ in., 12.7 × 6.5 cm
Museo Rosso, Barzio (D 9) (ill. p. 172)
*San Francisco venue*

Cat. 236 Medardo Rosso/Photographer Unknown, *Bookmaker (also known as "Sportman"),* after 1894
Vintage photograph, irregular dimensions, c. 5 × 2½ in., 12.7 × 6.5 cm
Museo Rosso, Barzio (D 10) (ill. p. 172)
*San Francisco venue*

Cat. 237 Medardo Rosso/Photographer Unknown, *Bookmaker (also known as "Sportman"),* after 1894
Vintage photograph, 2 × 1⅛ in., 5.1 × 2.9 cm
Museo Rosso, Barzio (D 13) (ill. p. 172)
*San Francisco venue*

Cat. 238 Medardo Rosso/Photographer Unknown, *Bookmaker (also known as "Sportman"),* after 1894
Vintage photograph, 6⅝ × 4 in., 16.8 × 10.3 cm
Museo Rosso, Barzio (D 19) (ill. p. 172)
*Bilbao venue*

## ALPHONSE MUCHA
(1860–1939)

Cat. 239 Anonymous, *Mucha with Auguste Rodin on the Occasion of His Visit to Bohemia and Moravia in Conjunction with Rodin's 1902 Exhibition in Prague,* 1902
Modern print from original glass plate negative
Mucha Trust, © Mucha Trust 1999

Cat. 240 Anonymous, *Mucha and Rodin at Rodin's Exhibition in Prague,* 1902
Modern print from original glass plate negative
Mucha Trust, © Mucha Trust 1999

Cat. 241 Alphonse Mucha, *Annah la Javanaise, Mistress of Paul Gauguin,* rue de la Grande Chaumière, Paris, c. 1894
Vintage print, 7 × 5⅛ in., 17.75 × 13 cm
Mucha Trust, © Mucha Trust 1999 (ill. p. 182)

Cat. 242 Alphonse Mucha, *Paul Gauguin Playing the Harmonium in Mucha's Studio,* rue de la Grande Chaumière, Paris, c. 1895
Modern print from original glass plate negative
Mucha Trust, © Mucha Trust 1999 (ill. p. 182)

Cat. 243 Alphonse Mucha, *The Seasons,* 1896
Color lithograph, 40½ × × 21¼ in., 103 × 54 cm each
Courtesy of Posters Please, Inc., © Mucha Trust 1999

Cat. 244 Alphonse Mucha, *Summer (panel from "The Seasons"),* 1896
Color lithograph, 40½ × 21¼ in., 103 × 54 cm
Courtesy of Posters Please, Inc., © Mucha Trust 1999 (ill. p. 191)

Cat. 245 Alphonse Mucha, *Société Populaire des Beaux-Arts,* 1897
Color lithograph, 24¼ × 18 in., 62.5 × 46 cm
Courtesy of Posters Please, Inc., © Mucha Trust 1999 (ill. p. 178)

Cat. 246 Alphonse Mucha, *Study for Decorative Plate with the Symbol of the Exposition Universelle, 1897,* rue du Val de Grâce, Paris, c. 1897
Modern print from original glass plate negative
Mucha Trust, © Mucha Trust 1999

Cat. 247 Alphonse Mucha, *Study for "Iris" from "The Flowers,"1898,* rue du Val de Grâce, Paris, 1897
Vintage print, 7 × 5⅛ in., 17.75 × 13 cm
Mucha Trust, © Mucha Trust 1999 (ill. p. 186)

Cat. 248 Alphonse Mucha, *All the Works of Mucha,* 1898
Color lithograph, 23¾ × 17¾ cm
Courtesy of Posters Please, Inc., © Mucha Trust 1999

Cat. 249 Alphonse Mucha, *Cover of "Wiener Chic" (January 1905),* 1898
Monochrome lithograph, 14¾ × 10⅞ in., 37.5 × 27.6 cm
Courtesy of Posters Please, Inc., © Mucha Trust 1999 (ill. p. 189)

Cat. 250 Alphonse Mucha, *Flower Study (cornus kousa chinensis),* rue du Val de Grâce, Paris, c. 1898
Modern print from original glass plate negative
Mucha Trust, © Mucha Trust 1999

Cat. 251 Alphonse Mucha, *Model Posing in Mucha's Studio,* rue du Val de Grâce, Paris, c. 1898
Modern print from original glass plate negative
Mucha Trust, © Mucha Trust 1999

Cat. 252 Alphonse Mucha, *Model Posing in Mucha's Studio,* rue du Val de Grâce, Paris, c. 1898
Modern print from original glass plate negative
Mucha Trust, © Mucha Trust 1999

Cat. 253 Alphonse Mucha, *Model Posing in Mucha's Studio,* rue du Val de Grâce, Paris, c. 1898
Modern print from original glass plate negative
Mucha Trust, © Mucha Trust 1999 (ill. p. 183)

Cat. 254 Alphonse Mucha, *Self-Portrait in the Studio,* rue du Val de Grâce, Paris, c. 1898
Modern print from original glass plate negative
Mucha Trust, © Mucha Trust 1999

Cat. 255 Alphonse Mucha, *Violinist,* rue du Val de Grâce, Paris, c. 1898
Modern print from original glass plate negative
Mucha Trust, © Mucha Trust 1999

Cat. 256 Alphonse Mucha, *Le Pater,* 1899
Illustrated book, 13 × 9⅞ in., 33 × 25.1 cm
Courtesy of Posters Please, Inc., © Mucha Trust 1999

Cat. 257 Alphonse Mucha, *Model Posing in Mucha's Studio,* rue du Val de Grâce, Paris, c. 1899
Modern print from original glass plate negative
Mucha Trust, © Mucha Trust 1999 (ill. p. 188)

Cat. 258 Alphonse Mucha, *Model Posing in Mucha's Studio,* rue du Val de Grâce, Paris, c. 1899
Modern print from original glass plate negative
Mucha Trust, © Mucha Trust 1999 (ill. p. 188)

Cat. 259 Alphonse Mucha, *Model Posing in Mucha's Studio,* rue du Val de Grâce, Paris, c. 1899
Modern print from original glass plate negative
Mucha Trust, © Mucha Trust 1999 (ill. p. 183)

Cat. 260 Alphonse Mucha, *Study for the Design for the Menu of the Official Banquet of the Exposition Universelle, Paris, 1900,* rue du Val de Grâce, Paris, c. 1899
Vintage print, 4¾ × 3⅜ in., 12 × 9 cm
Mucha Trust, © Mucha Trust 1999

Cat. 261 Alphonse Mucha, *Study for the Design for the Menu of the Official Banquet of the Exposition Universelle, Paris, 1900* (later adapted for Plate 1 of *Documents Décoratifs* [1902] and the cover of *Paris Illustré* [December 1903]), rue du Val de Grâce, Paris, c. 1899
Vintage print, 4¾ × 3⅜ in., 12 × 9 cm
Mucha Trust, © Mucha Trust 1999 (ill. p. 190)

Cat. 262 Alphonse Mucha, *Cover of "Cloches de Noël et de Pâques" by Emile Gebhart,* 1900
Lithograph, 11¾ × 8⅝ in., 30 × 22 cm
Courtesy of Posters Please, Inc., © Mucha Trust 1999

Cat. 263 Alphonse Mucha, *Self-Portrait,* c. 1900
Vintage print, 17¾ × 13 in., 45.1 × 33 cm
Collection of Jack Rennert (No. 29), © Mucha Trust 1999

Cat. 264 Alphonse Mucha, *Self-Portrait in the Studio,* rue du Val de Grâce, Paris, c. 1900
Modern print from original glass plate negative
Mucha Trust, © Mucha Trust 1999

Cat. 265 Alphonse Mucha, *Study for "Cloches de Noël et de Pâques,"* rue du Val de Grâce, Paris, c. 1900
Vintage print retouched with pen and ink, 3⅜ × 4¾ in., 9 × 12 cm
Mucha Trust, © Mucha Trust 1999

Cat. 266 Alphonse Mucha, *Study for "Cloches de Noël et de Pâques,"* rue du Val de Grâce, Paris, c. 1900
Vintage print retouched with pen and ink, 4¾ × 3⅜ in., 12 × 9 cm
Mucha Trust, © Mucha Trust 1999

Cat. 267 Alphonse Mucha, *Study for "The Morning Star" from "The Moon and Stars,"* rue du Val de Grâce, Paris, c. 1901
Vintage print, 7 × 5⅛ in., 17.75 × 13 cm
Mucha Trust, © Mucha Trust 1999

Cat. 268 Alphonse Mucha, *Cover plate for "Documents Décoratifs,"* 1902
Lithograph, 18⅛ × 13 in., 46 × 33 cm
Courtesy of Posters Please, Inc., © Mucha Trust 1999 (ill. p. 190)

Cat. 269 Alphonse Mucha, *Model Posing in Mucha's Studio,* rue du Val de Grâce, Paris, c. 1902
Modern print from original glass plate negative
Mucha Trust, © Mucha Trust 1999 (ill. p. 183)

Cat. 270 Alphonse Mucha, *Model Posing in Mucha's Studio,* rue du Val de Grâce, Paris, c. 1902
Modern print from original glass plate negative
Mucha Trust, © Mucha Trust 1999

Cat. 271 Alphonse Mucha, *Cover of "L'Habitation Pratique" (April 1910),* 1903
Lithograph, 13½ × 12½ in., 34.3 × 31.8 cm
Courtesy of Posters Please, Inc., © Mucha Trust 1999 (ill. p. 188)

Cat. 272 Alphonse Mucha, *Study for "The Madonna of the Lilies" (1905),* Paris, c. 1903
Modern print from original glass plate negative
Mucha Trust, © Mucha Trust 1999

Cat. 273 Alphonse Mucha, *Study for "The Madonna of the Lilies" (1905),* Paris, c. 1903
Modern print from original glass plate negative
Mucha Trust, © Mucha Trust 1999

Cat. 274 Alphonse Mucha, *Mucha's New York Studio,* 1904
Vintage print, 17¾ × 13 in., 45.1 × 33 cm
Collection of Jack Rennert (No. 51), © Mucha Trust 1999 (ill. p. 182)

Cat. 275 Alphonse Mucha, *Figures Décoratives,* 1905
Set of 40 lithographs, 18½ × 13¼ in., 47 × 33.7 cm
The Fine Arts Library, University of Texas at Austin, © Mucha Trust 1999

Cat. 276 Alphonse Mucha, *Study for Maude Adams in the Role of Joan of Arc,* New York, c. 1907
Modern print from original glass plate negative
Mucha Trust, © Mucha Trust 1999

Cat. 277 Alphonse Mucha, *Self-Portrait with Easel in Front of "Comedy,"* New York, 1908
Modern print from original glass plate negative
Mucha Trust, © Mucha Trust 1999 (ill. p. 176)

Cat. 278 Alphonse Mucha, *Study for the German Theatre in New York,* New York, 1908
Modern print from original glass plate negative
Mucha Trust, © Mucha Trust 1999

Cat. 279 Alphonse Mucha, *Princess Hyacinth,* 1911
Color lithograph, 49½ × 32⅞ in., 125.5 × 83.5 cm
Courtesy of Posters Please, Inc., © Mucha Trust 1999 (ill. p. 187)

Cat. 280 Alphonse Mucha, *Study for the Slav Epic canvas "The Slavs in Their Original Homeland" 1911,* Zbiroh Castle, Bohemia, 1911
Modern print from original glass plate negative
Mucha Trust, © Mucha Trust 1999

Cat. 281 Alphonse Mucha, *Model Posing in Mucha's Studio,* Prague, c. 1911
Modern print from original glass plate negative
Mucha Trust, © Mucha Trust 1999

Cat. 282 Alphonse Mucha, *Study (possibly for "Slav Epic"),* Zbiroh, c. 1912
Modern print from original glass plate negative
Mucha Trust, © Mucha Trust 1999

Cat. 283 Alphonse Mucha, *Family Group, Red Square,* Moscow, 1913
Modern print from original glass plate negative
Mucha Trust, © Mucha Trust 1999 (ill. p. 181)

Cat. 284 Alphonse Mucha, *Family Group, Red Square,* Moscow, 1913
Modern print from original glass plate negative
Mucha Trust, © Mucha Trust 1999

Cat. 285 Alphonse Mucha, *Horse and Cart,* Moscow, 1913
Modern print from original glass plate negative
Mucha Trust, © Mucha Trust 1999

Cat. 286 Alphonse Mucha, *Man and Boy, Red Square,* Moscow, 1913
Modern print from original glass plate negative
Mucha Trust, © Mucha Trust 1999 (ill. p. 181)

Cat. 287 Alphonse Mucha, *Red Square,* Moscow, 1913
Modern print from original glass plate negative
Mucha Trust, © Mucha Trust 1999

Cat. 288 Alphonse Mucha, *Red Square,* Moscow, 1913
Vintage print on card, retouched with pen and ink, 2¾ × 4 in., 7 × 10 cm (print)
Mucha Trust, © Mucha Trust 1999 (ill. p. 181)

Cat. 289 Alphonse Mucha, *Three Men in Red Square,* Moscow, 1913
Modern print from original glass plate negative
Mucha Trust, © Mucha Trust 1999 (ill. p. 181)

Cat. 290 Alphonse Mucha, *Woman Carrying a Bundle, Red Square,* Moscow, 1913
Modern print from original negative
Mucha Trust, © Mucha Trust 1999

Cat. 291 Alphonse Mucha, *Woman with a Basket, Man and Boy in the Background, Red Square,* Moscow, 1913
Modern print from original glass plate negative
Mucha Trust, © Mucha Trust 1999

Cat. 292 Alphonse Mucha, *Zdenka Cerný,* 1913
Color lithograph, 74½ × 43⅜ in., 189 × 110 cm
Courtesy of Posters Please, Inc., © Mucha Trust 1999 (ill. p. 180)

Cat. 293 Alphonse Mucha, *Zdenka Cerný. Study for the Poster,* Chicago, 1913
Vintage print retouched with pencil and ink, 5⅛ × 7 in., 13 × 17.75 cm
Mucha Trust, © Mucha Trust 1999 (ill. p. 180)

Cat. 294 Alphonse Mucha, *Study for 50 Crown Banknote of the Republic of Czechoslovakia,* Prague, 1919
Modern print from original glass plate negative
Mucha Trust, © Mucha Trust 1999 (ill. p. 183)

Cat. 295 Alphonse Mucha, *Study (possibly for "Slav Epic"),* Zbiroh, c. 1920
Modern print from original glass plate negative
Mucha Trust, © Mucha Trust 1999

Cat. 296 Alphonse Mucha, *The Artist's Son and Daughter, Jirí and Jaroslava. Study for the Cover of "Hearst's International" (January 1922),* New York, 1921
Vintage print retouched with pen and ink, 7 × 5⅛ in., 17.75 × 13 cm
Mucha Trust, © Mucha Trust 1999 (ill. p. 185)

Cat. 297 Alphonse Mucha, *Study for "Russia Restituenda" (1922),* Prague, c. 1921
Vintage print, 7 × 5⅛ in., 17.75 × 13 cm
Mucha Trust, © Mucha Trust 1999 (ill. p. 192)

Cat. 298 Alphonse Mucha, *Russia Restituenda,* 1922
Color lithograph, 31⅜ × 18 in., 79.7 × 45.7 cm
Courtesy of Posters Please, Inc., © Mucha Trust 1999 (ill. p. 193)

Cat. 299 Alphonse Mucha, *Study for the Slav Epic Canvas "Apotheosis of the Slavs, 1926,"* Prague, c. 1924
Modern print from original glass plate negative
Mucha Trust, © Mucha Trust 1999 (ill. p. 185)

Cat. 300 Alphonse Mucha, *Study for the Slav Epic Canvas "The Coronation of the Serbian Tsar Štephán Dušan as East Roman Emperor, 1926,"* Zbiroh, Bohemia, c. 1924
Modern print from original glass plate negative
Mucha Trust, © Mucha Trust 1999

Cat. 301 Alphonse Mucha, *Mucha and His Daughter, Jaroslava, Posing for the Poster "DeForest Phonofilm, 1927,"* Prague, c. 1926
Modern print from original glass plate negative
Mucha Trust, © Mucha Trust 1999 (ill. p. 192)

Cat. 302 Alphonse Mucha, *The Artist's Daughter, Jaroslava, as Model for the Poster Announcing the Opening of the Slav Epic,* 1927
Vintage print
Collection of Jack Rennert (No. 93), © Mucha Trust 1999 (ill. p. 184)

Cat. 303 Alphonse Mucha, *DeForest Phonofilm,* 1927
Color lithograph, 60½ × 30 in., 153.5 × 76 cm
Courtesy of Posters Please, Inc., © Mucha Trust 1999 (ill. p. 192)

Cat. 304 Alphonse Mucha, *The Slav Epic,* 1928
Color lithograph, 72¼ × 31⅞ in., 183.6 × 81.2 cm
Courtesy of Posters Please, Inc., © Mucha Trust 1999 (ill. p. 184)

Cat. 305 Alphonse Mucha, *Study for a Window in St. Vitus Cathedral,* Prague, 1931
Modern print from original glass plate negative
Mucha Trust, © Mucha Trust 1999

Cat. 306 Alphonse Mucha, *Self-Portrait,* ca. 1937
Vintage print, 17¾ × 13 in., 45.1 × 33 cm
Courtesy of Posters Please, Inc. (#96), © Mucha Trust 1999

## EDVARD MUNCH
(1863–1944)

Cat. 307  L. Forbech, *Eva Mudocci with her "Emiliano d'Oro,"* c. 1902
Gelatin print, 6⅛ × 3¼ in., 15.5 × 8.2 cm
Munch-museet, Oslo (ill. p. 196)
*Bilbao venue*

Cat. 308  Edvard Munch, *Man's Head Surrounded by Woman's Hair,* 1896
Hand-colored lithograph, 15 × 17½ in., 38 × 44.4 cm
Munch-museet, Oslo
*San Francisco and Bilbao venues*

Cat. 309  Edvard Munch, *Poster for Ibsen of "John Gabriel Borkman" in Théâtre de l'Oeuvre, Paris,* 1897
Lithograph, 10¼ × 14 in., 26 × 35.5 cm
Munch-museet, Oslo
*San Francisco and Bilbao venues*

Cat. 310  Edvard Munch, *Model in Munch's Studio, Berlin, Version I,* 1902
Collodion print, 3⅜ × 3¼ in., 8.5 × 8.4 cm
Munch-museet, Oslo (ill. p. 209)
*Bilbao venue*

Cat. 311  Edvard Munch, *Model in Munch's Studio, Berlin, Version II,* 1902
Collodion print, 3⅝ × 3½ in., 9 × 8.8 cm
Munch-museet, Oslo (ill. p. 209)
*Bilbao venue*

Cat. 312  Edvard Munch, *Nude with Long Red Hair,* 1902
Oil on canvas, 47¼ × 19⅝ in., 120 × 50 cm
Munch-museet, Oslo (ill. p. 209)

Cat. 313  Edvard Munch, *The Violin Concert,* 1903
Lithograph, 18⅝ × 21½ in., 47.3 × 54.5 cm
Munch-museet, Oslo (ill. p. 196)

Cat. 314  Edvard Munch, *Nude Self-Portrait at Åsgårdstrand,* 1903
Gelatin print, 3¼ × 3⅝ in., 8.2 × 9.2 cm
Munch-museet, Oslo (ill. p. 207)
*Bilbao venue*

Cat. 315  Edvard Munch, *Bathing Men,* 1904
Oil on canvas, 76⅜ × 114⅛ in., 194 × 290 cm
Munch-museet, Oslo (ill. p. 207)

Cat. 316  Edvard Munch, *Nude Self-Portrait, Half-Length,* probably 1904
Collodion print, 3⅜ × 3⅜ in., 8.7 × 8.7 cm
Munch-museet, Oslo
*Bilbao venue*

Cat. 317  Edvard Munch, *Study for "Portrait of Friedrich Nietzsche,"* 1905
Crayon and charcoal on cardboard, 28¾ × 39¾ in., 73 × 101 cm
Munch-museet, Olso (ill. p. 198)

Cat. 318  Edvard Munch, *Friedrich Nietzsche,* 1905–6
Oil and tempera on canvas, 78¾ × 51⅛ in., 200 × 130 cm
Munch-museet, Oslo (ill. p. 198)

Cat. 319  Edvard Munch, *Elisabeth Förster-Nietzsche,* 1906
Oil on canvas, 64½ × 39¾ in., 164 × 101 cm
Munch-museet, Oslo (ill. p. 199)

Cat. 320  Edvard Munch, *Self-Portrait in a Room on the Continent I,* probably 1906
Gelatin print, 3½ × 3½ in., 9 × 9 cm
Munch-museet, Oslo (ill. p. 201)
*Bilbao venue*

Cat. 321  Edvard Munch, *Self-Portrait in a Room on the Continent II,* probably 1906
Gelatin print, 3¼ × 3⅜ in., 8.3 × 8.7 cm
Munch-museet, Oslo
*Bilbao venue*

Cat. 322  Edvard Munch, *Self-Portrait Sitting on a Trunk I,* c. 1906
Gelatin print, 3½ × 3¾ in., 8.9 × 9.5 cm
Munch-museet, Oslo (ill. p. 201)
*Bilbao venue*

Cat. 323  Edvard Munch, *Self-Portrait Sitting on a Trunk II,* c. 1906
Gelatin print, 3¼ × 3⅛ in., 8.3 × 8.1 cm
Munch-museet, Oslo
*Bilbao venue*

Cat. 324  Edvard Munch, *Portrait of Rosa Meissner in the Waremünde Studio (Weeping Girl),* 1907
Tinted gelatin print, 3⅜ × 2⅞ in., 8.7 × 7.3 cm
Munch-museet, Oslo (ill. p. 202)
*Bilbao venue*

Cat. 325  Edvard Munch, *Weeping Girl,* 1907
Oil on canvas, 47⅝ × 46⅞ in., 121 × 119 cm
Munch-museet, Oslo (ill. p. 203)
*Bilbao venue*

Cat. 326  Edvard Munch, *Weeping Girl,* 1909
Oil on canvas, 34⅞ × 28⅜ in., 88.5 × 72 cm
Westfälisches Landesmuseum für Kunst und Kulturgeschichte, Münster (ill. p. 202)

Cat. 327  Edvard Munch, *Female Nude (Anna),* 1920
Oil on canvas, 59⅛ × 41½ in., 150.2 × 105.4 cm
Sarah Campbell Blaffer Foundation, Houston (ill. p. 208)

Cat. 328  Edvard Munch, *Self-Portrait Before "Marat's Death" IV,* 1930
Gelatin print, 4⅛ × 3⅛ in., 10.5 × 7.8 cm
Munch-museet, Oslo
*Bilbao venue*

Cat. 328a  Edvard Munch, *Self Portrait in Profile in Front of "Youth on Beach" and Watercolors, made during eye disorders,* 1930
Gelatin print, 4⅜ × 3¼ in., 11.1 × 8.2 cm
Munch-museet, Oslo (ill. p. 210)

Cat. 328b  Edvard Munch, *Self Portrait with Glasses in Front of Two Watercolors,* 1930
Gelatin print, 4⅛ × 3⅛ in., 10.5 × 8 cm
Munch-museet, Oslo (ill. p. 194)

Cat. 329  Harald Patz, *Eva Mudocci and Bella Edwards,* 1902
Gelatin print, 17½ × 11¾ in., 44.5 × 30 cm
Munch-museet, Oslo (ill. p. 196)
*Bilbao venue*

Cat. 330  Unknown, *Elisabeth Förster-Nietzsche,* c. 1905
Collodion print, 5⅞ × 4 in., 14.8 × 10.2 cm
Munch-museet, Oslo (ill. p. 199)
*Bilbao venue*

## FRANZ VON STUCK
(1863–1928)

Cat. 331  Anonymous, *Study for "Kreuzigung Christi"* c. 1913
Modern print from original negative, 7⅛ × 5⅛ in., 18 × 13 cm
Fotomuseum im Münchner Stadtmuseum (Inv. 96/8-3) (ill. p. 221)

Cat. 332  Adolf Baumann, *Franz and Mary von Stuck in Roman Costume at the Künstlerfest "In Arcadia,"* 1898?
Gelatin silver print, 5⅞ × 4⅝ in., 14.8 × 11.9 cm
Nachlaß Franz von Stuck Privatbesitz (ill. p. 216)

Cat. 333  Edward Steichen, *Portrait of Franz von Stuck with the Spear-Throwing Amazon,* c. 1901
Platinum print, 6 × 8 in., 15.3 × 20.2 cm
Nachlaß Franz von Stuck Privatbesitz (ill. p. 212)

Cat. 334  Franz von Stuck, *Study for "The Guardian of Paradise,"* c. 1889
Albumen print, 9⅜ × 6¼ in., 24 × 16 cm
Münchner Stadtmuseum, Graphik- und Plakatsammlung (ill. p. 215)
*Dallas venue*

Cat. 335  Franz von Stuck, *Guardian of Paradise,* 1889
Oil on canvas, 98⅝ × 66 in., 250.5 × 167.5 cm
Museum Villa Stuck, Munich, Gift of Hans Joachim Ziersch (Inv. G91 1-2) (ill. p. 214)
*San Francisco and Dallas venues*

Cat. 336  Franz von Stuck, *Poster for International Art Exhibition,* 1893
Lithograph on paper, 38¼ × 27½ in., 97.2 × 70 cm
Münchner Stadtmuseum, Graphik- und Plakatsammlung (Inv. B1/75)

Cat. 337  Franz von Stuck, *Amazon,* 1897
Bronze, 14⅛ in., 36 cm
Private Collection (ill. p. 212)

Cat. 338  Franz von Stuck, *Poster for the 7th International Art Exhibition in the Glass Palace,* 1897
Lithograph on paper, 28¼ × 39⅜ in., 71.7 × 100 cm
Münchner Stadtmuseum, Graphik- und Plakatsammlung (Inv. B1/29)

Cat. 339  Franz von Stuck, *Study for "Franz and Mary von Stuck in the Artist's Studio" (Franz),* February 1902
Gelatin silver print, 6⅛ × 3⅞ in., 15.7 × 10 cm
Münchner Stadtmuseum, Graphik- und Plakatsammlung (Inv. G70/318/34B) (ill. p. 217)
*Dallas venue*

Cat. 340  Franz von Stuck, *Study for "Franz and Mary von Stuck in the Artist's Studio" (Mary),* February 1902
Set of 4 gelatin silver prints on matting, 4⅛ × 3⅛ in., 10.5 × 8 cm; 4⅛ × 3¼ in., 10.5 × 8.2 cm; 6⅝ × 4¼ in., 17 × 10.7 cm; 6½ × 3⅞ in., 16.4 × 9.7 cm (Mat = 11¼ × 8⅝ in., 28.5 × 22 cm)
Münchner Stadtmuseum, Graphik- und Plakatsammlung (Inv. G70/318/74-77C) (ill. p. 217)
*Dallas venue*

Cat. 341  Attributed to Mary or Franz von Stuck, *Mary in Velázquez Costume,* 1908
Gelatin silver print, 11⅝ × 15¾ in., 29.5 × 40 cm
Museum Villa Stuck, Munich, Gift of Hans Joachim Ziersch (Ph-P-94/797-40) (ill. p. 219)
*Dallas venue*

Cat. 342  Attributed to Mary or Franz von Stuck, *Mary as a Greek,* 1910
Gelatin silver print, 15¾ × 11¾ in., 40 × 30 cm
Museum Villa Stuck, Munich, Gift of Hans Joachim Ziersch (Ph-P-94/797-24) (ill. p. 219)
*Dallas venue*

Cat. 343  Attributed to Mary or Franz von Stuck, *Mary as a Greek,* 1910
Gelatin silver print, 15⅝ × 11⅝ in., 39.8 × 29.6 cm
Museum Villa Stuck, Munich, Gift of Hans Joachim Ziersch (Ph-P-94/797-33) (ill. p. 219)
*Dallas venue*

Cat. 344  Attributed to Mary or Franz von Stuck, *Mary as a Greek,* 1910
Gelatin silver print, 6¼ × 4⅜ in., 15.8 × 11.2 cm
Nachlaß Franz von Stuck Privatbesitz

Cat. 345  Attributed to Mary or Franz von Stuck, *Study for "Tilla Durieux as Circe,"* c. 1912–13
Gelatin silver print, 15½ × 11⅝ in., 39.5 × 29.5 cm
Museum Villa Stuck, Munich, Gift of Hans Joachim Ziersch (Ph-P-94/797-41) (ill. p. 219)
*Dallas venue*

Cat. 346  Franz von Stuck, *Tilla Durieux as Circe,* c. 1912–13
Mixed media on paper, 21¹/₁₆ × 18¼ in., 53.5 × 46.5 cm
Private Collection (ill. p. 218)

Cat. 347  Franz von Stuck, *Crucifixion of Christ (Kreuzigung Christi),* 1913
Distemper on canvas, 74¾ × 65 in., 190 × 165 cm
Museum der bildenden Künste, Leipzig, Germany (ill. p. 220)

Cat. 348 Attributed to Mary or Franz von Stuck, *Mary with a Dark Hat*, 1915
Gelatin silver print, 2⅞ × 1⅞ in., 58 × 44 cm
Museum Villa Stuck, Munich, Gift of Hans Joachim Ziersch (Ph-P-94/797-41) (ill. p. 222)
*Dallas venue*

Cat. 349 Franz von Stuck, *Mary in a Red Chair*, 1916
Oil on canvas, 42⅛ × 36¾ in., 107 × 93.5 cm
Nachlaß Franz von Stuck Privatbesitz (ill. p. 222)

Cat. 350 Franz von Stuck, *Sisyphus*, 1920
Oil on canvas, 40½ × 35 in., 103 × 89 cm
Katharina Büttiker Collection, Galerie Wühre 9—Art Deco–Zürich, Switzerland (ill. p. 8)

## FÉLIX VALLOTTON
(1865–1925)

*Cat. 351 Félix Vallotton, *Gabrielle in a Nightgown Standing before an Open Cupboard*, n.d.
Modern facsimile, 3½ × 4¾ in., 9 × 12 cm
Archives Jacques Rodrigues-Henriques

*Cat. 352 Félix Vallotton, *The Old Port of Honfleur at Low Tide*, n.d.
Modern facsimile, 3½ × 3½ in., 9 × 9 cm
Archives Jacques Rodrigues-Henriques (ill. p. 234)

Cat. 353 Félix Vallotton, *Portrait of Gabrielle Vallotton Seated in a Rocking Chair*, c. 1900
Oil on board laid on panel, 17¾ × 25⅝ in., 45 × 65 cm
Collection Josefowitz (ill. p. 226)
*San Francisco and Dallas venues*

*Cat. 354 Félix Vallotton, *Gabrielle Vallotton Seated before a Fireplace*, 1899
Modern facsimile, 3½ × 3½ in., 9 × 9 cm
Archives Jacques Rodrigues-Henriques (ill. p. 230)

Cat. 355 Félix Vallotton, *Madame Vallotton and Her Niece Germaine Aghion*, 1899
Oil on cardboard, 19⅜ × 20¼ in., 49.2 × 51.3 cm
The Art Institute of Chicago, bequest of Mrs. Clive Runnells, 1977.606 (ill. p. 231)

Cat. 356 Félix Vallotton, *Madame Vallotton at Her Dressing Table*, 1899
Tempera on cardboard, 22⅝ × 30¾ in., 57.5 × 78 cm
Kunsthaus Zurich (ill. p. 229)

*Cat. 357 Félix Vallotton, *Gabrielle Vallotton Knitting in a Rocking Chair*, c. 1899–1902
Modern facsimile, 3½ × 3½ in., 9 × 9 cm
Archives Jacques Rodrigues-Henriques (ill. p. 228)

Cat. 358 Félix Vallotton, *The Laundry Woman, The Blue Room (La Lingère, Chambre bleue)*, 1900
Tempera on board laid on canvas, 19⅝ × 31½ in., 49.9 × 80 cm
Dallas Museum of Art, Foundation for the Arts Collection, Mrs. John B. O'Hara Fund in honor of Mrs. Alfred L. Bromberg (1996.48.FA) (ill. p. 224)

*Cat. 359 Félix Vallotton, *Gabrielle Vallotton Manicuring Her Nails*, 1901
Modern facsimile, 3½ × 4¾ in., 9 × 12 cm
Archives Jacques Rodrigues-Henriques (ill. p. 229)

Cat. 360 Félix Vallotton, *Summer (Bathers in Repose)*, 1912
Oil on canvas, 79⅛ × 98⅝ in., 201 × 250.5 cm
Musée cantonal des Beaux-Arts de Lausanne, Switzerland (ill. p. 232)

Cat. 361 Félix Vallotton, *Boats in the Port of Honfleur, Evening Effect*, 1913
Oil on canvas, 28¾ × 21¼ in., 73 × 54 cm
Private Collection, Switzerland (ill. p. 234)

## PIERRE BONNARD
(1867–1947)

Cat. 362 Pierre Bonnard, *Self-Portrait*, c. 1889
Oil on board, 8⅜ × 6¼ in., 21.3 × 15.9 cm
Private Collection (ill. p. 247)

Cat. 363 Pierre Bonnard, *The Family Dog Approaches the Camera while the Terrasse Children Look On*, 1898, Noisy-le-Grand
Modern print from original negative, 11¼ × 15⅜ in., 28.5 × 39 cm
Musée d'Orsay, Paris (Pho. 1987-30-18) (ill. p. 262)

Cat. 364 Pierre Bonnard, *Jean and Charles Dancing: Behind Them Is Andrée Terrasse and on the Far Right Is Madame Eugène Bonnard*, 1898, Noisy-le-Grand
Vintage print on albumen paper, 1½ × 2 in., 3.8 × 5 cm
Musée d'Orsay, Paris (Pho. 1987-31-3)
*Dallas venue*

Cat. 365 Pierre Bonnard, *Madame Mertzdorff and, from Front to Back, Robert, Renée, Jean, and Charles Terrasse*, 1898, Noisy-le-Grand
Modern print from original negative, 12⅝ × 9⅞ in., 32 × 25 cm
Musée d'Orsay, Paris (Pho. 1987-30-9)

Cat. 366 Pierre Bonnard, *Madame Mertzdorff, Andrée and Jean Terrasse*, 1898, Noisy-le-Grand
Modern print from original negative, 9½ × 12⅝ in., 24 × 32 cm
Musée d'Orsay, Paris (Pho. 1987-30-5)

Cat. 367 Pierre Bonnard, *Renée (?) Hugging a Dog*, 1898, Noisy-le-Grand
Modern print from original negative, 11¼ × 15⅛ in., 28.5 × 38.5 cm
Musée d'Orsay, Paris (Pho. 1987-30-4) (ill. p. 262)

Cat. 368 Pierre Bonnard, *Robert Terrasse*, 1898, Noisy-le-Grand
Modern print from original negative, 9½ × 12⅝ in., 24 × 32 cm
Musée d'Orsay, Paris (Pho. 1987-30-16) (ill. p. 257)

Cat. 369 Pierre Bonnard, *Madame Mertzdorff and Robert Terrasse*, 1898–99, Noisy-le-Grand
Modern print from original negative, 7⅛ × 9½ in., 18 × 24 cm
Musée d'Orsay, Paris (Pho. 1987-30-22)

Cat. 370 Pierre Bonnard, *Madame Mertzdorff Holding Vivette Terrasse, Charles Bonnard, and Robert and Renée Terrasse in the Background*, 1898–99, Noisy-le-Grand
Modern print from original negative
Musée d'Orsay, Paris (Pho. 1987-30-23)

Cat. 371 Pierre Bonnard, *Andrée Terrasse Drying Charles, Who Executes a Dance Movement*, summer 1899, Grand-Lemps
Vintage print on albumen paper, 1½ × 2 in., 3.9 × 5 cm
Musée d'Orsay, Paris (Pho. 1987-28-14) (ill. p. 238)

Cat. 372 Pierre Bonnard, *Charles, Jean, and Andrée Terrasse*, summer 1899, Grand-Lemps
Modern print from original negative
Musée d'Orsay, Paris (Pho. 1987-27-1) (ill. p. 245)

Cat. 373 Pierre Bonnard, *Charles, Robert, Jean, Andrée, and Claude Terrasse*, summer 1899, Grand-Lemps
Modern print from original negative
Musée d'Orsay, Paris (Pho. 1987-27-2) (ill. p. 244)

Cat. 374 Pierre Bonnard, *Charles Terrasse and His Nursemaid (Cropped)*, summer 1899, Grand-Lemps
Vintage print on albumen paper, 1½ × 2 in., 3.9 × 5.1 cm
Musée d'Orsay, Paris (Pho. 1987-28-12)
*Dallas venue*

Cat. 375 Pierre Bonnard, *Pierre Bonnard by the Side of the Pool Playing with Renée, while a Nursemaid Holds Robert, and Charles and Jean Terrasse Sit in the Pool (Andrée Terrasse Is Cropped at the Left)*, summer 1899, Grand-Lemps
Vintage print on albumen paper, 2¼ × 3 in., 5.6 × 7.7 cm
Musée d'Orsay, Paris (Pho. 1987-28-54) (ill. p. 245)

Cat. 376 Pierre Bonnard, *Ker-Xavier Roussel and Edouard Vuillard, Who Is Taking Bonnard's Photograph; in the Background Is Saint Mark's Basilica*, 1899, Venice
Modern print from original negative
Musée d'Orsay, Paris (Pho. 1987-27-5)

Cat. 377 Pierre Bonnard, *Ker-Xavier Roussel and Edouard Vuillard, Who Is Taking Bonnard's Photograph; in the Background Is the Doges Palace*, 1899, Venice
Modern print from original negative
Musée d'Orsay, Paris (Pho. 1987-27-6)

Cat. 378 Pierre Bonnard, *L'Indolente*, c. 1899
Oil on canvas, 37⅞ × 41⅜ in., 96 × 105 cm
Private Collection (ill. p. 236)
*San Francisco and Dallas venues*

Cat. 379 Pierre Bonnard, *Marthe Lying on Her Left Side, Seen from the Back*, 1899–1900, Paris
Vintage print from original negative on albumen paper, 1½ × 2 in., 3.8 × 5.1 cm
Musée d'Orsay, Paris (Pho. 1987-31-26)

Cat. 380 Pierre Bonnard, *Marthe Lying on Her Back, with Her Left Leg Bent*, 1899–1900, Paris
Vintage print on albumen paper, 1½ × 2 in., 3.8 × 5.1 cm
Musée d'Orsay, Paris (Pho. 1987-31-28) (ill. p. 236)
*Dallas venue*

Cat. 381 Pierre Bonnard, *Marthe Lying on Her Back, with Her Face Hidden by a Table*, 1899–1900
Vintage print on albumen paper, 1½ × 2 in., 3.8 × 5.1 cm
Musée d'Orsay, Paris (Pho. 1987-31-29)

Cat. 382 Pierre Bonnard, *Edouard Vuillard Holding His Kodak*, spring 1900, Grand-Lemps
Modern print from original negative
Musée d'Orsay, Paris (Pho. 1987-27-15)

Cat. 383 Pierre Bonnard, *Edouard Vuillard with His Kodak and Renée*, spring 1900, Grand-Lemps
Modern print from original negative
Musée d'Orsay, Paris (Pho. 1987-27-16)

Cat. 384 Pierre Bonnard, *Madame Mertzdorff, Renée, and, at the Far Right, Ker-Xavier Roussel*, spring 1900, Grand-Lemps
Modern print from original negative
Musée d'Orsay, Paris (Pho. 1987-30-27)

Cat. 385 Pierre Bonnard, *Renée Looking at Edouard Vuillard*, spring 1900, Grand-Lemps
Modern print from original negative
Musée d'Orsay, Paris (Pho. 1987-27-18) (ill. p. 262)

Cat. 386 Pierre Bonnard, *Renée Looking at Pierre Bonnard*, spring 1900, Grand-Lemps
Modern print from original negative
Musée d'Orsay, Paris (Pho. 1987-27-17) (ill. p. 262)

Cat. 387 Pierre Bonnard, *Illustration for Paul Verlaine's "Parallèlement,"* 1900
Book, 11¾ × 10⅛ × 1¼ in., 29.9 × 25.7 × 3.2 cm
Special Collections, Dallas Public Library (ill. p. 243)

Cat. 388 Pierre Bonnard, *Marthe Standing, Viewed from the Side*, 1900–1901, Montval
Vintage print on albumen paper, 1½ × 2⅛ in., 3.9 × 5.4 cm
Musée d'Orsay, Paris (Pho. 1987-31-32) (ill. p. 238)

Cat. 389 Pierre Bonnard, *Photograph Taken by: Pierre Bonnard Seated in Profile,* 1900–1901, Montval
Modern print from original negative
Musée d'Orsay, Paris (Pho. 1987-30-43)

Cat. 390 Pierre Bonnard, *Photograph Taken by Marthe: Pierre Bonnard Viewed from the Back,* 1900–1901, Montval
Modern print from original negative
Musée d'Orsay, Paris (Pho. 1987-30-44) (ill. p. 243)

Cat. 391 Pierre Bonnard, *Chloe Bathing, from "Daphnis and Chloe,"* 1902
Lithograph, 15 × 13 in., 38.1 × 33 cm (mat size)
Lent by The Metropolitan Museum of Art, Purchase, Edward Powis Jones Gift, 1988 (ill. p. 242)

Cat. 392 Pierre Bonnard, *Bathing: Vivette (on the Right) in the Pool with a Nursemaid and Other Children,* 1903–5, Grand-Lemps
Modern print from original negative
Musée d'Orsay, Paris (Pho. 1987-27-49) (ill. p. 240)

Cat. 393 Pierre Bonnard, *Bathing: Vivette (in the Foreground) with Robert and Two Other Children,* 1903–5, Grand-Lemps
Modern print from original negative
Musée d'Orsay, Paris (Pho. 1987-27-50) (ill. p. 240)

Cat. 394 Pierre Bonnard, *Marthe Bathing,* 1907–10, Médan or Villènnes
Modern print from original negative
Musée d'Orsay, Paris (Pho. 1987-30-47)

Cat. 395 Pierre Bonnard, *Bathers in a Park,* c. 1908
Oil on canvas, 26 × 28½ in., 66 × 72.4 cm (oval)
Sarah Campbell Blaffer Foundation, Houston (ill. p. 244)

Cat. 396 Pierre Bonnard, *Self-Portrait with Beard (Portrait de l'artiste),* c. 1916–20
Oil on canvas, 11⅜ × 18 in., 29.5 × 45.7 cm
Private Collection (ill. p. 246)
*Dallas and San Francisco venues*

## EDOUARD VUILLARD
(1868–1940)

Cat. 397 Edouard Vuillard, *Amfréville: View from a Window,* n.d.
Vintage print, 3½ × 3½ in., 8.9 × 9 cm
Archives Salomon, Paris (ill. p. 263)
*Dallas venue*

Cat. 398 Edouard Vuillard, *Annette Roussel,* n.d.
Modern print from original negative
Archives Salomon, Paris (ill. p. 260)

Cat. 399 Edouard Vuillard, *At Villeneuve-sur-Yonne: Misia Natanson by an Open Door,* n.d.
Vintage print, 3½ × 3½ in., 8.8 × 8.9 cm
Archives Salomon, Paris
*Dallas venue*

Cat. 400 Edouard Vuillard, *The Vuillard Family at the Table,* n.d.
Vintage print, 3¼ × 3⅜ in., 8.3 × 8.6 cm
Archives Salomon, Paris (ill. p. 252)
*Dallas venue*

Cat. 401 Edouard Vuillard, *The First Steps (Les Premiers Pas),* late 1890
Oil on canvas, 20⅜ × 14¾ in., 51.8 × 37.5 cm
Dallas Museum of Art, Gift of the Estate of Mrs. Barron Kidd (1994.220) (ill. p. 254)

Cat. 402 Edouard Vuillard, *Portrait of the Artist's Grandmother,* 1891–92
Oil on canvas, 25⅝ × 21¼ in., 65.1 × 54 cm
Hirshhorn Museum and Sculpture Garden, Smithsonian Institution. Gift of the Marion L. Ring Estate, 1987 (ill. p. 261)

Cat. 403 Edouard Vuillard, *Interior,* 1892
Oil on cardboard mounted on canvas, 10¼ × 20 in., 26 × 50.8 cm
Acquired 1954, The Phillips Collection, Washington, D.C. (ill. p. 254)

Cat. 404 Edouard Vuillard, *Woman in an Interior,* c. 1892
Oil on canvas, 8¹⁵⁄₁₆ × 5⅞ in., 22.7 × 15 cm
Collection Foundation Pierre Gianadda, Martigny, Switzerland (ill. p. 260)
*Dallas and San Francisco venues*

Cat. 405 Edouard Vuillard, *Interior with Women Sewing (L'Aiguillée),* 1893
Oil on canvas, 16⅜ × 13⅛ in., 41.6 × 33.3 cm
Yale University Art Gallery, New Haven, Collection of Mr. and Mrs. Paul Mellon (ill. p. 250)

Cat. 406 Edouard Vuillard, *Misia and Thadée Natanson,* c. 1897–98
Modern print from original negative, 4 × 4 in., 10.2 × 10.2 cm
Archives Salomon, Paris (ill. p. 256)

Cat. 407 Edouard Vuillard, *Misia Natanson,* 1898
Vintage print, 3⅜ × 3⅜ in., 8.5 × 8.6 cm
Archives Salomon, Paris (ill. p. 259)
*Dallas venue*

Cat. 408 Edouard Vuillard, *Around the Table: Bonnard (?) Holding Renée, Madame Mertzdorff, a Little Girl, and a Servant Holding Vivette,* spring 1899, Grand-Lemps
Vintage print on albumen paper, 3¼ × 3⅜ in., 8.2 × 8.6 cm
Musée d'Orsay, Paris (Pho. 1987-29-6) (ill. p. 262)
*Dallas venue*

Cat. 409 Edouard Vuillard, *Bonnard Photographing Renée; Roussel and an Unidentified Child,* spring 1899, Grand-Lemps
Modern print from original negative
Musée d'Orsay, Paris (Pho. 1987-29-1) (ill. pp. 238, 262)

Cat. 410 Edouard Vuillard, *Bonnard, Roussel (Seated on the Ground), Renée, and a Little Girl,* spring 1899, Grand-Lemps
Modern print from original negative
Musée d'Orsay, Paris (Pho. 1987-29-2) (ill. p. 260)

Cat. 411 Edouard Vuillard, *Bonnard Tickling Renée,* spring 1899, Grand-Lemps
Vintage print on albumen paper, 3¼ × 3½ in., 8.3 × 8.8 cm
Musée d'Orsay, Paris (Pho. 1987-29-5) (ill. p. 262)
*Dallas venue*

Cat. 412 Edouard Vuillard, *Feeding Vivette: Madame Mertzdorff, Vivette, Renée, and an Unidentified Child,* spring 1899, Grand-Lemps
Modern print from original negative
Musée d'Orsay, Paris (Pho. 1987-29-3)

Cat. 413 Edouard Vuillard, *Madame Eugène Bonnard, Misia and Ida Godebska,* spring 1899, Grand-Lemps
Vintage print on albumen paper, 3⁷⁄₁₆ × 3½ in., 8.8 × 8.9 cm
Musée d'Orsay, Paris (Pho. 1987-29-7) (ill. p. 262)
*Dallas venue*

Cat. 414 Edouard Vuillard, *Mother and Child,* 1899
Oil on cardboard, 20 × 23 in., 50.8 × 58.42 cm
Glasgow Museums: Art Gallery & Museum, Kelvingrove (ill. p. 258)

Cat. 415 Edouard Vuillard, *Roussel, Madame Mertzdorff, and Renée,* spring 1899, Grand-Lemps
Modern print from original negative
Musée d'Orsay, Paris (Pho. 1987-29-4) (ill. p. 262)

Cat. 416 Edouard Vuillard, *Misia and Thadée Natanson,* c. 1899
Modern print from original negative
Archives Salomon, Paris (ill. p. 252)

Cat. 417 Edouard Vuillard, *Natanson Country House with Romain Coolus,* c. 1899
Vintage print, 3½ × 3½ in., 9.0 × 9.0 cm
Archives Salomon, Paris (ill. p. 259)
*Dallas venue*

Cat. 418 Edouard Vuillard, *At the Window,* c. 1900
Oil on board, 18⅞ × 24½ in., 48 × 62 cm
San Francisco Museum of Modern Art, Partial gift of Mrs. Wellington S. Henderson (ill. p. 261)

Cat. 419 Edouard Vuillard, *Vuillard's Apartment, rue Truffant,* c. 1899–1901
Modern print from original negative, 4 × 4 in., 10.2 × 10.2 cm
Archives Salomon, Paris (ill. p. 256)

Cat. 420 Edouard Vuillard, *Lucie Hessel on a Chaise,* 1901–3
Vintage print, 3⅜ × 3⅜ in., 8.5 × 8.7 cm
Archives Salomon, Paris (ill. p. 256)
*Dallas venue*

Cat. 421 Edouard Vuillard, *Interior,* c. 1902
Oil on cardboard, 20 × 26½ in., 50.8 × 67.4 cm
Dallas Museum of Art, Gift of the Meadows Foundation Incorporated (1981.137) (ill. p. 252)

## CONSTANTIN BRANCUSI
(1876–1957)

Cat. 422 Constantin Brancusi, *View of the Studio with l'Ecorché,* c. 1901
Gelatin silver print, 11⅝ × 9⅜ in., 29.7 × 23.9 cm
Didier Imbert Fine Art, Paris (DI #1439) (ill. p. 277)

Cat. 423 Constantin Brancusi, *Sleeping Muse,* c. 1910s
Gelatin silver print, 9¾ × 7 in., 23.7 × 17.8 cm
Mayor Gallery, London, and David Grob (ill. p. 268)

Cat. 424 Constantin Brancusi, *The Prayer,* c. 1907
Gelatin silver print, 11⅜ × 9 in., 29 × 23 cm
Didier Imbert Fine Art, Paris (DI #1450) (ill. p. 282)

Cat. 425 Constantin Brancusi, *The Kiss,* c. 1907–8 (cast before 1914)
Plaster, 11 × 10¼ × 8½ in., 27.94 × 26.03 × 21.59 cm
The Patsy R. and Raymond D. Nasher Collection (ill. p. 270)
*San Francisco and Dallas venues*

Cat. 426 Constantin Brancusi, *The Sorceress,* 1916–24
Maple with two-part base of limestone and oak, 38¼ × 18⅝ × 18½ in., 97.2 × 47.3 × 47 cm
The Solomon R. Guggenheim Museum, New York (ill. p. 281)

Cat. 427 Constantin Brancusi, *The Child in the World: Mobile Group,* c. 1917–20
Gelatin silver print, 11¾ × 9⅛ in., 29.8 × 23.3 cm
Camera Works, Inc. (ill. p. 284)

Cat. 428 Constantin Brancusi, *The Kiss,* c. 1918–23
Gelatin silver print, 9¾ × 7 in., 24 × 17.9 cm
Didier Imbert Fine Art, Paris (DI #1449) (ill. p. 271)

Cat. 429 Constantin Brancusi, *Beginning of the World,* c. 1920
Marble, metal, stone, 30 × 20 × 20 in., 76.2 × 50.8 × 50.8 cm
Dallas Museum of Art, Foundation for the Arts Collection, gift of Mr. and Mrs. James H. Clark (ill. p. 273)
*Dallas and San Francisco venues*

Cat. 430 Constantin Brancusi, *Mlle. Pogany II (Bronze),* c. 1920
Gelatin silver print, 9⅝ × 7 in., 24.4 × 17.8 cm
Mayor Gallery, London, and David Grob (ill. p. 272)

Cat. 431 Constantin Brancusi, *Mlle. Pogany II, Profile View,* c. 1920
Gelatin silver print, 9⅛ × 6¾ in., 23.2 × 17.2 cm
Courtesy of Zabriskie Gallery, New York (ill. p. 280)

Cat. 432 Constantin Brancusi, *Studio with Polaire,* c. 1920
Gelatin silver print, 15 × 12 in., 38.1 × 30.48 cm
Camera Works, Inc. (ill. p. 283)

Cat. 433 Constantin Brancusi, *View of the Studio with Mlle. Pogany,* c. 1920
Gelatin silver print, 7 × 9 in., 17.8 × 22.9 cm
Collection of Miles Booth (ill. p. 272)

Cat. 434 Constantin Brancusi, *View of the Studio with Portrait of Mme. L.R.,* c. 1920
Gelatin silver print, 9 × 6⅞ in., 22.9 × 17.5 cm
Mayor Gallery, London, and David Grob (ill. p. 273)

Cat. 435 Constantin Brancusi, *View of the Artist's Studio,* c. 1920–25
Gelatin silver print, 9⁷⁄₁₆ × 11¹³⁄₁₆ in., 23.9 × 30 cm
Indiana University Art Museum: Gift of Lois Lord (94.95)

Cat. 436 Constantin Brancusi, *Leda (Marble),* c. 1920–26
Gelatin silver print, 7 × 9⅜ in., 17.8 × 23.7 cm
Mayor Gallery, London, and David Grob

Cat. 437 Constantin Brancusi, *Mlle. Pogany I (Marble),* before 1921
Gelatin silver print, 8⅞ × 7 in., 22.7 × 17.8 cm
Mayor Gallery, London, and David Grob (ill. p. 269)

Cat. 438 Constantin Brancusi, *The Kiss,* c. 1921
Gelatin silver print, 19¾ × 15⅝ in., 50 × 39.7 cm
Indiana University Art Museum: Gift of Lois Lord (94.97) (ill. p. 271)

Cat. 439 Constantin Brancusi, *Self-Portrait (Artist Carving "The Seal"),* c. 1922
Gelatin silver print, 13⅜ × 10⅝ in., 34 × 27 cm
Didier Imbert Fine Art, Paris (DI #1386) (ill. p. 266)

Cat. 440 Constantin Brancusi, *Self-Portrait,* c. 1922–23
Gelatin silver print, 7½ × 5½ in., 19 × 14 cm
Didier Imbert Fine Art, Paris (DI #1390) (ill. p. 264)

Cat. 441 Constantin Brancusi, *The Newborn II* (c. 1920) and *Head of a Sleeping Child* (1916–20), c. 1923
Gelatin silver print, 9¼ × 11¾ in., 23.7 × 29.8 cm
Mayor Gallery, London, and David Grob (ill. p. 275)

Cat. 442 Constantin Brancusi, *White Negress,* c. 1923
Gelatin silver print, 11½ × 9¼ in., 29.21 × 23.49 cm
Courtesy of Zabriskie Gallery, New York (ill. p. 279)

Cat. 443 Constantin Brancusi, *Self-Portrait (Artist Seated, Carving the "Endless Column"),* c. 1924
Gelatin silver print, 9⅜ × 11⅞ in., 23.8 × 30 cm
Didier Imbert Fine Art, Paris (DI #1389) (ill. p. 282)

Cat. 444 Constantin Brancusi, *Self-Portrait Working on the "Endless Column,"* c. 1924
Gelatin silver print, 7⅛ × 9 in., 18 × 23 cm
Didier Imbert Fine Art, Paris (DI #1384) (ill. p. 282)

Cat. 445 Constantin Brancusi, *Bird in Space,* c. 1925
Gelatin silver print, 11¾ × 7¹³⁄₁₆ in., 29.9 × 18.1 cm
Indiana University Art Museum: Gift of Lois Lord (94.94) (ill. p. 274)

Cat. 446 Constantin Brancusi, *The Cock and Sleeping Muse,* c. 1925
Gelatin silver print, 8⅞ × 5⅞ in., 22.4 × 15 cm
Didier Imbert Fine Art, Paris (DI #1403)

Cat. 447 Constantin Brancusi, *The Blond Negress,* 1933
Polished bronze, 15¾ × 7 × 5⅞ in., 40 × 17.8 × 14.9 cm
The Patsy R. and Raymond D. Nasher Collection
*San Francisco and Dallas venues*

Cat. 448 Constantin Brancusi, *Self-Portrait,* c. 1933–34
Gelatin silver print, 15⅝ × 11¾ in., 39.7 × 29.8 cm
Didier Imbert Fine Art, Paris (DI #1385) (ill. p. 282)

Cat. 449 Constantin Brancusi, *Leda in Flight,* c. 1934
Gelatin silver print, 7⅛ × 9½ in., 18 × 24 cm
Mayor Gallery, London, and David Grob (ill. p. 278)

Cat. 450 Constantine Brancusi, *View of the Studio with "Leda" and "Fish,"* after 1934
Gelatin silver print, 9⅜ × 11¾ in., 23.8 × 29.7 cm
Mayor Gallery, London, and David Grob (ill. p. 274)

Cat. 451 Constantin Brancusi, *View of the Studio with "Endless Column,"* c. 1935
Gelatin silver print, 11⅝ × 9⅜ in., 29.5 × 23.8 cm
Mayor Gallery, London, and David Grob

Cat. 452 Constantin Brancusi, *The Seal (Le Miracle),* c. 1936
Gelatin silver print, 9⅜ × 7 in., 23.4 × 17.8 cm
Indiana University Art Museum: Gift of Lois Lord (94.93)

Cat. 453 Constantin Brancusi, *"Endless Column" at Tîrgu Jiu,* c. 1938
Gelatin silver print, 11¾ × 9⅜ in., 29.8 × 23.8 cm
Indiana University Art Museum: Gift of Lois Lord (94.96) (ill. p. 277)

Cat. 454 Edward Steichen, *Portrait of Constantin Brancusi,* 1922
Gelatin silver print, 9½ × 7½ in., 24.1 × 19 cm
Indiana University Art Museum

## PABLO PICASSO
(1881–1973)

Cat. 455 Alinari, *Domenico Ghirlandaio's "Birth of St. John the Baptist" in the Church of Santa Maria Novella, Florence, Italy,* 1870–80
Albumen print, 7½ × 9⅞ in., 19 × 25 cm
Archives Picasso, Musée Picasso, Paris (ill. p. 298)

Cat. 456 Alinari, *Detail of "The Adoration of the Magi" by Leonardo da Vinci,* 1870–80
Albumen print, 7⅝ × 9⅞ in., 19.5 × 25 cm
Archives Picasso, Musée Picasso, Paris (AP PH 12480) (ill. p. 303)

Cat. 457 Alinari, *Detail of "The Adoration of the Magi" by Leonardo da Vinci,* 1870–80
Albumen print, 9⅞ × 7¼ in., 25 × 18.3 cm
Archives Picasso, Musée Picasso, Paris (AP PH 13444) (ill. p. 302)

Cat. 458 Anderson, *Photograph of "Madonna and Child with St. John the Baptist and a Chorus of Angels" by Boticelli in the Borghese Gallery, Rome,* 1860–80
Albumen print, 8 × 10⁵⁄₁₆ in., 20.4 × 26.2 cm
Archives Picasso, Musée Picasso, Paris (AP PH 13464) (ill. p. 305)

Cat. 459 Anderson, *"The Burial of Count Orgaz" by El Greco,* 1870–80
Albumen print, 10⅛ × 7⅝ in., 25.7 × 19.5 cm
Archives Picasso, Musée Picasso (AP PH 3630) (ill. p. 296)

Cat. 460 Anonymous, *Carte de Visite Portrait of a Boy,* n.d.
Albumen print, 4⅛ × 2½ in., 10.5 × 6.5 cm
Archives Picasso, Musée Picasso, Paris (AP PH 3415) (ill. p. 305)

Cat. 461 Anonymous, *Carte de Visite Portrait of a Young Boy,* n.d.
Albumen print, 4⅛ × 2½ in., 10.5 × 6.5 cm
Archives Picasso, Musée Picasso, Paris (AP PH 3369)

Cat. 462 Anonymous, *Carte de Visite Portrait of a Young Boy,* n.d.
Albumen print, 4⅛ × 2½ in., 10.5 × 6.5 cm
Archives Picasso, Musée Picasso, Paris (AP PH 3373)

Cat. 463 Anonymous, *Berber Woman, Algeria,* 1860–80
Albumen print, 9½ × 6⅞ in., 24 × 17.5 cm
Archives Picasso, Musée Picasso, Paris (AP PH 12517) (ill. p. 292)

Cat. 464 Anonymous, *Detail of "The Burial of Count Orgaz" by El Greco,* 1870–80
Albumen print, 8½ × 7 in., 21.6 × 17.8 cm
Archives Picasso, Musée Picasso, Paris (AP PH 3628) (ill. p. 296)

Cat. 465 Anonymous, *"Christ Bidding His Mother Farewell" by El Greco,* 1870–80
Albumen print, 8⅝ × 6⅞ in., 22 × 17.5 cm
Archives Picasso, Musée Picasso, Paris (AP PH 3629) (ill. p. 299)

Cat. 466 Anonymous, *Woman and Child,* Egypt, 1860–80
Albumen print, 10¾ × 8¼ in., 27.3 × 21 cm
Archives Picasso, Musée Picasso, Paris (AP DH 12512)

Cat. 467 Ricardo Canals, *Portrait of Pablo Picasso,* 1904
Gelatin silver print, 6¼ × 4½ in., 16 × 11.5 cm
Gift of Sir Roland Penrose
Archives Picasso, Musée Picasso, Paris (AP PH 120)

Cat. 468 Etienne Carjat, *Carte de Visite Portrait of a Young Boy,* n.d.
Albumen print, 4⅛ × 2½ in., 10.5 × 6.5 cm
Archives Picasso, Musée Picasso, Paris (AP PH 3355)

Cat. 469 Etienne Carjat & Cie, *Carte de Visite Portrait of a Young Boy,* n.d.
Albumen print, 4⅛ × 2½ in., 10.5 × 6.5 cm
Archives Picasso, Musée Picasso, Paris (AP PH 3354)

Cat. 470 Paul Emile Miot, *Gougou, Prince of the Mic-Macs,* 1859
Albumen print pasted onto cardboard, 5¾ × 4⅜ in., 14.6 × 11.2 cm
Archives Picasso, Musée Picasso, Paris (AP PH 15673) (ill. p. 290)
*San Francisco venue*

Cat. 471 J. Muhn, *Photograph of the Painting "The Visitation" by Ghirlandaio,* 1860–80
Albumen print, 10⅞ × 8¼ in., 27.5 × 21 cm
Archives Picasso, Musée Picasso, Paris (AP PH 13463) (ill. p. 298)

Cat. 472 Pierre Petit, *Carte de Visite Portrait of a Young Boy,* n.d.
Albumen print, 4⅛ × 2½ in., 10.5 × 6.5 cm
Archives Picasso, Musée Picasso, Paris (AP 3364)

Cat. 473  Photo Richelieu, *Carte de Visite Portrait of a Young Boy*, n.d. Albumen print, 4⅛ × 2½ in., 10.5 × 6.5 cm Archives Picasso, Musée Picasso, Paris (AP 3358)

Cat. 474  Pablo Picasso, *Young Man with a Fan*, c. 1899–1900 Cyanotype, 2³⁄₁₆ × 2¼ in., 5.3 × 5.6 cm Archives Picasso, Musée Picasso, Paris (AP PH 3622) (ill. p. 10)

Cat. 475  Pablo Picasso, *"The Absinthe Drinker" in Progress*, 1901 Gelatin silver print, 6¼ × 4⅜ in., 16 × 11 cm Archives Picasso, Musée Picasso, Paris (AP PH 15367)

Cat. 476  Pablo Picasso, *"The Aperitif" in Progress I*, 1901 Gelatin silver print, 6¼ × 4¼ in., 16 × 10.7 cm Archives Picasso, Musée Picasso, Paris (AP PH 15376)

Cat. 477  Pablo Picasso, *"The Aperitif" in Progress II*, 1901 Gelatin silver print, 6 × 4⅜ in., 15.1 × 11 cm Archives Picasso, Musée Picasso, Paris (AP PH 15369)

Cat. 478  Pablo Picasso, *"Crouching Woman and Child" in Progress*, 1901 Gelatin silver print, 5⅜ × 4⅜ in., 13.3 × 11.2 cm Archives Picasso, Musée Picasso, Paris (AP PH 15366) (ill. p. 299)

Cat. 479  Pablo Picasso, *Evocation (Burial of Casagemas)*, 1901 Oil on canvas, 59 × 35⅜ in., 150 × 90 cm Musée de l'Art Moderne de la Ville de Paris (ill. p. 297) *San Francisco and Bilbao venues*

Cat. 480  Pablo Picasso, *"La Gomeuse" in Progress*, 1901 Gelatin silver print, 6¼ × 4⅛ in., 16 × 10.5 cm Archives Picasso, Musée Picasso, Paris (AP PH 15372)

Cat. 481  Pablo Picasso, *"Portrait of Gustave Coquiot" in Progress I*, 1901 Gelatin silver print, 4⅝ × 3½ in., 11.8 × 8.8 cm Archives Picasso, Musée Picasso, Paris (AP PH 15364) (ill. p. 289)

Cat. 482  Pablo Picasso, *"Portrait of Gustave Coquiot" in Progress II*, 1901 Gelatin silver print, 4⅞ × 3¾ in., 12.3 × 9.6 cm Archives Picasso, Musée Picasso, Paris (AP PH 15365) (ill. p. 289)

Cat. 483  Pablo Picasso, *Self-Portrait in the Studio*, 1901 Gelatin silver print (superimposition), 4¾ × 3½ in., 12 × 9 cm Archives Picasso, Musée Picasso, Paris (AP PH 2800) (ill. p. 288)

Cat. 484  Pablo Picasso, *Study for "Evocation,"* 1901 Pencil on the back of a reproduction, 16⅜ × 11⅜ in., 41.6 × 29 cm Musée Picasso, Paris (MP 442) (ill. p. 297) *San Francisco venue*

Cat. 485  Pablo Picasso, *"Woman with a Chignon" in Progress*, 1901 Gelatin silver print, 6¼ × 4⅛ in., 16 × 10.5 cm Archives Picasso, Musée Picasso, Paris (AP PH 15970)

Cat. 486  Pablo Picasso, *Study for "Two Sisters (L'Entrevue),"* 1901–2 Pencil on paper, 17¾ × 12⅝ in., 45 × 32 cm Musée Picasso, Paris (MP 447) (ill. p. 298) *Bilbao venue*

Cat. 487  Pablo Picasso, *Study for "Two Sisters (L'Entrevue),"* 1901–2 Pen and black ink on the back of a reproduction of Michel-Lévy's "Le Couvert" in *L'Art français*, 13⅝ × 10⅝ in., 34.6 × 27 cm Musée Picasso, Paris (MP 448) (ill. p. 298) *Bilbao venue*

*Cat. 488  Pablo Picasso, *The Blue Studio*, 1901–2 Facsimile of original gelatin silver print, 4¾ × 5½ in.,12 × 14 cm Archives Picasso, Musée Picasso, Paris (AP PH 2813)

Cat. 489  Pablo Picasso, *Mother and Child*, 1902 Pen and black ink on paper, 10¼ × 8 in., 25.9 × 20.3 cm Musée Picasso, Paris (MP 456) (ill. p. 303) *Bilbao venue*

Cat. 490  Pablo Picasso, *Nude Woman Imploring the Heavens*, 1902 Pen, brown ink and tinted wash with scraping on paper, 12¼ × 9⅛ in., 31 × 23.2 cm Musée Picasso, Paris (MP 457) (ill. p. 303) *Dallas venue*

Cat. 491  Pablo Picasso, *Woman Imploring the Heavens*, 1902 Pen and black ink on beige paper, 8½ × 7⅜ in., 21.6 × 18.7 cm Musée Picasso, Paris (MP 458) *Dallas venue*

Cat. 492  Pablo Picasso, *Nude Man with Raised Arms*, 1902–3 Pencil and pen with black ink on paper, 22 × 15¼ in., 55.8 × 38.9 cm Musée Picasso, Paris (MP 464) *Dallas venue*

Cat. 493  Pablo Picasso, *Portrait of a Bearded Man*, 1902–3 Pen and India ink on paper, 6⅝ × 5¼ in., 16.8 × 13.2 cm Musée Picasso, Paris (MP 453) (ill. p. 291) *San Francisco venue*

Cat. 494  Pablo Picasso, *Portrait of a Man (Blue Portrait)*, 1902–3 Oil on canvas, 36⅝ × 30¾ in., 93 × 78 cm Musée Picasso, Paris (MP 5) (ill. p. 291) *San Francisco venue*

Cat. 495  Pablo Picasso, *Crucifixion and Couples Embracing*, 1903 Pencil and blue crayon on paper, 12½ × 8⅝ in., 31.8 × 21.9 cm Musée Picasso, Paris (MP 477) (ill. p. 301) *Bilbao venue*

Cat. 496  Pablo Picasso, *Study for "Life" (Etude pour "La Vie")*, 1903 Pen and brown ink on paper, 6¼ × 4⅜ in., 15.9 × 11 cm Musée Picasso, Paris (MP 473) (ill. p. 300) *San Francisco venue*

Cat. 497  Pablo Picasso, *Portrait of Roberto Canals*, 1904 Gelatin silver print, 6 × 4¼ in., 15.3 × 10.7 cm Archives Picasso, Musée Picasso, Paris (AP PH 2802)

Cat. 498  Pablo Picasso, *Boy with a Pipe*, 1905 Oil on canvas, 43¼ × 32 in., 100 × 81.3 cm Greentree Foundation, New York (ill. p. 304)

Cat. 499  Pablo Picasso, *Fernande*, 1905 Bronze with green patina, 14¼ in., 36.2 cm R.T. Miller, Jr. Fund, 1955, Oberlin College Museum of Art, Oberlin, OH

Cat. 500  Pablo Picasso, *Study for "La Toilette,"* 1906 Charcoal on paper, 24 × 15¾ in., 61.2 × 40 cm Lent by The Alex Hillman Family Foundation (ill. p. 292) *Dallas and San Francisco venues*

Cat. 501  Pablo Picasso, *Study for "La Toilette,"* 1906 Watercolor and pencil on paper, 9½ × 6½ in., 24.1 × 16.5 cm Private Collection (ill. p. 292)

Cat. 502  Pablo Picasso, *Three Nudes*, 1906 Gouache, watercolor over pencil on paper, 24¾ × 19 in., 62.9 × 48.3 cm Lent by The Alex Hillman Family Foundation (ill. p. 294) *Dallas and San Francisco venues*

Cat. 503  Pablo Picasso, *Two Youths (Les Adolescents)*, 1906 Oil on canvas, 61¾ × 46⅛ in., 157 × 117 cm Musée National de l'Orangerie, Paris (ill. p. 295) *Dallas venue*

Cat. 504  Pablo Picasso, *Composition with Violin*, 1912 Pencil, charcoal, gouache, and newspaper on paper, 24 × 18¼ in., 61.1 × 46.5 cm Private Collection (ill. p. 19) *San Francisco and Dallas venues*

Cat. 505  Gugliemo Plüschow, *Naked Youths, Karnak*, 1896 Albumen print, 8½ × 6⅜ in., 21.7 × 16.2 cm Archives Picasso, Musée Picasso, Paris (AP PH 12511) (ill. p. 294)

Cat. 506  B. Trolet, *Carte de Visite Portrait of a Child*, n.d. Albumen print, 4⅛ × 3½ in., 10.5 × 6.5 cm Archives Picasso, Musée Picasso, Paris (AP PH 3409)

Cat. 507  Joan Vidal Ventosa, *Portrait of Fernande Olivier, Pablo Picasso, and Ramón Reventós*, 1906 Gelatin silver print, 6⅛ × 8⅛ in., 15.5 × 20.5 cm Musée Picasso, Paris (MP 1998.x) (ill. p. 286)

Cat. 508  C. & G. Zangaki, *Two Bicharine Sisters*, Egypt, 1860–80 Albumen print, 11 × 8¼ in., 28 × 21 cm Archives Picasso, Musée Picasso, Paris (AP PH 12514) (ill. p. 292)

## APPENDIX A

Cat. A  Edgar Degas, *Dancer from the Corps de Ballet*, c. 1896 Modern reprint Bibliothèque Nationale de France, Paris

Cat. B  Edgar Degas, *Dancer from the Corps de Ballet*, c. 1896 Modern reprint Bibliothèque Nationale de France, Paris

Cat. C  Edgar Degas, *Dancer from the Corps de Ballet*, c. 1896 Modern reprint Bibliothèque Nationale de France, Paris

Cat. D  Edgar Degas, *Self-Portrait with Sculpture by Bartholomé*, c. 1898 Modern reprint Bibliothèque Nationale de France, Paris

Cat. E  Pierre Bonnard, *Charles, Robert, and Jean Terrasse*, summer 1899, Grands-Lemps Modern reprint Musée d'Orsay, Paris (Pho. 1987-28-6) (ill. p. 244)

Cat. F  Pierre Bonnard, *Fruit Picking, with Various Participants Including Andrée Terrasse and, in the Foreground, Renée*, 1899–1900, Grand-Lemps Modern reprint Musée d'Orsay, Paris (Pho. 1987-28-22) (ill. p. 240)

Cat. G  Pierre Bonnard, *Marthe Standing in the Sunlight*, 1900–1901, Montval Modern reprint Musée d'Orsay, Paris (Pho. 1987-31-34) (ill. p. 242)

# Bibliography

DEGAS TO PICASSO, GENERAL LITERATURE

Adhémar, Jean. *Une Vision Nouvelle.* Paris: Bibliothèque nationale, 1955.

Barthes, Roland. *Camera Lucida: Reflections on Photography.* Trans. Richard Howard. New York: Hill and Wang, 1981.

Benjamin, Walter. *Illuminations, Essays, and Reflections.* Ed. Hannah Arendt; trans. Harry Zohn. New York: Schocken, 1968.

*Beyond Painting and Sculpture.* London: British Arts Council, 1973.

Braun, Marta. "Muybridge's Scientific Fictions." *Studies of Visual Communication* 10 (winter 1984): 2–21.

———. *Picturing Time: The Work of Etienne-Jules Marey (1830–1904).* Chicago and London: University of Chicago Press, 1992.

Challe, Daniel, and Bernard Marbot. *Les Photographes de Barbizon. La Forêt de Fontainebleau.* Paris: Editions Hoëbeke, Bibliothèque nationale, 1991.

Coke, Van Deren. *The Painter and the Photograph: From Delacroix to Warhol.* Albuquerque: University of New Mexico Press, 1972.

Crary, Jonathan. *Techniques of the Observer: On Vision and Modernity in the Nineteenth Century.* Cambridge, Mass., and London: MIT Press, 1990.

Delevoy, Robert L. *Symbolists and Symbolism.* Geneva: Rizzoli, 1978.

Delpire, Robert, and Michel Frizot. *Histoire de voir: Une histoire de la photographie.* 3 vols. Paris: Centre national de la photographie, 1989.

Dorra, Henri, ed. *Symbolist Art Theories: A Critical Anthology.* Berkeley, Los Angeles, and London: University of California Press, 1994.

Galassi, Peter. *Before Photography: Painting and the Invention of Photography.* New York: The Museum of Modern Art, 1981.

Henderson, Linda D. *The Fourth Dimension and Non-Euclidean Geometry in Modern Art.* Princeton, N.J.: Princeton University Press, 1983.

Jacobson, Ken, and Jenny Jacobson. *Etude d'après nature: Nineteenth Century Photographs in Relation to Art.* Essex: Petches Bridge, 1996.

Jammes, Isabelle. *Blanquart-Evrard et les origines de l'édition photographique française: Catalogue raisonné des albums photographiques édités 1851–1855.* Geneva and Paris: Droz, 1981.

Jay, Martin. *Downcast Eyes: The Denigration of Vision in Twentieth-Century French Thought.* Berkeley, Los Angeles, and London: University of California Press, 1993.

*Kunst aus Fotografie.* Hanover: Kunstverein, 1973.

*L'Art du nu au XIX siècle: Le photographe et son modèle.* Paris: Hazan, Bibliothèque nationale de France François-Mitterrand, 1997.

Lemagny, Jean-Claude, and André Rouillé, eds. *A History of Photography: Social and Cultural Perspectives.* Cambridge and New York: Cambridge University Press, 1987.

*Malerei nach Fotographie.* Munich: Münchener Stadtmuseum, 1970.

*Malerei und Photographie im Dialog: Von 1840 bis Heute.* Ed. Erika Billeter. Bern: Benteli Verlag, 1977.

Marien, Mary Warner. *Photography and Its Critics: A Cultural History, 1839–1900.* New York: Cambridge University Press, 1997.

McWilliam, Neil, and Veronica Sekules, eds. *Life and Landscape: P. H. Emerson, Art and Photography in East Anglia, 1885–1900.* Norwich: Sainsbury Centre for Visual Arts, 1986.

*Medium Fotografie—Fotoarbeiten bildender Künstler, 1910–1973.* Leverkusen: Stadtisches Museum, 1973.

*Mit Kamera, Pinsel, und Spritzpistole: Realistische Kunst in unserer Zeit.* Ruhrfestspiele Recklinghausen, Städtische Kunsthalle, 1973.

Mozley, Anita Ventura, ed. *Eadweard Muybridge: The Stanford Years, 1872–1882.* Palo Alto, Calif.: Stanford University Museum of Art, 1972.

*Le Mouvement.* Preface by André Miquel and forewords by Alain Berthoz and Marion Leuba. Nîmes: Jacqueline Chambon, 1994.

*Muybridge's Complete Human and Animal Locomotion.* Introduction by Anita Ventura Mozley. New York: Dover Publications, 1979.

Newhall, Beaumont, ed. *Photography: Essays and Images. Illustrated Readings in the History of Photography.* New York: The Museum of Modern Art, 1980.

Pohlmann, Ulrich. "Etudes d'après nature: Barbizon und die französische Landschaftsphotographie von 1849 bis 1875," in *Corot, Courbet und die Maler von Barbizon: Les Amis de la nature,* pp. 406–16. Ed. Christoph Heilmann, Michael Clarke, and John Sillevis. Munich: Klinkhardt & Biermann,1996.

———. "The Dream of Beauty, or Truth Is Beauty, Beauty Truth: Photography and Symbolism, 1840–1914," pp. 428–47 in *Lost Paradise: Symbolist Europe.* Montreal: The Montreal Museum of Fine Arts, 1995.

Raupp, Karl. "Die Photographie in der modernen Kunst." *Die Kunst für Alle* 4 (1889): 325–26.

Scharf, Aaron. *Art and Photography.* London: Allen Lane, 1968. Reprint, Penguin Press, 1974.

*Seeing the Unseen.* Rochester, N.Y.: International Museum of Photography at George Eastman House, 1994.

Sheldon, James L., and Jock Reynolds. *Motion and Document—Sequence and Time: Eadweard Muybridge and Contemporary American Photography.* Andover, Mass.: Addison Gallery of American Art, 1991.

*Skulptur im Licht der Fotografie: Von Bayard bis Mapplethorpe.* Bern: Benteli, 1997.

Starl, Timm. *Knipser: Die Bildgeschichte der privaten Fotografie in Deutschland und Österrich von 1880 bis 1980.* Munich: Koehler & Amelang, 1995.

Szarkowski, John. *Photography until Now.* New York: The Museum of Modern Art, 1989.

Varnedoe, Kirk. "The Artifice of Candor: Impressionism and Photography Reconsidered." *Art in America* 68, no. 1 (January 1980): 66–78.

———. "The Ideology of Time: Degas and Photography." *Art in America* 68, no. 6 (summer 1980): 96–110.

### GUSTAVE MOREAU

Bittler, Paul, and Pierre-Louis Mathieu. *Catalogue des dessins de Gustave Moreau.* Paris: Musée Gustave Moreau, 1983.

*Catalogue des Peintures, Dessins, Cartons, Aquarelles.* Paris: Musée Gustave Moreau, 1974.

*Gustave Moreau symboliste.* Zurich: Kunsthaus Zürich, 1986.

Huysmans, Joris-Karl. *A rebours.* Paris: G. Charpentier, 1884. English edition: *Against Nature.* Trans. Robert Baldick. Baltimore: Penguin Books, 1959.

*L'Inde de Gustave Moreau.* Paris: Editions des musées de la Ville de Paris, 1997.

Kaplan, Julius. *Gustave Moreau.* Los Angeles: Los Angeles County Museum of Art, 1974.

Lacambre, Geneviève. *Maison d'artist, maison-musée: L'exemple de Gustave Moreau.* Paris: Réunion des musées nationaux, 1987.

———. "Documentation et création: l'exemple de Gustave Moreau," pp. 79–91 in *Usages de l'image au XIXe siècle.* Société des Etudes romantiques et dix-neuviemistes. Paris: Editions créaphis, 1992.

——— et al. *Gustave Moreau: Between Epic and Dream.* Chicago: The Art Institute of Chicago, 1999.

Mathieu, Pierre-Louis. *Gustave Moreau, with a Catalogue of the Finished Paintings, Watercolors and Drawings.* Boston: New York Graphic Society, 1976.

### EDGAR DEGAS

Armstrong, Carol. "Reflections on the Mirror: Painting, Photography, and the Self-Portraits of Edgar Degas." *Representations* 22 (spring 1988): 108–41.

Baumann, Felix, and Marianne Karabelnik, eds. *Degas Portraits.* London: Merrell Holberton, 1994.

Boggs, Jean Sutherland, et al. *Degas.* New York: The Metropolitan Museum of Art, 1988.

Churchill, Karen L. "Degas and Photography: An Annotated Bibliography and List of Published Images." *History of Photography Monograph Series* 27 (spring 1990).

Crimp, Douglas. "Positive/Negative: A Note on Degas's Photographs." *October* 5 (1978): 89–100.

Daniel, Malcolm, ed. *Edgar Degas, Photographer.* New York: The Metropolitan Museum of Art, 1998.

Janis, Eugenia Parry. "Edgar Degas' Photographic Theater," pp. 451–86 in *Degas: Form and Space.* Ed. Maurice Gauillaud. Paris: Centre Culturel du Marais, 1984.

Kendall, Richard. *Degas: Beyond Impressionism.* London: National Gallery Publications, 1996.

Newhall, Beaumont. "Degas: Amateur Photographer, Eight Unpublished Letters by the Famous Painter Written on a Photographic Vacation." *Image* 5, no. 6 (June 1956): 124–26.

Varnedoe, Kirk. "The Ideology of Time: Degas and Photography." *Art in America* 68, no. 6 (summer 1980): 96–110.

### AUGUSTE RODIN

Beausire, Alain. *Quand Rodin exposait.* Paris: Editions Musée Rodin, 1988.

Becker, Jane R. "'Only One Art': The Interaction of Painting and Sculpture in the Work of Medardo Rosso, Auguste Rodin, Eugène Carrière, 1884–1906." Ph.D. diss., Institute of Fine Arts, New York University, 1998.

Butler, Ruth. *Rodin: The Shape of Genius.* New Haven, Conn., and London: Yale University Press, 1993.

Cladel, Judith. *Rodin: The Man and His Art.* Trans. S. K. Star. New York: The Century Co., 1918.

Elsen, Albert E. *In Rodin's Studio: A Photographic Record of Sculpture in the Making.* Ithaca, N.Y.: Cornell University Press, 1980.

———, ed. *Rodin Rediscovered.* Washington, D.C.: National Gallery of Art, 1981.

Pinet, Hélène. *Les photographes de Rodin.* Paris: Musée Rodin, 1986.

———. *Rodin et ses modèles.* Paris: Musée Rodin, 1990.

———. *Rodin sculpteur et les photographes de son temps.* Paris: P. Sers, 1985.

Rodin, Auguste. *Rodin on Art and Artists: Conversations with Paul Gsell.* Trans. Romilly Fedden. New York: Dover, 1983.

### PAUL GAUGUIN

Bodelson, Merete. "Gauguin and the Marquesan God." *Gazette des Beaux-Arts,* 6th ser., 57 (March 1961): 175.

Brettell, Richard, et al. *The Art of Paul Gauguin.* Washington, D.C.: National Gallery of Art, 1988.

Childs, Elizabeth C. *In Search of Paradise: Painting and Photography in Fin-de-Siècle Tahiti.* Berkeley and Los Angeles: University of California Press, forthcoming.

Danielsson, Bengt. *Gauguin in the South Seas.* New York: Doubleday, 1966.

Dorival, Bernard. "Sources of the Art of Gauguin from Java, Egypt and Ancient Greece." *Burlington Magazine* 93, no. 577 (April 1951): 118–22.

Field, Richard. *Paul Gauguin: The Paintings of the First Trip to Tahiti.* New York: Garland, 1977.

———. "Plagiaire ou créateur?" pp. 115–30 in *Paul Gauguin: Génies et Réalités.* Paris: Hachette, 1961. Reprint, Société Nouvelles des Editions du Chêne, 1986.

Guérin, Daniel, ed. *Paul Gauguin.* Paris: Gallimard, 1974.

Lemasson, Henri. "La Vie de Gauguin à Tahiti." *Encyclopédie de la France et d'outremer* (February 1950): 19.

Marks-Vandenbroucke, Ursula Frances. "Gauguin—Ses Origines et sa formation artistique." *Gazette des Beaux-Arts,* 6th ser., 47 (January–April 1956): 35–50.

Teilhet-Fisk, Jehanne. *Paradise Reviewed: An Interpretation of Gauguin's Polynesian Symbolism.* Ann Arbor, Mich.: UMI Research Press, 1983.

## FERNAND KHNOPFF

Burns, S. "A Symbolist Soulscape: Fernand Khnopff's 'I Lock the Door upon Myself.'" *Arts* (January 1981): 80.

Delevoy, Robert L., Catherine de Croës, and Gisèlle Ollinger-Zinque. *Fernand Khnopff.* Brussels: Editions Lebeer-Hossmann, 1987.

*Fernand Khnopff 1858–1921.* Hamburg: Kunsthalle, 1980.

*Fernand Khnopff and the Belgian Avant-Garde.* New York: Barry Friedman, 1983.

Howe, J. W. "Fernand Khnopff's Depiction of Bruges: Medievalism, Mysticism, and Socialism." *Arts* (December 1980): 126–31.

———. *The Symbolist Art of Fernand Khnopff.* Ann Arbor, Mich.: UMI Research Press, 1982.

Kosinski, Dorothy. *Orpheus in Nineteenth Century Symbolism.* Ann Arbor, Mich., and London: UMI Research Press, 1989.

———. "The Gaze of Fernand Khnopff." *Source* 11, nos. 3–4 (spring–summer 1992): 26–33.

Legrand, Françine-Claire. "Das Androgyne und der Symbolismus," pp. 75–112 in *Androgyne-Sehnsucht nach Vollkommenheit.* Berlin: Neuer Beriner Kunstverein, 1986.

———. *Le Symbolisme en Belgique.* Brussels: Laconti, 1971.

de Maeyer, Charles. "Fernand Khnopff et ses modèles." *Bulletin des Musées Royaux des Beaux-Arts de Belgique* 1–2 (1964): 43–55.

Metken, Günter. "In sich Vergraben—Zu einem Bild von Fernand Khnopff," pp. 433–39 in *Wunderblock—eine Geschichte der Modernen Seele.* Vienna: Wien Festwochen, 1989.

Morrissey, L. D. "Exploration of Symbolic States of Mind in Fernand Khnopff's Work of the 1880s." *Arts* (February 1979): 88–92.

———. "Isolation of the Imagination: Fernand Khnopff's 'I Lock the Door upon Myself.'" *Arts* (December 1978): 94–97.

Olander, William. "Fernand Khnopff: 'Art or the Caresses.'" *Arts* (June 1977): 126–31.

Ollinger-Zinque, Giselle. "Fernand Khnopff et la photographie," pp. 19–23 in *Art et Photographie/Kunst en Camera.* Brussels: Europalia 80/Belgique 150, 1980.

## MEDARDO ROSSO

Barr, Margaret Scolari. *Medardo Rosso.* New York: The Museum of Modern Art, 1963.

Becker, Jane R. "'Only One Art': The Interaction of Painting and Sculpture in the Work of Medardo Rosso, Auguste Rodin, Eugène Carrière, 1884–1906." Ph.D. diss., Institute of Fine Arts, New York University, 1998.

Caramel, Luciano. *Medardo Rosso.* New York: Kent Fine Art, 1988.

———. *Medardo Rosso.* London: The South Bank Centre, 1994.

Fagioli, Marco. *Medardo Rosso: Catalogo delle sculture.* Florence: Opus Libri, 1993.

Fezzi, Elda, ed. *Medardo Rosso: Scritti e pensieri, 1889–1927.* Cremona: Editrice Turris, 1994.

Lista, Giovanni. *Medardo Rosso: Destin d'un sculpteur, 1858–1928.* Paris: L'Echoppe, 1994.

Moure, Gloria, ed. *Medardo Rosso.* Santiago de Compostela: Centro Galego de Arte Contemporánea, 1996.

Palazzo della Permanente. *Mostra di Medardo Rosso (1858–1928).* Milan: Palazzo della Permanente, 1979.

Rosso, Medardo. *La Sculpture impressioniste.* Ed. Giovanni Lista. Paris: L'Echoppe, 1994.

de Sanna, Jole. *Medardo Rosso o la creazione dello spazio moderno.* Milan: U. Mursia editore S.p.A., 1985.

## ALPHONSE MUCHA

*Alphonse Mucha: Pastels, Posters, Drawings, and Photographs.* An Exhibition at the Imperial Stables, Prague Castle. London: Mucha Foundation with Malcolm Saunders Publishing Ltd., 1994.

Arwas, Victor et al. *Alphonse Mucha: The Spirit of Art Nouveau.* Alexandria, Va.: Art Services International, 1998.

Kuroda, Seiki, and Takeshiro Kanogoki. *Alphonse Mucha: His Art and Life.* Tokyo: Tokyo Shimbun, 1995.

*Mucha: 1860–1939.* Paris: Réunion des musées nationaux, 1980.

Mucha, Jiri. *Alfons Maria Mucha: His Life and Art.* New York: Rizzoli, 1989.

Ovendon, Graham. *Alphonse Mucha Photographs.* London: Academy Editions, 1974.

Rennert, Jack, and Alain Weill. *Alphonse Mucha: The Complete Posters and Panels.* Boston: G. K. Hall, 1984.

## EDVARD MUNCH

Eggum, Arne. *Munch and Photography.* Newcastle upon Tyne: The Polytechnic Gallery, 1989.

———. *Munch und die Photographie.* Wabern-Bern: Benteli-Werd Verlags, 1991.

*Witkacy, Metaphysische Portraits. Photographien 1910–1939, von Stanislaw Ignacy Witkiewicz.* Leipzig: Connwitzer Verlag, 1997.

## FRANZ VON STUCK

Becker, Edwin, ed. *Franz von Stuck: Eros and Pathos.* Amsterdam: Van Gogh Museum, 1995.

Birnie Danzker, Jo-Anne et al. *Franz von Stuck: Die Sammlung des Museums Villa Stuck.* Munich: Museum Villa Stuck/Prestel, 1997.

———. *Franz von Stuck und die Photography.* Munich: Museum Villa Stuck/Prestel, 1996.

Heilmann, Eva, and Alexander Rauch. *Franz von Stuck: Gemälde, Zeichnung, Plastik aus Privatbesitz.* Passau: Museum Moderner Kunst, 1993.

Voss, Heinrich. *Franz von Stuck, 1863–1928.* Munich: Prestel, 1973.

## FÉLIX VALLOTTON

Brunière, Isabelle de la, and Philippe Grapeloup-Roche. "Vallotton and the Camera: Art and the Science of Photography." *Apollo* 99 (June 1994): 18–23. (Also appears as an essay with the title "La Photographie au service de la peinture" in the exhibition catalogue *Félix Vallotton,* organized by L'Annonciade Musée de Saint-Tropez, Besançon, 1995, pp. 29–44.)

Ducrey, Marina. *Félix Vallotton, la vie, la technique, l'oeuvre peint.* Lausanne: Edita S.A., 1989.

Koella, Rudolf, ed. *Félix Vallotton.* Munich: Hirmer Verlag, 1995.

*L'Art du nu au XIX siècle: Le photographe et son modèle.* Paris: Hazan, Bibliothèque nationale de France François-Mitterrand, 1997.

*Nabis, 1888–1900.* Munich and Paris: Prestel, 1993.

Newman, Sasha M., ed. *Félix Vallotton: A Retrospective.* New York: Abbeville Press, 1991.

## PIERRE BONNARD

Clair, Jean. "Bonnard ou l'espace du miroir." *La Nouvelle Revue Française,* no. 176 (March 1967): 510–15.

Heilbrun, Françoise, and Philippe Néagu. *Pierre Bonnard: Photographs and Paintings.* Trans. Dianne Cullinane. New York: Aperture Foundation, 1988. French edition, Paris: Editions Philippe Sers, 1987.

————. "Artists as Photographers" in *Paris in the Late Nineteenth Century.* Canberra, New South Wales: National Gallery of Australia; New York: dist. Thames and Hudson, 1996.

Makarius, Michel. "Bonnard et Proust: Les Couleurs du temps retrouvé." *Cahiers du musée national d'art moderne* 13 (1984): 110–13.

Newman, Sasha, ed. *Bonnard.* Washington, D.C.: Phillips Collection; Dallas: Dallas Museum of Art, 1984.

Terrasse, Michel. *Bonnard, du dessin au tableau.* Paris: Imprimerie Nationale Éditions, 1996.

Whitfield, Sarah, and John Elderfield. *Bonnard.* London: Tate Gallery Publishing, 1998.

### EDOUARD VUILLARD

Easton, Elizabeth Wynne. *The Intimate Interiors of Edouard Vuillard.* Washington, D.C.: Smithsonian Institution Press for the Museum of Fine Arts, Houston, 1989.

————. "Vuillard's Photography: Artistry and Accident." *Apollo* 99 (June 1994): 9–17.

Groom, Gloria Lynn. *Edouard Vuillard, Painter-Decorator: Patrons and Projects, 1892–1912.* New Haven, Conn.: Yale University Press, 1993.

Salomon, Jacques, and Annette Vaillant. "Vuillard et son Kodak." *L'Oeil,* 1963. Also appears as a separate essay published by the Lefevre Gallery, London, 1966.

Thomson, Belinda. *Vuillard.* Glasgow: Glasgow Art Gallery and Museum, 1991.

### CONSTANTIN BRANCUSI

*Brancusi.* New York: Brummer Gallery, 1926.

*Brancusi Photo Reflection.* Text by Friedrich Teja Bach. Paris: Galerie Didier Imbert, 1991.

*Brancusi: The Sculptor as Photographer.* Essay by Hilton Kramer. London: David Grob Editions; Lyme, Conn.: Callaway Editions, 1979.

Brown, Elizabeth A. "Through the Sculptor's Lens: The Photographs of Constantin Brancusi." Ph.D. diss., Columbia University, 1989.

*Constantin Brancusi 1876–1957.* Texts by Friedrich Teja Bach, Margit Rowell, and Ann Temkin. Paris: Musée National d'Art Moderne, Centre Georges Pompidou, Paris; Philadelphia Museum of Art, 1995.

Giedion-Welcker, Carola. *Constantin Brancusi 1876–1957.* Basel and Stuttgart: Benno Schwabe & Co., 1958; English edition, trans. Maria Jolas and Anne Leroy. New York: George Braziller, 1959.

*Leda: La Serie et l'oeuvre unique (Les Carnets de l'Atelier Brancusi).* Texts by Marielle Tabart et al. Paris: Editions du Centre Pompidou, 1998.

*Little Review* (New York) 1, no. 1 (autumn 1921), number solely dedicated to Brancusi, 24 plates of Brancusi photographs, essay by Ezra Pound.

Partenheimer, Jurgen. *Constantin Brancusi: Der Kunstler als Fotograf seiner Skulptur.* Zurich and Munich: Kunsthaus Zürich, 1976.

Tabart, Marielle, and Isabelle Monod-Fontaine. *Brancusi Photographer.* Paris: Centre National d'Art et de Culture, Musée National d'Art Moderne, 1997; English edition, trans. Kim Sichel, New York: Agrinde Publications, 1979.

*This Quarter* 1, no. 1 (spring 1925), special Brancusi supplement as premier issue, 46 plates, 41 of Brancusi photographs, no text.

### PABLO PICASSO

Baldassari, Anne. *Picasso and Photography: The Dark Mirror.* Trans. Deke Dusinberre. Paris: Flammarion, 1997.

Brown, Jonathan. *La Vie de peintre de Pablo Picasso.* Paris: Le Seuil, 1977.

————, ed. *Picasso and the Spanish Tradition.* New Haven, Conn., and London: Yale University Press, 1996.

McCully, Marilyn, ed. *Picasso: The Early Years, 1892–1906.* Washington, D.C.: National Gallery of Art, 1997.

Penrose, Roland, and John Golding, eds. *Picasso in Retrospect.* New York: Harper & Row, 1980.

Richardson, John, with Marilyn McCully. *A Life of Picasso.* Vol. 1, *1881–1906.* New York: Random House, 1991.

Rubin, William. *Picasso and Braque, Pioneering Cubism.* New York: The Museum of Modern Art, 1989.

————. *Picasso and Portraiture: Representation and Transformation.* New York: The Museum of Modern Art, 1996.

Zervos, Christian. *Pablo Picasso.* Vol. 1, *1895–1906.* Paris: Editions Cahiers d'Art, 1957.

# Index